LAST CHANCE FOR EDEN

cover:

Edward Ruscha
Little White Girl, 1989
Acrylic on canvas
30 x 30"
Private Collection
Photography: Paul Ruscha

endpapers:

Lari Pittman
Untitled #1 (A Decorated Chronology of
 Insistence and Resignation), 1992 (detail)
Acrylic and enamel on four mahogany panels
96 x 256"
Collection Jean-Pierre and Rachel Lehmann
Courtesy Jay Gorney Modern Art
Photography: Douglas M. Parker Studio

Last Chance for Eden

selected Art Criticism by Christopher Knight
1979 – 1994

EDITED BY MALIN WILSON FOREWORD BY DAVE HICKEY

Art issues. Press
Los Angeles

Art issues. Press
The Foundation for Advanced Critical Studies, Inc.
8721 Santa Monica Boulevard, Suite 6
Los Angeles, California 90069

This publication has been made possible through the generous support of Lannan
Foundation. Additional funding has been provided by the Peter Norton Family
Foundation and the Challenge Program of the California Arts Council.

Series editors: Gary Kornblau and David A. Greene
Designed by Tracey Shiffman, Shiffman Young Design Group
Printed by Typecraft, Inc.

Manufactured in the United States of America

Library of Congress Cataloguing in Publication Number: 95-60023
International Standard Book Number: 0-9637264-2-0 (cloth) 0-9637264-4-7 (paper)

For Fernando Sarthou, *who was there for every word*

contents

preface (ix)

Editor's Notes
by MaLin Wilson (x)

Foreword
by Dave Hickey (xiv)

Artists

Peter Alexander (5)

Charles Arnoldi and
Laddie John Dill (8)

John Baldessari I (10)

John Baldessari II (14)

Hannelore Baron (16)

Billy Al Bengston (17)

Wallace Berman (20)

Elmer Bischoff (23)

Lee Bontecou (26)

Jonathan Borofsky (28)

Chris Burden (31)

Hermenegildo Bustos (34)

Vija Celmins (39)

Larry Clark (42)

Ron Davis (44)

Roy Dowell (48)

Lorser Feitelson and
Helen Lundeberg (49)

Eric Fischl (53)

Judy Fiskin (56)

Helen Frankenthaler (58)

Frank O. Gehry (61)

Hendrik Goltzius (63)

Leon Golub (67)

David Hammons (70)

Palmer C. Hayden (73)

Roger Herman (76)

Eva Hesse (79)

David Hockney (81)

George Inness (85)

Jim Isermann (88)

Alexej Jawlensky (91)

Larry Johnson (94)

Mike Kelley I (95)

Mike Kelley II (98)

Mike Kelley III (101)

Ellsworth Kelly (103)

John Frederick Kensett (105)

Vitaly Komar and
Alexander Melamid (107)

Jeff Koons (110)

Leon Kossoff (113)

Barbara Kruger (115)

Jacob Lawrence (118)

Annie Leibovitz (120)

Sherrie Levine (122)

Helen Levitt (126)

Roy Lichtenstein (129)

Andrew Lord (131)

Alexis Smith (205)

Kiki Smith (209)

Gary Stephan (212)

Wayne Thiebaud (216)

Édouard Manet (134)

Tung Ch'i-ch'ang (219)

Sylvia Plimack Mangold (137)

Richard Tuttle (222)

Robert Mapplethorpe (139)

Bill Viola (223)

Allan McCollum (142)

Andy Warhol (225)

John M. Miller (143)

Elizabeth Murray (146)

Alice Neel (148)

EXHIBITIONS, EVENTS, ETC.

David Park (151)

Miss Piggy and the *Pietà* (231)

Ellen Phelan (155)

American Portraiture in the
Grand Manner (235)

Lari Pittman I (156)

Exile (239)

Lari Pittman II (157)

Authentic Reproductions (240)

Jacopo Pontormo (160)

Otis Clay (243)

Liubov Popova (163)

The Vatican Collections (246)

Stephen Prina (166)

Nuremberg:
A Renaissance City (248)

Charles Ray (168)

MoCA: A New Museum
for Los Angeles (251)

Rembrandt van Rijn (172)

Gerhard Richter (173)

The Olympic Art Fiasco (256)

Mark Rothko (177)

L.A. Freeway:
The Automotive Basilica (260)

Henri Rousseau (180)

The Place for Art
in America's Schools (266)

Edward Ruscha I (184)

Edward Ruscha II (189)

Art in the San Francisco
Bay Area (269)

August Sander (192)

The Macchiaioli (273)

Adrian Saxe I (194)

Adrian Saxe II (197)

Japanese Photography
in America (276)

Jim Shaw (200)

Henrietta Shore (202)

The Criticism of
Robert Hughes (338)

Hate Mail (343)

Degenerate Art (345)

On Drawing (350)

An Open Letter to Attorney
General Edwin Meese (279)

MoMA in L.A. (353)

Abstract Surrealism into
Abstract Expressionism (283)

African-American
Quiltmaking (359)

Photography and Art:
Interactions Since 1946 (286)

Worker Photography
Between the Wars (362)

American Craft Today (289)

Mexico: Splendors
of Thirty Centuries (365)

Musée d'Orsay (292)

101 Years of California
Photography (368)

Wallraf-Richartz
Museum/Museum Ludwig (295)

The Brave New NEA (371)

Van Gogh's Market (298)

The NAMES Project AIDS
Memorial Quilt (373)

The Armand Hammer
Collection (299)

Inventing Still Life (376)

Mira! The Canadian Club
Hispanic Art Tour (303)

The Vietnam Women's
Memorial (380)

Picasso: Creator and Destroyer (304)

Can L.A. Help Heal
the Arts? (385)

The Human Figure in
Early Greek Art (306)

Two Murals, Two Histories (387)

Against Nature:
A Show by Homosexual Men (309)

Painting in Renaissance Siena (313)

List of Illustrations (394)

Richard Neutra at UCLA (316)

Acknowledgements (398)

The Dada and
Surrealist Word-Image (319)

Selected Bibliography (405)

The Minneapolis
Sculpture Garden (323)

Index (407)

Case Study Houses (325)

Thrift Store Paintings (328)

Is L.A. a World-Class
Art City? (331)

preface

CHRISTOPHER KNIGHT
February 1995

The period covered by this volume begins with the emergence of an internationally resonant art culture in Los Angeles, where all of these articles were written, following the enthusiastic and important false start of the late 1950s and 1960s and the nerve-wracking torpor of the 1970s. Most were written quickly, on the run, for publication in the daily press. Except in rare instances and minor ways, I have resisted the temptation to rethink and rewrite the views expressed within them. The terrors and thrills of speediness are simply intrinsic to journalistic art criticism. You try to get used to it.

There would be no book without the remarkable diligence, unfailing good spirits, and gifted editing skills of MaLin Wilson. At Art issues. Press, Gary Kornblau and David A. Greene have been models of editorial insight and care. Because a good editor can make a writer appear better than he actually is, I am grateful to those at various publications represented here, especially the *Los Angeles Herald Examiner* and the *Los Angeles Times*. Special note is due to the early confidence of Peter Bunzel, Gary Spiecker, and others at the late, lamented *Herald*, who gave a novice the latitude to discover his voice. Among fellow critics, Peter Schjeldahl and Dave Hickey have been estimable colleagues, not least because they also understand newspapers; with uncommon generosity and humor, Bruce Kurtz set the initial example. Lannan Foundation has been peerless in its support of this collection; I am especially grateful to Patrick J. Lannan, Jr. and Lisa Lyons. Finally, enduring thanks are due to my family for their steadfast love and support.

Editor's Notes

MALIN WILSON

Santa Fe, New Mexico, 1995

The *Los Angeles Herald Examiner* hired Christopher Knight as staff art critic in 1980 based on the strength of his first freelance newspaper article, "Miss Piggy and the *Pietà*." Included in this collection, it contains all the characteristics of Knight's mature voice: a clear line of argument, humor, a Pop sensibility, a highly developed ethical code, historical depth, and an assertion that art is essential to a free and democratic society. The *Herald*, then engaged in a losing circulation battle with the *Los Angeles Times*, was known for seeking out writers with knowledge and flair rather than assigning staff reporters to "cover" the arts. Knight brought to the newspaper his interests in theater and popular culture, years of graduate work in art history, and a variety of museum experience, including work as a curator, educator, and publicist.

So, Christopher Knight began writing art criticism as a working journalist, on the beat with relentless deadlines, for a paper struggling to survive. From the beginning, he submitted two (sometimes even three) columns a week. Although this volume of 129 selected writings may strike the reader as rather large for a compendium of art criticism—and it is—it represents only 10 percent of Knight's output during the relatively brief span of 1979–94. During that time Knight also wrote forty-five freelance pieces, primarily essays for exhibition catalogs and a few rare articles for periodicals.

Since art first went public in the eighteenth century, critics have adapted themselves to a variety of rhetorical styles and relationships. Today, mass media, especially television and popular magazines, are dominated by celebrity profiles and entertainment scoops, while most serious art commentary is confined to reviews in trade, professional, and special-interest periodicals. In a 1990 random sampling of 109 daily newspapers in *Editor and Publisher Yearbook,* 11 percent listed an art editor or critic on their masthead. Of the fifteen newspapers in the United States with circulations over 500,000, only seven identified art critics.[1] Most newspaper editors and publishers place a low value on criticism, relying on readership surveys that indicate cultural news is looked at by only one in four readers (the average for all articles is 35 percent, with "Dear Abby" claiming 51 percent). Although many dailies have an art writer on staff—who must also double as a reporter and interviewer—only *The New York Times* and the *Los Angeles Times* have full-time positions for more than one art critic. Clearly, art criticism is an odd and exotic profession in this country, especially as practiced and reinvented by Christopher Knight.

With no established precedent for art criticism at the *Herald*, Knight had to define his own job as he began circulating through the Southern California sprawl. Of course, arts coverage is *not* the same as art criticism, and Knight recognized the paucity of criticism then available in Los Angeles. He decided to target an audience already curious about art; that "one in four" would be the reader who counted. Respecting the critical approach established in the 1970s by *The New York Times*, Knight decided to address his readers as peers, as people who already understood the demands of inspired art and who wanted to engage the ever-changing particularities of complex situations. Knight wrote and continues to write vividly and elegantly, so that readers may follow his thought processes as he untangles difficult issues. Knight seeks ultimately to frame the right questions rather than to provide authoritative answers.

Knight's career at the *Herald* coincided with the international art mania of the 1980s, and a burgeoning museum and gallery scene in the Los Angeles metroplex. There is no doubt that he changed the course of cultural events in Southern California through persuasive commentary, including incisive analysis of bureaucracies and museums and a courage to engage in public brawls with large institutions and established powers. When the *Herald* finally folded in 1989,[2] Knight had become the most influential art critic in the western United States, and his move to the *Los Angeles Times* was an inevitable, if somewhat uneasy, match. Whereas the *Herald* was once the "other" newspaper in the Los Angeles market, at the *Times* Knight became the other critical voice in the national arena. Although Knight still wrote for his Southern California reading public, his words suddenly carried a much broader impact.

The structure of this book, which places a section devoted to "Artists" first and "Exhibitions, Events, Etc." second, is a straightforward recognition of the primacy of artists within the art world. Knight noted in an interview that "Without [artists], there is no art world, there are no institutions, there are no events, there are no issues."[3] In all cases, the original newspaper headlines have been replaced with explicit titles. The illustrations are in black and white not simply because Knight is a journalist, but because we did not want to further the common assumption that color reproductions permit a suspension of disbelief: Unless art is intended by an artist for mass reproduction, it is simply not reproducible. Although the articles in the "Exhibitions, Events, Etc." section are in chronological order, each piece was selected for its individual significance, not as a narrative of the evolution of art in Los Angeles. The reader will find fragmented and random reflections from the years 1979–94, with comments on art events, reviews of significant excavations of California history, and analyses of major international exhibitions organized by curators in Southern California and elsewhere.

Underlying all is Knight's passion for whatever he might

find loose in the culture, rather than for fitting those loose "whatevers" into his own program. Knight hasn't only championed such L.A.-based artists as John Baldessari, Mike Kelley, Lari Pittman, Edward Ruscha, and Alexis Smith—all of whom came to national or international prominence during his tenure—he has persistently sought out underrecognized artists such as Henrietta Shore and Hermenegildo Bustos, and hitherto obscure movements such as Japanese-American photography in Los Angeles between the two World Wars. He has often gone far afield to look at quilts, folk art, and odd venues such as the short-lived Exile art gallery.

Much is missing from this collection, with regrets. Twice as many articles could have been included with conviction. The majority of essays were written after 1986, when Knight's voice clearly gained strength and confidence. By that time he had seen innumerable artworks, digested an enormous amount of reading, and written thousands of column inches. In the nothing-to-lose-and-everything-to-gain climate of the *Herald*, Knight became a better wordsmith. He was acknowledged for it with a National Endowment for the Arts Critics Fellowship in 1984 (the last year before the fellowships were quashed during the Reagan administration), and five Chemical Bank Awards for Distinguished Newspaper Art Criticism (1982, 1984, 1986, 1987, and 1991). He has since honed his already considerable skill at delicately describing works of art, and continued to develop both political savvy and an intolerance for the arrogance of power. While most newspaper critics confine themselves to reviewing objects in an exhibition, Knight has also widened that lens, analyzing museums' presentations of exhibitions as a theater critic might. He discusses direction, sets, and plot, letting the public in on information usually possessed only by insiders.

During my extended dialogue with Christopher Knight throughout the crafting of this book, and despite the tedium of the many tasks involved in assembling such a huge body of work, my appreciation for his sense of proportion, his generosity and ready good humor, his determination and mettle, and the rigorous intellectual standards he has set for himself, has greatly increased. I feel privileged to retrieve this material from newsprint and extend its life.

I thank Dave Hickey for his vivid foreword, which hums with precise understanding of Knight's unlikely and exacting love affair with Los Angeles. None of this would have been initiated without the support of Lannan Foundation and the personal support of Lisa Lyons, art program director. And, finally, my ability to edit this book rests on the resilient and loving support of my husband, Greg Powell.

1. All statistics quoted in this paragraph are from Leo Bogart, "The Culture Beat: A Look at the Numbers," *Gannett Center Journal* (Winter 1990): 23–35.

2. Between 1960 and 1990, 130 daily newspapers were lost in the United States—many of them second and third papers, and most of them afternoon papers in metropolitan areas.

3. Author's interview with Christopher Knight, August 8, 1992, deposited with the Archives of American Art, Huntington Library, San Marino, California.

Foreword

The Residence of the Spectator

DAVE HICKEY

> He pushed…fragmentation and competition for attention far
> beyond the properties of the object, extending them into
> the scarier arenas of taste, style, mythology, and history. After
> all, sensuality and violence, elegance and tawdriness are not
> objective categories. In doing so he wades into social and cul-
> tural territory that isn't just the home of the object; it's the
> residence of the spectator as well. Amidst its mass of fitfully
> contested meanings his work suddenly introduces the audi-
> ence as a full collaborator in the creation.
>
> *Christopher Knight on Adrian Saxe*

Sometime within the last three years, in prescient ex-
pectation of this occasion, I copied this sentence of Henry Thoreau's
into my notebook:"All that a man has to say or do that can possibly con-
cern mankind, is in some shape or other to tell the story of his love—
to sing; and if he is fortunate and keeps alive, he will be forever in
love." Coming upon this sentence again the other day, it struck me as
an apt characterization of Christopher Knight's strategy as a practic-
ing critic. Thoreau's peculiar conflation of rapt hedonism, dry sto-
icism, and homiletic earnestness seemed just the right blend for an
expatriate puritan like Knight, who has set up shop in the tropical
ruin of Los Angeles—especially if we keep in mind that, for the prac-
ticing critic, the apparently Arcadian condition of being "forever in love"
entails a great deal of traffic and fast language, and if we acknowledge
further, as Thoreau certainly would, that our praise of what we love is
empowered, more often than not, by our displaced loathing for every-
thing we hate.

Still, however you attenuate it, there *is* a romance go-
ing on here; and the essays collected between these covers comprise a
meditation on the Emersonian wager that there is some intimate con-
nection between pleasure and virtue. Actually, they constitute an epis-
tolary love story of sorts, although not a romantic one of the
Whitmanesque variety, in which art and song achieve the dissolution
of the self into the infinite "nature" of things. Christopher Knight is too
plain for that. In his cosmos, there is no magic, nor any presumed con-
tinuity between the content and the context, between Nature and Culture,
the Self and the Other; but neither is there any way of extricating
them from their intimate entanglement. So the romance of culture, as
chronicled here, is a comedy of manners, a dance of power, played on an

infinitely complex stage for very high stakes.

As critics often do, Knight comes closest to articulating his own agenda in his praise for an artist whom he likes and respects. Reviewing an exhibition of Stephen Prina's monochrome paintings, Knight recommends Prina's elaborate contextualizing strategies for their knowledgeable engagement of "every facet of how a work of art is received into the larger consciousness—the cultural life of the art world, of the general public, and of history." He goes on to remark that the autonomous work of art never tells "the full tale." Nor does it ever in these pages. Knight may be reviewing an exhibition of African-American quiltmaking in Long Beach, but the surrounding city, the republic, the global village, and the setting of history itself always resonate around that occasion, so these contexts are never truly absent from the texture of his commentary.

Nor could they be in a city like Los Angeles, where the everyday task of looking at African-American quilts involves driving from glitzy Downtown through the barrio, past palm-lined Anglo enclaves of crypto-Moorish mansions, across the riot-ravaged ghetto of South Central, through the endless sun-blanched tracts of Inglewood and Compton, the hilly postwar jumble of coastal Torrance, and then down into the old port of Long Beach—exposing oneself in the process to a dose of cultural complexity that would stun the average New Englander into catatonia and permanently deplete his lust for urban experience. But Christopher Knight is not your average New Englander. Although he was born in Westfield, Massachusetts and educated in Upstate New York, Southern California was always, in earliest memory, Knight's ultimate destination.

He achieved it in 1976. Coming out of graduate school, Knight accepted a curatorship at the La Jolla Museum of Contemporary Art and discovered that, coco palms notwithstanding, cultural institutions tend to exhibit a certain degree of sameness worldwide. So, after three years of escalating institutional politics and gradual estrangement from art and artists, Knight lost interest. He considered university teaching, but immediately realized that the university offered essentially the same options as the museum. Instead, he took a job as a working journalist, writing art criticism and cultural reportage for the now-defunct *Los Angeles Herald Examiner*.

At the time, the *Herald* was the adversarial newspaper in Los Angeles, and, as such, it was willing to tolerate a good deal of adversarial commentary from its young critic. So, during his tenure at the *Herald*, Knight was both free and forced by the exigencies of competition to evolve the jargon-free idiom with which he now chronicles the dissolution of Modern culture for the *Los Angeles Times*; and although one can occasionally find traces of "the discourse of Postmodernity" in the writing, "theory" functions, in Knight's practice, rather as it did in D. W. Winnecott's, like a "teddy bear lying about."

You have to have it; occasionally, you need to hug it; but otherwise, you just get on with your work.

Properly characterized, however, in the interest of inquiry, I would suggest that Christopher Knight's theoretical teddy bear, however bereft, is an evolved *ursus major*, combining the traits of a pessimistic Foucault with those of a hedonistic historicist. Mister Bear's habitat is a territory measured along axes defined by power-and-pleasure, pleasure-and-virtue, virtue-and-context. But finally, for any critic working in Los Angeles, the atmosphere of Postmodern theory is simply the atmosphere—a conceptual climate as elusive and ubiquitous as ornithology for the birds—a discourse of sublimity. Los Angeles *is* Postmodernism, warts and all. So, in Knight's practice, the parameters of theory have all but disappeared into the contingent structures of the great metropolis from whose image factories they were, in fact, derived.

Gradually, over the years, Los Angeles has become as much a character in Knight's writing as Addison's London or Baudelaire's Paris was in theirs, embodying Postmodernity as fully as Addison's London embodied the Enlightenment, or as Baudelaire's Paris bespoke his own Modernity. Try sitting down, as I did on a whim, with this book and a map of Los Angeles. Pinpoint the scattered venues as they occur, and then, perhaps, you will understand—and understand, further, why Los Angeles's vast palpable presence hovers as powerfully behind Knight's observations on a Documenta in Kassel as it does behind his views on Wayne Thiebaud at Newport Beach.

Having said all this, however, I should note that, from the outset, they have cut a curious figure in public and in print: the city and the critic, the pristine New Englander and the Babylon of stupid dreams, the eponymous Knight of Christ and the City of Fallen Angels. Simply put, Knight's prose aspires to puritan virtues unheard of in the Hollywood Hills—to an unadorned lucidity and a level of moral seriousness hitherto unrecorded on those twisting streets choked with ersatz jungle, disguising secret hideaways. And yet, at its best, Knight's prose lays like a fresh coat of dew over the opulent decadence of his chosen Eden, always alight with cool intelligence but fueled, at its heart, by a cosmopolitan version of Thoreau's swooning affection for tumult and multiplicity. So they made a go of it; and the slatternly, sun-drenched metropolis could not have dreamed a more serious lover, nor the puritan hedonist a more ravishing and exasperating object of desire.

We are all, of course, beneficiaries of this romance, and to suggest the efficacy of its symbiosis, I refer you to W. H. Auden's trenchant essay on the mystery story. In "The Guilty Vicarage," Auden compares the British and American manifestations of the mystery story and distinguishes between them as narratives of desire. Specifically, Auden distinguishes Agatha Christie's romances of the village and the country manor from Raymond Chandler's picaresque tales of Los Angeles,

suggesting that their metanarratives take place in different universes—that Agatha Christie's stories take place in Eden, while Chandler's transpire in Hell. So Christie tells the story of the snake in the Garden, Chandler the narrative of Orpheus in Hades.

Christie's detective, either Miss Marple or Poirot, represents institutions of society. He or she is called into a setting of Arcadian repose where a clandestine snake, behind the mask of innocence, has ruptured the Edenic order. The British detective, then, is charged to unmask the snake, to excise its evil influence, and to restore the beneficent, prelapsarian social order—and, quite logically, does so: Q.E.D.—Paradise regained. Chandler's detective, on the other hand, is the champion of innocence in the country of the damned, the seeker after the truth amidst a parliament of liars, the knight of virtue in a population of criminals condemned by their complicity in the corrupt social order. So, Philip Marlowe's task is to search the underworld, to walk the mean streets of Los Angeles and somehow detect, not guilt, but innocence behind the mask of guilt—purity behind the mask of corruption.

This is the great mythological narrative of Southern California—the terminal American dream: of personal salvation in the ruined garden of our national innocence, of redemption at the dead end of our cultural aspirations. And it is this metanarrative, I would suggest, that binds Christopher Knight's project to the city in which he practices it. In a culture whose critics in the mass media have devoted themselves for many generations to the assignment of guilt, the maintenance of "standards," the defense of institutions, and the restoration of prelapsarian harmony, Knight, like Marlowe (whom Chandler called a knight), is always on the lookout for innocence.

Whether he is defending George Inness's pictures against Nicholas Cikovski's appropriation of them as proto-Modernist artifacts, or defending Sienese painting against the covert art-historical agendas in the Metropolitan Museum's wall texts, or defending Robert Mapplethorpe's photographs against governmental homophobia, Christopher's agenda remains constant: to discover and recover, wherever possible, the innocence of the object by laying bare to the general public the covert institutional and mercantile agendas designed to mystify and recruit it to ends other than its own. Thus you will find a great deal less "interpretation" in this book than you might expect, and a great deal more art rather carefully dis-interpreted, re-contextualized, counter-interpreted, and granted its independence. Knight's *positive* agenda, then, with regard to the work of art, is simplicity itself. "Set it free and let it shine," he seems to say, "there is public virtue in private pleasure—in the Jeffersonian pursuit of happiness."

The defense of images and the critique of institutions, however, are not activities much encouraged these days, and as a consequence, for the past decade Christopher Knight has probably shed

more light, exerted more influence, and imposed less ideology than any critic of his generation. His journalistic criticism has provided the single, unoccluded, Postmodernist porthole through which consumers of mass media—the citizens of the republic—might peer into the hermetically sealed submarine of contemporary "high culture" and see it, for once, for what it really is. In doing so, he has provided the one venue in which the secular civilian might regularly find works of art discussed in vernacular English—celebrated and demystified—stripped of their auras of institutional and mercantile power, and made available again to the nonprofessional beholder.

Otherwise, the mighty cultural submarine slides invisibly onward, powered by privilege and manned by bureaucrats who regard themselves as the primary providers of "high culture" to the citizens of this republic. It is occasionally glimpsed by magazine writers like Peter Schjeldahl or Janet Malcolm, Robert Hughes or Peter Plagens, but these sightings are few and far between. When asked, of course, these primary providers will tell you that they need "coverage," not public critique, although, deep in the entrails of the submarine, progressive ambitions abound among the crew and staff. You cannot pick up an art magazine or an academic journal without coming upon numerous exhortations that we somehow wrest the materials of culture from the network of power relations in which they languish; and yet, for every 500,000 words of in-house critical exhortation, there is probably one word of such criticism directed to the secular population— one word actually aimed at disclosing these networks of power to the citizens who flail amongst them. That word is usually Christopher Knight's, and the response to that word from these "primary providers of culture" is usually a howl of anguished betrayal. Peter Schjeldahl calls Knight a smiling Jacobin, and he is probably not far wrong.

In short, there is no one else doing what Christopher Knight has done and continues to do—not in public, and not for a nonprofessional readership. Nor is there any commercial or institutional mandate that anyone else should try to do the same—to critique a city's beloved cultural institutions rather than admonish its presumptuous artists. So, not surprisingly, there are no universities educating writers in Knight's brand of secular discourse, nor any newspapers seeking to publish such writing, nor any cultural institutions in search of discourse like Knight's, which faithfully fulfills Michel Foucault's definition of critique as "the art of not being governed."

So this book is not one of many of its kind. It is a single beacon—the product of Christopher Knight's singular vision, his unflagging industry, and his unwavering commitment to plain-spoken independent public discussion. Still, the simple fact that Knight has been able to do this job, which he has invented for himself, for a major American newspaper should suggest that the title of his collection is less ironic than

you might otherwise have thought. And here I speak for Christopher and for myself, as well, when I suggest that there *are* ways in which Los Angeles is a "last chance for Eden"—just as there are virtues to living in the reification of Postmodern sprawl, in a city where the vices of Modern culture have not yet reached a state of institutional gridlock—where, even as we speak, the surf is up and avenues of improvisation are open, due to administrative oversight. There are secret places here, hideaways where walls have not been built, so the wind blows through, and always, there are other parts of town, other possibilities, waiting, lost and mysterious, out there under the sheltering palms, freeway-close.

Las Vegas, Nevada, 1994

Last Chance for Eden

Artists

Peter Alexander

January 1983 In 1972, Peter Alexander began to incorporate subject matter into his art. Like much painting and sculpture of the late 1960s, the work on which his reputation had developed was nonfigurative, geometrically precise, perceptually oriented, and architecturally related. His vividly colored cast-resin wedges—whether chunky and pedestal-bound or attenuated and nearing human scale—fused a precisely ordered, classically austere form with a romantically coloristic interest in light that, together, approached a metaphysical content. Their optical ambiguity and jewellike perfection spoke of a transcendentalist dream of achieving a state of hyper-clarity through perceptual awakening.

Sunsets—the surprising subject matter Alexander began to explore in an extensive series of pastel and gouache drawings—would seem to be the polar opposite to this poetic idealism. With their built-in allusions to treacly Hallmark greeting cards, to Sunday painters in seaside "artists' colonies," and to hobbyist photography, sunsets are among the most debased images imaginable for serious aesthetic consideration. Coming as it did on the heels of the so-called Light and Space movement—generally considered to be Los Angeles's first wholly original contribution to contemporary art and a style with which Alexander himself had been allied—the adoption of sunsets as motif also assumed a ready potential for misinterpretation as simply being parody.

As a subject for art, the sunset is decidedly clichéd. Images and ideas become clichés, of course, precisely because they embody meaningful cultural truths; but, through the accretions of time and a haphazard consensus, these singular truths solidify into repetitive, standardized forms: The archetype devolves into the stereotype. Within American popular culture, the radiant sunset is the stereotypical embodiment of "poetic idealism"; its archetypal source is the Emersonian blend of reason and faith that stands at the core of both nineteenth-century transcendental philosophy and its visual manifestations in the landscape imagery of such painters as Thomas Cole, Asher B. Durand, Frederick Church, John F. Kensett, Martin Johnson Heade, and others.

Ironically, 100 years after its efflorescence in American landscape painting, the sunset as an aesthetic image stands as the popular art equivalent to the fine-art content of much of the Light and Space movement. (Indeed, it could be said that by the mid-1970s, Los Angeles's identification with the aesthetics of Light and Space had itself become a cliché.) Alexander's initial forays into the sunset motif evolved from a genuine and intuitive recognition of the potency manifest by its incarnation in first- and second-generation Hudson River painting, as well as from a conscious recognition of its currently debased status as a visual cliché. In a "blend of reason and faith," this embrace of the sunset as subject speaks primarily of a shift in attitude toward—rather than

an abandonment of—the interests found in his earlier resin sculptures.

A cliché is a formal structure, and it was through several shifts in the formal structure of his art that Alexander began to dismantle the conceptual purism of his earlier work. The real mass and space of geometric sculpture became the picturesque illusionism of two-dimensional drawing. The mathematical, architectonic, wholly invented form of the wedge was subsumed into the variety of actual views seen from his studio high above Tuna Canyon, the landscape of the world intruding on the landscape of the mind. The high-tech, machine-tooled perfection of cast resin gave way to the autographic gestures and random accidents of pastel and gouache on paper. The dazzling-but-austere classicism of the sculpture became the dazzling-but-emotional romanticism of the drawings.

Peter Alexander
Sunset
1975

Alexander's sunsets are subjectively inflected—they have an emotional core. Some are lonely and meditative, some darkly ominous and forbidding. Others are brash and explosively ebullient, or erotically lush and sensual. Some revel in a cheap and tawdry glamour, others haughtily display an elegant aloofness. The objective world—the depicted sea, sky, clouds, and light, as well as the materials from which these images are made—assume subjective states. The organic vitalism of natural phenomena is matched by an organic vitalism of human emotion.

These emotional equivalences, however, incorporate a rational, measured sensibility. Whatever the aerial pyrotechnics, a foreground plane is generally established at both the top and bottom of the picture, while the view recedes in an orderly fashion to the juncture of sea and sky at the horizon. The sun as an object within nature is never seen; only its atmospheric light in the moments of transition from day to night connects the earthly and the heavenly. The naturalistic rendering in many of Alexander's earliest drawings quickly evolved into varying degrees of stylization. A serpentine squiggle of pastel on paper; an intensified range of natural colors or an arbitrary selection of nonnatural hues; dribbles of metalflake mixed with glue; and dramatic, starkly patterned black-and-white images developed during the decade,

Last Chance for Eden

fully merging the naturally occurring with the artificially applied.

Within two years of beginning this exploration of the clichéd imagery of the sunset, Alexander made his first tentative foray into perhaps the most debased medium of popular art: glitter on black velvet. The values that have attached themselves to these materials echoed those attached to his subject. Even more than in the pastels and gouaches, the velvet sunsets tended toward deliberately manipulated linear patterns and surface designs, while the simultaneously light-reflective and light-absorbent velvet yielded an ambiguous, almost painterly sense of atmospheric space. This fusion of the linear and the painterly in the velvets—which, by the end of the decade and in greatly altered form and enlarged scale, would come to dominate Alexander's work—accelerated the synthesis of intellect and idea with introspection and reverie that had been announced in the drawings. Fact and fancy merged. The organic vitalism of the world, space, and time is controlled in both the velvets and the drawings by inorganic laws: A discrete asymmetry and a consciously decorative ordering, for example, are recurrent devices in his art.

These sunsets begin to approach what Barbara Novak, in her landmark study *American Painting of the Nineteenth Century*, identified as an oriental attitude in which the artist loses individual identity through a revelation of the invisible essence of an all-encompassing Nature. It is important to remember, however, that nature, in the form of the sunset, is not the actual subject of these works. The sun still sets over the sea in the view from Alexander's studio window; but it is a sunset literally colored by our experience of every other sunset we have ever seen, whether it was a product of Nature, of Hudson River transcendentalism, or of Hallmark commercialism. The true subject of these drawings is cultural devolution—the sunset as a potent, archetypal image that has atrophied and gone stale. They are not direct transcriptions of a natural phenomenon, but of a cultural phenomenon. In them, the artist loses identity through a revelation of the invisible essence of an all-encompassing Culture.

The emotional core of Alexander's sunsets, therefore, is tied less to nature than it is to culture. He attributes the conscious life of organic vitalism not to the common objects of nature, but to the ordinary structures of contemporary culture; his animism personifies and dramatizes the collective cliché, thus setting the stage for the revivification of the potent truth within. Santayana's observation on Lucretius—that the things of nature have their poetry not because of what we make them symbols of, but because of their own movement and life—has been applied to nineteenth-century American landscape painting; here it is extended to the common, standardized, hitherto debased things of popular culture. Like other mundane experiences of contemporary life, the sunset cliché has its poetry not because of what we've made it a sym-

bol of, but because of its own movement and life. In his sunset drawings of the past decade, Alexander began the arduous task of unlocking the poetry within the ordinary prose of life.

Charles Arnoldi and Laddie John Dill

September 18, 1983 Like God before it, painting was widely rumored to have died somewhere around the beginning of the last decade. If the current abundance of painting both here and abroad is a reliable guide, such pronouncements of the death of that particular activity were indeed premature. Instead, painting seems to have gone underground for an extended period, either through a general refusal of the audience to consider as legitimate the painting that was still being done, or through the conversion of painting's strategies into other modes of activity on the part of artists themselves.

Charles Arnoldi and Laddie John Dill are two artists who appear to have taken the latter route during the 1970s, the decade in which both came to prominence in Los Angeles. The art gallery at Cal State Fullerton has mounted a dual exhibition, containing mostly recent works but with a smattering of earlier examples, that gives some indication of the approaches taken by these artists over a decade's time. Beyond their own friendship, the pairing of these two artists is appropriate given the broad commonality in their work. For in very different ways, each seems to have been consumed by a single problem—namely, how to make a painting by not painting. Despite interesting kernels to be found in their art, the exhibition reveals just how thin a premise this is for sustaining a body of work.

The reputations of both artists began to solidify between 1971 and 1974 when each was in his late twenties (Arnoldi is now thirty-seven, Dill is forty). It is difficult to follow a complete, developmental thread for either artist in the current exhibition, since the decision to pair recent work with earlier examples leaves out a good deal. These are not miniature retrospectives. Of the seventeen Arnoldis, nine were made in the last two years and eight between 1970 and 1974; as a result, none of the "volcano" or "logjam" works and none of the paintings on canvas from intervening years are present. In Dill's case, eight of the eleven works date from about the last two years, and none was made before 1976; hence, absent are the sand/glass/neon installations, which initially brought him attention (and which I find to be his most interesting efforts, based on the single example I've seen other than in reproduction). The question of how to make a painting by not painting has been considered, by both artists, within the context of painting itself that prevailed in the 1960s. At issue was elementary pictorial structure—that is, the development of an image that was coincident with

the structure of the painting. In the 1960s, Frank Stella's black, copper, and silver paintings, as well as his later "protractor" canvases, can perhaps be considered the paradigm.

Arnoldi attacked the situation in 1970 by lashing together small tree branches into a planar configuration. This twig structure became a linear "drawing" hanging on the wall. All of his subsequent work has been a variation on this theme, including the freestanding thickets of painted twigs meant to be seen in the round—making a painting by not painting but making a sculpture instead.

Dill began, around the same time, by using poured and mounded sand into which colored neon tubes and planes of glass were embedded—"painting" on the floor in an almost environmental manner with light, space, ground, etc. as literal entities. The current exhibition begins shortly after his transition to wall-bound works in 1973, when cement, often flecked with shards of glass, became the favored material. Here, the edge of glass and the thickness and ridges of smeared cement functioned as a kind of interior drawing, while the natural oxidation of the cement's limes and alkalis, as well as the random dispersal of water marks, resulted in a kind of painting.

Arnoldi's "thickets" and Dill's "landscapes" brought a dimension of nature to the issue of elemental pictorial structure. That natural dimension extended to human taste and sensibility as well, given the arbitrary patterns formed by the lashed-and-painted twigs and by the smearing of cement and the chosen placement of glass. This is what connects their work to late-1960s developments in specifically Southern Californian art; and it is also fundamental to the dilemma posed by this work.

Nature has been transformed into the technology by which "a painting that is not a painting" could be made. What assumed center stage in the process was the very existence of this new technology, while the issue of structure-as-image (or even of art itself) was merely the preexisting blueprint by which the new technology was assembled. Not surprisingly, both artists have come to be identified with their respective technologies; Arnoldi as "the artist who uses twigs," Dill as "the artist who uses cement." But like all material objects that are solely the products of new technology, an art based only on new materials is simply design. At the entrance to the university gallery hangs Arnoldi's first twig-piece (*Untitled*, 1970) and an early cement painting by Dill (*Untitled*, 1976). The remainder of the show ends up as merely a collection of design variations. It is entirely legitimate to place pure style as a central issue in painting (a lot of good art that investigates this arena comes to mind), but nowhere in this show will one find the sense of criticality that is essential to that enterprise. Instead, this art is simply stylish.

Given the context that their art has established for itself,

Arnoldi's and Dill's most recent work has locked itself into a double bind. Over the last year or two, both have turned to making paintings that *are* paintings—Dill in oil on stretched canvas and Arnoldi in acrylic on laminated-plywood sheets—but they can't help but look like just another design variation. Dill's retain, loosely speaking, the imagery found in his cement pieces, so they look bizarrely like paintings *of* his earlier work. Arnoldi has begun to use a chainsaw to hack away at the painted-plywood surface, with the result that this even-newer technology looks like a grotesque parody of Expressionist verve. Remarkably, in her extensive essays in the show's accompanying catalog, critic Jan Butterfield declares that both artists' recent work has found itself squarely within the current Expressionist mainstream. "They were spawned in the '60s, came to maturity in the '70s, but are artists of the '80s," she writes, "specifically in relation to their involvement with gestural imagery and new expressionism." If such an assertion is true, then it may be time to resurrect God from the realm of the dead. For if stylish design has become the mainstream for painting in the 1980s, then God help us.

John Baldessari I

March 1990 These are Wallace Wood's Rules of Drawing:
1. Never draw what you can copy.
2. Never copy what you can trace.
3. Never trace what you can cut out and paste down.

Wise words for our cultural times. Now, just who is Wallace Wood? And why does he espouse this pragmatic trinity of artistic laws? Don't ask me. Don't ask John Baldessari, either. He's happy to hand out photocopies of Wood's laconic plan, which he stumbled across one day (he doesn't remember quite where) and tacked to a studio wall. But its source remains a mystery. Certainly the blank anonymity of these fateful Three Commandments is part of their witty charm—and also part of what makes them so Baldessarian.

Since before 1970, when the artist consigned almost all his early paintings to the flames of a crematorium, then had the ashes interred in a funerary urn, Baldessari has been cross-examining life in a culture where nameless authority and power are endemic. In producing a varied body of intellectually rigorous, often wickedly funny art, he helped to sow the seeds of Conceptual art, which quickly took root and subsequently has flowered in mutated profusion throughout Europe and the United States.

Still, the complex course of Baldessari's work over the past twenty-five years has not been easy to follow. Although occasionally shown in galleries in Los Angeles and New York, Baldessari's work

of the 1970s was most widely seen, and enthusiastically embraced, in Europe. Conversely, the work employing altered movie stills and news photographs, which he began to make in the late 1970s, and which is among the most compelling art of the past decade, has been shown most often in the United States. It's safe to say that Europeans (but not Americans) are very familiar with early Baldessari, while Americans (but not Europeans) know the later work best. Few have a handle on it all. That is about to change. Now the subject of a much-anticipated retrospective organized by Los Angeles's Museum of Contemporary Art, where the exhibition opens late this month, a panoply of Baldessari's art will tour to San Francisco, Washington, D.C., Minneapolis, and New York. Hardly missing a venue at a major American museum of contemporary art, the show demonstrates a widespread conviction about the artist's stature and his influence.

Baldessari could hardly have emerged from less promising circumstances. Born and raised in National City, an aptly named suburb sandwiched between the border towns of San Diego and Tijuana, and a veteran of teaching stints at local high schools, community colleges, and even a camp for juvenile delinquents, he was nearly forty when he literally buried his artistic past and started over. In art, a newly pitched battle had been raging against doctrinaire formalism—against what could be called "Clement Greenberg's Rules of Painting," in honor of the powerful New York critic whose ideas had congealed into aesthetic dogma. Greenberg and his formalist followers insisted that modern art told a progressive tale of distinct refinements in the unique properties of each artistic medium. (Painting, by prolific example, was king.) To Baldessari, however, art was simply the instrument for an understanding of the relationships among human beings. Surely the medium was there to serve him, not the other way around.

Just as surely, such weighty disputes must have seemed very far away from the sleepy Navy town of San Diego. What brought it close, besides the opinionated friendship of a very small group of local artists, was the written word. Baldessari is an insatiable reader— poetry, linguistic theory, art criticism, history, fiction—who once toyed with the idea of becoming a writer and critic. Like the painter Edward Ruscha, to whose art of the 1960s Baldessari's owes a significant debt, he began to deploy both images and words in the only notable group of works that predate his artistic "death and resurrection." He's used painting, drawing, photography, film, video, prints, billboards, found objects, installations, and assorted variations, combinations, and permutations thereof—a multiplicity that insists anything is usable, so long as it is used well.

The Pencil Story (1972–73) is typical of the deceptive simplicity of Baldessari's means: It's just a sheet of heavy cardboard, about 2 feet square, onto which are glued two decidedly inartistic snapshots,

together with some text. One photograph shows a stubby pencil, basic tool of drawing and of writing; the other shows a pencil freshly sharpened. The hand-lettered text beneath them tells a familiar tale: "I had this old pencil on the dashboard of my car for a very long time. Every time I saw it, I felt uncomfortable since its point was so dull and dirty. I always intended to sharpen it and finally couldn't bear it any longer and did sharpen it. I'm not sure, but I think that this has something to do with art."

And it does, including Baldessari's nagging assertion of doubt about just what constitutes art's boundaries. His work often bespeaks a decided humility—not meekness, for its rigor declares a sharp ambition, but respectfulness, in recognition of art's capacity to engage the life and mind of another. ("I will not make any more boring art," he penitently promised in a 1971 lithograph.) Typically, he scales down any high-toned showiness that might signal a pompous dissertation on mythologies of Modernist culture, which he gleefully takes on anyhow. The Modernist faith in art's capacity to transform is metaphorically suggested by the "before and after" motif of *The Pencil Story*. Further, its pairing of photographs slyly recalls Andy Warhol's 1962 painting of a nose job, in which before-and-after illustrations were photo-silkscreened from an advertisement for plastic surgery. Yet, with cardboard and snapshots Baldessari nimbly banishes the "art signal" of paint on canvas, his dashboard colloquy toppling aesthetic inquiries from any consecrated perch atop a pedestal. Despite what often has been claimed of Conceptual art, the material simplicity of this and so much else in his work of the 1970s did not propose that everyone is an artist—only that anyone could become one. *The Pencil Story* is a parable. Its lesson, central to the larger orbit of Baldessari's art, is that ordinary levels of grinding discomfort can lead to emancipating action: Abandon pointlessness! Sharpen sensibility!

An early hint of the nascent parable appears in a work called *Wrong* (1966–68), one of a series of nominal paintings whose dimensions were determined not by aesthetics, but by practicality (the canvases just fit through the door in the artist's van). The title, rendered by a commercial sign-painter, is neatly printed beneath a goofy photograph of Baldessari, who stands awkwardly before a palm tree in a suburban front yard. The painting's "wrongness," not its "rightness," tells the truth: The pictorial composition is inept (Wrong), its mechanical production devalues the artist's hand (Wrong), the representational image contradicts abstraction's dominance in the hierarchy of modern art (Wrong), the black-and-white scheme disregards the primacy then being claimed for Color-field painting (Wrong)—and, yes, the excruciatingly uncomfortable portrait of the artist as a young suburbanite is most definitely Wrong.

Baldessari left San Diego in 1970, settling into the Los Angeles studio he has occupied ever since. Invited to teach at the new

California Institute of the Arts, the Walt Disney-inspired school where a fantasia of cross-disciplinary culture was Imagineer-ed (if never actually realized), he launched an exacting course called "Post-studio Art" and brought to campus an international array of visiting artists—Lawrence Weiner, Sol Lewitt, Daniel Buren, Hans Haacke, Robert Smithson, Douglas Huebler, and many more. Directly, through his own students, or indirectly, through nearly twenty years of shaping curriculum, Baldessari has been America's most significant art teacher since Hans Hoffmann opened his legendary New York school in 1933. Ironically, it's through the success in the 1980s of many of those students (David Salle, Eric Fischl, Matt Mullican, Mike Kelley, etc.) that Baldessari finally drew attention in the United States, as so many aesthetic roads seemed to lead back to CalArts. The recognition roughly coincided with a newly potent resonance in his art. As more words began to appear in more artists' work, Baldessari (again like Ruscha) steadily drained them from his own.

John Baldessari
Two Dwarfs
1990

Writing got subsumed by pictures, but the focus of these ambitious works remains syntactical relationships familiar from language studies. Made from undistinguished movie stills and news photographs that the artist crops, enlarges, conjoins, and sometimes colors, the pictures' subjects and authors are always anonymous. Or, perhaps it's more accurate to say that their subjects and authors are us. Generic images created by the culture, these media pictures are so pedestrian as to be nearly invisible. Like Matisse making paper cutouts, Baldessari draws with a pair of scissors, then recasts the photographic narratives through often darkly provocative juxtapositions. From banal, seemingly innocuous media imagery he coaxes forth the submerged fantasies, hidden fears, and obscured desires of a collective unconscious.

Serendipitously, the ripening of Baldessari's work coincided with the Age of Reagan, which amply demonstrated that media's crude power lies in creating superficial signals that are thickly emotional. Their points, as in *The Pencil Story*, are dull and dirty; in sharpening them Baldessari finds emancipation.

To have created a lyrical body of work out of the raw materials of mass culture is a remarkable achievement, not least because the media has long since been shown to be a colossal failure for the communication of complex moral ideas. And Baldessari, who as a young man came close to pursuing a scholarship to the Princeton Theological Seminary, is indeed a moralist. He's an artist for whom authoritative questions of right and wrong, which always threaten to tighten into a noose, must forever be kept clear and open. Late-twentieth-century Westerners apprehend their basic worldly relationships through media channels, and they have found their visual poet in an artist who discovered his own place in the world through those same conduits. In Baldessari's imaginative wake, even Wallace Wood's admonitory rules don't stand a chance.

John Baldessari II

April 27, 1990 The exhibition of John Baldessari's new work at Margo Leavin Gallery leads off with something rather startling: Installed opposite the gallery's front door is a two-panel painting, 19 feet in length. This big painting is a surprise because of its author, not its size. Baldessari's mature career, currently surveyed in a twenty-five-year retrospective at the Museum of Contemporary Art, has been occupied with a contradictory dilemma: Without using paint, canvas, or any of the other conventional tools used since the Renaissance, is it possible to make an art that is equivalent to painting? For a media-dominated culture, this puzzle is more than theoretical. His early work posed the question, while the middle work set about rigorously rethinking the very nature of art itself. The later, widely embraced work has proffered an affirmative answer.

Baldessari's achievement has been to act as midwife for a kind of "Everyman's painting," born of a union between venerable conventions common to the history of art and thoroughly modern images taken from mass media. He has since the 1980s wielded scissors to crop publicity stills scavenged from obscure movies and alter the focus of documentary or journalistic photographs clipped from newspapers and magazines. Enlarged and conjoined, these generic pictures have echoed all manner of traditions evident from five hundred years of painting: seventeenth-century still lifes, academic history paintings, Baroque allegories, Regency portraits, Rococo architectural decorations, even twentieth-century abstraction. At MoCA, this central aspect of Baldessari's art is somewhat obscured by a less than judicious choice of work from the past decade. (Several superior works are absent, while the important "Vanitas" series is completely ignored.) Indeed, one of the nineteen recent works at Leavin Gallery, several of which show Baldessari in top form, might well address the conflicted experience of having an important museum retrospective.

The diptych *Two Dwarfs* casts Diego Velázquez's most poignant subject as a confrontation between an adult dwarf and a tap-dancing, Fred Astaire-like child got up in white tie and tails. The deceptively simple composition is a media reflection of a visually radical hall of mirrors first engineered for painting by Velázquez, which pushes into the present a complicated and today obscure relationship. In the democratic palace of contemporary culture, the identities of aristocratic patron and court entertainer are blurred. Which one is really privileged, which the jester?

Two Dwarfs is exceptional, as are three of Baldessari's meditations on modern abstraction. The simplest features peasants on a promontory facing an organic black blob abutted by a blue square, tilted in the manner of Malevich. They've fallen to their knees, as if in a scene from a Postmodern *Song of Bernadette*, astonished at the miracle of art's redemptive vision.

In another, three people are transformed into a Modernist holy trinity—they're painted red, yellow, and blue—and stand atop a tall, skinny, photographically manufactured desert mesa. Rather like the "zip" in a Barnett Newman painting, this vertical stripe splits a horizontal void at the composition's middle. Baldessari pays homage to a modern icon, then upends its heavenward thrust with the figure of a gravity-bound mountain climber deftly leaping across the void.

The third work is a pungent essay on formalist painting, accomplished with a single altered photograph of arctic explorers. The small but hardy band is daringly led by a kind of Clement Greenberg figure, who voyages into the unknown: a field of colorful, brightly painted glacial fissures, dangerously arrayed against the white void of nature in a manner oddly reminiscent of a Morris Louis painting. Tentatively poking at the ice, "Clem" cautiously tests the figure-ground relationship that unreliably supports them. By a single cut of the godlike artist's scissors, this pictorial gestalt could be forever altered.

With these precedents in mind, the show's seemingly anomalous painting becomes a bit less startling. *Black and White Landscape with Torch* shows abutted images of cloudy smoke and steam, photo-mechanically reproduced in vinyl paint on canvas. One puffy cloud signals an apparently productive oil refinery, the other is a menacing sign of an apparently destructive conflagration (a small, red brush stroke acts as both igniting flame and photographically engulfed paint). The painting soon recalls Alfred Stieglitz's photographs of clouds, which he famously called "Equivalents." Although not as rich as other works in the show, this nominal painting does suggest how Baldessari's vision can both obliterate and refine a host of possibilities for art. He seizes on the familiar, then opens it up to new meanings.

Hannelore Baron

December 4, 1987 Hannelore Baron's collages and, especially, assemblages can be excruciating to look at. They're like physical lesions produced by extreme functional neurosis, demonstrable lesions that paradoxically have been made precisely in order to heal the ruinous disorder. Baron, who died this year at the age of sixty-one, was largely self-taught as an artist, and she exhibited her work only rarely. Born in Dillengen, West Germany, she fled the Nazi persecution in 1941 and emigrated to New York, where she remained until her death last April. Baron was about fifteen when she departed Europe, but youthful trauma runs deep. There can be no doubt that the unimaginable horrors of the Holocaust reside at the core of her impulse to make art. Evidence of that awful source is everywhere to be seen in her nonfigurative work: remnants of the pale stain of blood, the barb of sharp wire, the sooty blackness of ash, the finality of the coffin. Yet hers is not an exegesis concerning specific historical events as much as it is a living example of confrontation with terrible nightmares.

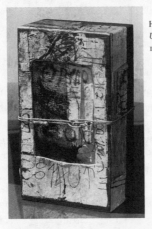

Hannelore Baron
Untitled
1982 – 83

Baron's often tiny assemblages are the most powerful works on view in the current exhibition at Jack Rutberg Fine Arts. (The show, which spans the last decade, includes fourteen framed collages and fifteen boxes that are more reminiscent, in tone and feeling, of Kurt Schwitters than of Joseph Cornell.) More than the ruminative collages, they possess an awful immediacy. A small assemblage from 1981 is an eloquent example. The shallow, coffinlike box is painted dark brown. Covered by a glass lid, it contains shards of wood, carefully tacked in place. Bits of soiled string and tattered, ink-stained cloth have been wrapped around the fragments of wood or around themselves and tightly knotted. The box—barely 4 inches high, 10 inches wide, and an inch or so deep—is

16

held together by another length of twine that is wrapped once, twice, around it, like a cord that holds together an immigrant's cardboard suitcase. Originally, this ordinary little box held bars of cream cheese (the product label is discernible, through the brown paint, at either end). Now it holds intense, tightly coiled thoughts of pain and anguish, of time passed and moments endured, of rituals enacted and life lost.

Because they must be framed, the collages seem sealed off in a way the assemblages don't. There is, in many of the assemblages, a convincing sense of precariousness that is largely absent from the collages; it makes the fully three-dimensional works more compelling. Baron's fragile little boxes have the authentic intensity of potent memento mori. Once seen, they're not easily forgotten.

Billy Al Bengston

December 11, 1988 The public success of Billy Al Bengston's art has held remarkably steady for nearly a quarter-century. From the exquisite, sprayed-lacquer paintings he began to make in 1960, which today retain the edgy power to visually bedazzle and critically startle the viewer, to the wan and spiritless decorations unhappily monopolizing his output of the past fifteen years or more, which mark a near total dissipation of artistic engagement, Bengston has watched his general popularity expand in ever-larger circles. The chief benefit of the artist's retrospective survey, which may be seen currently in the Anderson Building at the Los Angeles County Museum of Art, is the opportunity to sort out the actual nature of the artist's achievement. Because the early work is rarely seen in any depth, the more recent paintings have cumulatively obscured his prior accomplishment. At LACMA, Bengston emerges as an artist who caught a moment of epiphany and rode it like a perfect wave.

Titled "Billy Al Bengston: Paintings of Three Decades," the show was organized by the Contemporary Arts Museum in Houston, where it was first seen last May. Gathered together are some eighty paintings and watercolors ranging in date from 1959 to the present. The surprisingly clumsy centerpiece of architect Brian Murphy's installation design is a skewed room built from raw plywood and crowned by a dropped ceiling made from iron pipe and black plastic mesh. Spotlights are ignominiously clamped to the pipes, while electrical cords are gaily wound around it. This lumbering room is plainly meant to recall the controversial installation of Bengston's art at LACMA in 1968, which the artist supervised in collaboration with then-emerging architect Frank O. Gehry. (I did not see the earlier show, but documentary photographs in the catalog accompanying the current presentation reveal a design of considerably greater élan.) Most important, its plywood walls hold all dozen or so of the only notable paintings in the survey.

Glamour and showy display have been Bengston's stock in trade from the very start. In the 1960s, his bewitching skill with a spray gun yielded some astonishing pictures. They rank with the very best from that convulsively chaotic decade. Meant emphatically to seduce, they accomplished the feat through the cool and distanced application of hot and richly saturated colors of a kind common at the drive-in diner but never before seen in painting.

Nothing could have been further from expectation at the time. Bengston, who was born in Dodge City, Kansas, in 1934, but whose family had moved to Los Angeles a year before his 1949 enrollment into Manual Arts High School, is of a generation of artists on the West Coast whose initiation into painting coincided with the ascendance of the New York School. Pale pastiches of Abstract Expressionism were common products among artists of the period, Bengston included. (None, alas, is included in the show, but a fluid and brushy canvas from 1958 is reproduced in the catalog.) The earliest picture on view is *Grace* (1959), a flat, graphite-black painting whose image of a heart, centralized on the canvas in a device borrowed from Josef Albers, transforms a vaunted work of high art into a homemade valentine grandiloquently offered to an unseen lover. (You, perhaps?) It's a blunt and surprising little painting, for in a few deft maneuvers Bengston managed to take on, and fully displace, the reigning artistic orthodoxy of the day.

How? In the preceding years the triumphant international embrace of Abstract Expressionism had encoded painting with the purest form of subjectivity imaginable: The painted field of the canvas was fetishized as the embodiment of the artist's self, which was wholly independent and uninterested in bowing to the presence of a differentiated viewer. By sharp and decisive contrast, *Grace* accomplished a nimble reversal: Bengston punningly put a familiar symbol for "heart and soul" at the center of the mutely brushed canvas, and he quietly nudged into view an admission of a consciously intended recipient for his extravagant valentine. As a final nail in the Abstract Expressionist coffin, the graphite blackness of the repetitively brushed canvas draped a mourning veil over the grave of the New York School.

The eradication of the expressive self from a position of prominence was the hallmark of the radical disruptions that characterized significant American art in the heady years between 1959 and the end of the 1960s. Pop, Minimalism, Performance, and Conceptualism together constituted a fundamental sea-change for art, one whose myriad forms all shared an environmental thrust. The context within which art existed relentlessly pushed into the foreground, simultaneously acknowledging the presence of the spectator residing there. In a culture increasingly dominated by the prerogatives of mass media, art began to rigorously clarify, and to make highly self-conscious, the situation of passive spectatorship in which one unavoidably found

oneself. The aesthetic encompassed a political dimension, too, which was to erupt in the streets during that tumultuous decade: Given a social order rigidly stratified by ethnicity, economic status, gender, and sexuality, the degree to which the legions of disenfranchised were left helplessly watching on the sidelines came into ever-sharper focus. In the glamorously preening, dazzlingly flashy paintings Bengston began to make, the operative term was emphatic display—literally, to show off or to spread before view. Inside the plywood cube at LACMA, the drop-dead allure of radiant metalflake and the physically punchy charm of aluminum paintings that have been bashed with a ball-peen hammer (the so-called "dentos") attest to the artist's penchant for engagingly off-putting pageant and display. In the show, Bengston's two finest paintings are the two most vulgarly glamorous: *Buster* (1962), a square picture in which a sergeant-stripe chevron floats in an orb of metallic turquoise, pink, purple, and fuchsia, surrounded by a mandala of orange and yellow pinspots; and *Boris* (1963), a vertical rectangle, surrounded by glowing spots reminiscent of light bulbs on a makeup table, in which the mirror-mirror-on-the-wall answers its own siren call as the fairest of them all.

Billy Al Bengston
Buster
1962

Much has been made of the artist's passion at the time for motorcycle racing (one picture in the show sports a motorcycle logo), and the competitive, swaggering, daredevil showiness of the sport explains its connection to his art. Bengston's trademark chevrons put you in mind of a drill sergeant's demanding precision. Likewise, *Buster* and *Boris* are named after Keaton and Karloff, old-fashioned movie stars (not arty film actors) for whom consummate physical skill was the transformative agent that sent the mundane spinning into the stratosphere. In these two paintings, Bengston puts hot-rod Kustom Kandy Kolors through their paces in a drill so seamlessly executed as to dissolve macho dandyism into the meditative poetics of a Zen rite. A generation later, these surfside mandalas still knock you for a loop.

There are, altogether, only a dozen or so of these heady paintings in the show. The rest is toothless decoration—not the razor-sharp

kind that can tellingly elucidate one's place in the speedily shifting scheme of things, but the kind to which the adjective "mere" inevitably is attached. The decline is rapid and precipitous. A Bengston chronology might go like this: In 1958 he had his first solo show; in 1962 he had his first solo show in New York; in 1968 he had his first museum show; in 1970 he had his first museum show in Europe; by 1972, at the latest, it was over.

This chronology matches exactly the parabolic rise, apogee, and decline of Los Angeles in its first go-round as an important artistic center. It's as if, without a competitive stage on which to strut, Bengston couldn't maintain the audacious trajectory of his art. He certainly participated in opening up a general territory that was to be mined by subsequent painters. But it's revealing that his art didn't directly fertilize any younger artists of distinction. It's revealing, too, that Bengston's most important descendant is an architect—Frank Gehry, who is slightly older than he but whose particular debts to the artist's early work are increasingly apparent (and long acknowledged, in general, by Gehry). The social and environmental space of architecture, especially an architecture in which "lowly" materials like plywood and chain link are physically transformed by quirky compositions of consummate skill, is a fitting legacy for Bengston's 1960s bravura.

wallace berman

January 24, 1988 In the landmark exhibition "Photography and Art: Interactions since 1945," which was mounted last summer at the Los Angeles County Museum, Wallace Berman occupied an uncomfortable position. He sort-of-maybe seemed to fit but not-quite-really. The uneasiness, alas, is not surprising. Berman is, after all, rather typical of artists working on the West Coast in the postwar years: He's mostly a mirage, an illusion, a chimera—an influential figure who, on the rare occasion his art is approached today, vanishes into a haze of half-remembered legends and apocrypha.

Little of Berman's work from the late 1940s and 1950s survives. Almost nothing remains of his first, and only, exhibition of assemblage sculptures at the Ferus Gallery, which in 1957 was shut down by the police and landed Berman in jail on outrageous charges of obscenity. No public collections house a substantial body of his subsequent art. The bibliography concerning his career is shockingly brief and incomplete. A decade has passed since an attempt was made to come to grips with Berman's complex and often frustratingly arcane work, and even that was limited by the tragic circumstance. The retrospective show, organized by the Otis Art Institute and sent on tour to three museums in the West, was prompted by the untimely death of the artist. In 1976, at the age of fifty, Berman was killed in a car crash.

Last Chance for Eden

For this reason, the show of works from the Berman estate currently on view at L.A. Louver Gallery is both welcome and frustrating. It's good to have a chance to see a considerable body of work, but it's a sampler from a career that you hardly feel you can know. The show is large. Nine works date from 1963 to 1969, while the remaining forty-five were made during the last six years of Berman's life. Three are sculptures, each consisting of an ordinary rock chained to the pedestal (in one case the rock is encased in a box) and adorned with a painted letter from the Hebrew alphabet. Most of the rest are collages, made with an old-fashioned copier machine called a Verifax, for which the artist is most widely known today.

Wallace Berman
Homage to Artie
1965

On the evidence, there is no reason to regard Berman as a pivotal or major figure. He's sometimes mistakenly squeezed into that rarified slot because he apparently was the first artist to use an office copier to any convincing artistic effect; but being first really only counts in sporting events and scientific expeditions. Yet, Berman is certainly what could be called a "little master." If his oddly compelling and quirky art didn't fertilize a broad field of subsequent artistic activity, it nonetheless represents the intersection of so many conflicting currents that it's something of a miracle he was able to juggle them all with such obvious grace. The Verifax collages, especially, occupy an unusual position.

Verifax, developed by Kodak from research begun in the 1940s, is a wet-print process of making copies that employs a disposable negative and treated paper. Berman used the copy machine to fabricate collages, usually in a gridded format. The classic image that gets repeated in these works is of a hand holding a transistor radio. The radio speaker has been replaced by another picture: serpent, cross, nude, engine, athlete, mushroom, spider, window, galaxy, flower, padlock, hubcap, mandala, and many, many more. In most of Berman's collages the Verifax has been printed as a negative image, rather than a positive one, and the sepia tone yields a worn, aged appearance. Ironically, this picture

wallace berman

made with up-to-the-minute technology merges with the look of an ancient Mayan tablet. Or, imagine the Dead Sea Scrolls as they would have been produced by Xerox.

Berman's transistor radio—and, in one anomalous collage, a portable Sony television set—is turned on and tuned in to the music of the spheres. And that celestial music, he suggests, also is embedded in the very process of making art: The grid of radio images is often vertical, rather than square; in the exhibited collages the place at which the taller vertical row crosses the shorter horizontal row usually features a radio sporting a picture of a cross. Image and structure thus describe each other at the very heart of the work, and both are central to a larger cosmology.

Art Is God Is Love, Berman's well-known epigram, often repeated in the journal called *Semina* he published in the late 1950s, is a pretty straightforward declaration of his own artistic position. In a manner considerably different from, but nonetheless related to, the contemporaneous paintings of such disparate artists as Mark Tobey and Mark Rothko, Berman's enterprise revolved around the cultivation of the sacred. With titles like *Temple* and *Veritas Panel*, the boxy assemblage sculptures he showed at Ferus in 1957 might be considered as containers for fragments of an ideal truth. They're modern reliquaries.

So, too, are the Verifax collages. They're containers for photographic copies, or "re-created" images. Sexually explicit pictures are common in Berman's art—their presence in the Ferus show is what led to his arrest—and so are references to cycles of birth, death, and resurrection. It's as if the Creation gets re-played—re-created—in the activity of making a work of art. Hence the appropriateness of a copier as an artist's tool.

I've often wondered how Berman first came upon the idea of using the copy machine to make art, and it wouldn't surprise me if he saw some cosmic coincidence in its very name. Language is an important feature of Berman's work. The Hebrew aleph, for example, which among much else is a sign of the unity of the Creator, is often stenciled on his collages and painted on his chained rocks. Word-wise, it isn't a very far leap from the 1957 assemblage sculpture called *Veritas Panel* to the Verifax machine, which he began to use that same year. Is it too much to guess that Berman found some wry pleasure in the name Verifax—or "true facsimile"—for an art bound up in sacred ideals of resurrection and rebirth?

Following the notorious 1957 Ferus show, Berman moved to San Francisco and Marin County; four years later, he returned to Los Angeles. Part of the reason his career as an artist stands as a potentially rich mine of insight lies in the period it spans and the terrain it covers. He seeded much of the California assemblage movement. He was an integral player in the Bay Area Beat scene. Having been one of

Last Chance for Eden

those who lit the fuse in the 1950s, he returned to the Southland just as the art scene began to explode. More important, Berman's work turns on the complex crosscurrents that saw the existentialism of the 1950s erupt into the libertine radicalism of the 1960s. The self-satisfaction which marked the mood of the Eisenhower era, and which had rendered left-wing politics virtually inert, had nonetheless conspired to establish a potentially volatile situation. Without a political channel, resistance to prevailing values was directed into oppositional ways of living and of thinking—which is to say, into the life of a counterculture. Berman's is an art that speaks tellingly of those extraordinary counterculture years.

Elmer Bischoff

January 11, 1987 The Elmer Bischoff retrospective at the Laguna Art Museum has something of the air of a testimonial dinner about it. This is a place of warm remembrances and cheerful anecdotes, of ringing tributes and fervent applause, not of serious assessments of the veteran artist's work and the place of his long career in the larger scheme of things. It's too bad, because Bischoff deserves better than a retrospective-as-gold-watch.

Together with his colleagues Richard Diebenkorn and the late David Park, Bischoff came to some prominence in the mid-1950s as a practitioner of what quickly came to be called Bay Area figurative painting. Abstraction had been his mode in the 1940s, a conviction further fueled by the larger successes of Abstract Expressionism late in the decade. Following Park's earlier lead, Bischoff turned to figurative imagery in 1952, although he retained an Abstract Expressionist structure for his representations of people (usually women) seated alone in bedrooms, isolated in offices, or paired in living rooms, as well as in his many pictures of bathers. Twenty years later, though, Bischoff switched again: In 1972 the representational figures disappeared from his work in favor of idiosyncratic, feathery, often brightly colored shapes and patches of brush strokes. Recognizable imagery has not returned since.

With a generally fine selection of thirty-five paintings and a dozen works on paper, and including pictures made between 1947 and 1985, the retrospective does provide a welcome opportunity to follow Bischoff's long career. (The show, which is concluding a four-city tour at its organizing institution, has been only slightly reduced in size from its debut in San Francisco thirteen months ago.) Yet, the lens through which Bischoff is seen is a decidedly muddied one. The easy distinctions being made here between Bischoff's figurative paintings and his abstract paintings seem hopelessly naive. The exhibition casually emphasizes a polarity between them. The catalog, for example, groups

together reproductions of abstract works, regardless of date, and does the same with figurative ones. The two supporting essays have been loosely divvied up along the same lines. Careful attention to the paintings, however, reveals a degree of consistency that spans Bischoff's entire career.

Easy distinctions between abstract painting and figurative painting have never seemed more impossible to make than they do today. No doubt because the much-vaunted "triumph of American painting" in the 1950s was tied to abstraction, as the ineluctable standard-bearer of a truly modern art, abstract painting came to occupy a position of separateness from, and superiority over, paintings which contained recognizable images. They were "more modern."

Elmer Bischoff
Girl Wading
1959

The easy distinction was assaulted early on, of course, most brilliantly in the paintings of Jasper Johns. And throughout the 1950s there were painters who shuttled back and forth between the two modes, most notably Willem de Kooning. Still, easy distinctions between abstract and figurative painting continue to be made all the time. Today, they tend to find their greatest utility in marketing schemes. After a decade dominated by Neoexpressionism, in which all manner of recognizable (if often peculiar) images cavorted across canvases, we have lately been seeing in the galleries a host of pictures that are devoid of representations of people, places, or objects. Obviously, the marketplace can handily promote these works to art consumers with a tried and true sales pitch: Abstract paintings are "new." Or, to update the rhetoric of the 1950s, they are "more Postmodern."

However, this is not to say that many of these "new abstract paintings" are devoid of all representational qualities. For what they tend to be full of is representations of other abstract paintings, and of the very idea of abstraction itself. If painting is a visual language, these pictures propose, then abstraction is a *figure* of speech. In short, it is the metaphorical aspects of Bischoff's paintings that need to be addressed.

And when they are, a decided continuity between his figurative and abstract paintings clearly emerges.

Bischoff is a colorist of considerable gifts, and it is through color that his paintings achieve their most immediate impact. Carefully calibrated chromatic atmosphere also serves as a means through which the artist articulates space. Although the application of paint always hugs the flat surface of the canvas, the color, often arrived at through layers of assorted hues, opens up the surface to spatial depth. At its best, his color breathes. Line, with which figures or shapes or divisions are rendered, is wedded to gesture in Bischoff's art. The manner derives from Abstract Expressionism, and from the latter's own derivation in the practice of automatic drawing. Fluent gestures are orchestrated into the overall composition of Bischoff's pictures as they develop, rather than being arrayed according to some preconceived plan. So, color and line occupy twin positions of prominence in Bischoff's art, and it is the tensions between the very different demands of each on which his paintings rise or fall.

A structural principle is also evident in all of Bischoff's paintings, from the very earliest abstractions to the most recent work. Whether abstract or figurative, Bischoff composes his paintings upon a grid. Often, a painting will be divided into distinct quadrants. On occasion, the overall grid will correspond to a portion of the representational image in the picture, such as the windowpanes in *Orange Sweater* (1955) or the cityscape in *Yellow Lamp Shade* (1969). Sometimes the edges of organic, abstract shapes will define an invisible grid (*Untitled*, 1952), one which is occasionally tilted on the diagonal (*No. 87*, 1985).

In *Girl Wading*, a beautiful work from 1959, the complexity of Bischoff's use of the grid is in shining evidence. Two examples of that complexity will suffice: The horizon of the watery landscape is bisected by an open, vertical area of stacked colors that neatly traverses foreground and background; and the vivid light illuminating the bather's stiffly vertical right leg falls into dark shadow along a crisp line that, not by chance, corresponds exactly to the horizon. With such deft maneuvers as these, intangible properties of space and of light are interwoven with the conceptual structure of the grid.

As an organizing principle, the pure geometry of the grid has been familiar in modern art. Examples are legion. Commonly, it has functioned as a refusal of the impure world of the everyday, and as the assertion of an idealist realm of mind in which the self can be reconstituted or made anew. It is in this way that Bischoff has employed the device throughout his career, regardless of whether that reconstituted self on the canvas has taken the shape of a recognizable image or an organic patch of color. It's worth noting that his pictorial emphases on radiant color, on moving gestures, on fleshy figures in bristling landscapes, on "breathing" space, and on organic shape all represent nature set against the ordering principle of grid-as-mind.

If Bischoff's art thus concerns itself with the philosophical origins of being—a concern that ties his art to the ethos of Abstract Expressionism—then it should not be surprising that his figurative work of the 1950s so often represents classic Western myths of origin: His many bathers and recumbent nudes recall the classical theme of the Golden Age, or the myth of Eden. These fictional constructions, whose remoteness from the social space of postwar American life is part of the subject of Bischoff's art, partake fully of the traditional Modernist dream of an ideal domain of freedom. And Bischoff's nonfigurative paintings represent the same absolute in abstract terms.

The retrospective's formalist emphasis on maintaining a strict polarity between Bischoff's figurative and abstract work obscures this crucial aspect. Importantly, formalism itself derives from the same Modernist dream: The image of the artist is that of one unaffiliated with the larger social world, one whose artistically reconstituted self is formed in opposition to society. Thus, Bischoff's figurative paintings of the 1950s, the period of triumph for American abstract art, are revered in the exhibition as signs of his assertive individuality and independence. His shifts between the (supposedly) incompatible realms of the abstract and the figurative are offered as evidence of his unwavering commitment to the dictates of inner need.

Revealingly, Robert Frash, Laguna Art Museum curator of the exhibition, opens his catalog essay with an extended ode to the beauty of the Northern California landscape, into which the artist was born in 1916, while critic Jan Butterfield closes hers with a similar paean. Between them, Elmer Bischoff's art is unfolded as the embodiment of "natural expression." Alas, nothing could be further from the truth, for culture simply is not natural. In many respects, the Elmer Bischoff retrospective is representative of the conventional way in which art made on the West Coast is habitually attended to. Yet another golden opportunity for elucidation has been missed.

Lee Bontecou

April 5, 1993 "Lee Bontecou: Sculpture and Drawings of the 1960s" is a small gem of an exhibition. With ten relief sculptures, one pedestal-bound construction, and thirteen drawings on paper or canvas, it occupies a single gallery at the Museum of Contemporary Art. Curator Elizabeth A. T. Smith has succinctly surveyed a significant, early body of work by an artist of note who has not been much encountered lately.

Beginning in 1959, when she was twenty-eight and working in New York, Bontecou developed an idiosyncratic form of relief sculpture. Crossing techniques of two-dimensional painting with those of three-dimensional sculpture was a major current of the period, and

Bontecou endowed the newly emergent hybrid with a distinctive flavor. Imagine a painting whose canvas surface has been subjected to fierce internal pressures, until finally it expands and erupts and splits open at the seams to reveal dark and mysterious interior spaces, and you'll have some idea of the peculiarity of her approach. Over an armature of welded metal, she stretched canvas or tarp salvaged from old laundry bags, military fatigues, and even fire hoses. The abraded swatches of heavy gray, green, and beige fabric were sewn together with bits of wire— sutures, really, like those that seek to close a wound. If laid flat on the floor, rather than hung on the wall, the reliefs would have the appearance of topographical maps describing a landscape ravaged by bomb craters or volcanic cones. These protruding, circular holes are often backed with black velvet, which visually transforms the interior space of the crater into a seemingly bottomless pit. Sometimes the holes are blocked by jagged metal saw blades. The allusions to landscape are then joined by suggestions of human anatomy, from a menacingly grinning face to an ominous *vagina dentata*. In this way Bontecou deftly builds on the Surrealist tactic of a simultaneity of vision, in which identity is in perpetual flux. Opposing concepts of figure and ground are inseparably fused, much the way traditional ideas of painting and sculpture are.

At MoCA, Bontecou's reliefs date from 1959 to 1966. Her first, tentative forays, typically small, are quickly transformed into complex constructions 5 or 6 feet on a side and several feet deep. Later reliefs employ fiberglass and polyester resin, painted in a manner that implies a cold, metallic surface; one of them even incorporates into its asymmetrical pattern the hard shells of crabs, locating a fearsome equivalent to her man-made machinery in a natural form of carapace. As the decade progressed, her work increasingly developed an edge visibly reminiscent of science fiction, which is most plainly seen in the drawings. Graphite, charcoal, and deep, black soot are rubbed into paper or stretched muslin, creating crisp forms that allude to everything from gas masks and jet engines to flying saucers and landing craft. Strangely organic, these forms also cast a stark shadow of militarism. Miraculous creation and utter annihilation come together in these seductively horrific images. So do a sense of brutally prehistoric antiquity and grim, scorched-Earth futurism.

Bontecou's is a brand of Cold War sculpture that outpaces that of most of her older colleagues. In the exhibition, the artist is presented as something of an anomaly in the early 1960s, and it's obviously true that her work is distinct from the highly visible currents of Pop and Minimalism that together form the period's watershed. However, in another way, she is completely of the moment. Bontecou took on a largely flaccid and unconvincing tradition of Abstract Expressionist sculpture from the 1950s, and, through the infusion of a decidedly feminist set of strategies, she brought it to a stunning and dramatic conclusion.

We tend to think of the New York School as a painter's

realm, with practically the sole exception of sculptor David Smith. In fact, there was a legion of sculptors producing large-scale work, often in bronze, that grappled with precisely those themes finally given convincing form in Bontecou's art. Theodore Roszak, Herbert Ferber, Ibram Lassaw, Seymour Lipton, and others created a style that might best be described as "Mesozoic sci-fi." Their freestanding sculptures were the meeting ground for a variety of conflicting impulses: prehistoric monsters and post-historic satellites, spiny forms and streamlined shapes, organic growth and technological brutishness. In the apocalyptic aftermath of World War II, and as the nuclear cloud grew more ominous overhead, they proposed a new, mutant vision in which life was held in a precarious balance. At least, that is what they attempted. The commitment of these artists to hidebound ideas of sculpture—most emphatically announced in the proliferation of bronze—resulted in work that came down firmly on the side of old-time tradition. In the face of a profoundly different world, the sculpture vacillated between pompous and silly.

Bontecou found another way. As a woman in an art world almost exclusively attuned to the work of men, she had no need to hew to prevailing artistic forms. Taking out her metamorphic needle-and-thread—and her literal bits of canvas cloth and wire—she stitched together sculpture and painting, coming up with a formally mutant mix that sent the content spinning. The work in MoCA's exhibition brings to a conclusion one set of Abstract Expressionist principles, while cracking a door on fundamental shifts that other artists would soon explore.

jonathan borofsky

December 22, 1989 Like lightning that suddenly explodes from the quiet gathering of invisible, charged particles in the atmosphere, Jonathan Borofsky's best work manages to pull you up short by igniting a sudden *crack!* of recognition. A spectator, wide-eyed and delirious, is left momentarily reeling.

Borofsky's great *Ballerina Clown*, a monumental sculpture unveiled last week at the conspicuous corner of Main Street and Rose Avenue in Venice, is just such an extraordinary concatenation of forms. Thirty feet tall, mechanized, vividly painted, and perched on a soap box high atop an architectural pedestal, the gently kicking dancer wears oversize gloves and the bulb-nosed mask of a sentimental circus clown. A figure rather like an eccentric, street-side orator magically elevated to civic symbol, *Ballerina Clown* stands as a poignant, sharply observed visual essay on everybody's worst nightmare: the gentle soul magnanimously determined to add at least a slender grace note to the world, yet pitilessly being taken for a laughingstock.

A certain irony marks this ego-wrenching subject. For

there are those who, caught unawares by Borofsky's startling sculpture, harbor a sneaking suspicion that it might be they who are being made the fool. Stand at Rose and Main for any length of time and you're bound to see and hear the full range of possible opinion about the piece, from shrieks of stunned delight to grumpy grimaces. It's understandable. Yes, the sculpture could claim a heady modern ancestry, from Watteau's Pierrot and Degas' dancers to the circus performers of Picasso and Seurat. In my experience, however, nothing, anywhere, is quite like Borofsky's dancing giant.

Jonathan Borofsky
Ballerina Clown
1989

Ballerina Clown does connect in the memory with objects familiar from the daily landscape, most notably the cartoon colossuses peddling hamburgers, automobile tires, exterminators, and such all along roadside America. Astutely sizing up the sculpture's highly public site, the artist has chosen to speak with a common vocabulary of public forms. Perhaps because we're used to dismissing those commercial signs as junky ephemera, at best, or as intrusive eyesores, at worst, there is an initial dazed resistance to seeing a related motif inhabiting the vaunted precinct of public art. That is where we have come to expect something decorative and pretentious, not to mention airlessly innocuous.

Still, I think there is another reason Borofsky's sculpture might draw some fire amid enchantment. Like anything foreign or strange, *Ballerina Clown* is a convenient magnet for whatever unfocused feelings of ill will might linger toward Venice Renaissance, the huge real estate development to which it is attached, and for which it was commissioned. Succinctly described in publicity materials as "an upscale, mixed-use project" featuring 1.6 acres of "retail shops, restaurants and deluxe upscale condominiums with ocean views," Venice Renaissance was built by Harlan Lee & Associates and the Anden Group, and designed by architect Johannes Van Tilburg. As a project, it's a typically banal, pastel behemoth by the beach. Corinthian columns notwithstanding, the "rebirth" lifelessly proposed by the block-long Venice Renaissance is one in which a faded neighborhood gets relentlessly gentrified—surprise!—thus retelling a single-minded tale of real estate

that is just about synonymous with the modern story of Los Angeles, of California, of the United States. The sculpture is the single best thing about the place.

Jonathan Borofsky frequently adapts past motifs in his work to new situations, wholly remaking them in the process, and that is what he has done here. *Ballerina Clown* began life in 1982–83 as a gallery-scale sculpture that woozily sings a recorded rendition of the self-absorbed Frank Sinatra hit "My Way." The oddly affecting piece is among the artist's best. Subsequently, this tutu-and-toe-shoe-clad dancer turned up as a nearly life-size graphic figure, her left hand holding a kite string from which a plastic ring bobbed, in a series of hand-colored lithographs. (They may be the world's first animated prints.) The Venice figure, in keeping with its monumental new scale and the demands of its bulky site, has been made less spindly than in these earlier incarnations. Gone are the ballerina's lace tights, the kite string and plastic ring. It is wired for sound, but reportedly won't sing except on unnamed special occasions. (I can't wait!) Balancing *en pointe* and perpetually kicking her mechanical right leg, she holds together left thumb and forefinger in a gesture somewhere between a Buddhist pose of meditation and the all-American signal for "OK."

Remarkably, Borofsky's sculpture draws life from, and gives it back to, its inimical context. Given the public and commercial setting, a peculiar spin attends its deft allusion to roadside signage. Real estate development is typically hawked with beneficent, lofty claims, which invariably seem to result in a built environment that's proud to wear a grotesque public face. And that is a pretty good description of a poised ballerina wearing the clownish mask of the fool.

Of course, the rosy rhetoric of civic uplift also fuels the claims commonly made for public art, claims that have left the landscape littered with dross. It's rare indeed for public art to critically address its own situation, but that's what *Ballerina Clown* triumphantly does. Venerable is the legacy of the tragicomic court jester, whose license it is to publicly ridicule the very institutions that support him.

At Venice Renaissance a second commissioned sculpture is more typical of the bland mediocrity commonly churned out to match the fulsome rhetoric. Guy Dill's *The Harmic Arch* is a 75-foot span of welded, skeletal, geometric shapes that vaults over the Navy Street entrance to the parking garage. ("Harmic" is reportedly a Sumatran word meaning "coming from a humble/heroic element.") Garage entrances tend to be ugly, if plainly necessary, and this one is no exception. Appended to the architectural forms of the building, the Tinkertoy shapes of the sculpture create luxury camouflage for the unsightly driveway—chiefly for the benefit of residents in the half-dozen "deluxe upscale condominiums," whose ocean-view balconies loom out over the concrete abyss. By rather stark contrast, Borofsky's streetside sculpture admits of both

deeply human desire and equally human failing. A communal gesture of remarkable generosity and goodwill, it's a momentous work of public art.

chris burden

June 28, 1992 No sculpture in recent memory has demonstrated as keen and disturbing an artistic intelligence as Chris Burden's *The Other Vietnam Memorial.* A chilling commemoration of a grim facet of the modern American psyche, the memorial offers further compelling evidence that, at forty-six, Burden is among our most significant artists.

Imagine a desktop Rolodex as designed by the Pentagon, and you'll have some idea of what the sculpture looks like. Machined from brute steel, fitted with copper plates in place of revolving paper cards, and exploded to enormous scale (it stands 13 feet tall), the sculpture shrouds bureaucratic weaponry with an icy glamour. The copper sheets, which subtly recall printing plates, are etched with a seemingly endless list of Vietnamese names in tiny black letters. Some identify specific people who perished during U.S. involvement in the Indochina conflict. The rest are computer-generated fabrications. Exact records being unavailable, Burden used a basic catalog of nearly 4,000 names and had them mixed-and-matched through a computer. Three million is the total number of war dead during America's involvement, which includes about 250,000 Vietnamese soldiers and 1.5 million civilians in the South, and some 700,000 military and 250,000 missing in action in the North, plus estimates of heavy losses in embattled border regions.

Commissioned last year for "*Dis*locations," the Museum of Modern Art's first substantive show in nearly twenty years to attempt to chart the shifting tides of contemporary art, the memorial is in the collection of the Lannan Foundation in Los Angeles, where it has just gone on public view. (It's being shown with another extraordinary sculpture from the foundation's collection, Burden's 1979 *The Big Wheel.*) There, it does lose one small chord of resonance that reverberated like a tuning fork through MoMA's galleries. In 1970, when MoMA presented its last major contemporary show, a stir was created by German expatriate artist Hans Haacke, whose contribution was a notorious site-specific piece called "MoMA Poll." Visitors to the show— a survey of new Conceptual art titled "Information"—were invited to cast ballots on the question: "Would the fact that [New York] Governor [Nelson] Rockefeller had not denounced President Nixon's Indochina policy be a reason for you *not* to vote for him in November?" Two to one, visitors answered "yes"—even though the Rockefeller name (and money) had been synonymous with the Manhattan museum from the start. Nelson had been chairman of MoMA's board; his brother, David, was then its chairman, and their mother had been one of the four founders

in 1929. But the poll results were clear.

Burden was a graduate student at the time Haacke took his famous poll; consciously or not, his Vietnam sculpture managed a subtle engagement with MoMA's past. Two decades later, *The Other Vietnam Memorial* reverberates against the sad and savage failures of history. Of course, the sculpture's "monumental implications" can't be contained by a single art museum. The loss in its change of venue to L.A. hardly matters. Because the sculpture was conceived and built in the wake of last year's Persian Gulf War, the fury of Desert Storm offers an originating context far more significant than one museum's exhibition history. Before, during, and after the military adventure in the gulf, few Americans regarded the Iraqi people as mortal enemies. Enmity was instead focused like a laser beam on their leader, whom we re-created almost overnight from favored U.S. ally into the new Adolf Hitler. A personification of evil, Saddam Hussein stood in for the indifferent crowd.

Chris Burden
*The Other
Vietnam Memorial*
1991

Yet today Hussein remains in place, while tens—perhaps hundreds—of thousands of Iraqi civilians are dead. That we neither know nor seem to care about the actual number of slain "enemies" is less a testament to collective inhumanity than a brutal symptom of the psychological shutdown necessary for war. Wars cannot effectively be fought against individual men and women, each with a human face and heart. To do so would be unbearable. Therein lies the harrowing power of the Vietnam Veterans Memorial in Washington, Maya Lin's masterful wedge of etched, black granite embedded in the earth, to which Burden's memorial obliquely refers.

The list of the 57,939 dead American men and women on the Vietnam Veterans Memorial does put a viewer face to face with the enormity of the tragic carnage, while personalizing each and every life. Yet, it also accomplishes something unexpected and even more agonizing. Societies typically build memorials to commemorate their own war dead, not their enemy's. But those distinct boundaries are blurred in Maya Lin's design. The black granite wall is polished to a mirror

Last Chance for Eden

finish; it reflects the face of every visitor across its sea of names, which seems to stretch to the horizon. All Americans are obliquely acknowledged, regardless of their relationship to the event. Not unlike the Civil War—which defined the American story as surely as the Peloponnesian did the ancient Greeks'—the Vietnam conflict was, in heart-wrenching ways, a war in which Americans fought Americans. The Veterans Memorial powerfully remembers those who died, yet it doesn't let us look away from the battle that raged—and still rages—among ourselves. Its emotionally vivid power doubles.

Burden's *The Other Vietnam Memorial* couldn't be more different in intention and effect, but it does elaborate on the great precedent in Washington. For if Lin's showed us that the enemy is ourselves, his shows us how that enemy thinks. Burden's sculpture luxuriates in the cool refinement and technical complication of its own heavy-industrial manufacture. Sleek, finely tooled, and exquisitely crafted, it is first and foremost a brute machine, filing empty integers into a data bank of names. The ninety-six copper "printing plates" create a kind of smooth metallic skin, into which foreign-sounding names are etched. Fabricated identities for unknown individuals transform flesh and blood into computerized information. Millions of anonymous dead are made equivalent to John and Jane Doe. The style of the monument, which mimics public sculpture, haplessly befits a bureaucratic culture—especially one that has come to define itself according to technological goals and achievements.

Its title is an important clue to the old-fashioned, deeply entrenched idea that made this foreign adventure possible. *The Other Vietnam Memorial* doesn't just get you thinking about the other monument in Washington. It also declares that Burden's sculpture has been designed as a memorial to those we habitually conceive to be "the Other." Transcending topical politics, the hoary conception of a Homogeneous Us versus an Alien Them allowed the fruitless slaughter. *The Other Vietnam Memorial* is as much an officially sanctioned tribute to American fear, ambition, and loathing as it is to slain men and women. Its shocking moral ambivalence is the source of its riveting power.

That's why the most distressing feature of its New York debut last fall was the degree of seemingly willful blindness spoken in the critical response, much of which ranged from tepid to angrily dismissive. Burden got rapped, and rapped again, for not sentimentalizing his memorial. Roberta Smith, who assumed that the scale of the human carnage was the sculpture's main point, wrote in the *New York Times*: "[There] is often a sense that the message and the medium are out of sync . . . that the concept has been emphasized at the expense of form with results that can be earnest and preachy, or that don't seem inevitable. It's not clear, for example, why the three million names in Mr. Burden's piece . . . had to be etched on copper; the impact of their great numbers would have been much the same had they been printed on paper

covering the walls."

Holland Cotter similarly lamented in *Art in America*: "[Once] you had read the explanatory tag at the entrance, you 'got' the piece, and it was hard to take it any further. The fact that the names of the war dead listed here were essentially stand-ins took away some of the work's emotional charge. You were left wanting to feel more fully drawn into the piece." In *The Nation*, Arthur Danto likewise complained: "It touches no emotions, not least of all because the names are generic Vietnamese names, designating anyone and no one. The power of Maya Lin's masterpiece is that there is a direct causal and semantic tie between each name and a specific individual, so that in touching that name one is multiply related to that very person. . . . [Burden's memorial] shows disrespect for the very persons it was meant to represent."

Danto is innocently unaware that the virulent power of just such disrespect is a central subject of *The Other Vietnam Memorial*. He and other critics refused to see what Burden had wrought, choosing instead to lament what he had *not* wrought—namely, an equivalent to the black granite wall in Washington. Consider their common discomfort over the computer-generated list of names, a discomfort they try to banish rather than to feel. Instead of disturbing their own expectations, the absence of an emotionally vivid, comfortably recognizable experience was repeatedly projected as a sign of the failure of the artist.

Why such a bizarre collapse of critical standards, in which one artist is berated and dismissed for not having produced a work of art that replicates another's? The powerful claim on the American imagination exerted by Maya Lin's great memorial may be one explanation. So might the inexperience of critics in New York with the work of the California-based sculptor. (Recall that no museum in Manhattan had the prescience to host Burden's 1988 touring retrospective, which proved to be the most important that year.) You get the feeling, though, that an even more powerful motive is the lingering, subconscious desire to be absolved of guilt and complicity in the Vietnam debacle. Burden didn't deliver a feel-good catharsis in *The Other Vietnam Memorial*. In the shadow of the mountain of corpses, imagine how presumptuous that would have been—especially since Desert Storm showed that nothing much has changed.

The truth is hard but simple. Burden's firm refusal to sentimentalize the conflict is not a defect. In fact, it's the touchstone to the sculpture's enduring brilliance.

Hermenegildo Bustos

December 15, 1991 Hermenegildo Bustos (1832–1907) is the most important Mexican painter of the nineteenth century. If you've

never heard of him—well, don't be surprised. A year ago, few in the United States had. Bustos's reputation has been rather like the proverbial stone dropped into a pond. At its center, the splash was dramatic, while its ripples have been slowly expanding in larger and larger circles. Finally they've reached our shores.

The center of the pond is the provincial village of La Purísima del Rincón in central Mexico. There, Bustos was born, lived almost all his life, and died at the age of seventy-five. For the past year, five of his paintings have toured the United States as part of the sprawling "Mexico: Splendors of Thirty Centuries," now concluding its much-remarked journey at the Los Angeles County Museum of Art. If you haven't seen the Bustos pictures yet, proceed directly to the ground-floor galleries of the Hammer Wing.

Bustos painted countless ex voto images for neighbors desperate to express gratitude for divine intervention in their earthly tragedies, as well as occasional religious pictures. Most significantly, he made often mesmerizing portraits of local bourgeoisie and peasants. So important to the establishment of civic pride was this work that, eventually, the town he lived in would come to be called La Purísima del Bustos. Soon after his death, however, Bustos was forgotten. The bloody, protracted Revolution of 1910 intervened. Not until the 1930s did interest revive, in the person of poet and diplomat Francisco Orozco Muñoz, who began to collect the painter's work. A retrospective was mounted in 1952, and the circle now encompassed the state of Guanajuato, whose eponymous capital has since become the principal repository of Bustos's art.

Today, an extraordinary permanent display at the Alhóndiga de Granaditas, an imposing regional museum in the lovely silver-mining hill town, includes six ex votos, a small religious picture, two highly unusual little paintings of celestial phenomena, and some forty-nine portraits. They range in date from 1850 to 1903, and most belong either to the museum or to the National Institute of Fine Arts in Mexico City, which has placed them on loan. Ten more portraits—including an early, decoratively stylized and unusually hermetic painting of the artist's wife Joaquina Rios—are housed a few blocks away, at the intimate Museo del Pueblo. Bustos's paintings have since been regularly shown in exhibitions in Mexico City, and occasionally they've cropped up in displays in Paris and London. The selection at LACMA is somewhat uneven, given what could have been assembled, but it offers an intriguing introduction nonetheless. Among them is Bustos's sole self-portrait, an austere, highly refined, and somehow vaguely eccentric image. The gaunt, mustachioed artist shows himself proudly dressed in a crisp, dark uniform with gold buttons and crosses—a pure invention, since he never served as a soldier.

Bustos painted this great, grave picture exactly a century ago. Sometimes, it takes a while for word of greatness to spread. But now

that it's here, it's worth considering just what makes these pictures so compelling—compelling enough to catapult Bustos to so prominent a position. The task is not an easy one, and guideposts are hard to come by. Almost nothing in English has been written about him, including many basic biographical facts. The most comprehensive study is a 1981 catalog (in Spanish) by the eminent Mexican art historian Raquel Tibol, for a show in Guanajuato, but it's long since out of print. [Editor's note: reprinted in 1992] A few articles have cropped up in far-flung periodicals—the earliest being a 1943 essay by Walter Pach in *Art in America* magazine announcing "A Newly Found American Painter," the most recent a 1985 essay by Nobel laureate Octavio Paz in the glossy journal *FMR*. And the catalog to "Splendors" makes some noble stabs at interpretation, although even its enthusiasm sometimes derails.

Notably, the catalog bemoans the "unsophisticated compositions" of Bustos's two known still lifes, one of which is in the show. In reality, they are astonishing inventions, unlike anything this critic has seen before. *Still Life with Pineapple* (1877) shows about two dozen fruits and vegetables laid out across the surface of the smallish canvas. Each is painstakingly depicted in a Realist manner, with soft and uniform lighting entering from high up on the left, as if you're looking down on the pear, potatoes, pineapple, and such resting on a table top. There, the Realism ends. Bustos hasn't arranged the fruits and vegetables in a bowl, a pile, or any other naturalistic display. Instead, they're all lined up, one after the other, in half a dozen fairly neat horizontal rows. Each is painted as a self-contained entity, and the big pineapple and a trio of skinny beans are turned on the diagonal, in order to fit their shapes into the seamless composition.

In other words, Bustos's still life has been arranged according to the logic of the picture plane, rather than to any naturalistic conception of how these objects would be encountered in the world. Its gridded format, in which the surface of the canvas becomes the self-conscious surface on which the images rest, is thoroughly modern. More than just a case of a naïve painting by a folk artist that resembles the stripped-down abstractions characteristic of modern art, the composition instead embodies a modern way of seeing.

Whether Bustos had any training as a painter isn't known for sure. Some think he may have apprenticed in his youth at the studio of Juan Nepomuceno Herrera in the nearby city of León, but accounts suggest little about his life before adulthood. They do show that Bustos was a devout Catholic, who organized religious pageants and perhaps restored paintings in local churches, and that he was a jokester, certifiably eccentric, and held himself in rather high esteem. They also reveal him as a jack of many trades: laborer, carver, silversmith, quack doctor, pawnbroker, carpenter, band musician, and even a seller of a kind of ice cream. Painting was plainly just one of many things Bustos did

to get by. (Making ex votos seems to have been a particularly lucrative business for him; many are extant, though their attributions aren't always reliable.) Even more than the other inventive trades in which he engaged, his painting speaks of an unusually inquisitive nature that reveled in the sensuous pleasure of the world.

Hermenegildo Bustos
Self-Portrait
1891

The still life shows how. No allegory is intended, no narrative implied, no myth recounted in a picture such as this. Always you are conscious that the fruit has been laid out for just one purpose: simply for you to *see*. Bustos goes even further in his determination to use paint principally as a vehicle of perception. Different types of potato and different stages of ripeness of the same fruit are painted side by side. Pieces have been cut out of several of the fruits, to show you what they look like inside. The cut side of a lemon faces forward, its pulp and seeds open for inspection; next to it rests an uncut lemon, its textured rind a dazzling yellow. It may even be the same lemon, simply turned over by the artist and, on the canvas, turned over in your mind. Change, uniqueness, and variety are magically conveyed.

This perceptual emphasis is also plain in two small, very eccentric images painted on tin and housed in the Alhóndiga. One is a halation of yellow color on a pale blue ground, depicting an inexplicable celestial phenomenon (rather like an aurora borealis) that Bustos witnessed in the western sky, beginning September 16, 1883, and ending April 10, 1886. The other records his sighting of four different comets—the first, a dazzling arc of light in 1858, the last a pale wisp of luminescence in 1884. Their commemoration of miraculous events in little paintings on tin is obviously related to the ex voto tradition, as is the description of the event carefully printed by hand below the images. What's remarkable is that Bustos would return to a picture to make additions, diarylike, after as much as twenty-six years. It's an ex-

ample of his obsession with perceptual experience, and of his conception of art as both a commemoration of and a parallel to it.

It is in Bustos's portraits of the people of his town—the earlier on canvas, most of the later on tin—that this obsession comes together most powerfully. In a prosperous (if not wealthy) region where silver mining had once driven the economy, a number were commissions from the bourgeois citizenry. The most beautiful is of an unidentified woman with a shawl. Painted when Bustos was just twenty-nine, it shows a serene, middle-aged woman, her pearls, golden earrings, brooch, and rings a sign of her station, the prayer book prominently clutched in her hands a sign of her piety. However, something else about this picture makes it mesmerizing. In his best work Bustos paints with excruciating attention to detail—every eyelash is rendered, one by one—while the massing of forms is simplified and elegant. Here, those traits collide in a dazzlingly complex passage where the delicate fringe of the woman's shawl cascades across her vibrant, boldly patterned, orange and black dress. This bravura passage is a visual seduction that pulls you in close to scrutinize the painting. Deftly, Bustos puts you in a position parallel to the artist scrutinizing his sitter.

Bustos also took commissions for special occasions like a wedding or to commemorate the death of a child. "Get me Bustos!" you imagine locals crying, whenever an event of note came to pass. Among the most haunting of the latter is *Niña Muerta: Francisca Quesada* (1884), a small picture of a dead infant, wrapped in a red blanket, clad in a white bonnet, and of sallow skin. Among the most puzzling is a lovely, undated family grouping in which a sorrowful father and mother flank and embrace their black-garbed daughter, who stares almost blankly ahead: Do the parents share her grief in mourning—or is it they who are mourning for a deceased daughter, posthumously commemorated here?

Other portraits apparently were painted of the artist's friends and neighbors. Most of these little pictures are oil on tin, which became Bustos's preferred medium after about 1870. (Tin is common to areas where silver is mined, and was widely used for ex votos.) Unstintingly direct, the portraits are never idealized, record every blemish or irregularity, but are never cruel. As much as Courbet, his devotion is to the glory of what his eye can see.

Generally, Bustos's portraits partake of the standard conventions of the genre, especially among academic artists of the era: three-quarter view, waist or chest high, oval framing, even light. Yet, these are anything but academic in feeling. Why? There's no way to know for sure, but looking at these pictures it's unthinkable that Bustos hadn't seen portrait photographs. The "miracle" of the still relatively new medium, which was as influential in Mexico in the second half of the nineteenth century as anywhere else, surely would have galvanized his perceptual instincts in ways that academic training would only have

blunted. Indeed, that Bustos worked outside the academic influence of his time is likely his saving grace, and one important factor setting him apart from the usual litany of artists from the period on whom praise is incongruously heaped. José María Velasco, the lauded landscapist whose work recently fetched a record-setting $2.2 million at auction, is a perfectly respectable painter. But his skillful mastery of a narrowly academic manner is his principal, and rather meager, achievement.

Bustos is certainly erratic in his work. Sometimes, you can put two pictures side by side, and it takes a while to recognize that both were painted by the same hand. This is especially true of the sharp, seemingly irreconcilable differences between his folkish ex votos and his best portraits. It's an exaggeration to say that the only consistent quality in his art is its inconsistency, but like most exaggerations it springs from a well of truth. It also explains why he's so important. Unlike Velasco, who meant to stand tall on the shoulders of academic tradition, the painter from La Purísima del Rincón had more profound aspirations. Hermenegildo Bustos meant to look his fellow human beings in the eye. In his paintings, we meet their startling gaze.

vija celmins

January 1992 In 1966, Vija Celmins made a number of grisaille paintings of American, German, and Japanese airplanes from the era of World War 11. Horizontal and relatively small—each canvas is about 16 inches in height and 26 or 27 inches in width—these Realist images, thinly painted in oil, are painstakingly described through careful brush work. Extraordinary, hauntingly beautiful paintings, they constitute the artist's first mature works (just two years out of graduate school at UCLA, she was twenty-seven when she made them), and they stand among the most compelling of the period. More resolved than the muted, quirky little pictures of such domestic objects as a gooseneck lamp, a space heater and a hot plate, which had immediately preceded them, the airplane paintings are no less eccentric in spirit. Where did these taut and peculiar gems come from?

Celmins might have been aware of the group of five grisaille paintings of airplanes made by the German artist Gerhard Richter two years earlier, in 1964, but I doubt it. Neither artist had as yet developed a reputation beyond a small circle of associates and colleagues, and with most eyes focused on art produced and shown in New York, there's no reason to suspect artists at work in Düsseldorf and in Los Angeles would even have known of each other's existence on the planet. Besides, like the disparity in size and emphasis between their pictures—the German's are twice as large, and they convey a dramatic sweep associated with great events—the tenor of Celmins's and Richter's paint-

ings is quite different. His feel relentless, oppressively gray, and cold as ice. Hers are intensely focused, almost claustrophobic in their scrutiny, but there seems to be a hint of warm color radiating from the under-painting—all of which adds up to an odd sense of the highly personal and contemplative.

Vija Celmins
German Plane
1966

Still, the similarity in both subject and grisaille technique is notable. Richter, who is older, was born in Dresden, East Germany, in 1932 and was barely a teenager at the close of World War II; in 1961, he left the Soviet satellite and crossed over to the West. Celmins was born in Riga, Latvia, in 1939, just as the war was beginning; her family fled to eastern Germany, then to West Germany following the partition, and finally to the United States (Indianapolis), all by the time she was ten. If her childhood was spent on the move, her adolescence was spent in the heartland of an adopted homeland that was also on the move: For the first time, the country was asserting its international authority. Clearly, in their paintings of military aircraft both artists are thinking in very different ways about past episodes of obvious importance to their own lives. The imagery is loaded with contradictions and ambiguities, given a per-sonal encounter with war that was inevitably a defining experience.

For Celmins, the experience of art, especially Abstract Expressionist art, also ranks as a prominent episode. First as a student at the John Herron School of Art in Indianapolis from 1958 to 1962, and then at the start of her three-year stint at UCLA, Celmins painted prin-cipally in an Abstract Expressionist manner. (The limpid, light-filled ab-stractions of Arshile Gorky were her chief inspiration.) The inherited imperatives of the style were second nature to her by the time she was in graduate school, which was reason enough for her anxiousness to throw off the mode. In 1964 that is what she began to do, with small and muted paintings of simple domestic appliances.

It's important to remember that, among painters, the artis-tic explosiveness of the 1960s happened in a powerful vacuum, which had been created by the enervation of abstract art. Most all the emer-gent Pop artists, and a significant number of the Conceptualists, had theretofore painted in one variation or another of a pale Abstract

Last Chance for Eden

Expressionist style. They knew it was vapid and empty. They knew, too, that the pressure to maintain a certain artistic momentum was high, a pressure made all the more apparent by the 1961 publication of Clement Greenberg's critical anthology *Art and Culture*. Greenberg had carried the torch for twenty years; where it would be passed was now at issue.

One after another, artists began to make work in which the dominant imperatives of abstraction were paradoxically represented in figurative or literal terms. Andy Warhol's art stepped up on a soap box (filled with cleansing Brillo pads) and gave us advertisements for the bravura brush work and loaded-on paint that had come to be known by the colloquial name of Abstract Expressionist soup. Roy Lichtenstein got out his *G.I. Combat* comic books to do opposing battle in Greenberg's war against any art that strayed from abstract doctrine and had his screaming fighter pilots take direct aim at the so-called poured paintings of Helen Frankenthaler and Morris Louis (*Okay, hot-shot, okay! I'm pouring!*). Edward Ruscha rendered the pervasive standards and norms by which both art and mass culture were now defined, in environmental pictures of ubiquitous Standard gas stations and Norm's coffee shops. To remove any doubt about the abstractness of art, John Baldessari had a sign painter spell it out. Sigmar Polke and Gerhard Richter, Europeans who had been on the receiving end of the aggressively successful international export of American Abstract Expressionism, sought to balance the deficit in aesthetic trade by sending aloft a style these former East Europeans dubbed Capitalist Realism.

Finally, Vija Celmins entered the battle with assorted images of fighter planes. Pointedly, she made them small. The supposedly defunct genre of easel painting was harnessed for a purpose: to faithfully represent, in otherwise contradictory terms, the absolute primacy claimed for the picture plane. The imagery she chose is deftly tied to the form. For an artist whose youthful commitments had been to Abstract Expressionism, the intimate scale of these works must be seen as a sharp repudiation of the 1950s prohibition against easel painting. Furthermore, the repudiation was accomplished not by mere petulant refusal, but by making the form absolutely essential to her enterprise. As Greenberg himself had once written, albeit in a claim about the problematical future of the easel picture as a vehicle of ambitious art ("The Crisis of the Easel Picture," reprinted in *Art and Culture*), its form is determined by its social function, which is precisely to hang on the wall. An easel painting is, in short, a suspended plane—the exact image Celmins began to paint and even used as the title for a canvas from 1966.

Celmins's "picture planes" are multivalent. Their grayness alone accomplishes four principle tasks: It acknowledges the source of the images in black-and-white photographs; it establishes the principal coloration of the painting as deriving from the metallic color of the central object (an airplane) that is described; it creates a modu-

lated, all-over surface for the painting, an abstract uniformity of tonal gradation that is held in tension by the contrary illusion of a figure (the airplane) against a ground (the pictorial space); and it stands in stark contrast to the bright, synthetic, aggressive hues prevalent in contemporaneous figurative painting, both Pop and Photo-Realist.

The sly wit in the artist's approach is among these paintings' great pleasures. You don't laugh out loud in front of a Celmins "picture plane," but the diabolically clever and self-assured way in which she attacked her subject, wrestling it to the ground, generates wide-eyed glee. None is so remarkable as *Flying Fortress*, a soaring image in which the entire tail section is, for no immediately apparent reason, breaking away from the body of the airplane. Of course, the presence of a convincing illusion of a three-dimensional object in space means that, despite the artist's careful demonstration that the photographic source of this image is itself quite flat, the flatness of the picture plane has been radically breached. So, Celmins shows us the ostensibly permanent stronghold that constitutes a fortress literally coming apart at the seams.

She also insists, in lucid and consummately refined pictorial terms, that pictures are magical places where virtually anything is possible. In 1966 Celmins put painting on a new plane, and in 1967 she set it aside to go on to other things.

Larry Clark

February 22, 1984 "Obscenity" is the word that keeps stumbling around in the brain as the eye follows the sequence of images in Larry Clark's photographic odyssey, *Teenage Lust: An Autobiography*. True, there are photographs of sexual coupling and erotic posing, of violence and human decay, but it is most emphatically *not* these pieces of paper that are pornographic or obscene. These stark and often artless images push such ideas out of the manipulative realm of dreams or fantasies on which obscenity feeds; instead, it comes squarely to rest in the ordinary world of desperation where human lives are lived. For together, Clark's photographs constitute an autobiographical rumination that is a harrowingly poetic essay on survival.

Teenage Lust is on view at Tortue Gallery, as well as in a self-published book of the same title that appeared late last year. Clark's reputation as a photographer borders on the cultish, in part because he is most widely known for a suite of pictures (and a book) called *Tulsa*, in which drug addiction and death played a prominent role, and in part because his own past reads like a darkly sinister version of a picaresque novel. (Selections from *Tulsa*, which was released more than a decade ago, are also on view at Tortue.) Prison, amphetamine cravings, prostitution, knifings, flights from the law—his life has the furtive ap-

peal of sensationalist tabloid journalism, the kind that "respectable" folks wouldn't be caught dead reading but about which they'll passionately argue. Ultimately, however, this conflicting appeal is matched by the difficulty in locating his work: It does not comfortably reside within any one photographic tradition. Clark uses photographs almost in the manner of raw material with which to examine his life: It is not necessarily the photographs themselves, but the quality of that examination in which his art is found.

Larry Clark
from *Teenage Lust*
published 1983

Clark's work evinces a literary sensibility. The photographs in *Teenage Lust* begin with snapshots of Clark as a child in the late 1940s—with his parents at a restaurant, holding a kid's camera with a Roy Rogers logo, in a commercially artful pose (his mother ran a door-to-door baby picture business). With the exception of a very few pictures, it skips his teenage years and moves into the peripatetic travels and adventures, legal and illegal, that followed. It is this absence of images from those high school years that forms the raison d'être of *Teenage Lust*. In a typewritten statement tacked on the wall midway through the exhibition, Clark writes, "*since i became a photographer i always wanted to turn back the years.*" In 1972 and 1973 he returned to Tulsa and "*the kid brothers in the neighborhood took me with them on their teen lust scene. it took me back.*"

The sequence of images the photographer made during this return to Tulsa forms only a small part of the nearly 100 pictures in the suite. The rest are documentary pictures of friends (several made by people other than Clark), photomontages of his stint in the Army, frolics in the mud in New Mexico, the birth of his child, even newspaper clippings of courtroom trials (complete with mug shots) in which Clark was involved. Circling back on his youth is the motivating impulse for this book and suite of photographs, but Clark returns to the scene armed only with the single tool he did not have when those years were lived. Looking through the framing lens of the camera and sifting through whatever pictures it makes become a metaphor for consciousness of life itself.

Whether mundane snapshot, anonymous photojournal-

Larry Clark

ism, or exquisitely "artful" image, the photographs in Clark's work function, first and foremost, as simple visual evidence that an event took place, a life was lived, a locale was visited. His pictures carry no inherent truth beyond the simple fact that the world "out there" passed momentarily before the lens of a camera, behind which another human being stood. His pictures carry no moral weight or immoral revelations. Instead, they are inert objects—truly raw material—that function as a catalyst, a spur toward self-reflection on the lost world of which these photographs are merely shadows. Thus, the traditions which Clark's work recalls are less photographic than they are more broadly artistic. *Teenage Lust* is reminiscent of such sculptural strategies as assemblage, in which found objects are brought together in poetic couplings often of a hauntingly autobiographical nature. Clark's own teenage years—a period of his life that passed by lustily, dangerously, excessively, yet with a decided numbness—are most certainly the subject of this suite of pictures. Their content, however, like the content of any good autobiography, is an acute consciousness of life in the present day: *Teenage Lust* obliterates numbness.

It is in this regard that the most recent photographs in *Teenage Lust* assume a special intensity. Undated, but apparently taken in the late 1970s, they are photographs of teenage hustlers—of children—on 42nd Street in Manhattan. The pictures are devoid of sentimentality or moralizing commentary but are filled with what can only be called a strange generosity. Obscenity and pornography focus on dreams and desires, and turn on the resulting estrangement from the commonplace of daily life. But these *are* pictures of ordinary life, a life that is itself estranged from dreams by the pressure of survival. Desire and dreams are a faint but haunting flicker in the dark eyes of a boy who stands at the rain-soaked steps of the subway; they are the numbing tools he's learned to use to sell himself in order to go on living.

In the text at the end of Clark's book, the photographer writes of these pictures: "It's what the kid is offering. The picture is of what the kid is offering. The kid is offering himself. He's selling something. It's more a look than anything. It's a look, right? It's an entire attitude. It's a way of seeing things but it's all polished up. It's point of sale." This is the kind of offer that respectable folks wouldn't be caught dead confronting, but about which they'll passionately argue. No, it's not Larry Clark's photographs that are obscene; it's not his photographs at all.

Ron Davis

september 24, 1989 In the twenty years since Ron Davis fabricated his classic, 12-sided-polygon paintings from polyester resin and fiberglass, the artistic landscape has been transformed utterly. So thorough has

the overhaul been, in fact, that attempts even to suggest the scope of the alteration by naming just a few of its more prominent features—the outright collapse of ruling formalist theory, for example, or the derailment of Modernist faith in the primacy of abstraction—seems faintly ridiculous. For this reason, the encounter with Davis's glamorously eccentric paintings in an exhibition at BlumHelman Gallery is strangely disconcerting. It's a flat-out beautiful show; yet, with their sleek surfaces of highly polished plastic, they look as if they could have come fresh from the studio only yesterday. (Several have in fact recently returned from the conservation lab, so they're pristine in the extreme.) The newness that was resoundingly claimed for these shaped abstractions when first shown two decades ago—newness in the sense of originality of conception and innovation in technique—has seeped into their synthetic flesh, like Basil Hallward's post-murder portrait of an eternally youthful Dorian Gray.

Davis made a total of twenty-nine of these polygonal paintings, of which seventeen are in private or public collections. Nine of the remaining dozen have been brought together for the exhibition. Because they're large—nearly 12 feet across—and the Santa Monica gallery is small, they'll be rotated a few times before the show closes. The chance to retrospectively immerse oneself in an artist's finest work comes infrequently. (The last time an important group of these paintings was brought together was at the Los Angeles County Museum of Art in 1981; four of those are now at BlumHelman.) Davis's dodecagons are more commonly encountered one at a time, as isolated examples in museums. These nine paintings vary widely in achievement, but the level of interest remains unerringly high as you chart the progress of an artist testing the fecund possibilities of the form and materials.

Some hit it just right: the chunky radiance of *Dodecagon*, the sly optics of *Radial*, the controlled precision of *Wedge*, the all-stops-out bravura of *Zodiac*. Others are awkward, even flaccid, as in the muddled attempt to complicate spatial illusionism that mars the painting called *Spindle*. Either way, the exhibition captivates. And frustrates, too. To look at these luscious paintings is to be reminded, one more dispirited time, of the virtually unconsidered history of important art produced in Southern California. Souvenirs of a historical moment that seems both ancient and shockingly recent, Davis's idiosyncratic dodecagons press their claims upon the present in wholly unexpected ways. Yet, save for the ring of the cash register, which may well signal a market seizure of these under-recognized paintings as unpanned gold from the Boom Town Sixties, they're engulfed by a deafening silence.

At first blush, it might seem odd to say that fiberglass paintings by Ron Davis would bring to mind that eternally depressing subject. After all, his critical success came relatively early and with decided force. The moment can be pinpointed with exactitude. In April 1967, a few months before the artist began to elaborate into complex

dodecagons the simpler, diamond-shaped paintings he had been making for the past few years, the critic Michael Fried declared, in a cover article in *Artforum* magazine: "Ron Davis is a young California artist whose new paintings, recently shown at Tibor de Nagy Gallery in New York, are among the most significant produced anywhere during the past few years, and place him, along with [Frank] Stella and [Walter Darby] Bannard, at the forefront of his generation." Davis was not quite thirty. *Artforum* was still being published in Los Angeles (just two months later the magazine pulled up stakes and relocated to New York). The city was riding the crest of its first wave of art fever, sprouting commercial galleries that showed both imported and local talent.

Ron Davis
Roto
1968

Institutional venues also were thriving. Frank Stella's drawings had just been shown at UC Irvine (Stella's oddly shaped paintings were important precedents for Davis's, and both had taught at Irvine), as had Morris Louis's Color-field paintings at LACMA (Michael Fried had written that exhibition's catalog). The Jackson Pollock retrospective circulated by the Museum of Modern Art was about to arrive in town (Pollock's atmospheric skeins of paint would soon find their way into Davis's splashier dodecagons), and American abstract painting was enjoying its hard-won, and soon to be lost, reputation as the apogee of truly significant modern art.

The twenty-year fast-forward to the BlumHelman Gallery is disconcerting because, despite the eerie freshness of Davis's dodecagons, and regardless of the wholly altered world of art into which they're now being inserted, the paintings hover in a vacuum. Fried's rhetoric, however insightful, is hopelessly dated, yet it remains virtually the last word on Davis's art. As far as these resplendent paintings go, the critical discourse in which they once actively participated has been frozen in the irretrievable past—with no likely thaw in the offing.

The BlumHelman Gallery has published a handsome catalog on the occasion of the exhibition, complete with an essay by mainstream New York critic Barbara Rose. With its lavish illustrations, prominently placed list of a dozen celebrated collectors of other do-

Last Chance for Eden

decagons, and essay by an old-line critic, it carefully conspires to fix an aura of stability. The book is plainly geared toward marketing the pictures. Don't get me wrong; the gallery is just doing its job. Still, in the near total absence of any ongoing critical or historical discourse concerning almost any important American art produced outside Manhattan, and in the essay's tired rerun through an occluded point of view, the yawning vacuum threatens to swallow Davis's paintings whole. In her essay, Rose flogs, yet again, the standard lines that have been endlessly repeated since Fried wrote them in 1967. To wit: Ron Davis is an important artist because he used innovative techniques to make traditional three-dimensional illusionism, bedrock of the Renaissance, conform to such fully modern notions as literalness and truth to materials. Rose also pens several snide remarks about contemporary art in general, and Los Angeles in particular. Most are just dopey, but a few are quite amusing. My favorite: "Unlike many leading Southern California artists (Davis moved from San Francisco to L.A. in 1964), Davis admired and understood New York School painters, especially Clyfford Still, who briefly taught at the San Francisco Art Institute, which Davis attended."

Factual elisions aside—Davis was born in Santa Monica and raised in Wyoming, not in that Boston of the West, San Francisco, and Clyfford Still's six, nonsequential years of teaching at the Art Institute had ended in 1950, when Wyoming Ronnie was still in short pants—Rose's "dumb as a painter" slap is clever. Davis is said not merely to have admired the New York School; ascending on a heavenly updraft, he, virtually alone among the rabble, "understood" it.

Plainly unawares, Rose has tumbled into an arena about which Davis's dodecagons have much to tell us. The posture of know-nothingism was quite popular among Los Angeles artists in the 1960s. Given the hammerlock of the New York School, what more useful American tradition could there be to call upon than that of the dimwitted country rube, out on the wild frontier, handily fleecing them thar know-it-all city slickers? Earthy know-nothingism, as distinct from European-style urbanity, also fit within a larger, more decisive scheme. A distinctly American idea of "the primitive" reverberated against our culture's booming fixation on itself as the most advanced civilization in history. This image, which is one way to describe basic ingredients of the New York School, had evolved, since the mid-1950s, a particular character in Los Angeles. The principal sign of this primitivism was craft: exquisite, rigorous, complicated, eye-popping craft. Davis's dazzling dodecagons will keep you guessing as to how he achieved his stunning spatial illusions (a gallery handout explains his difficult, and slightly wacky, procedure), but they fairly scream their masterful technical wizardry. Craft has long been the cozy home of holistic nature myths. Davis's mysteriously crafted paintings up that ante to precipitous heights. Fiberglass and polyester shake off the dust of craft's historical obsolescence and

push its anchoring myths into the present. Meanwhile, the rigorously centered, calendrical forms further objectify the vitalist faith.

Ron Davis's dodecagons are remarkable paintings from a remarkable moment. Fried, Rose, and others may be content to crabbily regard them as moral signposts pointing to a lost salvation in a venerable past, but they're far more important than that. The dilemma is, will we ever know how much?

ROY DOWELL

February 3, 1989 Roy Dowell's paintings set their sights on a seemingly contradictory aim: to make of abstraction something concrete and representational. As amply demonstrated by the selection of forty-four paintings and collages, all dating from the 1980s, that is currently on view at the Otis/Parsons Art Gallery, the effort can result in exceedingly odd and quirky paintings. No singular trajectory is revealed by the survey, no methodical pursuit, with one foot carefully placed in front of the other, that has moved steadily along in the past eight years. Dowell is instead the kind of artist who keeps himself open to all manner of surprising possibilities, and who looks out for sudden bends in the rapidly advancing road. Preparing for the spectator a painted ground in which that attitude can take root and blossom seems fundamental to his aim.

The earliest works in the show are about a dozen small gouaches on paper from 1980–82, in which Dowell first began to play with concatenations of seemingly unrelated objects, shapes, and spaces. Exceedingly simple in bearing, an apparent sophistication is nonetheless already at work. The turning point in the exhibition is a smallish, strangely skinny, horizontal canvas from 1983 that is split vertically at the right. The division in *Untitled* #280 forms two abutted but wholly independent painted fields, each with its own eccentrically sovereign abstract imagery that is itself a complex proposition. Regardless of the absence of any apparent relation between the two fields, they happily coexist in a dynamic equilibrium.

The paintings of the past five years have sought to complicate this initial thrust, to deepen and enrich the soil. Dowell's small collages, which are almost uniformly strong, seem to be the place in which he first works out ideas. Given his larger aim, which is itself a kind of collage of contradictions, the medium is appropriate. The subject of Dowell's paintings is how to live—a subject central to abstract painting from the very beginning, but one that came under heavy attack in the 1960s and 1970s. The assaultive insistence on commandeering painting's literal properties—surface, edge, scale, contour—was in part a way to undermine the sense of abstraction's increasingly exclusive and controlled moralism. The assault made for remarkable work, which hand-

ily won the day; but it also resulted in a certain loss. Since 1980, Dowell, among other notable painters, has been attempting to piece together an abstract art that would emphatically embrace the literal while simultaneously restoring abstraction's traditional moral edge—albeit one in which inclusiveness and release are now the crucial virtues.

Roy Dowell
Untitled #405
1988

Dowell's tack has been, in part, to return to the moment of derailment. The high moralism of Clyfford Still and the formal rigor of Hans Hoffmann are indirectly invoked, as are numerous other painters from abstraction's Golden Age. Yet in his canvases Dowell gives equal painterly weight to abstract forms of a rather different order: linoleum flooring, TV test patterns, wrought-iron garden gates, automobile logos, etc. Never nostalgic, there's a 1940s and 1950s feel to his paintings that is distinctly of the 1980s. Given such complex interactions, the picture doesn't always gel. But when it does—as in *Untitled #330*, *Broadcasting the Word*, *The Planets Properly Aligned*, *Enter and Be Rewarded*, and several others—Dowell's art manages to achieve a happily disjunctive union somewhere between the lofty aspirations of high-mindedness and the low charm of dinette decoration. It's a very good place to be.

Lorser Feitelson And Helen Lundeberg

April 12, 1981 Los Angeles, as everyone with at least a passing interest in art knows well, has been considered the "Second City" of American art for the last twenty years. With that designation comes what could be called the Second City Syndrome. Central to this Syndrome is the concept of the Overlooked Master (overlooked by the New York art establishment, that is), who, against seemingly insurmountable odds, managed to produce a body of work that holds its own when compared

to that of the eastern mainstream. Prior to the 1960s, before L.A. became the Second City, the Overlooked Master had another role to play: Standard Bearer of the Modernist Faith while camped among the Philistines.

Lorser Feitelson
Hardedge Line Painting
1963

Two Los Angeles painters often considered the archetypal Overlooked Masters are Lorser Feitelson and Helen Lundeberg. Lundeberg, whose family moved from Chicago to Pasadena when she was four years old, and Feitelson, who came to Los Angeles in 1927 after study in New York and Paris, toiled in this artistic desert of their own free will and fought the Philistines tooth and nail. In 1948 Feitelson even had to defend the murals he painted for the Hall of Records against charges of communist content leveled by city officials, an episode which was soon to be overshadowed by the infinitely more glamorous Hollywood blacklist period.

In an effort to transform these Overlooked Masters into Recognized Masters, the San Francisco Museum of Modern Art and the UCLA Art Council have cosponsored "Lorser Feitelson and Helen Lundeberg: A Retrospective Exhibition," currently on view at UCLA's Frederick S. Wight Art Gallery. As SFMOMA's director Henry Hopkins writes in the exhibition catalog's introduction, "We hope that a close examination of the work, an alertness to the dates of innovation, and developed painting theory will continue to expand the recognition long denied them because of their decision to work on the West Coast, outside of what was recently the geographical mainstream."

Doubtlessly it will. But one can't help but think when looking at their work that Feitelson, who died in 1978, and Lundeberg, who at the age of seventy-two continues to paint, had things other than recognition on their minds. One even has the sense that, had East Coast fame accompanied their development as artists, their work would not have evolved in the manner that it did. For despite the horribly overcrowded installation of this exhibition (which totals some 100 canvases),

Last Chance for Eden

one readily sees a continuous interaction between them in shared iconography and subject matter. While each maintains a distinct identity, both indulge in introspective explorations that deal with the identity and union of man and woman. It is as if, absented from the Modernist mainstream, this wife and husband drew support from one another, and made that mystery the subject of their art.

Feitelson's figurative works, regardless of the formal explorations of Cubo-Futurist structure or his own permutations of Surrealism, deal with sensual or erotic themes: several *Bathers*, *The Judgment of Paris*, *Genesis*, *Narcissus*, *The Allegory of the Golden Apple*, and *Love: Eternal Recurrence*. Even still-life elements such as pears and apples and eggs allude to sexual organs. Lundeberg's work is filled with traditional feminine symbolism: sea shells and flowers, arches, a halved cherry juxtaposed to a similarly shaped cross-section of a womb. Her later abstractions, like *Reclining Landscape* and *Cloud Shadows*, fuse landscape imagery with suggestions of sinuous female torsos.

Helen Lundeberg
Double Portrait of the Artist in Time
1935

Both artists deal with the integration, unification, and balancing of opposites. Lundeberg's series of "Mirror" paintings in the early 1950s and her recurrent interest in architectural interiors that ambiguously open into exteriors fuse spatial dichotomies. Time and again Feitelson commits the cardinal sin of "good" composition by bisecting the canvas. In his 1953 *Stripes* the canvas is split down the middle with a black band, and each half is composed of stripes of different widths, colors, and values. Although each half is completely different from the other, they are perfectly balanced and integrated into a continuous whole that makes the bisection imperceptible at first glance. Around 1950 he first built forms from plain, unprimed canvas (a device Lundeberg was later to adopt), so that negative space became positive form, figure and ground shifted back and forth.

Feitelson's mature work, the "Magical Space Forms" of

the 1950s and the "Hardedge Line Paintings" of the 1960s and 1970s, expand these developments in completely nonfigurative terms. Diane Degasis Moran's excellent catalog essays discuss the formal workings of these paintings:

> In these deceivingly simple essays reside both the Mannerist principle of imbalance and tension and the Oriental aesthetic of the juxtaposition of object and void. . . . His work became rigorously minimal, but his reduced images had little to do with the neutralized images of other artists of the sixties and seventies which represented a striving for coolness and remoteness. Rather, they were the results of a conscious intent to eliminate all extraneous elements from the work so that the spectator might focus on the pictorial event in question.

Although she acknowledges the possibility, I don't think Moran goes far enough in identifying that "pictorial event"; it is decidedly sexual in nature. Consider a work such as *Hardedge Line Painting* of 1963. The canvas is painted a vibrant red-orange on which three turquoise arcs are dispersed, with the lines and resulting shapes oscillating between figure and ground. The central ovoid thrusts into the channel created by the other two splayed arcs, but the lines never touch. The optical effect created by the juxtaposition of colors (which are exact opposites on the color wheel) sets up an excited vibration in the eye. The electrified near-touch of these forms is reminiscent of the spark of life generated by the hand of God as it approaches the outstretched finger of the sensuously recumbent form of Adam in Michelangelo's Sistine Ceiling. (On a rather more mundane level, it is interesting to note that the vernacular term in basic composition and design classes for shapes that touch or almost touch is "kissing.")

Lundeberg's abstract paintings of the period likewise continue explorations of mysterious dialectical harmony, but to less successful effect. A painting such as *Planet #3* of 1965 still incorporates bands of color that allude to both landscape and female form, but here it is encased in arcane theory. We view this terrain through a squared circle, the *quadratura circuli* of alchemical philosophy, in which the square equals matter and the circle equals spirit. But such symbolism is so remote as to be virtually alien and therefore, for the purposes of pictorial communication, nonexistent. Lundeberg is at her best in the paintings of the 1930s (such as *The Red Planet* and *Double Portrait of the Artist in Time*) in which her cerebral introspection is carried by the simple force of recognizable objects. And as might be expected from a pair of artists whose work consists of shared though individual evocations of the union of opposites, Feitelson's directness and clarity work to best advantage in his abstract canvases.

Eric Fischl

October 1984 Eric Fischl is a profoundly civilizing painter. His subjects are the Big Themes—life, death, sin, freedom, myth—but he arrives at these through the private claustrophobia, the small confrontations, and the little catastrophes by which such grand and elusive abstractions assume a position on a par with concreteness. (The big themes are a matter of scale, not size; the only claim to bigness made by his paintings is to bigness of spirit.) Fischl is a civilizing painter because he is working toward the renewal of a sensibility which can reclaim the spectator from savagery and brutishness. In his humaneness, taboos get up-ended: There are things that *must* be touched because they're sacred or they're cursed.

The haunted power of Fischl's work derives from freewheeling collisions between public and private recollections. Even though you know you've never seen these images before, even though their larger ordinariness is charged with alien details, you somehow seem to "remember" them the moment you first see them. It isn't exactly déjà vu, because the feeling of having previously experienced the situation is matched by an equally potent feeling of its refreshing novelty. In making his paintings, Fischl works with preexisting images, both conceptual and physical: He first conceives of a scene in general terms, choosing from among the things seen, thought, and felt that are collected in the private storehouse of personal memory; he then pilfers from the public storehouse of images collected in magazines, books, snapshots, ads, and the like to find appropriate costumes, faces, settings, and gestures. Through a quite literal process of re-collection, then, he weds these public and private images on his canvases in highly ceremonial mixed marriages. It is not uncommon to regard both these storehouses as potent systems of power and as debilitating sources of mystification; yet the way the artist uses that recognition is unusual. Instead of mounting a useless assault against the deadening and coercive conformity of media imagery, Fischl merely embraces it in order to draw its power and bewilderment to his own purpose. (In this, he's like the judo master who smiles at the sight of an exceedingly powerful opponent, secure in the knowledge that it represents a mountain of strength to draw upon.) Conversely, rather than sink into the psyche's muffled realms of terror, sensuality, meanness, and perversity, in order to privately exorcise the demon-guilt by means of solemn adjuration, he cheerfully ushers them to the center of his public stage and lets them take their bows. Through these acts of selective re-collection, the public is made private, the private is made public. In this inside-out displacement of the power and mystery residing in each, Fischl establishes a Ground Zero where former modes of thought, of feeling, and of action are as useless as a camel in the Arctic. (In formal terms, such inside-out displacement was a leitmotif

of Minimalism; part of Fischl's achievement has been to have pushed those means beyond the purely formal.)

The pervasiveness of the odd sense of recollection, which manifests itself even in the simplest of Fischl's paintings, conjures so many wide-open points of entry to his work that you fall into them quite before you know what's happened. His paintings exert a palpable closeness, an immediate intimacy with the spectator that is disorienting and destabilizing. They seem to have performed a quiet and unheralded invasion of privacy, but it's an invasion achieved through your own complicity. Fischl is a kind of history painter manqué, for he describes a recollected world of human actions while refusing to fabricate the prescriptive contours that traditional history painting demands. By remaining descriptive rather than prescriptive, he transforms the seemingly insignificant into the crushingly consequential. A simple change in skin tone—from a deeply tanned arm to a lightly sunburned back to pale white buttocks—becomes a dazzling voyage in sensuality (it's like peeling back successive layers of exposure). Elsewhere, the benign and playful image of a half-naked adolescent girl kneeling on a bed and hugging a big black dog acquires the temper of malignancy through the simple presence of a cigarette burning in an ashtray on the nightstand.

The uncanny sense of familiarity radiating from these pictures is a familiarity that breeds distress. Like the charged particles of air that are felt, but not seen, in the moments before a storm, the sense that something is about to happen (the denouement?) hangs silently but heavily in the atmosphere. Filled with the tensions of the approaching collapse of the normative, these situations are seized as possibilities for release. (More than anything else, I think, it is this condition that generates the overwhelming aura of eroticism and of violence in almost all of Fischl's paintings.) These "remembrances of things anticipated" yield a horrifying poignancy which comes from the realization that what is about to happen is what you can't recollect. A chasm of conflicting possibilities yawns wide as Fischl gleefully declares, "This is your public and private recollection as much as mine; you come up with your own next move."

Sanford Schwartz once described Lucas Samaras as an artist who operates by imagining what it would be like to be different; the same goes for Fischl. Not incidentally, his switch from abstraction to figuration nearly a decade ago began with a made-up narrative about a metaphysically inclined fishing family in Nova Scotia—a rather far cry from his own middle-class origins on Long Island. But for Fischl, the creation of such a disguise ended up as a concealment, as the mere fabrication of a false appearance. He abandoned the method. Since then, it's as if he has shifted his sights a notch to ask, what is different? And different from what? For the past several years, Fischl has imagined what it would be like to be different by capturing and exploiting a re-collected

Last Chance for Eden

world. In this way, he doesn't create his imaginings—he re-creates them.

Recreation is the background hum of nearly all his pictures. At the beach, around the backyard pool, in the bedroom, at a party, in a pleasure boat—leisure situations comprise the ambience through which the characters in his paintings move. As often as not, water or the proximity to water plays a prominent role in these recreational pictures, reverberating with the deepest memory of generation and functioning as an arena for modern rituals of regeneration. Innocence and voluptuousness, loss of innocence and vulgarity, the whole sweep of feeling is born-again in Fischl's paintings.

So, too, is a species of humanity that Harold Rosenberg declared dead and buried nearly twenty years ago. For against an imagery of social and cultural disintegration, lusciously performed on his canvases in a buoyantly theatrical way, Fischl reconstructs an audience of spectators who are recognized as informed amateurs. Always clear enough to be read, the activities in his paintings are perfectly legible yet utterly resistant to any attempts to get a confident grasp on what's really happening. A glass of iced tea precipitously poised on the edge of small disaster, a toy Indian crushed by the weight of an orange, the tightly coiled tails of two high-strung canines, a red pom-pom on the green hat jauntily worn by a mechanical monkey—to scan the details in search of iconographic clues to the scenario is to come up against small but lovingly rendered fragments which, in their impenetrability, become harrowingly ominous. Worse, such relentless breaking-up of the image into details and juxtapositions in a futile search for the revelation of hard truths merely hastens the onslaught of disintegration. When faced with Fischl's paintings, the spectator is bereft of a concept of expertise.

The spectator who is an informed amateur should not be confused with "the common man." Today, the common man is a professional, one who professes faith in the details; the social order is an accumulation of experts, of detail-men in cryogenics, jogging, bus driving, population control, art, demographics, banking, baking, ad infinitum. Indeed, uncommon is the man who, aware of his own primitiveness, uses that awareness as the platform on which to perpetually reconstruct a scaffolding of mysterious design. Performing for an audience of informed amateurs, Fischl's paintings make us those uncommon men.

In this way, his paintings are polemical. For however luxurious and languorous they may be, however casual or ordinary the ambience in his images of beaches, backyards, and bedrooms, they speak with the aggressive force of a passionate and pictorial species of criticism. Memory and perception depend on the faculty of imaging; in an almost neo-Platonic way, recollection is a concept of great importance to Fischl's art because it provides the continuity of self-consciousness. (As Plotinus insisted, only by memory does the embodied soul possess an image of itself.) Yet through continuous displacement—the trans-

position of public and private, of amateur and specialist, of commonness and mystery, of the empirical and the metaphysical, of the sacred and the cursed—he smuggles trouble into the established creeds and systems by which self-consciousness congeals. Fischl doesn't struggle against those creeds and systems in order to establish newer models; he simply uses the existing ones in order to renew dynamic tension. Continuity, thus disrupted, takes on the palpable aura of suspense. Vertiginous pressures of surprise, discovery, even disenchantment are released as Fischl's civilizing process suspends our stubborn longings for equanimity and for certainty. Recollecting Matthew Arnold's critical disquisition, his paintings help produce a situation that is favorable to re-creation.

Judy Fiskin

spring 1988 Judy Fiskin's photographs insist on making chaos out of order. Strict taxonomy seems to rule her method, but the easy scrutiny her pictures casually solicit reveals a shipshape, highly disciplined world that is, in fact, teetering at the edge of full collapse. Her camera blithely amplifies the torque.

Jittery and strangely exciting, the encounter with these pictures is a liberating tonic. Fiskin's photographs unfold slowly, revealing themselves in cumulative glimpses. The apparent regularity of an ornate, bilaterally symmetrical house from the series "More Stucco" subtly begins to destabilize as you are drawn into the picture. The scene is perfectly ordinary. And something is horribly wrong. The dominant horizontals of the roof and balcony, and of the street in front of the house, gradually begin to splay, like the spreading fingers of a hand. The reason is obvious and involves no grand deceit: The house is merely built on a moderately sloping hill. But the result is immoderate: a taut picture of a domestic enclave putting its best face forward while seemingly under intense internal pressure. It's quietly straining against flying apart.

In six series of pictures made between 1973 and 1981, the artist carefully and deliberately coaxed forth the parameters of her work. "Stucco" (1973–76), "35 Views of San Bernardino" (1974), "Military Architecture" (1975), "Desert Photographs" (1976), "More Stucco" (1978–79), and "Long Beach" (1980–81) began the taxonomic study. Each is assembled as a formal analysis of its subject—collecting, sorting, ordering, cataloging information—as if classifying stucco bungalows by genus and species would reveal some inherent order in the culture that produced them. Fiskin's photographs are paradigmatic of an age that opened with committed faith in the promises of scientific salvation (is it any wonder that the term "photography" was invented by a scientist?) and that is ending with the radiant apotheosis of bureaucracy.

These six initial series also mark a concentrated effort

at determining the components of a specifically photographic way of seeing. The black-and-white pictures seem burned into the photographic paper, with intermediate gray tones as well as small details often sacrificed at the luxurious altar of stark blacks and harsh whites. (Visually, the effect is rather like suddenly removing your sunglasses on an intensely bright day.) Through the "Desert Photographs," the format of the image is rectangular; since then, her pictures have been square. Either way, the images are always framed by the thick, black edge of the negatives from which they have been printed. Always, too, they are centered in a large white field of standard photographic paper—a DMZ between the image and the world.

Judy Fiskin
Untitled Geometric Façades,
from "Dingbats"
1982

Most important, with exterior dimensions restricted to a scant few inches the images are invariably quite small. You come up close and peer at Fiskin's photographs—searching, scrutinizing, scanning, snooping—much the way she must have done while setting her sights through the camera's viewfinder. Everything outside the tiny picture falls away, an extraneous distraction. The viewpoint on the picture is always that of the passerby, someone who stands outside the scene at a mid-range distance, like a witness. This sense of slight detachment is enhanced by the total absence of people from Fiskin's locales. The only person present at the scene seems to have been the photographer; the only person present at the picture is you.

The intense, private, highly concentrated experience thus engendered endows Fiskin's photographs with a distinctly cerebral air. They're like thoughts in the process of forming—rudimentary, crudely drawn, partly structured, sharply outlined yet indistinct—thoughts which have been projected outward and fixed in mid-occurrence. Her work is informed by the heady precedent of Conceptual art, and by such matter-of-fact snapshooters as Edward Ruscha.

An attunement to artifacts of popular culture is evident in her typical choice of subjects: vernacular buildings, flower arrangements by hobbyists ("Some Aesthetic Decisions" [1984]), displays of

furniture and period rooms ("Portraits of Furniture" [1987–88]). Importantly, her discovery of the camera as her medium was seamlessly intertwined with a second, equally critical discovery: She suddenly knew she wanted to be an artist. Fiskin has said that she landed on photography as her medium completely by accident. A graduate student in art history at UCLA, she had borrowed a camera to use in an iconography project. She looked through the lens and immediately knew that taking pictures is what she wanted to do.

The concurrence between the idea of using a camera and the idea of becoming an artist is, in its way, a twin revelation that gets replayed again and again in Fiskin's photographs. Emphatically drawing attention to photographic seeing, her pictures also gnaw away at the muffled and homogenizing trajectory of the everyday. With steadily increasing brilliance, they are subtly structured so that the spectator experiences a like disclosure. For me, a turning point in Fiskin's photographs came in 1982, when she began an extensive series of pictures of the pervasive, oddly decorated boxes that passed for apartment architecture in suburban Los Angeles in the 1960s. "Dingbats" kicked out the jams. Dozens of nonsensical stylistic categories were invented for these ubiquitous (and nonetheless weird) buildings, categories such as "Peaked Roofs," "Geometrics," "Side Stairways," and—the giveaway—"Eccentrics." Ordinary dingbats are, by definition, eccentric. Fiskin's photographs restored the sense of free and unpredictable serendipity that is always lost through the encrustations of time.

Photographs with a documentary veneer most often operate in the reverse. They shut down differences to deliver a coherent, if not necessarily pleasant, sense of universal identification for the viewer. With a picture of a forlorn bunch of flowers imprisoned in a bird cage, or of a balletic side table nervously balancing on corkscrew point, we are not talking "The Family of Man"—at least, not in the stale and sentimental way we have come to expect from the avalanche of pictures that daily comes our way. That is the wonder of Judy Fiskin's photographs, and that is the achievement of her art.

Helen Frankenthaler

February 9, 1990 If you go to see "Helen Frankenthaler: A Paintings Retrospective"—and you should—be sure to ask yourself some questions. For starters: Why did Frankenthaler's brand of New York School abstraction, which seemed to hold an edgy promise in the 1950s, devolve into decorative grandiloquence a decade later? By what strange paradox did a type of oil painting that owed so much to watercolor—the one, great tradition of American Modernism—begin its rapid decline at precisely the moment the artist switched to water-based paints?

Down what garden path of reasoning did the Los Angeles County Museum of Art cheerfully traipse to conclude that, in 1990, a Frankenthaler show would turn out to be anything other than utterly beside the point?

Difficult questions all, especially for the first substantive retrospective of a living woman artist this museum has ever seen fit to display. Still, such queries at least give you something to think about in the blank face of most of Frankenthaler's paintings from the last twenty years. "Helen Frankenthaler: A Paintings Retrospective," newly opened at LACMA, had its debut last summer at New York's Museum of Modern Art. Organized by E. A. Carmean, Jr., director of the Modern Art Museum of Fort Worth, Texas, where the show was last seen, it includes a modest forty paintings. The earliest is the now-legendary *Mountains and Sea* of 1952, the most recent a darkly romantic 1988 painting called *Casanova*.

As even casual observers of postwar painting know well, *Mountains and Sea* is noteworthy principally because of its technique. Following a twentieth-century trail of pictorial effects that meanders through Kandinsky, Miró, Gorky, and especially Jackson Pollock, Frankenthaler fashioned a way to get inside the pictorial arena, physically, in order to draw with fluid color: The picture's pale wash of hues was composed by pouring thinned oil paints from a coffee can onto a large piece of canvas laid flat on the floor, then allowing them to soak directly into the raw cotton duck. *Mountains and Sea* was the artist's epiphany. The first so-called stain painting, it soon inspired Morris Louis and Kenneth Noland to make abrupt alterations in the direction of their art, yielding the veils and targets we know today. And thanks in large part to her 1960 retrospective at the Jewish Museum, Frankenthaler's work eventually was claimed as progenitor of an ill-fated jumble of abstract modes, variously to be known as Color-field, Lyrical, and Post-Painterly Abstraction.

This latter plethora of competing, tightly nuanced terms gives some indication of the degree of desperation surrounding old-line New York School abstraction in the tumultuous 1960s. Hemmed in by the new geometries of Minimalism on one side, and by the brashly commercial images of figurative Pop on the other, the flaccid dogma of the New York School was soon outflanked.

Ironically, Frankenthaler's own initial achievement had come from some cleverly insightful maneuvering of her own. The simplest way to think of her art is as a species of watercolor. As with such prewar painters as John Marin and Georgia O'Keeffe, Frankenthaler attempted to marry traditionally European Modernist ideals to a distinctly American feeling for landscape. And like them, she chose fluid color as the connubial agent. While her American forebears had indeed painted scores of landscape canvases, their most convincing evocations of Edenic nature, either witnessed directly or recalled, were more often confined to watercolor on paper. In the Modernist hierarchy of artistic mediums, watercolor is nice, but painting occupies the highest

Helen Frankenthaler

rung. *Mountains and Sea* seemed to open an avenue to accommodate both. In the months before she painted *Mountains and Sea*, Frankenthaler had completed a series of watercolors from nature. (Her work on paper was the subject of a 1985 exercise at New York's Guggenheim Museum; none, alas, is included here.) In staining canvas with thinned paint, Frankenthaler found a way to bring this watercolor tradition to the grand, mural-size scale of oil painting necessary to a post-Pollock world.

In the show, the paintings made between 1952 and 1962, while frequently muddled, do possess an astringent energy. They speak of an artist attempting to make a stubbornly resistant medium do her bidding. Pictures such as *Round Trip* and *Winter Hunt* exude the lively stop-start of an improvisatory staining, dragging of the brush, pushing of color, and nudging of shape. The titular trip, or hunt, can be compelling.

But there's a hitch: Oil paint, thinned with turpentine, will spread, but it certainly isn't fluid. In her early work, the visual evidence of the paint's resistance to fluidity is seen in the separation of the gum and oils from the color. Through capillary action, oily turpentine is pulled into the canvas weave, leaving a kind of halo around the residue of pigment. It looks odd, but this "ring-around-the-color" actually helps to underscore the dissonant, material conflict behind the arrival of a finished picture.

Frankenthaler's is an art that depends on the difficult struggle involved in internalizing landscape—that is, in using painting's demanding terms to create a comfortable *place* in which to be. In this regard, any aura of resistance is salutary. Yet in 1963 she banished it outright in a sudden switch to the new acrylic paints. A plastic, water-soluble pigment that is as fluid as can be, acrylic generated swift and self-satisfied fields of color. A few of these paintings from the later 1960s can claim a quick, all-at-once charm that is logolike in bearing, but none really sustains the ponderous freight they're asked to tow. Like overfed pashas, their now-formulaic rhetoric is gassy and bloated.

The decade-by-decade review at the County Museum of Art breaks down as follows: seven canvases from the 1950s; thirteen each from the 1960s and the 1970s; and seven from the 1980s. The result is a show that opens with a small burst of excitement but is over, abruptly, by the third room. Alas, the galleries continue on. And on. Worse, as a retrospective the show is something of a sham. The curator declined to write a catalog essay in which the artist's career would be examined within its larger, exceedingly tangled historical context. Instead, he blithely refers the reader to other books about Frankenthaler (by the critic Barbara Rose and the curator John Elderfield), thus allowing a sly mix of authoritative canon and accumulated legend to speak on his behalf. What he offers in its place is a series of heavily footnoted entries on each of the forty paintings in the show. The upshot is that lowly mortals such as you and me are meant simply to assume

Last Chance for Eden

Frankenthaler's exalted stature, while these forty paintings shall henceforth be regarded as masterpieces. This may help to explain the extremely unusual hanging of the show, in which the often sizable canvases have been hung surprisingly high on the wall. Like old-style altarpieces, they force you to look up to them, quite literally, while simultaneously insisting you keep your distance.

For a serious artist whose reputation was, for good or ill, bulldozed under some twenty years ago, the rather astounding blind faith demanded by this exhibition is leavened only by the strangely refreshing willfulness of its formidable arrogance. And that is why you ought to see the show, as long as it happens to be in town: The minor blip of Frankenthaler's art aside, you can at least get a quick, insightful lesson in techniques of curatorial intimidation.

Frank O. Gehry

May 1, 1989 Among the manifold pleasures of living in the heart of Hollywood is having the Frances Howard Goldwyn Regional Branch Library as my neighborhood *biblioteca*. You see, the Frances Howard Goldwyn Regional Branch Library was designed in 1983–84 by the architect Frank O. Gehry, he of chain-link fencing fame. To those like myself, for whom art is a habit of more than passing fancy, Gehry operates as an artist's architect, which adds distinctive charms to the abundant pleasures of using his buildings.

It's hard to say whether Gehry is exactly thought of as an artist's architect by the six jurors who had the great and good wisdom to bestow upon him the weighty Pritzker Architecture Prize, which is being announced today in Chicago by the Hyatt Foundation, sponsors of the accolade. I suspect he is. The sixty-year-old architect, who was born in Toronto but who became a U.S. citizen in 1950 while a student at USC, has never been shy about declaring the importance to his work of contemporary art and artists. They've helped shape his thinking about how building forms should arise. From the celebrated sculptors Donald Judd and Claes Oldenburg, to any number of artists in the burgeoning milieu of Los Angeles, where Gehry has long based his architectural practice, he has gleaned much insight about space, imagery, and visual language. The Pritzker Prize citation—which will be presented to Gehry at formal ceremonies in Japan later this month, along with a handsome bronze medallion and an even more attractive check for $100,000—is notable for an almost total absence of commentary about the influence of other architecture on his work and for the plethora of references to the visual arts.

As reported by the estimable Bill N. Lacy, secretary to the jury, the citation is rather pointed in its declarations. Gehry's is "a

sophisticated and adventurous aesthetic that emphasizes the *art* of architecture." His body of work "reflects his keen appreciation for the same social forces that have informed the work of outstanding *artists* throughout history, including many contemporaries." His buildings are "juxtaposed *collages* of spaces and materials." He works with "a sureness and maturity that resists, in the same way as *Picasso* did, being bound either by critical acceptance or his successes."

The italics are mine, but the sentiment seems clear. It may be too much to suggest that the jury was trying to send a larger message through its selection of this particular architect, who emphasizes a cross-disciplinary approach. Still, at a time when a high priority is being given to the difficult question of collaboration between architects and artists, the jury has singled out for applause a supremely gifted architect who for twenty-five years has been happy to raid the minds of artists. (This year's jury, incidentally, was composed of Giovanni Agnelli, chairman of Fiat in Torino, Italy; J. Carter Brown, director of the National Gallery of Art in Washington, D.C.; Ada Louise Huxtable, former architecture critic of *The New York Times*; architect Ricardo Legorreta of Mexico City; 1982 Pritzker laureate Kevin Roche of Hamden, Connecticut; and Jacob Rothschild, chairman of the board of trustees at London's National Gallery of Art.) What has Frank Gehry learned from art and artists? I'm not so sure about Picasso, but some things are obvious.

The 1964 Danziger Studio on Melrose Avenue, which was Gehry's first important building, is a sculptural, stripped-down, Minimalist form that seems fully of its moment. The hardware-store materials for which he is famous—chain-link fence, corrugated sheet metal, plain old two-by-fours—arise from a network of impulses shared by assemblage and Pop art. The row of false classical columns that march in front of the "mock court" on the campus of his much-lauded Loyola Law School (1981–84) are a witty Popism. The huddled cluster of independent rooms that collectively make up the celebrated Winton Guest House (1983) in Wayzata, Minnesota, forms a tender composition reminiscent of nothing so much as a still-life painting by Giorgio Morandi.

Other relationships to art and artists are more difficult to describe, because more profound. Gehry's own house in Santa Monica— a notorious structure in which the architect started with an ordinary bungalow from the 1920s, then built a second structure around it, much to the dismay of certain neighbors—is a case in point. The kitchen/dining room of the house, an open-plan format that Gehry added on to the original bungalow, stands where the driveway used to be. Its floor is asphalt, reminding you of the recent history of the place; you can clean it with a garden hose. One interior wall of this long room, which is still covered in clapboards, was formerly the exterior wall of the house. So, the living-room window now looks out onto the kitchen/dining room, and vice versa. I once sat in this disarming room

for a very long while before it finally occurred to me why the place exerted such an extraordinarily vivid presence. Suddenly, I realized I was sitting outdoors and indoors at one and the same time. Particularly in its domestic spin, this unnerving yet viscerally understandable experience owes a clear debt to Oldenburgian wit. Meanwhile, the simultaneity of inside-and-outside space arrives from a deep understanding of the radically disruptive sculpture of Donald Judd, in which the traditional separation is replaced by a seamless unity of interior and exterior.

I see I have managed to ensnare Gehry completely within a web of visual art here. Certainly, had Pop art and Minimalism never been, his architecture would be rather different than it is. But Gehry is an artist's architect, not an architect's artist. At least a nod must go to architectural precedent and practice in understanding the fundamental importance of his work, and of its worthiness for the highest acclaim. For what is Frank Gehry's house in Santa Monica but the architectural apotheosis of California's vaunted indoor-outdoor living? To be there is to physically inhabit a disjunctive image, which is neatly framed by the suburban picture window. It may not look it at first, but the Gehry House stands on a firm foundation whose bricks include historic haciendas and suburban tract housing, as well as the rather loftier aspirations of Richard Neutra and Rudolph Schindler.

The house also stands on principles derived from Russian Constructivist sculpture and architecture early in the twentieth century. But let's not get into that, except to note that it represents a moment when heady attempts were being made to dismantle barriers between supposedly independent disciplines. Instead, let's look forward with blissful anticipation to the building of his design for the $100 million Disney Concert Hall on Bunker Hill. And let's gladly add Frank O. Gehry's name to the distinguished list of eleven previous Pritzker laureates, among them Philip Johnson, Luis Barragan, James Stirling, I. M. Pei, and Richard Meier. It fits.

Hendrik Goltzius

April 5, 1992 Although he was Northern Europe's most eloquent practitioner of Mannerist art, it's been a while since the name of Hendrik Goltzius has set off many bells. The Dutch engraver and painter enjoyed enormous popular success at the turn of the seventeenth century, when his sensuously intricate art was widely coveted. But as the Mannerist style was eclipsed, he was steadily relegated to ever-darker shadows. For Goltzius's reputation, the problem was acute. In the Netherlands, exotically Mannerist painting had the misfortune to be usurped by a form of Realist art that, at least on its face, couldn't have been more different in its aspirations and achievements. His position at the pinnacle was followed by no less a figure than Rembrandt.

The fact that fewer than fifty paintings by Goltzius's hand are known hastened his decline into relative obscurity. A hugely successful printmaker, his theatrical visual style had seen wide distribution; but, in 1600, at the age of forty-two, he abruptly gave up the printing medium. His output as a painter during his remaining seventeen years was modest. Whatever prominence in the history books the elder painter was to maintain was due largely to his landscape drawings. They're praised as innovative because they're among the first of what was to become the hugely popular seventeenth-century genre of plein air representations of the Dutch countryside.

Hendrik Goltzius
Jupiter and Danäe
1603

Lately, the narrow esteem in which the artist has long been held has started to widen a bit. Hendrik Goltzius isn't exactly in vogue again, but his art is starting to speak to us in ways it hasn't before. In 1990, one of Goltzius's rare paintings was acquired by the Philadelphia Museum of Art. It became the centerpiece of a small but appreciatively noted exhibition of related prints and drawings that closed at the museum in February. Now, a second, similar kind of show has opened in Los Angeles, although here the venue is quite different. Prepare to log some mileage, for the absorbing exposition is taking place at three institutions scattered between downtown and Malibu.

Goltzius's spectacular painting *Jupiter and Danäe* (1603) was acquired by the Los Angeles County Museum of Art in 1984. The complex composition is filled with a never-ending string of surprises, which together add up to a dizzyingly sexy essay on the dangerous pursuit of pleasure. For a "Masterpiece in Focus" presentation, the radiant, newly cleaned canvas has been paired with a small wash drawing in brown ink, lent by Sacramento's Crocker Art Museum. The little image shows a seraph hovering over a pot of coins. Titled *Honor above Gold*—a wry play on the artist's auric last name—it served as Goltzius's personal emblem. The drawing is related to the big LACMA painting, which depicts the moment a smitten Jupiter transformed himself into a shower of gold dust in order to slip through the ceiling cracks and

Last Chance for Eden

enter the locked bedchamber of the voluptuous, sleeping Danäe. The Roman gods were nothing if not ingenious.

Artistically, Goltzius turned out to be their clever equal. A show of "Sixteenth-Century Northern European Drawings" at the J. Paul Getty Museum demonstrates how. It includes two of his works on paper, one a black-chalk drawing of the bust of an angel, the other a 1585 model for an engraving. Both convey the German-born expatriate's extraordinary gift for making evanescent, otherworldly experiences strangely palpable. The ink study for an engraving is, like the LACMA painting, a scene of godly lust—an adulterous Venus and a philandering Mars, caught in the act by a cuckolded Vulcan. There is more going on in its few square inches of paper than in most wall-size frescoes: the dramatic discovery of the illicit act, the swooping arrival of a host of mocking gods, the heavy labors at Vulcan's nearby forge. Yet, like jump-cuts in a movie, the crashing together of these packed, disjunctive spaces creates a complex narrative occurring over an extended period of time. Goltzius tells his story in a wildly exciting, oddly modern way. The exquisite bust, which dates from about a decade later, is far simpler in design. It shows a monumental, impishly elegant head, deftly orchestrated to glance over its winged shoulder. The angel's windblown hair vigorously sweeps your eye across the page and up into the curving fragment of wing, creating a remarkable feeling of vaporous uplift for the airborne figure.

The largest segment of the tripartite show is the survey of eighty-eight Goltzius prints at USC's Fisher Gallery. Organized by graduate students under the supervision of gallery director Selma Holo and Professor Glenn Harcourt, and with a catalog both thorough and concise, "Hendrik Goltzius and the Classical Tradition" admirably manages to demonstrate a circuitous but crucial path followed by the artist. Goltzius, who was born almost forty years after the death of Raphael, reveled in Mannerist artifice as a wide-open avenue for self-invention. The striking, exaggerated visual effects of the internationally important style meant to complicate and reform the classical grandeur of High Renaissance art. The artist had been born into an artistic world whose living giant was the elder Michelangelo, the painter who had ushered in the Mannerist style. So, classicism stood as a restrictive set of old-fashioned, out-of-date rules for Goltzius—at least, they did until 1591, when he made a fateful trip to Rome.

During his eight years or so in Italy, surrounded both by Renaissance permutations of antique classical style and by countless examples of its ancient origin, stale tradition was transformed into a living presence. In the first room at the Fisher Gallery the classicist tradition is everywhere in evidence, from engravings based on paintings by Raphael to those depicting such famous works of ancient statuary as the *Apollo Belvedere*. In Rome, Goltzius didn't entirely lose his affinity for Mannerist exoticism. His engraving of the Farnese Hercules, seen from

behind, sharply exaggerates the bulging musculature of the original antique sculpture. And the technical accomplishment of his graphic work always retains a Northern European feel, akin to such influential predecessors as Albrecht Dürer and Lucas van Leyden. Instead, the significance of his Roman sojourn is in the way Goltzius's firsthand experience of classicism was to deepen the resonant maturity of his eventual return to Mannerist style. Because Mannerism meant to undermine the classical limitations of High Renaissance art, Goltzius first needed to achieve fluency in the classical language. LACMA's *Jupiter and Danäe*, painted several years after his return to Holland, might glow with a roseate hue indebted to the painter's Venetian encounter with the art of Titian (who painted several famous versions of the subject). But the tone of Goltzius's interpretation of classical Roman mythology is inescapably Northern, not Southern.

The painting is frankly weird—weird in the old sense of suggesting supernatural, mysterious, and ghostly things. A phantasmagoria of rich and sensual surfaces describes a bewilderingly complex cross-referencing of details. *Jupiter and Danäe* features two main protagonists. Goltzius has added a variety of other duos to elucidate the central seduction, and to radically alter the typically accepted meaning of the myth. These pairs conspire to make a painting of unusual impact. On the floor next to the sleeping beauty stands a clear crystal bowl, plainly symbolizing Danäe's purity, and an upright gilded chalice, decorated with wild Bacchanalian revelries and Jupiter's emblem, an eagle. With these, the stage is set. Diagonally opposite, at the upper left of the canvas, a male and a female cherub clutch bags of gold—sacks whose likeness to sexual organs is unmistakable. Beneath these cherubs, at Danäe's feet, a treasure chest filled with coins is decorated, like the chalice, with eagles. The chest is slowly opening, in a delicate echo of the crimson-satin drapery at the upper right, which is being opened to reveal Danäe's luxurious body. At the center of the canvas, nearly hidden away amid the dense array of limbs, drapery and grinning faces at the picture's heart, Goltzius places the most shocking pair of all. Danäe's elderly maid, who gently tries to awaken her sleeping mistress, holds a golden bowl to catch the shower of coins about to fall across Danäe's creamy flesh. The radiant bowl forms the twin of the crone's veined and pointedly exposed breast adjacent—an extraordinary conjunction of sex and corruption that is further underscored by the leering face of Mercury above. Mercury, of course, is the Roman god of commerce.

Goltzius's *Jupiter and Danäe* is a radical reworking of the standard Roman myth, in which Danäe's mystical impregnation by an all-powerful god was divined by later Christian doctrine to be a prefiguration of Mary's virgin impregnation. Here, the artist depicts purity about to be sullied by greed, wealth, and power. The image of mercenary love is a stunning rebuke to theistic authority by an artist

lately returned from Rome.

A rather big gulf separates this exotic picture of baser lusts from plein air landscape drawings of the Dutch countryside, for which the artist is now known. Both are animated by a commitment to the world of human nature, but the high regard reserved for Goltzius's landscape drawings (none of which are included in these shows) is largely based on a formal conviction that favors naturalism in art above all else. In fact, as LACMA's painting and this engaging triple-bill show, it's the artist's skill as a brilliant revisionist of established creed and doctrine that speaks most persuasively to the present day.

Leon Golub

DECEMBER 23, 1984 At sixty-two, Leon Golub is the new kid on the block. During the last few years, his large, unstretched paintings of murderers, torturers, and mercenaries have galvanized attention and landed squarely in the eye of the art-world hurricane. To be sure, the Chicago-born artist received some notice in the 1950s for his scarified paintings of totemic figures and, twenty years later, for his wrenching images of the Vietnam War. But neither episode carried the weight, the feeling of utter necessity, that Golub's work has manifested in the last five years or so. How did it happen?

"Golub," the retrospective exhibition that opened last week at the La Jolla Museum of Contemporary Art, goes a very long way toward answering the question. The show, in fact, is among the most significant offerings of the year. In some forty paintings dating from 1952 to the present, it traces an evolution in which the artist's subject matter, which has always remained relatively constant, meshes seamlessly with his own experience. In the process, our own situation is harrowingly revealed.

There are those who argue that mainstream art of the last thirty years simply had no room for the potent tributary occupied by Golub's work (the exhibition catalog alludes to such a notion). In decades dominated by varieties of abstraction, or by the slick surfaces of Pop imagery, Golub's brand of crusty figuration languished on the periphery. By extension, the stunning success of Neoexpressionist painting in recent years is claimed as the source of our ability suddenly to see the value of his work—and the error of our ways. However, to posit such an argument is to trivialize matters by reducing Golub's art to a level of mere taste floating on the tides of fashion: Once he was out, now he is in. Worse, it runs counter to the very qualities that make his recent work so important. For the argument maintains that power or authority resides in the mysterious, inaccessible reaches of the center, while Golub's art locates its complex nature at the very peripheries on which he, as an artist, found himself for more than twenty years.

Surfaces—the outward, physical peripheries of paint-
ing itself—have always been crucial to Golub's art. The earliest works
in the show are easel paintings in which primitive, iconic figures are built
up from cracked and clotted mixtures of oil paint and lacquer. The
ravaged surfaces of such pictures as the two-headed *Siamese Sphinx 1*
(1954), *Damaged Man* (1955), and *Orestes* (1956) make palpable a kind
of ancientness that has been dragged through the tumults of history into
the Holocaust-ridden present. Yet the obvious references to antiquity, to
classical mythology, and to tribal cultures in these paintings serve to
distance them: They "stand for" a complex human condition that has al-
ways prevailed, rather like erudite, visually footnoted commentaries
on the historical moment in which they were made. Indeed, it's nearly
impossible to look at these scarified paintings of mutilated figures with-
out thinking of then-current events: the first explosions of hydrogen
bombs, the recent death of Joseph Stalin, the execution of the Rosenbergs
as atomic spies, the witch hunts of Joe McCarthy. Paradoxically, the paint-
ings suffer from a topicality that merely leaves the spectator with a residue
of indignation or despair.

A decade later, that topicality surfaced explicitly in Golub's
art. Now working on an enveloping, mural-size scale (inspired, in part,
by his interest in Picasso's *Guernica* and his encounter with Orozco's
mural *The Triumph of Prometheus*, at Pomona College), Golub made
the atrocity of Vietnam the subject of his paintings. The sources of the
battling figures in such paintings as *Gigantomachy III* (1966) and *Napalm
I* (1969) can be found in everything from the Great Altar of Zeus at
Pergamon to contemporary sports photographs clipped from magazines.
But by 1972, Golub began to base his paintings directly on news pho-
tographs of the Southeast Asian war itself.

What is important about these paintings is the way in
which they are made. They are large, free-hanging sheets of torn canvas
on which Golub painted soldiers and civilians, mayhem and tragedy, then
scraped the pigment down into the tooth of the fabric. Sometimes,
the half-dried scrapings were mixed with fresh paint and used to repaint
portions of the picture. The result is a highly tactile surface that has
the repugnant look of scabbed wounds on flayed skin.

Like most political art in this century, these works called
attention to a situation about which something should be done. It's as
if Golub was attempting to act as a corrective to the media imagery then
flooding America's living rooms: His art sought to endow the strangely
immaterial quality of photojournalism and television with the physi-
cal truth of the horrors those images represented; and it tried to slow
down the eye, which skips and stumbles across these huge and clotted
paintings, in order to counteract the inurement caused by the acceler-
ated rate of repetition in modern media. Not surprisingly, and not un-
like his own work from the 1950s, indignation and despair remained the

unhappy poles of feeling to which these paintings were limited. Yet through his confrontation with media imagery, Golub seems to have found the key to the puzzle with which he'd been grappling for two decades. For during the past five years or so, he's been painting the topography of power that the mind knows to exist, but that has remained utterly inaccessible to the eye of the camera: the moment when the thug stuffs the body into the trunk of his car; the terrifying, eternal instant when the mercenary puts the gun to his victim's head; the second when the leering torturer shoves the bound and gagged woman to the ground; even the jocular camaraderie among assassins at play.

The remoteness of these subjects, the secrecy within which terrorist and mercenary alike must move, endows them with the potency of the imaginary. Golub's familiarity with camera-wrought images of all kinds is evident in everything from the cropping of the pictures to the sense of his having captured the decisive moment. But they're like paintings derived from photographs that never could have been taken. The brute physicality of Golub's earlier work becomes the platform for psychological realities that, finally, seep into the realm of imagination. They ooze into the foreground from the periphery of consciousness, lodging themselves irrevocably in your brain.

Indeed, there is an excruciating intimacy to the social relations played out in these paintings. The specificity of observation extends to the precise gesture of a thumb, the wrinkle of a shirt sleeve, the slimy curl of a lip, the knowing glance between comrades. (Golub still works from media imagery; his sources range from the sports pages to pornographic magazines.) The characters in these paintings have remarkably precise and individuated personalities; that is, they evoke an astonishing degree of humanness. Ironically, the very commonness of these pathological creatures begins to divest them of all claims to strangeness or abnormality.

In *White Squad III* (1982), a victim, hands bound behind his back, writhes helplessly on the floor. His uniformed executioner leans forward, gun poised, lips pursed and slightly smirking in anticipation of the victim's head smashing to the floor from the impact of the bullet. To the right stands a second uniformed figure, a jaunty young man staring you in the face—and looking provocatively sexy. Desire and intimacy flow from the painting to the spectator in a perfectly natural way; your nervous system twitches. You're getting to know these guys, beginning to feel an undeniable curiosity about, even an attraction for, these fully human killers. In this way, the most profound social relations examined in Golub's paintings are with the spectator. For it is we who are clearly implicated in the evil they represent. The humanness of Golub's torturers turns our self-righteous assumptions of these monsters inside out: Their pathologies, the diseases of their souls, are no longer abnormal; they're shockingly ordinary—as ordinary as we are. Golub's

art is expository, not didactic. It does not show things as they might be, as if the artist could somehow stand outside the messy contradictions of life, but exposes them as they actually are. His paintings don't make direct appeals for action, nor do they outline specific changes for politics or society. Rather, they infiltrate one's whole sense of social existence and affect one's consciousness of how things are. Golub's paintings are of fundamental importance because they are political in the deepest, rarest sense. By moving to the periphery he arrives at the center: The spectator is aroused from within.

David Hammons

August 21, 1991 David Hammons's art is about power, and about locating the sources of power within the personal and social context of one's life. For an artist who is black in a world where established power is white, this generates an art with considerable power of its own.

The entrance lobby to the San Diego Museum of Contemporary Art, where Hammons's important retrospective exhibition opened Sunday, houses two recent works that introduce the breadth and depth of the forty-seven-year-old artist's longstanding interest in the subject. One is frankly political, the other slyly so. *How Ya Like Me Now?* (1988) achieved some notoriety last summer when the billboard—which features an image of the Rev. Jesse Jackson done over in blond hair and blue eyes, as if he were white—was attacked with sledgehammers by offended neighborhood residents. Hammons's big picture, its sneering title spray-painted across the bottom in the manner of graffiti, scathingly asserts that only an African-American cast in the comfortably familiar guise of European-Americans would have a chance for authentic power in the United States. The assault against this billboard, which came at the hands of blacks, represented a determined and heartfelt rejection of any blue-eyed alteration of a political leader whose rise to national prominence had come from within the black community itself. Pleased by this vivid response, Hammons incorporated it into the work: Now the billboard is displayed behind a fence-like barricade made from sledgehammers and with an American flag standing to one side.

The second work in the lobby is a coat rack filled with dresses, pants, shirts, and jackets, all of them jet black; propped on the floor beneath them is a blind person's white cane. *Death Fashion* (1990) lines up clothing that represents the hip, de rigueur costume of denizens in the mainstream art world. For Hammons, of course, blackness is more potent than a changeable uniform or mere fashion statement for a white-dominated art world. Leave your blindness at the door, his funerary wardrobe suggests.

Hammons traffics in the unpredictable, socially volatile

intersection between the worlds of politics and art. He's done so from the start. The retrospective, which includes some seventy-five assemblages and mixed-media works from about the last twenty-five years, and which was organized by curator Tom Finkelpearl for the Institute of Contemporary Art, P.S. I Museum in New York, features a room of more than two dozen early drawings and "body prints" made in Los Angeles in the late 1960s and early 1970s. Inking his own body and pressing it onto paper—or, in the case of a 1968 sculpture called *Admissions Office*, pressing it against a window pane fitted in a locked door— Hammons paired the exclusion of African-Americans from the mainstream structures of social life with their exclusion from the imagery of the visual world. Pressing his own body into the service of reproduction could not have been more pointed.

David Hammons
Bag Lady in Flight
1982 (recreated 1990)

Hammons pulls together a variety of sources in his work. Artistic traditions of assemblage and Dada are everywhere to be seen— not least in sculptures such as *Kick the Bucket* (1988), in which a graceful loop made from dozens of joined bottles of cheap, rot-gut wine traces a cartoonlike trajectory for a tin bucket held aloft by the loop. The punning title invokes the important precedent of Marcel Duchamp; and the street aesthetic of employing common materials in the service of racially specific commentary recalls the work of Mel Edwards, whose "Lynch Fragment" sculptures turn steel shackles into Cubist-related fetishes and masks.

 The concise visual economy that marks Hammons's best work also speaks of the artist's early training in advertising. Like an advertiser, he plainly wants to grab an audience by speaking from a position of accessibility in a setting that is not hermetic. For instance, making a basketball hoop from a plastic milk case nailed to a beat-up door or an old trash can atop a pole (the series "Higher Goals" [1986–90]) restores to the high-stakes corporate business of sports the original, ad hoc playfulness of James Naismith's peach-basket game. Decorating the homemade hoops with bottle caps fashioned in patterns adapted from African

textiles confers a totemic poignancy on basketball's contemporary image as a narrow escape route for athletically gifted ghetto kids.

The pristine, white-walled galleries of a contemporary art museum, especially in a wealthy enclave such as La Jolla, might not seem to qualify as an accessible place—which may explain Hammons's witty decision here to paper several gallery walls with stenciled and floral wall coverings. The austere institution is given a down-home look. And, as always, Hammons is playing by his own rigorously perceptive rules, not by the museum's. Last spring, the artist—a twenty-five-year "overnight success"—turned down an invitation from New York's Whitney Museum to participate in its prestigious biennial exhibition. His refusal declared that his participation is what confers status on the museum, not the other way around. Long ignored by the institutional establishment, he wasn't about to become a blue-eyed blond for the occasion.

Direct confrontation and biting wit are ever-present in his art. Yet, in his evocative use of materials Hammons is also capable of remarkable grace and delicacy. Two of the most elegantly beautiful works in the show are generic portraits installed side by side: *Bag Lady in Flight* (1982), in which greased and flattened paper bags, decorated with nappy hair, trace a sinuous arabesque across the wall; and *Roman Homeless*, executed last year in Italy, where he now lives, in which a cornucopia-shape of wire mesh is festooned with scavenged tennis balls and crystal teardrops and shrouded beneath a sumptuous rag of stained brocade.

The exhibition's tour de force is an installation that magically distills and makes visceral a central quality of black experience in the United States. It begins with the loud and joyous sound of a gospel choir singing *Jesus Is the Light*, which emanates from a darkened room. Inside, 100 glowing, phosphorescent little figures of a crucified Christ hover miraculously in the darkness, like a Milky Way of salvation twinkling in the night sky. Suddenly, and without warning, the music stops in mid-chord with deafeningly silent abruptness, as the blinding light of a half-dozen naked bulbs flashes on. The joyful chamber is revealed to be a blistered tenement room or shanty, built from tin walls and peeling paint. A cheap plastic fan blows across the plastic crucifixes dangling from the ceiling, and a "boom box" sits quietly on a high shelf. Your eyes (and brain) slowly adjust to this grim sight, but soon the lights go out again and the inspiriting music swells. Renewed and revivified by the illuminating reality of the street, the phosphorescent light of Jesus glows more brightly overhead.

It's hardly a revelation, intellectually, to say the church has been a stout anchor for black culture in a hostile America. But what that visceral dynamic means, underneath the skin, has never been more eloquently told than in David Hammons's art.

palmer c. hayden

May 22, 1988 Writers and musicians dominate the legacy of artists instrumental in the efflorescence of the New Negro Movement, begun in the 1920s. Among the painters involved with the heady assertion of racial pride, which was sometimes called the Harlem Renaissance because of the concentration of artistic activity in that New York City neighborhood, none has achieved the stature of, say, poet and novelist Langston Hughes. It is difficult to know just why that should be so—especially when a painter as good as Palmer C. Hayden (1890–1973) is among the artists who, if not exactly anonymous, are surely far less well known than they ought to be.

Most recently, a few paintings by Hayden were included in the survey exhibition "Hidden Heritage: Afro-American Art, 1800–1950," which was shown two years ago at the California Afro-American Museum in Exposition Park. The standout on that occasion was a small, 1936 picture called *Midsummer Night in Harlem*, a deceptively simple composition that actually managed to orchestrate a cast of nearly 100 characters into something approaching a light romantic opera.

Midsummer Night is on view again, this time in a very welcome exhibition of twenty-nine paintings and nine watercolors that, together, provide at least a rough sketch of an artistic career that spanned nearly fifty years. "Echoes of Our Past: The Narrative Art of Palmer C. Hayden," organized by guest curator Allan M. Gordon for the Museum of African American Art, celebrates the bequest of a collection of Hayden's paintings to the institution by the artist's widow.

Hayden, who was born Peyton Cole Hedgeman in Tidewater, Virginia, in 1890, followed a not uncommon course in the 1910s. Having moved to Washington, D.C., at sixteen, and having traveled as a roustabout with the Ringling Brothers Circus, he relocated to New York in 1912. The great migration of blacks from the rural South to the industrial North, which accelerated exponentially during the war years, set the stage for the Harlem Renaissance of the following decade.

In the 1920s a fundamental program of the New Negro Movement, which claimed highly influential leaders in W.E.B. DuBois and Alain L. Locke, was to promote a specific role for the artist in the new black society they intended to create. Simply put, that role was to identify, to celebrate, and to artistically embody the heritage and destiny of black life. In the exhibition, Hayden's paintings speak of that role in both subject matter and style. The earliest-dated picture in the show— and it should be noted here that precise dates are unknown for nearly one third of these paintings—is a still life composed from a huge bowl of tiger lilies and a carved African bust. Elsewhere, genre scenes abound: friends playing checkers or singing around the kitchen table, berry pickers, a couple courting, etc. The church and religious life are also fre-

quently depicted. Stylistically, these pictures vary widely. Straightforward Realism (*Fetish and Flowers*) and playful caricature (*Checkers Game*) will be found. There is evidence of the artist's five-year sojourn in Paris, from 1927 to 1932, in such Matissean images as *Central Park Summer*. Often, however, a folkish Neoprimitivism (*Midsummer Night in Harlem*, *Baptizing Day*) or a flattened, abstracted patterning with the visually syncopated rhythms of jazz (*Beale Street Blues*) reveal how Hayden explored style itself as an evocation of black cultural history and traditions.

Certain parallels can of course be drawn between the specific aims of the New Negro Movement and the more general ones of Social Realist or American scene painting, which sought a faithful depiction of or social commentary on American life and came to the fore in the 1930s. The Harlem Renaissance, however, was something significantly different for the self-perception of black Americans.

Palmer C. Hayden
*Died wid His Hammer
in His Hand*
1944 – 47

Like any renaissance, the Harlem Renaissance exhumed traditions long-lost or forbidden. The reason was not merely to know what had happened in the past or where one came from, although that was certainly part of it. Whether in Renaissance Florence, with its disinterment of classical antiquity, or in nineteenth-century France, with its neoclassical revival, or in Renaissance Harlem, with its exhumation of African traditions, the procedure is the same: Almost inevitably, Modernist self-consciousness is formed through a renewed relationship to the ancients. The exhumation and knowledge of traditions were meant to provide a point of historical reference from which to actively define, through contrast or knowing imitation, the present moment.

Why was such definition necessary? W.E.B. DuBois, who received his Ph.D. from Harvard just two years after Hayden's birth, was a generation older than most of the artists of the Harlem Renaissance he was so instrumental in shaping. When the migration from the rural South to the industrial North occurred, DuBois was around fifty. He thus was able to see clearly the crisis it engendered (indeed, *Crisis* was the name he gave to the magazine in which many of his ideas were articulated). As much as anything, the unnerving crisis was one of modernity. Modernity

is the consciousness of being in a new epoch—which the leaders and participants of the New Negro Movement most certainly felt.

In addition to subject matter and style, Palmer Hayden employed a remarkably simple yet effective device with which this Modernist self-consciousness was made palpable. Time and again, he orchestrated the picture in such a way as to identify his own presence—and, by extension, our presence as viewers—in front of the canvas. In the beautiful *Fetish and Flowers*, this self-consciousness is accomplished with a third still-life element: a simple ashtray, with a burning cigarette, prominently displayed in the foreground at the table's edge. Someone unseen is made known. In *Baptizing Day*, the country river in which stand the white-robed initiate and the clergy opens up to span the bottom edge of the canvas. There, oversize lily pads call attention to our point of view on the baptismal scene: We are positioned in the river, too, just downstream from the initiate.

Among the most effective examples of this device of locating the spectator in relation to the scene will be found in the "John Henry Series" of paintings. The series, which is Hayden's most famous body of work, chronicles the heroic legend of the black railroad builder who died at Big Bend Tunnel competing with a steam-driven drill. The operatic cycle reaches its apogee in *Died wid His Hammer in His Hand*, the scene where John Henry, surrounded by a mourning crowd, lies dead on the ground. He is depicted lying flat on his back, arms outstretched, in a pose clearly meant to allude to the Crucifixion. Significantly, we view this scene from a space Hayden has left in the encircling crowd of mourners—a space that, not by accident, puts the spectator closest to the huge silver hammer still gripped in the Christlike hero's outstretched hand. It is plain just who, in the present day, is meant to pick up that hammer and finish the job left incomplete by a heroic ancestor.

Ironically, it may be this very compositional device—this one-on-one correspondence Hayden so deftly establishes between painting and viewer—that explains the disparity in reputation between painters of the Harlem Renaissance and artists who worked in other mediums. Perhaps most important is a cardinal difference between writing or music and painting: Writing, when printed, or music, when scored or recorded, can be many places at once; a painting, on the other hand, can only be in one place at a time. The multiplicity inherent in books, sheet music, or records is a quality quite different from the singularity of paintings. I am not saying one is better or worse than the other, merely that they have certain formal characteristics that are different.

Because achievement is in part a function of the degree to which an artist's work fertilizes subsequent activity, one of the chief differences is this: Reproducible mediums such as writing or music offer greater chances of being broadly effective, especially if the artist happens to be one who is socially disenfranchised. For without a pub-

lic platform from which to speak to the multitude, a superabundance of intimate conversations is essential to making oneself heard. Writing and music do this. Whatever the case, this exhibition deserves a wide hearing. Certainly it is but a thumbnail sketch of an artist whose career deserves a full-scale examination. Still, the show itself is decisively "picking up the hammer" left in the outstretched arm of Palmer Hayden.

Roger Herman

september 26, 1982 Like numerous American and European artists in the past few years, Roger Herman has been described as a "Neoexpressionist" painter. The German-born artist, who now lives in Los Angeles, is currently having his second one-man exhibition at the Ulrike Kantor Gallery. It is a sizable show (sixteen paintings and four woodcuts) of often sizable works (the largest is a diptych 16 feet in length), so the gallery also has opened a temporary annex a few doors away. Regardless of what one wishes to choose as a label for the artist, the paintings are exceptional.

Herman's is not an authentic Expressionism, although his paintings are loaded with Expressionist signs. Sex, death, and power, for instance, are recurrent subjects—the first in two paintings of sexual intercourse between faceless participants, as well as in several versions of three female figures whose ancestry lies in classical renditions of the three graces; the second in a large painting of a human skull called *Mexican Painting* and in two versions of French Revolutionary hero Jean Marat, lying slain in his bathtub; and the third in a variety of forms. Power is implicit in a looming image of a classical building, titled *Wall Street*; in the pictures of the politically motivated assassination of Marat; in the familial double portrait of the artist's parents (they are seen from below so that they become gargantuan in a manner reminiscent of Socialist-Realist depictions of political leaders or of monumentalized workers); and in a painting and several woodcuts of Indians with flared Mohawk haircuts, the romantic vision of the "noble savage" of the American wilderness.

Expressionism's common appropriation of a wide array of artistic traditions is evident as well. Two large landscape paintings with nearly identical images of mountains recall Cézanne's extensive series of Mont Ste. Victoire pictures, here swelled to gigantic scale in a massive engorgement of paint. Further, the similarities between the two panels brings to mind Robert Rauschenberg's *Factum I* and *Factum II*, two nearly identical paintings of the 1950s in which the artist mocked the individuality supposedly inherent in Abstract Expressionist art. The two "Marat" paintings reprise the subject of Jacques Louis David's famous painting of his slain compatriot, while the "three graces" are reminiscent, in style and subject, of paintings by the late Bay Area painter

David Park. And Herman's use of the woodcut (the form of print-making least popular in the past several decades) cannot help but re-call the German Expressionist revival of the technique earlier in this century. Most obviously, Herman's use of paint is an Expressionist sign. He has a penchant for the acidic and the bilious in his choice of col-ors and, in a painting like the large *Marat*, is capable of composing an entire picture in shades of crimson, orange, deep violet, and black. And everywhere his paintings are built from thick, gestural slashes of paint and runny dribbles of thin pigment.

Roger Herman
Father/Mother
1982

But what is odd about these paintings is that their parts are not *Expressionist*—they are devoid of the direct, emotive energy one associates with Expressionism—but are Expressionist *signs*. They seem strangely filtered, as if seen through a fog. However tradition-minded, the image in the large, 16-foot *Marat* is not taken from the clas-sic painting by David (who, significantly, composed his remarkably touching 1793 painting directly in the presence of the body of his dead friend), but from a scene in Abel Gance's film *Napoleon*, in which the writer Antonin Artaud played the murdered revolutionary. The colors of Herman's painting even give the image something of the fil-tered look of an infrared photograph. Similarly, his huge painting of his parents transforms these personally significant individuals into pub-licly heroic "types." Their idiosyncrasies as people—both physically and emotionally—are subsumed in the welter of sketchy, gestural paint. Like the image, the weight of twentieth-century tradition has drained the idiosyncratic, emotive quality from Expressionist handling of paint; it, too, is now a "type," so overloaded with rhetorical baggage that its use keeps us from fresh, direct experience.

What Herman manages to do in the best of these works—the double portrait of his parents, the large *Marat, Wall Street*, the twin moun-

tains and several of the woodcuts among them—is to load Expressionist sign upon Expressionist type until they can't be sorted out and all we can see is the painting itself. The specificity and idiosyncrasy of these works is simply to be found within their very physicality and presence on the wall, as well as in the nature of our experience of them.

The sense of history and tradition in Herman's work is both personal and cultural. Significantly, he emphatically melds them both together: His parents become heroic (or cultural) "types," while the Expressionist brush stroke is drained of autobiographical (or personal) meaning. These reversals are disarming. They result in paintings with a distanced quality, a remoteness not unlike watching your own life pass by on the surface of a television screen. Looking at Herman's paintings is like watching yourself being watched—you feel connected but separate. They exhibit a genuine poignancy, even a sadness, but it is a sadness one always feels when faced with extraordinary beauty.

"Neoexpressionism" is a deceptive term. Its prefix misleadingly suggests that the operative impulse is revivalist—that Neoexpressionism intends to resuscitate the abandoned search for emotive imagery that lurks deep within us, beyond the reach of conscious control yet harboring true freedom. It suggests, in short, that the search that fueled German painters in the early 1900s and abstract painters in the 1940s is being revived. But to regard Neoexpressionism as such a revival is a mistake. Indeed, to do so would be to accept that an unbridled desire for primal utterance and raw "self-expression" is anything more than the very cliché by which popular culture has come to define the artist and his method. *Lust for Life* and *The Agony and the Ecstacy*, to cite two wildly popular pulp-novel biographies (of Van Gogh and Michelangelo, respectively) that were transformed into silver-screen epics, are perhaps paradigms of this pop-culture myth of the artist digging into the purity of his soul in the search for absolute creative freedom. The emotive or "expressionist" force suggested by the very words "lust," "agony," and "ecstacy" is, in fact, nothing more than a vernacular variation on the Judeo-Christian tradition of sin, damnation, and redemption. That such a view of self-expression—as supposedly pure and absolutely free—has been so thoroughly embraced by our culture (someone once aptly described self-expression as "a cultural opiate") is a clear example of the degree to which our very deepest emotions, once thought to be beyond conscious control, are indeed politically and socially inflected.

In fusing the personal and the cultural, and in plainly stating the multitude of historical traditions from which this fusion issues forth, Herman reconnects the emotive to its complex source. What is "new" about his "Neo"-expressionism is the degree to which it reveals that subjectivity—the myth of self-expression and primal emotion as the liberating motive force for art and life—is anything but freely felt.

Eva Hesse

July 15, 1992 It's remarkable that there has never before been a retrospective of the sculpture of Eva Hesse. Her untimely death in 1970 robbed us of an unusually gifted artist whose star was rapidly ascending, and since then her reputation has broadened in scope and deepened in resonance. Hesse is today commonly—and correctly—regarded as among the most significant sculptors of the late 1960s. Nonetheless, the retrospective exhibition of eleven early paintings, sixty-seven drawings, and thirty-five sculptures and reliefs now at the Yale University Art Gallery is the first thorough examination of Hesse's work ever mounted. Beautifully organized by Helen A. Cooper, curator of American paintings and sculpture at the Yale gallery, and with an indispensable catalog featuring excellent contributions from a variety of scholars, together with extensive excerpts from the artist's voluminous and illuminating diaries, the show is a knockout.

Hesse's career was brief. She was barely thirty-four when she lapsed into a coma and died, after a year-long battle with a brain tumor, and her mature work dates from just the last four years of her grossly truncated life. Born in Hamburg, Germany, two years after voters gave Hitler the presidency, she and her Orthodox Jewish family fled the Nazi persecution and emigrated to New York when Eva was three. Deciding to become an artist while still in high school, she studied at several local art schools and, finally, at the Yale School of Art and Architecture. Throughout her education, it was painting, not sculpture, that Hesse pursued. This is crucial to remember, for one revelation of the retrospective is just how important painting is to an understanding of Hesse's extraordinary sculpture. The pivot is a wall relief called *Hang-Up*, which dates from January 1966. A wood rectangle 6 feet high and 7 feet wide, its configuration is plainly reminiscent of a painting's stretcher bars. The bars have been wrapped with strips of cloth painted gray, in tones that gradually slide from off-white at the upper left corner to dark, smoky gray at the lower right. These opposing corners are further linked in a most unusual way: A thin, steel tube, tightly wrapped with gray-painted cord, loops wildly out from the frame a good 6 feet or more into the room. Constructed from all the necessary parts, *Hang-Up* looks like a wounded, carefully bandaged painting that has been put on life-support.

Hesse plainly sensed that painting, to which she had committed her first half-dozen years as an artist, was a suffering invalid. By the mid-1960s, Abstract Expressionist painting had faltered. The tide of Minimalist sculpture was newly cresting, while Pop art was simultaneously challenging the uniqueness of the traditional canvas by exalting camera images mass-produced for commercial culture. So, Hesse gave the patient a bracing jolt.

Artists have long made paintings depicting sculptures, but sculptures of paintings are considerably rarer in the history of art. And what an odd contraption *Hang-Up* is! The traditionally fictive space between a painting's stretcher bars is transformed into real space, while a makeshift snare is sent out to entrap the world—including hapless passing viewers—into its enclosing precinct.

Again and again in Hesse's work of the next four years, terms aligned with painting are applied to sculpture. The fifty fiberglass and resin tubes of *Accretion* (1968) stand on the floor and lean against the wall, betwixt and between the discreet realms in which sculptures and paintings are usually found, their shapes recalling bolts of unstretched canvas casually lined up. Yards of cheesecloth are soaked in latex and draped over a dowel in *Contingent* (1969). In *Right After* (1969) and *Untitled* (1970), tangled webs of cord and wire coated with resin and latex are suspended by hooks from the ceiling, as if the dancing skeins of paint in a Jackson Pollock had been strung up by their ankles. Such sculpture acknowledges the fundamentals of gravity and mass, but unconventionally. Although sculpture traditionally tries to overcome its earthly bonds by climbing skyward, Hesse's articulates gravity by succumbing to it. More often than not her sculptures hang suspended—as paintings do.

In the show, *Hang-Up* announces a distinct dividing line between Hesse's mature sculpture and the increasingly eccentric but immature painting that came before. Between 1960 and 1966, the rapid evolution of four particular phases can be identified in Hesse's art. The first consists of loose, brushy paintings, usually in dun-colored paints layered over more luminous under-painting, in which figures often merge with their surrounding space. The second is the arrival of abstract, mechanomorphic forms—a Surrealist fusion of machinelike and organic shapes, cavorting in an indeterminate space—typically rendered in lively colors. (Surprisingly, these somewhat recall the contemporaneous paintings of John Altoon.) Next comes the peculiar elaboration of these painted forms into three-dimensional reliefs, with the addition of plaster, papier-mâché, metal, cord, and other collage materials, built up from the surface of the painting. Finally, using painted papier-mâché and cord slathered over and wrapped around inflated balloons, rubber hose, inner tubes, and such, Hesse left traditional painting behind. As she did, the relationship awkwardly (and perhaps unconsciously) implied between the human body and a work of art in her earliest figure paintings became overt. Hesse found materials whose industrial qualities recalled a machine aesthetic, but whose likeness to human skin was explicit: Works like *Schema* and *Sequel* of 1967 incorporate thin sheets of latex, while several 1968 sculptures are made from fiberglass and rubber. The origin of these works' sensibility in the mechanomorphic paintings of several years before is plain, even though their style is completely different.

One of the great pleasures of the retrospective is the op-

portunity to see all five parts of 1968's great *Sans II*. Long dispersed, they've been reunited for the first time since Hesse's debut solo exhibition at New York's Fischbach Gallery, shortly after the sculpture was completed. Made from translucent amber fiberglass, each segment is a rectangular box subdivided into two rows of six boxes open on one side. Lined up end to end, the five segments compose a wall sculpture nearly 56 feet in length— although the repetition of forms suggests it could extend into infinity. This mathematical repetition of geometric forms is basic to Minimalist sculpture of the period, but the irregularities of its industrial material, its fleshy luminescence, and its visual appeal to tactile values aren't. Eros slyly makes its way into Hesse's art, carried by intimations of the inseparability between the beauty and mortality of the flesh.

Hesse's art finds echoes in the contemporaneous work of Bruce Nauman, Robert Morris, and certain other artists, but its closest relative seems to be the sculpture and wall drawings of her friend and greatest champion, Sol Lewitt. No one would mistake a Hesse for a Lewitt, so stylistically different are they, but the art of both can be characterized by strict repetition of forms made highly erratic and personal through individual touch and vision. Hesse is today an important precedent for a younger generation of artists who, at this highly charged moment, have made the politics of the human body their subject. Her compelling fusion of cerebral Minimalist principles with eccentric, intuitive forms is a powerful spiritual ancestor. The timing of the retrospective should widen her influence.

David Hockney

February 1982 There are painters who are also photographers. Then there are painters who, like most of the rest of us, happen to take pictures from time to time. And whenever a well-known painter happens to be a picture taker, those photographs are an immediate source of more than cursory interest.

About eighteen months ago, I had the opportunity to leaf briefly through several of David Hockney's photo albums from the late 1960s. They are big, bulky, overscale books, bound in leather and gold-stamped with the dates spanned by their contents. They strongly resemble in weight and appearance the volumes of an encyclopedia or an atlas, a similarity enhanced by the nature of the Kodak Instamatic and 35-mm pictures inside: These wide-ranging snapshots chronicle a vast terrain. There are pictures of the back end of a city bus and of the front end of a Los Angeles Police squad car; images of a lawn sprinkler spinning in a suburban yard and of the jutting corner of the mammoth building in Los Angeles known as CBS Television City; dozens of views of palm trees and several of an enormous "Carpeteria" sign, held aloft by

a latter-day Colossus of Rhodes. There are pictures of friends and of strangers on the street, candid shots and orchestrated poses, portraits and still lifes and landscapes. Hockney is a painter who happens to take pictures, but the nearly 30,000 photographs that he has assembled in some one hundred albums over the past twenty years suggest he takes them more frequently than just "from time to time." There is a voraciousness here, an appetite for the things of the world.

Hockney has said that his attraction to photography stems from the camera's demands for "intense looking." In a 1968 photo album, page after page of photographs record the Santa Monica living room of writer Christopher Isherwood and artist Don Bachardy that would become the setting for a painted double portrait later that year. The earliest photograph shows the pair seated in boxy wicker chairs before an open window. Later pictures record the chairs empty and from several points of view, with the window shutters closed; others zero in on a coffee-table still life of books, a bowl of fruit, and an ear of Indian corn; and four examine Isherwood's profile from slightly differing angles.

These pictures are like "sketches" made in anticipation of a painting that was to end up substantially different from any of them. Each is a fragment in which a bit more of the subject is revealed. The setting of the finished double portrait is greatly simplified from the actual living room, as if comprehensive seeing allowed Hockney to eliminate extraneous details. Significantly, in the finished painting Isherwood looks at Bachardy, who looks straight at us, who look at the painting.

Hockney does not faithfully transcribe photographic information into paint on canvas (he is far from a Photorealist), and the relationships between paintings and photographs follow no formulas. Turn an album page, and there, suddenly, is an almost offhand photograph of Peter Schlesinger propped up against an automobile. The pose startles, then jogs the memory: It is the same pose that later appeared in a painting of Peter in a swimming pool. The casual, playful, often intimate nature of many of Hockney's photographs frequently makes looking through the albums more like snooping in a diary than reading a formal autobiography.

Whether in his photographs or in his painting the personal, subjective viewpoint dominates Hockney's work. There is a fundamental difference, however, between the kinds of subjective decisions to be made in each medium. A painting has edges, but the things it can frame are entirely arbitrary. The "intense looking" that the camera demands is, to a significant degree, a function of its properties as a framing device for what already exists in the viewfinder.

As if to crowd as much as possible within the frame of the photograph, Hockney frequently takes pictures of other frames. Photographs of interiors focus on transparent windows framing bits of the outside world, while exterior shots frame open and shuttered win-

dows. Figures are framed by doorways leading to other rooms and by the spatially ambiguous, translucent patterns of water in a swimming pool. Reflective mirrors are a frequent subject, able to frame and include that part of the room that exists behind the camera's lens. And the individual pictures in Hockney's "joiners"—sequential views of a scene that are pasted together—are often cut and "reframed," bumping edges against one another. In all these examples, the artist exploits the camera's basic mechanical properties, but the very clarity of his determined attention to framing and to qualities of light (transparency, translucency, reflection) puts the subjective vision in control of the camera's mechanical limitations.

The experience of rummaging through these photo albums anticipates the experience of looking at the gridded Polaroid composites that Hockney began to make earlier this year. Hockney describes the process employed in these extraordinary new Polaroids as "drawing with a camera." In the full-length seated portrait of David Graves (*Pembroke Studios, August 27, 1982*), for instance, 120 separate Polaroids are assembled in a grid pattern to form the image of a figure seated in a book-lined interior. As in the earlier "joiners," organically related framing edges bump up and sound against one another throughout the intricate composition of the portrait.

The shattered image, built up from dozens of interlocking planes, bears superficial resemblance to the fragmentation of Cubist paintings. Hockney openly acknowledges the resemblance in several of these works: The tabletop assemblage of plastic fruit, a newspaper, and guitar in *Yellow Guitar Still Life* recalls numerous Cubist paintings; *Henry* [Geldzahler] *Cleaning His Glasses* looks remarkably like Pablo Picasso's 1910 *Portrait of Ambroise Vollard* somehow transformed into the synthetic colors of Polaroid film; and these "drawings" composed from scraps of photographic paper even recall Georges Braque's and Picasso's invention of collage.

But these are not simply camera-trick gimmicks made in homage to the master. Nor is his method new; other artists have combined multiple photographs to form a composite using techniques similar to those Hockney employs here. Rather, the technique and the Cubist allusions seem to spring less from a desire to find ways to *make* an image than they do to find ways to *see* an image, to allow the reality-based objects that photography captures to reveal themselves in concert with the artist's eye. That impulse, coupled with the instantaneous, notational quality of Polaroids, makes these works not just photographs but drawings as well.

Each single Polaroid in the composite records its image frontally and in focus. Blocking out the rest of the pictures in the grid and looking at a single square—Graves's folded hands, for example, or the floor lamp in the background—one can see that each has been

taken at relatively close range. The clarity and scale of the floor lamp in its photographic frame is closer to that of the folded hands in their photographic frame than to what our eyes would perceive if we were standing at a fixed position in the room. When assembled together in the grid to form the composite image, everything in the picture—whether foreground, middle ground, or background—is seen close-up on a collapsed, shallow plane. Like the hard, bright colors of Polaroid film, the composite image is dense, highly saturated, and synthetic.

Arranged sequentially in horizontal and vertical rows, the Polaroids become a kind of "visual list" of things in the room: shelves, books, lamps, eyeglasses, lips, lapels, fingers, a vase, tulips, a chair, wicker, socks, shoes, carpeting, a mirror, and so on. Each object and each picture is an artifact, and each artifact is given equal weight by the non-hierarchical composition of the grid. In this aesthetic democracy, every object is to be enjoyed for the visual pleasure it yields, and each of these separate voices in the polyphonic chorus is equivalent to the whole of the David Graves portrait. The visual pleasure here is a sensuous exploration of surfaces. The artist moves around the room, approaching the object of desire, embracing it at a distance as the shutter clicks and the electronic motor purrs, then retreating and moving on to the next. The composite image is reconstructed from a composite of sensory experiences, of surfaces seen and collected. The wholly mundane compendium of objects in the room assumes the dimensions of a spectacle. The charms of these "spectacular drawings" is precisely their expansiveness, their nonexclusionary quality. The isolating eye of the camera segments the views, but the reassembled grid juxtaposes things of starkly different natures: The hard geometry of shelves abuts the softness of narrow chin and full lips. The grid is a rational structure for an exercise in intoxicating sensuality. The drab and insignificant become the singular and radiant.

Like Hockney's scores of photo albums, each of his composite Polaroids is compiled of encyclopedic yet partial bits of "intense looking" collected over time. And the subject matter in albums and composites is much the same. As with the individual photos in the albums, the Polaroids can be compared to images in the inventory of the artist's paintings; as sketches they anticipate paintings to come. As an intimate record of moments in the artist's life they offer evidence of his unique point of view. But, more than the pictures in the photo albums, the Polaroids stand as complete and self-sufficient entities as well. David Hockney is a painter who happens to take pictures from time to time. Now, it seems, he is becoming a painter who is a photographer as well.

George Inness

February 23, 1986 It's good to see an exhibition take on an artist whose work we think we know and try to cast a wholly new and revealing light on his endeavor. Too often, mere reconfirmation and minor elaboration mark historical shows, as if the important artists of the past have been pinned down in all the ways that really count. Shaking up our received ideas about a body of work is, of course, no simple task: Radical insights and the ability to persuade us of their legitimacy and value aren't easy to come by. Still, when it works it's extraordinary.

When it doesn't, it's extraordinary in a rather different way. "George Inness" is an exhibition at the Los Angeles County Museum of Art that has such a radical revision in mind for the nineteenth-century American painter best known for his tonal, richly atmospheric landscape paintings of the 1880s and 1890s. As the first big survey of Inness's work in nearly forty years, the show has bravely seized a rare opportunity for a major overhaul in our thinking about the artist. Bravery is admirable, but this attempt suffers a crushing defeat.

Increasingly, American painting of the last century has been the focus of the kind of scholarly reassessment that, during the past fifteen years or so, has been directed at contemporaneous European art. The Inness show goes one giant step further: While nineteenth-century American art has always been dimmed by the bright light of European Modernism, a case is made here for considering Inness himself to be among the first truly modern artists. It's quite a claim. That neither the curatorial viewpoint nor the artist's paintings themselves can support such a reading makes for great expectations grossly unfulfilled.

LACMA curator Michael Quick supervised the exhibition, but his collaborator Nicolai Cikovsky, Jr. is the one who means to show us Inness's modernity. Now curator of American art at the National Gallery, where the show will make the final stop on its five-city tour next summer, Cikovsky has been the primary authority on Inness ever since his 1965 doctoral dissertation finally was published nine years ago. His command of every nuance of the artist's biography is formidable, as is his knowledge of the complex currents of American art in the second half of the nineteenth century. What pales, however, is Cikovsky's grasp of modernity. His essay in the accompanying catalog is constructed in such a way as to ascribe all manner of received ideas about the Modernist milieu to Inness, but it adds up to circumstantial evidence that just doesn't stand up in court.

It's worth making a list of some of those attributes, and decoding what they're intended to suggest:

"Wherever his contemporaries were going, [Inness] was going the other way." Translation: Inness was an individualist.

"He paid a price for this contrariness, this disobedi-

ence of the practices and principles of his contemporaries. When they were being praised and honored, Inness was ignored." Translation: Inness was a misunderstood rebel, and he suffered for it.

"Only later in the century, in literally more modern times, others came to see, as Inness had foreseen, that artistic form had distinct claims of its own to beauty, meaning and expression from whatever it might depict." Translation: Inness was ahead of his time, an avant-garde painter, and a formalist one at that.

"Wilderness landscapes were history paintings and mythology. Inness's civilized landscapes were modern paintings, legible signs of his affiliation with the modern present as against the mythologized past." Translation: Inness embraced progress.

"According to [his early] critics, he is not merely misguided; he has criminally transgressed the limits of public comprehension." Translation: Inness saw art as a vehicle for smashing social boundaries.

More such passages could be cited. Yet these suffice to give a clear indication of the degree to which the traditional conventions we commonly associate as having arisen from the European Modernist milieu are being applied to the American's life: individualism, rebelliousness, suffering, avant-gardism, formalism, progressiveness, transgression, and the like. Toss in Inness's spiritual inclinations (he avidly embraced the teachings of eighteenth-century mystic Emanuel Swedenborg), his bouts with melancholic depression (some believe he attempted suicide in later life), the luminous coloration and ambiguous forms in his late paintings, and you've got an artist who, as Cikovsky claims, is "very like Rothko."

The curator doesn't go quite so far as to declare that if you removed the cows from an Inness landscape you'd have a 1958 Mark Rothko painting of the void, but that bizarre suggestion is certainly meant to hover in the background. The problem isn't that any or all of Cikovsky's statements aren't true; Inness was very different indeed from most of his American contemporaries. The problem is that, taken together, these attributes don't necessarily add up to modernity. Cikovsky's focus on establishing parallels in formal structure sets up a classic fallacy, because similarity doesn't always mean connection.

Like his Hudson River predecessors, Inness began by executing tightly controlled landscapes, but he soon came under the spell of European Old Masters. He studied briefly with the French-born painter Régis François Gignoux, who passed on his own interest in seventeenth-century Dutch landscapes and the French classicists. Indeed, the American's attachment to European classicism, especially that of Claude Lorrain, was deeply felt; it was further enhanced by his sojourns in Italy and France. And his encounter with the romantic, atmospherically moody landscapes of the Barbizon painters showed him a way to merge his own classicist embrace of order with evocative expressiveness.

The fundamental difference between Inness and his fellow American painters was the degree to which he believed in the importance of painting as a self-expressive medium. For him, a native school of landscape painting didn't just come from faithful transcription of indigenous nature; it arose from the subjectivity of the artist and the principles of painting, as well as from the visible world around him. What's important to realize, however, is his conviction that all three features needed to be held in careful equilibrium. No doubt enhanced by his study of Swedenborgianism, a regard for the unity of all things was of utmost concern.

Cikovsky tries to convince us that Inness's subjectivity makes him modern, but it's a simplistic view that distorts the Modernist program. He maintains that, in such paintings as *Early Autumn, Montclair*, done three years before the artist's death in 1894, Inness records a self-expressiveness, a quality of thought and feeling that was new to American art; and that the self-evident display of concern for the painting as a formal arrangement of shapes and colors underscores its modernity (you can almost plot the features of this landscape on a mathematical grid). He's right about the self-expressiveness and the formal concern, but he's wrong when he ignores the way in which those qualities were used to produce an image. Inness went to great lengths to harmoniously balance a painting's qualities as a formal object, as a self-expressive field *and* as a depiction faithful to the settled natural landscape. None takes precedence over the others.

Indeed, Inness rejected French Impressionism as a "passing fad" because it put the subjective eye in the first rank. Such privilege, which was fundamental to the Modernist faith that each man should decide for himself how to live, was antithetical to his own conviction about the unity of all things. Likewise, the Postimpressionists that Cikovsky claims as Inness's contemporary Modernist counterparts had reversed the polarity evident in the earlier Barbizon painting that the American whole-heartedly embraced: Rather than begin with the physical world and then "subjectivize" it according to feeling, Gauguin, Van Gogh, and others took feeling as the starting point and objectivized it in the form of a painting. The self was elevated to a level superior to nature. There's no reason to believe that Inness ever saw things that way.

Neither did he "foresee" what others came to see in "more modern times." Throughout his life, Inness was guided by the classical tradition in which the disorder of everyday life was banished. Should we be surprised that people slowly began to embrace his art in the decade after the devastating and destabilizing Civil War? His was an art of grave certainties, of an absolute claim to harmonious unity—and thus, most assuredly, not modern.

With more than sixty paintings tracing the artist's work from the 1850s to the 1890s, the Inness exhibition is clearly worth see-

George Inness

ing. To be sure, it's sad to realize that we may have to wait another forty years for a revealing account of this important artist. It's sadder still to realize that the National Gallery is devoting its efforts to pumping up American artists into inflated Masters of Modernism. Distorting Inness to make him "very like Rothko" is but an attempt to extend the so-called triumph of American painting backward in time to the nineteenth century. Although Michael Quick does try to put the late paintings into context, serious scholarship is in short supply. If nothing else, the obvious wackiness of claiming Inness's modernity may help put to final rest the waning appeal of formalist art history. For no finer lesson than this can be imagined as a demonstration of its capacity for gross deformation.

Jim Isermann

January 26, 1986 Flower Power is back—sort of—and Jim Isermann has got it. The look of his recent work is positively psychedelic: assaultive colors, vibrant energy, synthetically organic patterns, a strange warping of time. However odd or even silly such an enterprise might sound, the artist has tapped a vein of considerable richness.

Isermann's current exhibition, which is on view at the Kuhlenschmidt/Simon Gallery in West Hollywood, is titled "Flowers." The centerpiece is a large furniture ensemble fabricated in the shape of a child's rudimentary drawing of a flower; the brightly painted wooden petals form tables separating seats woven from the plastic webbing commonly found on patio chairs. The form of this seating arrangement is reminiscent of the kind of intricately patterned, wrought-iron garden settee that wraps around the trunk of a tree, or perhaps of a circular, tufted Victorian chair that would be crowned by a potted palm. Its style, however, is more akin to the sort of bright plastic seating you'd find in an airport waiting room or the arcade of a suburban shopping mall. Given its configuration, in which the chairs face away from one another (one wag dubbed it an "unconversation pit"), you sit isolated and aloof from anyone else who happens to be sharing the resting place. All the better to stimulate detached contemplation of the "garden" of thirty paintings of flowers, each a standard 4-foot square, that are arranged in an enclosed grid pattern on the surrounding walls. Time in the space is measured by a double row of six jerkily ticking wall clocks, while steady illumination is provided by five garish chandeliers suspended from the ceiling. Each clock and lamp has been fashioned in the shape of, or decorated with, a flower motif.

Isermann's psychedelia refuses all links to serious artistic tradition, but it is embraced so blatantly and adoringly that his work seems utterly impossible without it. The paintings of Andy Warhol hover in

the conceptual background of Isermann's undertaking, specifically the "Flower Series," with which Warhol had his 1964 debut at New York's Leo Castelli Gallery. With his seemingly infallible sense of the social pulse of the moment, Warhol had an assistant make a silkscreen from a photograph torn from a botanical catalog, and the "Flower Series" that resulted blossomed in a riot of random color. Within a few short years, Flower Power had become a central leitmotif for the blooming counterculture.

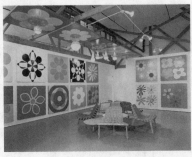

Jim Isermann
"Flowers" (installation)
1986

Isermann's art has always arisen from an impure field. The forms, shapes, and palette of earlier works have had direct ancestry in, among others, the geometric abstractions of Piet Mondrian and the organic Surrealism of Jean Arp. At the same time, Isermann's sculptural renditions of these sources—in the guise of furniture, lamps, clocks, and painted wall plaques—lay direct claim to the common translation of "high art" images and motifs into "popular art" decorative styles of subsequent generations. The sequential transformation of an organic relief by Arp, exalted by the museum, into a kidney-shaped coffee table, exalted by the suburban living room, collapsed in Isermann's organic-relief-cum-coffee-table sculpture.

Collapsed, too, was the boundary that separated the discipline of art from the larger world of manufactured objects. The existence of such a boundary once allowed for the shock and scandal that erupted when artistic production aggressively crossed the clearly delineated borderline. Isermann's art is neither shocking nor scandalous. Indeed, its emphatic, hip-sixties bearing seems as fashionable as it can be. The effect is disarming. For the absolute need to instantly and scornfully dismiss as superfluous, crass, and merely venal all that is fashionable or trendy is among the most entrenched of received ideas in contemporary culture. The extreme fashion consciousness so evident in Isermann's work manages to turn that cliché response on its head by directing itself toward a more provocative and fruitful end: The hearty embrace of fashion insists upon the embeddedness of art within a larger field of social practice. And that insistence is further underscored through the functional nature of these chairs, clocks, lamps, and, by implication, paintings.

For this reason, the retrieval of psychedelic imagery, born of the social upheaval that was the late 1960s counterculture, is inspired. Commentators of all persuasions regard that convoluted period as the signal of a deep and disruptive rent in the social fabric, one whose ramifications are still being felt (and argued) today. Paradoxically, a decided numbness shrouds those feelings: That period of profound crisis seems like ancient history recorded in a mythological universe rather than an internationally resonant phenomenon central to American life barely fifteen years ago. Isermann's "Flowers" are far from a sentimental wallow in nostalgia. Instead, they reconsider a key transitional period through the mimicry and conflation of certain mannerisms in its stylistic language.

From acid-head posters to "visionary" paintings to elaborately painted vans, psychedelic art drew on one of the most deeply entrenched traditions of modern Western thought: the Romantic tradition that invoked the purity of nature as an alternative to the moribund forms of inherited culture. The style that quickly evolved was appropriate to the technological society in which it emerged: hard-edged, synthetically chromatic, frequently adapted from the intricate Art Nouveau interlace that, at the turn of the century, had sought to marry natural forms and machine production.

In its attempted subversion of the structures of establishment culture, the psychedelic program exalted the biological individual, as witnessed by the comic-book elevation of Mr. Natural to the tribal throne. Similarly, a tribal pattern of living was celebrated as appropriate to this idealized return to nature. (In McLuhan's global village, a worldwide tribe would flourish.) Artistically, as the late critic Tom Albright observed of San Francisco,

> Collective and frequently anonymous expression was emphasized. Jazz, always chiefly a soloist's art, gave way to rock music, which was built on a more integrated concept. [And] among visual artists, there was a new preoccupation with Jung's concept of the collective unconscious, as distinct from the individual unconscious emphasized in Freudian psychology. The model was the universal archetype rather than the individual neurotic dream.

The primary visual expression of the counterculture was functional—clothing, decor, advertising—an overlay of psychedelic decoration on utilitarian products, which thus identified their "tribal" integration within the social collectivity of the subculture. In retrospect, a fundamental contradiction asserts itself. For if the social program of the psychedelic 1960s drew upon a deeply entrenched tradition of modern Western thought—the purity of nature as an alternative to the moribund forms of inherited culture—just how truly oppositional could the counterculture hope to be? The "revolution" was, in fact, merely the repeti-

tion of a ritual and thus easily absorbed into long-established patterns of dominance and control.

Indeed, a not dissimilar ritual had been regularly replaying itself in the aesthetic realm of the modern era, from Impressionist painting of the nineteenth century to Abstract Expressionism of the decade immediately before: The ritual effort was channeled toward "naturalizing" the emergence of such cultural forms as industrialism and capitalism, forms that, in increasingly large scale, threatened annihilation. Pop art was the first visible artistic mode to throw a monkey wrench into the proceedings, to seek to cause a rupture in the seamlessness of the ritual. Its commercial subjects and mechanical style of production effectively began to drain the self-expressive, biological individual from the center of the artistic enterprise. ("I want to be a machine," Warhol insisted—and he meant it.) And the naturalizing tendency began to recede into the distance, as there suddenly appeared monumental paintings of gaily colored flowers silkscreened from a photograph reproduced in a catalog.

As with the work of certain other artists, Isermann has pushed this development toward its logical conclusion. His environment of flowers is an exegesis wholly spoken in a language of pop images and cultural stereotypes. The naturalizing tendency is emphatically rebuked. The invocation of the purity of nature as an alternative to the moribundity of inherited culture, so pervasive throughout the history of the modern era, is brought forth on an environmental plane—not of a struggle for "inner truth," but of the operation of cultural codes. In the process Flower Power takes on a whole new set of implications. Among the artist's fundamental gifts is his ability to reveal the complexity of such a situation through a remarkable simplicity of means. It hasn't always worked in past endeavors, but Isermann's current outing is an especially resonant success.

Alexej Jawlensky

January 25, 1991 The turning point in the small but marvelously precise exhibition of paintings by the early twentieth-century Russian-born painter Alexej Jawlensky, recently opened at the Long Beach Museum of Art, arrives in the fourth of the show's five galleries. Seemingly slight, and at first imperceptible amid the painterly seductions of Jawlensky's radical use of vibrant color, the subtle change is nonetheless decisive. Simply, the eyes close in Jawlensky's portraits.

Earlier, the coal-black disks and stylized lozenges that dominated his portrait heads of the late 1910s had created an intense, commanding point of linkage for a concentrated exchange between viewer and image. Even before, in such blunt portraits as *The Gardener*

(1912)—a humble peasant who has been transformed into the image of a modern, visionary prophet through glowing rings of brilliant color— Jawlensky has burned the old man's eyes into the canvas, ringing the lids and the bright blue irises with hard, black lines to rivet the subject's outward gaze. In a manner owing a certain debt to the portraits of Van Gogh, but far more mystically inclined than the earthy Dutchman ever was, Jawlensky's portraits emphatically want to put you face to face with something ethereally transcendent. Sometime around 1920, however, the disks and lozenges flatten out, most often into horizontal lines or thin rectangles. These closed eyes suggest the face of neither sleep nor death, but of silent meditation. From an aggressive effort to connect the portrait to the audience, by returning in the painted image the viewer's concentrated gaze, Jawlensky now began to coax a contemplative sense of loss and distance. Closing their eyes, he literally shut the portraits' metaphoric "doorway to the soul."

Alexej Jawlensky
Elongated Head A
1920

This effort began with several portraits titled *Christ*— one clear indication of the artist's commitment to painting as a spiritual quest. "Alexej Jawlensky: From Appearance to Essence" manages to trace that quest with a degree of breadth and depth that belies its relatively small size. The show includes just forty-seven pictures, painted between 1906 and 1937, from among hundreds the artist made. Many are very small—especially those from the artist's last years, when dimensions little more than a few inches were not uncommon. (Jawlensky suffered from progressively crippling arthritis, which necessitated a reduced scale and finally forced a cessation of his painting four years before his 1941 death.) But the museum's show benefits from a judicious selection of fourteen loans from public and private collections around the country, as well as from the generally high level of quality of its own Milton Wichner Collection, from which the remaining thirty-three

paintings and works on paper have been drawn.

Half the loans to the exhibition will be found in the first room. All are paintings that predate Jawlensky's 1914 expulsion, as a Russian national, from Munich at the outbreak of World War 1. These are paintings by a man clearly obsessed with the expressive possibilities of brilliant color, intent on learning both its vocabulary and its recent history in advanced European painting. In them, the artist avidly tries on techniques and motifs borrowed from a wide range of sources, including Symbolism, Postimpressionism, and traditional Russian icons, and from such artists as Vasily Kandinsky, Gabriele Münter, and Emil Nolde. Cruelly, Jawlensky's expulsion from his adopted homeland began the process through which his own accomplished but unresolved painting would begin to find its way. After twelve years in the military, he had emigrated from St. Petersburg to Munich to pursue his art, and he had established a comfortable life during the eighteen years he was there—thanks to the personal devotion and financial support of Marianne von Werefkin, who gave up her own career as an artist to become Jawlensky's champion. All that was quickly torn asunder when he was forced to flee to Switzerland.

Imagine Jawlensky's predicament. He was fifty years old, without a home or country, increasingly destitute, and as yet had not found a means of expression for the spiritual yearnings that guided his artistic ambition. Soon, two events conspired to transform Jawlensky's painting. First, he met Emmy Scheyer in 1916. (Jawlensky gave her the affectionate nickname, Galka, a Russian word for crow.) Yet another artist who abandoned her own work to champion his, Scheyer offered unwavering encouragement for the ever more radical abstraction of Jawlensky's small landscape paintings, and of the great series of portrait heads (including portraits of Scheyer) that, in the Long Beach exhibition, announce the arrival of the mature period of his art. The second cataclysmic event was the war itself, more brutal and devastating than any heretofore unleashed. For Jawlensky, who had exchanged a career in the Russian Imperial Army for a spiritual pursuit in art, the mountain of ten million corpses must have had a profound impact. World War 1, further dramatized by the Bolshevik revolution in the country of his birth, marked a sharp dividing line between an old world that lay in smoldering ruin and a new and modern one waiting to be built.

Jawlensky now began to construct portrait heads from scratch. Some were abstracted pictures of Christ—an image of death and spiritual resurrection created through the language of painting. In the rest, specific traces of individual or personal identity were traded in for the generic, seemingly universal forms of geometry. And soon, he closed his portraits' eyes. Turning the painted face away from contact with the outer world and toward an inner one results, for the viewer, in a contemplative feeling of separation and isolation. A parallel iden-

tification with the picture, which Jawlensky had searched for from the start, is ironically established.

The show at Long Beach concludes with a gallery devoted to the tiny, darkly radiant "Meditations" of the 1930s. In these radically simplified paintings, a few black lines, laid over layers of brushy color, connect to describe a brow, a nose, a mouth, and a pair of closed, meditating eyes. The near impossibility of holding a brush in his increasingly crippled, arthritic hands surely accounts for the stark simplicity of their forms. So, no doubt, does the dark cloud of economic collapse and imminent war once again gathering force around him.

Larry Johnson

December 20, 1990 Judging from his exceptional new Ektachrome prints on view at the Stuart Regen Gallery in West Hollywood, it is the winter of Larry Johnson's discontent. Figuratively and literally.

Here, discontent signifies the opposite of contentment, but it flatly means the opposite of content, or essential meaning, too. Johnson's large-scale pictures, which feel as empty as the vacuum of outer space, are radically drained of typical notions of visual meaning. Each features a snowy landscape, but it's more than just the image that generates their frostbitten coldness. Johnson's pictures—they're photographic, but it doesn't do to call them photographs—feature text-laden signs incongruously planted in Disneylike renditions of icy winter fields. Each Ektachrome print began as a small landscape painting. Commercially printed text was then added to a space left for the sign, and the whole thing was photographed. One print, enlarged to as much as 5 by 7 feet, was made, and the small painting destroyed. Each print is thus a "unique original," which deftly collapses painting, printing, and photography into one another. The huge enlargement of the painting and its printed typeface fuzzes their edges, softening the crisp line and the saturated colors. Indigo skies are pierced by barren trees, clumps of freshly fallen snow artfully cap the mountaintops, and neither animal nor human being is glimpsed. In fact, the only trace of human life is the presence of the big signs, one per picture, which carry peculiar tales about beauty, existentialism, transcendence, identity, and alienation—classic subjects in modern art.

Johnson's stories aren't lofty or learned. They have the chummy, casual demeanor of gossip or gags; the dissertation on beauty is told through chatty references to hand creams and cosmetics, the one on transcendence is a black joke about dead rabbits. And visually, the disconcerting image of a sign-in-the-wilderness recalls nothing so much as illustrations in a children's book, or perhaps a common animation

Larry Johnson
Untitled (Jesus + I)
1990

cel. With their showy air of highly refined triviality, there's something dan-
dified in both the image and the text. Johnson is a virtuoso of a camp aes-
thetic, which is here turned toward the banal pretentiousness of the canons
of modern art. But his own art never sneers. Instead, its icy coldness is
bracing—and unnerving. Johnson's pictures are like wake-up calls. No
one appears in the remote and empty picture to read his signs—no one
save the solitary viewer in the gallery who stands before them. And any
questions of essential meaning are democratically left to him.

Mike Kelley I

April 8, 1984 Mike Kelley is a master of low-budget
Conceptualism. He's the kind of artist who can take the most compli-
cated cultural mythology and unravel it with a bunch of simply rendered
drawings, some tin cans, and a few strange but concise witticisms. The
flimsiest and most meager of means assumes a crystalline density. "Works
from 'The Sublime' " is Kelley's current exhibition, on view at Rosamund
Felsen Gallery. The several dozen drawings, paintings, and objects in
the show are related to a recent performance by the artist, executed as
part of the "Explorations" series sponsored by the California Institute
of the Arts and the Museum of Contemporary Art. It's not necessary
to have seen the performance to embrace this show, however, an en-
semble which is as good as anything Kelley has ever done. For "The
Sublime" takes on a specific cultural mythology that has been one of the
most enduring features of American life for two centuries; and it's
more than equal to so ambitious a task.

One of the hallmarks of the present moment in art is the
determined and voracious exhumation of the past. The most obvious in-
dicator of this activity is the attachment of the prefix "Neo–" to all man-
ner of styles, not least to the assorted manifestations of Neoexpressionism
in Germany, Italy, and America. There are those who believe that neo-
anything is just an ill-conceived attempt to reheat a comfortable and fa-
miliar past style, and who thus reject it out of hand for failing to live

up to its original ethos. Neo-mania, these detractors say, is merely a depressing symptom of exhaustion, timidity, or ignorance.

Certainly, any number of third-rate artists could be hauled out as evidence to support such an assertion, but to argue a case with the worst examples is the true symptom of exhaustion, timidity, and ignorance. For the exhumation of the past has more to do with shaking the comfortably familiar attitudes of the present than it does with popping some freeze-dried *ism* into the microwave. Neither exhaustion nor timidity nor ignorance is fueling these current developments. Rather, it's an attempt to sift through the chaotic swirl of received ideas that daily inundate contemporary life. The codified tenets of Modernism that are taught in every art institution in the land are as much a part of the problem as those in any other sphere of life. The call to history speaks of a recognition that all ideas have sources, and a knowledge that, until one tracks down those sources, the claim cannot be made that those ideas are *yours*. However useful or valuable, without that journey they're just deadened clichés blindly mouthed. Once retrieved, however, those ideas can be brought to bear on the present moment in order to reveal its workings. "Neo-" doesn't just mean new or newly reheated; it means a new and *different* manner.

Mike Kelley is among those artists avidly rummaging around in the past and, like many of the best Europeans who are engaged in similar activities, it's a national past that is the site of the dig. For if there is any way in which Americans have traditionally pictured the world, it's through an abiding faith in the value of the sublime. From Frederick Edwin Church's majestic views of fiery, Ecuadoran volcanoes in the 1850s to Clyfford Still's majestic views of fiery slabs of paint in the 1950s, the sublime has been conceived as a fundamental principle of beauty. In the face of a majestic infinity incarnate in a wild and savage nature, the viewer's acute awareness of his own insignificance paradoxically furnished a path toward transcendent union with the infinite. To experience the sublime was to be engulfed by an aesthetic reverie, whether that reverie was colored by fear and dread or by light-headed wonder.

The notion of the sublime that Mike Kelley calls forth is of a very different order. It's the light-headed experience felt while standing before a majestic mountain of media, the ooing-and-aahing as Mauna Loa erupts on a 21-inch TV screen. It's the dizziness engendered by gazing at a night sky animated by shooting movie-stars. It's the swooning nausea that looms large when poised at the brink of the "ausable chasm" of contemporary culture. The drawings in his exhibition are a veritable anthology of the traditional devices that signify the sublime, but each is subverted by its contemporary idiom. Majesty, having to do with size and scale and exemplified by mountain scenery, is here embodied in a large drawing of the craggy peaks that form the

cover logo used by Cliffs Notes—those abbreviated versions of the majestic classics of literature so dear to the hearts of high-schoolers everywhere. In Kelley's hands, the deafening silence that is the terrifying cue to transcendental vision is rendered as a mute and sleazy carnival mime whose tears of despair are painted on his cheeks. Elsewhere, the confrontation with infinity is cast as an encounter with a picture frame inside a picture frame inside a picture frame, all drawn as a swirling, black-and-white miasma not unlike an acid-head's psychedelic poster. And ethereal transcendence is upended as a group of boozy drawings on the subject of the morning-after-the-night-before; appropriately, these hangover jokes are painted on giant cocktail napkins. Kelley's drawing style in these and other works is skillfully awkward. They don't seek to dazzle with transparent facility; instead, the drawings seem designed to call attention to themselves as deliberate fabrications. His attraction to the sublime is matched, therefore, by a refusal to succumb to un-self-consciousness. (As Henry James put it, happiness isn't worth having unless you know you have it.) In a hilarious, six-panel painting where the focal point of the landscape is likened to a belly button, the point is explicitly made: In picturing the world, the eye is led to the contemplation of your navel.

As an organizing principle for the way in which we are accustomed to picturing the world, the concept of the sublime slowly but surely underwent a radical shift from the time of Frederick Church and the Hudson River painters to the time of Clyfford Still and the Abstract Expressionist painters: Nature worship was emphatically transformed into culture worship. Yet our faith in culture as a pure and spiritually innocent realm is nothing but a sham, however strong its pull may be. Thus, Kelley insists on using culture in its most ordinary and mundane form—from cocktail-napkin "art" to the "literature" of Cliffs Notes—in order to keep himself out of a pulpit. What makes Kelley's exhibition so engaging is the way he's able to harness the freedom and the full expression of feeling that is integral to America's Romantic tradition of the sublime *without* getting tangled up in the moralistic—and ultimately coercive—idealism that seems to cling to that tradition. The sublime wilderness is not to be found in some remote corner of the continent or in some primitive and universal mythology, as earlier painters have insisted. It's right here, right now, and "transcendence" is merely being awake and conscious of what is at hand. "There is no tomorrow," wails a hangover victim on one of Kelley's giant cocktail napkins. "Oh yes there is," comes the reply. "The morning after the intoxicating pleasure of experience is the headache of responsibility."

If that isn't neo-sublime, I don't know what is.

mike kelley 11

July 5, 1992 The prismatic rainbow of color in Mike Kelley's corridor of criminality, *Pay for Your Pleasure*, provides a tasty coating of sugar for the bitter pill its several dozen culture heroes demand that viewers swallow. Lining the installation's narrow hallway are looming portrait heads of celebrated male artists, poets, patrons, and philosophers, all rendered in colorfully graphic style, like so many T-shirt advertisements in the back of *The New York Review of Books*. Painted from photographs by a commercial artist, each is paired with a disconcerting quotation by its culturally revered subject, a quotation pointed in its insistence on the outlaw dimension of creativity. A sampling:

"I think the destructive element is too much neglected in art."

Piet Mondrian

"I love the unfrocked priest, the freed convict; they are without past and without future and so live in the present."

Francis Picabia

"Men like Benvenuto Cellini ought not be bound by laws."

Pope Paul III

By the time you reach the end of the hallway, the dissonance between all those happy-land colors and such dour declarations becomes a full-fledged moral conundrum. For there, taking the place of a heroic summation about creative criminality, you find exactly the reverse: Kelley has installed a work of art made in prison by a convicted murderer, a candid example of criminal creativity.

At the 1988 debut of *Pay for Your Pleasure* in Chicago, a painting by mass murderer John Wayne Gacy was shown in the hall. At the Museum of Contemporary Art in Los Angeles, which owns the installation, a drawing by "Freeway Killer" William Bonin has been displayed. And at London's Institute of Contemporary Arts, in the compact, twelve-year survey of the L.A.-based artist's work that has been traveling in Europe since April, the corridor leads to a blocky portrait-bust, created in cement in 1977 by Glasgow gangster Jimmy Boyle. The piece becomes wryly site-specific, as the murderer's art changes with each location in which *Pay for Your Pleasure* is shown.

Kelley's provocative installation gaily throws a monkey wrench into all sorts of entrenched assumptions about art. One is the romantic faith in art's value as a universal gauge of personal authenticity and worth. Another is the blandly sentimental assumption that art's highest purpose is to be redemptive. The gooey notion that art should somehow be good for you—vitamin C for the soul—is very American, and it's a sentiment Kelley skewers with Catholic wit. Because the one original work of art in the installation turns out to have been created by an evil villain, he's placed contribution boxes at the entrance to the

corridor, into which visitors are invited to deposit cash for charitable organizations assisting victims of violent crimes. You're bluntly reminded to pay for your voyeuristic pleasure, as you sidle up to peruse the killer's aesthetic product. Like old-fashioned religious indulgences, the contribution boxes let you relieve your gnawing cultural guilt.

Kelley has been shown regularly in international exhibitions in the last few years—*Pay for Your Pleasure* was well received in Berlin's big "Metropolis" show in 1991—and curiosity about his prior endeavors has risen accordingly. This survey is the first in-depth look at his art for European audiences. "Mike Kelley: Works, 1979–1991" presents a provocative if tightly condensed sketch of the artist's protean development during the last dozen years. It also provides an enticing preview of what we can look forward to in 1993, when New York's Whitney Museum of American Art holds a full-scale, mid-career retrospective. The European survey, organized by Thomas Kellein for the Kunsthalle in Basel, Switzerland, has also been seen in abbreviated form in Frankfurt, Germany, and its tour has drawn such interest that, late last month, an additional venue was added: the Museum of Contemporary Art in Bordeaux, France.

London's ICA is not large, but seven complete or partial bodies of work are being shown, together with assorted drawings. The show begins with spirited self-portraits of the artist as a haunted poltergeist, cotton "ectoplasm" streaming skyward from his nose. The hilarious images, which lampoon art's spiritual inner visions, were made in 1979 in collaboration with artist David Askevold, shortly after Kelley's graduation from CalArts. Chronologically, drawings, slides, and props for the important 1982–83 performance piece *Confusion* are next, followed by a selection of the large, colorful, often achingly defiant (and funny) felt banners from 1987–88. (Imagine Sister Corita or the Singing Nun filtered through a psychopathic Henri Matisse, and you'll have some idea of the banners' graphic look.) Then comes *Pay for Your Pleasure*, and selections of the altered illustrations from high school history and social-studies books, 1989's *Reconstructed History*. Finally, the show is completed by *Craft Morphology Flow Chart*, a diabolical, anthropological analysis of homemade stuffed animals that was among the standouts at last year's Carnegie International in Pittsburgh, Pennsylvania, as well as by *Lumpenprole*, a large 1991 floor sculpture that, to my knowledge, has not been shown in the United States.

In all these works, Kelley is engaged in a relentless inquiry into the often sentimentalized role ascribed to art and artists by the modern world, with "the artist as transgressor" a prominent theme. Here, the transgressor of society's restrictive status quo is more than likely to be presented in the guise of the acne-studded adolescent misfit engaged in disorderly conduct, rather than as the artist who busts up formal limits.

Kelley's art creates a distinct tension between a kind of

embraceable "all-American Everyman" and those teeming hordes our culture typically batters down. Take the big, room-size, crocheted blanket in *Lumpenprole*. Laid out on the floor, its flat pattern of multicolored, zigzag stripes is interrupted and given bulging dimension by assorted, highly suggestive lumps. As with the guilty pleasure attendant to scrutiny of a murderer's art, the audience engages in sly, bedroom voyeurism. What's going on under the big blanket is more than meets the eye— or, rather, more than doesn't meet the eye, given the hiddenness of the activity. The floor-bound disposition of the piece, which Kelley has used in a number of works incorporating blankets and stuffed animals, clearly means to recall the canvas-on-the-floor technique with which Jackson Pollock made his famous drip-paintings. Here, however, the conception of Pollock's art as a field of transcendent activity is both recognized and repudiated. In this tribute to the alienated and antisocial "lumpen-proletariat"—of which Pollock himself could be considered to have been a member—the energetic life-force locked deep within the inner fabric of the work of art is rather more basic than what is usually ascribed to Abstract Expressionist painting. Sex, as Baudelaire told us, is the poetry of the people.

Mike Kelley
Disembodied Militarism (detail)
1988

Kelley's frequent use of old, tatty stuffed animals and awkwardly handmade plush toys salvaged from the ignominy of the thrift shop is most prominently represented by the sprawling *Craft Morphology Flow Chart*. Diversified assortments of dolls have been photographed as if convicts, measured like candidates for the morgue and laid out for inspection in familial groupings on rows of cheap folding tables. An arts-and-crafts fair in the neighborhood church basement is seamlessly merged with a Joseph Mengele-like laboratory. The grubby toys are surrogates for the idealized dreams of childhood that have been inevitably battered, soiled, and damaged. They deftly upend the com-

mon cliché in modern art of youth as a gateway to a lost realm of purity and innocence. In Kelley's art, childhood is a breeding ground for disappointment, prelude to the nightmare of adolescence.

Teetering between youthful promise and adult constriction, the grim fun house of adolescence is a pivot for much of his work—as it is for a substantial number of provocative, younger American artists today. In Kelley's case, there's an added resonance. As his floor pieces simultaneously embrace and reject the founding ethos of Pollock for contemporary American art, so his gleeful use of adolescent metaphors does the same for the hot-rodding, anti-intellectual, surfer-boy high jinks that, in the 1960s, shaped the founding ethos of art in Los Angeles. Kelley remakes them both, and takes art to a new plateau.

Mike Kelley III

July 1, 1994 Never have the ground-floor galleries of the Anderson Building at the Los Angeles County Museum of Art looked more beautiful than they do right now, hosting the touring exhibition of Mike Kelley's fiercely intelligent, often ferociously witty art. At its debut last fall at New York's Whitney Museum of American Art, where the mid-career survey was organized, the show looked first rate. It looks even better here.

Part of the reason is simply that the nearly 200 drawings, sculptures, and installations have been presented with impeccable care in a sequence of rooms that maintains a high level of interest from beginning to end. With the exception of two sculptures that employ recorded sound, unfortunately placed in adjacent galleries that make for some dissonant cacophony, you'd be hard-pressed to fault the elegant and informative mechanics of the display. More to the point, though, is that Kelley, who is based in Los Angeles, has shown in this city almost every season since his memorable solo debut in 1981, and often with exhibitions that rose far above the usual gallery fare. The LACMA survey, which opened Thursday, offers a joyful opportunity to revisit a good deal of that older work; to draw connections among disparate bodies of work produced during the last fifteen years; and, in some instances, to discover work that hasn't been shown here before.

Kelley is an avatar of the power and humanity inherent in recognizing the radical impurity of human experience. His art searches out dark and soiled places where defects, fault lines, and inadequacies are obvious and routine, and where failure takes on the poignant, fragile, even heartbreaking beauty that accompanies any loss of self. He finds evidence of that bittersweet condition throughout American culture. Remember Sad Sack, the hapless Army private of comic-book fame? At some inevitable point in a *Sad Sack* narrative, the dedicated grunt

would typically wind up face-down in a garbage dump or, worse, a latrine, suffering yet another in a seemingly endless sequence of daily degradations. Kelley, in an extensive series of ink drawings derived from these squalid tales, renders the flying swill in gestures as graceful, fluid, and balletic as an Abstract Expressionist painting. Pointedly, the pictures leave out any representation of a human figure; in these "Garbage Drawings," an absent self is surrounded by the radiant choreography of used tin cans and old banana peels. Abstract Expressionist painting's down-and-dirty liveliness, long since drained away in its elevation to the pristine heights of our cultural pantheon, is cleverly restored. Simultaneously, the drawings acknowledge that an apparently bottomless pit of degradation yields the renewable fossil fuel that runs the modern machinery of mass culture.

In plangent ways, Kelley's work regularly mixes up common categories of high culture and low. The aim is not to bring one down or shore the other up, as much as to suggest that both create their own uniquely imprisoning boundaries. Each pretends to characterize normalcy. Likewise, drawing on his own working-class Catholic background, the forty-year-old artist often performs a similar amalgamation of high church and low. A series of brightly colored banners describes feel-good homilies in the cheery style of Sister Corita, while dark, existentially tinged references to the satanic theatrics of heavy metal music abound.

Kelley's assault on cultural purity, high or low, is frequently leavened with sometimes bawdy, always sly humor. A work called *Citrus and White* consists of two lumpy spheres made from clusters of grungy, used stuffed animals and plush toys, suspended on cords before two plastic wall sculptures, geometric, pristine, and Minimalist in bearing. The faux-Minimalist sculptures are actually giant room deodorizers, which periodically spray clouds of lemon-fresh disinfectant in the general direction of the soiled, Pop love tokens. Elsewhere, a hand-crocheted afghan of orange wool, spread out on the floor, features a row of stuffed dachshunds—"autograph hounds," once beloved of teenage girls with rock 'n' roll crushes and lately retrieved by Kelley from the discard bins of area thrift shops—all lined up along a single brown stripe down the middle of the blanket. The doggy pun implied between an afghan and an autograph hound is compounded by the blanket's goofy imitation of a Barnett Newman stripe painting, which constitutes that artist's signature style.

Kelley's art is unusual in its eager embrace of symbols of adolescence with which to conduct intellectual discourse. Indeed, his detractors typically point to his affection for scatological humor, metalhead music, tales of teenage sex, stuffed animals, coarse language, and the rest as collectively indicative of an appalling absence of artistic maturity. But adolescence is, in fact, among the most significant inventions of the modern world. Unknown before our time, it embodies a social dynamic almost completely ignored by visual artists. Wedged between

Last Chance for Eden

the supposed innocence of childhood and the normative maturity of an adult universe—both conditions that have been regularly plumbed by modern artists—this neglected, betwixt-and-between period turns out to be a perfect vehicle to drive home Kelley's anti-purist vision.

Near as I can tell, Kelley's burlesque renunciation of aesthetic purity is just about the most thoroughly effective assault on postwar formalist doctrine yet achieved by an artist. Formalism, which regards aesthetic purity as art's highest value, has been the target of repeated fusillades for nearly thirty years. However, its attackers have almost always missed the bull's-eye. They've labored to banish aesthetics from artistic consideration, when the problem has not been aesthetics at all, but the demand for aesthetic purity. Kelley's resonant and insightful work dramatically reorients priorities. By elevating radical impurity to a position of aesthetic prominence, this scathingly funny, deeply moral art generates a liberating sense of individual and collective pleasure.

Ellsworth Kelly

summer 1985 Ellsworth Kelly's lithograph *Philodendron 2* is a straightforward contour drawing, in black on white, of a single curving stem and four gracefully splayed leaves. The figurative delineation, the compositional interrelationships among the parts, the balletic placement of the image within the flat space of the paper—all these features appear so casually perfect, so intuitively "right," so carefully yet effortlessly calibrated to within an inch of their lives as to utterly defy rational explanation. Perhaps the challenge inherent to defiance explains why, whenever I'm faced with Kelly's seemingly simple work, I immediately find myself wondering, "How does he *do* that?"

As usual, this turns out to be a woefully unproductive question to ask. Kelly does it merely by possessing a remarkable degree of skill at facture, as if his hand and his eye were one and the same appendage (the visual and the physical are always inseparable in his art). It's the same hard-earned skill possessed by the Parisian *ébéniste* who fabricated the very first cutout objects designed by the artist in 1950, and the same skill possessed by the gifted artisans at Gemini G.E.L. with whom he often works today. And it's the kind of skill that is simply necessary to forging what I tend to think of as "the ecological perfection" of Kelly's art, one which seeks to clarify and make visible the totality or pattern of relations in the artistic medium's environment as a whole. Placing that clarity front and center, both visually and physically, has been the principal hinge of Kelly's art for thirty-five years. It is no less important to the four white, painted-aluminum reliefs, the eleven single-sheet lithographs, and the one lithographic triptych recently made at Gemini. Given the long-running centrality of this propo-

sition to Kelly's artistic enterprise, the more productive question to pose is not how does he do it, but why?

From the beginning, Kelly's art has performed a systematic, and ever more complex, erasure of the thesis that a work of art is primarily meaningful as a document of personal experience. This ambition joins his work to the tradition of Constructivist form (his early interest in, and admiration for, the work of Georges Vantongerloo is well known); but it bears a strong, if less obvious, connection as well to Kelly's interest in automatic drawing, the operations of chance as an artistic strategy, and the work of Jean Arp and Joan Miró. For all these represent, in the end, attempts at depersonalizing the personal gesture in order to clarify the seemingly random environment we inhabit.

In a way, what Kelly did was take the notion that a work of art is the record of the life of an individuated, or even universal, personality—that is, of the inner life of the artist or of the artist as exemplar—and turn it inside out: By using a variety of means to drain virtually all traditional evidence of the artist's personality from his work, he sought to construct objects whose effect would be to revise and heighten the *spectator's* sense of his own self in relation to the world. To view art in this way was an estimable advance over considering it to be the expression of an individual mind. For rather than chase the phantoms we presume to be lurking in the artist's head, we are confronted with the complex relations that characterize our own practical situation.

In the 1950s and early 1960s, when Kelly was shaping and refining the means by which to accomplish this aim, such a proposition was a radical repudiation of a prevailing artistic norm. Today, when the charismatic force of personality threatens to swallow up virtually everything, it occupies a contrapuntal position to a prevailing norm of the entire culture. Kelly's is an art that seeks to orient. For this reason, the abjuration of personality from his art marks a concerted and significant alteration of humanist tradition. This is not to say that the human subject has been squeezed out. On the contrary, the human subject is emphatically located where it should be—namely, in the person of the spectator standing before the object. Kelly's art opens up a wide and generous space in which the spectator can freely move.

How does he *do* that? When looking at *Philodendron 2*, the startling immediacy with which I find myself asking that question, rather than the question itself, seems most pertinent. It's as if, with great suddenness, and in sharp contrast to the ordinary flow of events, everything has clicked into coherent place. Functioning synchronically as all-at-once objects in space, Ellsworth Kelly's art banishes movements in time in order to enhance our own essential prospects for mobility.

john Frederick Kensett

July 28, 1985 John Frederick Kensett's paintings of coastal areas stretching from the Shrewsbury River in New Jersey to the Massachusetts Bay are among the strangest and most beautiful in all of nineteenth-century American painting. In composition and paint-handling, the natural landscape, atmosphere, and light of their chosen sites are about as meticulously rendered as one could imagine; for all their professed fidelity to natural phenomena, however, they are nonethe-less endowed with an ethereal and otherworldly cast that speaks of a sec-ular divinity. Nature isn't merely a stage in Kensett's paintings: It's a central character in a finely honed morality play.

If there's some disappointment to be found in the ex-hibition "John Frederick Kensett: An American Master," it won't be located in the forty-five paintings and the handful of works on paper that have been brought together for this, the largest survey of his work since the memorial exhibition mounted shortly after his untimely death, at the age of fifty-six, in 1872. True, a more generous sampling of his drawings would have been appreciated, as would a few examples of the engraved banknotes or book illustrations he executed as a lad. Kensett, like many artists of his generation, was trained as a commercial graphic artist, and the attention to linearity and tonal precision, as well as to the tides of popular style that he learned as an apprentice in his un-cle's printing shop, informed the mature paintings begun in the late 1850s. Likewise, one of his several copies of Claudian or Dutch land-scapes, painted during his first voyage to Europe in 1840, perhaps would have underscored the central position of prominence given to certain cultural traditions by the Connecticut-born artist.

These are small complaints, however, for the paintings that have been selected provide ample and well-considered opportunities for understanding the trajectory of Kensett's art. Organized collabora-tively by the Worcester Art Museum and the Metropolitan Museum of Art (which, incidentally, Kensett helped to found), the show has been in-stalled in the galleries of the County Museum of Art in loosely chrono-logical fashion. A remarkable transformation occurs in Kensett's art between the first gallery, which concentrates on his early variations on familiar Hudson River School style, and the second: Beginning in the late 1850s, his landscapes emptied out. Kensett underwent a radical alteration in direction—at least, it would appear on the surface that he did.

From dark and densely populated woodland and moun-tain vistas, filled not only with the minutiae of nature but with obvi-ous allusions to classic landscape painting of earlier European vintage, his canvases became lighter, airier, more abstract in feeling, as if a mys-terious and silent breeze had swept the landscape clean. The horizon line lowered, the sky became an infinite expanse. In the coastal scenes, the

trinity of earth, sea, and sky interlocked in a divinely inspired harmony, while evidence of human occupation, often in the form of sailboats sliding peacefully across the glassy water, spoke quietly of the integration of civilization within the timeless clockwork of nature.

A sense of gentle but strong-willed concentration—as palpably felt as the luminous atmosphere—marks these compelling paintings. It is rather startling to realize that this shift toward an almost mystical radiance and harmony not only came about, but became increasingly refined, during an era of social tumult the likes of which America had never seen before. How is one to reconcile the development of Kensett's art with a time that culminated in the physically and psychically bloody devastation of the Civil War? What is one to make of a mystically inflected painting that emerged contemporaneously with Darwin's scientifically revolutionary treatise on natural evolution? Despite his principal residency in the newly burgeoning metropolis of New York City, was Kensett somehow blithely unaware of, or untouched by, the cataclysmic social changes attendant to rapid urban expansion? Given his prominence and position of influence within politically powerful circles in Manhattan, how is one to gauge the immediacy of his considerable artistic success?

It is in this regard that the show is somewhat disappointing, even though the presentation does fit seamlessly with a central thrust of the artist's work. For Kensett's art sought primarily to heighten the common consciousness of his time through the elevation of a mythology of the past; meanwhile the exhibition attempts the same for the reputation of the artist.

"John Frederick Kensett: An American Master" bills itself as a reappraisal of the artist and his work, but it really isn't. The art of the nineteenth century, both in America and in Europe, has been the subject of much critical inquiry during the past fifteen years or so, and its purpose has been to reassess and revise the long-established methods by which we have considered how pictures speak and what they have to say. For American art, this phenomenon has been abetted by an obliging commercial market for pictures (to "reassess" neglected artists can obviously keep the wheels of fortune turning), while the celebratory nationalism of the bicentennial, not to mention the rather more virulent strain that has shown itself in recent years, have also played their part.

The current exhibition, however, seems content merely to ride that revisionist wave without ever plugging in. The presentation, along with the various texts in the handsome catalog, does add much to the accumulation of information we have about the artist and his milieu; but the goal is not to rethink Kensett's art, to burrow more deeply into the cultural circumstances in which it emerged and to push us into a newly critical awareness of its historical meanings. Instead, traditional art-historical scholarship is brought to bear for the purpose of reinforcing our standard perceptions of Kensett and his art. Kensett isn't

so much the active subject of the reappraisal as he is the passive beneficiary: Rather than revise our view of Kensett and his relationship to nineteenth-century culture, the show wants to revise our view of the number of masters acceptable for the Pantheon.

Kensett's worthiness for inclusion is seen as a function of his similarity to an established creed of greatness. What is that creed? In a way, it is not altogether different from that espoused in Kensett's own art. His tranquil and mystically inflected paintings stood as counterweights to the socially convulsive realities of the decades through which he lived. They constituted a visual articulation of a committed, promissory faith in the continuity between an idealized past and a harmonious future. At mid century, when the urbanization and industrialization of the natural paradise were well under way, with all the concomitant struggles for the apportionment of privilege and of power that always accompany moments of radical change, Kensett's paintings functioned as a kind of bulwark: He pictured a compelling and transcendent realm of continuity and stability. In a world of social turmoil, his paintings sought to reassure that all would go on as before, and they further cloaked that promise in the radiantly authoritative veil of divinity. In this regard, the affirmation of John Frederick Kensett as an American "master" takes on a decidedly different cast.

vitaly кomar and Alexander мelamid

March 7, 1993 If twentieth-century skyscrapers are, as has long been claimed, modern "cathedrals of commerce," then the stunning new mural recently completed by the artist team of Komar and Melamid ranks as a worthy pendant to the bountiful basilica of business. *Unity*, as the painted relief-mural is named, stretches across 90 feet of undulating walls in the entrance lobby to the First Interstate World Center in downtown Los Angeles. A triptych, its three panels bring together a trio of angels. Their links to the past, the present, and the future are at once celebratory and refreshingly judicious. For unlike run-of-the-mill public art, *Unity* doesn't just mouth sweetly boosterish aesthetic platitudes. Instead, the mural adopts a critical position in relation to its site, artfully recognizing and harnessing the complexity and contrariness of public life. Komar and Melamid have made a dramatically decorative embellishment for the lobby of an enormous bank's skyscraper; yet, they've done it with critical insight and satirical wit, as well as ornamental skill.

Vitaly Komar, forty-nine, and Alexander Melamid, forty-seven, are Russian-born émigrés to the United States. Having collaborated for more than a quarter-century, first in Moscow, then in Israel, they've worked in New York and New Jersey for nearly fifteen years.

For the imagery in *Unity*, they turned to this city's name. Indeed, there has been a proliferation of *los angeles*—angels—in recently unveiled public art around the downtown core. Lili Lakich's *L.A. Angel* is a long, signlike arabesque of neon sprouting from an automobile tail fin, beneath a roadway overpass on Olive Street. Cynthia Carlson's *City of Angels* is a clumsy, painted relief featuring eleven stylized angel wings, installed above an escalator at Union Station. Even Jonathan Borofsky's self-portrait sculptures of "flying men," suspended over the train platform in the Civic Center station of the Metro Rail Red Line, can be thought of as secular seraphim. The arrival of yet another flock of celestial beings at First Interstate might suggest a certain paucity of imagination in works of art designed to engage the public life of the city. With Komar and Melamid, however, that just ain't so. Their angels have important business to do.

Vitaly Komar and
Alexander Melamid
Unity
1993

At the Stroganov Institute of Art and Design in the late 1950s, Komar and Melamid had thorough training in the tedious pomposity of typical academic style. (They reportedly met during a field trip to a Moscow morgue, where they studied cadavers for an anatomy class.) From the beginning of their collaboration, however, their work has had a Pop edge, executed with the Socialist Realist demeanor once required by Soviet officialdom. Pop art is nothing if not subversively aware of the ways in which visual and verbal clichés can be pried open to reveal the unthinking, interior pieties of a culture. Try considering Pop clichés as a kind of bright, jazzy, hard-sell version of the conventions that rule academic art, as well as of the pedantic visual etiquette that governs duly authorized Socialist Realism. When this team of dissident artists departed from the Soviet Union in 1977, they left with a battery of artistic tools useful for examining the visual cues of Western officialdom.

Architecturally, the image of the skyscraper as a "cathedral of commerce" has a long history. (Not for nothing does the Chrysler Building have Notre Dame-like gargoyles.) Perhaps its most notable, Postmodern example is Philip Johnson's design for the AT&T building on Manhattan's Madison Avenue. The First Interstate World Center can claim no immediately recognizable religious iconography. It's more

abstract, although the pristine, off-white, finely detailed shaft of the seventy-three-story building—the tallest in the Western United States—is certainly a rigorously idealized form. In the decoration of the lobby, Komar and Melamid provided the necessary icons. To do it, the artists went to the source. Large inscriptions in English and Spanish on aluminum panels beneath the triptych explain that the 1781 decree of Gov. Felipe de Neve formally designated the region as El Pueblo de la Reina de los Angeles sobre el Río de la Porciuncula (The Town of the Queen of the Angels on the Porciuncula River). The name recalled the Franciscan origins of Fray Juan Crespi, who had served as the diarist for the Spanish expedition that first came to the basin twelve years before. That expedition had arrived one day after celebrating the great Franciscan feast held in honor of Our Lady of the Angels of Porciuncula Chapel, housed in the Basilica of Saint Mary of the Angels near Assisi, Italy.

Komar and Melamid's triptych centers on an exuberant relief figure of an angel, which is flanked by two convex panels, each featuring a painted angel. The form of these painted angels derives from examples in the thirteenth-century Porciuncula Chapel. Garbed in diaphanous white robes, the simpering angels are loosely painted on a surface of mottled brown, their limpid eyes cast heavenward. The angel at the right strums a mandolin, the angel at the left holds open a wide book (perhaps a hymnal). If their smallish scale seems a bit inadequate to survive the large, eccentrically shaped lobby, they nonetheless provide a suitably nostalgic frame for the dynamic central image. The basic form of the central relief, which is composed from a half-dozen individual pieces, also derives from the Porciuncula angels, although the relief is considerably larger and more emphatic than its gossamer siblings. Long, streaming blond tresses frame a face whose eyes, again, gaze heavenward. Clad in a flowing blue robe over a dark, yellow undergarment, this angel likewise fingers a mandolin. Comically, the celestial guardian is poised over the inviting, concave portal leading to a bank of elevators, which stand ready to whisk the visitor heavenward to the ethereal reaches of a towering skyscraper. Enter, it says, and ascend.

Where the relief angel differs sharply from its Italian counterparts, however, is in its accessories. The figure hovers before the abstract, geometric, red and yellow patterns of a tenth-century Buddhist banner. Its halo is a burst of gold-leaf borrowed from pre-Columbian images of the feathered serpent, Quetzalcoatl, principal deity of the Aztecs. It is crowned by a mahogany headpiece, whose form derives from Nigerian masks. Finally, and in keeping with this assembly of spiritually related accoutrements, which are emblematic of a variety of cultures from Europe, Asia, Africa, and the Americas that make up the demographic mix of latter-day Los Angeles, the angel is held aloft by a symbol associated with the American Indian. The muscular, spreading, silver wings, made from brushed aluminum, are those of an eagle.

Komar and Melamid clad their angel in spiritual raiments of multiple cultures, in a buoyant and graceful celebration of both ethnic diversity and the multitude of sacred faiths. Still, this is not simply a promotional work of art, meant to offer a benign soapbox to glossy civic sentiment. Pointedly, the angel's wings are not those of just any eagle. If the angel's great, silver wings look strangely familiar, take a quarter from your pocket or purse and look at the eagle on the back. A historic cathedral may be one stylistic source for this unusually resonant work of public art, but commerce is the other. In the lobby of First Interstate, money creates the wings to heaven. As surely as it celebrates the diversity of Los Angeles, the triptych also satirically articulates the way in which multiculturalism, as a newly official and institutionalized doctrine, also becomes the cloak and crown for the customary angel of commerce. You may well be panhandled for a quarter on the streets outside this sleekly imposing downtown corporate tower—a common enough experience, but one that lends a certain poignancy to the angel hovering inside. Stamped in the space between the eagle's wings on a U.S. quarter is a U.S. motto: E Pluribus Unum. Out of many, one— or, as Komar and Melamid have optimistically titled their mural, *Unity*. With its multiple layers of meaning and their conflicted resonance for our day, they have fashioned a work of public art worthy of the name.

Jeff koons

December 14, 1992 The catalog to the Jeff Koons retrospective exhibition contains no biography of the artist. None at all. This is exceedingly odd, because museum retrospective catalogs always include a biography, even if it's just an abbreviated list of where and when the artist was born and went to school, and where he now lives and works. But not the Jeff Koons catalog, published in conjunction with the show lately opened at the San Francisco Museum of Modern Art and organized by curator John Caldwell. Don't turn to either for the story of the artist's life. Ironically, the glaring absence of a bio, typically an essential component of any retrospective, turns out to offer one pivotal revelation of the show: There is, in fact, no Jeff Koons—before or beyond or outside the artistic project he has undertaken. His sculptures, their public display, and the published reviews about them are, in essence, the artist's only identity.

The piece introducing Koons's first coherent body of work is a framed poster made from an ordinary childhood photograph. The boy, formally posed and brightly scrubbed for the occasion, his hair neatly parted and combed, sits with his arms folded across a coloring book, a box of rainbow Crayolas before him and one crayon clutched in his hand. Like St. Catherine's knife-edged wheel or Paul Revere's sil-

ver mug, the coloring book and crayons are attributes describing the central feature of the sitter's life. The grade-school picture was probably photographed in the early 1960s, but its transformation into an actual work of art—into a Portrait of the Artist as Young Man—dates from 1980. Titled *The New Jeff Koons*, the picture is precisely that. It marks the beginning of his artistic self-reinvention—America, of course, being the gloriously triumphant Eden of self-reinvention.

If *The New Jeff Koons* sounds like a product, rest assured that it is. This late-model persona is accompanied by the arrival of new Hoover shampoo polishers and new Shelton wet/dry vacuum cleaners, which constitute his sculptures from 1980–81. Encased in pristine Plexiglas boxes atop rows of bright, white, fluorescent lights, the machines are oddly anthropomorphic in appearance. Stacked or standing vertically, they're like spit-and-polish soldiers. Reclining horizontally, they're like embalmed personages of note, now reverently lying in state. Koons's shiny cleaners—literally *brand* new—are wafted heavenward on cold clouds of unyielding fluorescent light. You can practically hear the angels' Muzak chorus.

Why polishers and vacuums? On one hand, the displays of machinery represent the apotheosis of the venerable history of American marketing, exemplified by the door-to-door vacuum cleaner salesman. On the other, they embody an excruciating cleanliness, which is what one wants and expects from newness. Newness means leaving that dirty, unclean past behind, in favor of an innocent, unsoiled, and thus totally idealized dream.

Cleanliness turns out to be a prominent leitmotif in Koons's work. Is there another artist who, when deciding on a durable material in which to cast a large percentage of his sculpture, settled on stainless steel? Among its chief assets is the capacity to sparkle with the gleam of silver without any fear of ever tarnishing. The intoxicating pleasures of art are thus perpetually promised by liquor bottles, decanters, and ice buckets, all gleamingly cast in stain-free steel, while any messy fear of hangover is precluded by the untouchable terms of a work of art. When pigs turn up in Koons's sculpture—and they do, three times—they're never near the slopping trough. They're pink and pudgy, like the huge, polychromed wood sow in *Ushering in Banality*, which sports a jaunty green bow and is escorted by winged cherubs. Koons's animals are, in fact, relentlessly domesticated. Dogs, penguins, and chirping birds display a benign creepiness, like the cutesy-poo forest creatures in *Bambi* or the weird bluebirds that dressed Cinderella for the ball. Emblematic is the double portrait *Michael Jackson and Bubbles*, which features the pop star and his pet chimpanzee, pointedly dressed in identical gilded uniforms. Like the idealized, bizarrely anthropomorphic vacuum cleaners, the black youth and his monkey embody projections of mass-culture desire—they are both portrayed as white. Nearly

six feet in length, this shocking sculpture is an effigy of an audience-created fantasy, which resonates against its status as the largest porcelain knickknack in the world.

When it comes to sex, cleanliness isn't next to godliness in Koons's art. It *is* godliness, with all the moral anxiety inevitably attached to any conception of forbidden fruit. His famous *Rabbit*—an inflatable Easter toy resurrected in stainless steel—transforms Hugh Hefner's logo for sexual fecundity into a goofy, icily forbidding little monster that's part domesticated icon of pagan ritual, part inflatable sex doll. (If Brancusi had been American rather than Romanian, his phallic sculptures might have looked like this.) Koons's computer-generated paintings made from explicit photographs of sexual intercourse with his wife, former porn star and member of Italian parliament Ilona Staller, entangle many of these threads. Plainly staged for the camera, they have a kind of lurid cheerfulness with virtually no erotic charge. Even the physical grime of *Dirty—Jeff on Top* is obviously body makeup, its Mojavelike setting a painted backdrop. Scattered around the paintings are sculptures: Jeff and Ilona in assorted *Kamasutra* positions fabricated from transparent colored crystal, and idealized busts of the lovers, chiseled from white marble that's as pure—and chilling—as the driven snow. Finally, these intimate acts of marital bliss are watched over by carved and painted wooden dogs, traditional symbols of fidelity. The perky terriers in *Three Puppies* are New World descendants of the one at the feet of the husband and wife in Jan van Eyck's great *Arnolfini Wedding Portrait*.

"Made in Heaven," as this final and most recent ensemble of work is punningly titled, is a wild oxymoron: clean pornography. It's Disney Does Debby Does Dallas. (Clean dirty pictures or not, the museum has posted warning signs outside the "Made in Heaven" gallery cautioning minors, while the most explicit painting, illustrated in the catalog, has not been hung. Puritan terrors run deep.)

Koons is principally a sculptor, but a marked transition occurs in his work in 1986: He stops making sculpture and begins, specifically, to make statues. Sculpture, as a modern ideal, toppled the bourgeois conception of statuary, but Koons puts the statue back on its pedestal. He isn't the first to do so. Robert Graham is a long-time statue maker. But, where Graham continues to exalt Modernist idealism, Koons makes a radical revision. He turns the traditional cliché of the work of art inside out: Rather than embodying a spiritual or expressive essence of a highly individuated artist, art is here composed from a distinctly American set of conventional, middle-class values. Nothing gets transcended. Existing only as a work of art, "Jeff Koons" is a complete and self-contained fabrication, constructed as a shockingly clear image of late-twentieth-century bourgeois aspiration.

The show makes one significant misstep. Like the Crayolas that are attributes identifying the artist in the youthful photograph,

Koons's wondrously vulgar statues are attributes identifying us in our current predicament. Most of his statues from the past half-dozen years are multiples, not unique objects, but no multiple examples are displayed. That marketable multiplicity is an important part of their meaning. Still, the misstep isn't disastrous. In fact, the show does what retrospectives are supposed to do: It puts the artist in perspective—in this case, an artist who has been quite difficult to see, amid all the smoke and mirrors that have surrounded his career. Koons turns out to be neither as awful nor as great as his detractors and his champions make out. However, given the current pandemonium over identity politics in art, it's essential to pay attention to this peculiarly disturbing precedent. The exhibition removes any doubt that he's an important young artist—whoever Jeff Koons might actually be.

Leon Kossoff

May 16, 1982 One of the primary reasons for having made the pleasant trek to the Santa Barbara Museum of Art's "Eight Figurative Painters" exhibition last February was to see the work of Leon Kossoff. (The other was to see that of Frank Auerbach, who, not incidentally, is a close friend of Kossoff's.) His half-dozen paintings and drawings revealed the fifty-five-year-old Londoner to be a painter of the first rank. Surprisingly, Southern California is turning out to be the best place in this country to see Kossoff's work. Aside from his inclusion in the Santa Barbara show (which traveled there from Yale) and in a survey of recent British art called "This Knot of Life," mounted two and a half years ago at L.A. Louver Gallery, Kossoff's paintings have been largely unseen in this country. Happily, his first American solo exhibition is currently on view at L.A. Louver. The fourteen paintings and four charcoal drawings, dating from 1967 through 1981 but focusing on the last three years, offer a satisfying overview of the artist's considerable gifts.

In the early 1950s Kossoff was a student of the late British painter David Bomberg, one of the driving forces behind the pre–World War I Vorticist school. The Vorticists developed a harsh, mechanistic style in response to their perception of "the vortex of modern life," a style with significant debts to the fury and splintered agitation of Italian Futurism. Bomberg's influence can still be felt in Kossoff's paintings, although the latter eschew the overwrought desire to carry a social message. Instead, his rather grim and prosaic subject matter—portraits, somnambulist urbanites, vaguely industrial landscapes—is rendered in an energetic engorgement of paint in which both formal and substantive qualities partake of a decidedly controlled disorder.

Kossoff employs a linear drawing style in which great hunks of paint are scraped and dragged across the surface of the work.

The images in *View of Hackney with Dalston Lane, Monday Morning, Self Portrait No. 5*, and others appear to have emerged from a wrestling match with paint. Viscous webs of stringy pigment tie together disparate objects, trailing across the picture like bubble gum stuck to your shoe. As a result of this all-over dispersion of pigment and randomly charged visual incidents, there is no focus of vision in these paintings. The eye tumbles and slides through the picture haltingly but with great speed. By contrast, Kossoff's friezelike images have a static, monumental quality about them. Four subway commuters—shoulders hunched, empty eye sockets staring, arms plastered to their sides—lurch through *Booking Hall, Kilburn Station No. 2*. His *Nude on a Red Bed*, outlined in a heavy black contour, hovers flat against the surface of the picture, a primitive odalisque reminiscent of Matisse's *Blue Nude*. Even the playful commotion of *Children's Swimming Pool, 12 O'Clock, Sunday Morning*, viewed from an aerial perspective, has a stillness more akin to heat waves rising from pavement than to the youthful boisterousness unleashed by play.

Leon Kossoff
*Booking Hall,
Kilburn Station No. 2*
1977

This static monumentality is enhanced by the very thickness and physicality of the painted surfaces. Each is framed in a shadow box that reveals the actual depth of the painted board, and the paint surface literally wraps itself around the edges of the picture. As objects, these paintings are like chunks of slate excavated from a quarry, artifacts whose images appear built-up through time and embedded in geological strata.

In the structure of his urban landscapes, Kossoff flirts with Renaissance space; but the slight aerial perspective, the emphasis on linear drawing, and the sheer bulk of paint prevents these views from achieving an illusion of spatial openness. Rather, the receding ground plane in *Kilburn Underground* or *Children's Swimming Pool* or *Dalston Lane* heaves forward toward the picture plane, and the buildings and figures are poised on the brink of spilling off the surface. None of Kossoff's figures are engaged in clearly directed activity—they sit or recline or play or simply pass through the scene. It is their environment that is doing something, that heaves and swells and threatens to topple over

these blank-faced people.

The power of Kossoff's draftsmanship (which is what holds together his paintings) is clearly revealed in his charcoal drawings. *Entrance, Kilburn Underground II* looks into the vaulted space of a nearly empty subway station and is bisected by a vertical column. His dynamically suggestive slashes of charcoal turn the space into a gaping jaw held open by the buoyant presence of the central column. Kossoff's drawing style has a kind of tensile strength that is pulled to the very point where it threatens to break apart. But it never does. In his paintings the taffylike pull of the drawing style is matched by the sense of compression of the heaving surface and the compacted mass of pigment. Both his images and his paint surfaces exert a visual pressure in which the painting seems ready to burst. However calm or serene the reclining nude, the portrait of his father resting, or the figures passing through the urban landscape might be, they (like their environment) are suspended in a state of tenuous balance.

It is, I think, this sense of what can only be described as *poise* that makes Kossoff's work so affecting. His is a world in which potential cataclysm surrounds the most prosaic activity or occurrence. But that pell-mell urgency is matched, line for line, moment for moment, by his brilliantly controlled handling of paint. His paintings are concrete manifestations of the simultaneous volatility and studied restraint that increasingly characterizes survival in contemporary life. There is, in the exhibition, a very small self-portrait of the artist, painted last year. Like the wonderful, large paintings of Kilburn Underground and Dalston Junction (which reach dimensions of 5 by 7 feet), this little 10-by-8-inch work is filled to capacity with Kossoff's brand of controlled disorder. The artist's face emerges from the welter of pigment like a manifestation of visionary desire—matter becomes energy, and energy matter. It is a compelling image of an individual's capacity for being.

Barbara Kruger

July 4, 1990 In twentieth-century art, politics has found its most direct expression in murals painted on public walls. Whether officially sanctioned by a public or private sponsor, or whether painted "on the run" as energetic graffiti, the words and images in politically engaged murals mean to take a stand. By contrast, Barbara Kruger's chameleon-like new mural appears able to change its conceptual colors according to the shifting currents of the day. This is not to say the artist has no firm convictions to set forth in her pointedly monumental work of art. Instead, choosing up sides on polarized issues seems less important to her than finding ways to stir the sluggish sediment of popular involvement with them. Kruger doesn't offer answers in her art. She interjects questions.

Untitled (Questions) was painted last week on the south wall of the Museum of Contemporary Art's Temporary Contemporary, a former warehouse in Little Tokyo. It melds the traditional thrust of political murals with the graphic sensibility of advertising billboards in order to achieve two goals. One is simply to act as a sign for passersby to identify the museum building, which is quite nondescript and difficult to locate even from the nearby corner of 1st Street and Central Avenue. The other function is, simply, to be a work of art.

The street sign is the easy part. Nearly three stories high and more than two thirds the length of a football field, the commercially painted mural is hard to miss. So is its composition, which approximates the American flag. The upper left corner is a blue rectangle with white letters that announce: "MoCA at the Temporary Contemporary." The remainder is a red field whose white sentences divide the expanse into visual stripes. The chosen composition obviously flags MoCA for the passerby, but it also evokes something more subtle and provocative. Such public buildings as courthouses, post offices, and city halls are typically the ones that fly the flag out front. Kruger's flag-mural insists that the art museum be counted as a place for important public business, too—the business of expressive thought, enacted in the social context of a public place.

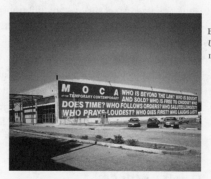

Barbara Kruger
Untitled (Questions)
1989 – 90

Call it street democracy in action. In four lines of simple text, Kruger's mural poses nine direct questions: "Who is beyond the law? Who is bought and sold? Who is free to choose? Who does time? Who follows orders? Who salutes longest? Who prays loudest? Who dies first? Who laughs last?" These simple queries are disconcerting, in part because of the emphatic scale of the blaring wall—even glimpsing it from a few blocks away generates a double-take—but, more shrewdly, because their form contradicts expectations. Big street signs, whether billboards or business logos, almost always address the viewer as a passive observer. They declare: Do this, Buy that, Come here, Take my word for it. If they ask anything, they merely ask for your surrender. But not

Kruger's big sign. Her mural addresses you as a peer, as a citizen or fellow member of the public world. It means to start a conversation. The huge and startling painting speaks loudly in order to be heard above the urban din; still, you're pointedly addressed as an active participant in disputatious public life.

Even though we casually expect it from a modern work of art, identity is not being asserted here. Identity is, instead, precisely the issue held in question. The nine queries repeat, like a mantra, a single word: *Who* is beyond the law? *Who* is free to choose? *Who* prays loudest? Kruger no doubt has her own answers, as might any passer-by who ponders the list. Those answers might differ or they might be the same; yet, once identified, virtually any answer implies that not everyone fits the bill. Only some people are beyond the law. Not all are in fact free to choose. Certain people do pray loudly. Against this poignant human reality, Kruger's mural presses the great American ideal of complete equality, symbolized by the flag. Acting upon the questions gains urgency.

Kruger's mural has been in the making for more than eighteen months. Originally planned to have been painted in May 1989 as part of MoCA's widely discussed exhibition "A Forest of Signs: Art in the Crisis of Representation," it ran into some unanticipated roadblocks. Various city agencies had to give the go-ahead, and bureaucracy grinds slowly. Also, the museum approached neighborhood organizations in Little Tokyo about its plans. There, the project came upon an unexpected complaint. The original design for the mural featured the nine questions as a border framing the image of the flag, with the text of the Pledge of Allegiance as the white stripes. Some people took offense. The mural faces the embarkation point from which thousands of Japanese-Americans were sent to relocation camps during World War II, their loyalty to their country shockingly in question. Daily, these imprisoned citizens were forced by the state to recite the Pledge of Allegiance. Aggravated by a flag-waving presidential campaign in 1988, which no doubt inspired Kruger's meditation, the mural unintentionally rubbed painful wounds.

In keeping with the public spirit of the mural, the New York-based artist met several times with neighborhood groups in order to work out a mutually satisfactory solution. At one point she switched the bordering questions and the striped Pledge, finally removing the Pledge altogether to arrive at the version now gracing the Temporary Contemporary's wall. There's no way to know which of the three designs would be best without trying them all, but the finished mural is powerful and eloquent. And, it has accrued new resonance that could not have been anticipated when the project was first conceived. A loyalty oath—far less cruelly threatening than at Manzanar but still chilling nonetheless—is today being demanded of artists themselves, should they wish to participate in public programs sponsored by the National Endowment for

Barbara Kruger

the Arts. Kruger's nine questions were not originally posed with the present censorship crisis in mind. (Ironically, "A Forest of Signs" did receive federal funding.) But wrapping the museum in the flag and wondering *Who salutes longest?* is clearly as American as the Fourth of July.

Jacob lawrence

June 14, 1993 Of the two series of narrative paintings by Jacob Lawrence now being shown at the Los Angeles County Museum of Art, the second is the most powerful and revealing. The first, which uses thirty-two small panels to outline the life of the great nineteenth-century abolitionist Frederick Douglass, shows an artist in the throes of learning how to compose pictures for his chosen format. Often the compositions are cramped, clumsy, and unfocused, as if Lawrence were having trouble identifying the significance of the episodes in Douglass's life, except from a dryly historical perspective. The second series, which outlines the life of Harriet Tubman in thirty-one small panels, shows a startling sea-change. It's as if a cleansing breeze has blown through, and Lawrence has suddenly connected with his subject's buoyant and invigorating example. With great skill, and even flashes of brilliance, Lawrence merges the heroic saga of the nineteenth century's other great abolitionist with his own developing story as an artist.

"Jacob Lawrence: The Frederick Douglass and Harriet Tubman Series of Narrative Paintings" has been touring for more than two years. The compact exhibition was organized by the Hampton, Virginia, University Museum, in whose collection the paintings have been held since their 1967 gift to the museum from the Harmon Foundation, established in 1926 to support African-American art. The connection with the Harmon Foundation is apt, since the remarkable Harlem Renaissance of the 1920s was the basis on which Lawrence was to build his art. Born in Atlantic City in 1917, he moved to Harlem with his family at age thirteen. Lawrence was too young to have been a participant in forging the New Negro Movement's eager fusion of Realist style, Americanist philosophy, and ethnic consciousness. Aaron Douglas, chief theoretician of the visual arts for the Harlem Renaissance, was eighteen years his senior. But that's the point. Lawrence entered a world in which mature concepts of art and cultural identity were a given—the first such moment in black American history. He inserted himself into an established tradition, however new that tradition was, and he remade it to his own ends.

Lawrence was just twenty-one when he began the Douglass series. Like countless American artists who would subsequently emerge into major significance, he was sustained during those brutal years of the Great Depression by the nation's first foray into government

support for the arts, the WPA's historic Federal Art Project. The Douglass pictures were not his first series. A year earlier Lawrence had completed "Toussaint L'Ouverture" (1937–38), chronicling the former slave who had brought independence to Haiti. Nor was the Tubman series his last. "The Migration of the Negro" and "John Brown" followed in 1940 and 1941. The Douglass and Tubman pictures are especially significant, though, and not just because the lives of these two Maryland slaves were to intersect in the fight for human liberty. Together they represent the initial transition of Lawrence's art from a minor to a major key. They're crucial signposts in the developing life of an important young artist. The paintings in both are all of an identical size—12 by 17⅞ inches—although some are deployed horizontally, some vertically. The medium is the same, too: casein tempera, a milk-based paint whose dry, flat colors have a soft richness. The two narrative series are laid out like frames in a storybook, each image set off by a narrow white border, marked out in pencil. Imagine a merger between a children's reader and Giotto's great narrative of the life of Christ in Padua's Arena Chapel.

Jacob Lawrence
Harriet Tubman Series No. 7
1939 – 40

In fact, the Harriet Tubman series does incorporate numerous references to Christian iconography: The snake in the Garden is echoed in a panel that shows young Harriet sprawled on the ground, having been struck in the head by a slave master's overseer; the Crucifixion in a panel that shows a whipped slave, accompanied by an ugly quote from statesman Henry Clay rationalizing why descendants of Africans must be sacrificed for American liberty; the Pietà in a panel that represents Tubman nursing a fallen Union soldier. The result is a saga that feels larger than any single individual. This sense is also heightened by a surprising anonymity: It's Tubman's story, but never is portraiture a consideration. When Harriet is first introduced in panel four, she's unidentifiable among a playful group of children. In the graphically powerful

Jacob Lawrence

picture in which she saws logs, her bowed head completely obscures her face. Elsewhere, she's hidden by her hands or a shawl, or her face is rendered schematically. The narrative says "Harriet Tubman," but Lawrence makes her Everywoman too.

A mythic grandeur rapidly overtakes the otherwise humble series. The gravity is heightened by Lawrence's simplified, but never simplistic, style. The log-sawing panel is perhaps the most extraordinarily composed, with the stark shapes of Tubman's powerful body massed against a brown hill in the background. The leftward slope of the hill cuts across the rightward slope of Tubman's big shoulders, creating a visual seesaw evocative of the forceful, up-and-down motion that describes her tedious work. Tubman's strength and diligence, which served her well in her subsequent years smuggling fugitive slaves northward on the underground railroad, is conveyed with a marvelous specificity. It's also significant that Lawrence was painting the series late in the 1930s. The lingering trauma of the Great Depression built pressure for jingoist conformity, which was the antithesis of these pictorial celebrations of the great American tradition of civil disobedience.

The earlier Douglass series has its moments, as in a joyously luxurious image of a slave master's bedroom. It demonstrates Lawrence's clear adoration for the vivid art of Matisse. But mostly you feel as if the young painter is trying things out. Some work, some don't. Not until the Tubman series has he assimilated those experiments and begun to make them his own. Finally Lawrence loosens the tight, illustrational reigns of his narrative project, which had held the Douglass pictures in check. The Tubman series claims a half-dozen panels of exceptional pictorial invention, many evocative of the great Modernist painter Arthur Dove. These panels, several almost wholly abstract, provide eloquent testimony of an artist deeply immersed in a heady process of self-discovery and self-invention. It's exactly the process that transformed the ancestral heroine who is the paintings' subject. From one series to the next, the youthful Jacob Lawrence internalized a history he had merely set out to celebrate.

Annie Leibovitz

May 1992 Pandemonium surrounds the touring exhibition "Annie Leibovitz: Photographs, 1970–1990." A crush of autograph-seeking fans on opening night at the Phoenix Art Museum, an adoring SRO audience at the artist's public lecture the next day, record-busting attendance during the show's run, a last-minute extension of two weeks in order to accommodate the desires of an unfulfilled throng, a catalog bearing down on the best-seller lists—the tumult is understandable, even if disconcerting. Leibovitz is a celebrity photographer, but

she's also a photographer who's a celebrity.

Her celebrity is only indirectly based on the quality of her portraits of actors, singers, athletes, and such, which are rarely more than clever. Rather, her status as a luminary is an invention of *Vanity Fair*, a magazine that took a talented commercial portrait photographer and recreated her as a star photographer of stars. Her name is often promoted on the magazine's cover, with layouts tagged as "exclusives." Now, in the wake of the rollicking success of the traveling show, which was organized by the International Center of Photography in New York in conjunction with the National Portrait Gallery in Washington, where it has already been seen, the April issue of *Vanity Fair* features " 'Women Who Shock,' by Annie Leibovitz." This "one person show" of photographs of American artists, a mainstream pop spin on *Artforum*'s trade gimmick of artists'-project pages, means to acknowledge Leibovitz's own supposed stature among them.

It's only logical, then, that the motif pictured in the preponderance of Leibovitz's most widely remembered images is precisely this relationship between celebrity identity and pop-culture context. Her 1979 picture of Bette Midler is an aerial view showing the recumbent singer-actress, arms and legs akimbo, her torso and bed covered by a blanket of scarlet roses. Recall that the advertising tag for a thinly veiled movie version of the tawdry life and drug-induced death of the legendary Janis Joplin declared: "Bette Midler IS The Rose." After you've been poked in the eye by the photograph's blunt illustration of some ad copy, you are invited to reflect on a dull cliché: Life is a bed of roses for the ascendant movie star, whose Oscar nomination came from playing a tragic celebrity felled by its hidden thorns.

Leibovitz's picture of Midler was made in 1979, and it's among the first of many from the past decade in which the figure and the ground are united. John Belushi and Dan Aykroyd are dressed in Blues Brothers drag, and their faces are painted blue. Steve Martin wears white tie and tails, crudely smeared with black paint, and he poses in front of a Franz Kline painting. Whoopi Goldberg lies submerged in a white porcelain bathtub filled with milk, her protruding brown face and limbs appearing severed from her unseen torso. A white Lauren Hutton lies naked in a bath of brown mud, a "photographic negative" of the Goldberg picture. A primeval Sting, his naked flesh caked with drying clay, stands on one leg, egret-style, in the cracked and arid emptiness of the California desert. Keith Haring, also naked, is painted white and covered with his trademark pictograms, as is the all-white living room into which he visually disappears.

In all of these photographs, the figure melds with the ground, while the ground is often an image of established art. In addition to Martin-as-Kline and Haring-as-Haring, there are pictures of Christo, wrapped; Carl Lewis as a variation on Myron's discobolos; and

David Byrne as a Magritte. Posed on horseback, Arnold Schwarzenegger stands in for every equestrian statue based on Caesarean prototype.

Leibovitz first studied to be a painter. Formally, her merger of figure and ground makes for flattened pictures with a graphic punch. The attribute is appropriate to the demands of the modern magazine page, and it's a smart move for photographs whose compositions must be malleable enough to allow for cropping in the hurried process of lay-out. In the exhibition the magazine format is mimicked, or at least re-called, by the use of white frames on white gallery walls affixed with white labels sporting printed text. Given the jarring scale attendant to room-size walls, however, the surely unintended result is photos that look surprisingly puny. More important, though, it's hard to know for sure whether the graphically astute creation of figure-ground com-pression was driven by concern for pictorial content. I'd guess it's vice versa—that the magazine form dictated the parameters of content. That explains why Leibovitz's photographs are commercially success-ful but stuck in art's minor leagues.

The exhibition is doubly disappointing because, finally, there's no reason for the show to exist. The concept of "vintage" prints for mass-media photographs is absurd (in any case, the exhibition prints were printed by studio assistants), and you do feel vaguely foolish look-ing at these pictures while standing up. Although it's amusing to people-watch in the crowded galleries, seeing Leibovitz's photographs reproduced in the lavishly produced catalog is really enough, since it's far closer to the intended format than museum walls could ever be. And no nettle-some historical or critical essay burdens the book. Its only text is a chatty interview conducted by Ingrid Sischy, editor of *Artforum* during the decade Leibovitz came into her own, and now editor of *Interview* mag-azine. In the book, the celebrity figure disappears into the pop-culture ground, just like Bette, Steve, Whoopi, and the rest.

sherrie levine

October 26, 1986 Sherrie Levine is making paintings. They're smallish, rectangular, gridded images on mahogany panels in which wax and casein paint are used to make alternating squares of contrasting color, like a psychedelic checkerboard. The paintings don't have descriptive ti-tles, only numbers.

That an artist is making paintings is not, in itself, re-markable. The singular achievement of the past decade has been paint-ing's triumphant return from the grave, and new paintings are now seen everywhere. However, that *Levine* is making paintings is remark-able—at least, on the surface it is. Since 1981, her notoriety has been based on appropriations of photographs made by other people. These

have been of two kinds. One kind is rephotographed photographs, in which she took famous prints by, among others, Edward Weston, Walker Evans, and Alexander Rodchenko, then photographed the photographs, mounted and framed them and signed them with her own name. They bore the titles *After Edward Weston*, *After Walker Evans*, *After Alexander Rodchenko*. The other kind she called collages. They consisted of photographic reproductions of paintings by artists such as Egon Schiele and Vincent van Gogh that she cut out of books, pasted on paper, framed and signed with her own name. These were titled *After Egon Schiele* and *After Vincent van Gogh*.

Sherrie Levine
After Edward Weston: 1
1980

 The reason Levine's decision to paint is remarkable only on the surface is that an uncommon intelligence has marked all her work to date. When you look back on her art from the past five years, there's been a steady complication, a continual upping of the ante that has now been taken to precipitous heights in these deceptively simple checkerboards. They constitute her best work to date, which is somewhere in the vicinity of the most provocative, nettlesome, and destabilizing art being made today.

 Levine didn't make a giant leap from photographic reproductions to paintings. She's the kind of artist who pushes at the ever-enclosing edges of things, edges that always threaten to tighten like a noose. She seems to follow these small leads in a manner both intellectual and intuitive, so different bodies of work aren't neatly sewn up but tend to overlap one another instead. In between starting the photographic works and starting the panel paintings (which began as striped images about a year and a half ago), she made drawings. Again relying on pictures in books, she traced reproductions of works by Matisse, Schiele, Leger, Miró, Klee (several of the latter may currently be seen with the checkerboard paintings at Daniel Weinberg Gallery), and oth-

ers, usually adding watercolor washes. In 1985, she began a group of plywood works, framed and mounted behind glass, in which the randomly occurring knots in ordinary sheets of cheap plywood were embellished with gold leaf. More recently, she's been embellishing the knots with white casein (a half-dozen of these are also at Weinberg).

Both the drawings and the plywood works continued to develop her long-standing involvement with reproduction and machinelike regularity, but they signaled a shift as well: The artist's hand became prominent in the enterprise. The gold knots, especially, sanctified human intervention, given their ironic gilding of the places where, in the manufacture of plywood, nature has "failed" and human beings have had to fill in the holes. Like medieval icons, Levine's gold leaf (Is "leaf" a wry pun in the context of wood?) applied a kind of halo to the work.

Most important, the plywood works seem to have taken Levine into the arena of formalist painting in which the recent checkerboards find their peculiar resonance. (Giving them numbers as titles—a practice common in the 1960s—underscores the formalist connection.) For what are embellished knots on otherwise unembellished sheets of plywood but a decided, if decidedly loopy, emphasis on the intrinsic properties of the medium?

I don't think these plywood works are great. True, the machine-made plywood deftly undercuts the formalist thinking of critic Clement Greenberg, who tried to make culturally shaped ideology seem an irrevocable force of nature, while the golden halos make a joke of Michael Fried, who endowed formalism with the force of papal doctrine. But almost all the best painting of the last decade has already laid the claims of those critics to rest. Instead, the plywood works seem like reasoned preparations for Levine's full-scale plunge into painting. They let you know that she's not interested in a reactionary return to formalism, that she understands (and embraces) the critical unseating of that doctrine. Yet, they also let you know that formalist painting was itself not without importance and that there's something left to be done with it. The plywood paintings may not be great, but they are significant. They build a bridge.

The checkerboard paintings, like the plywood ones, are unique in the body of Levine's mature work because they don't appropriate anyone else's art wholesale. They're more oblique. The flat, gridded pattern of one-inch squares puts you loosely in mind of formalism, in general; the jangly, chromatic dazzle of her chosen color-schemes suggests Op art of the 1960s, more specifically; and the combination of the two makes you think of the painter Bridget Riley, in particular. It isn't that any of these are directly referred to in the paintings. They're more in the spectator's memory, and the paintings nudge them into the foreground with a glancing blow.

Thinking of Riley, another fundamental difference comes

to the fore: All of Levine's prior work appropriated images by male artists. As a woman, she focused on reproductive capacity, while the master images came from men. Conventional social roles and cultural hierarchies were intrinsic to the work. They're intrinsic to the checkerboard paintings, too.

How? Formalism upheld an ever more rigorous articulation of the intrinsic properties of the medium as the progressive route to authenticity. But it left something out. (I'm about to walk into treacherous territory here, but one of the chief pleasures of Levine's art is the way it pushes you farther and farther out onto thinner and thinner ice. The danger is thrilling.) Simply put, one social and cultural convention of painting is that it has always been a man's art. Think of the hazy origins of painting (and, for that matter, of writing) in Western civilization. Agriculture, which superseded hunter-gatherer society, meant that there could be a surplus of food, and surplus allowed for the human settlement that fostered civilization. In turn, surplus meant that some way had to be devised to identify whose surplus belonged to whom. Marks—rudimentary image-words—were painted on food containers and pots. Women are thought to have been the principal makers of those pots and containers; indeed, it was women who did the farming. It was men who made the pictures through which ownership was identified. What does this imply?

Think of the most important artists of the past ten or fifteen years. Most—though certainly not all—of those who are women have used photography, performance, video, installation, sculpture, and mixed media. Most—though certainly not all—of the painters have been men. Why? Think of the hierarchy of mediums in art. Painting is almost always at the top of the heap, and it has been for centuries. Sometimes it's been toppled, but always it returns, just as it has reclaimed the pinnacle in recent years. In the process, gross deformations have occurred. I've long suspected that the confusion about the late Georgia O'Keeffe, who to my mind is among the most overrated painters of the century, has everything to do with this unshakable hierarchy. O'Keeffe's extraordinary achievement is not to be found in paint on canvas but in watercolor on paper—and watercolors are very far down the list on the socially and culturally fabricated hierarchy of art. Her achievement has been deformed because of it. What others have suffered a like fate?

To be sure, I am utterly unprepared to make any full-scale argument about all this. (In several places I can hear the ice begin to crack.) Still, if one puts the conventional hierarchy of art together with the suggestion that painting has been the most conventional language through which male desire has been spoken, then it's not too difficult to see why the two have gone hand in hand from the beginning to the present day. Indeed, all sorts of unexamined conventions come to the foreground in Levine's checkerboard paintings—which explains quite clearly

sherrie levine

the artist's carefully thought-out move into painting itself. Nor is it insignificant that these works put one in mind of formalist issues, Op art, and a woman painter: All are now disenfranchised, and the nature of disenfranchisement is an operating principle in Levine's art. For Levine to have now begun making straightforward paintings—just when the first shudder can be felt of a backlash against the current proliferation of painting—is itself a measure of her complex artistic intelligence. A challenging feminist critique is alive and well in her art.

In the past, I've been skeptical about Levine's work. You could get the photographs, collages, and drawings without really spending much time looking at them. But the checkerboard paintings are different. Small, delicate washes of dry casein mixed with warm, translucent wax are built up in puddled layers that don't fill in the geometric regularity of the penciled grid; sometimes, a hint of contrasting underpaint peeks through. The exposed grain of the wood accentuates the grid, providing a counterpoint between precise structure and the organic, puddled shapes of paint. The grain, too, is made tactile by the paint that covers it, like bones sensed under skin. (Agnes Martin joins Bridget Riley in these paintings' ancestral background.) They project an ascetic, monastic quality that makes you think of a scribe painstakingly copying manuscripts while subtly reinterpreting them by adding remarkable decorative embellishments.

Slow to reveal themselves despite the often frenetic jumps and optical shifts provided by the color, they are very sensual paintings. Indeed, that jazzy, out-front quality is tempered, and made strangely poignant, by a profound sense of isolation and solitude. These are intensely private pictures. What's remarkable about Levine's seemingly simple checkerboards is the way she's burrowed into a dazzlingly complex scenario. That feature alone gives her work an edgy, disruptive jangle that is not simply the result of her juxtapositions of red and green or of blue and orange squares of color. They're hair-raising paintings because Sherrie Levine has decided to voyage straight into the belly of the beast.

Helen Levitt

January 12, 1994 In *New York* (circa 1945), one of eighty-four photographs of life in the modern city that make up the enchanting Helen Levitt retrospective newly opened at the Los Angeles County Museum of Art, four men are arrayed across a shallow picture plane like mythological figures on a classical Roman frieze. Three stand at a railing, one sits on a stoop. Three look off to the side at something (or some things) unseen beyond the camera's range of vision; one peruses a newspaper, his back to the viewer.

Self-contained and isolated from one another, despite a

close proximity enhanced by the visual compression of lighting and composition, all four men are engaged in a solitary but intimate practice: observing and being observed. It seems a distinctly urban trait, this paradoxically connected quality of individual isolation, and one which makes apposite the otherwise generic title of the photograph. The three male faces that we can see on this urban frieze conjure "the ages of man"—youth, middle age, old age—a continuity given a quiet spin by the single mystery man who is turned away from us. The specificity of New York life in the 1940s is transformed, becoming most any city, most anywhere, most any time.

Helen Levitt
Children
1940

Given the foreground prominence of these men, it takes a moment to notice a fifth person in the picture. From an open window at the rear, a little girl, her curly-haired head resting on her hand, looks bemusedly out on the scene at which we are gazing from the other side. Like a female version of a heavenly putto in a Baroque painting, this cherubic child dreamily observes these half-mythic, half-mortal men below her. She assumes an ambiguous place in the scheme of things, somewhere between the innocent, blank slate of childhood and an all-knowing realm of divinity. Pointedly, the photographic jolt of the picture is carried by this unobtrusive little figure hovering in the background. For we soon realize that the artist has orchestrated her casual, street-side scene to let us know that, finally, this child mirrors us.

Helen Levitt is not a popularly well-known photographer; but as this single picture so vividly attests, she is certainly an extraordinary one. A quintessential "artist's artist," she is highly regarded among her peers. The distinction fits the tenor of her work. The show overflows with images of an unusual tone: Banal at first glance, her views of life in the unglamorous streets of the metropolis tend to blossom slowly, finally deepening with a peculiarly intimate resonance.

Part of Levitt's uniqueness lies in the difference between her photographs and those of well-known American social documentarians of the 1930s, the era of great social crisis when she began to make pictures. She photographed almost exclusively in a variety of decaying

neighborhoods of NewYork—the city of her birth, which she has rarely left during her eighty years and which she has used as the title for almost all her work.Yet, her photographs do not speak of public issues as much as intimating private meditations. Hers are visual poems, not polemics. Her friendship with the likes of writer James Agee and painter and art historian Janice Loeb, and her admiration for the photographs of Walker Evans,Weegee, Henri Cartier-Bresson, and others testify to the lyrically poetic interests of her art. As is common in our own turbulent moment, such work is easily swamped by the noisier clamor of more contentious art.

And then there are the children. Children are Levitt's great subject.They appear in about two thirds of the black-and-white and color pictures in the show: in the background, on center stage; playing, fighting, daydreaming; disappearing into shadowed doorways or reflected in storefront windows. As with the latter-day putto observing the urban frieze of New York, Levitt's children are both remote in the half-remembered mystery of their youthfulness and conceived with an almost shockingly blunt intimacy. Levitt doesn't sentimentalize children—or, rather, sentimentality becomes just one among a panoply of facets through which children are fully seen.

One way Levitt was able to capture the feeling of the childlike quality of a consciousness in formation was through her choice of camera. In 1936, she bought a Leica—the small, hand-held camera that, unlike a boxy view camera, for the first time allowed photographers a degree of obscurity on the street. To make herself even more inconspicuous, Levitt fitted the camera with a right-angle lens. She could face one direction and shoot, but her camera would be taking a picture ninety degrees to the side.The result is subjects who, if they are aware of the photographer's presence at all, are not actors playing to or shying away from the camera.When you look at Levitt's photographs you see the world out of the corner of her eye.

That's where Helen Levitt has been for the past fifty years, too, as far as the art world goes—over there, in the corner of its eye, never completely out of sight but rarely ever in the direct line of vision. But the retrospective is changing that.Together with an excellent catalogue by the show's curators, Sandra S. Phillips and Maria Morris Hambourg, it goes a very long way toward establishing Levitt as a superior artist of her generation. Its thoughtful installation at LACMA is provocative in juxtaposing earlier work of the 1930s and 1940s with more recent, often color pictures made since the end of the 1960s. (Levitt made few photographs during the 1950s:A film shot and edited with Agee and Loeb and released in 1952 is in the show, but technical difficulties prevented its preview, and a studio burglary in 1966 obliterated all evidence of her 1959 return to still-camera pictures.) The juxtapositions of past and present underscore the continuity of her artistic concerns.

Last Chance for Eden

ROY LICHTENSTEIN

February 1, 1994 Roy Lichtenstein was among a number of artists who playfully put the pop in Pop art between 1961 and 1965, sweeping away the pale doldrums into which third- and fourth-generation recapitulations of Abstract Expressionist painting had by then so dismally fallen. Yet what's interesting about the Lichtenstein retrospective that opened Sunday at the Museum of Contemporary Art is that this wildly inventive moment turns out to have been the prologue for a wry but nonetheless surprisingly sober career for the now seventy-year-old artist. Don't be amazed if you leave the show firm in the conviction that Lichtenstein started out wildly Pop but soon settled into becoming a latter-day neoclassical painter.

The exhibition at MoCA is considerably smaller than it was at its debut last fall at New York's Solomon R. Guggenheim Museum. The 120 paintings originally displayed have been whittled to eighty-one, the twenty-three sculptures to ten, the ten drawings to none. With certain caveats, the show is stronger for the editing. On the down side, only one of the important "brush-stroke" paintings begun in 1965 is on view at MoCA; yet, these ironic paeans to the gorgeous slathers and drips of Abstract Expressionism form the clearest, most succinct summation of a central thread of Lichtenstein's art. Meanwhile, the strangely beautiful (and typically underestimated) pictures of the surfaces of mirrors are not shown to full advantage. Happily, however, relatively few of the trims in the show date to the remarkable five-year period when Lichtenstein began to discover his artistic voice by adapting modern comic-strip style to the musty clichés of Abstract Expressionist rhetoric. Nearly half the paintings and sculptures in the thirty-year retrospective date from 1961 to 1965.

While some great examples from those fecund years are sorely missed, the forty-three on view make for an extraordinarily compelling array. *Look Mickey* (1961), Lichtenstein's first all-cartoon canvas, begins the survey with a pointed fusillade. The painting uses its blunt, red-yellow-blue primaries to fashion a slyly hilarious riff on artistic solipsism. As Mickey Mouse looks on with bemusement, a typically wild-eyed Donald Duck raves hysterically about the giant fish he thinks he's caught on the other end of his tugging fish line. All the while, Donald is completely unaware that the whopper is in fact inside his own coat-tail, which he's neatly hooked behind his back.

The reigning Expressionist faith in a self that can know only its own experiences, its own states of being, is given the boot in this surgically incisive image. The "big, American themes" grandly associated in the 1950s with the muscular, aggressive expanses of Abstract Expressionist painting here come apart at the seams, while the bigger, even more American theme of popular culture takes center stage.

Abstraction, then acclaimed as the peak of a long, Modernist road to artistic heights, gives way to vintage Disney and the Sunday funnies. In a famous magazine article, the volatile Abstract Expressionist painters had been dubbed "The Irascibles," and who in the pop-culture pantheon is more irascible than Donald Duck?

In the lexicon of traditional art, a cartoon is a spontaneous, preparatory study for a sleekly finished painting. It was the crudeness of such cartoons to which Impressionist canvases had been derisively compared nearly a century before, when a modern sensibility erupted. Lichtenstein, a mature thirty-eight in 1961, was again restoring a sense of urgency to a contemporary artistic milieu gone stale and wan. Look, Mickey! The usual claims for a primacy of feeling being more truly recorded in abstract rather than figurative art have gotten deliciously upended!

Roy Lichtenstein
Look Mickey
1961

Like Andy Warhol, Lichtenstein surveyed the tired, restrictive, and overworked terrain of American avant-garde art in his risible Pop paintings of the early 1960s. In *Drowning Girl*, a brunette goes under for the count, swirling in an abstract tidal pool of paint. De Kooning's notorious pictures of women become comic-strip blonds, overcome with existential anxiety. Painting as autobiography is shown as an unexpressive list of jottings in an ordinary appointment book. Elsewhere, the cover to a high school composition book recalls Pollock's dark, jagged gestures in black automobile paint. In dazzling war-comic images of fighter planes, the battle over abstraction's stranglehold on contemporary art is addressed. "Okay, hot-shot, okay! I'm pouring!" screams a fighter pilot in a burst of machine-gun fire, wittily mowing down critic Clement Greenberg's contemporaneous dissertations, which promoted the so-called poured abstractions of Morris Louis and Helen Frankenthaler.

Needless to say, once the battle was won and Pop art stood triumphant, Lichtenstein couldn't keep fighting a vanquished foe. His art wobbles a bit, especially in big, 1968 canvases based on Art Deco designs of the 1920s and 1930s. Their significance lies primarily in focusing on the American artistic style most popular when mass culture was being born—a style that lives on nostalgically today. Audience

taste is their subject, while the relationship between audience and art is incisively (and melancholically) considered in Lichtenstein's next major body of work. The mirror paintings (1969–71) apply mass-graphic style to effectively represent the shiny, silvered surfaces of variously shaped looking glasses. Their most disorienting quality is the utter absence of a reflected image. Like Dracula, you stand full-bodied before these Pop mirrors, yet you cannot see your apparently deadened, bloodless self.

Throughout the 1970s and 1980s, and continuing to the present, Lichtenstein widened his scope from the urgent, Abstract Expressionist focus of his early work. All of modern painting has since become grist for his image mill: Impressionism, Cubism, Futurism, Constructivism, Surrealism—these and more are quoted. So is architecture, specifically the entablatures supported by columns on classical buildings. Lichtenstein's are pointedly neoclassical, however, and therein lies a key to his post-Pop art. For just as neoclassical artists of any revolutionary age—including powerful moments in the eleventh, fifteenth, seventeenth, and nineteenth centuries—have built their work on classical foundations, so does he.

The difference is that, for Lichtenstein, it is the classics of Modernism, not of antiquity, that are the columns holding up the entablature of his art. (In 1988 he made a failed attempt to paint the *Laocoön*, the famous Roman copy of a first-century A.D. Greek sculpture beloved of the Renaissance; fortunately, it's not in the show.) Since at least 1972, his own classic Pop works of the 1960s have also turned up as sources, represented within new paintings much the way Matisse showed his own paintings in the backgrounds of new work.

In moments of great upheaval, such as our own, neoclassicism means to suggest a stable continuity with the past. By also showing how far we've come since then, the unique importance of the present is punctuated. And yet, when the distant mists of antiquity are replaced by the pressing realities of the modern world, as Lichtenstein has done, something else intrudes. A sobering sense that perhaps we haven't come so very far at all reverberates through this beautifully skeptical show.

Andrew Lord

June 9, 1985 Andrew Lord's exceptional sculptures are pictures that have been pushed, pulled, coaxed, and cajoled into volumetric space. Although his vases, bowls, pitchers, and plates are hand-built and made from glazed and fired earthenware, they have little if anything to do with traditions of pottery and crafts. (Look closely and you'll discover hairline cracks at the juncture of a vessel's handle and body, fissures that would lead any self-respecting potter to consign the jug to the scrap heap.) Rather, it is to pictures of pottery that Lord has turned

his formidable artistic attention, especially to painted pictures of pottery. The British-born sculptor, who now lives in New York, is currently having his second solo exhibition in Los Angeles, at Margo Leavin Gallery; and it is an affair marked by a keen formal and conceptual intelligence. It's as if he had accepted Baudelaire's invitation to undertake a fateful journey to a world of harmony and sensual pleasure, and so has traveled deep inside the mysteriously beautiful, two-dimensional world of a still life by Cézanne or Matisse. Lord has ripped the sinuous fruit bowl or patterned ginger jar from its flattened moorings and brought it back alive.

Lord's sculptures are unabashedly beautiful and luxurious, albeit in unconventional ways; but there's something oddly disturbing about them, too. His Baudelarian voyage has its darker side: These domestic objects seem to have been rescued from a prison of imagery, from an underworld of departed souls, like Eurydice led back from Hades. This time, however, the Orphic rescue has been successful, and now that the pots and plates are "back" they have some rather harrowing tales to tell.

Pictorial traditions of painting constitute the realm from which Lord's sculptures have forthrightly emerged. Formally, he is among a handful of artists who have been slowly but surely rescuing pictorial sculpture from the hell of exhaustion and redundancy to which it is has been consigned for more than twenty years. In the early 1960s, signs of that exhaustion were everywhere. George Segal tried to cope by making pictorial sculpture that was environmental; to do it he resorted to the death mask, plaster casts of living people converted into empty shells. A more enlightened approached was taken by Claes Oldenburg, who managed to avoid the sentimentality that sank so much of Segal's work by simply insisting on literalness: If the genre had become flaccid, so be it; Oldenburg's soft and droopy sculptures were as flaccid as flaccid could be, and their contours drew themselves in space through the literal force of gravity. Finally, and in the most radical gesture of all, the pure sculptural forms of Minimalist geometry dealt with the problem by banishing pictorial considerations altogether. Today, a generation later, that very banishment is the strategy that has become tired and redundant, as pictorial sculpture was before it.

Lord, who is too young to have been involved in any of this firsthand (he was born in Britain in 1950), is nevertheless stuck with the result. So, like numerous artists of his generation, he's gone back to the origins of the dilemma to sort things out. In his particular case, that means sifting through the radical disruptions of Cubism, as well as its immediate ancestry in the paintings of Matisse and, especially, Cézanne. The tradition of twentieth-century pictorial sculpture issued forth from the extraordinary assemblages of tin, cardboard, wood, and wire that Picasso made in the 1910s and from his open-framework "drawings in space," coengineered with the metalsmith Julio González, in

the decade that followed. Lord's debts to Cubism are everywhere apparent, but it is, I think, to the still lifes of Cézanne that the fundamental debt is owed. His conte crayon drawings are plainly Cézannesque in their articulation of pictorial syntax. In them, we look at and onto and around the depicted vase or pitcher, as multiple viewpoints on a single object are unified into a continuous surface and contour. The complex of relationships between lip and body and handle and space is opened up and made fluid, responsive to the peregrinations of the spectator's eye.

Andrew Lord
31 Black pieces.
1985

As Cézanne brilliantly made clear, and Lord's drawings reiterate, a picture is about a chosen motif, whether mountain, jug, or portrait; it's also about the process of seeing that motif. The relationships among objects, light, space, and time are thus expanded to include the activity of the spectator as a fundamental and irreplaceable part of the syntax. In his work, Lord doesn't merely emulate the past, although it's evident that he wants to reconstruct a tradition. So he takes that Baudelarian voyage and brings the pots back from history, depositing them squarely in the present. His sculptural objects are extensions, into the third dimension, of his deftly rendered drawings (the forms seem to have been arrived at through a perfect union of logic and intuition). It's rather astonishing to look at a drawing of a pitcher, turn around, face the pitcher itself, and then be able to move around it. Lord's vessels don't look like the ordinary domestic variety you'd find around the house; but they do look completely normal, authentic, and "real" nonetheless. There's a pronounced sense of familiarity embedded within them, while in a completely contradictory manner you feel as if you're seeing them for the very first time. In this way, Lord's sculptures make a direct assault on a central piety of artistic practice: They're about the chosen motifs and about the process of seeing those motifs—but they're about *already having seen* the motifs as well.

Imagery, in an image-saturated culture, inflates the illusion of having seen the motif that is depicted. We all have "seen" the surface of the moon and the swollen bellies of Ethiopian children, have "witnessed" the conflagrations in Southeast Asia and in a Philadelphia

ghetto, too. We haven't, of course, seen any such things, for it is imagery that we most often experience. Lord drives a wedge into the illusion of "having seen" and splits it wide open. To the syntactical equation of authentic experience he adds our thorny relationship to the swirling illusions of modern imagery itself. His goal, therefore, is presence and weight, and his sculptures transform the weightless phantoms of illusion through the undeniable gravity and tensions of pictorial decisions. The graphite-gray glaze on many of the pots is dense and opaque, thus making the form read as a sharply contoured shape and so enhancing the pictorial lift. At the same time, that very density compounds the physical materiality of the piece and yields a sense of monumentality to these modestly scaled vessels. Here and there, a tiny squiggle of gold will bubble to the surface or ooze out beneath the base, adding a complicating inflection of reflected light to the scenario. And in certain pots, jars, pitchers, and plates that are brightly glazed in simulated reflections of electric light, the artist assumes the role of a latter-day Impressionist surveying the play of artificial illumination as it falls across an image.

Henri Bergson, whose scientific writings in many ways paralleled the contemporaneous pictorial discoveries of Cézanne, observed in 1889: "We have to express ourselves in words, but most often we think in space." A century later, our culture expresses itself most emphatically in images. In his often remarkable pictorial sculptures, Andrew Lord seems intent on retrieving thought in space.

Édouard Manet

October 2, 1983 Édouard Manet is one of very few artists whose paintings can induce an audible gasp. They did so in their own time of nineteenth-century salons, and they still do so today. It hardly matters whether the encounter is with a work not often seen except in reproduction, like the powerfully enigmatic *Luncheon in the Studio* (1868), which hangs in a museum in Munich; or whether it's with one of the most familiar monuments in the entire history of art, like the extraordinarily erotic *Olympia* (1863), a portrait of the prostitute Victorine Meurent that has held court in the Louvre Museum for more than seventy-five years.

Opinion as to whether or not Manet intended his work to induce such gasps has fluctuated back and forth ever since the paint was still wet. We know that he was at least as shocked by the scandal that erupted upon the showing of *Olympia* in the Salon of 1865 as contemporary observers were by his painting. His friend since childhood, Antonin Proust, later reported the painter's intent: "I render, as simply as can be, the things I see. Take 'Olympia,' could anything be plainer? There are hard parts, I'm told. They were there. I saw them. I

put down what I saw." What Manet saw was extraordinarily complex even though, as he put it, nothing could be plainer. To look at his best paintings is to look into a time marked by chaos and exhaustion, and a moment filled with loss but engorged with unsatiated life. It was the confrontation with this strangely conflicting but apposite vision that caused his contemporaries to stop dead in their tracks, regardless of whether they approved of what they saw. And it is the not dissimilar moment in which we find ourselves today, I think, that makes our present confrontation with Manet so profound.

Manet died of tertiary syphilis on April 30, 1883, three months after his fifty-first birthday. In the centenary of his death, the Louvre Museum and the Metropolitan Museum have joined forces to mount a retrospective exhibition of ninety-five paintings, forty-five drawings, watercolors, and pastels, and fifty prints—the most extensive gathering of Manet's work since the memorial exhibition at the École des Beaux Arts mounted ninety-nine years ago. To describe this exhibition as great would be superfluous, even redundant. Certainly the absence of *Luncheon on the Grass* and, even more, of *Olympia* from the presentation at the Met leaves a sizable hole at the very heart of the show (reportedly these paintings are not allowed to leave France), but it cannot be denied that the exhibition is the most important museum undertaking in recent memory.

Manet's position as the "father" of modern art is well known, even though his role has often been distorted to exclude the wholeness of his work in favor of the isolation of the formal qualities of his art. This latter point of view, which has descended from the writings of Manet's great friend Émile Zola, is certainly central to any understanding of the paintings; the sheer slide of white paint dragged by a brush that forms the petticoat rustling under the hem of the dress in *The Street Singer* embodies a palpable, almost painfully beautiful sensuality that is the pivot on which the whole of Manet's art turns. But in the context of the predominantly brown tonalities with which the picture is composed, this flash of white also serves to draw the eye relentlessly toward the teasing, upturned edge of the woman's voluminous skirt, and thus to the forbidden limbs that skirt enshrouds. Manet's excision of half-tones from his paintings, his flattening of space into glorious patterning, his emphasis on the surface qualities of paint on canvas cannot be divorced from the larger iconography of his work. Over the past two decades much research has been done in this area; for instance, sources for certain of Manet's pictures have been found in Velázquez, Goya, Thomas Couture, Dutch painting, and others. This longstanding bifurcation of Manet's art (aside from speaking eloquently of that art's richness and complexity) reminds me of Maurice Denis's famous observation in 1890: "It is well to remember that a picture—before being a battle horse, a nude woman or some anecdote—is essentially

Édouard Manet

a plane surface covered with colors assembled in a certain order." Manet's paintings deny any such before-or-after placement, insisting instead on their simultaneity.

Indeed, it is this very simultaneity that generates such power in his work. For me, one of the great revelations of the current exhibition is a pervasive sense of loss, paradoxically matched by a stunning presence, in Manet's art. One finds it directly stated in the form of death: *The Dead Toreador*, *The Dead Christ with Angels*, the ritual slaying of the beast in the several bullfight pictures, *The Execution of Maximillian*, and others. More often, one finds it covertly but nevertheless emphatically there. In the autumnal painting *The Railroad*, a woman looks up from her book while a little girl, her back to us, gazes at the ethereal cloud of steam and smoke as a train passes by; all three are at once present and not present. In most of the full-length portraits—*Proust, Boy with a Sword, Mlle. V . . . in the Costume of an Espada, The Tragic Actor, The Fifer*, etc.—the theatrical costuming and the clear sense of a scene that has been posed for the moment of painting lends the inescapable feeling that the image has been set up for you to see, and then will disappear forever. The wistful, often melancholy gaze of his subjects, particularly in the later paintings, puts a condition of absence front and center. The fragility and transience of life is evoked by the glistening *Soap Bubbles* and the recurrent use of the curling spiral of lemon peels, borrowed from Dutch *vanitas* still lifes. Even the quotation of specific images by Giorgione, Titian, Raphael, and other Old Masters as well as their "updating" in modern dress and readily identifiable Parisian locales suggest, in part, an exorcism—a simultaneous acknowledgment and killing off that is as blunt and brutal as the dead body in Manet's *Christ*.

There is, in the exhibition, a tiny painting called *The Bunch of Violets* that, in its few square inches, serves up every bit as much of the strangely compelling nature of the role of this sense of loss in Manet's art as any of the more grandly scaled pictures. Sent as a tribute and message of friendship to the painter Berthe Morisot, it is composed of a folded fan, a blue-edged note with her name inscribed, and a vivid bunch of violets. A flower much favored by bourgeois dandies (of which Manet himself was one), the violet is an exotic bloom which, when cut from the plant, has only the most fleeting life before it wilts and blackens. From the moment of its cutting—the moment when its ruin is assured and thus brought into view—the beauty of its softness, its color, its very existence takes on a vivid and delirious clarity.

In a way, it was only through the real and the metaphoric death of the dominant French culture in the mid-nineteenth century that the sense of "the modern" could have been born. Manet's was not a revolution from without, however, a sweeping away of all that was decadent and moribund in order to build a Utopia on a clean and pristine field. Rather, it was a revolution from within, one that was acted

out on the surface of his canvas. For Manet's paintings have the quality of a performance—the very quality, I think, that has led to the overemphasis on their formal properties. And at the center of that performance is the mutual possession of the artist and his subject, whether a celebrated whore or an anonymous barmaid at the Folies-Bergère. For these reasons, Manet is among the most startlingly generous painters imaginable. That such paintings are still capable of inducing an audible gasp a hundred years after the artist's death makes them more important now than ever before.

sylvia plimack mangold

October 13, 1992 In the mid-1960s, Sylvia Plimack Mangold began a group of paintings, drawings, and prints of a most peculiar specificity. Their simple subjects were wooden floorboards in light-filled rooms, frequently with a bit of white wall and baseboard in the upper register. Save for an occasional wood-framed mirror standing on the floor and leaning against the wall, these rooms are empty of furnishings—and of people, pets, plants, or any of the typical accoutrements of modern domestic environments. In their stripped-down simplicity they recall an American vernacular tradition of architecture. But the hardwood floors and white walls are also as specific to the postwar New York art world as colossal spaces were to seventeenth-century Rome: These are the spaces of artists' lofts and downtown art galleries.

That they are, in Mangold's art, totally emptied of objects is of considerable importance. Not created to hold chairs and tables, paintings and sculptures, they are instead spaces meant to be entered and occupied by the self-consciously perceiving eye. Mangold is a Realist, but what she describes in her work is the mysterious fact of perceptual understanding, which lies at the core of contemporary artistic inquiry.

"Sylvia Plimack Mangold: Works on Paper, 1968–1991" is a concise and absorbing show that, by concentrating on the New York-based artist's often compelling graphic work, lays out the highly focused trajectory of her career. Organized jointly by the University of Michigan Museum of Art and the Davison Art Center at Wesleyan University, the twenty-six prints and forty-three drawings are on view in a handsomely installed exhibition in the Grunwald Center for the Graphic Arts at UCLA's Wight Art Gallery.

Mangold's work on paper is sometimes executed as a preparatory study for a painting, and sometimes as a finished work in itself. For the show, the prints and drawings have been divided into five groups, which articulate the chronological sequence of sometimes overlapping subjects that have occupied her since the 1960s: floors and mirrors; floors and rulers; fields marked off by masking tape; landscapes

sylvia plimack mangold

near her house in Washingtonville, New York; and, finally, trees, typically silhouetted against a background of sky. Beginning with the rigorously ordered, Modernist geometry of hardwood or linoleum floors and ending with sinuous renderings of oak and locust branches might seem an odd path for an artist to take. But, as this show makes plain, all Mangold's art is geared toward probing and defining the nature of perceptual space. Try thinking of the unusual sequence of her investigations as sort of Mondrian-in-reverse.

Sylvia Plimack Mangold
Study for Ruler Reflection
1976

Mangold began her images of floors in 1965, and in 1972 she inserted her first mirror into the scheme. Mirrors are a device common to the history of art, from Velázquez and Titian to Lichtenstein and Smithson, and they perform a complex function in Mangold's art. Because they are reflective, the mirrors show the space that would have been behind the artist as she was drawing; and, because a mirror's reflection is, in fact, a flat illusion on a two-dimensional surface, it also mimics the flat illusion of space that Mangold has rendered in the drawing itself. So, simultaneously, the presence of the mirror expands and contracts the picture's space. It makes the drawing breathe.

It does something else, too—something disconcerting. A reflection of the artist, who would have been seated before the mirror as it leaned against the wall, is nowhere to be seen. Mangold has erased her own image from the space. In effect, to create the picture she has looked right through herself. As a spectator, you get to look into a mirror in a way you never could, except through the fiction of art. The odd sense of self-effacement and displacement that results is fundamental.

Sylvia Plimack was a student at Yale University's School of Art and Architecture from 1959 to 1961, a remarkable period when she counted among her peers Chuck Close, Rackstraw Downes, Eva Hesse, Brice Marden, Richard Serra, and Robert Mangold (whom she married). Her work, like theirs, was to become part of a larger effort

Last Chance for Eden

to dismantle the prominent essentialist myth that had congealed around Modernism, which said the expressive self is what was embodied in a work of art. When Mangold (or a spectator) looked into her mirror, she didn't see a representation of the essence of her being. Instead, she saw the defining context of existence. Rather like Dracula, who casts no reflection in a looking glass, the expressive self was dead.

This is the underpinning to all Mangold's subsequent work, which is explored with a keen logic and, on occasion, a wry wit. For example, when she began to include measuring devices in her rigorously controlled pictures, she chose ordinary rulers conspicuously printed with names like Westcott Flexible Stainless Steel; EXACT Level & Tool Mfg. Co., Inc.; and Non-Skid Flexible Dual-Rule. As with the mirrors, her rulers were deployed in pictorial space in ways that confound expected rules of linear measurement: An 18-inch ruler, drawn in perspective, could calibrate a distance equal to a 12-inch ruler; or, a pair of identical 24-inch rulers could seem to be uneven, depending on the perspective. Their "flexible," "exact," and "dual-rule" names are turned into resonant puns. The slyest joke of all is found in the reference to stainless steel. The word first cropped up in a 1974 drawing that shows two identical rulers abutted at right angles on a wooden floor, so that one appears to be shorter than the other. Its pointed title is *Flexible and Stainless*. In the vaunted abstract art of Helen Frankenthaler and Morris Louis—an art of liquid color soaked into raw canvas that came to be called stain-painting—Modernism's essentialist myth found its last-gasp champions. Mangold, using a pair of identical measuring devices whose placement in her picture made them seem to contradict each other utterly, transformed essentialist absolutes into visual hash. Her disconcerting image favored rulers that embraced flexibility—and that were emphatically stainless.

Without fanfare or spangles, the show at UCLA gives you just what you need for a full encounter with this challenging and often exquisite art. It's a model of tight editing and careful documentation, as befits an artist of Mangold's perceptually demanding temperament.

robert mapplethorpe

July 2, 1989 Are you now, or have you ever been, a member of the Robert Mapplethorpe fan club?

Today is the day the exhibition "Robert Mapplethorpe: The Perfect Moment" was to have opened at the Corcoran Gallery of Art in Washington, D.C. Its sudden cancellation just nineteen days before its commencement, by a museum happy to arrange its schedule in response to fear of government reprisals, sent out a shock wave more ghastly than any mere photograph could ever do.

Mapplethorpe, whose death last March at the age of forty-two tragically robbed us of an immensely gifted artist working at the peak of his abilities, was frequently the focus of divided criticism during his career. Within four years of his 1973 arrival on the art scene, his elegantly refined, sometimes sexually explicit images began to generate wide notice and comment. Both his champions and his detractors tended to be outspoken in their avowals or their denunciations. When it came to Mapplethorpe's art, rarely did anyone stake out a middle ground.

The tradition continues. When the cancellation of the show came, and the announcement was made that an artist-run space called Washington Project for the Arts had stepped in to host the show (it's set to open there on July 20), a friend expressed dismay that the issue of artistic freedom and First Amendment rights had come to rest on an artist whose work was merely "sensationalistic." He meant the adjective as a term of sharp derision, of course, and I responded in quick demurrer. However, the comment stuck in my mind, the way things with an unexpected resonance often do. The more the word kept rattling around my head, in fact, the more I was inclined to think my friend is right: Robert Mapplethorpe's photographs *are* sensationalistic. Where we part company is in my new-found conviction that their sensationalism is precisely the source of their greatness.

Stylistically, Mapplethorpe's photographs rely on a formal, stripped-down precision that elevates sensory pleasure to a high aesthetic plateau. Surface is exalted, both in the luxuriousness of his platinum and gelatin-silver printing techniques, and in his occasional juxtaposition of photographs with panels of fine linen or opulent silk. Surface, too, is a focal point of subject matter, especially in the lustrous play of light over human skin. Mapplethorpe's is an all-out embrace of the lyrical eloquence of sensory appeal.

Drawn toward what Susan Sontag once called the eros of photography, which identifies subject with surface, Mapplethorpe was hardly an innovator. Instead, he was upping a familiar artistic ante. After all, the principal fight in photography's quest for legitimacy at the beginning of the twentieth century had been waged on precisely this epicurean battleground. In 1904, the art critic Sadakichi Hartmann first condemned the elaborate but then-common darkroom manipulations that sought to make photographs mimic paintings. Calling on photographers "to work straight," Hartmann argued for the celebration of the medium's own inherent qualities. "Rely on your camera, on your eye, on your good taste and your knowledge of composition," he wrote, "consider every fluctuation of color, light and shade, study lines and values and space division, patiently wait until the scene or object of your pictured vision reveals itself in its supremist moment of beauty—in short, compose the picture which you intend to

take so well that the negative will be absolutely perfect and in need of no or but slight manipulation."

This refined, voluptuary approach describes the photographic art of Robert Mapplethorpe—not by accident is the exhibition in Washington titled "The Perfect Moment"—as it describes as well a long and much heralded tradition in American photography, whose celebrated practitioners include, among others, Paul Strand, Imogen Cunningham, and Edward Weston. Indeed, if there is a photographer to whom Mapplethorpe most clearly owes a formal debt, surely it is Weston. Mapplethorpe's floral studies, still lifes of shells, and abstracted close-ups of corpuscular nudes gesture across decades to Weston's, whose work of the 1920s, 1930s, and 1940s stands as a monumental achievement.

Where Weston and his critical champions regarded his photographs as essays in pure form, however, Mapplethorpe recognizes a specific cultural disposition. Here, in the realm of subject matter, his art establishes its own compelling importance, allowing the younger artist to escape the tired fate of being a mere follower of long established convention. For if Mapplethorpe's formal means call upon a vaunted, typically American tradition of sensory appeal, his subject matter invokes a more popular meaning of sensationalism.

The first cue comes in the abundant floral studies, which never examine nature in any natural setting. All of Mapplethorpe's flowers are cut off from a natural environment, captured in exquisite vases or isolated before blank, studio backgrounds. Bringing lush fragments of the natural world into the purview of the artist's studio, they deny that anything an artist represents can ever be described as wholly natural. Similarly, these typically gorgeous floral pictures invoke the citified aestheticism of the dandy, through the familiar symbol of the delicate cut flower. The symbol speaks of that moment when the innocent blossom is severed from its natural root, its ruin thus assured and its fleeting beauty therefore intensified.

While Mapplethorpe photographed a variety of subjects, he can be said to have concentrated on three principal motifs in his art, in addition to the flowers. This trinity is telling: The first is homosexual eroticism, with men frequently naked or in authoritarian garb (the singular dynamic of sadomasochism is featured in perhaps the most notorious of the artist's pictures). The second is African Americans, particularly black men, and particularly in relation to suggestions of enormous sexual prowess (whether singly or paired, sometimes with white women, Mapplethorpe's naked black men are invariably possessed of prodigious endowments). The third subject is women, especially as cloaked in the commanding mantle of strength and power (the pioneering female bodybuilder Lisa Lyon was the subject of a 1983 book called *Lady*).

Gay men, blacks, women—it isn't difficult to divine a commonality among Mapplethorpe's principal choice of subjects.

Robert Mapplethorpe

Unsurprisingly, he was at his best with subject matter closest to him, and at his weakest the farther he had to reach. His pictures of Lisa Lyon, for example, strike me as rather pedestrian fashion photographs. Of equal importance to the chosen subject, however, is the unequivocal emphasis of his compositions. Mapplethorpe doesn't underline the supposed "truth" of his depictions of these typically disenfranchised classes of people. They, like his flowers, are almost never photographed in natural settings. Instead, he repeatedly composes them according to the ways in which mainstream culture has projected its own debilitating fears onto them, like distorted slides on blank screens: in its leather and chains, the "terrible danger" of homosexuality; in its priapic grandeur, the "sexual threat" of the black man; in its makeup and musculature, the "treacherous power" of woman. The subject matter of Mapplethorpe's art is indeed frequently sensationalistic—which my Webster's defines as "arousing a quick, intense, and usually superficial interest or emotional reaction." However, it is hardly the artist who has made it so. The sensationalism in these pictures derives from the quick, intensely superficial fearfulness endemic to mainstream society, to which these motifs owe their form.

I don't think it's any accident that Mapplethorpe, who in the early 1970s came to use the camera only after a half-dozen years spent studying painting, followed the path he did. It's important to remember the social restiveness of the period and the new critical interest in reassessing Modernist conventions. Is it any wonder that Mapplethorpe, as a gay man who came to maturity in the years that gave birth to the modern gay rights movement, might have a rather different take on the conventional, Modernist aestheticism of Weston, Cunningham, and Strand—an aestheticism that is known, with newly retroactive irony, by the generic term "straight photography"?

Masterfully deploying its given techniques, which had long since become identified with the mainstream, Robert Mapplethorpe took straight photography to a hitherto unimagined place. He used its exquisitely refined devices to picture the darkest and most fearful imaginings of mainstream American society, imaginings about everything the straight world wasn't. Distinctly sensational photographs, Mapplethorpe's art is a profound and noble achievement: the sacred consecration of the socially profaned.

Allan McCollum

May 26, 1989 Allan McCollum's simultaneous inclusion in "A Forest of Signs: Art in the Crisis of Representation," the sprawlingly enlightening exhibition of thirty artists currently at the Museum of Contemporary Art, as well as in a small solo show lately opened at

Richard Kuhlenschmidt Gallery, has conspired to suggest something hitherto invisible to me in his recent work: The sculpture turns on a finely honed edge of militaristic insinuation.

At the gallery, McCollum shows six of the "Perfect Vehicle" sculptures he's been making for several seasons: bulky, reinforced concrete forms that are reminiscent of ginger jars. These are the largest versions I've seen; suddenly, at 6 ½ feet tall, they wobble in the mind as helmeted, anthropomorphic sentinels. The sculptures are all identical, save for the decorator paint jobs (salmon, lavender, pink, etc.). The faceted, ginger-jar form also results in a view that remains exactly the same as you walk around each piece. They have no distinguishable fronts or backs or sides. Because the lid and body of the jar are made from a single piece, there's no way to know whether they're solid or hollow, either. Mysteriously silent, these jars wait to be filled with thought. Here is what I fill them with: In their highly regimented, chilled perfection the sculptures seem strict, absolutist, even totalitarian in bearing. Under the designer exteriors—a kind of decorator camouflage—these instrumental vehicles have all the cuddly charm of a tank.

At MoCA, McCollum shows some 10,000 "Individual Works," a long table top covered by a layer of widgetlike objects, each just 2 inches by 5 inches. Cast from plaster and enameled, and vaguely like machine parts, no two are alike. At least, I think no two are alike. You scan the hundreds of rows comparing one to another, but the generic similarities and often subtle differences among the 10,000 utterly defeat the task. Perhaps in this sea of seemingly machined objects you could actually find two identical widgets—and, come to think of it, how can you be sure there really are 10,000? You have no choice but to take it on faith. McCollum's passive-aggressive sculpture is downright diabolical. Being "defeated" by a sculpture is an exceedingly odd experience, especially when you realize that these nonfigurative objects look like nothing so much as first cousins to a hand grenade.

John M. Miller

December 14, 1986 Since the early 1970s, John M. Miller has been making paintings of uncommon rigorousness and exceptional beauty. As with many Minimalist painters, he's the kind of artist who establishes what would appear to be an impossibly severe and restrictive set of moves on the canvas and who then proceeds to open them up into a remarkably inclusive array of possibilities.

Miller's current exhibition at New City Gallery is his first solo show in L.A. in more than six years (in the interim he's shown elsewhere, including a one-man exhibition at the Walker Art Center in Minneapolis). His relative absence from the galleries is not surprising,

John M. Miller
Untitled #41
1986

because Minimalist painting has suffered a fate not unlike that of International Style architecture: By the late 1970s, it had become an all-purpose whipping boy, an easy mark for simple dismissal as boring, repetitive, anti-humanist, not "new." The twin juggernauts of Postmodern architecture and Neoexpressionist painting needed royalty to overthrow in order to capture the throne, and took their venerable icons where they found them.

In the process, the often extraordinary buildings of such architects as Mies van der Rohe tended to be swept into the critical dustbin along with the horrible (and infinitely more commonplace) boxes of steel and glass built by third-rate architects, who conceived of the International Style as a mere "look" that could be cheaply reproduced. In painting, something slightly different happened. Those artists who had established secure positions in the first wave of Minimalism—Ellsworth Kelly, Agnes Martin, Brice Marden, Robert Ryman, and certain others—weren't trampled down, they were elevated to the status of Old Master. (Unlike architecture, paintings don't get tossed into the critical trash heap so easily: With marketable commodities, there are investments to protect.) Those artists mining the rich vein opened by Minimalism but not yet securely established in the pantheon were pushed aside. All of which is to say that Miller's paintings have been underground a while, enjoying (or suffering through?) a kind of cultish affection while the spotlight has been trained elsewhere. It is not to say that they've lost any of their mind-bending brilliance.

Miller's paintings are all surface. Rectangular bars of color, tilted on the diagonal, march across the raw canvas in a strict grid pattern. The pattern forms a perceptual "weave" that reaffirms the physical weave of the canvas itself, while simultaneously offering a counterpoint: The canvas weave is horizontal and vertical, the perceptual weave is diagonal. In an odd way, however, the structure of the pattern formed by the bars (and by the unpainted canvas around them) is also radial, seeming to branch out in all directions, like rays of light. (This "radial

Last Chance for Eden

grid" results in a peculiar perceptual experience that can best be described as circling a square.) Still, there is no single, unitary center to be found in this all-over, radial expansion. The implied center is everywhere and nowhere.

Miller's reliance on excruciatingly precise calibrations of scale, shape, edge, and contour represents a straining toward the utmost literalism achievable in painting. To this extremely rational program he adds an equally emphatic emphasis on painting's most irrational element—namely, color. The bars that parade across his canvases appear, at first glance, to be black. Slowly, they reveal themselves to be, in one instance, a dense, dark red, or in another, an equally dense blue. The radial composition of these pictures is indeed like expansive rays of light, and that radiant light is chromatic.

Miller's paintings owe much to the Los Angeles variant of Minimalism that rose to prominence in the late 1960s and early 1970s, and that has acquired the unwieldy moniker of Light and Space art. The perceptual phenomena explored by such artists as James Turrell, Robert Irwin, and Larry Bell constitute the immediate ancestors of Miller's paintings. By draining all remnants of artistic subjectivity from the work of art, they sought to put the spectator's act of perception at the center of the enterprise. Their work was (and is) sculptural and environmental in nature, establishing and revealing the contexts in which perception occurs.

For a painter restricted to a two-dimensional field, though, the property of "real space" in which the perceptual act occurs is obviously problematic. Miller deals with it by cranking up the literal, surface properties of his art to the nth degree. In the process, he complicates the seemingly simple elements of scale, edge, contour, shape, color, and composition to such an extent that he pushes something else into the perceptual foreground: time. Miller's deceptively simple paintings demand long, slow concentration; without it, they're literally impossible to see.

A cursory glance at Miller's paintings yields a dizzying, eye-gouging array of optical shifts and shimmies that we associate with Op art. (For this reason, his work has often been foolishly regarded as an out-of-sync variant of Op.) Yet, at a certain point in time, what appears to be visual chaos turns over into stunning perceptual clarity. Everything in his paintings clicks into perceptual place and begins to hum. Suddenly you begin to watch yourself watching, to see yourself seeing. The spectator's perception gets emphatically framed—which is, ironically, about as literal a description of painting as could be imagined.

John M. Miller

Elizabeth Murray

August 16, 1987 A decade ago, Elizabeth Murray grabbed
hold of a number of dangling artistic threads that, although concur-
rent in an art world suddenly fragmented and becalmed, seemed wholly
incompatible with one another. The bright, flashy, cartoonish quality
of Pop art was one thread. The material rigor of Minimalist abstrac-
tion was another. And painting on canvas itself, which was widely con-
sidered a moribund and hopelessly old-fashioned medium in a world of
space travel and electronics, was still another. Tentatively at first, but with
steadily increasing skill and complexity, Murray began to weave these
threads together in her art. Yet, as is made plain by the two dozen
paintings and sixteen drawings in the midcareer survey that opened
recently at the Museum of Contemporary Art, Murray didn't end up
with a seamless piece of whole cloth when she was through. Instead,
those various threads came together in her work to form a kind of
cat's cradle—one that is forever metamorphosing, playfully rearrang-
ing itself, occasionally tying itself in knots and always ready to engage
the spectator in another twist in the pattern.

Organized jointly by the Dallas Museum of Art and the
List Visual Arts Center at MIT, "Elizabeth Murray: Paintings and Drawings,
1976–1986" convincingly establishes the artist as one of the finest painters
of her generation. Richly populated with imagery that is never wholly
abstract yet never quite figurative, her often eccentrically shaped can-
vases speak with a compellingly quirky voice.

Murray, who was born in Chicago in 1940, was still an
art student when the brash glamour of Pop, followed by the stripped-
down rigor of Minimalism, came to center stage in 1962 and 1964, re-
spectively. Those were precisely the years she received her B.F.A., from
the Art Institute of Chicago, and her M.F.A., from Mills College in Oakland.
At a young artist's point of entry into serious work, it's common for
the new art of the moment to form the substructure of whatever will
follow. For Murray, as for certain others of her generation, the twin phe-
nomena of Pop and Minimalism were to form a dual platform on which
she subsequently was to build her own idiosyncratic art.

You won't find consumer brands or movie stars in her
paintings, because it's not the specific repertoire of Murray's images that
is Pop in nature. The present exhibition doesn't include work from
her formative years (roughly from 1964 to 1975), but the generally ex-
cellent catalog that accompanies it shows her painting a series of iconic,
star-studded pictures of the Empire State Building shortly after her 1967
arrival in New York. She had chosen a subject beloved by tourists and
had framed it with cartoonlike pictures of the jungle. Even in repro-
duction, the Empire State Building picture looks like the work of a
provincial artist, but it is revealing. Newly arrived in Manhattan, Murray

felt like a tourist in the urban jungle, so that is what (and how) she painted. Throughout her career, a level of ordinariness and attention to the everyday has marked her subject matter, while she's long painted in a bright, broad, often high-keyed palette. As with the work of Claes Oldenburg and certain others, the Pop aspect of Murray's subject matter centers on emphatically domestic objects. The kitchen table, the coffee cup, the family dog—these signs of domesticity are everywhere to be seen in Murray's art. Significantly, they merge in her paintings with signs of the artist's studio—paintbrushes, palette, and even the artist's hand are equally commonplace images. (The overlay might well be traced to her involvement with feminism in the late 1960s and early 1970s.) Begun at a moment when faith in the radical possibility of abstract painting had disappeared, even her emphasis on abstraction seems well-worn.

Elizabeth Murray
Sail Baby
1983

In addition to the range of subject matter, the Pop aspect of Murray's style is found in its cartoonishness. One can rightly cite all manner of educated references to Cézanne and Cubism and Surrealism in these paintings, but more often than not it's the overexcited rambunctiousness of the common cartoon that swamps the art-historical homages. Popeye, as much as Picasso, is her hero. Often it's the eccentric shape of Murray's canvas that seems cartoonlike. The bulbous, swelling shapes of all three interlocking canvases in *Sail Baby*, for instance, look like comic strip thought-balloons; the shape repeats and gets larger from left to right, suggesting some sort of odd narrative about the big, yellow coffee cup that is the central image. The bright blue interior of the cup is painted in such a way that it appears to be a solid, not a liquid or a void, and it seems to swell toward the left; at the bottom, a similar shape in glowing purple (a saucer?) does the same, except it pulls visually toward the right. An undulating ribbon of vivid green wraps all the way around the picture, visually holding together the splintered painting while looking for all the world like a cartoonist's rendering of an aroma.

Both in form and in image, Murray's paintings are like gi-

ant jigsaw puzzles whose crazily shaped pieces want very much to merge seamlessly together, yet they never quite fit. Simultaneously explosive and implosive, they seem caught in a tense and prickly moment of possible transformation or appeasement. Even the images are poised between total abstraction and descriptive representation; with one foot in each camp, the image could go either way. That sense of possibility gives Murray's best paintings their resonance: You feel that, with enough careful attention and mindful nudging, everything may suddenly click into harmonious place. This fundamental structural sense derives from Minimalism, and it provides the rock-solid underpinning for all of Murray's art.

Yet Murray's paintings are exceedingly high-strung, too (her coffee-cup imagery has a caffeine jolt). What a normally cold, emotionally temperate Minimalist structure can't accommodate is that frantic sense that inflects every aspect of her domestic realm. For that, cartoonishness is essential. The cartoon is the great modern medium for conveying the madness of the everyday. Before the modern era, the term "cartoon" described an artist's full-size preparatory study for a painting, a fresco, or a tapestry; in other words, cartoons were meant to be coarse and unrefined pictorial utterances. Indeed, the absence of polish and civilized demeanor in cartoons is what has made them a perfect vehicle for worldly social and political commentary: Cartoons assault accepted form. There's a playful, antsy quality to Murray's assaults. She wants to overturn the numbing restrictiveness of her domestic subjects, but she's not after some utopian dream that would require wiping the slate clean and starting fresh. Instead, she lets things take their own course while she simultaneously strains hard to keep it all together.

Murray is juggling a lot of elements here, and the delicate balance sometimes goes way out of whack. A number of paintings, especially from 1985, push the eccentricity of her shaped canvases into hypermannerism. They seem arbitrary and forced. More often than not, though, she gets just the right pitch. The installation of Murray's paintings and drawings at MoCA is just right, too. There's not a single right-angle to any of the gallery rooms at the Temporary Contemporary, and the subtly skewed walls turn out to be perfect vehicles for Murray's similarly skewed art. This is a happy case of an installation design helping to articulate the nature of the art it presents. For Elizabeth Murray's paintings are steadfast in their determination to follow an ambiguous and relentlessly oblique course.

Alice Neel

April 5, 1983 Alice Neel's best paintings are triumphant images. Her subject matter is perfectly ordinary—family and friends, the recurrent theme of mother and child, even a Thanksgiving turkey sit-

ting in a sink—but her paintings are anything but ordinary. Indeed, the power of her work resides in its very refusal to provide a refuge from the real world. Neel looks and she looks hard. Most important, when she sees the world around her, rarely does she blink.

Alice Neel
Nancy
1981

 "Alice Neel: Paintings, 1933–1982" is a long overdue exhibition, on view at the art gallery of Loyola Marymount University. We've had rare opportunity to see the New Yorker's paintings in the past—once in the Los Angeles County Museum of Art's pioneering show "Women Artists, 1550–1950," in 1977, and again in the Newport Harbor Art Museum's survey of recent portraiture, "Inside Out: Self Beyond Likeness," in 1981—so the current undertaking offers welcome redress. Organized by the gallery's director, Ellen Ekedal, this survey of thirty-five paintings focuses on the work of the past two decades—mostly portraits, with an occasional still life or landscape—with just one picture from the 1930s and only three from the 1950s. The earliest is *Snow on Cornelia Street*, from 1933, a small and decidedly conventional landscape of an urban alley in which everything is flattened into a jigsaw puzzle of muted color-shapes.

 This is an essentially conservative picture in which Neel demonstrates an assured grasp of the basic constituents of traditional easel painting. Its inclusion here is useful, however, since it gives us something of an inkling as to why her paintings from the 1960s to the present day are of a different breed than her early work. She has always been attentive to the nature of traditional easel painting (elements of Arthur Dove, Milton Avery, and Edward Hopper, among others, are not uncommon in her early work), and her paintings exhibit a distinct facility with the conventions of Modernist pictorial form. But with increasing regularity (beginning in this exhibition with a haunting 1962 portrait

of David Rosenberg, brother of the critic Harold Rosenberg), Neel uses tradition and convention as a means to an end quite unlike anything that has come before.

For instance, in a 1981 portrait of her daughter Nancy, the woman is seated on the edge of a captain's chair that has been placed near the corner of a room. Everything about this picture is poised, self-assured, and intricately orchestrated, yet it exudes a sense of unrelieved tension. The plane of the floor tilts upward into a vertiginous precipice. The corner where the walls would ordinarily meet has vanished altogether into empty space, while the angle of the juncture between the floor and the wall at the right would, if followed to its logical, perspectival conclusion, collide impossibly with the middle of the rear wall. And the chair on which Nancy sits is animate, its parts a serpentine series of undulations, its rails and the shadows they cast a series of chromatic vibrations. As in much of her work from the past twenty years, Neel here employs a vivid blue line to trace the contours of various body parts: a leg, the chin, knotted fingers, the bridge of the nose. She even goes so far as to distance the blue line about an inch away from Nancy's left arm, as if it were an aura with a will of its own. The device is like an electric current that charges the sitter.

In her most compelling works, the world Neel depicts is off-balance and about to be upset: There is no such thing as terra firma. And the people that populate her discordant, heaving world are squarely at its center, seemingly the focus of its torque. There is such confidence to the complex orchestration of these paintings, however, such straightforward, wide-open mastery at the heart of her convulsive worlds, that one cannot help but feel that this is what these paintings really are about—an eyeball-to-eyeball confrontation with whatever situation presents itself on the horizon. Neel's are paintings of intense moral honesty. According to the catalog which accompanies the show, the artist dislikes the term "portrait" when applied to her work, as well she might. She is up to something more important here than mere physiognomic likeness or trivial psychological reportage. In the strongest works in this show—pictures like *Nancy and Olivia*, *Ian and Mary*, *Hartley* (her son), *Geoffrey Hendricks and Brian*, and even the Thanksgiving turkey— Neel is making paintings of a difficult but triumphant way of living.

The catalog, alas, is the weakest link in the exhibition. Its author, art historian Ann Sutherland Harris, asked in a 1977 article in *ARTnews* magazine, "What is the finest portraitist that America has produced since 1900 doing in a run-down apartment building on the Upper West Side [of New York City] surrounded by her own masterpieces? Why are people afraid of these bold images of humanity, bereft of flattery but brimming with life?" Harris had chosen Neel as her candidate for the most underrated artist of the twentieth century. Now, six years later, she has attempted to answer her own questions in the current show's catalog.

My resistance to this approach is no doubt aggravated by the feeling that Harris has come to the wrong city to complain about the New York art establishment's indifference to a talented artist—the line of Los Angeles candidates is long—but it goes deeper than that. Harris identifies a constellation of social factors that she feels has contributed to the slow acceptance of Neel's work (not the least of them is the difficulty that women artists still face in our culture); but her own essay, I think, provides the best example. While she begins by observing that "too much attention [has been] paid to her as a personality and too little to a serious analysis of her work," what we get as the biographical essay unfolds is attention not only to Neel as a personality, but to her *paintings* as personalities. It is a matter of opinion whether or not, as Harris claims, "There is no one painting anything that can be described as a portrait today who can rival her ability not only to capture an unmistakable likeness but to invest it with an inner life." To me, however, Neel's art seems involved with weightier things than this.

Likeness and investiture with inner life—like the very conventions of Modernist pictorial form and the traditions of easel painting that Neel has so long employed—are simply the means the artist uses, rather than ends in themselves. Indeed, I would suggest that it is her involvement with traditions and conventions that has held back the broader acceptance she so clearly deserves. For Neel's development as an artist coincides with a period in which formal invention, as an end in itself, was held in high critical esteem. And it seems less than accidental that interest in her art did not begin to flower until the 1970s, a decade in which the primacy of formal issues as a value began to be attacked on every front. However well-intended or unwitting, Harris winds up in a dead-end argument based on a cult of personality. But mythologizing the artist does a disservice to an art that springs from Neel's own refusal to mythologize her sitters—particularly when that clear-eyed refusal is what generates a good deal of these paintings' claim on our attention.

David Park

March 19, 1989 David Park is a classic case. The first major Modernist painter to emerge in California, one whose finest work can hold its own with all but a few artists of his generation, Park is nonetheless more vague legend than vivid reality. He suffers the mixed blessing of being known principally as "Richard Diebenkorn's teacher," an honorific that backhandedly manages to transform his greatest paintings into a pedestal for someone else's. Indeed, Park's own work is rarely seen, never mind considered in more than stereotypical terms. And the stereotype, as usual, says less about the artist than about the desires

of those who mouth it.

In 1949, so the well-worn story goes, a disgruntled David Park destroyed the purely abstract paintings he had been making in the previous few years and suddenly returned to painting the human figure. Abandoning "alien" abstraction, which at mid-century represented the most avant of avant-garde practice, Park courageously went back to nature—his own, as well as that which is so abundant in California. Thus was planted a heroic seed, the tale continues, that grew into the first regional school of painting sturdy enough to hold its own against Abstract Expressionism in New York, the newly dominant capital of art. David Park is the father of Bay Area figurative painting, Elmer Bischoff the son, and Diebenkorn the holy ghost.

David Park
Rowboat
1958

Given the commonness of such loaded assertions about an artist who is nonetheless of decisive importance, it was with hopes high but fingers crossed that I approached "David Park," an exhibition just opened at the Laguna Art Museum. The show was organized by Richard Armstrong, a longstanding devotee of Park's work and associate curator at the Whitney Museum of American Art, where it had its debut last fall. At the end of a decade that has seen figurative painting return to prominence, and with current interest in art from California running high, the moment for an insightful reassessment of Park's work seemed right. The exhibition that resulted turns out to be a mixed success. The weak link is the catalog. Armstrong has contributed an essay that lays out Park's biography in more abundant detail than we've had before. It's also blessedly down-to-earth, avoiding hagiography and declining to trumpet presumed moral virtues in Park's supposed abandonment of "corrupt" abstraction in favor of divine figuration (as had been implied in the vainglorious "David Park: Unyielding Humanist," a 1977 retrospective at the Newport Harbor Art Museum). But the book falls far short. Virtually no attempt is made to place Park's mature work within the conflicting currents of artistic practice in the 1950s, or to decipher more than casual significance. Only half the catalog's job got done.

The show's strongest link, of course, is the art. The Laguna Art Museum was a last-minute addition to the show's limited tour—the Oakland Museum is the next and only other venue—and we can be thankful for their recognition of the importance of bringing the show to Southern California. They've performed a service no museum in L.A. was willing to take on. As a happy bonus, the galleries of the Laguna museum have never looked so good.

The fifty-eight paintings and twenty drawings and watercolors selected for the show date from 1950 to 1960, the period of Park's only historically significant work. The span reaches from Park's decision to paint the figure again, after his foray into complete abstraction, to the year of his untimely death from cancer at the age of forty-nine. The curatorial verdict to display only paintings from the 1950s is appropriate, for the show means finally to establish the importance of Park's artistic contribution, which is limited to that decade. What came before was preparation, crucial for the historian to know in understanding what the artist was subsequently to accomplish, but not worth major display until Park's larger reputation is fully secured. (Such are the difficulties of coming to terms with an artist who never worked in New York that, nearly thirty years after his death, Park's reputation is still in doubt.) Park had painted diligently and with some success for almost twenty years prior to the decade of his principal achievement. Born in Boston in 1911, he studied briefly in Los Angeles before settling in San Francisco. There he worked for sculptor Ralph Stackpole on a commission for monumental sculptures at the Pacific Stock Exchange, and met Diego Rivera, who was painting murals inside. Everything from Social Realism to Cubism to newly emerging Abstract Expressionism found haven in Park's erratic painting of the 1930s and 1940s, with but two recurrent themes running through all his diverse work: a general dissatisfaction with whatever he was doing, evident in his frequent changes of course; and a marked affinity for subjects drawn from classical mythology, to which he regularly returned.

The show opens with two small but provocative rooms of paintings and drawings from the early 1950s, in which Park was clearly feeling his way, slowly orchestrating the broad range of instruments now in his repertoire. Suddenly, in the two main galleries, the show comes to a crescendo. Indeed, fully half the paintings and most all the drawings in the exhibition date from 1957 to 1960, the brief but intensely productive years in which Park did his most important work. The show thus offers something of a jolt. The effect is like watching someone inventively playing around, then suddenly getting a bright idea and taking off with it.

The power of Park's pictorial conception in the late paintings is stunning. Its genesis is found in the earlier canvases, where the point of view is that of momentary glimpses on the passing scene, which have been paradoxically nailed down and monumentalized. Pressed up

David Park

close, as if you are part of the crowd or group that is depicted, you peer over the shoulder of a man in a cocktail lounge, take your place at the piano in a jazz band, or look through the crowd at a bus stop to the distant street beyond. Park sets up a sudden disjunction between foreground object and deep space, which abut each other side by side. In the late paintings of bathers and boaters, this pictorial device gets turned to elaborate and knowing ends.

In each of the late paintings, Park establishes a focal point at the pictorial center of the canvas. Often it's a geometric shape, made with a wide slather of brushy color derived from Abstract Expressionist facture. Always the mark describes an exact place of disjunction, the boundary where surface and space, object and absence collide and separate. This central fusion of object and space with the painterly mark of the brush becomes the structural principle for the entire picture. It gets repeated throughout the painting, like a theme and variations. In a remarkable way, independent and seemingly contradictory aspects of painting are brought into perfect accord, while vigorously maintaining their own identity. Boundaries dissolve. It's no wonder that Park's singular subject matter in all these late paintings is the myth of the Golden Age. Traditionally, bathers and boaters have represented the classical fable of a lost world of peace and harmony. No less than in the bathers of Cézanne and Matisse, Park meant to set the dream within a wholly modern syntax.

Park's specific choice of subject matter, in this exhibition as elsewhere, is almost never discussed. Yet, hardly incidental, subject matter was basic to his art. From his first serious attempts at painting in the 1930s, almost all of Park's classicized pictures were adaptations of traditional Golden Age motifs, albeit rendered in the folksy Realist style of American scene painting. Indeed, Park's interest in mythology was lifelong. At the age of twelve, he had made a crude picture of Persephone, the daughter of Zeus and Demeter, who was abducted by Hades and made his underworld queen. Fittingly, the final painting in the present show is a monumental, 1959 nude titled *Daphne*. The figure of the nymph—who was transformed into a laurel tree to escape the pursuing Apollo, god of sunlight, music, and poetry—here metamorphoses before your eyes into a dramatic space filled with jarringly sensuous slashes of color.

Park's moment was certainly brief, as this exhibition makes plain. Yet, to wax poetic over what might have been, had he not died so awfully young, is to blunt the point. For one who was capable of paintings such as *Bather with Knee Up*, *Four Men*, *Rowboat*, *Daphne*, and several others needs no purported help from sentimental gloss. It's enough to know that, as an artist, David Park is a classic case.

Ellen Phelan

October 20, 1989 The fragile reticence of Ellen Phelan's new paintings is a key to their attractiveness and success. Very slow to reveal themselves, these are paintings whose audible silences must be listened to before they will begin to speak.

The half-dozen canvases at AsherFaure Gallery, which date from 1989, depict atmospheric landscapes of low meadows and quiet, riverside copses. At least, they seem to depict landscapes when first you look at them. Soon, the tranquil fields, trees, and darkening clouds begin to dismantle themselves into carefully considered, painterly components. Landscape shimmers like a mirage, then dissolves into full abstraction. The paint, which is thinned and transparent, has been applied in fluid swipes and washes. Elsewhere, stippled marks suggest a sponge might also have been used. Working in oil on linen, Phelan restricts her palette to a pale range of grays and greens, and to tamped-down lilacs and blues. In this soft company, where tonal quality is all, patches of white can seem like a radiant, internal light. Deep layers of delicate color and forthright brushwork conspire to compose the images.

Ellen Phelan
Meadow Hampshire–Storm: Dark, Low Clouds
1989

The palpable space these paintings create seems to me a function of the time essential to your perception of them. As you look, the "landscape" literally unfolds itself. A process of erasure, it leaves behind elusive tracks and traces while building a sense of voluptuous anticipation. Whether intimate, as in the small *Trees at Water's Edge–River Test*, or expansive, as in the large *Meadow Hampshire–Storm: Dark, Low Clouds*, what you see seems perpetually in between. Although the artist's chosen titles claim the specificity of on-site notations, there's no way to know from the paintings if the landscapes do in fact describe verifiable locations. It doesn't matter. The poignant experience of nature's sensuous abstraction could hardly be more actual.

Lari Pittman I

December 8, 1985 Lari Pittman's new paintings signal the arrival of a mature and compelling artistic voice. His current exhibition at the Rosamund Felsen Gallery—his third solo show in as many years—represents not only an important leap in his development, but the retrieval and reinvigoration of a long-dormant artistic tradition. If radicality can be described as the discovery of the new in the old, Pittman's troublesomely beautiful new paintings are radical indeed.

The arena of decoration might seem an unlikely source from which such an observation could arise, but it is precisely the tensions between frivolity and seriousness in that genre that give Pittman's paintings their destabilizing spin. In the past several years, he has developed an idiosyncratic vocabulary of forms based on decorative motifs. His earlier work incorporated two-dimensional elements of collage, such as sheets of wallpaper and gold leaf, as well as three-dimensional objects attached to the surface of the painting—ornamentally carved picture frames, or even small shelves topped with knickknacks. Painting, dribbling, and making marks with both thin acrylics and goopy oils, Pittman tied the pictures together with an array of oddly evocative forms. They looked like ornamental pictograms filtered through Miró or Arp and caught between protoplasmic birth and rotting decay.

Collage and assemblage have disappeared in the new paintings, and they're stronger for it. Obvious decoration has been subsumed into painting itself. His earlier work suggested an equivalence between art and ornament, but the new paintings embody it fully. The result is an art that acknowledges painting's inherent decorativeness, while retaining Pittman's particular brand of conflict between growth and decay.

The twin functions of decoration are brought to the foreground, too. Pittman's work has always conjured ornamental motifs of the 1950s and early 1960s (the period of his childhood). These motifs have their primary source in the biomorphic Surrealism of the preceding decades: simultaneously sensuous and repulsive teardrop shapes, "primitive" talismans and spiny, amoebic forms. Watery cityscapes vacillate between romantically inflected memory-images and scenes of postapocalyptic destruction. (Stylistically, they're reminiscent of the kind of cheap, lit-from-behind landscapes of Venice you'd find in a cheesy restaurant.) Some are festooned with a garland of ribbonlike intestines, others float inside a paisley blob. Reconstructed stereotypes and clichés of their era, these ornamental concatenations are period pieces flavored with renewal. A cliché is a form of expression or meaning that has been frozen in place; devoid of life, it's a meaning whose truth or falsehood is secondary to the fact that it has died. Indeed, death and mortality are the stuff of Pittman's decorative iconography. And because these new paintings embody, rather than merely allude to, the decorative re-

ality of art, painting's capacity for expressive meaning is likewise revealed as having succumbed.

Pittman's paintings are corpses. (Given their Miróesque ancestry, these luxurious works are a wry twist on the Surrealist artists' stereotypical device for making images from the unconscious: the "exquisite corpse.") The invocation of the dead body of art opens up the second function of decoration, and it is this latter (and largely forgotten) purpose that the artist reinvigorates. Decoration isn't simply ornament; it's commemoration, too. To decorate is to bestow a token of honor, and Pittman's art places a painterly wreath at the grave of some of our most fundamental pieties.

Plymouth Rock, Colonial Power, Thanksgiving, The New Republic—the titles of these paintings are unambiguous. The social, political, and cultural values that form the foundation on which our lives rest are themselves largely ornamental. Cast in Pittman's nostalgic evocations of the stereotypical and the cliché, they decorate our collective ego. Scrawled across a painting called *The Veneer of Order* is the commemorative legend: "Nov. 19, 1985—Ten score and nine years ago our fathers brought forth on this continent a new nation conceived in Liberty, and dedicated to the proposition that all men are created Equal." You can recite it in your sleep. You want to believe it. You can't.

Secondary to the condition of being dead, truth or falsehood is banished from Pittman's art. As is flatly declared by a group of six painted gourds bearing the folkloric legends of *Faith, Hope, Charity, Kindness, Forgiveness,* and *Compassion,* his work functions instead as a memento mori. It poignantly but straightforwardly addresses mortality in an unembarrassed way. Carefully calibrated in its merger of value and sentiment, its intimacy is at once startling, endearing, witty, and luxuriously provocative. Behind the ornamentally decorative veneer of Pittman's work beats an honorifically decorative heart. At once cheerfully trivial and decidedly profound, his is an intensely moral art that is not the least bit moralistic.

Lari Pittman II

October 1992 Of all the stultifying prohibitions established by the postwar ascendance of American painting, none has been so bullheaded and tenacious as the prohibition against decoration. Since its modern banishment, the idea that decorativeness in painting is OK has barely penetrated the surface of artistic consciousness. A variety of assaults have been made against the prohibition in the past twenty-five years, most obviously Pattern and Decoration art, but only lately have the stakes been raised to precipitous heights. Call it the last great taboo.

Today, Lari Pittman is the most important American

painter of his generation to refuse the interdiction. Since 1982, in sequential series of brash and exuberant paintings typically made on mahogany panels, he has used decoration as the foundation for a provocative, increasingly elaborate, and finally poignant body of work. Pittman's most recent series, collectively titled "A Decorated Chronology of Insistence and Resignation," is indicative of the dizzying level of fluency and complication with which he now works. A compendium of the wildly proliferating images of this series, which are interwoven with a vivid, colorful profusion of abstract shapes and eccentrically patterned markings, would include the following: weeping willow trees, long-nosed puppets, madly buzzing bees, light bulbs (which, for current still life, are the equivalent of the candle), bomblike rocket ships, rope nooses (sometimes twined with pearls) dangling from inflamed sphincters, graceful piles of shit embellished with stylized acanthus leaves or festooned with jewels, underwear-clad silhouettes of muscular men, remnants of obscure scientific and mechanical devices, and more. Much more.

The centerpiece of the new series is an imposing polyptych 8 feet high and 22 feet long. When read from left to right, its four panels loosely convey a narrative of sex, death, and redemption, each punctuated with an insistent protest-rally sign. The first placard is a blunt appeal for the spectator's attention; it shouts: "HEY!" The second is more cryptic (do its gaily embellished letters "F.Y." mean "fuck you"?). The third and fourth—"S.O.S." and "R.I.P."—call for help (the international distress code, Save Our Ship) and then publicly mourn (Rest In Peace). The picture's inventive exuberance and lush ornamentation keep the imagery from being morbid. Like the flood of masked celebrants and leering grotesques in James Ensor's hallucinatory masterpiece *The Entry of Christ into Brussels in 1889*, the marching puppets of Pittman's "A Decorated Chronology of Insistence and Resignation" convey a determined, even spooky reverie in the face of chaos and decay.

As always, Pittman draws on established decorative traditions in assembling his complex composition. Gracefully stylized weeping willow trees, to cite one prominent new example from his expanding repertoire, were a familiar motif in colonial America to designate the sorrows of mortality. They proliferated on carved tombstones and, especially, on embroidered samplers. Samplers were rectangular pieces of cloth decoratively stitched by young schoolgirls in pre- and post-Revolutionary communities. Often embellished with homilies of Christian virtue, they were an eighteenth-century device for teaching needlework skills to daughters of the aristocratic and merchant classes. They were not regarded a major art—even in colonial America, a time and place when painting was in woefully short supply.

For Pittman's practice the appeal of a motif drawn from this all-American decorative tradition will be found precisely in the cultural marginality of samplers—in their status as "low" art of a "merely"

educative sort that only showcases "girlish" skills. For, today, a notable parallel could be drawn: At a Postmodern moment when sculpture, installation, camera-based, and Conceptual art clearly dominate, painting is the woeful art whose marginality is now most keenly felt. In Pittman's polyptych, the image of insistent mortality and resistance to its horror does not just signify the mortification of living flesh. It also concerns the condition of painting as a sickly, failing vehicle. Painting is cast as the artist's wooden puppet, a lifelike surrogate for the human figure, indignantly shouting, "Hey!"

Like Pinocchio, painting is a distinctly long-nosed medium because it lies. Pittman regards painterly deception not as a moral failing but as a simple fact—one that an artist can productively use if he recognizes, at the start, that painting is a world of honest artifice. Decoration is therefore as frankly unavoidable as representation has been shown to be. For what is painting if not, first and foremost, the embellishment of a surface, its ornamentation with colors, marks, and images? Because the decorative reality of painting has been so long and resolutely repressed, it percolates as an arena of enormous, untapped power. Pittman ignites its latent volatility. In the history of art, conjunctions of sex and death are not uncommon, but in the age of AIDS a specific edge frames the narrative. Pittman's commemorative paintings comprise an exuberantly homosexual polemic, in which the artistic prohibition against decoration is acknowledged to be inescapably political.

The ornamental web that is woven through Pittman's Decorated Chronology of Insistence and Resignation declares out loud that the traditional identification of decorativeness with effeminacy—either as "mere" women's work or as the "insignificant" province of gay men—forms the genesis of the modern taboo against its legitimacy for serious art. Significantly, though, Pittman does not deny the cliché. Instead he luxuriates in it. He even goes so far as to decorate piles of shit and to knit pearls through the strands of the hangman's noose. Why? Because he recognizes an important truth: In a culture that represses homosexuality, vigorously straining to keep it from official sanction or public view, the formation of gay consciousness requires an extraordinary act of imagination. One doesn't just seek to find one's place in the scheme of things. Instead, one must literally invent a world, embellishing the mundane in order to fabricate a dwelling in which one can finally exist. In the raucous exuberance of his lavish paintings, Pittman's unprecedented achievement has been to revel in an enterprise commonly scorned—and to illuminate the quiet nobility of the deed.

Jacopo Pontormo

MAY 28, 1989 The great, early-sixteenth-century *Portrait of a Young Man* by Jacopo Pontormo, which the J. Paul Getty Museum will buy at Christie's auction of Old Master paintings in New York Wednesday night, is going to look just great in Malibu.

No, I haven't lost my journalistic mind. Yes, all manner of events could intervene in the Getty's acquisition of the picture later this week: the total collapse of the global economy, a 9.0 earthquake that would send Malibu out to sea, the invasion of California by alien spacecraft—you name it. I'm writing confidently about the future for the very bald reason that the Getty simply *must* buy the painting. The museum really has no choice.

Pontormo (Jacopo Carucci)
Portrait of Cosimo I de' Medici
ca. 1537

Before I get to the reasons why, let me first tell you something about the picture. It's a gem. Though not unduly large—some 3 feet high and about 28 inches wide—the panel is nonetheless commanding. Jacopo da Carrucci, called Pontormo after his village of birth, ranks among the greatest Florentine painters ever. (If you doubt it, avoid the crowds at the Uffizi next time you're in Florence and drop into the Capponi Chapel at Santa Felicita, just across the river. Pontormo's hallucinatory *Entombment* will knock the wind out of you.) If his fame is not as great as others', that's largely because the whole genre of Mannerist painting, long ago thrown into disrepute, has only in this century begun to be fully—and rightly—rehabilitated.

Pontormo was born in 1494, just a few months before Leonardo da Vinci began work on his fresco *The Last Supper*, in Milan. His contemporaneous biographer, artist Giorgio Vasari, said he studied briefly with Leonardo upon arriving in Florence at eighteen. Soon he moved on to apprentice in the studios of Piero di Cosimo and Andrea del Sarto, two very different artists who shared a pronounced taste for

mysticism and the irrational. Pontormo quickly built his own reputation as a painter of rather odd temperament. In fact, Pontormo was something of a nut. His extensive diaries are filled with peculiar entries, such as painstaking lists of every scrap of food he ate and exhaustive ruminations on bodily functions. They reveal a disturbed, even paranoid character who, in his later years, locked himself away in a studio that, like a hermit's hidden dwelling, could only be entered by a ladder, which he could quickly retract. Yet, the diaries also suggest the nature of Pontormo's artistic genius, which in retrospect seems strangely modern. A perverse poetry marks his painting, with its often shocking palette, destabilizing shifts in scale, and impossibly distended forms. Imprinted with an almost Baudelairean commitment to disturbing beauty, his art seems to have found the calm, classical order of the High Renaissance an ever-tightening noose. He fitfully shook it off.

Pontormo's *Portrait of a Young Man* is sometimes known as *The Halberdier*, after the 6-foot weapon, called a halberd, he clutches in his right hand. It was probably painted in 1537, when the artist was about forty-three (he died after Michelangelo had begun work on *The Last Judgment* fresco, which covers the altar wall of the Vatican's Sistine Chapel). Deceptively simple at first glance, this truly beautiful picture grows deeply disturbing with more lengthy regard. The boy's torso is rendered in three-quarter profile, while his head, perched atop a graceful neck, stares straight ahead through limpid eyes. The eyes have it. The softly illuminated right eye is fixed outward on something the youth can see (by extension, he looks directly at the viewer), while the barely shaded left eye gazes toward some inner place, which softly blazes only in his mind's eye. Obviously a young nobleman, by his aristocratic bearing if not his dress (one scholar says he's wearing the outfit of a German mercenary), the youth seems poised between the sheltered ease of boyhood and the wearying demands of his adult station. His full, sensually rounded lips are ever so slightly parted, as if a sigh had thwarted speech.

The painting is also a voluptuously preening display of courtly power, in which the erotic and the militaristic unite. Isolated before an unadorned, pale-green fortress wall, the boy wears a buff-colored blouse and a long chain of golden links. His head is crowned by a flaming red cap, his loins are wrapped with equally crimson breeches. The firm wooden shaft of the tall halberd, and the suggestively phallic handle of the elaborate sword hanging at his waist, dramatically frame the lad's overtly stuffed codpiece. He's a strutting, if melancholic peacock.

The folks at Christie's have decided that the young man so astonishingly portrayed is none other than the young Duke Cosimo 1 de' Medici. And hey, why not? They've got a painting to sell. Others aren't so sure, despite the elaborate arguments of Pontormo scholar Janet Cox-Rearick in the sales catalog. But the name of the family of great Renaissance patrons will surely ring a bell even in new collectors, es-

pecially those anxious to hoist a symbolic flag. Every thread that binds the painting to fame and glory, however tenuously, is a cord of gold for the auction house.

Besides, for pedigree there's always the legacy of the Frick. Painting for painting, the Frick is the greatest small museum around. Pontormo's portrait was installed there in 1970, on loan from New York investor Chauncey Devereaux Stillman. (He'd reportedly bought the painting in 1927 for $37,000.) Although the Manhattan museum hoped the painting would remain there, and perhaps even be donated, the collector told Frick officials last December that the picture would be sold. Stillman died in January, and the estate proceeded with the sale. There's been quite a hue and cry about the decision, too. Nobody is taking seriously the perfectly silly, coals-to-Newcastle assertion that New York, in general, and the Frick, in particular, will suffer irreparable harm should the painting not be locally acquired. The claim is, however, having an unintentionally beneficial effect on the Getty Museum's prospects. For it is entirely possible that Pontormo's great portrait could leave the country, most likely disappearing from public view into a foreign private collection. That would be a shame. It's doubtful any American institution could compete for the purchase—except, of course, the Getty. Long regarded as a threatening, nouveau riche upstart, the Getty is starting to be seen as the last, best hope.

Christie's says the painting "is expected to bring in excess of $20 million." Everyone else says, "Way in excess." With modern paintings now bringing more than twice that sum, it's anybody's guess how high the bidding will go. However high, the Getty should simply spend whatever it takes to buy the picture. (If the idea still makes you nervous, look at it this way: Their acquisition will take the painting off the damnable market, once and for all.) The museum's first allegiance must be to the development of its collection. That must also be a principal allegiance of the J. Paul Getty Trust, of which the museum is but one of seven operating units. While education programs are nice, and so are research centers, conferences, and grants, art is better.

The big question seems to be, how much money is too much money for Pontormo's painting? The problem with the big question is that it places greenbacks in the driver's seat, as our culture's most commanding value. As the 1980s come to a close, we're teetering on the brink of losing sight of something crucial to remember: *It's only money.* If they've got a couple of CDs stashed away, the Getty Trust should have at least $300 million in spendable income this year. That ought to cover it. They could even finance the purchase, taking out a loan against assets and spreading payments over a couple years. I'm sure they'll figure out something.

There is irony to this. A half-dozen years ago, the international art world was terrified that the rich-as-Croesus Getty would

start madly writing checks and grossly inflate the art market. So, the Getty behaved with impeccable market manners, and things got grossly inflated anyhow. Institutionally, the Getty is one of few left standing with auction paddle in hand. Now it's time for them to use it. Getty Museum director John Walsh has long (and wisely) said that, whenever an opportunity to make a great acquisition might come along, they will. They did a few weeks ago, when they spent $17.7 million for one of the few truly great Renoirs. They did it before with the ancient Greek kouros and the Aphrodite, with the Ludwig collection of medieval manuscripts, with seven superb collections of photographs, and with James Ensor's modern landmark *Christ's Entry into Brussels in 1889*. They'll do it again in New York Wednesday night, too, when Pontormo's *Portrait of a Young Man* goes on the block. I can't wait until the painting gets here!

Liubov Popova

June 21, 1991 To understand the extraordinary significance of the work of Russian artist Liubov Popova (1889–1924), a rather intrepid leap is required. The reason is that her most startlingly original contribution came only after she repudiated easel painting.

Although she painted almost all her tragically brief life, often in bold and dramatically convincing ways, Popova's fundamental achievement will be found in the designs for textiles, typography, theater sets, and costumes dating from her last four years. This is not a field in which we are used to identifying the highest artistic merit, an arena where painting typically counts for more than "mere" utilitarian design ever could. Nor is this how Museum of Modern Art curator Magdalena Dabrowski, organizer of the otherwise indispensable Popova retrospective opening Sunday at the Los Angeles County Museum of Art, would assess the Russian's import. Yet that is precisely how the exhibition, which admirably lays out her trajectory in a clear and straightforward way, conveys Popova's remarkable development as an artist. Popova's art has been little-known in the West. Since LACMA's groundbreaking 1980 show "The Avant-Garde in Russia: 1910–1930," interest has accelerated. The fifty-five paintings and sixty-seven works on paper in the present exhibition make up the first substantive presentation of her art outside the Soviet Union. They confirm Popova's stature as an artist who, among the Russian avant-garde, ranks with Kazimir Malevich, Alexander Rodchenko, and Vladimir Tatlin.

Popova died of scarlet fever at the age of thirty-five. Along with other artists associated with the revolutionary government's Institute of Artistic Culture, she had formally rejected easel painting less than three years before, in late 1921. Perhaps the most compelling revelation of the retrospective is the pivotal role played by her last series of abstract

paintings in the subsequent triumph of her textile and theater designs. These "Space-Force Constructions," as Popova called them, constituted her most radical and original work to date. Typically painted on raw plywood, they are composed of open networks of crisscrossing straight lines, their intersections shaded in feathery brush strokes. (Imagine snow gently piled in the mullions of a window pane, and you'll have some idea of the abstract design.) Aiming to create lines of force across the surface of the panel, to generate ambiguous qualities of shifting space, and to banish any distinction between figure and ground, the seven "Space-Force Constructions" at LACMA are markedly different from anything else being painted in the period, and from anything Popova herself had done before.

This is important because the retrospective is a chronicle of Popova's accelerating assimilation of avant-garde styles, pioneered by others, in the seven years following her 1913 foray into the new Cubist idiom. She was a remarkably astute sponge, quickly soaking up and bending to her own will the most pertinent aspects of French Cubism, Italian Futurism, and her Russian colleagues' Suprematist and Constructivist abstraction. The speed with which she recognized and embraced avant-garde developments can be seen in the four canvases that introduce the show. In just five years' time, a staid if accomplished realist *Still Life*, begun when she was nineteen, gives way to the highly sophisticated organization of *Composition with Figures*, melding new Cubist and Futurist precedents. Picasso, Braque, Metzinger, Boccioni, Tatlin, Malevich—during the 1910s Popova took what she needed from them all, and more.

Liubov Popova
Objects from the Dyer's Shop (Early Morning)
1914

What this suggests, and what her paintings confirm, is that the language of art, rather than of nature, was the touchstone for Popova's work. Certainly, her early ink and pencil studies of tree branches resemble the general structure employed in her late "Space-Force Constructions." But it is to other art that she most often turned for inspiration. She also repeatedly reworked motifs from her own paintings. Three similar pictures of a seated nude were painted not just from

Last Chance for Eden

a live model, but from close observation of each other. A prominent detail of *Lady with a Guitar* (1915) turns up later that year as the focus of a painted wall-relief, which simultaneously recalls some ribbonlike forms in the still life *Objects from the Dyer's Shop (Early Morning)* from the year before. Even the stylized pose of a foot in a 1921 theatrical costume design is nearly identical to that of the early seated nude.

The show's catalog is very good at tracing the twists and turns in Popova's shifting stylistic journey. (Be aware that the color in the copious reproductions is awful; it's far too blue.) Yet formal analysis alone is insufficient for this art, and the curator offers no discussion whatever of the paintings' subject matter. A picture such as *Objects from the Dyer's Shop (Early Morning)* is curiously revealing for its subject, not just for its Cubo-Futurist style. In vivid colors spanning the spectrum, Popova lays out on a table the jacket of a uniform, a plumed hat, white gloves, and a shirt. The material transformation of these objects through saturation with color—the dyer's trade—is something she would have known from childhood. (Popova was the daughter of a prosperous textile merchant, who also happened to be a patron of the theater.) One can only wonder at the possible implications, just at the bloody launch of World War 1, of her choice of a military uniform as the pictorial object of transformation. Style, subject, and material here begin to be seen as all-of-a-piece, rather than as independent entities simply working in concert with one another as in a traditional composition. As Popova was to write at the time of her 1921 repudiation of easel painting, "Transformation for the sake of painterly or sculptural construction is a revelation of our artistic revolution."

Popova's clear and steady accumulation of radical artistic ideas eventually brought her to a purely abstract phase, indebted to (if quite different from) Malevich's Suprematism, until finally she reached the "Space-Force Constructions." Here, at the moment of her first wholly original effort, she stumbles for the first time. The paintings, which mean to unify pure and rational elements of surface, material, color, space, and movement, are simply not convincing. Painting was not easily repudiated, but when she finally did it, Popova's work took off. Textile and theater design, which had been a vocabulary familiar from her earliest years, became the real-life arena for the interaction of all those elements that frankly could not transcend the stubborn illusionism of painting.

Therein lies the surprise disclosure of the exhibition: Liubov Popova was to find her authentic voice not through the supposed success of her painting, but through its ultimate failure. In the current, belated effort to resuscitate her reputation in the modern avant-garde, a critical (if unsurprising) deformation is taking place. The artist is being made into a conventional hero, and the orthodox tale of heroic modern art is a story told principally through painting. Dare it be suggested that Liubov Popova's momentous achievement in design is unconsciously

regarded as lesser because, traditionally, costumes and textiles are seen as merely "women's work"?

stephen prina

July 28, 1989 Stephen Prina's "Monochrome Painting" is the single finest exhibition I have seen in a dozen years of regular visits to the Municipal Art Gallery in Barnsdall Park. An expansive project of subtle intelligence, wit, and persuasive effect, it confirms the arrival of an important artistic voice.

Although Prina's conceptual art has been shown in Europe and New York, it has only turned up hereabouts in a few group exhibitions—most notably, in "A Forest of Signs: Art in the Crisis of Representation," currently at the Museum of Contemporary Art. His work will inaugurate the new Luhring Augustine Hetzler Gallery in Santa Monica next September, but the Barnsdall exhibition is the artist's first solo show in Los Angeles, where he lives and works. Organized by the Renaissance Society in Chicago, where it was first seen in May, "Monochrome Painting" consists of three distinct parts. The suite of fourteen paintings, each one painted the same deep, light-reflective green, and each identified by a lengthy label, is the most obvious ingredient. We are in a gallery, after all, and monochrome paintings are what we have come to see. However, the accompanying exhibition catalog and advertising poster, both designed and produced by Prina, are intrinsic to the larger package. The artist means to engage every facet of how a work of art is received into the larger consciousness—the cultural life of the art world, of the general public, of history—and the art itself does not tell the full tale.

In the stark, almost brutal, concrete spaces of the cruciform Municipal Art Gallery, these spare, spotlighted, monochrome paintings are endowed with an ascetic rigor. (When I saw the show in Chicago, in the lobby gallery of a sleek new office tower, it had a chilling corporate air.) Chapellike, the installation of single-color paintings invokes the twentieth-century tradition of equating abstract painting with the mystical and transcendent. The lengthy labels adjacent to each painting underscore the equation. Typically, museum visitors look at labels before they look at paintings, especially abstract paintings; Prina takes advantage of that common habit, rather than pretending it doesn't exist or presuming it's wrong and trying to change it. His labels are as important as his paintings. Numbered with a Roman numeral, each painting is also identified on the label with one of the fourteen stations of the cross: The first painting is the first station, or *Christ Condemned to Death*; the sixth is *Veronica Wipes the Face of Christ*; the fourteenth is *The Entombment*; and so on.

The labels also reveal the source of each canvas's dimen-

Last Chance for Eden

sions. Prina's monochrome paintings are modeled on earlier monochrome paintings, from Kasimir Malevich's famous *White on White* (1918) through Ellsworth Kelly's *Two Panels: Yellow Relief* (1955) to Blinky Palermo's *Untitled* (1973). The fourteen models are chronologically arrayed, so that Prina's 1989 installation of single-color canvases puts itself next in line—the fifteenth station, as it were. Following *The Entombment*, this exhumation of past models issues forth as a resurrection.

The labels further tell you the medium of the model Prina chose, and what collection it's in—Malevich's oil painting is owned by New York's Museum of Modern Art, for example, while Kelly still owns the yellow relief. (The show's catalog also has a bibliography, which lists books where the models are reproduced, rather than references to Prina's other work.) And the labels also tell you that Prina's paintings are made of a commercial acrylic enamel on linen stretched over wood. At the artist's direction, these canvases were commercially painted by employees at the Champion Auto Body shop in Los Angeles. Suddenly, mixing the religious ambience with an automotive paint job invokes every pop cliché you can think of about California car culture—not to mention L.A.'s own artistic maturation in the 1960s, which is regularly interpreted as a trash apotheosis, a kind of Surf City Zen.

Prina's monochrome paintings are green (specifically, Papyrus Green Poly), a condition that makes a joke of labels that insist the painting's model is a yellow relief, or white on white, or, in the case of Yves Klein's patented color, "International Klein Blue." Why green? For starters, it's available. Green is about the only color not found in one of the chosen models. The paintings, catalog, poster, and announcement cards, all of them color coordinated, together establish a unified identity—"Prina green"—that's as label-conscious as, say, Klein blue or Reagan red. The selection of a color commercially tagged as "papyrus green" is also provocative. It summons Egypt, which is the standard historical origin of Western art, and recalls the invention of paper, which is the arena of writing and the common field for language and painting. The pointed use of "paper green" also can't help but invoke an economic indicator: It's the color of money. Painting as currency fills the chapellike space.

Like fission, Prina's excruciatingly controlled installation sets off a chain reaction of ideas that release a mighty load of energy. Painting has always been concerned with the problem of how to create space, and modern monochrome paintings have long been regarded as creating a pure, and therefore metaphysically inflected, space. Prina's do, too, but they haven't forgotten the problem of nuclear waste.

Prina's fourteen paintings create spaces in which to think. They wholeheartedly partake of the modern monochrome tradition, which most often asserts the primacy of the spiritual and transcendent, even as they bring to the genre a commitment to the material

and empirical. I suppose you could say they're radically empty. Culture, of course, abhors a vacuum. When you look at Prina's monochrome paintings, you busily fill them up.

Charles Ray

August 5, 1990 Charles Ray has disappeared. Once, the thirty-seven-year-old artist was regularly seen among the sculptural materials employed in his art. His naked body would lie perfectly still inside a horizontal steel box attached to the wall, with one arm dangling through a cutout hole to literally create a sculptural appendage, the other arm resting on the bump of a bony hip that peeked above the box. Or else he would stand, again naked, with his head in a lineup of ordinary objects placed on a high shelf: vase next to box next to gasoline can next to human head. Or, simpler still, Ray would pin himself against the wall with a plank, the dead weight of his torso pressed between the two, conspiring with gravity to suspend his body several feet off the floor. In these precocious student works, his body became a human painting hanging on a gallery wall.

The transformation of flesh and blood into the form of sculpture, domestic container, and painting came to an end about five years ago, as Ray began to disentangle his body from his art. A principal interest of these body-related works had been the peculiar, if frequently unexamined, relationship between a work of art and the spectator who encounters it. Simply by making the spectator aware that, as a viewer, he was not the only living, breathing half of the liaison, Ray clearly meant to disorient that common relationship. Made quietly unnerving, the spectator's discourse with art would be refreshed and vivified.

At least, it would be vivified in principle. In practice, that eye-opening refreshment did not quite work out. Ray's body sculptures had developed out of a larger artistic shift. His hybrid form brought together aspects of performance art and Minimal sculpture—two modes that had emerged in the 1960s in an effort to acknowledge and explore the complex social space in which art and meaning take shape. But, for me, encounters with Ray's body sculptures were marred by their decidedly demonstrative nature; they had a nagging aura of show-and-tell. As with the operatic installation art of Ann Hamilton, which also employs costumed actors as silently posed performers in elaborate tableaux, a conspiratorial quality of "let's pretend" defused the necessary tension of Ray's art. Certainly it was startling to come upon a naked person embedded in a sculpture. Yet, in order to convincingly stage the performance-sculpture, the mute artist/performer was required to ignore the spectator—to simply pretend you were not there. For an aesthetic determined to dig deep into a spectator's equivocal experience of art,

this was a rather ironic handicap. The body-to-body confrontation central to Ray's endeavor was safely intellectualized, out of physical harm's way. Your surrender to the situation was demanded.

A key ingredient in Ray's evolving solution to the dilemma has been to sidle off center stage, as his often compelling work of the last several years attests. Now, he lurks impishly in the wings. Ray began to make sculptures in which the essential pivot is often a perceived *absence* of the body. Typically, the spectator's presence fills in for the artist's. At its best, Ray's art becomes a vivid point of contact between the artist's out-stretched hand and yours.

Charles Ray
Self-Portrait
1990

A good chunk of Ray's work from the past five years may currently be seen in Newport Beach and Los Angeles. Nine sculptures dating from 1986 through 1989 are on view at the Newport Harbor Art Museum, including his great breakthrough piece *Ink Box*. And five more recent works, all but one made this year, are presently at Burnett Miller Gallery, where the Los Angeles-based artist has lately been represented. The Newport Harbor exhibition is the artist's first significant show at a museum—a single exceptional piece was included in last year's biennial exhibition at the Whitney Museum of American Art—yet, it's somewhat disappointing. The show feels lackadaisical. Several individual works are strong, and a few have not been seen here before; still, the selection as a whole seems decidedly haphazard.

Together, the concurrent exhibitions suggest several emergent themes in Ray's sculpture; at the museum, however, it's hard to discern any curatorial point of view at work, save for an apparent desire to offer a general sampler of the artist's increasingly important oeuvre. Nor is there a catalog or brochure, nor even a didactic label on the wall (according to a museum spokesman, a planned brochure has been delayed). The show, which will not travel, feels more like a commercial gallery presentation than a rigorous museum exhibition.

Ray's art frequently looks simple, but in fact it is often very difficult to install and maintain. (For proof, try filling an old-fashioned porcelain bathtub with water, then mounting it—vertically, not horizontally—on a wall. Ray's water-filled *Bath*, from 1989, floats impossibly in the space of the museum wall, as if seen from an aerial vantage point.) At least three of the nine works at Newport required heroic measures to accommodate. You have the sense that the complications of installation were all the museum could handle. Still, coupled with the actual gallery presentation at Burnett Miller, the perspicacious (and peripatetic) visitor will find numerous rewards. Together, the shows make plain that a lexicon of forms has begun to emerge in Ray's mature work, forms whose ancestry in his early body sculptures is clear. The shelf, or tabletop, is a recurrent motif, as are the rotating disk and the mannequin (a surrogate human body). And the box, or other type of container, is perhaps preeminent.

Space, a sculptor's principal medium, is keenly deployed within this range of forms, several of which can coexist in a single piece. *Table* (1990) is most eloquent in this regard. A simple table of steel, topped by a clear sheet of Plexiglas, is arrayed with a variety of containers—pitcher, bowl, drinking glasses, carafe, covered jar—also formed of transparent plastic. In each case, the plane of contact between container and tabletop has been cut out; if you put anything in the bowl, for example, it would go through to the floor. Intangible space seems to flow disconcertingly through the sculpture. The jar provides a subtle but important counterpoint to that flow, its cover rudely putting a lid on the action. Thus are the fluid properties of space made strangely visible, while emptiness is given energetic life.

Two earlier table sculptures also play with perceptual incongruities. One transforms a still life into a group of individual objects, each slowly rotating at an almost imperceptible speed; the other connects its assorted still-life elements by way of a network of tubes crisscrossing beneath the table's surface. (A fourth table, not in either show, removes the surface of the table altogether; each still-life element is suspended by a supporting rod, together identifying a plane of empty space.) Vaguely diabolical in bearing, these disparate sculptures show how Ray returns to a simple motif to mine it in a variety of ways. More important, there is something poignant and solitary about the table sculptures. The technical complexity of Ray's art is such that you tend to scrutinize the work in an effort to understand how it was made and, by extension, through what processes the idea might have originated. The table sculptures conjure someone sitting alone at a kitchen table—"contemplating the salt shaker," as it were, or thinking about the nature of things. The artist, in absentia, is suggested.

He also turns up as a costumed department-store mannequin in a recent self-portrait sculpture, as well as in an installation in

which a framed, photographic self-portrait is curved to fit the swelling, curved wall on which it incongruously hangs. The curved wall, irrationally bowed out into the room, seems to be responding to enormous hidden pressures; riding the crest of the wave, the artist's image is carried along for the ride. Ray's mannequin is very funny, in part because such things are supposed to be generic, not specific, and in part because artists' self-portraits typically tend toward the cerebral or emotionally refined, not toward assertions of cultural status as a commercial dummy. "That's not really me," this rudimentary self-portrait declares, its unexpected candor running contrary to the very genre of portraiture.

A slightly earlier manifestation of the department-store mannequin motif is also on view. This undressed, anatomically incorrect mannequin has been pointedly "corrected" by the artist. At first, the hyperrealistic genitals on the otherwise schematic dummy are startling; soon, it is the hyper-phoniness of the idealized dummy itself, with its typical department store style, that seems truly odd. Ray's addition to this bizarre creature, which was initially designed to be a surrogate for you and me, unearths an implied duet between idealization and taboo.

Technically, the obvious tour de force at Burnett Miller Gallery is a wonderful mechanized carousel titled *Revolution Counter-Revolution*. The base of a child-size merry-go-round rotates clockwise, at a fairly good clip. Four pairs of suspended ponies and two swings, all empty and awaiting riders, also rotate, but in the opposite direction. Ray has calibrated the speed ratio of these two conflicting rotations so the riderless steeds appear nearly stationary, suspended in space as the ground plane rushes away. Almost imperceptibly, the horses inch forward, as if against an unseen but overwhelming inertia.

More quietly, if nonetheless technically surprising, *7½-Ton Cube* (1990) is a pure white, pristine, perfectly milled three-foot block of solid steel. Its elegant, immovable bulk stands as wild counterpoint to Ray's most accomplished sculpture, the pivotal *Ink Box* (1986). A hollow, open cube of black-lacquered steel, also three feet to a side, *Ink Box* is filled to the brim with some 200 gallons of jet-black printer's ink. The quivering meniscus of ink that is the top plane of this menacing black cube forms a threatening surface just begging to be touched, even in the face of certain disaster. *Avant le deluge*, the hair-raising conflict between a desire to act and a denial of experience is tightly focused.

In the evocation of disarming conflicts such as this, Ray's art finds its most profound resonance. At his best, he is able to locate these complex perceptions deep in the bodily consciousness of the spectator. The High Modernist conception of the work of art as an all-knowing, all-seeing eye, disembodied and disengaged from the passive viewer but held aloft as his moral guide, is laboriously pulled back down to Earth. Charles Ray gives his art weight and dramatic space—and he acknowledges the same prerogatives for its spectators.

Rembrandt van Rijn

MARCH 8, 1992 Rembrandt's *The Raising of Lazarus* (circa 1630), darkly rendered in oil on a wood panel when the precocious artist was just twenty-four, is a small shocker of a painting. Slightly more than 3 feet high and a bit less than 3 feet wide, it depicts the most dramatic moment in the familiar New Testament story of the resurrection of the dead brother of Mary Magdalene and Martha. A triumph of imaginative power, it's an extraordinary work of art and a major early effort in Rembrandt's career. It also ranks among the greatest pictures in any Los Angeles collection. This amazing painting has hung in the Los Angeles County Museum of Art since 1972, the year it was given to the institution in memory of its former owner, the wealthy local banker Howard F. Ahmanson (1906–68).

Deep in a gloomy burial cave, lit only by a radiant glow emanating from somewhere beyond the picture's edge, Jesus stands atop a heavy stone lid that has been dragged from the dead man's tomb. His right arm raised high, he commands Lazarus to rise. Through Rembrandt's clever decision to pose the figure of Jesus in a manner adapted from conventional compositions of the triumphantly risen Christ, this supernatural event is subtly claimed as a mystical prefiguration of the forthcoming Resurrection. The pale, white-shrouded body of Lazarus, dead for four days, struggles to lift its sunken and sallow head toward the light.

We are not the only witnesses to this miraculous spectacle. The wide-eyed Magdalene, her golden hair illuminated by the picture's brightest light, throws up her hands and drops her jaw in a stunned and disbelieving gasp. Frozen in silence, three penumbral men adjacent to her bend forward and stare. Finally, from the deepest patch of pictorial darkness, which Rembrandt ironically casts in a plane closest to the viewer, the shadowy figure of Martha emerges. Faceless because seen from behind, she is cast as a dramatic counterpoint in the earthbound reaction to the unearthly miracle. Alone among the cluster of

Rembrandt van Rijn
The Raising of Lazarus
ca. 1630

Last Chance for Eden

spectators—a cluster that includes you, as you peer into the darkness—Martha reels backward, away from the amazing sight. The angle of her body, which conspicuously parallels both the angle of Jesus' upraised upper arm and the straining torso of Lazarus, unites all three into a concerted trinity, and propels her away from the opened tomb.

Does she recoil in terror? Perhaps. The nuance with which Rembrandt characteristically describes emotion in the faces or gestures of his figures is among his greatest gifts—a nuance nowhere more compellingly conveyed than in this picture's face of Jesus, who seems alternately fearful of, and surprised at, the magnitude of his awesome power. Yet, Rembrandt typically imagined his compositions as real events happening to real people in real places. Given such full-bodied complexity, another explanation for Martha's contrary pose seems equally plausible—and even more fitting. Simply, she is reeling from the stench. Martha, who is positioned closest to Lazarus, has drawn her body back from the terrible rot and the stink of putrefaction that would rise from a dead man's grave. *The Raising of Lazarus* may represent the first time a painter ever created an image meant to be *smelled* as well as seen.

Gerhard Richter

January 14, 1990 Between 1969 and 1979, a significant aspect of West German society underwent an astonishing transformation. The state's budget for police operations more than doubled. Allocations to the Federal Office for Defense of the Constitution increased sixfold. The budget of the Federal Criminal Bureau grew ninefold. And all these government institutions were granted expansive new authoritarian powers. For the first time in postwar German life—which is to say, for the first time since the Nazi terror—the police were suddenly allowed to tap virtually any suspect's telephone or to confiscate and open any mail crossing the country's borders. Official checkpoints could be set up at random on the streets, and any person incapable of producing proper identification could be detained for up to twelve hours. The creation of a vast, computer surveillance system able to provide quick, detailed information about individual citizens ensued, amounting to what has been described as a powerful security monolith within the Federal Republic.

This decidedly chilling advance in the state's capacity for self-defense was spurred by that uniquely modern affliction called terrorism. Growing out of the anti-Vietnam War student movement of the late 1960s, a loosely knit, internal terrorist organization called the Red Army Faction went about bombing cars in Bonn, torching buildings in Frankfurt, kidnapping and murdering businessmen and judges, hijacking Lufthansa airplanes, and more. Urban guerrilla tactics were

created in a violent effort to oppose and end Germany's economic and industrial support of the United States and its involvement in Southeast Asia. Idealistic and naïve, yet nonetheless violently disruptive, the goal of the Red Army Faction was nothing short of the overthrow of the capitalist system, which its members believed to be unavoidably militaristic, racist, and ultimately fascist.

Gerhard Richter
*18. Oktober 1977
(Plattenspieler)*
1988

Today, looking back across a profoundly conservative political decade, the calamitous story of the Red Army Faction seems a dusty chapter from ancient history. Yet, it is to this tangled, painful, and provocative moment from the decidedly recent past that the widely acclaimed artist Gerhard Richter turned in 1988. More specifically, the painter went straight to the bizarre climax of events and produced a suite of fifteen canvases based on police and press photographs surrounding the still-controversial deaths of the Red Army Faction's impassioned leaders. A quietly devastating body of work, these haunted, disturbingly beautiful paintings stand among the most remarkable artistic achievements of recent memory. Richter has purposefully exhumed an explosive historical moment, but there is no sense of vulgar exploitation to this discerning work. Instead, as an artist committed to reflection on deeply felt issues of great philosophical complexity, he typically casts his nets wide in search of points of departure. Here, the power of politics, of history, and of aesthetics, so often artificially forced apart, nimbly intermingle. That Richter's choice of subject inevitably would galvanize attention is in fact part of their stunning success: The voice of an artist is surgically inserted into the culture's larger dialogues.

First shown in Germany a year ago, then again in London and Rotterdam last summer and fall, Richter's suite of paintings last week began an eight-month tour to four cities in North America. At the St. Louis Art Museum, curators Michael Shapiro and Elizabeth Wright created a welcome opportunity for the work to be seen here before being installed, for a ten-year loan, at Frankfurt's new Museum of Modern Art. The show will travel to the Grey Art Gallery at New York University and the Montreal Museum of Fine Arts. It will end its tour by inaugu-

Last Chance for Eden

rating the new gallery at the Lannan Foundation in Los Angeles. Given the St. Louis Art Museum's venerable history of interest in modern German art—it claims a large and exceptional collection of German Expressionist paintings, with a special place occupied by the work of the great Max Beckmann—the Midwest museum was uniquely suited to the task.

The exhibition and the suite of paintings are titled "18. Oktober 1977." Early in the morning of that date, the bodies of Andreas Baader, Gudrun Ensslin, and Jan Carl Raspe were found inside their maximum-security cells at Stuttgart's Stammheim Prison, which had been built for the singular purpose of holding these convicted leaders of the Red Army Faction. Baader and Raspe each had a bullet in the brain. Ensslin, like her compatriot Ulrike Meinhof eighteen months earlier, was found hanging by the neck from a noose tied to the bars of a high window. What had happened depended on who was asked. Federal officials ruled the deaths a collective suicide, performed out of personal despair over life imprisonment with no chance of parole. Supporters of the group claimed that the deaths were a state execution, undertaken out of government despair over how to stop escalating terrorist attacks designed to force their release. Which answer is correct? Don't look to Gerhard Richter's paintings for a solution to the mystery, which remains a volatile topic of debate even to this day. Indeed, central to the elegiac power of this art is its stomach-churning insistence on the unlikelihood of ever knowing the answer for sure.

Richter shows us only selected vignettes. Two paintings describe scenes of the gang's arrest. There are three different pictures of a shyly smiling, self-reflective Ensslin, and three nearly identical ones on the coroner's slab—dead, dead, *dead*. There are two similar views of a blank-eyed Baader, sprawled on the floor in a black pool of blood. A single canvas shows Ensslin, hanged. Single canvases also are devoted to an empty, book-lined prison cell; a hallucinatory funeral procession, which winds through a roiling throng of people; a soft portrait of a young woman (Meinhof?), her right eye riveted as the compositional bull's-eye of the painting; and a smashed record on a record player, perhaps the one from which Ensslin is said to have gotten the electrical cord with which she fashioned a noose, or the one Baader is said to have had brought into his cell with a pistol secreted inside. Richter concentrates the sense of these paintings as being documentary evidence. His chosen models are clearly "official" black-and-white photographs—gathered from police files, the newspapers, and even the school yearbook or conventional family album. And every surface blemish, crease, or speck of dust that intruded on the photographic source is meticulously reproduced on the canvas. Because photographs, regardless of their subject, are chiefly evidence of moments gone and irrecoverable, the aroma of death is intensified. Simultaneously, however, Richter accentuates a gnawing quality of unknowableness.

Gerhard Richter

The images have been blurred. Sometimes he's dragged his brush over wet paint in horizontal or vertical repetition, creating woozy visions that read as quick scans across the scene. (*Cell* and *Funeral* have the wobbly look of stills from a movie made with a hand-held camera.) Elsewhere, Richter has carefully fuzzed the contours of objects, which yields an almost aqueous haze. Either way, the sharpness goes out of focus, the scene seems submerged. Made visually unclear, and with no clues as to the actual identities of the people, their evidential use evaporates.

Richter's technique also yields a luxurious sensuality. The creamy, painterly surfaces, with their exquisitely handled, seemingly infinite array of tonal grays, effortlessly seduce. Pulled up close to the surface, either to examine a tiny painting of a dead woman's sinuous profile or to peruse the dappled points of glowing light in a large canvas that shows a funeral march, it's easy to lose yourself in a concupiscent swoon of aesthetic reverie. Tendrils of pleasure and death smoothly, gracefully, horribly intertwine.

Death is not exactly a subject alien to the history of Western art. Richter's paintings are indebted to obvious modern examples, from Goya to Manet. And during the last two millenniums, how many crucifixions have been painted? But certain deaths are harder to accept than others. For art, the widely reported death of painting itself some twenty years ago turns out to have been among the hardest. Even now, after decades have passed, it's easy to find staunch disbelievers who deny its passing as the cultural medium of omnipotence, blindly insisting the corpse is alive and kicking. The doubters have been bolstered by a seemingly contradictory fact: Following a traumatic period of crisis, painting in the 1980s suddenly and with unexpected force returned to cultural prominence. But paintings, unlike people, aren't all created equal. The factor that matters most to any understanding of the exhilarating return of painting in the 1980s is that a number of exceptional artists were willing to face, and self-consciously to utilize, the awful catastrophe that was the medium's demise.

Richter was among them. After emigrating to Düsseldorf from East Germany in 1961, he had developed a painting style based on Photorealism, then switched to monochromatic canvases (often gray on gray), which he continued to paint into the early 1970s. In 1976, he began the work for which he is most widely known today. Big, colorful swaths of bright, gestural paint, in which squeegees have been swiped across the surface to veil and distance the abstraction, they look rather like gigantic, photographic transparencies of Abstract Expressionist canvases. That painting is metaphorically dead, and that photographic images record only moments that are gone, are two conditions Richter seamlessly weds. Emotive immediacy is tamped down beneath a cold internal light, as if all the blood had drained out of the picture. "18. Oktober 1977" compounds this deathly feeling. Try thinking of some of Richter's

titles as describing not just events associated with the demise of the Baader-Meinhof gang, but conventional attributes of representational painting and photography: an "arrest(ed)" and "hanged" image, a photographic "cell," a smashed "record player," and a picture "shot down." The tension between photography, as the principal carrier of imagery today, and painting, as an incomparable vehicle usurped, is visceral.

What makes "18. Oktober 1977" so extraordinary, and not simply a clever figurative recapitulation of Richter's earlier abstract paintings, is its evocation of a parallel event in political history. For the rise of photography and the death of painting in the 1970s is told through the simultaneous narrative of the Red Army Faction. This is why employing the notorious Baader-Meinhof gang as subject is brilliantly provocative, but not merely sensationalistic. These paintings have caused a furor in Europe, where the subject easily jabs raw nerves, while Americans blithely dismiss terrorism as an alien topic. (I don't recall last December's racist wave of letter bombs, sent to judicial officials in the South, being described hereabouts as terrorist assaults, which is what they were.) Richter simply opens discussion on a topic locked in the maximum-security prison we call taboo. For an artist raised in East Germany in the postwar years, the fate of the Red Army Faction in the supposedly free and democratic Federal Republic must have had a singular resonance. A kind of urban-guerrilla version of the old avant-garde, the Baader-Meinhof gang performed terrorist actions in committed opposition to the dominant culture. Fatefully, the capitalist institutions of government were thus given a wide opening for the enhancement of their own threatening rule—and they took it. Authoritarian state power, now greatly expanded, paradoxically had moved farther in the very direction the Red Army Faction had sought to forestall.

Richter, who repeatedly has insisted that painting is a moral act, does not politically eulogize terrorism in this suite. (The same cannot be said, alas, for the noxious essay by critic Benjamin Buchloh in the show's catalog.) Instead, "18. Oktober 1977" is a profound meditation on the storm cloud of death, one that gathers relentlessly in a multitude of guises.

Mark Rothko

June 8, 1986 More than sixteen years have passed since Mark Rothko bled to death in his studio, his arms sliced open with a tissue-wrapped razor blade. Given the nature of his death and the rush of events that followed, perhaps it shouldn't be surprising that Rothko and his work seem to be more puzzle than historical reality.

Still, the artist remains something of a stubborn enigma. Following that shocking tragedy, a sometimes bizarre sequence of events

conspired to stir up an already muddied pool. To see his work clearly was difficult. To separate out the romanticized mythology from the mundane facts of a life lived was nearly impossible. Finally, however, the clouds of confusion have begun to disperse. The publicity surrounding a landmark trial concerning the mishandling of the sixty-six-year-old artist's estate, which publicly revealed a degree of venality and corruption in the art world many were aware of but chose to ignore, has long since died away. The Guggenheim Museum's posthumous retrospective exhibition, which was among the most talked about shows of the 1978–79 season, has receded into memory. A grossly melodramatic television docudrama, produced by the BBC and aired in this country by the Public Broadcasting System, has gone peacefully to the video graveyard. *About Rothko*, a surprisingly inept and convoluted 1983 study of the artist's life and work by the distinguished critic Dore Ashton, has almost disappeared from the bookstores.

For these reasons, the timing of the exhibition "Mark Rothko: Works on Paper," now on view at the San Francisco Museum of Modern Art, has been fortuitous. Organized jointly by the American Federation of Arts and the Mark Rothko Foundation, under the steady hand of foundation curator Bonnie Clearwater, the show begins to untangle a good bit of the Rothko knot. And it does so by engaging in a bit of well-placed but tasteful myth-bashing.

In addition to his much better-known canvases, Rothko worked on paper from the later 1920s to the end of his life. Painting on paper, however, was not a discrete and singular activity. It served a variety of purposes at various times. In two works from the 1920s, he was engaged in learning established Cubist syntax in accomplished landscape images that owe a clear debt to the watercolors of John Marin. In the early 1930s, paper provided a medium for experimentation with materials; Rothko scored the image with a blade to give it a tactile surface, tried out different pigments, composed spontaneously with black poster paint and more. Later in the decade, and in the 1940s, paper became a testing ground for the creation of new imagery. The veiled and vaporous fluidity that could be achieved with watercolor was appropriate to the organic Surrealism that attracted him. These works on paper were used as studies for oil paintings, as elaborations of completed oils, or as finished works in their own right. During this period, the paper works record the evolutionary process of artistic thought in the closest and most revealing way.

In 1950, Rothko developed the classic image of luminous, fuzzy rectangles of color that was to occupy his work on canvas for the rest of his life. Painting on paper was set aside. (Of the more than eighty works in the exhibition, only a handful date from the early 1950s.) When he resumed working with paper later in the decade, it was to function as a parallel to his work on canvas—one that addressed related issues while

accommodating the very different demands of the medium. As new paints gained in popularity in the 1960s, especially magna and plastic-based acrylics, Rothko incorporated them into his work.

The most forceful revelation of the exhibition concerns these works from the 1960s. Rothko's paintings in the early part of the decade tended to rely on a narrow range of dark colors, but his paper pieces often retained the high-keyed pigments of the previous decade. Clearwater suggests, in the essential book that has been published in conjunction with the show, that the artist's experiments with acrylic and magna—paints that could be thinned with water or turpentine without significantly altering the strength of the color—explain the anomaly. Whatever the case, Rothko never completely abandoned rich, bright color in his works on paper in favor of the dark and brooding grisaille series that has long been thought to have been the fundamental concern of his final years. As if to underscore the point, the jacket of the accompanying book features a luminous painting on paper in vivid yellows and oranges executed in 1968. During the last year of the artist's life, he also employed sky blue, alizarin crimson, radiant violet, and other light-filled colors. These works on paper are about as far as one could imagine from the monumental images rendered in somber grays and browns and blacks with which the Guggenheim concluded its retrospective exhibition in 1978.

In part, these richly chromatic late works are not well known because of the torturous events following Rothko's suicide. Many had entered private collections in Europe shortly after they were made, and those that remained in the artist's hands were not readily accessible until the complications of the estate were finally sorted out. As a result, attention has been focused on the grisaille series from 1969. This is important, and the colorful late works deserve to be singled out for emphasis, because it reveals a tendency that often distorts analysis of works of art: We have the habit of reading paintings as material evidence of the artist's biography, placing the elucidation of his personality at the center of the enterprise. As Clearwater forthrightly declares in her essay (and not without a hint of deserved irritation), although it was known that the somber gray-and-brown paintings on paper were not the only works Rothko made at the end of his life, "many succumbed to the romantic interpretation that these paintings were the production of a depressed artist which contained premonitions of his suicide. . . . However, the psychological approach trivializes the last works and contradicts the artist's aims."

This is not to say that Rothko's emotional life played no part in the forms his art took, but it is to agree with critic Howard Singerman, who once noted that there is more to be discerned in Rothko's art than a cryptic series of suicide notes. The development of his work was a whittling away of what he felt to be extraneous, an aspiration to-

ward aesthetic essence in which pictorial content was reduced to volume, tone, and especially color. In this way, Rothko hoped to attain an art that would perform a kind of sacramental function, both embodying and clarifying the tragic condition of being. Whether or not such an aim is possible, and regardless of what it means in the late twentieth century to desire such a goal, there is irony in the clash between his aspirations and the way in which he has been romanticized: Although Rothko wanted to take the expressive self out of his paintings, much of the audience has been determined to stuff it back inside.

Rothko's paintings have been fetishized as talismans of the artist's personality. In many respects, he has been made the contemporary heir to the modern mantle of pathological genius worn by Vincent van Gogh: You are encouraged to trace his difficult yet hopeful life, and his descent into torment, through his canvases. From Van Gogh to Rothko, a significant alteration has occurred in this myth of the artist and his work. St. Vincent was jeered and berated during his life— a bourgeois failure—but he triumphed after death; by contrast, St. Mark was held prisoner, in solitary confinement, by worldly success. (In this regard, Rothko is the high-culture equivalent to the reigning tragic heroine of popular culture, Marilyn Monroe.) Either way the outcome was the same: The fetishization of the artist's work—its transformation from material object into cultural image—allows him eternal life, the transcendence of mortality. That this myth of the artist has been dominant for quite some time means that it performs a useful function. What does such a view offer to the spectator? It is, I think, a narcotic against the agony of history. The artist, separated out from the social forces that preceded and enveloped him, is made into a surrogate for our own flight into nostalgia and dreams. For if we can locate Rothko's life in his paintings, their presence before us functions as evidence of the conquest of mortality.

Such fantasy is obviously self-defeating. To squeeze the artist into a standard mold is to eradicate the identity we claim to hold so dear. "Mark Rothko: Works on Paper" is a worthwhile exhibition precisely because it goes a long way toward denying that mythology. In the process, Rothko's achievement begins to come into sharper focus.

Henri Rousseau

March 17, 1985 At this particular moment, the decision to organize a retrospective exhibition of the paintings of Henri Rousseau seems absolutely perfect. Remarkably, given the popularity of the artist, it's the first such show since the Frenchman's death seventy-five years ago. Yet the rarity of the opportunity to see a group of some sixty of his often extraordinary pictures is not really what makes the endeavor

so appropriate. For a certain attitude toward art itself, an attitude which speaks directly to our own cultural predicament, is embodied by Rousseau's most engaging paintings.

Despite the widespread sense of affection felt for such classic pictures as *The Sleeping Gypsy* and *The Dream*, Rousseau the painter has been more mythological fabrication than flesh-and-blood person: He's been a mystery man. Nicknamed *le douanier* (the customs inspector), he was in fact a minor functionary in Paris's municipal toll service. He did not, as has often been assumed, begin painting upon his retirement at the age of forty-nine, but had been a Sunday painter for many years. The artist never traveled to the tropical forests of Mexico, as the poet and critic Guillaume Apollinaire claimed; rather, he frequented the city's botanical garden and zoo and traveled to remote corners of his fervid imagination for his numerous charming and ethereal images of the jungle. Although the object of public mockery when he first began, in 1886, to show his paintings at the annual Salon des Indépendents, it is also true that he received favorable critical notice as an artist of unusual promise.

The legends are legion. Perhaps the most important contribution made by the retrospective, which was co-organized by the Museum of Modern Art (where the show is currently on view) and the Réunion des Musées Nationaux de France (it had its debut at Paris's Grand Palais last fall), is the degree to which it has sought to separate fact from fancy. The show is limited to the sixty-three paintings which, in the estimation of the museums, are of unquestioned attribution. Among them are several never before shown in this country, including the revealing work from 1890, *Myself, Portrait-Landscape*, which has been loaned by the National Gallery in Prague. The accompanying catalog features a careful chronology of the artist's life, while Roger Shattuck, author of the celebrated book on Parisian artistic life early in this century, *The Banquet Years*, has contributed an atmospheric, biographical sketch.

In short, this is just the sort of retrospective exhibition we've come to expect from MoMA: precise, scholarly, rigorous in ascertaining the facts, and so forth. Something, however, is missing; the show feels flat and constricted. All the pieces are there—or at least, enough of them to get a pretty good sense of the puzzle—but somehow they don't quite fit together. What's wrong?

In fact, Henri Rousseau himself has never seemed to fit comfortably within any of the established canons of modern art. Affinities can easily be traced between his work and that of numerous contemporaries, while certain of his strange and dreamlike images anticipated, or even directly influenced, the later paintings of Giorgio de Chirico and the Surrealists. It may well have been Rousseau's picture of a lion chewing on an antelope (*The Hungry Lion*, 1905) that led the critic Louis Vauxcelles to refer to the paintings surrounding it at the

Salon d'Automne as the work of "wild beasts"; but Rousseau's own paintings never fully shared the stylistic traits of those by Matisse, Derain, Rouault, or the others to whom the term *les fauves* has been applied. In the art of the two decades flanking the turn of the century, Rousseau always stands apart, seemingly self-contained in that airless space uncomfortably occupied by "the primitive painter."

Having gone to great lengths to establish as true a picture as possible of the highly mythologized artist, the exhibition then proceeds to knit this stubbornly errant thread into the larger fabric of modern art. MoMA curators Carolyn Lanchner and William Rubin have contributed a lengthy, and often illuminating, essay to the show's catalog. "Henri Rousseau and Modernism" acknowledges, at the outset, that the artist "is most often considered *sui generis*, a figure entirely apart, outside the mainstream of his own generation. . . . [And] his art is thought to have had little impact on our own." The essay establishes all manner of connections to contemporaneous painting and traces Rousseau's direct influence on artists as diverse as Picasso, Beckmann, Kandinsky, Leger, Ernst, Miró, and several others. There can be little doubt that the elder artist opened up scores of possibilities for painting; yet it also seems a clear distortion to conclude by agreeing with André Malraux that Rousseau's potency derives from his position as an "example to artists seeking to throw off the spent conventions of Western art." For among the most curiously compelling features of his work is the degree to which Rousseau was clearly *enthralled* with the conventions of Western art. What's more, a good deal of his potency will be found in the tensions between those conventional aspirations and his seemingly contradictory desire to be self-consciously modern.

That Rousseau saw himself as an exemplar of modernity is obvious from his famous assertion that he and Picasso were the two greatest living artists—"Picasso in the Egyptian style, I in the modern." That self-awareness was bolstered by the admiration Rousseau's work received from such adventurous painters as Odilon Redon, Edgar Degas, Robert Delaunay, and, of course, Picasso himself. Yet Rousseau, for his part, was always vocal in his praise for the paintings of Felix-Auguste Clement, Jean-Léon Gérôme, and Adolphe-William Bouguereau—the pictorially debased standard-bearers of the French Academy. In fact, like Édouard Manet before him, nothing would have pleased the *douanier* more than to have been counted among the academy's chosen few.

Legend aside, he was not so naive as to believe that his own quirky pictures bore any but the most remote resemblance to those of the academic mainstream. Yet this oddly conflicting desire to be embraced by the masters of convention, while at the same time remaining fully modern, is the key to Rousseau's unique charm. For in wanting to belong, but knowing that he didn't, the artist set about creating for himself a kind of Academy of One.

Myself, Portrait-Landscape is the first, fully articulated statement in this regard. Rousseau depicts himself as the Artist: grand, serious, brandishing his attributes of brush and palette like a sword and shield, and crowned by a floppy black beret. The figure is full-length, an atypical mode for avant-garde self-portraits but common to academic depictions of public officials or aristocrats. The Parisian landscape chosen for the painting is a celebratory vision of modernity: Along the quay of the Seine, moored before an iron bridge (the Pont des Arts), a sailing ship is bedecked with flags; in the distance the newly completed and extremely controversial Eiffel Tower rises above the urban chimneys, its open framework mingling with the gaily billowing flags of the ship; and to the right a hot-air balloon floats serenely in a pale blue sky, offering a new view of the world that just happens to align with Rousseau's far-off gaze. As can easily be seen in the picture, the artist repainted the lower portion of his body, making it smaller and less aggressive: Rather than stand before the new and dazzling world, as if to set himself in a position of separation and dominance, he altered the picture radically to put himself more firmly within it.

This odd amalgamation of academic or conventional motifs with those that are idiosyncratic and expressive recurs throughout Rousseau's work. His celebrated group of jungle pictures may not have issued forth from direct experience of the Mexican tropics, but neither do they make exclusive claim to a heritage in Paris's botanical garden. For the exoticism of North Africa was a fashionable subject in the world of academic picture-making, appearing in countless examples, while images of lions felling antelopes and such were a mainstay of popular bronze sculpture. And although the nude woman reclining on a Victorian couch in Rousseau's last, and perhaps greatest painting, *The Dream*, might find its model in Renaissance Venuses, Goya's Majas, Manet's *Olympia*, and a slightly earlier painting by Felix Vallotton that the *douanier* undoubtedly saw, it owes as much to the flattened contours of such hyperidealized works as Antonio Canova's academic sculpture of the aristocratic Pauline Borghese. Indeed, in *The Dream* it's as if the latter had been transported, like Dorothy Gale, to a land made strange by virtue of being at once completely familiar and utterly alien.

This sense of déjà vu is generated by much of his work, even though you know it's completely new. The use of familiar academic motifs for a celebration of modernity could hardly be described as hewing to academic norms in an effort to gain respect. Instead, it reveals a distinctly radical desire to remake a popular, commonly understood pictorial language for the purpose of speaking to new and unsettling experiences.

The exhibition seems content to demonstrate how *le douanier* is one of the pioneering masters of Modernism, one whose work profoundly influenced later masters. Despite the accuracy of the asser-

tion, however, Rousseau's finest paintings don't "throw off the spent conventions of Western art." Rather, they infuse the conventional with an idiosyncratic dizziness. And if that sounds like an artistic strategy adopted by countless artists of the present day, it's because Rousseau turns out to have been something of a proto-Postmodernist, too.

Edward Ruscha I

Summer 1988 By now, it is certainly a cliché to assert that painting operates as a field of language. In the 1980s the bibliography avowing as much has grown to immense proportions. The academies, having fully absorbed and extrapolated the doctrine in all its resplendent nuance, dutifully pass it on. The exhibition arenas, from galleries to museums to international expositions, are filled to overflowing with pictures-as-literal-texts.

Given the viscous and engorging glut, which sometimes seems on the verge of bringing art's ragged and necessary gyrations to a grinding halt, the timing couldn't have been better for the arrival of Edward Ruscha's recent silhouette paintings. This oddly eloquent master of the vernacular "painted word," who managed to expand Jasper Johns's waxen ruminations on linguistic signs into fully environmental scale a generation ago, has suddenly drained written language from his art. The fuzzy, velvety soft, densely absorbent silhouettes somehow seem to be shadows (or ghostly shades) left behind by vanished words. Sometimes, in a device as brilliantly seductive as it is devastatingly simple, Ruscha now inserts empty blocks of horizontal white space into the scene—a fill-in-the-blanks gesture that asks you to complete the image with your own private backstage text.

The silhouettes are not exclusive in Ruscha's current output. He still produces paintings and drawings that pair block-letter words, rendered by hand, with suggestive images, such as "city boy" spelled out on an aerial view of the luminously jeweled grid of nighttime Los Angeles; and he's been making some image-only pictures, too, such as an intense, vaguely ominous American flag in full baroque flutter against a raging, technicolor sky. But Ruscha's interest in the wordless silhouettes, which signals a new level of complexity in his already intricate art, has been emphatic. Provocatively, these recent paintings stand in an unusual relationship to his previous achievement.

"I Dont Want No Retro Spective" announced the pink pastel drawing that graced the cover of the catalog to Edward Ruscha's mid-career retrospective exhibition in 1982. The nervous declaration flatly voiced a fear—part superstition, part rational avowal, but wholly common among artists—that a retrospective reckoning inevitably gives birth to an aesthetic paralysis and a career lull. The drawing employs nu-

Last Chance for Eden

merous elements that have come to be identified with Ruscha's art. Its image is language. The language is the kind overheard backstage, in private, not for public consumption. The sentiment is a cliché, which means it is shared by many and therefore socially authentic. The absence of an apostrophe in the contraction "Dont," and especially the quirky splitting of the offending word "Retro Spective," give the simple sentence a considered deliberateness and a poetic lilt.

Finally, and perhaps most important of all, to voice the trepidation so prominently was classic Ruscha; for the placement of an antiretrospective statement on the cover of a retrospective catalog plays against the very situation in which it is encountered. Tellingly, the three pivotal moments in the development of Ruscha's art to date have been characterized by this explicitly contrary positioning. It's the kind of move a Hollywood director might describe as "playing against type."

One of those moments is the seemingly sudden appearance of the exceptional new silhouette paintings of the last three years. The other two, however, came twenty years before the retrospective; they were nearly simultaneous. In 1962, a productive outburst saw the first articulation of many of the pictorial ideas that would fuel his art for the next twenty-five years. Building upon initial forays started in 1961, he made a sequence of word-paintings that included the earliest example of language exploded to environmental proportions: the blaring logo of 20th Century Fox, in the picture titled *Large Trademark with Eight Spotlights*. That same year, Ruscha published his first thin volume of straightforward, deliberately ordinary snapshots, a book whose titles succinctly described the photographic contents: *Twentysix Gasoline Stations*.

Twentysix Gasoline Stations was a photographic voyage home. The intentionally inartistic pictures documented gas stations along Route 66, the great modern highway that formed an asphalt trail for westward migration across the United States before the network of freeways and superhighways was built. Ruscha had been born in Omaha, Nebraska, and raised in Oklahoma City, Oklahoma; he had completed his own trek west from the American heartland by loading up his car and moving to Los Angeles in 1956. But in this book he maneuvered a sharp U-turn: Beginning with a gas station in Southern California, the sequence of photographs follows a journey in the opposite direction, to Arizona, New Mexico, Texas, and Oklahoma.

As the curator Henry Hopkins once pointed out, the sequence of gas stations within each state does not conform to the geographical sequence found on a road map. (Of course, neither do the painted maps of the United States by Jasper Johns follow normal expectations, and Johns is an artist whose displaced ways of thinking were critical to the development of Ruscha's own.) The final photograph in the home-again odyssey departs from the west-to-east, state-by-state sequence, too, ending the journey somewhere other than

Oklahoma: The picture of a Fina gas station in Texas offers a cinematic closing pun—"The End"—while confirming once more that you can't, indeed, go home again.

Ruscha's *Twentysix Gasoline Stations* certainly partakes of a highly personal narrative. Yet the book nonetheless exudes a generic appeal that is as far from the autobiographical assertions of the expressive self as the dumb snapshots of commonplace gas stations are remote from the gestural bravura of Abstract Expressionist paintings. As a student at Chouinard Art Institute (now CalArts) in the late 1950s, the young artist had painted in an Abstract Expressionist manner derived from the example of Willem de Kooning and Franz Kline. His achievement as a painter in the early 1960s lay precisely in having absorbed the lessons of Abstract Expressionism, but in simultaneously having turned his back on the newly consolidated style. For Ruscha's mature work treated painting not merely as a means toward expression of the artist's interior life but, equally, as a culturally inflected sign.

Language—and especially generic language, such as that specified by *Large Trademark*—was the means through which the expressive self was drained form Ruscha's painting. With the new precedent of Jasper Johns (as well as a distinct interest in the work of Robert Rauschenberg and Marcel Duchamp), and skillfully trained in commercial graphic design and the pictorial language of advertising, Ruscha deftly executed another about-face. In his painting, the rhetoric of Abstract Expressionism was subsumed within the very language of mass culture, the vernacular against which it had been so carefully counterpoised. On wide, horizontal canvases that conformed to the lateral spread of the landscape, Ruscha painted gas stations gloriously crowned by the trumpeting logo of Standard Oil, as well as a familiar Los Angeles drive-in coffee shop called Norm's. On the occasion of his retrospective, the critic Dave Hickey wryly noted that, with such paintings, the artist was happily spelling out the modern assault on mass culture and its relentlessly encroaching "standards and norms."

Plucking written language out of his paintings now is akin to having inserted written language twenty-five years ago. By 1961–62, Abstract Expressionism was the stultifying artistic authority—the American model or type—against which Ruscha moved. At the age of twenty-five, he was engaged in the venerable practice of artistic patricide. A different, older generation needed to be usurped. Today, literal text itself has been transformed into a stultifying type, and Ruscha's silhouettes gain some assertive punch by playing against this new constriction. But there's a catch. The "standards and norms" of the present are those that his own art, along with that of many others, has been instrumental in constructing. The shadow play of his new paintings thus takes on a slightly different cast, one in which memory and personal narrative double back upon themselves.

186 *Last Chance for Eden*

Ruscha's silhouette paintings, which are often sooty black or deep blue, but which sometimes employ colors other than those suggesting dusk or nighttime, feature two prominent themes: domesticity and westward migration. Home and hearth are the leitmotif of *Digit House*, *Home Power*, *House of Trust*, *F House*, *Pine Setting* (in which a tract home is comfortably nestled), and *Jockey*, which features the image of a suburban lawn ornament common in the 1950s. *Your Name* features the image of a house, underneath which is printed the still-empty identifying tag, "Name: _____." *Affiliation* does the same, albeit with the image of a neighborhood church (the house of God). Perhaps the most potent of all the silhouette paintings is the domestic image of three houses receding in the distance, with progressively smaller, and yearningly empty, blank spaces forlornly left beneath them: NAME, ADDRESS, PHONE.

The historical trek west across the American continent is conjured in a variety of images of horses, desert cactuses, howling coyotes, Mexican señoritas, and, especially, several pictures of Conestoga wagon trains. In this context, Ruscha's contemporaneous paintings of four-masted sailing ships take on the suggestive aura of European exploration of the Western Hemisphere. (Conestoga wagons, in which settlers from the Atlantic coast made the perilous journey west toward the Pacific in the nineteenth century, were commonly known as "prairie schooners.") Among the earliest is *Cables, Fittings*, from 1985, in which the moorings of a great ship's sails are keen-edged black silhouettes set against a flaming red/orange sky. Once in a while, westward migration merges with domesticity in the same painting, as in the self-explanatory image called *Teepees*, or the one of two precariously listing ships wittily titled *Man, Wife*.

Ruscha's recent paintings encompass the aura of his prior work. In part, the recollection is formal. Often he calls upon a graphic device that is familiar from his very earliest paintings: Sharp, diagonal compositions recur. The looming logo of a movie studio in *Large Trademark with Eight Spotlights* (1962) is echoed in a painting such as the 1987 *Dry Frontier*, which is positively cinematic in the raking angle of vision it assumes—the creaky, lumbering wagon train passes you by as if you, or a camera, were lying on the ground, a conventional shot you've seen in a hundred ordinary Westerns. The compositional device accomplishes two expressive aims. First, it conveys a pictorial sense of vast distance, which translates in the mind into emptiness, solitary loneliness, and the passage of time. Second, it imparts a look of effortful struggle, a Sisyphean climb up an endlessly repeating hill.

More importantly, the sense of displacement, of homelessness and continual uprootedness, is a primary theme of his silhouettes, even as it was in 1962 with *Twentysix Gasoline Stations*. To look at the radiantly glowing image of a curly-headed, doll-like figure, dressed in crisp petticoats and emerging from a deep blue field, in the 1986

silhouette drawing *Little White Girl*, is to summon inescapable memories of Hollywood's living doll of the 1930s, Shirley Temple. Yet the specter (and an oddly ominous specter it is) in Ruscha's drawing of the little moppet who was cast in the movies again and again as the quintessential homeless waif, suddenly elicits memories of the artist's own classic word-painting of another foundling of the Great Depression: the round-eyed Little Orphan Annie. Add to this resonantly echoing scenario the 1986 companion drawing *Little Black Girl* and America's identity as "a place of displacement" sounds more deeply still, as it strikes a slightly different chord that harkens back to the Civil Rights movement so important to the ethos of the 1960s.

Such glancing allusions to Ruscha's own Pop paintings, books, and drawings of the 1960s enfold narrative pictures of mass culture itself into the artist's ongoing meditations on displacement. In 1962, when Ruscha made his gas station book, it was a photographic cousin of Jack Kerouac's slightly earlier novel of contemporary dislocation, *On the Road*. In addition, it alluded to a TV show called *Route 66*, which was at the peak of its ample popularity. *Route 66* starred two attractive young sidekicks, who drove their red Corvette convertible through an open-ended series of adventures on a ceaseless journey through the modern American West. The show was far from a programming anomaly in 1962, although it was dressed in an untypical disguise. For four years the television schedule had been jammed with shows on western themes, and that year saw a dozen: *Have Gun Will Travel, Gunsmoke, Bonanza, Cheyenne, The Rifleman, Marshall Dillon, Laramie, Wagon Train, The Virginian, The Wide Country, Rawhide*, and even *The Roy Rogers-Dale Evans Variety Hour*. Two guys in a sleek Corvette wandering Route 66 were just a couple of motorized mavericks, restlessly roaming the asphalt edge of the new frontier. The ghostly disappearance of *Route 66*—and of *Wagon Train* and of Ruscha's own prolapse odyssey, *Twentysix Gasoline Stations*—casts a shadow that is projected onto the canvas of the painter's *Uncertain Frontier* of 1987.

In this way, a primary difference between Ruscha's word-paintings and his silhouettes is the difference between speaking and listening. Youthfulness is characterized by an energetic urge to speak, maturity by the difficult need to listen. Part of the charm of his recent paintings is thus the seeming contradiction between pictures that are marked by uncomplicated simplicity and the way manifold layers keep getting added on. The silhouettes are like carefully constructed vessels that, miraculously, keep accepting more and more without ever quite filling up. Here, Ruscha pries open a fundamental principle of mass culture and turns it to his own ends: Mass-culture pictures of the world are ambiguous enough to be essentially void and thus able to become receptacles for almost any viewer's firm convictions or shapeless aspi-

rations. At the same time, the contours of the artist's silhouettes deftly pin down the venerable tradition within which the insoluble conflict resides. Ruscha's art is a vivid, and sometimes sweetly poignant, silhouette of the displaced psyche that fitfully inhabits mass culture.

Edward Ruscha II

December 1990 When I graduated from college in 1972, a friend honored the occasion with the gift of an odd little book titled *Thirtyfour Parking Lots in Los Angeles*. Published five years before, it was as its title says: a slim picture book, with nearly three dozen black-and-white aerial photographs of fields of lined asphalt.

The pictured parking lots are mostly empty (they must have been photographed early on Sunday mornings), and the patterns of the lots are wildly diverse. They range from the spare, rectangular grid of the Goodyear Tires office, which speaks of in-and-out convenience, to the sumptuous baroque splendor of Dodger Stadium, an ornate filigree that swirls around the precious diamond in the center. There's the gentle fan of the since-demolished Gilmore Drive-in Theatre, whose shape implores a gathering around a communal storyteller, and the slightly rustic yet nonetheless formal foliate garden of the Hollywood Bowl, summer home of the Philharmonic. These and other sharp differences among the parking lots belie a noteworthy similarity. In each, the standardized geometry of the parking stalls is countered by an irregular pattern of oil stains on the asphalt. They show, with undeniable clarity, where people do and do not typically choose to park their cars. Like fingerprints at a crime scene, the stains leave telltale traces of the patterns of human nature.

"Hoping you find your place in the parking lot of life," read the dedicatory inscription written inside my graduation gift, cheerfully offered to mark the all-American ritual of transition between youthful homeliness and adult entry into the world at large. From that moment on I was hooked. Be it ever so humble, there's no place like a work of art by Edward Ruscha.

Thirtyfour Parking Lots in Los Angeles is one of more than a dozen artist's books independently published by Ruscha in the 1960s and 1970s. In each, the title is an unadorned description of the straightforward pictorial contents: *Twentysix Gasoline Stations, Every Building on the Sunset Strip, A Few Palm Trees, Various Small Fires and Milk*. The deadpan clarity of this format—call it classic American plainspokenness—and the strange equivalence between the expository words of the titles and the didactic visual images of the contents—yup, those decidedly inartistic pictures show every building on the Sunset Strip, all right—has been a hallmark of his work in every medium. For the past

three decades Ruscha's paintings, prints, and picture books have melded graphic simplicity with incisive wit. And repeatedly, his play with word-and-image has sought to pin down, like a butterfly on a velvet cushion, an elusive circumstance of modern life. Moving through the infinite hall of mirrors that is the late-twentieth-century landscape, the fifty-three-year-old artist has become the visual poet laureate of spiritual displacement and psychological homelessness.

The job is fitting for an American artist, in general, and for an artist who works in Los Angeles, in particular. A nation and a city of global immigrants, both also epitomize mass culture to the world. And that larger world has increasingly come to recognize its own predicament reflected in Ruscha's art, as evidenced by a notable recent European survey exhibition that focuses on his paintings from the 1980s. Organized jointly by Paris's Centre Georges Pompidou and Rotterdam's Museum Boymans-van Beuningen, and seen in Madrid and London as well, the show comes home to roost this month at its only venue in the United States, L.A.'s Museum of Contemporary Art.

From Picasso and Braque on, the resonant merger of words and images has not been alien to modern art. Yet, rarely has it been absolutely central. Instead, the place where the interplay between text and picture has been fundamental is in the sophisticated mechanisms of commercial art, the authoritative visual language of mass culture. Like countless American painters since the nineteenth century, from Winslow Homer to Andy Warhol, Ruscha was initially trained as a commercial artist. He studied graphic design at the old Chouinard Art Institute in Los Angeles from 1956 to 1960, and he worked as art director for *Artforum* magazine between 1965 and 1967, before the publication decamped L.A. for Manhattan. And along the way, he became the first major artist to elaborate ways for making paintings in which the written word literally is the picture.

Boss, *War Surplus*, *Annie*, *Flash*, *Smash*—in 1961 Ruscha began to make paintings whose principal image was one, maybe two words. These were soon joined by graphically dramatic landscapes, exploiting sharp, diagonal compositions, which used booming language to render whole environments of words. It's hard to remember, more than twenty-five years after the fact, just how shocking and heretical the appearance of Pop art seemed to be in the 1960s. So much was at stake, so much seemed threatened. During the previous decade, and for the very first time, American painting had finally gained international recognition. And this hard-won legitimacy had been built on a twin foundation: a devout faith in pure abstraction as the crucible of the avant-garde; and an abhorrence of the "debased" artifacts of popular culture, or kitsch, as the outright enemy of art. The position had been most precisely articulated by the powerful critic Clement Greenberg, whose collected writings were published in a 1961 anthology. The widely influential lead essay on modern paint-

ing enumerated sharp distinctions between the terms of its title, "Avant-Garde and Kitsch." Such was the standard and the norm.

While still a student at Chouinard, where his studies in commercial design were leavened with stabs at making variations of Abstract Expressionist painting, Ruscha came across a reproduction of Jasper Johns's 1955 *Target with Four Faces*. (Appropriately enough, given the direction Ruscha's art subsequently would take, he found the picture in a 1957 issue of *Print* magazine.) Johns's bull's-eye target, painted in encaustic over newsprint laid on canvas, was both materially dense and visually flat. With its concentric rings, the target was also wholly abstract yet undeniably figurative. And inside the four wooden boxes lined up across the top of the canvas, partial casts of four faces—sliced off just above the tip of the nose and just below the mouth—deftly spoke of both the potential power of speech and the shattering silence of painting.

The photograph of Johns's extraordinary painting was to have a lasting impact on Ruscha. All its elements would come together, albeit in wholly reformed manner, in the younger artist's classic word paintings, which participated in establishing a total contradiction to post-war painterly traditions. Throughout the 1960s and 1970s, Ruscha experimented with and elaborated on those odd displacements. As is everywhere apparent in his compositions, his visual acuity is sharp. Yet so, too, is the artist's astonishingly perceptive ear. Almost never jokey, the language in his work is often nonetheless wildly funny—although for reasons that seem impossible to explain. The words, phrases, and sentences are like bits of overheard conversation that, when stopped in mid-chatter and suspended weightlessly in space, are mysteriously transformed into strange specimens of alien sensibility.

In the 1970s Ruscha also went about experimenting with eccentric materials—shellac on taffeta, spinach and egg white on moiré, gunpowder on paper—as if in search of substances that would themselves lend a further sense of trembling instability to the fleeting bits of language. The atmospheric fields against which these aphoristic utterances typically are written—rather like the roll of credits after a movie—have the transient feel of weather. The tangible language, poised to fade away like the vapor trails of skywriting, is loaded with portentous meaning that reverberates against its casually overheard demeanor. Having long pushed at the boundaries clustered at the intersection of art and mass culture, Ruscha ultimately found himself in a paradoxical position. Language having become, by the mid-1980s, a pervasive motif for whole squadrons of European and American artists, his own art had itself become the norm. There was only one thing to do: Ruscha drained the words from various new paintings. What was left behind were shadows—often dark, soft, sooty silhouettes of suburban houses, desert cactuses, and four-masted sailing ships—loaded images whose very being speaks of absence and displacement. Sometimes, a horizontal,

fill-in-the-blank white box accompanying the silhouette will signal the loss of language. And in those paintings in which words do still make an appearance, they are cast in a whole host of typographic guises: seemingly embroidered, like a monogram; scribbled loosely, like chalk against a blackboard; in florid Elizabethan style, warning of trouble.

This new body of work ranks among the most compelling of its time. To the repertoire Ruscha has now added a recurrent image of great beauty and poignance—a midnight blue expanse, crisscrossed by a fuzzy grid of lights that demarcates a city below as seen from a soaring airplane. In his work of the late 1980s, the echo chamber of mass culture has grown darker, edged with intimations of mortality.

August sander

May 23, 1991 In 1927, fifty-one-year-old artist August Sander selected sixty prints from his ongoing photographic series, "Man of the 20th Century," for a debut exhibition at a museum in Cologne, Germany, the ancient city where he had lived for nearly two decades and where he would remain until his death in 1964. Since the end of World War 1, Sander had turned his camera toward the creation of a monumental photographic survey of the German citizenry, selected from all classes, professions, trades, and political groups—an astonishing "atlas of types," as the historian Beaumont Newhall was to describe them, and one which the artist had planned eventually to publish in twenty volumes. The German people were photographed with a uniform straightforwardness—whether parliamentarian or painter, Gypsy or dwarf, postman or taxi driver—often utilizing a wide aperture that made the sitter appear crisp and the background a hazy blur.

Now, curator Weston Naef has made another selection of sixty Sander prints, this time for a debut exhibition drawn from the J. Paul Getty Museum's extraordinary collection of 1,276 photographs by the artist—the largest Sander holdings outside Germany. "August Sander: Faces of the German People" makes for a richly absorbing show, while also deftly complementing two other notable exhibitions in Southern California. One is the much-celebrated "Degenerate Art: The Fate of the Avant-Garde in Nazi Germany," recently at the Los Angeles County Museum of Art, wherein was chronicled the same political persecution of artistic expression that in 1934 brought a sudden halt to Sander's ambitious project. Sander had published only one of his planned volumes when the Nazis confiscated and destroyed all the unsold books, the printing plates, and some 40,000 negatives. They recognized—correctly—the threat to Nazi ideology posed by Sander's brilliantly developed aesthetic. Not only didn't his portraits rapturously idealize their subjects, neither did they merely describe the "types" of people that took

their turn posing before the lens. Instead, his photographs democratized. As much as it privileged politicians, police officers, and good bourgeois citizens, Sander's camera also privileged derelicts, carnival performers, and the physically different. All humanity was rendered equal and specific before the eye of the photographer—a position simply intolerable to the maintenance and expansion of fascist authority.

The other current show to which the Getty presentation might usefully be referred is called "Typologies," at the Newport Harbor Art Museum. An exhibition of contemporary photography, it demonstrates the resonant importance of Sander's precedent to recent art. "Typologies" examines the quasi-scientific sorting and cataloging of types of ordinary visual information common to the work of nine contemporary photographers. Among them are the German duo, Bernd and Hilla Becher, whose conscious debt to their countryman is well known; Candida Hofer, Thomas Ruff, and Thomas Struth, all students of the Bechers at the Kunstakademie in Düsseldorf; and Judy Fiskin, who works in Los Angeles and whose connection to Sander is indirect—namely, through her study of the photographs of Walker Evans, himself a devotee of Sander's art.

August Sander
Zwerge (Dwarfs)
ca. 1910

Weston Naef doesn't say so in the brochure that accompanies the Getty show, but his exhibition may well have meant to allude to Sander's continuing importance to photography today. The first pictures encountered in the gallery are nine portraits, "Persecuted Jews," made secretly in 1938, which have been hung in a grid pattern, three photographs high and three wide. Naef's installation design is here identical to the signature format typically employed by Bernd and Hilla Becher. Where the Bechers' pictures focus on brute aspects of the industrial landscape—the typology of modern forms repeated in the construction of blast furnaces, water towers, workers' housing, etc.—Sander's focus on the benign faces of men and women, young and old. Each is photographed singly, seated in a chair, hands folded in the lap, and in three-quarter view. This formal repetition, as with all Sander's groups

of photographs, functions in a surprisingly contradictory way. A sense of uniform equality is bestowed on disparate subjects, emphasizing their commonality; simultaneously, the uniqueness and individuality of each human being is underscored.

The profoundly poignant beauty that marks Sander's portraits comes as much from what is not seen in the photographs, as from what is. When you look at the "Persecuted Jews," you can't help being deeply aware of all those who were not photographed, of those untold members of a common class whose lives were lived beyond the camera's range. Doubt and ambiguity are built into the image, as each photograph subtly poses a question: "Why this one and not that one?" Inevitably, the presence in a Sander photograph of a musician, a waitress, or a bricklayer's mate evokes the absence of all other musicians, waitresses, or bricklayer's mates. Within this paradoxical aspect of his work lies the indelible brilliance of Sander's art. Sander recognized that the medium of photography possessed a fundamentally useful capacity. No single photograph exists autonomously. Each finds its authentic meaning through its relationship to all others. Therein lies the poetic power of "Man in the 20th Century."

A further implication of this awareness was suggested in the introduction to *Antlitz der Zeit*, or *The Face of the Time*, as the first volume of the projected twenty-volume set was titled. (A copy is in the Getty show.) The writer Alfred Döblin succinctly described Sander's practice as "comparative photography." These two words remain among the most insightful commentaries on the artist's genius. Like comparative literature, comparative photography forced something new—and important—into the relationship between a viewer and a work of art. Anyone who would truly know Sander's photography is prevented from passively consuming any single image as authoritative. Comparative photography required of the viewer an active consideration of options posed, choices made, and differences registered by each and every photograph. Within this dynamic, politically trenchant quality of Sander's art lies its haunting power, as well as its significance for the present day. As Sander once aptly put it, he had no intention "either to criticize or to describe these people, but to create a piece of history with my pictures." Conceptually, these multiple, democratizing photographs are to our own century what singular, aristocratic likenesses by court painters were to premodern eras.

Adrian Saxe I

NOVEMBER 10, 1985 As the bright sun of Modernism sinks slowly in the west, a jaw-dropping gasp at the radiance of its sunset colors tends to merge with a certain dread at the approach of dark-

ness. For some, Modernism's fundamental source of illumination is claimed to have been snuffed out, never to rise again. That source was Modernism's new historical consciousness: Hoary traditions long set in concrete weren't merely discarded in the collapse of the social order; they were fitfully contested to determine the level of their continuing viability. But now that Modernism itself is widely seen as the value set in concrete, a dark and gloomy question is being posed with increasing frequency: Has the ability to perform a salvage operation been lost in the midst of contemporary collapse?

Adrian Saxe's current exhibition at the Garth Clark Gallery offers evidence that, as with the work of certain other important figures, that mode of historical social criticism hasn't really been lost at all; it's been radically transforming itself instead. The show also presents further evidence that, at forty-two, the artist is in the front rank of ceramists today.

The reason for Saxe's emergent stature will not simply be found in the territory of spectacular craft and tour-de-force technique, although the artist's gifts in that area are nothing less than astonishing. (To isolate one example, the combination of stoneware and porcelain fired together in a single piece is no mean technical feat.) Nor is it merely a function of the remarkably perceptive intelligence—often liberally spiced with a wry or devilish wit—that characterizes his finest vessels. Rather, a certain quality of Saxe's work puts one in mind of the legendary developments in ceramic art that occurred around Peter Voulkos at the Otis Art Institute in the mid-1950s. This may seem an unlikely connection to make; stylistically, a vast and seemingly unbridgeable gulf separates them. Yet Saxe's work speaks with a revolutionary voice that is as loud and forceful as the one heard at Otis some thirty years ago. Importantly, it is in its own way a voice that builds on the revolutionary utterance spoken at Otis, a transformation that has been widely acknowledged as the most fundamentally far-reaching of its kind in this century.

We've not had much opportunity to witness this development in Saxe's art during the past ten years. He was born in Glendale and attended the old Chouinard Art School, graduating from its later incarnation as the California Institute of the Arts in 1974. He's taught at UCLA for more than a decade. Although his vessels have appeared in many group exhibitions in Southern California—more often than not standing out from the pack—he's had but one solo show of his mature work in Los Angeles, which took place three years ago. If a painter or sculptor of commensurate achievement had endured a similar degree of near invisibility here, it would be widely perceived as nothing short of a scandal.

The current show is small (additional work by Saxe will be included in a group exhibition at the Los Angeles Institute of

Contemporary Art, opening this month), but the nine vessels together provide an experience of compelling interest. Saxe's work is a mass of contradictions. Unabashed elegance abuts downright tawdriness. The natural earthiness of the ceramic medium collides with hyperrefined artifice. Bluntly physical monumentality wrestles with imagistic pictorialism. Architectonic or mechanistic forms swell with organic vitalism. Erotic sensuality competes with threatening violence. Aristocratic languor coincides with political restiveness. Intellectual seriousness spars with carnal play. With all these seemingly incompatible elements competing with one another for our attention, it's no wonder that the dazzling technical fusion of lumpish stoneware and delicate porcelain in a single piece took place. It was simply necessary to Saxe's larger conceptual thrust.

It is within that conceptual arena, rather than in terms of stylistic affinity, that Saxe is heir to the Otis legacy. The work produced in the 1950s by Voulkos, Ken Price, John Mason, Henry Takemoto, and the rest was itself marked by broad stylistic variety. Whatever the individual approach, the unifying quality of Otis Clay was its assault on a traditional canon of Western pottery: the dictate that all features of the object had to coalesce in harmonious, unitary integration. In a liberating gesture, Voulkos split apart each element of a pot—not simply foot, body, and neck, but the whole conception of form and surface—and rebuilt ceramics as a medium in which each element played against the other in a lively struggle for attention. Pitting muscularity of form against fragility of surface, or common two-dimensional shape against idiosyncratic form, Voulkos, Price, and the others achieved works with an ambiguous life and personality all their own.

The formal and material fragmentation so essential to the Otis revolution provides the underpinning to Saxe's work, most obviously in the discrete splintering of foot, body, and lid (or stopper) in his vessels: A volcanic stoneware base might support an elegant, heraldic body that is itself crowned by a golden stopper in the form of a baby's pacifier. His vessels hit you all at once, but you don't know where to look first; your eye tumbles and careens from place to place, alighting here and shifting there in a futile attempt to find an anchor. Saxe doesn't stop there. He pushes that fragmentation and competition for attention far beyond the formal and material properties of the object, extending them into the scarier arenas of taste, style, mythology, and history. After all, sensuality and violence, elegance and tawdriness are not objective categories. In so doing, he wades into social and cultural territory that isn't just the home of the object; it's the residence of the spectator as well. Amid its mass of fitfully contested meanings, his work suddenly introduces the audience as a full collaborator in the creation.

Not surprisingly, the door to this particular path was first opened, and then shoved wide, by a member of the Otis crew. Although Voulkos led the charge, the work of Ken Price has proven to be the more

Last Chance for Eden

fertile territory. In his work since the 1960s, Price has tampered with all sorts of cultural archetypes (and stereotypes), not the least of which has been the whole hierarchy of taste and propriety in the visual arts. For an important precedent for Saxe's work, you don't have to strain to locate *Happy's Curios*, Price's "elevation" of roadside souvenir ceramics into a dazzling assault on refined sensibility (the curios were shown in a memorable 1978 exhibition at the County Museum of Art). Saxe's vessels seem well aware of this parentage. Most often it can be detected in broad strokes that are hallmarks of Price's work: an odd tension between the erotic and the vaguely sinister, or a prominent tussle between three-dimensional form and two-dimensional shape. Sometimes the acknowledgment seems more pointed: Surely that tiny, exquisitely glazed snail atop one of Saxe's vessels is, at least in part, an affectionate nod in the direction of Price's *Snail Cups* of the 1960s.

Elsewhere, Saxe's vocabulary of forms and images can be read as literal translations of conceptual values. When he wants to shift gears between competing factions in a pot, he may well fashion a saw-toothed, mechanical gear to set it all in motion. Or, if a vessel requires a climactic punch, he might top it off with a golden set of "brass" knuckles. His work is certainly capable of invoking subtler notions as well, including the whole social and economic network of the decorative arts tradition—in which, of course, his own ceramic work participates. One of the finest pieces in the show is a luxurious, royal blue vessel decorated with a golden fleur-de-lis and crowned by a spherical bomb with a gaily upturned fuse. The crazed lust for Sèvres porcelain by the French monarchy—and the subsequent economic chaos brought on by overindulgence of monumental proportions—has long been recognized as one of the primary matches that lit the fuse of the French Revolution. With extraordinary ceramic work such as this, Adrian Saxe has lit a revolutionary fuse in his own particular way. Fortunately for us, the explosion is likely to provide a good deal of illumination in the night sky now descending.

Adrian Saxe II

November 13, 1993 Smart pots, sexy pots, cultured pots— Adrian Saxe's gorgeous ceramic vessels are regularly tagged by admiring critics with human attributes of braininess, erotic allure, and exquisite refinement, as if the vessels themselves were breathing, sentient creatures rather than hand-fashioned lumps of clay transformed by fire. The miraculous power of an almost godlike, pagan magic is unconsciously implied.

In the eagerly awaited retrospective exhibition that opened Thursday at the Los Angeles County Museum of Art, it's easy to see why. Vessels have long been regarded anthropomorphically, as is plain from

the common names ascribed to their component parts: lip, shoulder, body, foot. Saxe pumps up those associations in a host of formally inventive ways. Then, he goes them one better. He exploits subtle properties of ceramic presentation and display, in a manner that makes a viewer self-consciously aware of being addressed. You find yourself having an animated visual conversation with his work in ways common to art, not craft.

Adrian Saxe
Shirley's Friend
1989

Born in Glendale, Saxe has drawn on traditions prominent in California clay, both to build upon and to undermine them. On the occasion of the Los Angeles–based artist's fiftieth birthday, "The Clay Art of Adrian Saxe" brings together nearly 100 works made between 1967 and 1992. He's not been unmindful of contemporaries working in other artistic mediums, either, especially the sleek, slick, figurative and abstract forms of 1960s L.A. Pop and the excruciating perceptual precision of Light and Space art. Both were ascendant when Saxe was a student at the Chouinard Art Institute in the late 1960s, while the quality of craftsmanship so important to artists ranging from Craig Kauffman to Robert Irwin is simply intrinsic to Saxe's chosen territory.

As for clay, it had come through an extraordinary rebirth and efflorescence in the 1950s. The following years saw the emergence of a playful, often jokey approach called "Funk," which opened a floodgate of puns about clay, inspired by Pop and the legacy of Marcel Duchamp. If the Funk attitude, in its many variations, often seemed to trivialize ceramics in a not unworthy effort to deflate the pious rhetoric that had congealed around it, Funk's irreverence also spoke of a new anxiety toward the precarious status of the work of art in the contemporary world.

In the exhibition, Saxe's earliest work shows him groping through this tangled field. There are corny erotic jokes in clay and exquisitely glazed abstract objects, principally concerned with properties of reflected light. Growing technical mastery is everywhere in ev-

idence. There are also a dozen plates, mugs, and covered dishes—the traditional output of the craftsman potter who sells dinnerware to make a living—as well as a prototype jardiniere Saxe designed for potted plants at the Huntington Library and Art Gallery in San Marino. These utilitarian works, dating from the 1970s, are of interest for reasons other than their attractive (if mundane) formal qualities. Through them, Saxe began to consider the labyrinths through which art in general, and ceramics in particular, are given social and cultural value. He found that a simple porcelain plate might be as easy to make as a stoneware one but that it could also bring a higher price—if for no other reason than the thoughtless prejudices associated with the material. An exceptionally rich history for these tendencies, with all their social, cultural, political, and aesthetic ramifications, was on display in the expansive decorative arts collections at the Huntington.

By the end of the 1970s Saxe was well on his way to incorporating these considerations into his own work, as can be seen in two related ways. First, each distinct part of a vessel is increasingly emphasized, from form to surface, foot to lid. Second, each discrete part becomes a useful site in which an aspect of the tangled, global history of ceramics can turn up. Saxe's cross-cultural pots might mix the ancient vessel form of a gourd with a Chinese celadon glaze and Art Deco incising. Traditions from Asia, Africa, Europe, the Middle East, and the Americas collide.

About 1980, the eccentric form of a saw-toothed machine gear suddenly appeared, adapted by the artist from a design in a Pratt & Whitney machine-tool manual. A witty joke about his visual and conceptual shifting of gears among disparate cultural sources, the form also seems pointedly symbolic of a passing era. The gear's prominent appearance on a luxury item plainly announced the industrial foundation upon which the wealth of modern empires was built. Yet, subsumed into a purely decorative flourish made of porcelain or gilded—about as functional as your appendix—the gear waved goodbye to the Machine Age. In the homespun world of modern handicrafts, it was the triumph of machines that had given clay its claim to moral legitimacy as an oppositional force. Saxe's art signaled a cultural crisis. For more than a decade he has been mining this new and fecund territory. With outrageous humor and unspeakable beauty, he makes intensely seductive objects that exploit traditional anthropomorphic qualities associated with ceramics. Having pressed the question of the utility of his own art in a post-industrial world, his work engages us in a dialogue about our own place in a radically shifting cultural universe.

The result is that Saxe has become the most significant ceramic artist of his generation. For this reason, one small feature of the show is a keen disappointment. Organized by curator Martha Drexler Lynn and handsomely installed in sumptuous galleries on the second

floor of LACMA's Hammer Wing, the show instead should have been mounted in the temporary exhibition galleries of the Anderson Building for Twentieth Century Art. Given modern ambivalence about the very status of ceramics as serious art, and given the way in which Saxe's brilliant work has burst open those historical prejudices toward the medium, the museum missed a golden opportunity for a bold polemical statement. And because context confers meaning, it also lost an added layer of educational elucidation for the work of a major artist.

jim shaw

December 7, 1990 Got a record player? If you didn't chuck it out at some point during the successive waves of new technologies that rolled over recent decades—eight-track tape, cassette, CD—can the player that you kept accommodate a 45 rpm? Does it have a fat spindle that fits the big hole in the middle? If not, did you keep the spindle adapter? And if records themselves are today an endangered species, has a spindle adapter yet made the transition from plain household object to precious, hard-to-find antique? From artifact to collectible?

These and other pressing questions hang heavily in the air in Jim Shaw's current exhibition at the Linda Cathcart Gallery. Together with thirty mixed-media works and two dozen pencil drawings, the show includes a new 45 rpm record by the Dogz (Shaw and friends), who sing "It's Easter in My Brain" and "Willy Nilly." How does their music sound? I don't know. I don't have a record player, never mind a spindle adapter.

The front of the record's slip-jacket features a white rabbit standing tall against a yellow and violet ground, printed with psychedelic type. The back, also done up in crocus colors, features a cross-hatched Easter egg decorated with the sorrowful face of Jesus. Like the 45 rpm, the jacket's Flower Power design motif is also very 1960s. Locked inside this mysterious object, with its packaging's promise of hidden spiritual truth and mystical revelation, is The Answer to The Question.

Similarly, at the entrance to the show is an imposing, leather-bound volume, whose gilded title reads: *The Book of Life*. Inside the locked book, the name Billy is scrawled repeatedly across each page. This teenage ballpoint-mantra surrounds a cut-out space in the center, which holds a glass bottle. Inside is a slip of paper. "Paul is dead" declares the hidden message, sent by an unknown castaway and here consecrated as gospel inside a weighty tome.

That the essence of the matter is remote or unavailable seems central to Shaw's enterprise. So is the fact that while analyzing rock 'n' roll for clues to the meaning of life may be an adolescent's resourceful way to keep from going under during rather traumatic years, it's disreputable for serious adults. They must find other means—such

Last Chance for Eden

Jim Shaw
Anima Figure #2, Water
1988

as high art. On one hand, Shaw's mocking work debunks the Modernist myth of art as keeper of an ultimate, essential truth or meaning, while on the other it's sincerely obsessed with the perfectly human search for spiritual peace. The artist has found a way to rub the two together in his work to generate a good deal of surprising—and surprisingly poignant—heat.

Wildly funny, Shaw's format plays traditional literary and philosophical treatises against such new pop-culture forms as comic books, board games, and TV. Baseball cards intersect with the Tarot, Parker Bros.' *The Game of Life* travels the Stations of the Cross, Veronica's veil is an *Archie* comic printed on a handkerchief, and an earring stand takes the form of a many-handed dancing Shiva. The Bible, Freud, Eastern religions, William Blake, and more get tangled up in mass culture's dizzying web, in mixed-media works that make up mostly recent additions to an ongoing epic dubbed "My Mirage." This narrative saga, begun in 1985 and now numbering more than 100 pieces, tells the nominal story of Billy, a suburban 1960s kid in Middle America whose generic life is a trash-heroic battle between the forces of good and the minions of evil. All of uniform size (17 by 14 inches), each work in the series is like a page in a book of indeterminate length. Melding Minimalist regularity with Pop style to make Conceptual riffs, their structure is of the period too.

Setting "My Mirage" in the past accomplishes several things. History is claimed as a moral battleground. The decade of the 1960s is asserted as a cultural shift that cannot be merely wished away or trammeled underfoot, as some would like to do. And the present is established as the adolescence of an era born in that decade. The moral dilemma of history thus becomes the moral dilemma of today, as Billy's youthfully disoriented experience reflects our own oddly parallel universe.

Henrietta shore

May 20, 1990 Henrietta Shore is back. Sort of.

In 1986, about a quarter-century after the artist had died penniless and forgotten in a San Jose sanitarium at the age of eighty-three, Shore was the subject of a full retrospective of paintings, drawings, and prints at the little Monterey Peninsula Museum of Art in Northern California. (She had moved from Los Angeles to Carmel in 1930.) Subsequently that exhibition traveled south, without fanfare, to the Laguna Art Museum, where it was seen by Michael Quick and Ilene Forte, curators at the Los Angeles County Museum of Art, who last year acquired two pictures by the artist for the museum's collection of American painting and sculpture. And finally, the Turner Dailey Gallery is currently showing fifteen paintings, nine lithographs, and six pencil drawings—the first gallery presentation of Shore's art in thirty-nine years.

If this modest but nonetheless noteworthy spurt of activity doesn't exactly seem to constitute a tidal wave of enthusiasm and acclaim, that depends on what you're comparing it to. Weighed against the voluble fanfare surrounding Georgia O'Keeffe—the painter (or should I say saint?) whose name is most often murmured in the vicinity of Shore's radiant, and frankly strange, floral paintings—these recent developments hardly register at all. Yet, compared to the near total obscurity in which Henrietta Shore has languished since before World War II, they add up to a veritable tsunami.

Who was Henrietta Shore? The question is not as simple as it seems. This largely unknown artist turns out to be something of a paradigm for an entire era in modern American art. Her biography certainly can be sketched with relative ease. Born in Toronto in 1880, the seventh and youngest child of a comfortable bourgeois family, she went to New York at twenty to study painting with society painter William Merritt Chase. The apprenticeship was brief. Soon she switched to more rigorous and demanding classes with Robert Henri, whose admonitions to paint from the immediate world at hand would mark Shore's art for the rest of her life. Following a grand tour of European capitals and a stint at a London art school, Shore joined her brother and his wife on an extended journey to California in 1913. (Her departure meant that, by a few short months, she missed seeing New York's landmark exhibition of European modern art, the Armory Show.) In Los Angeles she decided to set up a studio, exhibited her work wherever she could, and helped to found the Los Angeles Modern Art Society. She stayed for seven years.

In 1920, just as women in the United States finally got the vote, Shore returned to the East and co-organized the New York Society of Women Artists. She also became an American citizen. Missing California, she returned to Los Angeles in 1923 and stayed another seven years, eventually moving to the Monterey Peninsula, where she worked

until the beginning of the war. Through middle age Shore enjoyed at least a modest success. She won prizes, garnered gallery and museum shows on both coasts (and one in London), and was the subject of a small 1933 monograph with essays by the impresario Merle Armitage, San Diego Fine Arts Gallery director Reginald Poland, and, most notably, her colleague and friend, the photographer Edward Weston.

From 1939 on, details are sketchy. Although Shore lived for another twenty-four years, no postwar paintings by her hand are recorded with any certainty, and the circumstances surrounding her commitment to a sanitarium in the late 1950s are vague. Whatever the facts, her quiet brand of Modernist easel painting was emphatically swept away in the years following the war by the arrival of New York School abstraction and its West Coast variants. Outside the narrow realm of occasional academic research, we've seen neither hide nor hair of it since.

Henrietta Shore
Gloxinia by the Sea
n.d.

Until lately. The return of Henrietta Shore is by no means complete, but that it's happening at all deserves a careful hearing. Together, the two paintings at LACMA and the exhibition at Turner Dailey reveal a typically provincial artist of undeniable skill who worked hard, blossomed late, and was possessed of occasional flashes of dazzling brilliance. Shore did not begin to come into her own as a painter until she was about forty, while two-thirds of the fifteen paintings in the gallery exhibition were made in the decades before (only five are dated after 1920). Portrait studies such as *Meditating*, circa 1910, and *On the Street*—undated, but redolent of Robert Henri and the cheery grime of his so-called Ash Can School aesthetic—are prosaic examples of period style, as are the few conventional landscapes in the show. By sharp contrast, the 1929 *California Cactus* is an exquisitely riveting picture. Except for a late cycle of murals, all of Shore's work is small. *California Cactus* is no exception, but it's nonetheless powerful for it. Against a shallow ocher ground, two flame-tipped succulents and a pair of leafy stems fill the space, rather like animated pinwheels. One cactus, reserved and demurely elegant, is shown in upward-reaching profile at the rear, while the sec-

Henrietta Shore

ond, showier plant is rendered frontally, as if it had somehow miraculously turned to meet the spectator's advancing gaze. Through carefully modulated tones, the leaves of this latter cactus get progressively brighter and more radiant as they approach both the frontal plane of the picture's space and the center of the plant; there, at the compositional nucleus, an eye-shaped bud of golden hue stares resolutely back. A nearby pair of sinuous tendrils, which occupy the foreground between the painting's unblinking "eye" and our own, begins to register an aura of exploratory searching. These California cactuses may be mundane desert plants, but Shore has masterfully orchestrated them to exude a numinous quality of bristling, sentient awareness.

Shore was by no means a prolific artist. In her mature work she painted slowly, laying on oil colors—green, violet, orange, magenta, cerulean—in thin, carefully built up, seemingly brushless glazes. Reflected through transparent color, light seems magically to glow from within the deepest recesses of the canvas. This extraordinary quality of illumination connects her to, on one hand, the conservative and fashionable plein air landscape painters of the day, and, on the other, to progressive photographers such as her friend Weston. While her best paintings blew away the mawkishly nostalgic reverie of so-called California Impressionism, they productively engaged in rigorous dialogue with Weston's luminous photographs.

At LACMA, the abstraction called *Life* (circa 1921) shows how downright peculiar Shore's visionary images could certainly be. This vertical canvas features two jack-in-the-pulpit forms, from which emerge white, streamlined, faceless bodies, one male and the other female. In the gray field between them arises a dark blue, biomorphic form (imagine the shape of an attenuated peanut). This blue shape, which flickers between being a negative space and a positive form, erotically suggests both a cavelike opening and a swelling tumescence. "I have worked to develop the gift of understanding of nature," Shore wrote to her brother, Egerton, in an inscription inside a copy of her monograph, "that I might best use that gift through my drawing and painting to express the love received from and given to God." The painting *Life* employs Modernist devices to fashion an abstracted depiction of Adam and Eve.

Any understanding of Henrietta Shore and her art must take into account another peculiar feature of this odd canvas, which seems to me decisive. The male figure in the picture emerges from a cuplike stem, or calyx, which grows rather awkwardly from an unseen place off the right edge of the canvas. By stark contrast, both the female calyx and the central blue "spirit" grow directly from an organic, abstract, red-orange shape, which is centrally placed and certainly reminiscent of the floating leaf of a water lily. Indeed, a lily pad it may well be. (At Turner Dailey there's a small, handsome lithograph of a water lily, dating from the end of the decade.) But I looked at this odd

shape for a long while before I realized what else it resembles. Unlike Adam, the abstracted figures of both Eve and the "spirit" are growing from an old-fashioned painter's palette.

The fundamentally Modernist idea that a painter could invent herself through art became the pivotal realization for Henrietta Shore's work. Likewise, that a *woman* could invent herself through art was the pivotal realization for Henrietta Shore's life. Shore's birth in 1880 had placed her, as a woman and as a painter, at a decisive juncture in American society. By the end of the century, full-scale industrialization was rapidly transforming women from robust producers into passive consumers, while art—the human ability to make things—was metamorphosing into leisure. Together, these twin developments caused the very idea of painting to be feminized. In the mind of mainstream America, art of any kind was becoming a less than manly thing to do.

The fact of Henrietta Shore's gender is of course the central reason for her almost total obscurity today, just as it was basic to the cruel poverty and suffering she was to experience in her own lifetime. The trauma of the Depression generated a reactionary, no doubt inevitable elevation of artistic traits associated with stereotypical masculinity, which reemerged in the postwar years as the "dynamism," "muscularity," and "action" of Abstract Expressionism. The woman from California was swept into oblivion. Shore's *Life* is certainly not among the greatest modern pictures of its time, nor could it even be claimed among the handful of the artist's most accomplished works. Those would come later, in stunning canvases such as *California Cactus* and *Gloxinia by the Sea*. (The latter I've seen only in reproduction, but if this painting from the early 1930s is even half as impressive in person as in a photograph, it ranks as Shore's consummate masterwork.) Still, the historical significance of *Life* is equally certain—especially for a city and a country whose artists have played an influential role in framing feminist cultural issues since the 1960s.

This peculiar painting is also among the first direct pieces of evidence of the full spread of early Modernism into the provincial culture that was the United States around 1920. Furthermore, it's as clear a testament as could be imagined to the utterly indivisible relationship between Modernist artistic principles and progressive social thought. The painting's new public home at LACMA, which signals at least the nominal return of Henrietta Shore, couldn't be more meaningful.

Alexis smith

April 1, 1992 In 1975, Alexis Smith made a collage out of macaroni—specifically, out of macaroni letters like the ones in a can of alphabet soup. Glued in a single line across a plain, 12-by-9-

inch sheet of heavy white paper, they portentously announced: "Words cannot cook rice—Charlie Chan." A number of rather profound differences could be cited between this odd little collage and the loftier pursuits of art—especially the aesthetically daring pursuits of Conceptual art so central to the period in which her collage was made. Among the most notable are its materials and its subject. A macaroni collage? Quoting B-movie philosophy? You and I could do that ourselves.

Which is, of course, very much the point. Alexis Smith's art is contentedly made from the stuff of modern convention. It's her raw material, with which she builds bridges to other realms. On one hand, thanks to Picasso, nothing could be more redolent of twentieth-century high art than collage. On the other, who among Smith's generation didn't do the macaroni version in the third grade?

Alexis Smith
Same Old Paradise
1987

"Alexis Smith," the twenty-year, mid-career survey of the Los Angeles-based artist's work that opened Sunday at the Museum of Contemporary Art, does a superlative job of tracking the complicated terrain from which this art emerged, without ever losing its focus on the specific trajectory of Smith's work. Curator Richard Armstrong of New York's Whitney Museum of American Art, where the show had its debut in November, has chosen the survey well, and its catalog is a model of clarity. Even if you've closely followed the development of Smith's mature work during the past dozen years, the exhibition will answer lots of questions.

It's also magnificently installed. The big pyramid gallery at the entry opens with an expansive, 1981 installation mixing murals and collages, and based on the play and opera *Porgy and Bess*. (During the run of the show, Gershwin will be periodically played on a grand piano in the corner. You might wish to dance.) Next, the small pyramid gallery presents "Past Lives," an evocative 1989 installation collaboratively produced with poet Amy Gerstler. The gallery also includes two early collages from the 1970s, including the macaroni masterpiece. Smith is turning out to be among our most important public artists, and her development of a particular kind of installation work in the 1980s, with its sources in collage, is deftly announced in these first two rooms. The remainder of the show is installed in MoCA's south gallery—the big, devouring, gymnasiumlike space that has chewed up and spit out

Last Chance for Eden

most every show installed there before. Five more collage-mural installations are included, along with numerous examples of early work and full complements of the three thematic series of collages Smith made in the 1980s. The gallery looks first-rate.

The attention to presentation and display is important because it represents the hurdle Smith herself overcame in finding a workable means for making her art. The earliest object in the show is *Colorado* (1971), a loose-leaf book with collage pages. Soon, this book format got flattened out, its pages disassembled and lined up, one after the other, in a horizontal row encased in a Plexiglas frame. It never felt quite right, although Smith perceptively played with the form—the horizontal expanse becoming a roadway littered with expository trash, or a city skyline harboring bits of unfinished stories. But the format remained awkwardly suspended between the private world of a book, read by one person at a time, and the public world of the gallery wall, to which it aspired. *Hello Hollywood* (1980) was the breakthrough piece. While retaining popular literary narrative and collage, Smith here discarded the book motif. She turned instead to a preexisting, verbal-visual form: those Burma-Shave signs once ubiquitous along roadside America. Smith paired simple objects—a strip of celluloid, a postcard, a red-checked bow, a party-favor horseshoe—with an actual poem from the advertising series, and she put the collages in frames tilted forward, like a cartoon imitation of drive-by movement. Silhouettes of receding palm trees or telephone poles (it's been installed in different ways at different times) are painted on the walls, and a bale of hay completes the ensemble. "Hello, Hollywood/Goodby, Farm/It Gave McDonald/That Needed Charm/Burma-Shave." Recontextualized, content fuses with form. A cornball Burma-Shave poem is opened up to reveal a queer narrative of Modernist transformation, which records (and cheers on) the passage of an agrarian culture and the arrival of a phantasmagorical urban world, predicated on image consumption. You're invited to consider this rather heady revolution from your perch atop a hay bale—a slyly funny, rural riff on the contemporary sculptural convention of the Minimalist box.

Smith's not simply a popularizer of arcane avant-gardism. Instead, her commitment to collaging together visual and verbal languages—movies, romance novels, magazines, advertising, and such—claims a more surreptitious aim. Using pop culture as her model, she's the artist as seductress—Scheherezade the Storyteller, as the title of a 1976 performance piece plainly declared. Smith wants to get under your skin and take you for an imaginative ride. Her attachment to the myriad "debased" forms that exist outside the mainstream of artistic culture makes many people inside that mainstream nervous. But it points to something significant, to the inescapable ordinariness of art in a postindustrial world. As Los Angeles has always existed outside the high-cul-

ture mainstream, standing as a global symbol of modern cultural debasement, it's easy to see why Smith's art probably couldn't have been made in another place—and why it has the capacity to speak to just about anyone, anywhere.

The retrospective chronicles the development of two principal tributaries in Smith's work. While related, each has its own distinct qualities. One is the explosion of collage to environmental scale, transforming with order and insight the vague and chaotic experience of our contemporary image glut. This is the source of her significance as a public artist. Although a colossal installation such as *The Grand*—the remarkable 1982 renovation of a three-story lobby in a Grand Rapids, Michigan performing arts center—can only be included here in catalog photographs, the seven installations that are on view show her range and command. They culminate with the extraordinary *Same Old Paradise*, a 1987 CinemaScope mural with collage, for which a permanent home (preferably in this city) ought to be found straightaway. The other tributary is the elevation of collage to the traditional stature of painting, an equation Smith creates by embracing, rather than rejecting, painting's myriad historical conventions. Still life, portrait, landscape, history painting, allegory, religious narrative—it's hard to think of a single genre Smith has ignored. Perhaps the clearest sign of her approach is her enthusiastic revival of the picture frame, banished from most "serious" postwar painting. For Smith, the decorative frame is integral to the collage.

These dual tributaries share important features. To the Modernist conception of art as an arena for self-invention and re-creation, Smith has added an insistence on art considered in its broadest sense. And her conception of selfhood is not essentialist; instead, the self is an endlessly variable fabrication glued together from scavenged parts. Hence her anointment of collage as a major medium. Smith's 1975 macaroni collage-cum-homage to Charlie Chan always manages to remind me of a famous 1969 statement by artist Sol Lewitt: "Conceptual artists are mystics rather than rationalists," Lewitt wrote, in an influential manifesto published while Smith was still an art student. "They leap to conclusions that logic cannot reach." The exhibition demonstrates it's a sentiment with which Smith's work passionately agrees—and, simultaneously, with which it takes pointed issue. She knows that words can do a lot, but they can't cook rice.

Kiki Smith

July 7, 1991 Cadavers, sputum, blood, flesh, sweat, se-
men, tears, mucus—the subject of Kiki Smith's art is the awful vessel
called a human body. At a moment when the body has become the
focus of political warfare of extraordinarily divisive power, from AIDS
to abortion, her work can be arresting. Sometimes she crafts allusive sur-
rogates or metaphors, while at others she makes sculptures and drawings
that faithfully describe the human anatomy and its miraculous fluids.
In the 1991 Biennial Exhibition recently at New York's Whitney Museum
of American Art, Smith's sculpture was unusually compelling. Not only
did it stand out among work by more than two dozen artists not pre-
viously shown in any of the museum's typically controversial surveys,
it also held its own among sculptures by numerous others with long-
established reputations. Smith's delicate bust made from crumpled pa-
per, which gazed down from a high shelf like a ghostly apparition of a
Giacometti bronze, and her pair of life-size nude figures, exquisitely
crafted from painted beeswax, were among the most memorable pieces
in the show. Before the exhibition ended, the Whitney had acquired
the pair of nudes for its permanent collection.

Kiki Smith
Untitled (Sperm)
(detail)
1990

Although the Manhattan-based artist has been in nu-
merous group exhibitions in Europe and the United States in the last
eleven years, including shows with the prominent New York collective
of the early 1980s called COLAB, Smith has shown actively in solo venues
only since 1988. The selection of the thirty-six-year-old sculptor for
the Biennial no doubt arose from a widely noticed solo exhibition the
previous year at the Museum of Modern Art as part of its "Project" se-
ries focusing on new work by younger or lesser-known artists.

Two of the sculptures from the presentation at MoMA are
now in the collection of the Lannan Foundation, where they have joined
one other work by the artist in an exhibition called "Body/Language,"
drawn from among the foundation's recent acquisitions. (Sculpture and
drawings by Mike Kelley and photomurals by Mitchell Syrop complete

the show.) Together with a sculptural installation and a suite of nine draw-ings currently at the Shoshana Wayne Gallery in Santa Monica, which includes a bust somewhat similar to the Whitney example, they provide a brief but incisive introduction to Kiki Smith's art.

Recasting Giacometti in paper, as it were, explicitly de-clares a sensibility informed by traditions of modern sculpture, yet de-cidedly wary of them. The three sculptures at the Lannan Foundation are untitled, as is frequently the case with Smith's work, and all employ rather anomalous materials: glass that has been cast, etched or silvered; paper-thin sheets of dusty black rubber; translucent, apparently handmade Japanese paper that has been cast and colored with ink. Like the beeswax nudes, these substances are delicate, quietly elegant, and refined. As against the traditional imperatives of sculpture, which lean toward the durable and permanent, her materials embrace the fragile and essentially transitory. Their unabashed exquisiteness invites close personal perusal, but their shocking fragility signals danger and mortality.

The flashiest and most aggressively seductive piece in the Lannan show is made from three thin sheets of rubber, together about 6 feet square, which have been laid out on the floor in the center of the room. This rubber skin is the nominal pedestal for a swarm of 230 spermatozoa, each 6 to 8 inches long and made from hand-cast glass, which are arrayed in a circular configuration like a tightly swirling whirlpool. The surface of each translucent, crystal sperm is softly frosted, which gently traps refracted light inside the form. Surrounded by a soft glow, this interior pin-spot of illumination is like a generative nu-cleus within semen. At once icy cool, white hot, and vaguely wicked, Smith's spilled seed is radiant with onanistic pleasure.

Nearby, a dozen cylindrical glass bottles, each 27 inches tall and 15 inches in diameter, are lined up shoulder-to-shoulder atop a chest-high, altarlike pedestal. Corroded with age, and silvered inside to create an impenetrably mirrored surface, each sealed bottle is etched with a single German word, written in an archaic script: *Urin, Milch, Blut, Durchfall, Tranen, Eiter*, and so on. The list names fluids produced by the body—urine, milk, blood, diarrhea, tears, pus, etc.—a body that is doubly recalled by the glass bottles. Not only do their mirrored sur-faces reflect the viewer's presence, but an anthropomorphic associa-tion is inevitable for any vessel, as a quick regard for its common breakdown into neck, shoulder, body, and foot makes plain. The com-position of this sculptural tableau suggests everything from conventional depictions of the Last Supper in Western art to a stylized laboratory in a horror movie. Smith's use of German words (she was born in Nuremberg in 1954, and heard both German and English from her earliest years), coupled with the poetically ritualistic associations of the archaic script, creates all manner of pungent references for the sculpture. From the twelve plagues that rained down on Pharaoh to the apostles, a subtle

inflection of religious iconography is inescapable.

In a related vein, I've taken to thinking of Smith's "paper Giacomettis," which she places on shelves high up on the wall, as nondenominational yet nonetheless heavenly surrogates who gaze down on the follies of mere mortals below, rather like the ancient gods or rosy-cheeked cherubs hovering in the margins of Baroque altarpieces and Rococo ceilings. And having already reveled in the proscribed pleasures of onanism, you now get to play the cheery part of Judas to her twelve mirrored vessels: Reflected in the silver surface of the apostolic configuration, you are isolated on the outside trying to look in.

Coupled with the tactile sensuality of her chosen materials—the desire to touch the fragile paper skin, or to cradle a crystal sperm in your hand, is strong—an undercurrent of sexuality runs through most all of Smith's art. Sometimes, however, as in the installation called *Tears Come* at Shoshana Wayne Gallery, it cannot carry the weight that is asked of it. Composed from droplet shapes of delicate paper suspended from dowels, *Tears Come* is a tiered mobile paired with a weeping paper bust. The flickering union of sorrow and sexuality declared by the title is simply not carried by the whimsically airy mobile and the paper head, from which streams of paper tears coyly dangle. Bathos intrudes.

By contrast, her strongest sculpture coaxes forth complex questions of both morality and mortality—terms commonly pitted against one another for coercive effect. But she does not play a strong-arm game. Sex and flesh and death are simply givens. Smith avoids any moralistic preaching through a deft device: Highly particularized, her sculptures nonetheless have an oddly generic feel, as if they are individualized samples from a larger class, which have been assembled for your close analysis. They have the look of specimens. The laboratory bottles are an obvious example, but nowhere is this specimenlike quality more forceful than in her cadaverous body-sculptures. At the Lannan Foundation, a devastatingly beautiful, life-size body of what appears to be an elderly man, riddled with blue arteries and stained red ink, has been literally torn limb from limb. Hollow and collapsed, the head and torso, the severed legs, and dangling arms are push-pinned to the wall, like a dissected bullfrog to a specimen board. The naked pair of Whitney sculptures, which seem to have been cast in wax from molds taken from an actual man and woman, rather like full-body death masks, are similarly offered up as specimens for your inspection. Each is suspended at the armpits from a steel scaffold bolted to the floor, its dead weight viscerally conveyed.

There is nothing morbid or horrific about any of these carcasses. To the contrary, what's shocking is their poignancy, the sheer loveliness of the puddled blood beneath the waxy skin or the way the flayed limbs describe a sinuous curve in space. As a sculptor, Smith's most

remarkable gift is her capacity to impart a pungent sense of dignity and awe to a human body that is more commonly battered in a multitude of unspeakable ways.

Gary stephan

May 1986 When Vittore Carpaccio painted *Hunting on the Lagoon*, around 1490, he included a trompe l'oeil image of a letter rack on the reverse of the smallish panel (it's about 2½ feet square). There are hinge marks on this latter side, and their presence has led some to suggest that the panel originally saw practical use as an interior shutter for a window in a house. When the shutter was opened into the room, the trompe l'oeil letter rack would have appeared to be hanging on the adjacent wall. When it was closed, though, you could still have looked at the window and seen a view of bowmen on the glassy lagoons of Venice, standing in their boats and shooting at birds.

It's easy to see why Gary Stephan is attracted to this painting (a poster reproduction hangs on his studio wall). Although nowhere near as grand as Carpaccio's large narrative cycles, this small panel is packed with sharply observed incident worthy of a complex Venetian pageant. Also, the four boats and standing figures, rendered in luminous tonalities and softly brushy paint, describe a complex space by way of perspective grids set in fully volumetric counterpoint to one another. The glowing, glassy atmosphere manages to transform this potentially discordant composition into a seamless web of almost mystical clarity.

Gary Stephan
1 2 5 4 5 8
1985

At their best, Stephan's own paintings operate in a not dissimilar manner, constructing poetic visual narratives—perceptual pageants—through an excruciatingly complex and carefully calibrated array of formal means. In a Stephan painting, a figure can metamorphose into a ground, a structural element transmogrify into an optical haze of color, deep and atmospheric space sit on the surface of the canvas like

Last Chance for Eden

a sheet of wrinkled skin—all with a seeming effortlessness and normality. Your eye can enter any point in the topography and emerge elsewhere, dazzled, as if a million light years away. In an abstract manner, it's not unlike the seamless voyage from Britain to Brittany that Carpaccio later conjured in a single picture of Saint Ursula and her pagan prince.

Stephan's interest in El Greco, Tintoretto, Cézanne, and other historical painters of perceptual magic is well known, and I remembered the Carpaccio reproduction in his studio when I first saw the paintings he had made in 1966 while a student at the San Francisco Art Institute. There's no reason to believe he had seen the Carpaccio as a student of twenty-four (the painting didn't enter a public collection—the J. Paul Getty Museum in Malibu—until 1979), and less still to suspect he knew of its utilitarian function as a window shutter. Nonetheless, in an oil painting on an eccentrically shaped masonite panel whose inscription at the lower left reads "magic motor boat," Stephan made an image of a tiny vessel gliding between two gently rising islands toward a vast and grayly placid sea. The panel, chipped and abraded and featuring five prominent nail heads along its upper edge, appears to hang like a drape from a rusted curtain rod affixed to the top. More than likely, the sensibility already emerging in this student work led Stephan to embrace, years later, such pictures as *Hunting on the Lagoon*. Carpaccio, and others, had what Stephan increasingly came to know he wanted for himself. And in light of this much remarked upon historicism, it's worth taking the present pairing of work from 1985–86 and from 1966 as an opportunity to look at Stephan's relationship to his own history as a painter.

The curtain rod, nail heads, abraded surface, and eccentric shape of the masonite board in the "magic motor boat" painting all speak of a concerted, if rather awkward, insistence on the materiality of the painting as a physical object (the curtain rod even looks like a jerry-built handle with which you could carry the painting around, like some oversize briefcase). The undulation of the bottom edge of the panel, lower at the left than at the right, helps unfurl the vast space of the open sea toward which the tiny vessel is headed. At the same time, it forms a rhythmic, linear echo for the sinuous curves of the islands and for the water lapping at their shorelines. Finally, its objectifying function turns the ground of the painting itself into a figure set against the wall. Space, surface, and figure are simultaneously interwoven.

The emphatic horizontality of this painting—it's less than 2 feet high but more than 5 feet wide—accentuates its topographical spread in distinct contrast to the vertical position of the spectator to whom it is addressed. In asserting its objectness, its literal physicality and similarity to us, it also asserts its independence. The curtain-rod-cum-handle functions in a similar way, inviting us to pick up the panel while reminding us that the picture is but a view. Likewise, the attempt at a

pale, tonal luminosity of color, especially inflected at the horizon, the shorelines of the islands, and the wake of the boat, is poised against the palpable brush strokes and lightly "damaged" surface. Finally, the presence of a simplified, almost graphic seascape image—a startlingly precocious, if unintended, forecast of the New Image painting that would turn up elsewhere in the next decade—would seem to contradict the multiple signals of literal objecthood.

The "magic motor boat" painting gives off a host of conflicting cues, which together establish a kind of fragmentary order. It would take nearly a decade for Stephan to begin to harness those cues in a sophisticated way (things really started to take off with the "Garden Cycle" of 1975), but much of the perceptual and conceptual vocabulary of his mature work will be found in embryonic form in the student paintings from 1966. The emphatic assertion of literal objecthood in these eccentric early paintings obviously owes a good deal to the disruptive propositions of emergent Minimalism. In the years around 1970, Stephan elaborated that literalist drive through experiments with plastic, rubber, and latex, as well as through process-oriented methods for constructing paintings. Like a host of other artists, he was engaged in the materially based (and seemingly self-contradictory) activity of trying to make paintings that weren't really paintings. Although a firm grasp was exceeded, they reached toward the utmost degree of literalism in which shape, scale, contour, and edge could establish a kind of simultaneous figure-ground throughout all aspects of the painting. Eventually, even the thin washes of luminous color describing eccentric, quasi-architectural shapes in the "Garden Cycle" managed to wed materiality with that most elusive entity, light.

Among the ironies of Minimalist painting, one which began to make itself widely felt in the mid-1970s was the simple recognition that a cardinal feature of the "specific object" called a painting was that it occupied an obdurately fictive space. Sculpture could (and already had) come down off its pedestal, leaving behind the fictive realm from which it had acquired the privileged status of art. Painting couldn't. If sculpture could easily wedge itself somewhere between the natural landscape and the constructed world of architecture, thus acknowledging the presence of the spectator in a literal field, painting by its nature retained at least a nominal tie to the conventions of art. This literal occupation of fictive space meant that metaphor was an operative principle for painting, while illusions of visual depth were ineradicable.

Historical conventions, the fictive space and metaphorical possibilities of painting, and frank illusionism—all these opened up as possibilities to be mined. However awkwardly nascent, all had been present to some degree as well in Stephan's paintings from 1966; and all were to assume greater focus, complexity, and power in his subse-

Last Chance for Eden

quent work. He was hardly the only painter to sense these newly opened options or to participate in their extrusion and, finally, to take full advantage of them. (Almost all the best new painting of the past decade has been involved in, or at least benefited from, this heady recognition.) Yet in the virtual flood of images that soon was pouring out in the wake of the shift, Stephan is one of comparatively few to have done so in an utterly convincing mode of abstract painting. That he's managed this feat by cranking up illusionism—bane of traditional Modernist abstraction—to positively extraordinary heights is but one sure measure of the radical alterations accomplished by art in the last ten years.

This is not to say that the forms in his paintings don't incorporate figurative associations, as long as you take "figurative" in the broadest sense (Miró's peculiarly engaging cast of "personages" comes to mind as a precedent). Torsolike, cuplike, breastlike, trumpetlike—they assert a powerful and palpable presence while maintaining a completely fictional character. Because a solid can be perceived simultaneously as a void in his pictures, or a dark surface slip into a luminously shimmering space, these figurative cues can't be pinned down to any specific, earthbound referent. (Although emphatically conforming to Stephan's literalist imperative, they can be downright extraterrestrial in bearing.) Instead, they always seem to be reforming themselves; and when they do, everything else in the painting transmogrifies, too. Stephan turns each element inside out in some way in order to prevent it from embracing any unitary reading. An overtly erotic interpenetration of formal elements does mark several of the recent canvases in the present exhibition: They exude an oceanic sexiness, sometimes playful, sometimes threatening, always exciting. Still, they aren't "about sex." Your perceptual grasp of his figures is more like a glancing blow: Perceiving a form, your mind races toward the safe harbor of what it already knows in order to establish a confidently stabilizing connection, only to then turn sharply, skid wildly, and skitter right on by that original assumption.

In this way, Stephan's paintings elegantly refuse to allow for any sedimentary settling of meaning. Rather, they forcefully launch the possibility that meaning might accrue. Even if one didn't know about the artist's frequent adaptations of historicist iconography and color schemes, the intensely choreographed design of his paintings makes clear that natural accident, such as the "wrinkled skin" that sometimes occurs, plays a minor role in his painting while highly conscious choice assumes a prominent one. Chosen, evaluated, approved, and gathered on the canvas, each element of his work has been massaged through the filter that is culture. Like Carpaccio's multivalent shutter, and perhaps reflecting his own pre-1966 training as an industrial designer, Stephan's paintings are cultural objects of use. They plow open channels between known territories, unfurling vast and surprising spaces toward which your mind has been vigorously propelled. The illustra-

tive image of a magic motorboat setting out to sea has become, twenty years later, a truly perceptual odyssey. Stephan builds the boat, we must navigate the shoals.

wayne Thiebaud

January 19, 1986 The most compelling feature of Wayne Thiebaud's paintings is their vulgarity. Indeed, at a moment in the late 1950s when gassy, high-blown rhetoric could no longer sustain conviction, the degree of commonness he was soon to inject into the artistic enterprise functioned rather like a cold and bracing shower enforced on an overheated body. The plainspokenness of his work of the early 1960s is deceptive, however, for Thiebaud drew on a complex variety of formal and conceptual means to accomplish his aim. And once the task was completed, a rather surprising development occurred.

The retrospective exhibition of some seventy of Thiebaud's paintings and a dozen of his drawings currently at the Newport Harbor Art Museum is, like the body of work itself, a rather contradictory affair. Organized by San Francisco Museum of Modern Art curator Karen Tsujimoto, who also wrote the lengthy and informative biographical text in the accompanying catalog, the show presents Thiebaud as both pre-eminent realist painter and as formalist master. This dual reading is not necessarily erroneous. Yet it does pose certain fundamental questions that the exhibition seems content to ignore. After all, if the formalist program has sought to expunge from art all gross impurities, and if realism seeks to admit into art's precincts the gross impurities that characterize the data of social life, a body of work based on the harmonious integration of purity and impurity would seem to occupy a most unusual position.

Although half of the exhibition is devoted to Thiebaud's work of the past decade, his familiar still lifes of severe yet lusciously rendered cakes, pies, hot dogs, gumball machines, and cafeteria counters, begun around 1961, set the stage for all that has followed. Despite their familiarity, these early paintings retain an unsettling bizarreness. The application of the Modernist emblems of formality, abstraction, repetitiveness, flatness, order, and literalness to lemon meringue pies, neatly quartered club sandwiches, and five-and-dime toys was—and is—startling, precisely because of the fusion of rarefied artifice with realist subject matter. At the time, this strange cohabitation was immediately seen as a cathartic brand of social criticism, as a scathing indictment of the banality and repulsiveness of mass culture. Thiebaud never saw his paintings that way, nor, today, do we. Yet realist painting is, by its very nature, embedded within a web of sociality; and Thiebaud's early still lifes are most revealing in this regard.

As Tsujimoto notes in the exhibition catalog, the years from

1957 through 1960 were critical in Thiebaud's development. Although no pictures from this period are in the exhibition, the complex of forces at work are essential to an understanding of the artist's accomplishment. Having given up nearly a decade-old career as a cartoonist, illustrator, and commercial artist in both Los Angeles and the Bay Area, Thiebaud had come to his vocation relatively late (he began painting in 1950, at the age of thirty, and spent the next three years in school). Supporting himself as an art director in a Manhattan advertising agency, he spent 1956–57 in New York at the height of the Abstract Expressionist fervor. His subsequent return to Sacramento coincided with the budding acclaim proffered to Bay Area figurative painting, in which figurative motifs were wedded to Abstract Expressionist facture. Just as the Happenings of the late 1950s had done for Roy Lichtenstein, the environmental aspects of Bay Area painting (and perhaps of the concurrent development of assemblage) may well have provided a congenial atmosphere for Thiebaud's forays into the depiction of common objects.

Thiebaud's still lifes must be seen within the context of this complicated web. Perhaps the clearest way to grasp their startling effect is to recognize the use to which he put Abstract Expressionism's much vaunted "loaded brush." By the end of the decade the gestural brush stroke had indeed become loaded, a wholly conventional device for the representation of Expressionist autobiography filled with transcendent meaning. Thiebaud, however, applied that loaded brush to purely descriptive ends. Instead of a self-expressive utterance, a slathered stripe of brown became the filling of a pumpkin pie, a thick puddle of blue the shadow cast by a cake. The correspondence between an oleaginous smear of paint on the surface of a canvas and the icing on the cake depicted by the painting was perhaps the weirdest (if perversely effective) method imaginable for completely draining the Expressionist ethos from the gestural brush stroke. The loftily elevated experience of the Abstract Expressionist aesthetic came crashing down into the mundane data of the wholly commonplace.

This wholesale removal of the individuated self from the center of the art-making project was, of course, a central feature of the Pop art movement with which Thiebaud was initially grouped. (It was as if his still lifes replied to Pollock's assertion, "I am nature," through the cheerfully aggressive presentation of *nature morte*.) Blunt, mute, untranscendent, but nonetheless wryly allusive of "sustenance" in the use of foodstuffs as primary subject matter, these paintings constituted an assault on the newly established hierarchy in Modernist painting. In fact, Thiebaud's "descent" from the heights into the "lower orders" was threefold: In addition to mundane subject matter executed not on monumental canvases but in traditional easel paintings, he brought all the slick, facile, and base techniques of the commercial graphic artist to the high-art enterprise; finally—and this is where Thiebaud's work

departs from the Pop mode of Lichtenstein and Warhol—that trivial subject matter and that debased commercial technique were employed at the service of traditional realist painting. Against the prevailing rhetoric of Modernism's supposedly ineluctable drive toward an ever more refined pictorial abstraction, Thiebaud heretically embraced realism. As the tripartite installation of the retrospective exhibition makes plain, he has restricted his work of the last twenty-five years to the traditional realist categories of still life, figure painting, and landscape.

The literary critic J. P. Stern once perceptively described the central issue of realism as "the creative acknowledgment of the data of social life at a recognizable moment in history." Certainly, Thiebaud's democratizing realism should not be surprising in the social context of the 1960s, just as the birth of the nineteenth-century Realist (with a capital "R") movement in France, with its banishment of aristocratic and theocratic subject matter in favor of a central iconography of peasants and bourgeois citizens, was hardly accidental in the context of the Revolution of 1848. But the primary achievement of his work lies in its unstinting recognition of cultural politics, as embodied in the inevitable establishment of canons for art, as itself an intrinsic feature of the data of social life at any moment in history. Through their fusion of acceptable Modernist emblems and unacceptable devices, his early paintings held in dazzling tension the conflict between those "higher" and "lower" orders of experience. It was, I think, this feature of his work that was so strongly felt (if inappropriately articulated) by early champions of the social criticism said to be embodied in his art.

Because realism is the most conservative of artistic styles, the one most favorable to alteration of aesthetic tradition rather than to outright revolution, neither should the conservative nature of Thiebaud's subsequent work, so abundantly represented in the exhibition, come as a surprise. Ironically, given the apparent sea-change embodied in his paintings from the 1960s, it was not so much the demolition of a restrictive Modernist canon that turns out to have attracted Thiebaud as it was the opening of a small door through which he could slip his own particular interests into established procedure. For his work, as a whole, is fundamentally formalist in bearing. Whether landscape, figure painting, or still life, his is a purely stylistic exercise in pictorial problem-solving within the standard sphere of composition, color, scale, space, and light. To be sure, Thiebaud's gifts in this regard can be formidable, especially in several of the recent paintings evocative of San Francisco's vertiginous urban landscape. They exude a sense of bright and cheerful nausea, yet they're rather like hothouse flowers, devoid of the vivifying tensions that characterize the earlier work. Ultimately the retrospective reveals Thiebaud to be an artist of unique, if narrow, vision.

Tung Ch'i-ch'ang

July 18, 1992 In 1555, when Tung Ch'i-ch'ang was born in Shanghai, China, Michelangelo had just begun his Rondanini Pietà, Titian and Tintoretto were at work in Venice, and Pieter Brueghel had lately returned from Italy to paint in Antwerp. When Tung died eighty-one years later, in 1636, the names of Rembrandt, Poussin, and Velázquez were among those finding their rightful place as the most celebrated of European art. As a painter, Tung Ch'i-ch'ang was their equal. What's more, within the complex traditions of Chinese painting with ink and brush, he left a legacy that would reverberate through his culture more deeply than could be claimed by any single European in his. The radically conceived, immensely sophisticated hanging scrolls, albums, hand scrolls, and calligraphies he produced in the second half of his long life influenced the course of painting in China literally for centuries, inspiring followers and inciting detractors but never being ignored. Even more than Picasso for the modern West, Tung was, for the next 300 years, the standard.

Tung Ch'i-ch'ang
*The Ch'ing-Pien Mountain
in the Manner of Tung Yuan*
1617

A quietly astonishing exhibition at the Los Angeles County Museum of Art chronicles the unprecedented art and influence of this remarkable painter and critical theorist. Organized by Kansas City's Nelson-Atkins Museum of Art, where the show had its debut last April, "The Century of Tung Ch'i-ch'ang: 1555–1636" records a

high-stakes drama of warring factions in a vigorous struggle for artistic dominance. And an exciting, strangely modern drama it is.

A scholar, tutor, and Ming statesman born into a distinguished official family, Tung was an amateur painter and calligrapher, albeit one of unusual gifts. He understood the intricacies of traditional Chinese painting with brush and ink on silk or paper, in which writing and painting were bound together through sophisticated visual poetry. The pictorial depiction of landscape was intimately connected to the graceful, energetic characters of hand-written calligraphy. A modest landscape was not so modest after all. For through its particular disposition of styles and forms and its deft allusions to some revered precedents and not others, it could write a visual history of China for the present day, which would set the course for the future. At the age of forty-one, Tung the scholar-artist set out to challenge—and finally overthrow—what he considered the technically advanced but spiritually moribund painting of professional artists in his day. The show charts the seemingly sudden arrival of a controversial idea, and then its elaboration and dispersal throughout the culture.

"The Century of Tung Ch'i-ch'ang" is a large exhibition, featuring exceptional loans from the Shanghai Museum and the Beijing Palace Museum, many of which have never been seen in the United States. In addition, works have been borrowed from a host of other public and private collections. A landmark show, it will likely generate considerable debate among scholars of Chinese painting, who have never before had the opportunity to examine so much of Tung's work in one place, together with so many examples by artists who could not escape the pull of his powerful influence. To assist viewers in this sprawling, often difficult exhibition, a useful, color-coded system of display has been devised. Tung's paintings are mounted against red silk backing, those of his followers and contemporaries are mounted against blue-green silk. If Chinese painting is new to you, you might find it helpful to follow the red "silk road" first, getting a handle on Tung Ch'i-ch'ang, and then go back to compare his paintings to those displayed on blue-green.

Tung's earliest dated paintings are eight fan-shaped album leaves from 1596. For the most part, they carefully follow the exquisite styles of earlier masters, in traditional Chinese manner. The album displays Tung's skill in an immensely difficult medium in which, once drawn, a line cannot be erased. What happens next is shocking. Just one year later, Tung painted a hanging scroll that feels like a manifesto. It too recalls assorted precedents, but now they're mixed together in stark collisions of drawing styles, complete with daring leaps in scale, flickering shifts in space, and a radical jumble of disjunctive planes. Initially *Wan-Luan Thatched Hall* seems brutish and ugly—until you learn to read its wild and unprecedented syntax. An illusionistic evocation of landscape has been joined by a pyrotechnic display of the means

Last Chance for Eden

of painting—the limitless range of possibilities with line, form, shadow, light, composition, and movements of the brush—a display straining toward the virtuosic.

Tung is happy to make a peacocklike show of his scholarly erudition, but he's not just showing off. Instead, the boundless capacities and expansive refinements of the individual artist's mind begin to be asserted as equal to landscape painting's traditional emphasis on nature. In *Wan-Luan Thatched Hall,* nature is portrayed as the physical embodiment of perpetual change—and as a projection of mind. China, you could say, is now posited by Tung as the indivisible twin of the Chinese. The profoundly philosophical element of his art is matched by a deeply political thrust. This scholar-artist, who tutored two future emperors during his career in government service, makes one thing plain: As the people go, so China goes.

At least four layers reveal themselves in Tung's extraordinary work. There's the evocation of landscape, with its vitalist exaltation of Nature-as-change. There's scholarly erudition, in complex allusions to artist-ancestors. There's the eloquent presence of the individual artist, through his eccentric orchestration of the image. And there's the material beauty of painting itself, conveyed through the autonomy of the brush mark. In his greatest work Tung holds this breathtaking repertoire together in dynamic tension. If a Western equivalent could be cited, it might be necessary to leap forward in time some 250 years, to the paintings of Paul Cézanne.

No painting in the exhibition is greater or more dynamic than Tung's 1617 hanging scroll *The Ch'ing-Pien Mountain in the Manner of Tung Yüan,* from the Cleveland Museum of Art. *Ch'ing-Pien Mountain* is Tung's *Mont Sainte-Victoire.* It begins, at the bottom edge, with a feathery little tree standing on a hillock, which provides easy visual entry into the picture's otherwise complex space. The journey starts, crossing an open field and beginning the ascent into the foothills, passing a small cabin, then twisting up an ever-steeper mountain path across sharp ravines and around forested cliffs. Suddenly, halfway up the scroll, the space miraculously seems to turn inside out, as if you've gone inside the enveloping, crystalline structure of the rock itself, finally to emerge, at the top, on the mountain's peak. There, as you look up farther still, the mountain through which you have just passed miraculously rises before your eyes, disappearing into the misty sky.

As with Cézanne's art, the picture's seemingly impossible, contradictory multiple views can at first be daunting, a visual brick wall that stops perception dead in its tracks. Soon, though, your eye busts through the barrier of habit to wander freely in the extraordinary space Tung has opened. It's an exhilarating feeling—and probably just what Tung Ch'i-ch'ang had in mind.

Richard Tuttle

December 25, 1987 Richard Tuttle's new sculptures are exceedingly odd. They are also first-rate. In fact, when it comes to recent sculpture, this is about as good as it gets. In a world that has been dominated by painting for a very long time, Tuttle's new work, currently on view at BlumHelman Gallery, means to utter a direct and strong-minded claim in favor of sculpture. The artist has accomplished the task through a wickedly subversive and decidedly witty maneuver: He's made painting jump down off the wall and perform in the middle of the room, rather like a wandering gypsy who's stopped to sing for his supper.

Tuttle's half-dozen sculptures are constructed from a variety of unusual materials, including sheets of Jiffy-foam, which is ordinarily used as a packing material, and the coated, coarsely woven fabric normally used in bookbinding. However, the principal ingredients are lengths of wood and canvas—which is to say, the physical supports used to make a painting. The wooden strips are propped against each other, rather like the poles of a tepee, while the canvas has been cut, sewn, and draped over the apparatus. Sometimes the fabric suggests clothing on a skeletal person, sometimes upholstery on a piece of furniture. One sculpture might have the character of a grand and regal personage, as rendered by a gifted puppeteer, while another might suggest an odalisque reclining on a daybed. Still another might evoke a collective tribal encampment, or a whirling dervish.

Virtually none of Tuttle's sculptures is in any way explanatory or descriptive (each is simply titled with a number). Yet every one is marked by a distinct, and distinctive, personality. Part of what allows for this freewheeling imaginative experience is the scale of these sculptures. Not necessarily small, all of them are low-slung and, at most, barely waist-high. Given their often playful demeanor, as well as their clothed or padded skeletal structure, they tend to conjure up thoughts of toys, pets, or even frisky children. Looking down at one of these benign oddities, you want to pat it on the head—if only you could be sure it even had one.

Richard Tuttle
Four
1988

Last Chance for Eden

One of Tuttle's sculptures, composed of a cluster of te-
peelike forms, has the look of a private gathering of hooded figures. The
image puts one firmly in mind of the late paintings of Philip Guston,
which were so important to the whole rush toward a new concept of
figure painting in the last decade. When Tuttle's newfangled "paint-
ings" climbed down from the wall and set up camp in the middle of
the room, they took the figures with them. Without for a moment
giving up on the Minimalist articulation of structure and real space,
or on its staunch refusal of illusionism, the artist has fashioned sculptures
with powerful connotations of a figural masquerade. They also took
along painting's much-examined relation to language: In addition to
the pointed use of bookbinding material, Tuttle has decorated several
of these sculptures with abstract glyphs drawn in magic marker. This
is the kind of gallery show that doesn't get assembled much these days:
utterly modest and unassuming in bearing, yet rich and endlessly provoca-
tive in execution.

bill viola

August 4, 1985 The first thing recalled to mind by Bill Viola's
remarkable installation *The Theater of Memory* is the Romantic heritage
on which so much of modern Western culture has been built. Born of
a deep social and intellectual crisis that was turning the late eighteenth
century upside down, the Romantic ethos emerged as a volatile criticism
of, and a hopeful antidote to, the engulfing rationalist, empiricist, and util-
itarian undertow that was reshaping the framework of social life. No work
of art more fully captures that ethos than Caspar David Friedrich's fa-
mous *Monk by the Sea*, in which a tiny, lone figure on a cliff confronts
the awesome emptiness of earth, sea, and sky: He stands on the physical
and conceptual brink of some elemental and mystical experience.

Viola's installation, which is among the relatively few high-
lights of the Museum of Contemporary Art's current group exhibi-
tion, "Summer 1985: Nine Artists," likewise seeks to function as a volatile
criticism and hopeful antidote for our own conflicting time. *The Theater
of Memory* is a large, darkened room in which a focused spotlight illu-
minates the upended roots of a sizable dead tree lying horizontally on
the floor. Suspended from its branches are several dozen electric lanterns,
their light bulbs flickering on and off in unison like preprogrammed,
man-made fireflies. The room is warm, the air stale and tinged with
the odor of perspiration and drying wood. An oscillating electric fan gen-
erates a small and gentle breeze that rustles wind chimes hanging from
a branch, filling the musty air with a fragile, tinkling sound. The deli-
cacy of that sound is butted by the loud, crisp crackling and popping
of electronic static emanating from the amplified sound track of a video-

tape being projected onto a huge, wall-size screen at the far end of the room. Likewise, the videotape imagery is dominated by visual static—the "snow," vertical rolls, interference, and such one normally tries to banish from the TV screen at home—while recognizable, if mundane, pictures suddenly emerge from the abstract fuzziness at seemingly random moments: a clapboard building, a person drinking from a teacup, a girl walking, an automobile careening over a steep embankment, and so forth. These ghostly images linger only briefly before dissolving back into the static soup, rather like pictorial equivalents to the phosphorescent dots of light from which an ordinary television picture is made.

There is an apocalyptic tone to this highly theatrical environment. From an initial feeling of aggressive chaos and irreversible decay, an uncanny sense of poignant euphoria slowly takes over. The jittery, dissolving lights and sounds plug right into your nervous system, while the barren, melancholic landscape of the room begins to appear as a projection of your mind. It thus becomes a territory of potential regeneration.

Spotlighted and situated at the entrance to the room, the ruined tree receives our immediate attention, as it does so often in landscape paintings from Constable's and Cole's to Van Gogh's and Mondrian's. Yet their traditional attribution of human presence and feelings to this object of nature—what John Ruskin so famously described as the "pathetic fallacy"—does not apply. Rather, the dead tree assumes a kind of ancestral function: It is history, the source from which a technological age has isolated the primordial qualities of light, energy, and elemental matter in very different forms. Here, the pathetic fallacy is embedded in the electrical and magnetic sounds and sights of a wholly man-made landscape—the breeze of a fan, the flickering lamplights, the gathering storm clouds of video imagery.

It would perhaps be too much to claim that the artist has consciously adapted the iconographic symbols of traditional Romantic art for *The Theater of Memory*, so firmly embedded in our unconscious cultural memory are they; but it is worth noting that Viola's statements in the catalog accompanying the show are prefaced by a quote from the Romantic artist par excellence, William Blake: "If the doors to perception were cleansed, then everything would appear to man as it is—infinite." Whatever the case, that iconography assumes a central position of prominence—as it does as well in Viola's second installation, called *Room for St. John of the Cross*, and in such single-monitor videotapes as *Chott el-Djerid (A Portrait in Light and Heat)*, which are also on view at the museum—although it has been transposed in a fundamental way. The elemental forces and mysteries that a Romantic painter would have located in the world of nature—as a nostalgic, memory-ridden opposition to the newly arising scientific and industrial world—have here been absorbed into the conceptual world of the spectator.

Last Chance for Eden

It's as if the Romantic desire for intense identification with nature "out there" had been usurped by Viola's desire for an intense identification with nature "in here"—that is, with nature as the landscape of human thought and perception.

Bill Viola
The Theater of Memory
1985

Why is that shift so fundamentally necessary? The rationalist, empiricist, and utilitarian forces that today are reshaping the framework of social life have assumed the guise of high technology, and it's turning the late twentieth century upside down. (This is why, I would suspect, the artist has chosen the electronic apparatus of video as his primary medium.) Given the incomprehensible immensity of those forces and their obvious capacity for destruction on a universal scale, Viola's work seeks to expand thought and perception to a commensurate degree. It's as if he's attempting to equalize internal and external pressure in order to ward off explosion or collapse.

There is, finally, a spiritual component to Viola's art, as there is to all Romantic utterances. For the second thing recalled to mind by this subtle and complex installation is Plotinus's ancient admonition: Only by memory does the embodied soul possess an image of itself. In *The Theater of Memory* everything seems familiar, even though it's newly felt, and both qualities serve to center the experience within the spectator: The uncanny sense of euphoria that is generated comes both from the experience of the place and from the consciousness of that experience. As in a dream made palpable, it's a place you occupy and that occupies you.

Andy warhol

January 19, 1990 High name-recognition value certainly accompanies the show of early graphic work by the late Andy Warhol, which opens Sunday at the Newport Harbor Art Museum. For an art that grew from advertising, it's only fitting. Still, Pop art of the 1960s remains among the most widely misunderstood artistic movements of the twentieth

century. Despite the crowd-pleasing notoriety it has enjoyed almost from the very start—or, maybe because of all the raucous public clamor, which meant that Pop could easily bypass slower traffic on the road to posterity, thus annoying the art world's mandarin gatekeepers no end— resistance to clear-eyed examination remains surprisingly strong. The clearest sign of the confusion is that the two most common readings of the art are completely contradictory to one another. With its soup cans, comic strips, and sleek Hollywood glamour, Pop is claimed to be: (a) a buoyant celebration of the spectacular machinery of consumerism, advertising, and all the new visual languages of mass culture; or (b) a withering critique of the vacant soul of consumerism, advertising, and all the new visual languages of mass culture.

Andy Warhol
with Otto Fenn
Nose Job
1952

Only a fool would deny that popular culture has something to do with Pop art. Only a fool could deny that art culture has something to do with it too. In fact, it's turning out that Pop's great triumph emerged from its purposeful inquiry into the gassy, suffocating rhetoric that characterized American painting by the end of the 1950s. Arriving at a moment of nerve-wracking vacancy in the precincts of culture, Pop art assumed the role of Abstract Expressionism's pointed nemesis.

The great, sprawling retrospective of Andy Warhol's career mounted last year at New York's Museum of Modern Art offered one welcome occasion to rethink the Pop phenomenon. The mammoth show focused principally on Warhol's paintings of the 1960s. Some people groused, complaining that even so large an exhibition drew an incomplete profile of its subject, but I thought the choice was just right. Warhol, still respected only grudgingly, needed to be emphatically represented at his peak. At the Modern, painting after painting from the 1960s made the brilliance of his work virtually inescapable.

With its forceful emphasis, the show provided a perfect foil for still another shot of reexamination. The Grey Art Gallery at New York University assembled a compact survey of the dozen years Warhol

worked as a prosperous commercial artist. Unexpectedly, this gathering of mostly 1950s magazine graphics, newspaper advertisements, menu illustrations, fabric motifs, record-album covers, book jackets, Christmas card designs, and photographs of department store window-dressing treatments began to answer complex questions about where the great paintings of the 1960s, resplendently installed up the street at the Museum of Modern Art, had come from. "Success is a job in New York . . . : The Early Art and Business of Andy Warhol" became the sleeper hit of the Manhattan art season.

It's too bad the Warhol retrospective came nowhere near California on its international tour. "Success is a job in New York . . ." almost didn't make it, either. Thanks to some eleventh-hour juggling, however, the Newport Harbor Art Museum was able to squeeze the show into its schedule. Miss the exhibition only at your peril, for lots of interesting points of convergence between Warhol in the 1950s and his Pop efflorescence in the 1960s await amiable discovery. The funniest is in a 1952 photograph of the twenty-four-year-old artist, made with his art-director friend Otto Fenn. By overpainting with black ink, Warhol's profile is made sleek and model-handsome, transforming the ethnic features of his Carpatho-Czech ancestry into an all-American look. This wittily altered photograph anticipates by a decade the famous *Before and After* painting, based on a plastic-surgery advertisement for a nose job.

The opportunity to think about Warhol's Pop art in relation to his commercial work of the previous decade is surely welcome. But try examining his commercial art while keeping the contemporaneous backdrop of Abstract Expressionism firmly in mind. Therein lies the key to understanding Pop. The reason is that much Pop art of the early 1960s can be productively thought of as Abstract Expressionist ideas represented by commercial, graphic images. A gritty style of newspaper advertising is employed to that end, for example, in Roy Lichtenstein's 1962 paintings in the collection of the Museum of Contemporary Art. Lichtenstein's *Meat* shows a cut of raw beef. *Strong Hand (The Grip)* shows muscle-building equipment. *Desk Calendar* shows a daily notebook with appointments logged. Together, these "raw, muscular, autobiographical" paintings compose an imagistic anthology of value-laden Abstract Expressionist language, concocted to describe the earlier paintings of Jackson Pollock, Franz Kline, Willem de Kooning, and the rest. Then there's Edward Ruscha. Also at MoCA is his 1962 *Annie*, whose title is written in fluid maple syrup—a drip-painting if ever there was one.

As for Warhol, the critic Dave Hickey began a similar decoding in last summer's issue of the quarterly magazine *Parkett*. Most famously, the nearly interchangeable splash-and-dribble of paint in late Abstract Expressionism was colloquially known as "soup"—so commercial-artist Andy turned to Campbell's. The existential pain of the

Andy warhol

1950s became the spur for all manner of Andy's tabloid images of personal disaster—*129 Die!*—while his pictures of electric chairs pointedly included signs invoking Beckett's silence. Pollock's romantic legend had been heroically capped when the automobile he was driving smashed into a tree, so Warhol painted car crashes. Marilyn, Jackie, and Liz took turns playing the role of De Kooning's powerful women, while the energetic directive for the artist to get "inside" the painting, bodily, is played out as footstep pictures of dance diagrams. Once you get the hang of it, you can find Ab-Ex clichés all over the Pop map. Off the top of my head, I'd add to Hickey's list Warhol's enormous paintings of flowers, taken from a garden photograph in a seed catalog: With the old, abstract expanse of color across the canvas now replaced by grass and blossoms, they literally became the "field paintings" described in painterly rhetoric of the day.

The show coming to Newport Beach is fascinating because it puts the advertising processes of commercial art in the foreground, and they are at the core of Warhol's Pop strategy. His job, as a commercial artist, had been to find concise, compelling images with which to sell purely abstract concepts, such as "sophistication," "uniqueness," or "casual elegance." His new job, as a Pop artist, was to do the same for Abstract Expressionist concepts, such as "the tragic," "the sublime," or "the transcendent." Warhol's Pop sold the image of art—or, more precisely, sold the reigning American image of art in the 1950s.

Today, a generation after Abstract Expressionism's phenomenal rise to international prominence, it's hard to imagine just how inspiriting the situation must have been: For the first time ever, an American artist could be of international consequence. At least, some could. In his memoirs, the art dealer John Bernard Myers tells of painter Helen Frankenthaler's calculating decision in 1958 suddenly to leave his gallery: Her new husband, the influential artist Robert Motherwell, did not approve of his wife being represented by a homosexual. And in the Grey Art Gallery catalog, Trevor Fairbrother relates an incident in 1959 in which, for similar reasons, Warhol's paintings were rejected for a show at the prestigious Tanager Gallery: The macho, male-dominated milieu of the New York School, now legendary, couldn't exactly accommodate an effeminate gay fop like Warhol. The dissonance in "high art" subject matter shown as "low art" commercial imagery describes, in aesthetic terms, the conflict between Abstract Expressionism's grand, universalist rhetoric of existential freedom and the vulgar reality of its exclusionary social milieu. "Success is a job in New York…" reveals how Pop's most exalted subject is its eloquent drama of personal freedom.

Exhibitions, Events, Etc.

Miss Piggy and the Pietà

What Jim Henson does with Miss Piggy is not a hell of a lot different fundamentally than the Pietà. Both communicate ideas through sculpture using skills and materials one has in a particular historical period.

STEVE BREZZO, ACTING DIRECTOR, SAN DIEGO MUSEUM OF ART

December 13, 1979 This has been a very confusing decade. Amidst all the turmoil surrounding questions of power—political, nuclear, economic, social—there appears a rather curious phenomenon. American art museums are experiencing unprecedented success. That's right, *art* museums. Though I won't attempt to explain this state of affairs, it is a situation worth noting, since most Americans regard art as a benign pleasantry that somehow exists on a plateau far above the daily drudge of life in these United States. They've been lining up by the thousands to see the burial relics of King Tut and the storehouse treasures from Dresden, and will soon be doing the same to see the several hundred works left in the Picasso estate. And, if all predictions hold true, they'll be turning out in record numbers at the San Diego Museum of Art for the recently opened exhibition, "The Art of the Muppets."

I have been thinking, since I read Steve Brezzo's comments (cited above) in an August 17 interview in the *San Diego Union*, of the first and only time I saw Michelangelo's *Pietà*. It was at the 1964 World's Fair in Flushing Meadow, New York. I was thirteen, and the excitement was, for a kid from a small New England town, a mixture of awe and apprehension at the sheer magnitude of the event. High on everyone's list of things not to miss at the fair were the General Motors, Ford, and IBM pavilions, and a pilgrimage to see the *Pietà*. Some 4½ centuries after Michelangelo laid down his chisel, the marble sculpture had been carefully crated, rigged with a special flotation device (just in case its voyage across the Atlantic ran into trouble), and installed in the borough of Queens. I have no memory at all of what the Vatican pavilion housing the masterpiece was like, but the enormous line of people and the endless wait remain vivid. Inside the pavilion, alone on a stage amid diaphanous blue veils and thousands of sparkling lights, sat the Most Famous Sculpture in the World. Recorded hymns swelled in the air and spectators on multitiered moving sidewalks were transported past the masterpiece.

I knew, however, that I was not really seeing Michelangelo's *Pietà*. On that autumn day in 1964 I saw *our* Pietà, the Pietà of twentieth-century American consciousness, a legendary sculpture by a legendary artist that was everything a work of art with a capital "A" was supposed to be. It was impossible to see Michelangelo's *Pietà*— the neo-Platonic conception of "divine grace made flesh" executed by a fifteenth-century mind of genius—through the spectacle surrounding

it. What I saw was an image, a contemporary American mirage of high culture appropriately apotheosized in a technicolor heaven, an image that, by its very manner of presentation, had more to do with American popular culture than with any personal, spiritual, or cultural manifestations of the Italian Renaissance.

I recount this story because, in a roundabout way, it seems relevant to the current goings-on at the San Diego Museum of Art. The Muppets exhibition is indicative of a new philosophical drift toward making the museum popular ("opening it up to the public," in their public-relations lingo), and it also raises questions as to the place of popular art in an art museum.

The increasing popularity of art museums has led numerous people to point out that museum attendance in America now outranks attendance at sporting events. While this surprising information conveniently ignores the millions of spectators glued to their TV sets during football season, the fact remains that more people than ever before are visiting museums. The phenomenon, however, seems less related to a sudden aesthetic awakening in America than to a general scramble for government, corporate, and foundation money. In this era of budgetary restraints, museums have come under pressure to justify their expenditure of funds. Funding agencies are much more likely to underwrite art exhibitions when there are assurances that a sizable number of people will attend. The more people, the better the chances of funding. In some ways, the system functions in a manner not unlike the Nielsen ratings in television.

In the past, touring the San Diego Museum of Art has not exactly been a popular thing to do when in Balboa Park. Its collection is not outstanding, though there are a number of excellent works, and the exhibition program has been rather lackadaisical. Both of these situations doubtless have something to do with money problems. But Steve Brezzo, acting director of the museum for the past several months, plans to change all that by turning the museum into what he calls a "cultural recreation center," by "taking the step over the hurdle of elitism," and by dismissing the notion that a museum director is an "aesthetic ayatollah," dispensing notions of art and taste from on high. The new philosophical direction is clearly populist.

While a phrase like "aesthetic ayatollah" makes for good copy, it should not distract us from the fact that there is something disturbing at the root of this new direction. It stems from a misunderstanding of the term "elitism" and in fact displays a backhanded contempt for the very public the museum claims to serve. The term "elitist" has been so misused in our language that it is glibly tossed off as a synonym for "wealthy snob." A glance at any dictionary, however, reveals the true meaning of the word: "The finest, best, or most distinguished; the choicest part." For an art museum, the application of the term is

clear—and desirable. One might even say that, given the correct meaning of the word, the fostering of elitism is the museum's function and responsibility. Brezzo claims in the *Union* article that for too long museum directors have "assumed responsibility for dictating taste and serving as aesthetic censors for a community." The degree to which this statement is true or false is less important than its implication that elitism is a monolithic term. On the contrary, elitism is a pluralistic term, and it is part of the function of a democratic society to support as many elites as possible—whether in the arts, science, sports, entertainment, or whatever is of interest to the citizenry—and to provide access to those elites to as many people as possible.

Brezzo also states that the museum must answer "the needs of as many constituents as possible." This hackneyed gibberish from 1960s liberal politics is absurd. Aside from the fact that the number of people who "need" art is ridiculously small, there are basically only two things that a museum needs to do to function responsibly: to preserve and present works of art, and to offer assistance to the public that wishes to learn about art. These seemingly simple requirements are, however, quite complex. By taking the populist approach, Mr. Brezzo apparently hopes that many first-time visitors to the museum will simultaneously be exposed to other museum offerings—a Giorgione portrait, a Cotan still life, an O'Keeffe abstraction—as if wandering off into the galleries and gawking at a Toulouse-Lautrec will miraculously uplift the great unwashed masses. This notion of the museum-as-Lourdes insults the very audience the museum hopes to attract, by implying that if only these lowly, ignorant souls can be lured into the gallery, their narrow, atrophied little minds can be liberated.

So, how to get the people in? King Tut, the all-time greatest attraction, is gone, and was far too expensive for a small museum anyway. Enter the Muppets. If the art museum is to be popular, then bring in popular art. The Muppets are just about the most popular characters currently on television, and the recent *Muppet Movie* was a box-office bonanza. The San Diego Museum would like to cash in on that bonanza in a manner in which everybody wins: Trustees are always pleased at large crowds in the galleries; the corporate sponsor, Home Federal Savings and Loan, and potential funding sources for future endeavors will be gratified at the attendant publicity; Steve Brezzo's chances at being named director of the museum will not be hurt by a show that's a runaway hit; and thousands of San Diegans will have a fun day cavorting with Kermit and Fozzie Bear and Big Bird. Only one element is missing that would make this a textbook example of the perfect show: The illumination of art is nowhere to be found in the proceedings.

In the history of what we call art museums, the fine arts have held the central focus of attention. Painting, sculpture, and related arts were joined, in this century, by exhibitions of folk art, the work of

skillful, untrained amateurs that bore an interesting relationship to the strange-looking works of modern artists. Concurrent with the development of modern art in the nineteenth and twentieth centuries, there appeared a new form, an art that grew out of the media: newspaper illustrations, magazine pictures, the movies, television. The popular arts, arts for "the people," have been one of the most extraordinary developments of the modern age, and one of the most maligned. Museums have traditionally been loathe to admit this "poor relation" into their home, succumbing for the most part only to film series and popular photography, with an occasional show of record-jacket design to add a bit of daring. This is an unfortunate situation, since what better forum for all the arts—fine, folk, and popular—than an art museum? The San Diego Museum's foray into the realm of popular art would be an adventurous, forward-looking move if it were not for one thing: The museum has done everything possible to pretend that the Muppets are *not* popular art.

In the October issue of *San Diego Magazine*, Steve Brezzo intones, "It's an interesting philosophical argument, whether the Muppets are popular culture or not." Well, it's not an "interesting argument" at all; it's a fact. In the *Union* quotation that precedes this essay, Brezzo makes the obviously foolish claim that Miss Piggy and the *Pietà* are both "sculptures" that tell us something about their respective cultures. Using this reasoning, that Pet Rock you got last Christmas is heir to the Venus de Milo. In the October issue of the museum's own publication, *Calendar*, Martin Petersen went to great pains tracing puppetry back to the fifth century B.C. in a valiant, if rather embarrassing, attempt to legitimize the Muppet exhibition with a history. This technique is not new (early twentieth-century Modernist painters tried the same approach); but it smacks of displaced royalty wailing about the historical validity of the divine right of kings. Vase painting was art in the context of Periclean Athens, but Corelle LivingWare is not art in the context of contemporary America. Similarity, it has been wisely said, does not imply connection. All of this nonsense about making the Muppets into fine art, using the flimsiest of rationalizations, does not bode well for the future endeavors of the museum. Miss Piggy may or may not hold the same public devotion in our culture that the *Pietà* held in Renaissance Rome, but the nature of *art* in our age is decidedly different from what it was in the fifteenth century. This elemental confusion—comparing apples to oranges—is disgraceful for an institution charged with educating the public. Museum exhibitions dealing with popular art are new and risky endeavors, therefore requiring great skill for those pioneers in the field who wish to devise illuminating methods of presentation. The San Diego Museum has balked at the prospect (and the challenge) by attempting to sidestep the whole issue; they have simply declared the Muppets to be "fine art." What was it that Brezzo was saying about aesthetic ayatollahs passing judgment from on high?

If Miss Piggy is, in the view of the San Diego Museum of Art, the modern *Pietà*, then perhaps the museum is not unlike the World's Fair. The fair is essentially an international trade exhibition, a market-centered complex designed to push products and tourism in a setting of grand popular entertainment. Back in 1964, the *Pietà* was as much a part of the entertainment as a chance to ride in a new Ford convertible or make a telephone call on a futuristic Bell "picturephone." Christ may have once been in the temple to banish the money changers, but this time He was "Appearing Nitely in the Main Lounge." That market-centered pressures now determine values in art was made quite clear in Andy Warhol's 1962 paintings of one-dollar bills. That these same market-centered pressures now determine values in the San Diego Museum of Art has been made quite clear in the 1979 exhibition "The Art of the Muppets."

American Portraiture in the Grand Manner

November 29, 1981 When Lady Diana Spencer's official portrait was unveiled in London several weeks before The Wedding, it elicited gasps from some and guffaws from others. As a quaint example of the long outdated genre of formal portraiture, the painting became absurd in the face of an ever mounting flood of media images of the next Mrs. Prince of Wales. The portrait also broke with the genre's tradition of depicting the sitter in a stately manner appropriate to her position in society—there Lady Di casually sat, dressed in informal attire. Like the future Queen of England herself, the painting had one foot firmly planted in tradition—a grand-manner portrait that functions as a mode of formal public address—and the other foot firmly planted in the present: a *People* magazine format of capturing the celebrity at home.

One rarely sees formal portraiture these days, with the possible exception of those usually half-length, business-suited, cookie-cutter figures that line the board rooms of corporate America. Yet the genre has a long and fascinating history in this country, a history that unfolds in an engrossing exhibition called "American Portraiture in the Grand Manner: 1720–1920," on view at the Los Angeles County Museum of Art. Organized by LACMA's curator of American art, Michael Quick, this exhibition of seventy-four works from a long-neglected artistic tradition is, with a few small reservations, an absorbing chronicle of 200 years of American aristocracy, how it saw itself, and how it wished to be seen by others.

It is sometimes difficult to remember that these eighteenth- and nineteenth-century paintings functioned primarily as means of public address. Grand-manner portraits presented an idealized pub-

lic image whose complex symbols and iconography could be readily de-
coded by contemporaneous audiences. Thomas Sully's 1811 portrait of
stage actor Frederick Cooke dressed as Shakespeare's Richard III can
serve as a metaphor for the other works in the show: These are char-
acters acting out a social narrative, self-cast players whose choice of cos-
tumes, props, and stage sets have been well-considered by both patron
and artist, for these accoutrements must speak for the mute, painted faces.

John Singleton Copley
*Sir William Pepperrell
and His Family*
1778

The "public" to which most of these paintings spoke,
however, did not mean "everybody," but a particular social class, usu-
ally aristocrats. This audience could be counted upon to read the elab-
orately coded messages of these paintings: the little lap dog that meant
fidelity in John Smibert's 1730 portrait of Mrs. Nathaniel Cunningham;
the fountain symbolizing virginal purity in John Singleton Copley's
painting of Mrs. Daniel Sargent thirty years later; the globe at the feet
of Henry Clay, in John Neagle's 1843 work, that is turned to South
America and wrapped in a billowing American flag—a symbol of the
orator's defense of the region's independence from European rule; and
the stone porthole from which John Oliver stares, a convention signi-
fying posthumous portraiture in Rembrandt Peale's 1824 work. Among
the most commonly used symbols that tied these Americans to European
traditions of aristocratic portraiture are the heavy drapery and austere,
colossal columns that echo the upright standing figures in Gerardus
Duyckinck's *Pierre Van Cortlandt*, Joseph Blackburn's *Benning Wentworth*,
Benjamin West's *Gov. James Hamilton*, Charles Willson Peale's *Conrad
Gerard*, Gilbert Stuart's famous *George Washington*, and several others.

Despite their frequency, these coded messages are to-
day readable mainly to the scholar rather than to the general museum
visitor. Yet the often enormous scale of these paintings is ready evidence
to anyone of the expense involved in both materials and labor and, hence,
of the wealth of the patrons for whom they were painted. One might
marvel at Copley's rather haughty evocation of the Holy Family with
John the Baptist as his choice of composition for the central grouping

of mom, dad, and the kids in the monumental *Sir William Pepperrell and His Family*, but the artist's skill in rendering the sumptuous stuff of satin, pearls, gold braid, and velvet no doubt accounted for a good deal of his acclaim among members of Boston's social set.

What makes these paintings examples of "public" address, however, is not just grand scale, grandiose theme, and placement in formal houses or public buildings. They are public because they are not simply statements made by singular, individual artists, but are creations of a whole society—of patron, of artist, of the values of the audience. These works of art were the visible locus of a complex of social elements. However celebrated the individual artist may have become, the public nature of most of these works proscribed the possibility of their becoming products of a purely individual creative act.

In the exhibition, the three superb paintings by Thomas Eakins are the earliest indication that the public thrust of such portraiture was beginning to crack. The readable signs are still present—the machinery on and under the desk of engineer William Marks, the conductor's baton and bouquet of roses in *The Concert Singer*, the black robes of the Order of Hermits of St. Augustine worn by Sebastiano Cardinal Matinelli—but in each case the figure is oddly out of joint with the formality of the portrait. Locked in an almost timeless, mathematically organized space that acts as quiet but tense counterpoint to the specificity of the moment which Eakins captures, the public address of the grand-manner style is wedded to the private introspection in which each figure—and the artist—is engaged. It is significant that none of these three paintings was commissioned by the sitter, but that all were executed from Eakins's own desire.

The Eakins portraits date from about the last decade of the nineteenth century, and the crack in the conventions of grand-manner portraiture that these works embody rapidly splits into a veritable chasm filled with sterility and fluffy pomposity. The final galleries end the exhibition with a whimper—Cecilia Beaux offers Mrs. Larz Anderson as a vacuous, pigeon-breasted creampuff, while Edmund Tarbell's *Marshall Foch* is as stilted and awkward as portraiture could possibly be. Indeed, one would trade in most of the last dozen or so paintings for a chance to glimpse John Singer Sargent's *Four Daughters of Edward Boit* or James Whistler's *Thomas Carlyle*, both absent from the show. (Sargent—with the exception of LACMA's own *Mrs. Edward Davis and Her Son, Livingston*—and Whistler are not well-represented here.)

The excellent catalog which accompanies the show has much useful information but contains a curious passage. The acknowledgments thank a collector for providing funds that allowed all the works in the exhibition to be reproduced in color. There follows a statement of regret that the collector's "acquisition of Dennis Bunker's [portrait of] *Anne Page* occurred too late in the process of publishing the cata-

logue for the painting to be discussed…as fully as its beauty and importance require." A four-page addendum to the book is included—with an entry on the painting that is longer than those on Copley and Eakins combined—more than making up for the omission. While one must be grateful to the donors for their generosity, referring to this pleasant 1887 picture as "among the most beautiful of American portraits" and going on to claim that with it, "American art came of age," is nothing short of ludicrous. One could argue, in fact, that its adherence to grand-manner principles is vastly overshadowed by its reference to a private, domestic scene, its quiet modesty, its passive innocence and sensuality. The painting is more neighborly than public.

This provocative and often illuminating exhibition conjures up two, perhaps interrelated, questions. Why did the need for grand-manner portraits, and their concomitant status as forms of public address, die out around the turn of the century? And why does this long-ignored aspect of American art suddenly seem so significant?

Perhaps the answer to the first question lies in what the late critic Amy Goldin once described as "our disbelief in the reality of the public world." With the rapid expansion of the media in the twentieth century, almost everything public became suspect. The control of public imagery by an aristocracy eroded, and public address was replaced by public relations. In the process, we increasingly assumed that public statements told us what we were supposed to believe, while we generally knew that the truth could be found elsewhere. "We expect the 'real' man to be the one we are not allowed to see," Goldin observed, "the one his mistress knows, or his tax consultant. The man at his most private." One looks askance at Joseph DeCamp's solemn and dignified 1908 portrait of Theodore Roosevelt, a quiet, tonal composition, all grays and pinks. This pensive public image is hardly the blustering imperialist of the "real" man chronicled in the press. We read the painting with the same doubt as we would a promotional press release.

This condition of disbelief in the public world is pervasive today, a condition no doubt reflected in the wealth of good contemporary art that addresses private needs, and in the dearth of good public art. However pompous one considers Copley's rendition of the Pepperells as the Holy Family to be, the painting speaks of an active, functional social contract among subject, audience, and artist. It should not be surprising that, at a time when art that can function in a public world is least available, our desire for it should be so strong. At least part of that yearning is satisfied, it seems, by "American Portraiture in the Grand Manner."

Exile

June 2, 1982 The apparent resolution of the controversy surrounding the proposed building design for the nascent Museum of Contemporary Art comes as exceedingly good news. In what appears to have been a classic case of too many cooks spoiling the stew, MoCA's five-man architecture committee had been functioning as a kind of coarchitect along with the project's designated architect Arata Isozaki. Now that a new working relationship has been established between Isozaki and the museum, things are expected to go along more smoothly.

Central to the dispute that erupted two months ago was the thorny issue of the quality of the gallery spaces: What is the ideal situation for viewing contemporary art? It is a question that has plagued many museums. Max Palevsky, MoCA trustee and chairman of its architecture committee, had insisted that the museum's focus of attention should be on the art it housed, not on the house itself. What was needed, he commented, was a building that would function as a "neutral backdrop."

The dispute raised two important and related questions: What considerations come into play when considering an environment for looking at art? And is a "neutral backdrop" one of them?

A clue to the answers to those questions can be found in a very unlikely place. A highly unusual new gallery that goes by the name Exile opened several weeks ago in downtown Los Angeles. Functioning as an artist-run co-op and operating on a shoestring budget, Exile is the very antithesis of the "neutral backdrop" philosophy that has come to dominate our expectations of the ideal qualities for an art gallery. It has been said that, more than any particular style, subject, or point of view advanced by modern art itself, it is the blank, pristine, cleanly lighted, white-walled gallery that is the common denominator of twentieth-century art. Virtually every commercial gallery in Los Angeles (and most everywhere else, for that matter) that deals in contemporary art is a variation on this traditional "white cube." Exile, on the other hand, is an old, run-down storefront whose back room once served as a machine shop. Located at 100 Winston Street, just off Skid Row, the building's exterior is distinguished mainly by the heavy, steel security grating that is usually left half-closed even when the gallery is open; an unassuming, hand-lettered sign hangs above the door.

Flying in the face of conventional wisdom, the interior of the gallery has been left pretty much as it was when its present occupants moved in. The walls are a drab, institutional green caked with years of grime and enlivened with graffiti. Cracking plaster and gaping holes left from a previous exhibition still dot the rooms. A large garage door takes up most of one wall in the back exhibition space, although it doesn't quite sit flush on the concrete floor; consequently, assorted flotsam and some rather unpleasant odors drift in from the alley outside.

Rudimentary illumination is provided by standard fluorescent lights and jerry-built spotlights. Exile is clearly not the comfortable, homogenized white cube that typifies the contemporary gallery. What is remarkable about it, however, is that the art on view suffers not a bit from the environment. Exile is so *unlike* every other contemporary gallery space that just walking into the environment gets your senses going—which is not a bad "backdrop" for the perceptual demands of looking at art. The gallery has such a particularized, vivifying character all its own that it surprisingly works to the benefit of the art on view.

There is, I would suggest, no such thing as a neutral backdrop. Even the traditional white cube is a loaded environment, functioning as it does as a kind of aesthetic sensory deprivation chamber. By removing any internal distractions and making art the focal point, it is supposed that the white-walled gallery will allow the qualities of the *art* to become more vivid.

It is no accident that the white-cube format for a gallery emerged in tandem with the art of the twentieth century. As sculpture came down off its pedestal and paintings cast off their heavy gold frames, the pure, idealized space of the white cube appeared on the scene to signal that what it housed was special, unique, and decidedly different from the random variegation of the street. Art, after all, is not the same as life, and it was the white-walled gallery that identified the special realm in which art existed. Far from being a neutral backdrop, the white cube came to function as the frame or pedestal that the art had cast off. Oddly enough, this traditional assumption is reversed at Exile: While the pristine blankness of the former intends to sharpen the qualities of the art being viewed, the uniqueness of the latter tends to sharpen the qualities of the viewer's perception. Exile functions as a frame or pedestal for the viewer.

The considerations involved in creating any environment for viewing art, while admittedly complex, still focus on just two factors. One of those, as Max Palevsky aptly pointed out, is the art that will be viewed. The other, as the extreme contrast between Exile and the traditional white cube makes clear, is the audience that will be doing the viewing. The art that MoCA will house simply needs the basic hardware of appropriate shelter, light, and space. The audience that MoCA will house needs a place with a highly particularized sense of character that distinguishes itself from contemporary homogeneity. When considering the environment for viewing art, the art only needs a building; the audience, on the other hand, needs architecture.

Authentic Reproductions

June 20, 1982 About six miles from Wilmington, in the Du Pont fiefdom called Delaware, stands a great country home, largely built

Last Chance for Eden

in this century, that houses the Henry Francis du Pont Winterthur Museum. Surrounded by a stunning 950-acre park, Winterthur's more than 190 domestic period-rooms contain an unparalleled collection of American decorative arts—furniture, silver, pewter, textiles, porcelain, wall coverings, as well as numerous paintings and prints—primarily from the eighteenth century. So comprehensive is the scope of the collection (particularly in the Queen Anne, Chippendale, and Federal periods) that the museum has received the rare designation as an "advanced study center" from the National Endowment for the Humanities.

Given its unique position within the historical study of American cultural life, it is with great dismay that one learns that Winterthur has leaped headlong into the repro biz. Scores of authorized reproductions (or, in the museum's peculiarly contradictory choice of words, "authentic reproductions") of 202 objects selected from the museum's collection of nearly 60,000 antiques are now being marketed through retail outlets across the country. Like many museums, Winterthur is facing mounting deficits. So, in an effort to stabilize the institution's financial base, the museum decided two years ago to license firms in the United States and abroad to replicate objects in its collection. The items chosen for the Winterthur Reproductions Program include an eight-panel, chinoiserie scenic wallpaper, circa 1770–90; an early eighteenth-century Queen Anne mirror crowned by a gilt phoenix; a "tree of life"-patterned cotton chintz fabric; a set of six mid-eighteenth-century sterling silver tankards by Paul Revere; and a late-eighteenth-century mahogany "tall clock." The museum has even had the Canvasback Art Company prepare chromo-lithographic reproductions of John Trumbull's 1790 painting *George Washington at Verplanck's Point.* The picture was, according to a museum spokesman, "Martha's favorite." Winterthur's annual budget is more than $8 million, and it is hoped that revenues from the sale of these reproductions— which range in price from $30 for a small brass box to more than $12,000 for a mahogany desk and bookcase—will offset decreasing income from beleaguered grant sources and the drain of inflation. But one wonders whether the enormous cost of the program, in terms other than financial, will balance the potential monetary income.

The Metropolitan Museum of Art in New York has been cranking out repros for several years, spurred by the commercial bonanza that surrounded the "Treasures of Tutankhamun." Shortly thereafter, Nelson Rockefeller cloned parts of his collection and opened a "gallery" on Manhattan's 57th Street. Like Winterthur, both took great pains to engage "the finest craftsmen," to establish "rigorous attention to detail," and to maintain "meticulous quality controls." All reproductions are carefully—even proudly—stamped with the sponsoring institution's name to ensure us that this is not an attempt at fakery. I, for one, am already convinced it's not. As a matter of fact, these reproductions are

about as genuine an expression of late-twentieth-century popular culture as I can think of. It is the very falseness of a Queen Anne mirror or a Paul Revere tankard made in 1982 in exact imitation of an eighteenth-century one that makes it "genuine" for our age. It is the practice of engaging the craftsman—whose skill of hand and eye is traditionally translated into the highly personalized expression of the handcrafted object—to execute the utterly impersonal duplicate that speaks so tellingly of our culture and its values.

The history of Western culture is replete with periods in which styles from the past were actively recycled through contemporary visions. Winterthur itself is filled, for example, with objects spawned by an early American rage for the "classical" which has been transformed into a contemporary idiom. So it is with the Winterthur Reproduction Program, in which eighteenth-century America gets the contemporary once-over. The replicated objects in the collection speak of the relentless urge of the modern age to substitute the essential reality with the reality of appearances.

In justifying its means for dealing with a legitimate financial need, the museum has claimed it is "extending to more people the opportunity to enjoy an intimate association with objects that have a history rich in American tradition." (Unmentioned, of course, is the fact that the $400 tossed after an artificial Trumbull painting or the $12,000 spent on a copy of a desk could buy a not insignificant amount of real art and antiques.) This is, in short, a populist justification for the viability of reproductions, based on the modern, and very American, notion of providing wider access to treasures previously restricted by rarity or cost. It is not a new claim. In 1857, the English critic John Ruskin asked whether "good art, as well as other good things," ought to be reproduced as cheaply as possible to be within reach of everyone. He decided not, arguing essentially that the resulting familiarity would inevitably breed contempt. In the 1930s, the German critic Walter Benjamin asserted that the authenticity, the authority—what he termed the "aura" born of creation in a particular place at a particular time— was lost in a reproduction.

I don't think I agree with Ruskin's attitude of familiarity breeding contempt, at least as far as art is concerned. And reproductions themselves have their own peculiar aura, born of the particular place and time in which they are made. The decorative arts, like the very concept of making reproductions, are one aspect of the popular culture of an era, whether it is the narrow range of taste of an aristocracy or the broader appeal of the mass world. The aura of Winterthur reproductions is not eighteenth-century aristocratic America but twentieth-century pop culture. Indeed, in the year 2082 it would seem entirely appropriate for a museum to display a historical "1982 period room" composed entirely from Winterthur reproductions.

The museum's actual collection consists of decorative arts made almost entirely in a preindustrial society. Paradoxically, its reproductions of that collection partake of the values of a postindustrial society. These "authentic reproductions" are the art-world equivalent of the TV docudrama, real events rewritten and restaged for your pleasure and consumption.

What is most disheartening about this program is the museum's very assertion that it is giving greater access to eighteenth-century art through marketing copies. For the American tradition with which Winterthur is giving consumers "intimate associations" has nothing to do with the history of the particular decorative art objects on which they're modeled, and everything to do with the history of spectral appearances being sold as substance. These ersatz antiques are a kind of aesthetic snake oil. While it would be a tragedy if the Winterthur Museum were unable to keep its fiscal head above the inflationary waters, one must ask whether the best way to balance the books is to run counter to the very purpose of the museum itself. If art museums have any function at all, it is to preserve, even to celebrate, the authenticity of experience that is the lifeblood of art. It is most assuredly not the museum's function to convince us of the bogus claim that the reproduction is the next best thing to being there.

otis clay

september 29, 1982 Among the facets of Los Angeles art that might best be described as having entered a mythic realm are the remarkable developments that occurred in the ceramics studios of the Otis Art Institute in the years following Peter Voulkos's 1954 appointment to the school's faculty. On one hand, this is entirely appropriate: The work of Voulkos and his students—Paul Soldner, Ken Price, John Mason, Billy Al Bengston, and others—forms a good deal of the foundation upon which rests this city's reputation as an important center for art. On the other hand, however, the myth has fallen prey to a less desirable situation: It has generated ill-founded and uncritically held beliefs about the work produced.

The simple reason for the latter is that individual ceramic pieces from the period are now largely unavailable for public perusal and rarely seen in any quantity. No museum in this city owns or regularly displays a significant collection of this watershed production (the Mr. and Mrs. Fred S. Marer Collection, generally regarded as the finest assemblage of these ceramics, is housed at Scripps College in Claremont, but it is not on permanent view), and, to my knowledge, the last full-scale examination of this fecund period took the form of an exhibition mounted more than fifteen years ago.

If for no other reason than this, "Otis Clay: The Revolutionary Years, 1954–1964"—an exhibition of nearly forty pieces by nine artists on view at the Garth Clark Gallery—would be worth seeing. As it is, however, the gallery's generally excellent selection of works (more than half are borrowed from other galleries and private collections, including the Marer collection, for the occasion) makes this small sampling of even greater import. Indeed, "Otis Clay" is, for me, something of a myth-buster.

I have been careful thus far not to use either of the common terms that have been widely applied to Otis Clay: "Abstract Expressionist ceramics" and "ceramic sculpture." The connotations of both, it seems, lie precisely within those ill-founded, uncritically held beliefs—the negative side of the myth—that the actual works in the show dispute. For while it cannot be denied that a good deal of this ceramic work was created with a concern for sculptural values and an awareness of contemporaneous developments in Abstract Expressionist painting, the "revolution" which occurred at Otis in the late 1950s is not to be found in ceramics attempting to mimic the conventions—longheld or newly won—of either sculpture or painting. Rather, it was a revolution within the traditions of pottery itself.

The painterly influences evident in many of these pieces are fairly diverse. Both a plate and a 13-inch vase by Bengston are enlivened with figurative decorations—a female head and fluid nudes, respectively—whose style clearly derives from Picasso, while the galactic interlace of abstract, biomorphic shapes on Henry Takemoto's small platter and large *Floor Pot* owe a significant debt to Joan Miró. (Not surprisingly, both Picasso and Miró were themselves making pots in the early 1950s.) Further, Jerry Rothman's three *Sky Pots*—boxy forms standing on pedestals—are covered with abstract landscape motifs reminiscent of the delicate colors and images of painter William Baziotes, or even Milton Avery. In these and other cases, the surface of the ceramic vessel is approached almost independently, the way the surface of a sheet of paper or a canvas would be: primarily as the ground for a pictorial rendition.

Likewise, the sculptural manipulations of the clay forms in this show range from Michael Frimkess's elegantly mingled allu-

Last Chance for Eden

sions to ancient Greek and traditional Western European pottery to John Mason's compelling, foot-high *Red Vase*, a vessel which has been formed by vigorous slicing, gouging, and buckling of the clay. In most instances, the potter's wheel has been abandoned in favor of hand-building methods, resulting in forms with a distinct, rough-hewn, often quirky presence. A twin preoccupation with painterly surfaces and sculptural forms, then, is indeed evident in these works, and only rarely does one take precedence over the other. But more importantly, these preoccupations are hardly unique to Western traditions of pottery-making.

What becomes clear in the best works in the show, however—in an exceptional *Vase with Two Handles* by Voulkos, for instance, as well as in several small cups by Price—is the way in which painterly surfaces and sculptural forms are not harmoniously integrated with one other, as the traditions of Western pottery have generally dictated. Instead they are intentionally played against one another, in order to establish a distinct tension between surface and form.

Voulkos's vase, for instance, is a thick, almost clumsy, muscular form that seems to swell and erupt; it even splits apart at the neck. Counterpoised to this straining at the seams is a fluid, delicate, white and pale-celadon glaze that runs and drips and puddles across the irregular surface. In a similar contrast, but with wholly different means, Price's oddly swollen little cups—the recurrent shape is a bit like a bulbous, doubly pointed flatiron—are glazed with playfully familiar, two-dimensional emblems: a brightly colored chevron adorns one, and a mottled sign that reads "Downey Motors 2" decorates another. In pitting muscularity of form against fragility of surface, or idiosyncratic three-dimensional form against familiar two-dimensional shape, Voulkos and Price achieve works whose internal elements compete with one another for our attention; they assume an ambiguous life and personality all their own. It is this latter quality which, despite their physically small size, endows these works with a monumental feeling.

The sense of life and personality in the best Otis Clay is perhaps closer in sensibility (if not in style) to a Japanese aesthetic of raku ware than to traditions of European or American pottery. But it is within the traditions of pottery itself—not painting or sculpture— that the Otis "revolution" occurred. No doubt the still-lingering pejorative connotation of craft (as a lesser art form) has contributed to the sculpturally and painterly inflected use of the terms "ceramic sculpture" and "Abstract Expressionist ceramics" to endow Otis Clay with the status of painting and sculpture. If the prejudices against ceramics continue to recede, however, that myth should likewise disappear.

the vatican collections

Like most ungainly behemoths that at-
tempt to fly, "The Vatican Collections: The Papacy and Art" has landed
here in San Francisco with a resounding "thud!" Through the clouds
of "firsts," "biggests," and "mosts" kicked up by the publicity apparatus
accompanying this supposed blockbuster, it is initially difficult to see
clearly this selection of works of art from the papacy's assorted collec-
tions, gathered since the founding of Old St. Peter's in A.D. 313. However,
when the dust begins to settle about halfway through the galleries, one
easily overlooked facet of the exhibition begins to come into view: It's
really not very good at all. Indeed, it may be enough to say that, in
matters of art, the popes have been far from infallible in their activities.

Nearly 1.5 million visitors have already viewed the highly
publicized exhibition during its run in New York and Chicago, and
another 750,000 are expected to troop through the M.H. de Young
Memorial Museum in Golden Gate Park. Almost everyone must by now
be aware that it is the *first* large-scale loan show ever sent abroad by
the Vatican; that it received the *biggest* organizational grant ever given
to a museum by a corporation ($3 million); and that it is the *most* ex-
pensive show ever mounted ($8 million). What might be its least apparent
quality, then, is that while ostensibly a chronicle of the history of pa-
pal patronage, the exhibition seems to represent, more than anything
else, a marriage between desire and need.

Pope John Paul II, whose blessing was necessary be-
fore the exhibition could take place, has been accurately and affec-
tionately called "The Traveling Pope." He perceives his role to be that
of a shepherd who must actively tend to his flock wherever they may
be, rather than passively waiting for the flock to come to him. That
the Catholic Church in America has been experiencing difficulties rang-
ing from the dwindling ranks of priests to mounting disinterest among
the young toward religion is well known. Thus, it appears that the Vatican
wishes this exhibition to function as a kind of goodwill emissary to
the United States.

For the Metropolitan Museum of Art, which originated
the show, it seems more an expression of bloated need—the kind of need
a junkie experiences. The addiction to blockbuster exhibitions has been
decried in many ways for many years, but the ravages it produces have
never been clearer than they are now. To put it bluntly, it speaks of plain,
old-fashioned greed. As the first-ever loan show from the Vatican, the
exhibition takes as its primary organizational motive the need of the
museum to garner yet another coup: They said it couldn't be done!

Well, they were right. It couldn't. For one indisputable
fact concerning the activities of the popes as patrons and collectors of
art for lo these many centuries is that in only two areas have the re-

sults been distinguished. The first is in the field of classical antiquities, a collection largely assembled in the eighteenth century and now housed in the Museo Pio-Clementino; selections from these holdings form one small part of the current exhibition. The second consists of architecture and architecture-bound works, ranging from St. Peter's itself to the glorious frescoes, sculptures, and decorations in various places within the Vatican; these present certain problems for travel. So, much of what one encounters at the DeYoung is frankly second-rate, from thirteenth-century champlevé-enamel reliefs of remarkable clumsiness to an eighteenth-century portrait of Pius VI by Pompeo Batoni, a very popular artist in his time who is eminently forgettable today. In the distressing case of almost all the tribal sculptures and twentieth-century "religious" paintings, the work is utterly last-rate. (These latter are placed at the end of the show, providing a suitably dismal finale to the enterprise.) The less than sterling quality of most of the offerings may be what prompted the decision to organize the exhibition chronologically—not by the date of the work but by the period of its acquisition by the Vatican. Deflecting our attention toward the succession of popes and their reasons for collecting at least has the virtue of distracting us from the art.

To be sure, there are some interesting if minor works by great artists (Fra Angelico, Bernini, and Raphael, in particular). And there are a very few truly great works: the stunning, Raphael-designed tapestry *The Miraculous Draught of Fishes*, which shimmers in the reflected light of a thousand-thousand silver-gilt threads; the powerful and highly influential Greek sculpture-fragment (of Hercules?) known as *The Belvedere Torso*; Matisse's beautifully orchestrated cut-paper collage *The Tree of Life*, which is a full-size maquette for the stained-glass window of his chapel at Venice; and Caravaggio's extraordinarily moving Baroque masterpiece, *The Deposition*. Yet, even here the museum has managed to interfere with the art. Apparently newly varnished, the large *Deposition* has been illuminated by spotlights in such a manner that, regardless of where one stands in the gallery, the upper register is obliterated by light-reflections glancing off its surface.

"The Vatican Collections," however, is neither a benign nor an idle travesty; would that we could escape with as much. Rather, it's aggressively touted junk food for the eye, the mind, and the soul. Falsely trumpeted as "a most extraordinary distillation and synthesis of some of the highest moments of human artistic achievement" (to quote from the catalog), the exhibition attempts to steamroll the audience. Consider the *Apollo Belvedere*, the once-famous Roman marble copy of a fourth-century-B.C. bronze. While to our eyes today the luminous figure of an Olympian god appears stiff and mechanistic, when it was unearthed during the antiquities-mad fifteenth century it was instantly hailed as the greatest sculpture in existence. Dürer used it as a model for a figure of Christ, Rubens in his cycle of paintings glorify-

ing Marie de' Medici. Goethe praised it to the heavens on a trip to Rome, and J. J. Winkelmann declared it the embodiment of "the highest ideal of art." Even the American Benjamin West turned to Apollo as the model for a heroic portrait of a Mohawk Indian. But what does the *Apollo Belvedere* mean to us today? Bereft of the tradition of classical education—a tradition with which Dürer, Rubens, Goethe, and the rest were intimately acquainted—we are utterly illiterate when faced with this marble man. We cannot read the sculpture's language except in formally descriptive terms: It is imposing, painstakingly carved, finely detailed, and elegant. Emptied of meaning, these hollow forms and our hollow perceptions wait to be filled. And they are, by a twittering chorus of firsts, biggests, and mosts sung by the trinity of museum, corporate sponsor, and church.

There has been some grumbling over the decision to send this traveling show to San Francisco rather than Los Angeles, site of perhaps the largest Catholic diocese in the country. All such complaints should herewith cease. Indeed, it may be an opportune moment to begin to count our humble blessings.

Nuremberg: A Renaissance City

February 26, 1984 Nuremberg is not the city that leaps to mind when the Renaissance comes up in conversation. Its most distinguished native son (and lifelong resident) was Albrecht Dürer, an artist most certainly to be reckoned with, while its temporary residents and visitors included the estimably bizarre painter Hans Baldung Grien, and the dizzyingly romantic artist Albrecht Altdorfer. Yet beyond these three, names such as Hans Springinklee, Wolf Traut, and Valentin Siebenbuerger ring very few bells.

There is good reason to reform that situation, and a recently opened exhibition at the UC Santa Barbara University Art Museum does indeed seek to raise Nuremberg from its now relatively obscure ranks and place it among the great cities of the Renaissance. With a population of some 40,000 in 1500—the year that prophecy had decreed would bring the apocalypse—Nuremberg stood near the Germanic center of the more than 100 autonomous political units under the nominal rule of the Holy Roman Empire. The emperors Maximilian I and Charles V reigned over an unprecedented period of economic growth and of the cultural expansion that so often follows such a period. "Nuremberg: A Renaissance City, 1500–1618," chronicles that expansion. Jeffrey Chipps Smith, who originally organized the exhibition for the Archer M. Huntington Art Gallery at the University of Texas, Austin, asserts in the informative gallery guide that accompanies the show: "[No] other German city produced as many major artists in as many fields

and no other city enjoyed the same long-term influence as Nuremberg."

Alas, the exhibition itself does not match the force of those words. They may well be true, but the more than 200 works that constitute the show—a few paintings and drawings, several small sculptures and decorative objects, numerous medallions, and, most abundantly, engravings, woodcuts, and other examples of the printer's art—leave one initially puzzled over the claims that are being made. The reason is not the general level of quality of much of the work on view. There are, to cite only the most important group, more than thirty prints and drawings by Dürer. This extraordinary assemblage alone is worth the visit, including as it does such well-known and highly significant prints as *Adam and Eve, Knight, Death, and the Devil, St. Jerome in His Study, Melancholia I*, and two from *The Apocalypse*, as well as a less familiar but exquisite ink study, *Four Heads in Profile*, and the highly influential *Treatise on Human Proportions*.

Albrecht Dürer
Knight, Death, and the Devil
1513

Nor is there a failure of strictly art-historical exegesis in this decidedly scholarly exhibition. Both the show and its handsome, hardbound catalog examine life in the city, the function of religious art and its alterations within the Lutheran Reformation, the rise of humanism and the impact of Italian art, and Dürer's central position within the cultural life of the city in the pivotal decades before and after 1500. Yet surprisingly scant attention is paid to perhaps the most fascinating, influential, and—especially for our own time—important feature of the period. For a very strong claim can be made that Nuremberg was, in the modern sense, the first major production-and-distribution center for artistic images. Unlike other Germanic cities such as Heidelberg and Vienna, Nuremberg had no great university. What it did have was a central geographic position along the major trade routes of the day. And it had Albrecht Dürer, too, a learned and highly cultured man who sought to make his art not only the embodiment of his most profoundly held beliefs, but a committed vehicle for their dissemination

as well. Regardless of any other claims one might wish to make for his genius—and there are many that can be deftly made—Dürer stands alone as the first important artist to take the unprecedented step of making prints his primary medium.

A print, of course, is a reproducible image. Unlike the unique and singular painting, with an edition of prints essentially the same image could be in Venice, in Flanders, in Vienna, and dozens of other places at the same moment. It could be incorporated into a book in order to reinforce, and to be reinforced by, the printed word, a word made possible by Gutenberg and others only fifty years before. Neither was it restricted to single ownership and thus to centralized power, but offered itself instead to multiple owners and broadly decentralized influence. Engravings were limited to the pocketbooks of the wealthier burgher, but the woodcut was available to those of more modest means. For these and other reasons, the most remarkable feature of the print was that it presented itself as a revolutionary political tool.

Printmaking, as the abundance of such works in the exhibition attests, became a virtual light industry in Nuremberg. The ability of prints to reach vast audiences—popular or sophisticated, literate or not—was not lost on Dürer and others. A few years before the prophesied doom, he issued both Latin and German editions of his now-famous book *The Apocalypse*, in order to take advantage of widespread interest in the subject. Along with other important features, *The Apocalypse* was the first publication of its kind to be wholly produced and executed under the auspices of a single artist: It was the first artist's book. Among its contents (and on view in the show) is *The Babylonian Whore*, a woodcut in which the temptress sits astride a seven-headed monster and entices kings and powerful merchants to their destruction. It was the publication and popularity of images such as this that eventually led to Nuremberg's official adoption of Lutheranism nearly three decades later. For the *Ninety-Five Theses* that Martin Luther nailed on the door of the castle-church in Wittenberg in 1517 turned on a single premise: Distrust false prophets, heed only the Word. Lutheranism gave to ordinary, individual men the burden and the responsibility of faith, and the print—reproducible, multiple, decentralized—played a crucial role in laying the groundwork for that Reformation. When Dürer issued his brilliant print *St. Jerome in His Study* in 1514—a technical masterpiece that married the traditional linearity of an engraving with the atmospheric tonalities of painting—the force of individual contemplation of "the Word" was powerfully made. And it was made equally by the image contained in the print and by the object of the print itself.

While the exhibition offers a wealth of information concerning its subject, much of this revolutionary sense is lost. (It should be noted that the role of mass-produced imagery is discussed in the book-length catalog, albeit usually in snippets.) Yet to my mind, it is the sin-

gle most important reason to restore Nuremberg to a position of prominence in the evolution of Renaissance thought.

MOCA: A New Museum for Los Angeles

April 1984 The first thing that must be said about "The First Show" is simply that it happened. For the inaugural exhibition at the Museum of Contemporary Art in Los Angeles accomplished two significant feats, beside which almost any critical complaints grow pale: First, it brought together more postwar art worth looking at than has been seen in Los Angeles since the launching of the Marshall Plan; and second, it brought to a resounding end the museum's interminable gestation period, a protracted incubation that lasted nearly four years. To consider "The First Show" as one might any large exhibition presents certain difficulties, however, since this particular gathering of paintings, sculptures, and installations is not a rigorous examination of a particular body of work. Rather, it is the temporary mounting of a hypothetical permanent collection for a museum, drawn solely from the holdings of private collectors. The exhibition and its accompanying catalog wholeheartedly seek to champion a cause identified and embraced by MoCA: The subject of "The First Show" is the wisdom and the efficacy of art collecting, both for private individuals and for public institutions. As a new museum largely without a collection of its own, and as a highly visible institution in a city not noted for the vibrant depth and breadth of private collections of contemporary art, MoCA has assumed for its debut an unabashedly propagandistic role. It has been said that art museums are the great churches of the twentieth century and, in a manner not unlike Pope Gregory xv's founding of the Congregatio de Propaganda Fide in the seventeenth century, this museum has forthrightly established jurisdiction over a missionary territory.

"We do not consider it our job to force contemporary art in one direction or another through propaganda or patronage," curator James Thrall Soby said of New York's Museum of Modern Art in 1944. MoCA, on the other hand, has aggressively adopted both approaches. Prior to the opening of "The First Show," the museum unveiled its first major event, a performance called "Available Light," which was commissioned for the occasion from choreographer Lucinda Childs, composer John Adams, architect Frank O. Gehry, and others. In its first two outings, then, MoCA has put propaganda and patronage at the forefront of its agenda. The question that lingers is whether such an agenda does indeed "force" (to use Soby's word) or at least restrict contemporary art, thus contributing to the manufacture of an academic culture. Certainly it does (it always has), but the prospects are neither as sinister nor even as programmatic as they are often supposed to be. For

the radically altered relationships between art and the larger social or-
der that have come about, often tumultuously, during the last forty years
have primarily conspired to alter drastically the scale of the proceedings.

Consider the Museum of Modern Art's own birthright
on that fateful afternoon in May 1929, when the idea for such an in-
stitution was presented to A. Conger Goodyear at a tea party hosted
by Lizzie P. Bliss, Abby Aldrich Rockefeller, and Mary Quinn Sullivan.
A scant five months later MoMA opened in temporary quarters with an
unknown young man named Alfred Barr at the helm and an exhibi-
tion of four of the founding fathers of art in this century—Cézanne,
Gauguin, Seurat, and Van Gogh—happily installed in its galleries. Crucial
to these rapidly unfolding events, however, was the condition of relative
public indifference within which avant-garde art then existed. Certainly
MoMA's inaugural exhibition attracted thousands (as did subsequent en-
deavors), but modern art was still very much an aberration in the minds
of most Americans. When it did come into their line of vision, it was
open to charges ranging from charlatanism to advancing a Communist
plot. More often it was simply ignored. Even a landmark show such as
the 1932 "Modern Architecture: International Exhibition"—which ush-
ered in the International Style and played a pivotal role in changing
the face of built-America—was among the most poorly attended of-
ferings of the young institution.

Of MoMA's own "first show," Henry McBride wrote
in the columns of the *New York Sun*:

> This enterprise, so long and so devoutly wished, is so large
> in its promises and so positive in its present attainments, that
> it seems to have come full-blown upon us over night. It truly
> makes us rub our eyes now that we have gone such a jour-
> ney to see that we have arrived at the destination. And the ex-
> hibition is so incontestably serious and so impressively alive
> that the astonishment will now be general that so many fences
> had been erected to keep this art from the public.

Quite the same sentiments could be applied to the debut of the Museum
of Contemporary Art, yet this infant has been born into a very differ-
ent world. No longer is it unheard of, or even uncommon, for an artist
in the current or recent vanguard to be widely venerated. Legions of ob-
servers now stand poised to pounce on whatever the latest trend might
be, or even to invent one. Federal, state, and local agencies are con-
vinced to a greater degree than ever before of the efficacy of offering
aid to art and artists, while galleries and museums are now widely seen
as effective tools in the social and economic rehabilitation of cities (as
witnessed by MoCA's own birthright as a linchpin within the urban
redevelopment plan for downtown Los Angeles). The list of such rela-
tively recent developments is long, and one is tempted to wonder when

the public will begin to demand that some fences be built in order to keep the onrushing flood of art away. Be that as it may, if the Museum of Modern Art came into being despite the public's general indifference, the Museum of Contemporary Art has come into being precisely for the satisfaction of public hankerings. For this reason, it is incontestably true that, had MoMA's inaugural been a resounding flop, it would have been unfortunate but hardly calamitous. Had MoCA's failed, the wreckage would still be spewing smoke and flames.

In the fallout of the explosion known as the 1960s, typified by the appearance of an art called Pop, culture of all kinds began to be transformed into a raucous spectator sport. Whether the burgeoning audience engages in critical examination or in stupefied genuflection does not alter the fact that artists today experiment, evolve, fail, and succeed under the vigilant eye of a curious and growing public. The dizzying rise of this spectator audience has fostered a new form of criticism that is indistinguishable from publicity. It has led to vigorous denunciations of playing to the crowd and to dithering charges of crass commercialism. It has witnessed the creation of some exceptional art while sweeping away the possibility of there even being an avant-garde. Not least of all, the instant insertion of new art into the roaring mainstream has sounded the death knell of Modernism. For an ineluctable feature of what it means to be Postmodern is to stand in the glare of the spotlight at center stage.

Los Angeles has a certain affinity for spotlights: It is no accident that the first buds of art's efflorescence shot forth here in the 1960s, nor that four of the city's five significant museums have been built since 1965. As the single institution to concern itself solely with postwar art—the very art which in many ways chronicles these radical alterations—MoCA has thus arrived at a moment of critical mass. In the cold heat of the spotlight, the performer just making its debut in "The First Show" has been experimenting, evolving, failing, and succeeding under the vigilant eye of the public since its moment of conception nearly four years ago.

Spotlights distort. They flatten features and drain color from whatever falls within the scope of their blinding light. Like much art of the past few years, MoCA has responded to this situation not through a refusal to accept its existence but through aggressive posturing, hyperopia, and excessive coloration. Since the idea for a new museum was first broached in 1979, its progress has seemed at times like an archly stylized outtake from *The Cabinet of Dr. Caligari*: Pontus Hulten was suddenly named director of the museum-idea and just as suddenly resigned the post; architect Arata Isozaki unveiled a model for the museum's permanent building, to be completed in 1986, then confided to a reporter that he was terribly distressed by the very plan he had just presented; financing collapsed for the $1-billion redevelopment pro-

ject that would provide MoCA with the land and the resources with which to build, then was rescued from the breach as a sequence of more modest "phases" that would begin with the new museum; just as the squabbles over the architectural plan appeared to have been resolved, the trustee chairing the building committee quit in disapproval. As these and other scenes flashed by, the steady spotlight continued to shine, casting every success or failure, however grand or insignificant, into excessively stylized patterns of high slapstick or low melodrama. Perhaps the most bizarre aspect of watching MoCA's extended and convoluted gestation was simply that no museum existed. There was stationery adorned with the museum's name, an office identified by a sign on the door, a telephone number listed in the directory, legal contracts and pledges, periodic press conferences, a growing and changing staff and board of trustees—but there was no museum. It seemed, at times, like the apotheosis of Conceptual art.

"The First Show" happened on November 20, 1983, and with it, MoCA happened too. The coming together of the omnipresent spotlight (complete with the added weight of a mysterious persona created over the course of nearly four years' time) and of an actual exhibition of often exceptional art was startling. While drawn from eight private collections in Europe and the United States (including the distinguished holdings of Dominique de Menil, Howard and Jean Lipman, Drs. Peter and Irene Ludwig, Giuseppe and Giovanna Panza di Biumo, Robert Rowan, Charles and Doris Saatchi, Taft and Rita Schreiber, and the Weisman family), the exhibition is installed in a loosely chronological fashion in the manner of most permanent public collections. As a result, the exhibition fosters the odd sense that the Museum of Contemporary Art has long been a prominent feature of the Los Angeles landscape: It radiates instant venerability.

To be sure, this effect is illusory. But it is not inopportune for the inaugural exhibition of a young institution whose brief life has followed a rocky path in a city whose flirtations with the art of our time have, on the whole, rarely led to fruitful consummation. "The First Show: Painting and Sculpture from Eight Collections, 1940–1980" consists of 149 paintings, sculptures, and installations, most by American and European artists who range from Old Masters (Willem de Kooning, Piet Mondrian, Jackson Pollock) to young blood (David Amico, Mike Kelley, Julian Schnabel). The chronology of "isms" represented leads from Neoplasticism to Neoexpressionism, while the alphabetical listing begins with Josef Albers and ends with Wols (Alfred Otto Wolfgang Schulze). Nowhere else can one see several installations (of varying quality) by Los Angeles artists associated with the phenomenological genre awkwardly known as Light and Space. The Pop art selections constitute a thumbnail anthology of the movement, while the intermingling of Abstract Expressionist paintings from several collections is generally ex-

cellent, particularly since Pollock, De Kooning, Mark Rothko, and Clyfford Still are each represented by more than one fine example. Certainly, a very long list could be made of very good artists whose work won't be found in this survey. (Most remarkable, given the locale of the museum, is that Edward Ruscha is unrepresented.) One also might assume that Picasso had died in 1939 on the evidence of this exhibition, devoted as it is to chronicling "the new." The installation, alas, is frequently unsatisfactory, despite Frank Gehry's spectacularly beautiful renovation of the two warehouses that serve as MoCA's temporary facility. (The 50,000-square-foot museum is industrially elegant, with a steel-trussed ceiling of redwood decking, wire-glass skylights, a south-facing clerestory, and an outdoor gallery of steel I-beams topped with chain-link fencing and spanning an asphalt cul-de-sac.) In the most egregious case, Richard Serra's massive steel wall, *Strike* (1969–71), is installed in a newly built room whose walls are much too low.

 If there is a larger drawback to the show, it is to be found in the attempt to do too much. Most notably, the two tiers to the exhibition—one an examination of collecting by private individuals, the other of institutional collecting—are awkwardly laid atop one another. The roughly chronological installation serves to obscure the sense of the eight collections as discrete entities. As a result, one is faced with an incomplete survey of the last forty years and without a clear sense of the individual motives and sensibilities of the collectors. It's not difficult to discern why this path was chosen. For the attempt to do too much is simply a feature of that elaborate confluence of factors that is bringing the museum into being, while doubling as a response to the broad and variegated audience it wishes to attract. "The First Show" must sell itself—and MoCA, too—to a host of constituencies, and what sells is what is most comfortably accessible and pleasantly familiar. At bottom, "The First Show" seeks to drive home a simple and uncomplicated message: Collecting art is good.

 As recently as a decade ago, one could have pointed to any number of artists who would not only have taken issue with that statement, but who actively devoted considerable energies to making art that might, in some way, challenge the very concept. The weakest element in MoCA's advancement of this simple message is its unwillingness to engage in a critical examination and dissection of the thorny relationships between postwar art and the marketplace. The catalog essays by curator Julia Brown, founding director Pontus Hulten, and art historian Susan C. Larsen are largely paeans to the enterprise; the remaining interviews with the eight collectors are often interesting but hardly challenging. (When Howard Lipman provocatively declares, "Everybody for whom I have no respect likes to be known as a collector," the unidentified interviewer merely asks him to suggest another title.) Nor are there ruminations on behalf of the museum as a col-

lecting institution and of the artist as "collectee." In assuming what amounts to a social issue as the subject for its debut, the museum has quite clearly begun with a definitive answer and then worked backward to fill in the docket. Along the way, strange things occur. For instance, at least a half-dozen paintings are encased in Plexiglas boxes. As in the case of Barnett Newman's *Onement vi* (1953), the box utterly obscures the picture. Having no painting to look at, one begins to consider the Plexiglas box: It signifies the need for protection, the necessity that the art be protected from *you*. Not being able to see the painting also transfers attention to the label on the wall and its pairing of the name of a celebrated artist with that of the picture's celebrated owner. Armed with this information (it's conveniently provided in English, Spanish, and Japanese) and faced with the reflective surface of the Plexiglas box, the subject of *Onement vi* becomes the audience's visible proximity to fame, to wealth, and to received greatness.

That sense of proximity, of course, is the fundamental resource on which museums have traditionally drawn in order to bring themselves from the far territory of an idea into the domain of actuality. It fueled the Museum of Modern Art in 1929, and it is fueling the Museum of Contemporary Art today. MoCA may have endured extreme gyrations during its four-year evolution, but they have merely been part and parcel of those which now characterize the larger world. "The First Show," like MoMA's inaugural exhibition fifty-four years earlier, is a safe show. Yet before the idea of a museum devoted to the art of our time had become a common fixture of our cultural life, MoMA had to invent itself by embracing the founding fathers of art in this century. Now that such institutions have assumed a position of prominence at center stage, MoCA has had to be set in motion by embracing the very foundation upon which rests the modern idea of a museum itself.

The Olympic Art Fiasco

October 1984 At the finish of the sprawling, multidisciplinary Olympic Arts Festival, the ambitious schedule of theater productions easily captured the gold, the uneven dance offerings came from behind to capture the silver, and music—despite an early, near-crippling injury (the cancellation of Robert Wilson's operatic spectacle, *the CIVIL warS*)—managed to take the bronze. The jubilation on stage and in the audience (not to mention at the box office) was almost enough to obscure the festival's most poignant moment: the visual arts commiserating with Zola Budd over their respective ignominies.

For a ten-week period beginning June 1, throughout metropolitan Los Angeles there were 427 performances by 145 international companies speaking twelve different languages, as well as

seven minifestivals featuring everything from movies to masks. Along the way, superstars inevitably emerged; foremost among them was Ariane Mnouchkine, the director of Paris's Le Théâtre du Soleil, who acted as broker for a dazzling marriage between Shakespearean drama and Kabuki style. Equally inevitable was the specter of international scandal; although Wilson managed to have each of the five acts of his twelve-hour opera *the CIVIL warS: a tree is best measured when it is down* produced separately in five different countries (Japan, Italy, France, Germany, and the Netherlands), the producers fell $1.2 million short of the funds needed to bring it all together in the United States. Finally, there was the inevitable contest for best-of-the-worst; by most accounts, that honor went to Nightfire, a Sausalito-based theater troupe that performed an "avant-garde aqua-ballet" in the swimming pool of Beverly Hills High.

However, the visual arts program as a whole was the true spectacle of calamity. For every triumphant production by the Royal Opera of Covent Garden (in its American debut), there was an art exhibition on so exalted a plane as "Los Angeles and the Palm Tree: Image of a City," the Arco Center for the Visual Arts' homage to a plant as seen in art and popular culture. For every magical reworking of Shakespeare by Le Théâtre du Soleil, there was a botched survey such as the Municipal Art Gallery's "Art in Clay"—an ostensible history of the ceramic arts in Southern California during the last three decades— that, in its unwavering commitment to boosterism at the expense of criticality, looked like it had been mounted by the Chamber of Commerce. For every mind-and-body endurance test offered by Pina Bausch's Wuppertaler Tanztheater (another American debut), there was an endurance test of a different sort in such exhibitions as the University of Southern California's "The California Sculpture Show," a twelve-work "survey" that tried in vain to make a case for the continuing vitality of monumental formalism.

Only one of the festival's two blockbuster exhibitions was successful: The Los Angeles County Museum of Art's brilliant revisionist exhibition "A Day in the Country: Impressionism and the French Landscape." Bolstered by a superb selection of pictures (including thirty-six from the Louvre and twenty-five from the Art Institute of Chicago, co-organizers with LACMA of the exhibition), the show synthesized much scholarship of the past decade concerning the landscape sites chosen by Impressionist (and Postimpressionist) painters. Examined and installed according to thematic motifs—urban sites, the public or private garden, the sea, and so forth—rather than chronologically or by artist, the paintings collectively revealed the limited number of subjects the Impressionists actually dealt with, despite the limitless range of landscape possibilities.

Meanwhile, the Museum of Contemporary Art converted its interim warehouse facility into a showroom for "The Automobile

and Culture," an exhibition that turned out to be all cars and very little culture. Interspersing nearly 200 works of art in which the image of an auto at least makes an appearance with some thirty vintage cars (including a lavender-pink 1951 Mercury that may be the most drop-dead-beautiful machine ever made), the show attempted a decade-by-decade chronicle of the impact of the automobile on modern culture. Hitching its wagon to social history, the museum put the cart before the horse. What was desperately needed was some insight into the impact of culture on the automobile. At its invention in the late nineteenth century, the automobile represented a new desire for independent, wide-ranging, and relatively unrestricted mobility. If Leonardo da Vinci's late-fifteenth-century drawing of a horseless wagon (included in the show in facsimile) was technically feasible, as many engineers today believe, then why did more than 300 years pass before a working automobile appeared? How and why did so seminal an invention appear in Europe and America at the end of the nineteenth century, rather than, say, seventeenth-century Japan? The show ignored such fundamental questions in favor of a simple recitation of sociohistorical facts; the changing mythology of the automobile was merely pointed out, decade after decade, without ever being penetrated. Strangest of all, in a show composed primarily of minor works by major artists and major works by minor artists, MoCA revealed just how *incidental* the image of the car has actually been to twentieth-century art.

The entire Olympic Arts Festival was schizoid. While the performing arts program was approached as a Documenta-style event in which a rambunctious international survey was pulled together into one big free-for-all, one could have attended every festival art exhibition and still have had no idea whatsoever of the raucous upheavals that characterize international art of the last decade. The reason for the disparity between the performing and visual arts components resides, I think, in the radically different selection methods employed by the festival's director, Robert J. Fitzpatrick. When named vice president for cultural affairs of the Los Angeles Olympic Organizing Committee (the LAOOC, a private corporation) well over three years ago, Fitzpatrick seemed the perfect choice. The festival would require skill in arts administration (Fitzpatrick is president of the fecund California Institute of the Arts), political savvy (he is a former Baltimore city councilman), and considerable fund-raising ability (he did much to stabilize CalArts's precarious finances). Initially budgeted at $10 million, with half that amount provided by the Times Mirror Corporation, the arts festival, like the games themselves, had to be mounted privately on a pay-as-you-go basis.

In assuming the directorship of the festival, Fitzpatrick rightly insisted on complete artistic control—and therein lies the rousing success of the performing arts program and the dismal failure of the visual arts component. Reportedly logging 300,000 miles in travel

from Europe to the Orient in order to handpick ensembles in theater, dance, and music, Fitzpatrick apparently logged about thirty miles traveling to art museums, universities, and corporate galleries in Los Angeles and environs to ask what *they* planned to do. In this way, LACMA's Impressionist painting exhibition and MoCA's auto show—both in initial planning stages before the decision to hold a festival was made—were transformed by a wave of the wand from the museums' next regularly scheduled shows into "official Olympic Arts Festival events."

Having shorter organizational lead time, smaller institutions apparently tailored their proposals to resemble their own idea of an Olympics crowd-pleaser: In the end, California and/or sports dominated the themes in the roster of shows. In addition to the above, the University Art Museum at UC Santa Barbara assembled a number of works of art featuring pictures of boats, together with a selection of real boats, for a show called "Rowing: Integrity and Tradition"; Olympic rowing events, of course, were being held at nearby Lake Casitas. At the Santa Barbara Museum, "Art of the States" presented contemporary American art owned by an anonymous California collector. The Newport Harbor Art Museum paired a preexisting New York exhibition of California art (which I happened to co-organize) with a California exhibition of New York art. The Municipal Art Gallery mounted a mid-career miniretrospective of local artist Carlos Almaraz, whose work is usually presented as Neoexpressionism with a Hispanic twist, but which is really old-fashioned Expressionism reheated with local color. Finally, the Pacific-Asia Museum, the Los Angeles Institute of Contemporary Art, and the George Doizaki Gallery presented tributes to traditional or contemporary arts and crafts from, respectively, New Zealand, Australia, and Japan—countries on the Pacific Rim, to which L.A. is America's gateway.

Thus, with "hometown pride" the common hook for nearly every art exhibition, we were treated to a Festival of Olympic Provincialism. If the fans at the various athletic stadiums were busy waving Old Glory and cheering "U-S-A! U-S-A!", art institutions were right in step, chanting "West-Coast! West-Coast! West-Coast!"

It should come as no surprise that the Olympic Arts Festival also chose to give its own institutional interests primary consideration. Several hundred thousand dollars were spent on commissioning new works conceived as monuments to, or souvenirs of, the locally hosted Olympic Games: Robert Graham's notorious theme-sculpture, placed at the Olympic Coliseum entrance; commemorative Olympic posters; a planned picture book of images taken by ten photographers during the two-week period of the games; and the most disastrous of these projects, ten permanent murals painted on freeway retaining walls leading from downtown L.A. to the Olympic Coliseum. The freeway murals are ostensibly a salute to the indigenous mural tradition in Southern California. In reality, they appear to have been exe-

cuted for two bizarre reasons: to entertain frustrated commuters stuck in the increased rush-hour traffic the Olympics were expected to generate by providing a kind of drive-through museum (welcome to the McDonald's of Culture); and to show off the indigenous mural tradition to tourists and residents who balk at venturing into certain "problem" neighborhoods, where many of the best murals will be found. (As one artist said to me, "You can bet that if Watts Towers could have been put on wheels, it would have been hauled out of 107th Street years ago.")

Aside from the numbing triviality of all but Terry Schoonhoven's mural, the most chilling feature of this debacle was the way it came into being. Since the freeways are publicly owned, the California Department of Transportation (Caltrans), worried that the murals might prove "offensive," required proof that a significant degree of community support existed for the scheme. Caltrans was quickly presented with letters of approval solicited from two city councilmen and one county supervisor, and on this basis gave the go-ahead. The indigenous mural tradition has always drawn its gritty strength from the collective vitality of the street; here, it was bureaucratically absorbed, chewed up, and spit out as Officially Authorized Graffiti.

The mural saga is only the most extreme example within a festival which presumed that whatever is worthwhile in art will best issue forth from the ministrations of the modern institution. In this regard, Robert Graham's much-maligned theme-sculpture deserves to be reconsidered: Held aloft on a rudimentary triumphal arch, a faceless, raceless, nationless Super-Everyman and Super-Everywoman decorate the landscape with the attributes of infallibility. The "Olympic Gateway," executed in a style that might best be described as Postmodern Mussolini, turned out to be an ironically appropriate symbol for the whole shabby affair.

L.A. Freeway: The Automotive Basilica

winter 1984 Three clichés form the popular image of Los Angeles: endless sunshine, Hollywood magic, and alluring cars. Together, this trinity conjures a picture of paradise, of the good life: sun-soaked beaches, backyards and barbecues, the icy glamour of klieg lights and the jitter of instant fame, status sensuality at 55 mph on an endless ribbon of freeway. Every heaven must have its hell, though, and L.A.'s is painted as a raging inferno of sun-baked brains, cheap dreams perpetually shattered, and overheated traffic jams.

This image of L.A. as a Boschian garden of earthly delights has long been a fixture of our popular culture. Rarely are any of its features the subject of lucid examination. However, David Brodsly's *L.A. Freeway: An Appreciative Essay* gives us the most profound analysis

of its subject since Reyner Banham's *Los Angeles: The Architecture of Four Ecologies*. In the process, the cliché of an automobile culture is restored to its proper place as a vivid California icon. The essay took shape as the author's senior thesis at the University of California, Santa Cruz (a fact that should restore at least a bit of faith in the state's increasingly imperiled university system). Evidently taking his cue from Banham, Brodsly has approached his subject ecologically; his freeway system is the visible locus of invisible social, natural, economic, and cultural vectors. A native of Los Angeles, he has woven in bits of personal history, too, but always for the purpose of illumination. Indeed, describing the essay as "neither a diatribe nor a paean," he declares in the prologue: "It is an 'appreciative' essay in the formal sense of the word. To appreciate freeways is not necessarily to like them but, more important, to consider them rightly. In essence, it is merely the act of seeing.... My hope was to understand the freeways, not to judge them."

Brodsly is intent on examining the freeway as a cultural artifact—in the broadest sense of the term—in order to see it for what it is: a public record of, and an interactive participant in, the shape of social experience. Quoting Joan Didion's oft-repeated observation that driving the freeway is "the only secular communion Los Angeles has," Brodsly ventures: "The more I think about the parallel, the more I realize how correct she is. Every time we merge with traffic we join our community in a wordless creed: belief in individual freedom, in a technological liberation from place and circumstance, in a democracy of personal mobility.... The L.A. freeway is the cathedral of its time and place. It is a monumental structure designed to serve the needs of our daily lives, at the same time representing what we stand for in the world."

Taking this "creed" in reverse order, the complex symbolism of the freeway begins to emerge. It was not the more than 700 miles of freeways that revolutionized transport in Los Angeles; that honor goes to the automobile, for which the freeway was constructed as a basilica. According to the author, on an average weekday the freeways in the Los Angeles metropolitan region are used for 5.8 million trips covering an astonishing 75.2 million miles of travel. Mobility in so vast a region is simply a necessity of life. So, unlike the variegated life on surface streets, the freeways were made to be monofunctional, "a sanctuary for such activity, designed specifically to serve its needs." The freeways, Brodsly argues, "have almost singlehandedly expanded the realm of the accessible, and thus they have enlarged what most people recognize as their metropolitan environment." As a result, they have delineated a wholly new sense of place, a sense whose most distinctive features are the experience of distance and time. As much as in any geographical, physical, or cultural aspect, one thinks of Los Angeles neighborhoods in terms of how far away they are and how long it takes to get

there. L.A. is a place of miles per hour. Usually raised above or sunken beneath the immediately surrounding urban or suburban topography, the freeway structures themselves also are a place apart—a "no place" that defines and is defined by the nature of passage.

As Brodsly makes plain, this expanded accessibility and its accompanying temporal fluidity have their darker side. Urban *immobility* may be a prime factor in breeding heterogeneous diversity, which the expanding range of the accessible undermines. But there is another quality to the experience of the freeway that strikes to the very heart, I think, of Los Angeles as a cultural construct:

> While it may appear far-fetched to compare a peak-hour commute with a stroll down a country road, the freeway has a certain quality that makes driving it the nearest equivalent to such an experience the average Angeleno is likely to have on a typical day. For here, rather than in Griffith Park or along the beach, *one receives a daily guarantee of privacy* [emphasis added]. Safe from all direct communication with other individuals, on the freeway one is alone in the world. You can smoke, manipulate the radio dial at will, sing off key, belch, fart, or pick your nose. A car on the freeway is more private than one's home.

Considered in this way—and anyone who travels the L.A. freeways with regularity, as I do, can attest to the general validity of the observation—the massive concrete and asphalt channels that radiate outward from the city's central core are not really public spaces at all. "That is not to say that they do not embody a public order," Brodsly adds, "[but the freeway] as a social environment supports none of the social relationships, none of the personal interactions, which characterize the truly public place." Rather, they are publicly conceived and executed places for the exercise of democratically private experience.

It is this that makes the freeways such a vital, living symbol of the decidedly paradoxical metropolitan ethos of Los Angeles. And it is this, too, that makes them not mere examples of late-twentieth-century technological and engineering skill, but a specifically modern and uniquely Southern Californian example of a particular breed of public art. We tend to limit our definition of art to those products which have been fabricated by individual artists. But there is also art that is the creation of a whole society, art that arises over time from collective intelligence, fateful trial and error, and the politically inflected struggles of shared effort. As such, it is a public art that embodies social values of fundamental import, striking to the very core of a culture's beliefs and aspirations.

Historically, this type of public art has been most familiar in architectural forms—for example, in the Gothic cathedral. Constructed over centuries, such works transcend individual capacity

and become parts of an extended social process. As the late critic Amy Goldin described these works, "They culminate [in] a result that is clearly within the public realm, and they exist among other objective physical facts. All of them are artifacts—artificial and at the same time supremely natural—linked to human life in a hundred poetic and unpoetic ways." If Brodsly (and, by implication, Didion before him) is correct in describing the L.A. freeway as the secular cathedral of its time and place, then it exists as a central icon of a larger faith, and functions, in the author's words, as "a silent monument not only to the history of the region's spatial organization, but to the history of its values as well."

Those admittedly complex and elusive values are tied, I believe, to a great transcendentalist tradition in the American perception of landscape. In a sense, the secularization of Christianity had, by the mid-nineteenth century, firmly embedded traditional symbols in landscape motifs. The convincing means of expressing religious experience that had been channeled into the themes of Christian art were now called into service for the revelation of divinity in nature. The raw, untouched land, sea, and sky of the American continent was perceived to hold the promise of a New Eden. In our own century, the popular mythology of the earthly paradise has been embodied in the landscape of Southern California. The reality of the horizontal expanse, of the boundless sky and the shimmering Pacific, has held for the twentieth century the possibility of becoming the ideal. If nineteenth-century Americans had few cultural traditions of their own, then at least they had their ancient trees. And if the semi-arid desert of Los Angeles had few cultural traditions, at least there was the technologically inspired dream of the ideal future.

To borrow historian Leo Marx's well-known terms, as "the Machine" increasingly invaded "the Garden" in the nineteenth century, introducing a man-made inferno into the eastern United States' natural paradise, the metamorphosis of L.A.'s natural geography into what would eventually become the automotive freeway was just getting under way. One hundred years after the official founding of El Pueblo de Nuestra Señora la Reina de los Angeles de Porciuncula in 1781, the rail link to the English-speaking East was introduced. "The first railroads were the major axes for the emerging settlement," Brodsly writes, "though they in turn reflected the region's natural geography; in general, they followed routes that had previously been used as Indian, Mexican colonial, or American stage trails." The continuing pattern of transportation that evolved over the next century consists of five lines of movement radiating from the site of the original pueblo (about fifteen miles due east of the Pacific and now coincident with downtown), which was dedicated, in almost medieval manner, to "Our Lady, Queen of the Angels." These five directional paths led to early Spanish settlements, themselves dedicated to various saints: San Fernando, Santa Monica, San Pedro, Santa Ana,

and San Bernardino. "A quick genealogy," Brodsly explains,

> shows that the route northwest along the Los Angeles River
> into the San Fernando Valley became a Southern Pacific [rail-
> road] line and later the Golden State Freeway; the route west
> to Santa Monica became the Los Angeles and Independence
> Railroad and later the Santa Monica Freeway; the route south
> to San Pedro became the Los Angeles and San Pedro Railroad
> and later the Harbor Freeway; and the route southeast to Santa
> Ana became another Southern Pacific line and later the Santa
> Ana Freeway. Three railroads headed east [toward San
> Bernardino] through the San Gabriel Valley, as do three free-
> ways today.

Brodsly goes on to assert that this extraordinary network of freeways, evolving over the past 100 years but largely completed only in the last 20, is incontestably "the single most important feature of the man-made landscape." However, this is not necessarily so. Equal consideration must be given to what appears at first glance to be a wholly natural landscape. It is well known that the Los Angeles Basin is, in fact, a semiarid desert, and that "water wars" have been an ongoing and prominent feature of the city's modern history. The channeling of water from such northern sources as the Owens Valley has transformed L.A. into a man-made oasis. Similarly, and not unlike its population, more than 95 percent of the region's lush plant life (including the ubiqui-tous palm trees) have been imported from somewhere else for the pur-pose of fabricating a garden city.

To a significant degree, then, nature is itself a crucially important feature of the man-made landscape. Like the freeways, na-ture became a vernacular invention constructed through the language of technology. Nature and culture have been so exactly superimposed as to obscure one another utterly: Quite simply, the nineteenth-century natural Garden exists in Los Angeles as an invented Garden. The secu-lar theology of this New Eden is enacted in the creed spoken in the automotive basilica. Constructed for the sole purpose of connecting the far-flung regions of the Garden, the freeway is a work of public art that has arisen out of a collective faith in the value of freedom to be independent, coupled with the corollary freedom to be alone. Forming a horizontal cathedral as transcendently ethereal as any of its vertically aligned, Gothic counterparts, the L.A. freeways are symbols of the le-gitimacy of public support for such values.

Brodsly is not prepared to go quite so far in his appre-ciative essay. The reason for this might be found in his tendency to see the freeways as aesthetic structures, almost wholly in formal terms:

> The freeway as a general form lends itself well to a consid-
> eration of its aesthetic potential. Freeways are imposing, con-

sciously designed structures, and the best of them can be strikingly beautiful. Outstanding examples are the interchanges...In fact, nearly every major interchange constructed since the early 1960s is of genuine aesthetic interest, providing an interaction of straight and curved shapes which delineate space much as a work of modern sculpture does.

This limited conception is reinforced by the selection of photographs that face each of the four chapter headings. Taken by Chris Micaud, they transform freeway ramps and cast-concrete pilings into abstract, planar sweeps and high-contrast shapes. Aesthetically conservative, if handsome, as photographs, they are reminiscent of styles employed by Edward Weston, Willard Van Dyke, Peter Stackpole, and other photographers working in California in the 1920s and 1930s, or of Precisionist paintings and photographs by Charles Sheeler, Ralston Crawford, and others working in the same period. Usually characterized by urban or industrial subject matter rendered as pristine, clean-edged, planar forms, Precisionist paintings and photographs transformed the man-made industrial landscape into an idealized, almost pastoral Arcadia. Indeed, in many respects this art was the machine-age equivalent to the clear silence of a transcendentalist vision embodied in nineteenth-century Hudson River and Luminist paintings of the natural Garden.

To conceive of the "freeway aesthetic" in abstract and purely formal terms, then, is to lose sight of its importance as a cultural symbol—that is, as a *representational* structure. What the automotive basilica represents aesthetically is much more than a merely "sculptural" delineation of space; rather, its beauty is an intrinsic feature of decidedly moral principles that have been championed by the public world.

Nevertheless, Brodsly has shown a perceptive and valuable understanding of his subject. As chance would have it, while reading his book I learned that initial federal funding was assured for the Southern California Rapid Transit District's plan to construct Metro Rail, an eighteen-mile subway system in Los Angeles. Brodsly's epilogue contains a brief but fairly convincing argument concerning the social and economic foolishness of any such fixed-rail transit system, and suggesting that the poor will pay while the rich ride. He concludes: "One thing is certain: the extreme value granted mobility in our society, a value incarnate in cars and freeways, will be one of the last to go." Social and economic questions aside, never underestimate the power of an icon—even if it seems to be just a cliché.

The Place for Art in America's Schools

April 3, 1985 From the beginning of compulsory education in America, the discipline of art has been treated as little more than a trivial joke by our public schools. Monday, the J. Paul Getty Trust decided to take it seriously. At a Washington, D.C. press conference designed to underscore the national scope of the problem, the Getty unveiled a seventy-five-page report, nearly three years in the making, that addresses the educational dilemma. At long last, a case is made for considering our global cultural legacy to be something a bit weightier than a world of finger paints and Play-Doh that is worth entering only when inclement weather prevents an exodus to the playground during recess.

That's the good news. The not-so-good news is this: Beyond its laudable and much-needed call for dedication to fashioning a rigorous public school curriculum that includes the study of art and its history as essential components of a worthwhile education, the Getty report is seriously—and perhaps fatally—flawed.

Beyond Creating: The Place for Art in America's Schools, as the report is titled, was prepared by the Getty Center for Education in the Arts. It represents the educational philosophy generally known as "back-to-basics," but it quite firmly (and correctly) suggests that art, like math, science, and language, is one of those basic disciplines. To that end, Lani Lattin Duke, director of the center, argues for the creation of a discipline-based program that would include not merely the making of art by children—the classes in drawing, painting, design, etc., largely found in our public schools today—but the study of art history, art criticism, and aesthetics (the philosophy of art) as well.

Establishing such a discipline-based program on a par with other academic subjects within the curriculum is obviously no small task. According to the report, less than 3 percent of instructional time in elementary schools is currently devoted to the fine arts. Some 80 percent of all secondary school students receive virtually no such education during four years of high school. And less than 3 percent of all school districts in the nation require even a single fine arts course as a graduation requirement. The ramifications of these dismal statistics are everywhere apparent, not least in the wholesale conversion of art museums into cultural recreation centers competing with Michael Jackson for your entertainment dollar. What is less apparent, however, is the ideology that underlies the Getty report. In two crucial areas, the study approaches its subject from positions of dubious value.

The first is an assumption, repeated throughout the study by most of the contributors, that is based on a fiction. Art is everywhere described as representing "the apotheosis of human achievement," as embodying a "universal language," and as creatively and imaginatively cultivating our senses, through which we may "ascend to the aes-

Last Chance for Eden

thetic." For these transcendent reasons, we are told, the study of art history, art criticism, and aesthetics is essential. But are these observations, which are in fact oft-repeated clichés about the importance of art, really true? The answer is no. Prior to the eighteenth century, one would be hard-pressed to find spokesmen for these positions. For they are in fact a legacy of a very particular historical moment—namely, the social and intellectual crisis at the heart of the Romantic epoch in the West.

In the eighteenth and nineteenth centuries, the belief in the "universality" of art's language developed from a need to unite the increasingly factional social order created during the tumultuous "age of revolution"; the myth of universality was a way of establishing cultural standards that would be common to all. The new faith in the value of "creative imagination"—which a medieval sculptor would have found to be a bizarre idea—represented a volatile criticism of rationalist, empiricist, and utilitarian forces that were shaping such new social frameworks as industrial capitalism. And that such universal, creative imagination equaled the "apotheosis of human achievement"—that is, that works of art stood separate from such prosaic realities as putting a roof over your head or clothing your children—was indicative of the degree to which art was becoming a marginal, specialized activity divorced from the very forces that were struggling for social justice and equality. Indeed, it is no accident that the program that the Getty advocates was itself born of these developments. For the very disciplines of art history, art criticism, and aesthetics *themselves* are largely the offspring of the Romantic era, the epoch of which modern culture is a shining product. It is doubtful that the African tribal masks, the pre-Columbian funerary object, or even the ancient Greek amphora which are among the illustrations in *Beyond Creating* represented this notion of art to the cultures that made them, the way a painting by Pissarro or a bronze sculpture by Arp frequently does to us today. For the clichés by which art is championed in the report are value-laden and history-bound: They constitute a belief that is particular to modern, urban, industrial, Western, capitalist culture. This belief is far from being timeless and universal, and does little to help us understand the richness of art not produced in that context. Ironically, the Getty's call for a discipline-based study of art history and criticism is made ahistorically and uncritically. Is the continuation of such thinking, which seems the antithesis of visual literacy, really what we want in our public schools?

The second problem with the report follows from the first. The Getty Center commissioned the Santa Monica-based Rand Corporation to design the study and analyze its findings. Five educators experienced in art-education research prepared case studies of seven school districts around the nation. The districts were chosen on the basis of evidence of past commitment to art education, and they wisely represent a wide range of educational approaches and types of communities—

large and small, rural and urban, wealthy and poor, and various grada-
tions in between. The researchers conducted in-depth interviews with ad-
ministrators, teachers, and parents. They reviewed complex curriculum
materials. They spent hours in on-site visits to classrooms. They recog-
nized the need for tailoring potential programs to individual schools in
individual communities. As a result of these efforts, the researchers iden-
tified three issues crucial to the initiation and maintenance of programs
to teach art as an independent discipline. First, current assumptions among
educational policymakers, teachers, and parents concerning the minor
value of art and its minimal place in the curriculum must change. Second,
politically adept advocates will be necessary to mobilize support in the
face of budgetary constraints in the schools. Finally, art programs need
to be conceived, developed, and maintained with the same rigorous
standards as those applied to other academic subjects.

Much wisdom, both theoretical and practical, will be
found in this research. Yet there is something troubling as well. For al-
though the report is profusely illustrated with photographs of young
people enjoying the study of art, there is virtually no indication any-
where in these pages that students—the potential beneficiaries of the
highly touted art education programs—have been a focal point of the
study. Certainly, illuminating information might not be gleaned from
interviews with six-year-olds. Yet one of the more remarkable features
of the case studies is just how long art education programs have been
in existence in some school districts. Palo Alto, California, and Virginia
Beach, Virginia, have been at it for 20 years; Whitehall, Ohio, for 40 years;
Milwaukee, Wisconsin, for an amazing 110 years. Numerous aspects of
their programs are highly rated by the researchers. Given their longevity,
however, it is reasonable to assume that literally thousands of adults now
living in those communities are the products of local schools in which
art education was a central feature of the curriculum. While some of the
parents interviewed may fall within this group, the report contains no
analysis of these program beneficiaries. Wouldn't it have been both in-
teresting and useful to know what these former students have to say
about their own childhood education; and, as a result, about the place
of art in their adult lives today? Isn't the latter what early training in
visual literacy is for?

Beyond Creating remains silent on this question. For at
heart, it is a study of educational management at all levels—from the-
orists to administrators to teachers to parents—as evidenced by the three
issues crucial to initiating programs: All consist of managerial advice.
It is a report by management, about management, for management.
However useful this information may be, the recipients of these man-
agerial decisions are considered merely passive consumers. The managers
know what's best for them. Is the continuation of such passive con-
sumption, which seems the antithesis of visual literacy, really what we

want from our public schools?

These two major flaws in the Getty report—an ahistorical conception of the nature of art and an emphasis on managerial problem solving—have plagued art education for decades. (Indeed, the report itself acknowledges that everything it advocates has been unsuccessfully championed by art educators for twenty years.) For to conceive of art as loftily removed from any sordid social implications, and to focus attention on carefully controlling the transmission of such a belief to younger generations, is to keep art in the arena of a special interest and to argue for the acceptance of those special-interest values by all. Such a program does not achieve the educational goal of promoting visual literacy. The Getty Trust has entered a very difficult arena that is well worth every ounce of effort it can muster. *Beyond Creating*, however, represents the first major disappointment to come from that young but formidable institution.

Art in the San Francisco Bay Area

July 1985 A book about decay and dissolution can have a certain invigorating liveliness, as Oswald Spengler proved shortly after World War I with the publication of *The Decline of the West*. In chronicling what he saw as the final transformation from "culture" to "civilization" in the nineteenth century, Spengler charged that the world had been swallowed up by the civilized city, a kind of urban black hole into which the variegated cultures of whole regions were absorbed, while the rest dried up. Unlike the long-gone days of the Orpheus movement or the Reformation, he wrote, the great intellectual decisions of the modern world take place "in three or four world-cities that have absorbed into themselves the whole content of History, while the old wide landscape of the Culture, become merely provincial, serves only to feed the cities with what remains of its higher mankind."

Thomas Albright's *Art in the San Francisco Bay Area* is also a book about decay, but it's not nearly as invigorating as one might hope. Although certain rule-proving exceptions do crop up along the way, the general trajectory it follows begins at the apogee (Clyfford Still's monumental, slaglike canvases from the late 1940s) and ends in a smoking pile of debris that is evidence of a cultural crash-landing at some unspecified point in the vicinity of 1970. Albright doesn't propose a Spengleresque vision of "The City," as San Francisco likes to call itself, but it's clear that he's dismayed at the overall decline in that region of the West. While he'll get no argument from me in that regard, it must also be said that there is a lot to quarrel with in his book—almost too much.

At his untimely death a little more than a year ago, Thomas

Albright occupied an unusual position within the cultural life of the Bay Area. He'd been reviewing art for the *San Francisco Chronicle* since 1957, first as an assistant to the highly revered Alfred Frankenstein, later in his mentor's chair as chief art critic for the newspaper. It was in the pages of *ARTnews* magazine, for which he'd been a longtime correspondent, that I got to know his writing, and certain of the key ideas set forth in his posthumously published book will be familiar to readers of the magazine. (The most notable, incidentally, is his elucidation of the forces that, during the 1970s, led museums to very much abandon the historical and critical functions they traditionally held in favor of a wrongheaded journalistic role; after twenty years as a journalist, Albright knew whereof he spoke.) There is little doubt that Albright was the most perceptive and articulate critical voice emanating from the Bay Area for quite some time, but there was also a growing sense that he felt the cultural aspirations of the region—indeed, of the nation—had somewhere taken a colossal wrong turn. *Art in the San Francisco Bay Area* does not attempt to enunciate that misdirection (would that it had), but it does end up doing so if only by default. For as it happens, the wrong turn was maneuvered by the author himself.

The book grew out of a series of lectures on the history of postwar art in the Bay Area that Albright delivered at the San Francisco Museum of Modern Art in 1974. The crucial point of entry to his critical thinking, however, will be found closer to the time he began to write reviews for the *Chronicle*, seventeen years before. In the late 1950s, the region was experiencing its first moment in the national artistic spotlight: Elmer Bischoff, Richard Diebenkorn, David Park, and several other lesser practitioners of what was quickly dubbed "Bay Area Figurative Painting" were making waves far beyond the shores of San Francisco Bay. At the same time, the new social phenomenon that had been gathering steam since the middle of the decade was being identified in the media, and San Francisco's Beat Generation was giving birth to a ragtag constellation of artistic attitudes that collectively became known as Funk.

Although the book, like most histories, is structured chronologically, Albright's thinking seems to fan out in both directions from this heady moment. The pervasive impact of Abstract Expressionism in the postwar years, with Clyfford Still as the dominant local presence through his teaching at the California School of Fine Arts (now the San Francisco Art Institute), sets the stage for the introduction of the figure into that gesturally expressive mode; at the other end, the assorted permutations of Funk into the early 1960s ring down the curtain.

At the center of Albright's conception is a quintessentially Romantic notion. The complex social currents of any given time are seen as a kind of manure which fertilizes artistic creation, the best of which grows and flowers and ultimately transcends its malodorous seedbed. This

organic view of art, which uses nature as its model, gets Albright into a good deal of trouble. For instance, of the parodist-in-pottery Robert Arneson he writes: "[His] work, and the sensibility it reflected, corresponded to the combination of rebellious iconoclasm and hip humor that characterized the contemporary mood." That may be true, but to me it's an inadvertently damning assessment, for it makes of art a kind of glorified mood ring designed to measure society's body heat.

Most of the book's eleven chapters are structured along these lines. They open by setting the American scene in politics, social life, economics, national and local mood, and so forth; next, they chronicle the sprouting of three or four leaders in a particular facet of Bay Area painting or sculpture; then the proliferation of related utterances is charted (in all, the work of more than 200 artists is discussed); and, finally, each chapter concludes by dismissing most of the work as second-rate, as hothouse hybrids of major innovations.

This procedure is a bit daunting for the reader, who is left wondering why he's bothered to wade through a cultural history of mediocre art; but, even worse, it leads the author into a process of tracing hopelessly tangled genetic codes in the Bay Area family tree. Of the early 1970s, for instance, we learn: "The most obvious [tradition] was the Pop-inspired Funk of Robert Arneson and the Neo-Dada Funk of William Wiley, but its lineage also included the fiercely independent, iconoclastic attitude of Clyfford Still (without the high seriousness and moral fervor); the representational bias of the Bay Area Figurative painters; and the confluence of the two historical veins of Surrealism that occurred in the mid-fifties sculpture of Jeremy Anderson—one mythic, Miróesque, and respectable (Adaline Kent, Robert Howard), and the other spoofing, Duchampian, and underground (the found objects of Clay Spohn)." This particularly snarled bit of rootage is meant, ironically, to illuminate the chapter devoted to the rise of "personal mythologies."

Eventually, Albright's epilogue lays out the fundamental flaw of his procedure. Discussing the dominance of "pastiche and eclecticism" in art as the 1980s began, he assails artists who "have spent too much time looking at surfaces (slides and reproductions) and immersing themselves in lore *about* art, and too little time in direct communication with art itself, or with the unprocessed experience of the street or countryside." The problem isn't merely that the very notion of "unprocessed experience" is a Romantic myth (the same one that sent transcendentalist writers wandering off into the woods and Paul Gauguin sailing off into the syphilitic South Seas); it's that the work of the first truly major artist to have developed largely in the Bay Area recognizes just how "processed" modern experience really is. Albright champions a flight from that reality; the artist, David Park, looks it squarely in the eye.

It is heartening that one of Park's paintings (*Four Men*, 1958) is illustrated as the frontispiece to the book, for this immensely

gifted painter has never received accolades commensurate with his achievement. Although Albright does indeed praise Park's work, he does so for precisely the wrong reason: it most emphatically did not represent a "return to nature" after the nonfigurative heroics of Abstract Expressionism—in fact, far from it. The Abstract Expressionist ethos—which itself sought the independent autonomy of "unprocessed experience" through the making of art—had rolled over San Francisco in the 1940s like the fog sliding over Twin Peaks. Transplanted from the intensely urban milieu of New York, in which it had originated, by way of imported teachers, reproductions, journals, and popular magazines, Abstract Expressionism had quickly become a cultural symbol for contemporaneity in the provincial city of San Francisco. Having himself slowly adopted the manner in the latter half of the 1940s, Park intuitively came to realize that, precisely because it had become a *cultural symbol*, Abstract Expressionism had paradoxically become a representational art. So he carted his own abstract paintings to the city dump and began to paint in a radically new way with straightforward representational images.

Park recognized that "unprocessed experience," especially in the middle of the media-mad twentieth century, was a myth—a recognition that, a few years hence, was to become the foundation of the work of Jasper Johns and Robert Rauschenberg and, a decade later, of Roy Lichtenstein and Andy Warhol (it's still a major factor in the recent varieties of Neoexpressionism). Albright, however, clings tenaciously to the myth, determined to equate the natural with the good. This may work for selling yogurt and sugar-free cereal, but it isn't likely to forge the reconciliation between the perfect order of the physical world and the self-evident corruption and chaos of life he seems to hope for.

Reading *Art in the San Francisco Bay Area*, one has the sense that a great, gaping wound was opened in the years following World War II, and that artists in the region chose either to chronicle the deterioration, to create a parallel universe of utopian goodwill, or sometimes to attempt both at once. Very few have sought to venture deep inside the belly of the beast. Throughout the story, Albright combines his prodigious talents as a journalist with a critical enunciation of the conflicting social and artistic ambience of those decades. This makes for a very useful book, in an archival sort of way, one whose value is enhanced by the more than 230 illustrations (nearly half in color) and by the biographical appendix which chronicles an astonishing 700 artists. The author displays a welcome affection for the oddball or grossly underappreciated artist, and he lays out this history dutifully and, as best one can tell, accurately. At times he seems unsure of whether he's writing a history of art or a history of the artistic life of a city (they're not the same thing), but on those occasions when he feels passionately about the art—most notably in the pages devoted to Still, to the bub-

bling to the surface of the Beat Generation, and to the psychedelic posters and acid-head "comix" of the 1960s—he is capable of such feats as going from Samuel Beckett to Professor Irwin Corey in a single sentence, and of making you believe it.

Art in the San Francisco Bay Area is the kind of book you'd like to get your hands on for a crash course in who did what, where, and when. That's no mean achievement, even if a true cultural history of the subject awaits the pen.

The Macchiaioli

March 9, 1986 "The Macchiaioli: Painters of Italian Life, 1850–1900" is that rare and exotic beast, the truly revealing historical exhibition. Virtually every aspect of the show has been guided by a keen intelligence and a generosity of thought that are nothing short of exceptional. Indeed, whatever it has to say about the particular works of art under consideration—and it says a lot—it stands as something of a curatorial model for exhibitions of its kind.

This is not to say that the show constitutes the last word on the production of the group of Tuscan painters who, in the 1860s, were both chroniclers of and active participants in the social and political movement of the Risorgimento, which sought the unification of Italy. The transformation of the Mediterranean country from more than a dozen autonomous regions, many under foreign influence or control, into a nationalist state was a complicated affair marked by a host of shifting attitudes. Likewise, the show itself seeks a shift in our attitudes toward understanding this art.

The paucity in American collections of genre and landscape paintings by the dozen artists surveyed, as well as the general obscurity of the movement as a whole relative to simultaneous artistic developments in other European countries, adds an element of discovery to the enterprise. Both the show and the superlative catalog that accompanies it open wide a door that has long been shut. In the process, a good deal of light and fresh air has been let in, and a passageway to further productive examination has been unlocked. "The Macchiaioli" (pronounced mahk-ya-*yo*-ly) was organized by Albert Boime, professor of art history at UCLA, and Edith Tonelli, director of the university's Wight Art Gallery, where the show can be seen. They enlisted the aid of Dario Durbe, director of the Macchiaioli Archive in Rome and the man responsible for uncovering much of what is known about the movement under study. The trajectory of their efforts has followed the revisionist path of inquiry into nineteenth-century art that has been so important for many years: Value judgments about styles or movements have been supplanted by an attempted clarification of the relation-

ships between history and art. Positivism, feminism, nationalism, science, patronage, religion, economics, and social life are among the factors that come into play. It isn't that biographical analysis of the artists and formal analysis of their paintings has been abandoned; rather, they are wedded to the larger milieu within which they took shape and to which they contributed.

Silvestro Lega
Il Pergolato (The Trellis)
1868

The wisdom of this curatorial point of view can be seen in the term used to describe the artists of the Risorgimento period: It encompasses a variety of subtle characteristics. Deriving from the word *macchia*, meaning a spot or patch, it refers to artists who, as early as the late 1850s, adopted a patchy or sketchy technique of painting that was meant to distinguish their work from the highly finished, licked surfaces of academic art. *Macchia* also meant "underbrush" or "scrubwood" and thus was an appropriate designation for the new focus on landscape painting by which these artists sought to exalt a newly emerging nationalist feeling. Their art was to picture the very stuff of the Italian countryside. The suffix *aioli* affixed to the root word was commonly used to designate plebian groups, workers, and even petty criminals. The modern philosophy of nationalism then taking shape throughout Europe was born of the conjunction of regional tradition, religion, and mass poverty, and had as a central premise the establishment of social equality. This badge of identification with the lowliest on the social hierarchy by largely middle-class artists served a greater purpose. Finally, as is so often the case with art in the modern era, the term was coined by a critic as a derogatory swipe at the loosely knit group. That the painters embraced it is a sign of their desire for complete separation from the values exalted by ruling authority. They reveled in their revolutionary "criminality."

This sort of complexity is fundamental to an understanding of the paintings produced by the Macchiaioli, and the exhibition gathers just such a wide range of meaning into its net. Silvestro Lega's *The Trellis*, which is among the few widely reproduced works from the period, might seem to be a simple picture of quiet leisure filled with the soft light of the afternoon sun. In the context of the burgeoning na-

Last Chance for Eden

tionalist ethos and its attendant social transformations, the picture reveals a subtle progressiveness. A clear division of labor and an equally clear separation of social class is depicted: Three bourgeois women and a child rest within the sheltering cover of the trellis, while the approaching servant stands alone in the sun. Yet the serving girl, who occupies the foreground, is rendered with an upright, dignified bearing virtually identical to that of the seated woman with a fan, who turns her head upon hearing the servant approach. Not insignificantly, Lega's composition puts the stately head of the servant and that of her mistress on a level of exact equality, while the placement of all five figures forms a diagonal path that leads through an opening in the trellis to the cultivated Tuscan landscape beyond. With this deft and beautifully orchestrated image, the artist pictures an emerging set of complex social relations.

The social space of painting is a primary focus of the exhibition's examination of the Macchiaioli. One of the remarkable features of this art is the way that social space is addressed to the viewer: He's incorporated into it. At least two prominent, recurring devices can be cited in this regard. One is the odd but frequent use of the pictorial panorama. Giovanni Fattori's *The Blue Sea* is a narrow, horizontal canvas barely 3 inches in height, yet 14 inches in width. The field of vision is literally widened into a continuous scan across the viewer's space. The second device occurs again and again in the genre scenes of late-nineteenth-century Italian life. As often as not, a figure seated in an interior or a couple walking across a verdant field is seen from the rear, back to the viewer. It's as if we've stumbled upon the scene, just casually entered the room, or passed the strolling couple and caught the players unaware. The candid quality of these depictions suggests a degree of honesty and frankness that endows such scenes as a group of women sewing red shirts for the revolutionaries, or even the morning toilet in a brothel, with an element of ordinariness, of natural rightness. At the same time, these images are self-evidently orchestrated as careful pictorial compositions. A distinct tension is established between our perception of the naturalism of the scene and its status as a cultural mode of address. In this way, these paintings consciously engage in a dialogue with the participant spectator.

So does the exhibition. It pointedly asks us to question the received biases toward modern art—especially French painting—that declare the existence of a natural progression of ever-advanced styles. The curators are careful to point to the violence done to our understanding of the Macchiaioli through the acceptance of such beliefs. Even though the Italians began to rely on a sketch technique a decade before the French Impressionists, as recently as 1982 exhibitions in Europe were categorizing the Tuscan painters as the "Italian Impressionists." Considering their art according to canons developed in another social

and cultural setting means that, inevitably, it cannot measure up. Furthermore, Italian culture is made a kind of satellite operating under the French sphere of influence. To be sure, many parallels can be drawn between Italy and France in the period, and between the art that was produced in those distinct regions. Yet with equal inevitability, to restrict attention to these parallels voids the lively and essential quality of difference between them.

The exhibition, then, assumes a distinctly political position—as well it should. The emergent nationalist ethos played a prominent role in almost all European (and American) art of the nineteenth century. After the seizure of Rome from the pope and its annexation to the Italian state in 1870, there arose a movement to regain those regions still under Austrian control. This irredentism was a strong motive for Italy's entry into World War I, and, as with the establishment of the National Socialist Party in Germany in 1919, a firm commitment to the welfare of the nation-state set the stage for Mussolini's rise to power in 1922. The fascist nightmare that followed, and that itself sought to eradicate all quality of cultural difference, is worth considering. So, too, is the Neoexpressionist art that has emerged with such stunning force in Italy and Germany during the past five or six years. In many respects, this art confronts head-on the wrenching dilemma of cultural identity in the modern world, a dilemma that is given an added torque by the recent totalitarian past of those countries. It's not too much to say that the work of the Macchiaioli constitutes an early phase in the ongoing attempt to come to terms with that predicament. Nor is it overstating the case to observe that the UCLA exhibition is a much-needed effort that has been thoughtfully directed toward an illumination of its conflicting contours.

Japanese Photography in America

May 18, 1986 Four years ago, a rather unlikely exhibition in a rather unlikely place turned out to be one of the indisputable highlights of the exhibition season. The show, which was quite small, was "Japanese American Photography in Los Angeles: 1920–1945," and the place, which was also quite small, was the art gallery at L.A. Valley College in Van Nuys. The ambition of the undertaking, however, was not small. It sought nothing less than to begin the arduous process of unearthing a significant artistic development in the recent past that had almost completely disappeared from view. Its thrust was archaeological.

That a number of photographers, most of whom had been born in Japan and immigrated to America, worked in Los Angeles between World War I and World War II was not entirely unknown. Certain of their pictures were prominently featured in several widely

distributed magazines and exhibition catalogs of the day, most devoted to the genre of Pictorialist photography. They appeared as well in enormously influential German publications of the 1920s and 1930s. Shigemi Uyeda's *Reflections on the Oil Ditch*, an extraordinary image of stunning formal and conceptual beauty, was reproduced by Laszlo Moholy-Nagy in his important 1938 book *New Vision: Fundamentals of Design—Painting, Sculpture, Architecture*. Edward Weston's first solo exhibition, in 1921, had been sponsored by a photography association, Shakudo-Sha, led by Toyo Miyatake; Weston had written of the importance of this early support by Japanese camera clubs in his *Daybooks*. Still, the twenty-year efflorescence of activity and achievement had long since fallen into obscurity. The waning interest in photographic Pictorialism, coupled with the shameful mass internment of Japanese Americans in the spring of 1942, conspired to erase the episode from our collective memory.

Kentaro Nakamura
Evening Wave
ca. 1927

Dennis Reed, who organized the Valley College show, has now returned with a larger, more complete chronicle of those events. "Japanese Photography in America: 1920–1940," which is on view at the George Doizaki Gallery, has slightly reduced the time frame of the earlier show while expanding the geographical purview. Twenty-six photographers are represented by more than eighty photographs. Artists working in Seattle, the Bay Area, Hawaii, and Los Angeles (by far the largest group) have been included, and a selection of those contemporaneous American and European publications is on view. The largest selection of pictures is a group of twelve photographs by Hiromu Kira, who, at eighty-eight, still resides in Los Angeles. Finally, in place of the small brochure that accompanied the initial exhibition, a sizable, fully illustrated and extremely useful book has been produced.

The central paradox of Japanese photography in America between the wars concerns its relationship to the Pictorialist aesthetic.

How could such frequently adventurous pictures have been born from an essentially old-fashioned artistic point of view? Since the invention of the camera in the nineteenth century, argument had centered on whether the device merely recorded the world in front of its lens in a wholly mechanical way, or whether this tool was capable of producing authentically artistic images. As is common at the arrival of any new medium, photography soon began to make its artistic claim by attempting to mimic accepted aesthetic conventions. Pictorialism sought to duplicate the look of painting. It emphasized soft-focus techniques because they appeared less "mechanical" and more "painterly," exploited the wide tonal range of intermediate grays available from bromide paper, and turned to romantic subject matter. The assault on the legitimacy of this strategy was already well under way, especially in the avant-garde hothouse of Alfred Stieglitz's 291 gallery in New York, when Japanese photographers on the West Coast picked up the method in the 1920s. Nonetheless, Pictorialism remained their standard for two decades, and with it, some remarkable and influential images were made.

The rudiments of how this strange paradox can be explained begin to emerge from the exhibition. To be sure, traditional Pictorialism was not cut off at the knees by the Steiglitz circle. It was too entrenched, too widespread, too protective of its established interests to disappear overnight. Kaye Shimojima's *Dusty Trail*, a standard romantic image of radiantly illuminated sheep in the forest, is positively nineteenth-century in bearing; and yet, it was hardly the only archetypically Pictorialist image produced in America or Europe in 1927. Born decades before, the genre had continued to flourish most emphatically (although not exclusively) among amateurs and hobbyists, and it was as a hobby that most Japanese appear to have first picked up a camera.

When they did, many brought to Pictorialism something special. For the genre originally had constituted itself according to traditional canons of European artistic sensibility: The painterly look it sought to achieve was the look of Western painting. In wedding camera images to motifs, forms, and styles derived not from Western painting but from the heritage of Asian art, Japanese photographers transformed the pictorialist traditions.

The union produced more than simple novelty—more than a United Nations pictorialism. The defeat of linear perspective, flat patterning, the simplification of form, and other traditional Japanese artistic devices conspired to produce a Pictorialist photography of distinctly modern tenor. Japanese art already had exerted a profound influence on the shape of European and early American Modernist painting, thus preparing the way for the embrace of this new Pictorialist mode. Hobbyists or not, Japanese photographers found themselves in the vanguard.

To some degree, the value Asian artists historically placed on tradition also may have contributed to the maintenance of a picto-

Last Chance for Eden

rialist approach by Japanese photographers well into the 1930s. This and other questions are raised by the exhibition. Some, however, are even more fundamental. Biographical information, sometimes including such basic data as an artist's first name or date of birth, is often sketchy or nonexistent. For certain photographers only a handful of prints remain. Our knowledge of events, associations, and crosscurrents is woefully limited. The cause of this dearth of archival information is, of course, racism. At the relocation of Japanese Americans to prison camps in 1942, all but a few essential possessions had to be abandoned, destroyed, or hidden away; rarely could photographs or related documents be counted among those essentials. By April of that year, it was illegal for anyone of Japanese ancestry to even own a camera. At war's end, at least one cache of photographs went up in smoke when a lunatic arsonist burned to the ground three homes and an adjacent lumberyard because it was owned by a Japanese American. In the four years since the Valley College show, much has been accomplished. The exhibition at the Doizaki Gallery goes a very long way toward reconstructing a skeletal framework for this "lost" period, as well as fleshing out those bones.

An Open Letter to Attorney General Edwin Meese

June 1, 1986 Dear Mr. Meese: You blew it. You had your chance and you blew it. Your hard-working Commission on Pornography issued its supposedly tough-minded report a few weeks ago yet failed to even mention what is now and always has been a veritable cornucopia of sexually explicit material. Worse, in doing so you overlooked one of the primary causes of any number of social nightmares now disrupting the peaceful sleep of the modern world.

I'm talking art, Ed. (May I call you Ed?) Maybe it's time you took an afternoon off and strolled down the Mall to the National Gallery. Like every other art museum in the Western world, the place is stuffed with pictures and statues of people in assorted states of dishabille. And a lot of them were made with the express purpose of exciting prurient interest.

I know most of those art-historian types want you to believe otherwise. But surely you're well aware of how sneaky those left-leaning liberal professors can be with all their ten-dollar words. (Half of them got to the Ivory Tower by going Behind the Green Door.) Demurely calling the prehistoric Venus of Willendorf a "fertility figure" is just hiding behind a euphemism for you-know-what.

Art and pornography aren't the same thing, but they're not mutually exclusive, either. Both of them can be prurient. Remember when that Supreme Court justice said he couldn't define obscenity,

but he knew it when he saw it? Well, Marcel Duchamp said pretty much the same thing about art. I assume you're a student of the sixteenth-century Reformation, that glorious period when the church finally realized that the ways of mortal flesh were getting out of hand. But did you ever stop to think that those folks knew whereof Marcel and the Supreme Court spoke when they decided to add strategic fig leaves to all those bawdy pictures of biblical and mythological figures?

The Victorians knew it, too. Anthony Comstock—that perceptive, late-nineteenth-century defender of the morals of the young— gave the lie to all that art-historical double-talk about how sexy art, by its nature, transcends pornography. "Strychnine is a deadly poison," he smartly argued. "Its effect when administered sugar-coated is the same as when administered otherwise. When the genius of art reproduces obscene, lewd, and lascivious ideas, the deadly effect upon the morals of the young is just as perceptible as when the same ideas are represented by gross expressions in prose or poetry."

You see, there just isn't any such thing as artistic purity. Take the decidedly prurient content of Titian's *Bacchanal*, a wild orgy where children are present; of Fragonard's *Happy Accidents of the Swing*, in which a cad looks up the billowing dress of a dimpled young lass on a swing; of Manet's *Olympia* or *Luncheon on the Grass*, in which the naked lady, Victorine Meurent, was practically the Linda Lovelace of 1860s Paris; or of Picasso's *Demoiselles d'Avignon*, which ought to be subtitled *Halftime in a Whorehouse*. The list is endless. To deny their prurience is to blind yourself to the truth: Art has any number of sordid social implications.

If you want proof of Comstock's warning, consider the skyrocketing teen-pregnancy rate in the last twenty years. Do you really believe the presence of *Playboy* in the magazine racks at the local drugstore is the cause? I've got news: Just a few weeks ago the *L.A. Times* carried a page-1 story whose headline blared, "Museum Mania Grips the Globe." Maybe, just maybe, it's more than mere coincidence that the rise in teen pregnancy is concurrent with the rise in popularity of art museums. Museums bring thousands of school kids in on tours every year, and they even give children discount prices on admission. Do you want your kids ogling orgies and naked hookers?

Think about it, Ed.

The possibilities don't stop there, either. Remember Chernobyl? All of a sudden, those godless commie technocrats stopped behaving like robots and slipped up in a very gross way. Why? They still aren't talking, but the evidence is plain: Just a few weeks before the big barbecue, Armand Hammer had unveiled his art collection in Leningrad. One of the few show-stoppers was Gustave Moreau's hallucinatory painting of Salome. In case you don't know, Salome was a high-class stripper whose bumps and grinds led poor John the Baptist

(a good Christian, by the way) to his doom. The Soviets were falling all over themselves to get a gander at this oriental ecdysiast—and promptly fell asleep at the wheel in Kiev. Talk about being lured to your doom. Art is dangerous.

Speaking of danger, Ed, when was the last time you were in the Rome airport? Italy's crawling with paintings and sculptures of lustful behavior, bestiality, inversion, and even the abuse of children. This guy at Yale, James Saslow, just wrote a book called *Ganymede in the Renaissance: Homosexuality in Art and Society*, and it tells the whole awful story. Cellini, Michelangelo, Correggio, and a lot of other Renaissance pornographers explicitly depicted Jupiter's sexual lust for an attractive boy (he even sent an eagle to kidnap the youth). This is only one of hundreds of such subjects drawn from pagan mythology that were popular precisely because they provided a pretext for nudity in art.

Porn causes violence, your committee deduced, overturning the 1970 commission that claimed there was no evidence that exposure to pornography contributed to delinquency, criminality, or emotional disturbance. Then what does it take to get you to see the connection between all those questionable paintings in Italy and the proliferation of terrorist acts there? Don't you find it just a wee bit odd that the Rome airport is named after Leonardo da Vinci?

Teen pregnancy, nuclear meltdowns, terrorism—I know you're as concerned about these problems as I am, Ed; what I don't understand is why you've chosen to defy the President. He wants government out of the free-market system, but apparently you don't. If the charges in the lawsuit filed jointly by Playboy Enterprises Inc., the American Booksellers Association, and the Council on Periodical Distributors Associations is true—the one that accuses your commission of trying to scare 7-Eleven, Thrifty Corp., People's Drug Stores, and others into removing certain magazines from their shelves by sending threatening letters identifying them as vendors or distributors of porn—then you're tinkering with the fundamental business law of supply and demand. The business of America is still business, and the demand for prurient pictures is being supplied.

There is a way out, Ed. All you have to do is recognize the prurient nature of a lot of art, then take action that avoids the business sector. That Saslow book, with all its smarmy pictures, was published by Yale University Press. Colleges are tax-exempt institutions. Can't you revoke their tax status or something for being pornographers? Meanwhile, museums get millions in federal handouts; can't you have the National Endowment for the Arts insist they take down their dirty little Fragonards before they're eligible for grants? What about those two artist-run alternative galleries in L.A.? They just got thousands from the NEA, yet one has published a book praising the "eroticism of TV" and the other is about to publish a magazine devoted to "the sex life of images."

This eroticism-of-images stuff is everywhere these days, and most of it comes from a bunch of French aestheticians who are regularly published in a leftist journal called *October*. (I don't have to remind you, either, that it was France that wouldn't let us fly over on the way to Libya.) MIT Press publishes *October*. Don't we have some research contracts for Star Wars or the MX missile that could be yanked from MIT until it cleans up its act?

I know it's usually denied that art is capable of displaying prurience, because art is seen as a privileged pursuit. Privilege means you can get away with more—like artist Eric Fischl, whose decidedly prurient painting of a boy masturbating in a wading pool gets proudly displayed in museums. It's a tough concept to grasp (lots of art-world regulars don't even get it), but the fact is that a painting is allowed to be lascivious because we suppose it is doing so for the higher purposes of art. Dirty magazines sometimes try to make that claim—remember all those photographs in the 1930s and 1940s of naked boys as Greek sculptures and naked girls as Goyaesque majas? But nobody really believes it. Art is said to transcend pornographic prurience, but I must confess that I can be just as titillated by a painting as by a magazine.

This talk of higher purposes, transcendence, and privilege really has to do with creating a double standard for judging the pornographic content of different kinds of images. A nudie painting by Fragonard is erotic, but a nudie photograph of Candi Samples is obscene. It seems everything is OK if an image knows its place—either in the rarefied world of art or in the back-alley world of sexually explicit magazines. That's why 7-Eleven got a letter claiming it was a purveyor of porn: Certain magazines were transgressing the boundary, slipping from the back alley (where they "belong") to the corner store (where they don't).

Your commission freaked out in the face of this threatened collapse of a precious double standard. There's nothing a right-wing conservative hates more than a challenge to official values, and using double standards to keep people and ideas firmly in their place is about as official a value as we've now got. Get hip, Ed. Your committee's support of a double standard is no different from the poses of those wimpy liberal academics who want us to believe that Manet's *Olympia* is really about the flatness of paint on canvas, not about parading a naked prostitute in front of bourgeois eyes. Once you understand that, there's no sense mucking about in the private sector when you've got plenty of opportunities to use the federal government to stop the free movement of people and ideas in the public sphere.

What you need to get this thing off the ground is a public-relations campaign. I've even got a slogan that will be easy to remember. That way, next time some art museum comes mewling to Washington for money to mount a show of sexually explicit paint-

ings, or a university press wants to use its tax-exempt status to subsi-
dize the publication of sexy books, you'll know what to say. It's easy,
Ed. Just say no.

Abstract surrealism into
Abstract expressionism

July 27, 1986 During the past several years, the Newport
Harbor Art Museum has been quietly but steadily developing into one
of the premier institutions of its size and scope in the country. Devoted
to the art of the twentieth century, with special emphases on the post-
war era and art in California, the museum does not allow its relatively
small scale to hinder the depth and resonance of its thought. Certainly,
NHAM stumbles on occasion; and given its frequent attention to very
recent artistic developments, the museum sometimes seems to be as un-
sure of how to fathom the current scene as the rest of us. Still, it man-
ages on a regular basis to mount exhibitions that stand as models of their
kind. Not only do such shows bring together works of considerable
achievement, they go a long way toward challenging and reforming
our assumptions about the art at hand. They are exhibitions that sug-
gest that the last word is rarely, if ever, spoken about the shape of cul-
ture, and they invite the audience to become actively engaged in a
vigorous, ongoing dialogue.

"The Interpretive Link: Abstract Surrealism into Abstract
Expressionism; Works on Paper, 1938–1948" is precisely this kind of rig-
orous presentation. It tackles a subject of decided complexity, and of
equally decided importance. The exemplary catalog that accompanies
the exhibition has a lot to tell us about the remarkable transforma-
tions from Surrealism into Abstract Expressionism in the years just be-
fore, during, and just after World War II. Yet it manages to untangle much
of the knot through the sheer force of the argument offered by the works
of art themselves. Those works are all on paper: drawings, watercolors,
gouaches, mixed media collages, oils, pastels, and other directly ap-
plied mediums, not to mention assorted combinations thereof. We com-
monly assign works on paper a lesser position in a hierarchy whose
pinnacle is occupied by paintings and sculptures, even though there is
no reason to always think that way. Indeed, doing so can obscure un-
derstanding. Much of Albrecht Dürer's brilliance can be traced to his
comprehension of the radical alterations that could be accomplished
through the wide distribution of prints (he was the first "media artist"),
while Georgia O'Keeffe's fundamental achievement will be found in her
extraordinary watercolors, rather than in her paintings on canvas. And
in the case of the twenty-two European and American artists surveyed
in "The Interpretive Link," works on paper constitute the most ap-

propriate means for tracing the course of a fundamental shift.

There are several reasons for this. For artists such as Roberto Matta Echuarren, Gordon Onslow Ford, and Yves Tanguy, who fled Europe in the late 1930s as the dark cloud of war gathered on the horizon, as well as for those who stayed, such as Joan Miró, the use of paper as a principal medium was both economically and practically feasible in a time of crisis and uncertainty. More important, however, was the larger sense of failure that was making itself profoundly felt in the stark face of global catastrophe. In the wake of the fundamental deficiency in conventional patterns of thought and behavior, new modes and methods clearly had to be found. And drawing has traditionally functioned as the arena in which exploratory artistic thought has been tried, tested, and carried out. Works on paper can be among the most intimately revealing records of developing artistic processes.

Although Miró did not emigrate to New York during the war, his art is a touchstone for what was to occur in America. (A retrospective of his work was mounted by the Museum of Modern Art in 1941, and it was a revelation to many artists in New York.) Employing thin and sometimes mottled veils of background color, which banished any sense of rational geometry or perspective space, Miró fashioned an antigravitational field populated by galactic forms. Imagination was set free to cavort, romp, and even threaten in a seemingly limitless space.

Mark Rothko
Tentacles of Memory
ca. 1945 – 46

A catalog of the abstract imagery found in "The Interpretive Link" gives a good indication of the path these artists took. Mark Rothko's aqueous watercolors suggest an undersea realm of protozoan creatures. The very different pictographic markings of Jackson Pollock and Adolph Gottlieb both allude to a moment of transition between prehistory and the codification of myths as symbols. Barnett Newman's crayon drawings conjure abstracted seed pods and organic matter, and they're endowed with titles drawn from ancient myth. Several of the gouaches by Richard Pousette-Dart suggest the inner tissue of plants or animals as seen through a microscope, while auras, spirits, and magical talismans pervade the works of John Graham, Wolfgang Paalen,

Mark Tobey, and Ford. The crabbed and spiky drawings of Matta exude a hallucinatory sense of terror and decay that is matched by the potent delirium of sexual release.

Galactic forms, protozoan creatures, prehistoric pictographs, ancient myths, spirits, and hallucinations—together, such images speak of a profound desire to be anywhere but in the mundane visible world of the earthly here and now. That such a craving manifested itself in the midst of a world in full collapse is not surprising. It would be a mistake, however, to consider this an escapist art, a simple flight from the horrors of the moment into a safe and comfortable realm of complacency and nostalgia. Indeed, the branch of Surrealism that relied on illusionistic renderings of ordinary objects combined in extraordinary ways—the branch typified by the work of Salvador Dali and René Magritte—was dismissed as incapable of producing any but the most minor ripples in traditional patterns of thought. Abstract Surrealism, the organic or biomorphic branch that sought to plumb untapped conceptual regions of the mind, moved to center stage as the foundation upon which the search for the new and unconventional would be made. These works on paper don't merely chronicle a move away from the moribund, they chart a move toward regions unknown.

In a seemingly contradictory way, this art is at once atavistic and revolutionary in spirit. In its reliance on ancient myth, nature, and the primitive, it surely searches for "lost" characteristics to be found in remote ancestors; yet it does so not for the purpose of reenthroning prior conventions, but to force a transformation in present ones. In the United States of the 1930s and 1940s, those pictorial conventions were dominated by Social Realism, a style every bit as traditionally depictive as the branch of Surrealism championed by Magritte and Dali. An art tied to description seemed stuck on the surface, unable to fully penetrate the illusions concealing truth. The work in "The Interpretive Link" is focused on the thorny but potentially liberating task of preserving subject matter while banishing depiction.

Abstract Expressionism was the culmination of that task. Few people would claim that the movement erupted full-grown from the brushes of these artists, like Athena from the brow of Zeus; but we do have a tendency to casually regard it as having wiped the slate of European Modernism clean, in a fundamentally American way. (This conception loosely parallels a simplistic reading of the war: Europe was devastated, America proceeded to build Western culture anew.) Yet, the work in this exhibition gives rise to a rather different point of view. Abstract Expressionism can be accurately claimed as the arrival of a fully mature artistic voice in America. But in its committed search for a nondescriptive art that would nonetheless embody a universal language, Abstract Expressionism begins to appear as the stunning culmination of a distinctly European brand of Modernism, one set into motion

by Kandinsky, Miró, and others.

This may partially explain why Matta and Arshile Gorky emerge as artists central to the developments of the 1940s (their work comprises nearly one fifth of the 137 pictures in the exhibition, and both are superbly represented). Gorky's lengthy assimilation of the work of Cézanne, Picasso, and Braque is well known, as is his "failure" to fully disengage himself from the influence of his mentors. For his part, Matta continually reaffirmed the ties to Surrealism he had begun to forge upon his arrival in Paris in 1934 (Surrealism's guiding light, André Breton, quickly labeled him the "absolute automatist"). Furthermore, the two artists scavenged from one another's work throughout the early 1940s. One could describe them as keepers of a flame to which other artists in New York were attracted like moths.

Together with its informative, readable, and handsomely produced catalog, "The Interpretive Link" not only gives rise to such provocative questions, it sheds a good deal of light on a complex period whose contours are far from settled. Quite simply, it's among the finest exhibitions to have been mounted this year.

Photography and Art: Interactions Since 1946

June 14, 1987 Finally, an exhibition has opened in Los Angeles that fully justifies the mountain of rhetoric that has been spoken in praise of the opening of new museums for the exhibition of contemporary art. In fact, one would be fully justified in describing "Photography and Art: Interactions Since 1946" as a landmark exhibition. Organized by Andy Grundberg, photography critic for *The New York Times* and guest curator at the Fort Lauderdale Museum of Art, and Kathleen McCarthy Gauss, curator at the Los Angeles County Museum, where the show had its debut last week, "Photography and Art" has tackled a question of fundamental importance.

Today, the contemporary art scene is replete with important artists who use the camera as a primary tool, such as John Baldessari, Anselm Kiefer, Barbara Kruger, Sherrie Levine, Richard Prince, Cindy Sherman, James Welling, and many more. None is an artist whom we would think of as a photographer in the same way we would, say, Ansel Adams or Paul Caponigro. For a variety of provocative reasons, their photography-based works aren't ghettoized by medium, nor do they constitute a separate tributary running parallel to other kinds of art. Instead, they're fully within the mainstream of current artistic thought. Grundberg and Gauss have attempted to chart the winding and often intricate path that led to this startling phenomenon. They've worked backward from the present, along the way eliminating from consideration such things

Last Chance for Eden

as documentary or street photography. In the process, the radical redefinition of photographic practice that has occurred emerges as a development more central to postwar art than it has ever seemed before.

The exhibition is very large—some 300 works by more than 100 American and European artists—and thus somewhat daunting. Yet, in conception and layout it makes a case so compelling as to invest new life in any weary visitor. The first few galleries rehearse the familiar directions of art photography in the decade following the close of World War II, directions typified by the legacy of Alfred Stieglitz and Laszlo Moholy-Nagy. Stieglitz's vigorous support for photography as a distinct, self-expressive medium and Moholy-Nagy's embrace of the camera as a constructive tool for reshaping perception dominated photographic practice until late in the 1960s. The American champion of Modernism and the European émigré who brought the teachings of the German Bauhaus to this country both died in 1946. Beginning the exhibition with the ghosts of these two photographers also underscores an important feature of the premise: "Photography and Art" considers its topic largely from an American perspective. The work of a number of European artists has been included—Bernd and Hilla Becher, Bill Brandt, Marcel Broodthaers, Victor Burgin, Jan Dibbets, and several more—but without exception, theirs is work that has been influential in the United States as well as Europe.

Cindy Sherman
Untitled
1981

The decision to focus on American photography, and on the impact in this country of work by carefully selected European artists, is not to be dismissed as a simple case of egregious chauvinism. Rather, it's critically justified in two ways: First, the picture-making uses of photographic imagery recently employed by Baldessari, Kruger, Levine, Sherman, et al. have largely constituted an American phenomenon; and second, the pivot around which the transformation was decisively to occur will be found on this side of the Atlantic.

The most startling gallery in the show comes early on. In fact, after perusing a few rooms of classic images by Ansel Adams, Minor White, Aaron Siskind, Wynn Bullock, and others from the established firmament, it's something of a shock to come upon four artists

whom one does not easily think of as photographers: One side of the room features paintings and prints by Robert Rauschenberg and Andy Warhol, and the other presents collages and books by Wallace Berman and Edward Ruscha. This union of "nonphotographers" from New York and Los Angeles spans roughly a decade, from 1955 to 1965.

Rauschenberg's familiar "combine paintings" of the mid- to late 1950s caused a severe rupture in our understanding of what a painting could be. His incorporation of old snapshots and postcards, as well as his use of silkscreen images and other transfer processes, explicitly described painting with terms normally applied to photographs: Rauschenberg used the work of art as a surface on which to re-present existing images.

It may also seem out of place to prominently feature a large painting such as Andy Warhol's 1962 *Black and White Disaster* in a show ostensibly devoted to photography, but it really isn't. As with all his classic works on canvas from the period, *Black and White Disaster* uses newspaper photographs that have been greatly enlarged and silkscreened onto the picture's surface. Taking Rauschenberg one step further, what comes through most forcefully in this exhibition is how Warhol's work could best be described as photographs masquerading as paintings. Given the status held by the medium of painting at the time, as well as the con- current stepchild status of photography, Warhol's was a brilliant way in which to force the issue of the primacy of photographic ways of see- ing in a media-soaked environment.

Wallace Berman doesn't fit easily into this show, ex- cept as an artist who used photographs in a materially innovative way. Still, his presence does set the stage for the arrival of Edward Ruscha, whose series of deadpan, pseudo-documentary books engaged pho- tography as a conceptual game. With *Twentysix Gasoline Stations*, *Every Building on the Sunset Strip*, and other books from the early 1960s—all of whose titles succinctly described their contents—Ruscha straightfor- wardly used the photographic image as a linguistic sign, not as a pic- torial device. This Conceptualist strain gathered numerous adherents as the 1960s progressed, chief among them Baldessari. As 1950s Rauschenberg culminated in 1960s Warhol, so 1960s Ruscha blossomed in 1970s Baldessari. These four artists emerge as the decisive figures in the transformation chronicled by the show. For the threads they wove together formed the fabric of the prominent photographic art of the last several years.

The exhibition also follows lesser tributaries generated by the shift from "art photography" to art informed by photographic principles. Although none of these experiments yielded results of ma- jor interest, they nonetheless served to embed photography more deeply into general artistic practice. If there is any unfortunate omission keenly felt in the show, surely it is the absence of work by the notable English

duo Gilbert and George. Ironically, their absence speaks of the difficulty that still pervades the realm where art and photography meet: According to the museum, the artists declined to participate out of a concern that the show would restrictively miscast them as photographers. That it succeeds in tracing the development of precisely the opposite phenomenon is a measure of the exhibition's thoughtfulness and care. Indeed, this is one rare instance where you wish the curators had overruled the artists and had borrowed work from cooperative sources despite their protestations.

Still, "Photography and Art" does not suffer fatally from the absence. Indeed, this exhibition is likely to be the standard by which its topic will be measured for a very long time. Likewise, the handsome and provocative catalog is certain to emerge as the fundamental reference on the subject. With its establishment several years ago of an extraordinary department of photography, the J. Paul Getty Museum decisively tilted the center of photographic study toward Los Angeles. With the mounting of "Photography and Art: Interactions Since 1946," the Los Angeles County Museum has significantly added to the shift. Although the show will be traveling to the Queens Museum next year, it's worth noting that not a single institution in Manhattan had the wherewithal to mount this most important show. That it peremptorily enlarges upon and redirects the narrow focus on photographic history so long advanced by the Museum of Modern Art is not the least of this exhibition's several momentous achievements.

American Craft Today

september 13, 1987 The most common question asked about the rather extraordinary state of the crafts today is perhaps the least productive: Have the crafts become a form of fine art? The issue raised by such a question is a false one. Art is a concept whose cluster of moments is perpetually reconfiguring itself. To attempt to answer the unproductive question is to assume that the art-cluster is timeless and eternal—that a woven basket or a beaded collar, a crystal goblet or a maple rocking chair need only be slipped into the timeless and eternal mold of art to see how it fits. If enough fit seamlessly, there follows the erroneous declaration, "Crafts are art!"

Nonetheless, the CEO of Philip Morris Cos., Inc., Hamish Maxwell, declares his impatience with nasty distinctions between crafts and art in the catalog that accompanies the exhibition "American Craft Today: Poetry of the Physical." So, in effect, does the book's principal essayist Edward Lucie-Smith. Philip Morris is picking up the tab for the national tour of the show, which is the largest presentation of its kind in nearly twenty years. Originally assembled last October for the in-

auguration of a new home for the American Craft Museum in New York, the exhibition is visiting seven sites around the country. Currently it can be seen at the Laguna Art Museum.

I don't suppose the CEO's silly impatience with distinctions between craft and art should be much cause for alarm. We're all used to tiptoeing through the public relations propaganda of corporate support for the arts. But there are other causes for concern, and most of them fall at the feet of the arts professionals responsible for this inflated show's numbing celebration of superficiality. Given its prestigious organizer, its influential corporate sponsor, its extensive exposure to the public, and, not least of all, its peremptory title, "American Craft Today" easily must be considered the voice of authority on the matter. If so, then a more productive question to pose might be this: Why is the state of American craft today such a mess?

On the surface, things have never been better in the craft arena. For one, business is booming. A whopping 286 artisans are represented in the show. (Nearly a quarter of them produce their wares in California.) The range of materials and kinds of crafts included—ceramics, jewelry, weaving, furniture, glass blowing, basketry, etc.—seem endless. The numbers alone suggest demand for the crafts is high, and the general assumption is that the explosion of interest, which began well over a decade ago, hasn't yet peaked. If this huge exhibition truly represents its curator's assessment of the cream of the crop, think how enormous the rest of the field must be.

Almost all the work in the show could be divided into one of two groups. One is objects that try so hard to be hip you want to gag (most of these have pastel color schemes, jagged edges, and asymmetrical designs). The other category encompasses objects so "sincere" in the old-timey goodness of their natural materials and painstaking methods that you want to gag twice.

What is the primary source of the affliction that has kept the crafts, as a whole, becalmed and bereft of anything but the most tepid excitement? It is instructive in this regard to consider that art critics are forever being berated for not giving adequate attention to crafts, be they baskets, quilts, or ceramics. Certainly, there are critics who have written well about one or another medium in general or artisan in particular. Yet, if the crafts today had any genuine vitality, as the contributors to the show's weighty catalog keep insisting they have, it hasn't surfaced in anything but the most sporadic and ineffectual way. What such a complaint actually reveals is a queasy but unspoken sense that, in the whole explosive phenomenon that has taken place since the 1960s, not a single persuasive critical voice has emerged from within the burgeoning crafts movement itself. The whole arena is marked by a nearly total absence of criticality.

Much of what passes for critical discussion in the show's

catalog is, in fact, nothing more than moony atavism. I had to blink my eyes when I read the following, which appears early in the catalog's introduction: "As our world becomes more dependent on technology, we are required to do specialized tasks that often disassociate us from a sense of total accomplishment. Craft, which by its very nature represents a unity of hand and spirit, counteracts this alienation, reaffirming the human element in daily life. Amid mass production the craft experience can impart greater meaning to individual expression."

Surely that bit of charmingly old-fashioned nonsense was written circa 1886 by William Morris, the founder of the arts-and-crafts movement in England, and not 100 years later, as credited in the text, by Paul J. Smith, director of the American Craft Museum! Smith left a few rather important words out of his exhortation, which ought to have gone like this: "Amid mass production, the craft experience can impart the *myth of* greater meaning to individual expression."

The perfume of nostalgia has never made for a healthy environment in which to think clearly, but it surely is a tried-and-true technique for selling wares. As I said, business is booming in the craft world. The poetry of the fiscal, not the physical, is a big part of the story of American craft today. The past twenty years have seen the explosive birth and growth of what could be called the artsy-craftsy movement. Spurred on by endless urgings from the leisure industry, a vast and solid body of ordinary people who quilt, throw pots, build bookshelves, and make jewelry is loose upon the land. Most of the craftsmen in "American Craft Today" are simply the pros—the Jack Nicklauses and Martina Navratilovas of the Sunday golf and tennis bunch. Why the do-it-yourself, artsy-craftsy phenomenon really began to take off in the 1960s is a complicated and not uninteresting question. (Goodbye William Morris, hello Philip Morris.) Needless to say, it never gets addressed in Lucie-Smith's often stupefying essay tracing the history of contemporary craft in America. Instead, he winds up flailing about in the quagmire-issue of whether or not the crafts have become art.

"Poetry of the Physical" claims that mastery of materials is the highest aspiration of craftsmen and thus the lesson we can learn from studying these objects. Another name for mastery of materials is technology. As with all material objects that are solely the products of applied technology, an art based on mastery of materials is simply design. As long as mere design remains the guiding spirit of American craft, I wouldn't count on the kind of radical disruption that could pump some juice into this mostly tired stuff. Technology has never been a cause for faith. Meanwhile, it would appear that the illusion of a vital crafts movement might spell trouble for those very few artists who actually are producing extraordinary work. (Yes, there most certainly are a few superb artists in the show.) How? At the moment, the craft world provides a parallel universe into which a gifted artist will periodically dis-

appear, his sharp point dulled and eloquent voice muffled in a space where mushy paeans to "the craft experience" are taken seriously. I don't worry that these artists will somehow contaminate their own work on such voyages; I worry that we will pillory them with guilt by association.

The attentive reader will have noticed by now that I've managed to get through this entire review without mentioning the name of a single craftsman or craftswoman. The omission is intentional. Since the show is essentially about nothing other than shopping, far be it from me to write ad copy. It seems, though, that I have to break my stride and mention just one, if only because a functional piece by the metalsmith Glen Simpson so clearly demonstrates the dilemma of craft today. His small, 16-inch implement is made of a hickory dowel and a sterling silver blade with 14-karat gold embellishments. Its descriptive title is *Number Two Shovel*. The joke is a good one, even if frustratingly ineffectual. For I doubt that widespread critical lightning will strike with the unalienated, unified-hand-and-spirit mastery of materials that exemplifies the fabrication of this Tiffany-grade, doggy pooper-scooper. Still, Simpson seems to have a pretty good handle on what is being shoveled in the crafts phenomenon celebrated by this show. With admirable concision, he's called a spade a spade.

Musée d'Orsay

October 18, 1987 For all its notable contemporary artists and exceptional museums, France has not been a major player in the international art scene for several decades. Instead, for the past fifteen years its capital city has been taking stock of the remarkable artistic holdings scattered about the nation and has been busily shuffling the deck. First there was the Centre Georges Pompidou (Beauborg), a disastrous foray into phony populism that has recently led to an at least workable renovation of the galleries housing its extraordinary modern collection. Then there was the Musée Picasso, an effort to rectify a long-standing and scandalous indifference toward this seminal artist by establishing a shrine to his monumental ego. Now the Louvre is in the midst of major reorganization, complete with a new, glass-pyramid entry designed by I. M. Pei. Last but not least, there's the new home for everybody's favorite art.

With an average of some 12,000 visitors a day since its inauguration ten months ago, Paris's much-anticipated Musée d'Orsay is clearly a rousing popular success. This news comes as no surprise, though, for the museum, devoted as it is to French culture in the second half of the nineteenth century, is now home to the extraordinary collection of Impressionist and Postimpressionist paintings formerly housed just across the Seine River in the galleries of the Jeu de Paume.

The public, of course, regularly displays its seemingly insatiable ap-
petite for the paintings of Manet, Monet, Degas, Van Gogh, and the
rest. If the Orsay's public popularity isn't a surprise, there is nonethe-
less a hearty shock in store for a first-time visitor to this completely trans-
formed railway station on the Left Bank. To put it as unambiguously
as possible: The Musée d'Orsay may well constitute the most brilliant
museum design of our time.

It has also been among the most controversial, especially
in France, where the idea for the state-sponsored museum was born un-
der the presidency of Georges Pompidou, evolved during the tenure
of Valery Giscard d'Estaing, and changed direction with the election
of François Mitterrand. For Americans, the idea that an art museum's
program might be influenced by the attitudes of the political party
occupying the White House seems ludicrous (even if that is regularly the
case at our State Department-funded National Gallery). Meanwhile, the
possibility that a Ronald Reagan would—or could—argue passion-
ately about the fine points of mid-nineteenth-century aesthetics is
impossible even to imagine. For the French, however, such assump-
tions are routine.

The political dimension involved in the museum's cre-
ation shows itself in many ways, some immediately pragmatic and oth-
ers more philosophical. Consider the expense of the mammoth
undertaking, which required the complete renovation and adaptation of
a long-abandoned railway station into a museum with very demand-
ing specifications. There were those who felt that 1.3 billion French
francs—more than $220 million—could have been better spent on so-
cial programs. At the other end of the spectrum was the thorny prob-
lem of choosing the appropriate date with which to begin this survey
of French art. Should it be 1848, with the founding of the Second
Republic? Or 1851, with the inauguration of the Second Empire? Or
perhaps 1870, with the establishment of the Third Republic, which re-
mained in place until the advent of World War II? Artistically, should the
story begin with Eugène Delacroix and the high-flown drama of
Romanticism, with Gustave Courbet and the blunt facts of Realism, or
perhaps with Édouard Manet and the gaggle of Impressionists? The point
to which one chooses to trace one's ancestry is always a volatile issue.

Delacroix and 1848 won out. But in the case of the Musée
d'Orsay, the issue was doubly complicated. For the protracted evolu-
tion of the museum, whose seed had been planted by Pompidou as early
as 1972, coincided with two intimately related phenomena. First was the
emergence, in academic circles, of revisionist art-historical studies; the
aim was to redirect attention away from pure aesthetics and toward
the social history of art, and nineteenth-century France had turned
out to be fertile territory with which to begin the project. Second
was the emergence of the concept of contemporary Postmodernism.

If its contours remain ill-defined to this day, Postmodernism nonetheless insisted that the modern era has slipped into the past.

The architects of the renovation were from the Parisian firm ACT. But the primary task of devising the interior was assigned to the Milanese designer Gae Aulenti, who exquisitely renovated the Palazzo Grassi in Venice two years ago. The museum includes the work of academic and salon artists as well as Modernists, and their conflicting viewpoints are well expressed by the train station itself. Opened in 1900, at the end of the great railroad era that stands as primary symbol of Modernism in France, the Gare d'Orsay was almost immediately obsolete. The original architect, Victor Laloux, built a modern iron structure yet clad it in stone. The result was a building whose progressive modernity was cast within a comfortably retrograde Beaux Arts vision of empire. In the renovation, Aulenti transformed the Musée d'Orsay into a stage on which a complex pageant is played out. She harnessed a suggestive vocabulary of architectural forms to elucidate conflicting threads that shaped the complex period. Her design is both historical and critical. Yet, she also clearly understands the perils of didacticism in museum installations, in which illustrative points tend to get outlined and works of art become mere footnotes to a curatorial text. Instead, she's used her design choices as allusive elements meant to suggest the complex currents of late-nineteenth-century France that shaped these paintings and sculptures.

Sometimes those design choices are as simple as the kind of lighting employed. The downstairs galleries, which house art made before 1870, are artificially illuminated with deftly handled reflected light. Upstairs, in the first rooms housing art after 1870, the paintings are naturally lighted through filtered skylights. A suggestion of the shift, which occurred around 1870, from painting in the studio to Impressionist paintings made outdoors is thus subtly but effectively made.

The grid is the basic organizing scheme for the entire building, as well as the chief decorative motif of the museum. The primary symbol of Modernism's abstract ideals appropriately underlies the whole design. The great, soaring space of the station's central nave is an awesome sight. Aulenti has turned this interior avenue into a grand "outdoor" boulevard, gently putting one in mind of Haussmann's nineteenth-century transformation of medieval Paris into the city of urban promenades we know today. (On the upper floor, a panoramic view of those very boulevards can be seen through the glass face of a huge clock on the building's exterior.) That first modern urban renewal program had profound social implications: It swept countless poor neighborhoods away from the central city in order to make way for the triumphant entry of the bourgeoisie in the century following revolution. Aulenti has flanked her interior boulevard, which is complete with academic and official sculpture, with rooms whose façades are vaguely

Last Chance for Eden

Egyptoid in feeling: Bourgeois dreams of empire, as well as subsequent French expansion into North Africa, are subtly conjured. The Musée d'Orsay is filled with such deft allusions to both the political and industrial revolutions and their aftermath, but never do they attempt to divert attention away from the art.

Not all is perfect, of course. The galleries for Gauguin and the Nabis are cramped and awkward, and the separation of the arts into discrete sections for painting, sculpture, photography, film, and the rest is less than ideal. Still, the Musée d'Orsay stands as a triumph. Not the least of its achievements is the modern myth it handily lays to rest: The pretense of a possibly "neutral" space for the effective presentation of art is dead and buried. That such an idea should be so forcefully stated in Paris—the nineteenth-century city that has now itself been transformed into one giant museum—is eminently appropriate.

wallraf-richartz museum/ museum ludwig

November 1, 1987 When the Wallraf-Richartz Museum/ Museum Ludwig opened last year in Cologne, a sizable chunk of the international art world was in boisterous attendance. Peter and Irene Ludwig, after all, are among the greatest collectors of our time, a couple whose knowledgeable acquisitiveness has resulted in everything from a truly exceptional collection of medieval manuscripts (which they eventually sold to the J. Paul Getty Museum) to the foremost group of American Pop paintings and sculptures anywhere (some of which were part of "The First Show" at L.A.'s Museum of Contemporary Art). Together with the German Gothic, Renaissance, and Baroque paintings from the former Wallraf-Richartz Museum, their holdings in twentieth-century art, never before seen en masse by the public, constitute the bulk of the display in this huge museum on the bank of the Rhine.

Then, too, the opening of this $165-million extravaganza was one link in a chain of such events that have been occurring in West Germany with what seems like clockwork regularity in recent years. Hans Hollein's materially lush design for the Municipal Museum in Mönchengladbach had been widely hailed (he promptly went on to win the Pritzker prize for architecture). So had Richard Meier's materially austere scheme for the Museum of Decorative Arts in Frankfurt, while, nearby, applause had also greeted Oswald Matthias Unger's inventive solution for the German Museum of Architecture. (Unger enclosed an existing small building within his new larger one, making the original building an actual part of the museum's architecture display.) Elsewhere, the acid-green floor of James Stirling's design for the New State Gallery in Stuttgart had been only one focal point in the love-it-

or-hate-it controversy that swirled around that rambunctious building. And regardless of what one thought of the icily beautiful (and sometimes numbing) new structure of cold black granite and even colder blue light designed by the team of Otto Weitling and Hans Dessing for Düsseldorf's Kunsthalle Nordrhein-Westfalen, nobody disputed the achievement of director Hugo Schmalenbach: During the past two decades, he had assembled a twentieth-century collection of astonishing quality.

The Ludwig Museum, too, is certain to take its place in the annals of late-twentieth-century architecture. The building was designed by the team of Peter Busmann and Godfrid Haberer. Perhaps having had two architects made this building what it is: a schizophrenic's nightmare.

On the outside, the museum is a marvel. It occupies a very important site in the heart of Cologne, a city of unrelieved ugliness save for sections of its innermost core. Like many German cities, this one was largely flattened during World War II, and the rebuilding that followed was perfunctory at best. Cologne, though, boasted certain distinct features that could be pulled together to create an exceptional urban center: a magnificent, soaring cathedral—one of the greatest in Europe—adjacent to the grand, cavernous train station situated on the riverfront. What was needed was a stroke of planning genius. Busmann and Haberer provided that miraculous stroke with a beautifully sited building whose rhythmic, shedlike curves form an eloquent transition between the cathedral's vertical Gothic tracery and the train station's wide horizontal vault. Aside from this distinctive profile, the museum's external plan, complete with cascading steps and ramps of brick paving, creates a series of passages, promenades, and outdoor rooms that gracefully link the church, the station, and the waterfront.

On the inside, the museum is a torture chamber. Many institutions could compete for the title of Worst Gallery Space Ever Built, but the Ludwig Museum has managed to blow away all competition in one mean-spirited barrage. (The folks at the L.A. County Museum should send a thank-you note.) The galleries are simply hateful. From the lumbering, neon-outlined staircase that crashes through the center of the building, like an art deco battering ram, to the inconceivable galleries, whose tall, skinny proportions relentlessly lead one's eyes up and away from the art, here is a masterful essay in how to build an environment unfit for man or painting.

And it gets worse.

Most of the galleries are laid out on either side of a central spine that runs perpendicular to the battering-ram-cum-staircase (as a floor plan, imagine a flattened rib cage). What this means is that the hapless visitor is repeatedly enticed into a series of galleries, only to be deposited eventually in a dead-end room. After two or three backtracking excursions through dreary confusion, the thought of venturing into yet another skinny cul-de-sac is enough to make one swear

Last Chance for Eden

off museums for life. Granted, there are astonishing pictures to look at along the way; but that's rather like swooning, "The icebergs looked awesome from my stateroom on the Titanic."

There is something else, however, that distinguishes the Museum Ludwig from all the others—something that initially had attracted the art world in a way quite unlike any of the other debuts. Simply put, the Ludwig Museum is located in Cologne. And in the remarkable return to prominence of European art in the past decade, Cologne has emerged as the indisputable center of Europe's marketplace. There are many reasons for this. The presence of the Ludwigs is one (they live in nearby Aachen), as a glance at the sheer volume of their holdings attests. The initial efforts of dealer Paul Maenz is another. Geography plays a part, too: Cologne is located virtually at the center of Western Europe. It's a trade-fair town, as well, with works of art part of the international commerce in everything from cars to kitchen appliances. Locals will also point out that there are historic reasons for Cologne's centrality. Look at the astonishing cathedral; its presence indicates the city's important past. Originally founded as a Roman outpost—a colonia—Cologne in the Middle Ages was not a feudal state but a Roman Catholic archbishopric. It was not a place whose economy turned on backbreaking labor and exploitation, but on intellectual pursuit and enlightenment. Today, the contiguity of the museum and the cathedral is more than mere physical fact. It's a history lesson.

Locals are less likely to point out that the link between past and present is not a pure matter of intellect and enlightenment, but of the simple concentration of raw power as well. Then it was the church; now it's business. West Germany is immensely rich. If it wasn't, Cologne wouldn't be the center of anything.

There's an easy way to start an argument in the West German art world: When marveling at the hundreds of millions of Deutsche marks poured into all those astonishing museums, simply mention that, well, of course, Germany is very prosperous and, you know, doesn't have a defense budget into which all that cash can be dumped. Eyes will narrow, nostrils will flare. Still, where cash goes, art goes. Farther along the Rhine, past all those crumbling castles nestled in misty hillsides, the city of Frankfurt, banking capital of West Germany—and, as a dealer said to me, the only place with a real, American-style skyline—is mounting an all-out effort to usurp Cologne. Sotheby's, the auction house, just moved its German headquarters there. The city's first international art fair is scheduled for next May. The burgeoning "museum mile" along the river will soon boast a sixth, nearby institution—a vast museum of modern art. Reportedly, galleries are eyeing the city as a potential home. As Cologne's Paul Maenz told the *ARTnewsletter* not long ago: "The artists I represent need the best location. If that is Frankfurt, I'll move there."

If only symbolically, the recent sale of the late Joseph Beuys's last major sculptural installation tells a tale. First offered to the Ludwig Museum, this work by Germany's chief artistic hero was sold to Frankfurt's unbuilt Museum of Modern Art when the Cologne institution balked at the price. Many dismiss Frankfurt as merely a nouveau riche interloper, without the great heritage of Cologne's refined past and, thus, unworthy of a prominent cultural mantle. But standing inside the Ludwig Museum, it's hard to take seriously such snobbish prattle. For here is a symbol of power that puts its best face forward to the street outside, while inside—where the art is—it's haughty, willful, indifferent, and cold. There's a cruelty to this museum in the heart of Cologne, and it speaks volumes.

van Gogh's Market

November 12, 1987 "Since I've been here," Vincent van Gogh wrote his brother Theo, referring to the three weeks and one day of self-imposed confinement to an asylum, "the desolate garden of large pines, under which a mixture of grass and various weeds grows tall and unkempt, has provided me with enough to work at, and I have not yet strayed beyond it. But the scenery of Saint-Remy is very beautiful, and I shall probably make my way into it by easy stages." The date was May 25, 1889; the place, Saint-Remy-de-Province, an asylum that formed part of a thirteenth-century monastery, northeast of Arles, where the artist confined himself for an entire year. And the "desolate garden," beyond which he eventually strayed, did indeed provide enough subject matter for him to paint—including, most likely, the roiling patch of purple, orange, and white flowers that swarm across the canvas he called *Irises*.

Irises is an infinitely superior picture to the faded version of *Sunflowers*, knocked down at auction many months ago for more than $39 million. (Museum-goers may remember *Irises* from the L.A. County Museum's 1984 Olympic Arts Festival exhibition "A Day in the Country: Impressionism and the French Landscape.") Whether that means *Irises* should be "worth more" than *Sunflowers* is, however, beyond logic.

For many, such a staggering price became an instant symbol, a benchmark, for all that is wrong in the art world—as if such a thing as a rational price could exist for what is, in the end, just a dirtied piece of cloth. Rational people know that in real terms of the marketplace, a painting is worth only what someone is willing to pay for it. In fact, the loony prices being paid for Van Gogh's pictures seem to me stunningly appropriate. Why? Not because cash is a reliable barometer of artistic genius, but because of what the action so pricelessly reveals about who we have become in 1987.

Last Chance for Eden

Consider, for a moment, the words we use to describe such mind-boggling sales: Crazy. Insane. Nuts. Lunatic. Mad. Sound familiar? They should. For these are the words we use to describe Vincent van Gogh himself. It's as if the passionate desire to own a painting by the sainted madman has come to require a degree of insanity equal to his own. It's as if to register that insanity through the public payment of a zillion dollars will put the buyer in a parallel universe of timeless and exalted immortality. Clearly, money is now the consecrated body and the eucharistic blood of our longed-for transubstantiation.

The irony is this: Van Gogh's insanity is not the source of his artistic genius, as we seem always ready to believe. No, the radiant indulgence of the artist's madness isn't what brought the magical swarm of purple irises gloriously into being. It's the other way around: Van Gogh painted precisely to keep the awful demons in his head at bay. He painted to forestall insanity. He made those endlessly amazing flowers to keep from succumbing to the ordinary madness that threatens to engulf each and every one of us, each and every day. The honor and humility of the struggle is what we sense in our gut when we look at Van Gogh's paintings, and it's what causes that little shiver way back in the shadow of our minds.

Thus they offer, too, a cautionary lesson. For contrary to our casual presumptions, which are so perfectly represented in the insanity of prices paid for Van Gogh's paintings, it was at that awful moment he succumbed to haunted craziness that his final ruin, not his genius, was assured. For that is the moment of insanity in which you put the gun up beside your temple and slowly pull the trigger. Crazy? Yes. A zillion dollars for a piece of dirtied cloth is very crazy, indeed.

The Armand Hammer Collection

January 31, 1988 If it hadn't been so appalling, it would have been an exercise in pure comic hilarity. A week ago, Occidental Petroleum chairman Armand Hammer tried to convince an otherwise preoccupied world that, despite all past evidence of its impossibility, he was about to become the first person in global history to successfully transform a sow's ear into a silk purse.

This miracle was to take place in Westwood, where the announcement was being made. For Hammer was not merely saying to the assembled press that he planned to build a private museum for his copious holdings. The eighty-nine-year-old industrialist was also declaring that he intended his Westwood gallery to be cast in the mold of New York's much-loved Frick Museum. Comparing his own meager collection to the incomparable Frick's was, for specific reasons I'll go into in a moment, the comical aspect of the proceedings. The ap-

palling part was the way seventeen years of public pledges were blithely given the lie. Since 1971 Hammer has taken every opportunity to bask in the glow of his philanthropic largess in reciting his intent to bequeath his collection to the Los Angeles County Museum of Art. In 1980 he even signed a document attesting to the plan. Although not legally binding, such documents are commonly used for planning. LACMA has shaped both its galleries and its collecting priorities in anticipation of the gift. LACMA trustees—such as Hammer—are supposed to have the best interests of their museum in mind. (Since the startling turnaround, I've been trying to recall what promises Occidental Petroleum has made concerning oil drilling along the Santa Monica coastline.)

As for the comedy: Hammer, who made the announcement with a perfectly straight face, was not lightly invoking the name of the Manhattan landmark, a museum housed in the Upper East Side mansion of industrialist Henry Clay Frick. In the late nineteenth century, Frick amassed a vast fortune from union-busting deals in coal, steel, and railroads and spent much of it acquiring an extraordinary collection of Old Master paintings, prints, and drawings; seventeenth- and eighteenth-century sculpture; and decorative arts. When he willed his Beaux Arts mansion and its drop-dead contents to the city of New York, Frick put into place the ingredients for what has since become a museum widely embraced with almost preternatural affection. People don't just like the Frick. They don't even just love it. People tend, instead, to regard the Frick as *theirs*. It's a place that may well be known and open to the vast public, but it finally belongs to each and every visitor's secret world of personal fantasies. It is indeed a private house.

Gustave Moreau
Salome Dancing Before Herod
n.d.

To get this kind of museum, which Armand Hammer now says he wants, New York architect Edward Larrabee Barnes has been retained by the octogenarian potentate. Barnes has designed some of the most congenial exhibition spaces in the country (the handsome

Walker Art Center in Minneapolis), as well as some of the most dis-
agreeable (the loathsome IBM Gallery for Art and Science in New
York City). When he spoke, Barnes seemed to understand fully Hammer's
desire for a Westwood Frick. After unveiling a very rudimentary model
of the proposed building, the architect read from a prepared descrip-
tion of the 79,000-square-foot museum. The terms he used were very
amusing, though he, like Hammer, kept a perfectly straight face dur-
ing the proceedings. The two-story, open-courtyard building, he said,
would be reminiscent of "a Florentine palace." It would be clad in white
Carrara marble, Carrara being the location of the Tuscan quarries
from which Michelangelo set free his sculptural stone slaves. To up-
date these clear allusions to the domiciles of Renaissance princes,
and to give them a necessarily modern L.A. twist, the architect went
on to note that the open courtyards would be covered by huge, re-
tractable canopies—"like the sails of a yacht" (ahem)—and that ac-
cess to the building, which will stand at one of the busiest traffic
intersections west of Florence's Porto Romana, would be simplified
by the inclusion of "a limousine drop-off" area (double ahem).

Let's call the new architectural style that Barnes unveiled
"California Medici." The general operating principle behind the lav-
ish style was, in the architect's words, simply "to design a house for
the collection." A house. Obviously a great house. A great aristocratic
house for a collection of art.

The architectural style for Hammer's $30-million build-
ing might be vastly different, but a great aristocratic house for a col-
lection of art is a very concise description of the Frick Museum. The
domestic aura of a house, however grand, has something to do with
the affection people feel for Manhattan's Frick. People don't simply
go there to see Bellini's *St. Francis in Ecstasy*, Piero della Francesca's *St.
John the Evangelist*, Duccio's *Temptation of Christ*, or any of the other
almost uniformly incredible works in the great aristocratic house on East
70th Street. If it's their first visit, they are making a pilgrimage to a sanc-
tuary that ranks as perhaps the greatest collection of its kind in the
nation. If not, they have returned to sit awhile in the home of old and
cherished acquaintances. Austere reverence soon gives way to tender-
ness and warmth.

This is not the experience one has in a big, sprawling,
heavily trafficked museum like the Metropolitan or the National Gallery—
or, for that matter, LACMA. No, the Frick isn't remotely like a bustling
airport terminal. Still, it isn't the domestic aura of the mansion alone that
makes the Frick so compelling. The labors of Bellini, Piero, Duccio,
and the rest have something to do with it. In fact, they have most to
do with it. For the Frick Museum, if it didn't have the incomparable
Frick collection inside, would just be a very nice house.

The almost pure comic hilarity of the proceedings a week

ago Thursday was the solemnly offered and reverently received suggestion that Armand Hammer's collection belongs in the artistic stratosphere that so easily claims the Frick. Who is kidding whom?

It may be too much to describe Hammer's collection as a sow's ear. Among its admittedly important paintings—and the handful that repeatedly get reproduced in articles about the collection—are Rembrandt's *Juno*, Van Gogh's *Hospital at St. Remy*, Gustave Moreau's *Salome Dancing Before Herod*, and Pissarro's *Boulevard Montmartre*. Admirable works all. Yet, the remaining several score pictures—many of them oil sketches—tend toward second-rate examples by first-rate names and third-rate examples by third-rate names. These are the ones that rarely get mentioned. A Maurice de Vlaminck still-life apparently painted with a kitchen spatula; a hilarious, cotton-candy sendup of Arcadian bliss by Marie Laurencin; the single worst Degas painting of dancers I've seen; the single worst Renoir idyll I've seen (and with the notoriously erratic Renoir, that's saying a lot); a bouquet of roses by Henri Fantin-Latour that gives new meaning to the word "dull"—these and other such egregious curiosities are more typical of the Hammer eye. Unless a pile of masterworks has been quietly added to the cache—quietude in art matters not being the typical Hammer style—the collection as a whole isn't even close to being a silk purse.

Bluntly, the Armand Hammer collection cannot sustain a museum of its own, however Fricklike the building might turn out to be. True, it contains the *Codex Leicester*, an eighteen-sheet, handwritten scientific manuscript by Leonardo da Vinci. There's also the group of 8,000-plus works (mostly graphics) by Honoré Daumier, which forms an indispensable study collection on the artist. However, one manuscript, one big study collection, and a handful of first-rate paintings do not a museum make.

Ironically, Hammer used to have a collection—of Old Master drawings—that was almost uniformly superb. Assembled by his art adviser John Walker, the collection was suddenly, and to the great surprise of many, *given* to the National Gallery last year. (Walker is director emeritus of the gallery.) The one group of works that would have lent uniform distinction to a Hammer Museum is gone.

When Hammer made his appalling announcement, leaving the paintings-poor County Museum in the lurch, it was frankly difficult to feel much sympathy for LACMA. The museum has been too concerned with limousine drop-off matters of its own since its inception, while artistic insight has too often come up second to empty grandstanding. Still, the conventional wisdom has been that LACMA is the big loser in Hammer's recent turnabout, that the County's weak collection would have been shored up by Hammer's holdings. Yet, make no mistake: Hammer's wildly uneven holdings also would have been shored up by those first-rate paintings the County does claim. Clearly, the

Hammer collection needs LACMA just as much as the LACMA collection needs Hammer.

Armand Hammer has wanted a lot in his long and celebrated life, and he's gotten a lot of what he's wanted. Plainly, though, what he now wants very badly—his own Westwood version of the Frick Museum—is certain to elude his grasp. He no doubt has the money and the political clout to get the place constructed. The only thing he doesn't have is the art to put inside. If built, an Armand Hammer Museum isn't even going to measure up to Henry Frick's guest house.

Mira! The Canadian Club Hispanic Art Tour

April 8, 1988 Hiram Walker, Inc. (like that other paragon of corporate culture, the folks who bring you Coors beer), has been sponsoring a regular promotional event designed to get a leg up on selling liquor to a rapidly expanding market. "Mira! The Canadian Club Hispanic Art Tour" is an ad campaign masquerading as an exhibition.

There are twenty-nine artists in "Mira!", which had its national debut last week at the Municipal Art Gallery in Barnsdall Park. The ethnic heritage of the twenty-two men and seven women whose work is on view includes a variety of Caribbean, Central American, and South American nations. They live and work in New York, New Jersey, Florida, Illinois, Washington, Texas, and California. They work in a number of different mediums (although almost never in sculpture). Some are Realists. Some are Surrealists. Some are Abstractionists. Some are Expressionists. Some are better than others.

However, the show casually damages the very art it claims to champion. One shunts aside any sense of this vaunted diversity in an effort to find the presumed common denominator of so-called Hispanic art—its "Hispanicness." This is a device by which the organizers (if not the artists) set these individuals apart and make them all the same. Paul Sierra's *White Water*—an energetic, heavily impastoed image of a careening boat that is perhaps the finest painting in the show—is thus made to have more in common with Virginia Jaramillo's utterly dissimilar, decorative abstraction on paper, or with Tony Mendoza's conceptualist photo and text, than with, say, the paintings of Richard Bosman (a well-known non-Hispanic artist), to whose work Sierra's bears an intriguing affinity.

Sierra's work would be better served in a discussion of the standard Romantic image of a boat adrift in, and buffeted about by, a hostile environment. Furthermore, the use of this image, which is familiar in other artistic contexts, may well be directly related to Sierra's experience as a Cuban exile. However, the Hispanicness of his art is not being used by this show to differentiate experience, but to put a

fence around it.

I suppose I would feel less appalled by this lamentable affair if Canadian Club, which has sponsored the tour on three occasions since 1983, would simply dispense with all the high-minded nonsense printed in its catalog and promotional material about recognizing "the diversity of Hispanic art that is enriching the American art world" and instead straightforwardly declare its true operation: to emphasize the sameness of Hispanics as a consumer market that could be further enriching this American corporation. That is all a show like this means to do, and there is a certain virtue to candidness. Supporters of shows such as this would no doubt reply that at least Canadian Club is patronizing Hispanic artists. To that I would agree, albeit in a rather different way: "Mira!" is about as patronizing as a show can be. In fact, it's almost enough to drive you to drink.

Picasso: Creator and Destroyer

June 10, 1988 Picasso was a creep. Yes, it's true. He was very mean to his wives and mistresses. He disowned his children. He regularly humiliated friends in public. He spread malicious gossip. He was a consummate manipulator. He had an ego the size of Brazil.

Picasso was a creep, all right, but this hardly qualifies as news. To serious observers of the cultural life of the twentieth century, it has not exactly been a secret that this pivotal artist was never Mr. Nice Guy. Together with the painter Georges Braque, Picasso may have fomented the artistic watershed that was the Cubist revolution, but it's doubtful he would have ever been selected for a date had he appeared as a contestant on television's *The Love Connection*.

There is, alas, at least one person to whom Picasso's less-than-charming personality came as something of a shock—one person that you'd hope might already know better, since she claims to have made the discovery long after having elected to write a biography of the protean artist. Arianna Stassinopoulos Huffington, whose biography of diva Maria Callas did for opera what the Luftwaffe did for London, was appalled by the revelation. In *Picasso: Creator and Destroyer*, just published by Simon and Schuster, Huffington feverishly recounts the artist's life and lusts while supposedly "exposing" his misogyny, his superstitious habits, and his youthful fling with a mysterious gypsy boy (no, I'm not joking). With all the depth and insight that the use of paid researchers can bring to bear, she's ripped the lid off a can of Spam.

Picasso isn't a howler of a book, nor is it a good trash-wallow. It's just dopey. We are meant to believe that the merit of an artist's work is commensurate to his or her goodness as a human being, as if paintings (or, for that matter, books) were merit badges representing

commendable character. In prose the color of a day-old bruise, Huffington portrays the artist as a larger-than-life monster careening around the heroic stage of the modern world. Hers is the sort of writing in which no one ever says, simply, "No." Rather, one enacts "monumental gestures of defiance." Neither does anybody merely live; instead, one "negotiates the mine-field of his life." Huffington needs such meretricious language because she sees the world in mythologically Olympian terms, and she means to taunt the gods. The first chapter, which chronicles Picasso's birth and childhood (he was, naturally, a mewling brat), is dotted with no fewer than a dozen pointed references to miracles, magic, and supernal mysteries.

Indeed, it is the myth of Picasso the Great that Huffington wants to challenge, so she begins by stacking the deck. She invents Picasso as a divinely inspired god born into an age when God had died. Slowly but surely, the Beelzebub lurking at the heart of modern life fights his way out, and Picasso, Prince of Darkness, is cast out of Huffington Heaven. The author builds a house of straw, then huffingtons-and-puffingtons and blows the house down. She sneers at the heroic mythology that has grown up around the artist (much of it at his own urging), then merely replaces it with a mythos of villainy. Filled with two-bit Freudianisms and phony feminism, the book is constructed on the shaky faith that paintings function primarily as autobiographical representations of their maker. In the finest tradition of personality journalism, Huffington reads Picasso's pictures as if they were snapshots in a photo album of his life. This leads to odd pronouncements. Because he seduced and destroyed women, we are told, Picasso painted them as if all chopped up. Misreading Sir Herbert Read's comment that *Guernica* is a monument to destruction, the artist is said to have been hailed as the genius of this century only because his destructive art mirrors this most destructive of epochs.

In truth, there's a simpler explanation for the supposed chopping up of faces in Picasso's art. Try this little test: Find someone you love, and press your lips close to theirs. Keep your eyes open, and look closely. What do you see? Eyes all askew? Two-sided noses? Distorted features? The shocking power of Picasso's art is a function of this stunning perceptual intimacy, this up-close confrontation with the routine miracle of life. Picasso's Cubism was a watershed because it proposed a spectator who was no longer static and kept in his place, but one who was constantly moving through time and space. And when he began to move, he moved in for a closer look.

Huffington doesn't get it—but then, she's not looking to understand. This is an arrogant book, and as cynical as the author claims her subject to be. By the end of the 475 grueling pages of text, it's pretty clear who the writer believes is the principal creator and destroyer, and it ain't the wild-eyed Pablo.

The Human Figure in Early Greek Art

November 20, 1988 A small and quiet stunner of an exhibition crept into town last week. "The Human Figure in Early Greek Art" is the kind of show that marries objects of exceptional beauty to a didactic purpose of unusual clarity. It means to tell a story that unfolded slowly over the course of some six centuries—a story of the arrival of classicism to Periclean Athens, which has functioned as a powerful founding myth for Western culture ever since—and it accomplishes its seductions through the mellifluent voices of unforgettable works of art. Ironically, it couldn't be more timely. For these ancient works of art, fashioned more than two millennia ago, nonetheless maintain the power to tell us something fundamental about the ordinary predicaments in which we find ourselves today.

Organized by the Greek Ministry of Culture, in association with Washington's National Gallery of Art, the show includes just sixty-seven objects. Selected from among the preeminent holdings of Athenian and Greek regional museums, it distills its subject through a highly refined group of superb sculptures, votive figurines, painted vases, and carved reliefs. The agenda of the exhibition can be neatly stated: to demonstrate, simply yet eloquently, how "Greek artists learned to represent the human figure in a naturalistic way." I'm quoting here from one of several didactic labels that lead visitors through the show, which has been elegantly installed in a sparse but highly stylized sequence of rooms on the lower level of the Los Angeles County Museum of Art. Among the oldest objects on display is a terra cotta figure of a mythological centaur, which stands 3 feet high. The stark allure of this simultaneously grave and playful statue has not diminished one iota since its making late in the tenth century B.C. The focal point of the exhibition is a bit more recent: the period between the eighth century B.C., when Greece began to expand its influence throughout the region, and the rebuilding of the Acropolis at the end of the fifth century B.C. Not until we arrive at a great funerary vase, or amphora, which dates from circa 750–735 B.C., do the organizers begin most clearly to make their point. It turns out to be something of a shocker. The tall-necked, two-handled jar is ornamented with row upon row of geometric patterns encircling its girth. At the rounded shoulders of the vessel, two wide bands are composed of abstract figures—the lower from a line of soldiers, the upper from mourners tearing their hair in the presence of the deceased, whose ashes this jar likely held. The black silhouettes are composed from diamond and wedge shapes, which reconcile these figures with the abstract decorations.

"The main scene on the amphora," we learn from the catalog that accompanies the show, "portrays the *prothesis* (laying out) of the dead noble before his burial. The dead man lies on a high bed ren-

Last Chance for Eden

dered in perspective. The painter, unable to show the body in perspective, depicted it in silhouette." I blinked my eyes to see if I had misread the assertion. I had not. This painted vase is among the most powerful that I have seen, yet, the painter who accomplished its extraordinary decoration was actually being given the back of a velvet-gloved hand: He is here claimed to have achieved his awesome triumph only as some sort of lesser consolation for having been "unable" to show the body in perspective. Perspective, or the technique by which an object in space is rendered as it might appear to the individual human eye, is here assumed to be the authoritative ideal toward which any painter naturally would strive. Failing that, he gave us something marvelous—but not quite right.

Anonymous Attic
Marble Relief of a
Victorious Boy Athlete
ca. 470 – 460 B.C.

 Put another way: The museum clearly wants us to believe that, if he could have, he would have, but he couldn't, so he didn't. This is quite an assumption, but it is not an aberration within the show. The didactic label on the gallery wall continues the subtle slant. "On pottery," it reads, announcing the ostensible nature of vase painting in the period, "images of man are subordinated to abstract ornament." Subordinated to? According to my trusty Merriam-Webster, that means images of man have been placed in a lower class or rank, or have been made inferior to, the patterns of dots, bands, interlaces, swastikas, and meanders in which this gorgeous vase is so luxuriously encircled. Certainly there are fewer human figures than abstract ornaments on the vase, but to say so is to state a quantitative fact. By sharp contrast, to say one is "subordinated to" the other is to make a qualitative judgment.

 The story that "The Human Figure in Early Greek Art" means to tell soon comes into sharp focus. It is a triumphant tale of the march from out of the darkness into the light, which goes like this: In the geometric period, when painters were "unable," they depicted their kind as "inferior" creatures. As the centuries went by their knowledge slowly grew until, by the victorious classical era, artists fi-

Early Greek Art

nally and magnificently had "learned" how to represent the human figure in a naturalistic way. By the end of the show we are at the end of the story. The final object is an exquisite marble relief, dated circa 470–460 B.C., in which a victorious boy athlete has been delicately carved in three-quarter view. A naturalistic illusion of a solid body embedded in space, the relief is a technical tour de force of great complexity and conviction. Apparently, the anonymous carver of this exquisite fragment finally got it "right."

Between the funerary vase and the carved relief, the story twists and turns along with assorted *kouroi* and *korai*, or standing figures of idealized youths and maidens, various painted cups, and numerous votive offerings. Each is meant to add an eloquent brick to the building of the chronicle of the birth of classical humanism. Out of the primitive darkness and into the glorious light: This narrative is among the most familiar in Western civilization, as a quick consideration of every story from biblical Genesis to cinematic *Star Wars* will attest. In cultural history, the view of an Italian Renaissance dragging Europe into a brilliant dawn after the brutally fearsome Dark Ages is a common example. Indeed, the particular story told by "The Human Figure in Early Greek Art" is itself the template on which the now wholly discredited tale of Dark Ages-into-Renaissance was patterned.

The show, in fact, tacitly presents triumphant classical humanism of fifth-century-B.C. Athens as having been an inevitability— as destiny. For to suggest the painter of the funerary vase wanted to render perspective but was unable to pull it off is to reduce him to a cipher within a predetermined course of events. Apparently, the Greek Ministry of Culture believes in fated glory. But they've clearly forgotten another useful concept from the classical past: hubris.

It is worth considering the assumptions on which this show has been based, as well as their ramifications. Naturalism in art is perceived as the ideal. The individual eye is privileged. The human subject occupies the spotlight at center stage. The ideal, toward which one strives, is dimly glimpsed in the future. Every step toward its realization is a milestone for progress. If these assumptions sound oddly reminiscent of tenets that came to the fore in our own modern era—from the naturalism of Gustave Courbet through the privileged eye of the Impressionists to Bauhaus ideals of progress—it is because cultures that describe themselves as modern always have been introduced by appeals to their ascendance from classical antiquity. (Not by accident was nineteenth-century Modernism preceded by Neoclassical art.) This ritual repetition serves, among much else, to blindly assert the social primacy of Western culture through the exclusion from consideration of any society that had the grave misfortune not to have been founded on such "bedrock" (as another didactic label in the show describes it). So much for Asia, most of Africa, and assorted aboriginal cultures, whose

Last Chance for Eden

art is uniformly "unable," and who are thus in apparent need of being brought into the golden chain of inevitability—of fated glory—that characterizes the West.

The reactionary nature of this show stands out in vivid high relief, coming as it does late in a decade that has been marked by intensive inquiry into the blinkered prejudices of Modernism and arriving in a city busily laying its own quiet claims for fated glory. Despite all, the show doesn't chart an evolution from a simpler to a better, more exalted state. It charts instead the knotty transformation of a culture—an alteration in which much was gained and much lost. "The Human Figure in Early Greek Art" does not consider that the ritual repetitions that it myopically reiterates are themselves the very stuff with which that gorgeous funerary vase has been so lavishly decorated. Pattern is repetition. Repetition is ritual. Ritualized activity is socialized behavior. Far from being "subordinated to" ornament, the figures on this funerary vase are full participants in the larger rituals of their collective social order—something the museum might consider, since it's a point of view not without its comforts or its solace in a eulogy to the dead.

Against Nature: A show by Homosexual Men

January 15, 1989 Whether we knew it or not, we have all been waiting for the exhibition "Against Nature: A Show by Homosexual Men." Although emphatically not a show of art about AIDS, it will nonetheless change the way you think about the profound alterations in American life being forged in the wake of this devastating medical emergency. The galleries at the artist-run alternative space LACE (Los Angeles Contemporary Exhibitions) are currently home to more than three dozen paintings, sculptures, photographs, mixed-media works, and videotapes, which together stand as an unprecedented curatorial achievement. Organized by writer Dennis Cooper and artist Richard Hawkins, "Against Nature" is a gallant and persuasive effort.

The AIDS crisis has generated a number of events in the artistic community in past years. The reason is not difficult to grasp: Because the epidemic has, in this country, principally claimed the lives of blacks, Hispanics, and gay men, the response to the medical emergency has been sluggish and flimsy. Even today, reports are regularly issued concerning the spread of AIDS "into the general population," a clear if subliminal assertion that blacks, Hispanics, and gay men remain excluded and restricted. Artists have been among those who, in the face of everything from shocking indifference to outright obstruction, have mobilized themselves. To date, shows have been mounted in sharp and enlightened protest of the homophobia and racism that have impeded progress

in bringing the medical emergency to a halt. Others have sought to diagram an activist response to the economic and political manipulations that swirl around the complex disease. Elsewhere, exhibitions have become the gentle dwelling for memorial convocations. Most often, as with the "Art Against AIDS" benefit and sale currently at the Pacific Design Center, exhibitions have gathered together works of art for the beneficial purpose of turning paint and canvas, ceramic and steel into much-needed cash. The necessity for such private fund-raising exhibitions is perhaps the clearest signal of the utterly appalling public conditions in this society that have made activist responses essential.

Yet, none of these rejoinders has been quite like "Against Nature." However important these various methods and approaches have been—and make no mistake, they have been crucial—something has always seemed terribly lacking. You could feel it in the inevitable frustration that tarries at the margins of such endeavors, a frustration carried along by the unspoken (but nonetheless ubiquitous) apprehension over the Goliathlike magnitude of the dilemmas being addressed.

Bruno Cuomo
(Doug Hammett)
Sleeping Beauty
(Paper Weight and
Bolo Tie Sets)
1989

What has been missing from these estimable efforts is the beginnings of an unraveling of a tangled and complex knot. For the AIDS epidemic is reshaping experience in deep and fundamental ways, causing transformations in our culture that will not be fully played out for generations. Demands are being made that we have only barely begun even to recognize, never mind address, and they pile one atop another at a relentless pace. I'm not talking here about devastating claims being pressed on the medical system of this or other countries, or about the political maneuverings and concealments that even today are shamefully—criminally—causing the epidemic to spread. These and other topical issues are clearly worth paying the closest attention to; still, things more elusive and equally essential are at stake. I am talking instead about the effects of new and difficult vicissitudes that works of art have the capacity to clarify and elucidate in ways unlike any other. Experience is being fundamentally altered by the proliferation of a virus called HIV.

This is why, like many others, knowingly or unknowingly I have been waiting for an exhibition that would, at least in some small way, begin to illuminate that mysterious and elusive difference.

"Against Nature" is that breakout exhibition. The clearest sign that something distinctive is happening lies in the atypical feeling with which the show is undeniably infused. By turns spirited, brave, celebratory, poignant, and funny, it is distinguished above all by an atmosphere of emphatic generosity. More used to shows that leave the aforementioned residue of querulous frustration, I was unprepared for the buoyant and inspirited effect of this surprising presentation.

It should be emphasized again that "Against Nature" is not a show about AIDS. The epidemic and its social and political contours are certainly not ignored, especially in a beautifully conceived computer program designed by Michael Tidmus called *Health and Morality: A Desultory Discourse*. (Reading its forcefully silent, horrifyingly dispassionate statements about the epidemic, I wondered whether this incisive program could be surreptitiously sent throughout the vast electronic network that has come to link us all together—a computer virus whose exponential spread might help to halt another.) Instead, this pointedly subtitled "show by homosexual men" is about the experience of a number of different people who share a common sexuality. The shift in focus accomplishes two things. Given the epidemic and its direct impact among homosexual men, AIDS is everywhere the subtext of the show. What stands in the foreground, however, is not the disease at all. Homoerotic sexuality itself occupies center stage, the felt and expressed desire that is of course a principal bond among homosexual men.

The homoerotic spectrum reaches from the dizzy romanticism of Arnold Fern's baroque theater curtain to Kevin Wolff's descriptive paintings of sexual self-determination. Sculptures by Johnny Pixchure and Carter Potter are both graphic and witty, while Nayland Blake's reliquaries (including one for the charred ashes of a text by the Marquis de Sade) put sex atop a martyr's altar. David Bussel lets you visually wrap yourself in the American flag while grinding the word "promiscuity" under your heel, as Doug Ischar unravels remarkably homoerotic representations of soldiers and suburbanites in 1940s pictures clipped from *Life* magazine. The video selection is almost uniformly strong, with hilarious high camp intermixed with cogent documentary. Perhaps the subtlest pieces are a half-dozen small, unlabeled plaster reliefs dispersed throughout the exhibition. Marc Romano's exquisitely crafted baroque decorations take the form of foliage that protrudes gently in the center—a swelling that quietly transforms the shape into a fig leaf about to throw off the shame that masquerades as modesty.

With its telling focus on sexual desire, "Against Nature" refuses to allow homosexuality to be defined by disease. It does so through

an apt repudiation. We have seen, in California as elsewhere, repeated efforts at categorizing AIDS along with syphilis and gonorrhea as a sexually transmitted disease (STD). But it is not an STD, any more than the flu or the common cold—both of which also can be passed during intimate contact—are STDs. AIDS is a group of symptoms that characterize abnormalities in the immune system and which have been generated by a blood-borne virus. The distinction is critical. The misattribution serves only to hinder treatment and research—and, not incidentally, to provide a hateful weapon for the continued oppression and disenfranchisement of homosexual men. Indeed, the misattribution of AIDS as a sexual malady is merely a transference of the long-discredited claim that homosexuality is itself an illness. With its attention clearly and candidly focused on sexuality and erotic desire, and the wide spectrum they encompass, "Against Nature" is anything but abject and dispossessed. More than almost any individual work in the exhibition, it is the collective power of the display that carries such authority.

One work must nonetheless be singled out. The remarkable *Sleeping Beauty* by Bruno Cuomo (a pseudonym of Doug Hammett) consists of several wall-mounted display cases, executed in woodsy, rustic style, for the exhibition of handcrafted cast-acrylic jewelry and paperweights. Where one would expect to find an arrowhead or coin embedded in the clear acrylic, the artist has instead inserted blood and semen, both infected with HIV. The modern faith in purity and essences, in peeling back the complex layers of conflicted and disorienting experience to find a saving distillation, a quintessence, a graceful soul residing at nature's core, here gets turned on its head: The lifeblood is now deadly.

Conventional wisdom asserts that AIDS has decisively changed—even ruined—sex. This exhibition's unabashed celebrations of the deep mysteries of human sexuality insist, as all statistics about sexual practices among gay men likewise attest, that undeniably difficult and vexing alterations in sexual practices can indeed be accommodated. Eros will survive. Truly serious jeopardy is harbored elsewhere. For collectively and with powerful individual works like *Sleeping Beauty* and Dennis Cooper's *Dear Secret Diary* (a short piece of fiction in the small but excellent catalog that accompanies the show), "Against Nature" recognizes something infinitely more potent and far-reaching than mere behavioral changes in the vicinity of sex. The nightmares of political villainy and corporate profiteering, the shunning estrangement of and reprobation for invaluable human lives, the relentless refusals of dignity, the usurpation by a virus of the most ordinary and commonplace miracle of all—we are witnessing a physical, moral, economic, and social collapse. For AIDS hasn't ruined sex. AIDS has ruined death.

painting in Renaissance siena

February 26, 1989 Everything I love about museums is on great and glorious display in the exceptionally beautiful exhibition at the Metropolitan Museum of Art, "Painting in Renaissance Siena: 1420–1500."

Just about everything I loathe about museums is prominently in evidence, too. This resplendent gathering of underappreciated paintings is unprecedented, but it has been served up to the public in a startlingly obtuse and incompetent way.

From the moment of its debut last December (the show remains on view through March 19 and will not travel), "Painting in Renaissance Siena" has been a very big hit. The local press has been unfailingly positive, even laudatory, and the crowds have flocked in. It's easy to see why. A comprehensive display of Sienese painting of the fifteenth century simply hasn't been done before. Nor is it likely another will be mounted for a very long time. Far less well known than fifteenth-century painting in nearby Florence—where names like Masaccio, Fra Angelico, and Paolo Uccello are strewn about—the panels, frescoes, and manuscript illuminations produced in the hauntingly beautiful medieval town of Siena hold for visitors the promise of discovery. Coupled with the now-or-never ambience of the show, the appeal is strong.

The Met is also just the right museum to have undertaken the organization (Keith Christiansen, curator of European paintings at the Met, admirably did the honors). The greatest holdings of Sienese painting are, of course, in Sienese churches, public buildings, and museums; but the Metropolitan claims perhaps the most important, and certainly the largest, group outside Italy. As our nation's premier art institution, it also has the prestige necessary to accomplish negotiations for loans of fragile panels. Airily installed around the atrium of the Met's otherwise horrid Robert Lehman Wing, "Painting in Renaissance Siena" gathers together nearly 140 works of art. Sassetta, Sano di Pietro, and Giovanni di Paolo are well represented, as are lesser painters from the region. Manuscripts, whose small pictures are often slighted in shows such as these, are much in evidence.

The Sienese were crazy about saints, in part because of their position as earthly sufferers who got swept up to heaven in miraculous ways, and much of the show is devoted to narrative cycles recounting assorted saintly lives. The exquisite fusion of mysticism, sinuous elegance, and opulent pageantry commonly ascribed to Sienese painting is everywhere to be seen. Neroccio de' Landi's *Madonna and Child with Saints John the Baptist and Catherine of Alexandria* (circa 1480, and lent by Pasadena's Norton Simon Museum) is typical of the show's glories—an exquisite panel by an artist not widely known. Elegantly

crafted, the panel employs masterful composition to endow its subject with mystical radiance. The central placement of the Madonna's hand is the picture's pivot. Impossibly arched—human bones just don't do what her hands are shown doing—the gracefully bowed hand is visually echoed in the arc of John the Baptist's, at the left, and of Catherine's, at the right. Lined up across the panel, their hands knit the picture together. The ecstatic composition is mainly built from curves, orbs, circles, and arcs. Formally, the saints and the Virgin and Child get inextricably woven together, with far more than decorative implications. The chief compositional circle inscribes the Christ child on Mary's lap, like a memory of the virgin womb. Her gracefully arched index finger and her counterpoised little finger point, respectively, straight into the child's pellucid eyes and his slightly opened mouth; the sources of all-seeing wisdom and the word of God are displayed. Around this quiet action revolves all else in the world described by this panel.

Sienese painting is a treasure trove of intricate and dazzling conceptions such as this. The exhibition handsomely unfolds the circuitous trajectory of this art, starting around 1420 and continuing to the end of the century. In this, the Metropolitan has done what great museums do best: used its resources to pull together an unparalleled array of exceptional objects. However, the museum has also done what museums regularly do worst: regurgitated thoughtless and unexamined bromides in the guise of historical elucidation. The entrance to the show is marked by a wall text, the kind commonly meant to give the general visitor a handle on the particular cultural situation that produced the art. At "Renaissance Painting in Siena," the general public gets handed nonsensical blather.

Things start out OK. The rivalry between Siena and Florence is laid out, and the great Sienese painters of the fourteenth century are given their due: Duccio, Simone Martini, and the Lorenzettis (Pietro and Ambrogio). The horrific plague of 1348 is rightly cited as a decisive moment, from which Siena never fully recovered (almost two thirds of its population was wiped out by the infamous Black Death). The second artistic flowering, which is the subject of the unprecedented exhibition, is then introduced. Things deteriorate rapidly. The museum's text is here worth quoting, at some length: "Whereas Sienese artists had been in the vanguard in the fourteenth century, in the fifteenth century the major innovations in art—one-point perspective, study from nature, the revival of interest in ancient art and theory—was [sic] the creation of Florentine, not Sienese artists." If this sounds a wee bit familiar, it's because the Metropolitan Museum has cast the rivalry between Siena and Florence in strictly Modernist terms: as a duel between a forward-looking vanguard and a bunch of old-fashioned traditionalists bent on preserving the status quo.

In reality, the rivalry is the story of a power struggle

between two world views, one of which—the Sienese—couldn't regain its strength after the brutal assault of the Black Death, and which faded in the wake of a changing milieu. The other world view—the Florentine—became the foundation on which modern culture in the West was to be built. Florentine painting now looks more convincing—"better"—because in it we see our own history, modern culture's ancestral self. To apply the terms of Modernism to the rivalry between Florence and Siena, as does the Metropolitan Museum, is simply an institutional means for affirming today's status quo.

So what is it that's notable about Sienese painting? Here, the museum goes into a steep nose dive. "The fascination of Sienese painting in the Renaissance derives from the responses of local artists to Florentine innovations, on the one hand, and to native traditions, on the other. A love of brilliant colors and silver and gold leaf goes hand in hand with a natural gift for storytelling and an innate feeling for landscape." A "natural" gift for storytelling? An "innate" feeling for trees and fields? Sure.

Neroccio de' Landi
Madonna and Child with Saints John the Baptist and Catherine of Alexandria
ca. 1480

You don't have to look farther than the famous four-teenth-century Lorenzetti frescoes in Siena's Palazzo Pùbblico, or Town Hall, to find out just how unnatural and learned are storytelling and landscape in Sienese painting. Generally regarded as the first major landscape in Italian art, the great fresco has a charmingly descriptive title: *The Effects of Good Government in the City and in the Country.* The aerial view shows the bustling walled city of Siena at the left, and the gorgeous rolling countryside spreading out at the right. The cityscape and the landscape are united by a peculiar system of perspective, found nowhere else in Italian painting. That perspective is radial. Imagine the spokes of a wheel: Siena's great town square was made the vanishing point, or hub, from which all daily activities of city and country are shown fanning out. The story this fresco tells is not one of natural and innate loves. It is an imaginative story of power and control: In a

town-hall chamber, seat of "good government," the painting depicts the triumphant authority of the city fathers over everything in the surrounding landscape.

Like that Lorenzetti fresco, introductory wall texts for exhibitions are meant, in subtle but nonetheless very real ways, to tell the general visitor how the museum thinks he ought to look at the art. Sometimes, what the museum has to say is far dumber than what you might have come up with had you simply muddled through on your own. Given the odd amalgamation of triumphant achievement and appalling failure, you could say "Renaissance Painting in Siena" is an all-purpose show. You could also, I suppose, learn an important lesson about the way powerful institutions work to maintain their own authority: Substitute Los Angeles for backwardly charming Siena and New York for mightily vanguard Florence, and you'll have a pretty good take on what passes for thought among many people today.

Richard Neutra at UCLA

June 11, 1989 Several years back, it took the unfathomable madness of an arsonist to bring to the brink of ruination downtown's Central Library, which is easily the finest work of public architecture ever built in Los Angeles. Several weeks ago, it took the equally inscrutable derangement of yet another arsonist to reduce the great architectural landmark of the Pan Pacific Auditorium to rubble. Only a fool would deny that these despicable acts, directed against our common cultural legacy, were insane. So what is one to make of the news that the next exterminating angel will actually be an institution of higher learning, which plans to wipe out a building designed by one of the leading architects of the century?

Within the next several months, UCLA is slated to demolish a major segment of the Corinne A. Seeds University Elementary School, an exceptional educational environment whose most notable features were principally designed by the celebrated architect Richard Neutra. This subtle and distinguished edifice will be razed to make way for the new, $67-million home of the John E. Anderson Graduate School of Management, a lumbering behemoth of a complex whose size reportedly will be second only to the university's huge medical facility.

Fueled by an initial gift of $15 million from attorney and entrepreneur John E. Anderson and his wife Marion, the expansion of the eponymous Anderson Graduate School of Management was subsequently bolstered by $5-million gifts from a home builder and a fast-food franchiser, and by a $1-million donation from a former ambassador to the United Nations Economic and Social Council and a cofounder of an executive-search firm. UCLA is also hoping for a $25-million al-

location from the state for the huge project, which will include new classrooms, computer and library facilities, faculty and research areas, administrative offices, and an executive education center, all in a tight cluster of a half-dozen buildings surrounding a circular courtyard. Completion is scheduled for 1993.

UES, as the elementary school and architectural gem currently occupying the site is commonly known, will be dismembered to accommodate the arrival of the business complex. You may not know of UES and its distinguished architectural legacy. I certainly didn't until last week, even though I've driven past the school a thousand times. Nestled in a sloping, wooded grove, most of the complex is sheltered by trees from the streaming traffic along Sunset Boulevard. Directly opposite Marymount High School, on a green island bounded by UCLA's Circle Drive, UES is a small oasis that serves as a kind of living laboratory for the university's Graduate School of Education. In fact, the secluded aspect of the private school is integral to its architecture.

UES was initially designed in 1948 by architect Robert Alexander, who sited the building along Stone Canyon Creek, which still traverses the property. In 1957 the school was enlarged by the firm of Neutra and Alexander. You don't need a Ph.D. in architectural history, just eyes, to know which of the two principals in the firm was largely responsible for the remarkable additions—the competent designer of the original building or the architect who, for nearly thirty years, had been producing some of the most stunningly inventive buildings in the country.

A Viennese-born expatriate, Richard Neutra was at the very forefront of modern architecture from 1929 on, when he built the universally acclaimed Lovell House at the edge of Griffith Park in the hills of Los Feliz. At his death in 1970, the seventy-seven-year-old architect could claim an exalted position among the first rank of designers in the modern era. At UES, the Neutra signature is most immediately seen in two places. The first is in the handsome, cantilevered canopy of the early childhood development building that fronts Sunset Boulevard—the most widely photographed, and thus most widely known, feature of the complex. The second is in the three pavilions hidden behind the leafy ravine at the southern end of the school. It is these that most fully embody Neutra's architectural aims.

Simple post-and-beam structures of concrete, stucco, wood, brick, and glass, the free-standing classrooms are connected by a covered walkway whose orientation carefully follows the gentle, organic curve of Stone Canyon Creek. The portico and the glass walls of the classrooms open onto garden patios, which are sheltered by trees, creating an informal, spatial transparency and penetration. Since 1925, when he designed a school of individual classrooms around an oval patio (it was never built), Neutra had been exploring the possibilities for social reconditioning through a revolt against educational regimenta-

tion. UES is the architectural embodiment of Neutra's idealist faith: The natural site enters the school, and vice versa, in an affirmation of the power of education through environment.

It is these three classroom structures and their portico that will be bulldozed to make way for the Anderson Graduate School of Management. Now, you aren't likely to find any reasonable person who would declare UES among Neutra's very greatest works. While an elementary school is intimately related to domestic issues, Neutra's most significant buildings are houses. Furthermore, his partnership with Alexander in the 1950s was contentious; understandably, the conflicts often led to comprised solutions. Still, a building not among the top 10 percent of Richard Neutra's output remains infinitely superior to 90 percent of the built environment.

Let's count the ironies of the university's demolition plan (which, I should add, is at this late date likely irreversible):

First, UCLA is guardian of the Neutra Archive, whose papers, plans, and drawings the architect donated in 1955. Apparently, guarding an actual building is too much to ask.

Second, in 1958 UCLA's art gallery was the scene of the first significant museum exhibition of Neutra's work. Then-vice-chancellor Vern O. Knudsen declared in the catalog introduction: "The University takes pleasure in presenting an exhibition which I hope will in some measure make plain Richard Neutra's great contribution to architecture and indeed to all mankind." So much for institutional memory.

Third, Thomas S. Hines, who authored the standard text on Neutra and co-organized the retrospective exhibition of his work mounted in 1982 at New York's Museum of Modern Art, is on the faculty at UCLA. His appeals to save UES fell on deaf administration ears.

Fourth, UCLA's own School of Architecture and Urban Planning is increasingly well-respected. One might think on-campus access to a fine building by a hero of the modern movement might count for something. If so, one apparently would be dreaming.

Architectural preservation is always a difficult subject. Questions of aesthetics and historical value must be balanced against baser but nonetheless important issues of pragmatic need. The call is never easy. At UCLA, however, the wrong call was made.

On June 1, Henry Cobb, a founding partner in the firm of I. M. Pei and Associates, the architect of the new Anderson Graduate School of Management and a thoughtfully articulate man, spoke elo-

Last Chance for Eden

quently at UCLA about his past corporate work, and about his plans for AGSM. Surprisingly, he described his building site as the last major parcel of undeveloped land on campus. He later referred, in passing, to three unidentified "pavilions" that would be "displaced" from the site. Never once in ninety minutes did the name of Richard Neutra pass his lips. The equivocation in Cobb's commentary was rather startling. But, then, neither will you find mention of the difficult preservation dilemma among the pertinent issues of *Management*, the official quarterly publication of AGSM that regularly extols the plan. Given the likely volatility of a more straightforward declaration that a Neutra building would be demolished, I suppose such absences are wise. I also suppose they help explain why, beyond the cloistered walls of the University of California, even a laudably tenacious citizens' watchdog group like the Los Angeles Conservancy, which monitors the fate of our architectural heritage, did not find out about the planned demolition until it was effectively too late to protest.

Henry Cobb concluded his lecture with an impassioned plea. The critical subject for architecture today, he said, is ethics, or the science of morality. He may be right. Where I would part company with Cobb's vigorous assertion is in his belief that the ethical dilemma now facing architects arises from our society's lack of consensus about values. For, however fragmented or conflicted, our society has indeed arrived at a firm accord. We may not like to speak it, and some may certainly find abhorrent the values thus embodied. Still, our ruling ethic plainly says that, ultimately, economic power may do pretty much as it pleases. If our prevailing ethical standard dictated otherwise, Neutra's graceful building simply would not stand at the brink of being quietly swept away. Sadly, the crude picture drawn by the impending destruction of Neutra's edifice somehow seems a perfect illustration of the American consensus in the 1980s: Brilliant cultural legacy gets trampled under brutally unthinking managerial imperative.

The Dada and surrealist word-image

June 18, 1989 At a time when major museum exhibitions seem unwaveringly committed to grand-scale, bullhorn publicity and phone-book-size catalogs with contributions from scores of footnote-happy academics eager to eradicate even the slightest pleasure one might get from a work of art, the tightly focused precision of "The Dada and Surrealist Word-Image" is something of a jolt. It's something to savor, too. On several notable counts, this is an unusually gratifying show. And if I have a quibble with one prominent aspect of the presentation, which opened Thursday at the Los Angeles County Museum of Art, the cavil pales in the face of the challenging and gratifying as-

sembly of art objects in the show.

The first notable feature of LACMA's "The Dada and Surrealist Word-Image" is simply its effort to examine an aspect of the museum's own permanent collection. The centerpiece of the show is René Magritte's 1928–29 painting *La trahison des images (Ceci n'est pas une pipe)*, or *The Treachery of Images (This is not a pipe)*, which LACMA acquired in 1978. A landmark of Surrealist art, it pairs a slickly painted picture of a pipe, which looks rather like a tobacconist's sign against its cream-colored field, with the denial in the title's parentheses. The disjunctive quality of an image of a pipe and words that deny it's a pipe is only puzzling until you realize that, well, of course this is not a pipe; it's a painting.

Joan Miró
Le Renversement
1924

And it's a painting that unfolds slowly, peeling back delicate layers of increasing complication and richness. You start with the puzzled assumption that something must be wrong: What do you mean, this is not a pipe? Once the veil has been lifted, and you've agreed with the words written across the painting's surface, your mind has subtly been prepared to peel back the cover from yet another seeming contradiction. This one is far more decisive, and far more disorienting. For the written language and the visual language may be saying the same thing, but they say it with very different implications: The positive picture of the pipe is equivalent to the negative words, which declare, "This is not a pipe." That a positive equals a negative is certainly a paradox. To know just how disorienting is this simple reversal of conventional assumptions, try this: Starting at page one, go through the newspaper looking only at the pictures, whether news photos or ads, while telling yourself out loud that the picture is its opposite. By the time you have a headache, you'll be convinced that pictures of any sort cannot help but lie.

Among the attributes of any picture is the way it can-

didly and spontaneously prevents disclosure. Magritte's image happily reveals its material qualities—this is painting—but, oddly, it is also engaged in concealment. A picture performs an erasure. This is something the artist Robert Rauschenberg made plain in the 1950s, when he erased a drawing by Willem de Kooning and displayed the negative results as a positive picture of his own. (In the exhibition, a 1929 painting by Magritte, appropriately titled *Le sens propre*, or *The Proper Meaning*, has been borrowed from Rauschenberg's collection.) That pictures casually prevent disclosure is also something known, and used to devastating effect, by sinister political manipulators from Deng Xiaoping to Roger Ailes. Such is the treachery of images, and such is the public value of examining the deceit.

La trahison des images (Ceci n'est pas une pipe) is the single most consequential Western painting in LACMA's collection. In the three-ring exhibition circus that has arisen in American museums during the past quarter-century, the idea of paying conspicuous attention to an institution's own artistic holdings has fallen out of fashion. Hard to toot on banners and bus cards, the permanent collection isn't likely to set the turnstile newly spinning, the cash register suddenly ringing. Certainly temporary exhibitions regularly include work from museums' permanent collections, but Magritte's canvas is placed very much as the crescendo of "The Dada and Surrealist Word-Image." Along with ten others by the artist, the painting is installed in the final room of the exhibition.

The show is pointedly designed to track down the picture's artistic ancestry, which it manages to do in a concise and provocative way. Small—just sixty-nine objects in three galleries—it's also deftly chosen. You can easily spend thrice as much time in this little show as in the huge assembly of bombastic reliefs by Frank Stella in the galleries next door. Curator Judi Freeman has wisely avoided an exhaustive anthology of every-pairing-of-image-and-word-ever-made-by-a-Dadaist-or-Surrealist, which is the more typical trajectory of shows like this. Instead, she's limited the artists to twenty-three, with the principal focus on the five most important to the topic: Marcel Duchamp, Joan Miró, Francis Picabia, Kurt Schwitters, and Magritte. These artists, who form quite a lineup, are shown in some depth, with the remainder offering curiously enlightening inflections or, as in the case of the poet and critic Guillaume Apollinaire, a record of profound influence.

Certain selections will stop you in your tracks. Adjacent pedestals, for example, hold two great works by Duchamp, both from 1916, that sound against one another. *With Hidden Noise* is the famous ball of twine sandwiched between two brass plates with four long screws; as its title suggests, a small object has been hidden inside the package, so that it makes a noise when shaken. The other is *Traveler's Folding Item*, which is less well known, but equally provocative: a black typewriter

cover, stamped on the front with the brand name "Underwood." No one has ever unscrewed the ball of twine to discover the object hidden inside, a profane act which would be an assaultive violation. Likewise, a rather smarmy, voyeuristic quality accompanies the thought of lifting the black "skirt" of the typewriter cover, inside of which one supposes a word-machine is hidden. As Duchamp enfolds language, sound, object, and image into a resounding exegesis on the power of concealment, these two sculptures also reverberate against the awful silences of Magritte.

"The Dada and Surrealist Word-Image" has several such moments of epiphany, in which familiar strands in the history of twentieth-century art suddenly weave together to form a whole cloth. It's endlessly engaging, and carefully installed to be proddingly suggestive rather than narrowly didactic. The art seems expansive, not circumscribed. And the historical subject of the show gains a pressing urgency today, when the relationships between pictures and texts form the arena for so much current art. Indeed, the timing of "The Dada and Surrealist Word-Image" couldn't be better, as it coincides with the big, sprawling show at the Museum of Contemporary Art, "A Forest of Signs: Art in the Crisis of Representation." For me, the only thing given short shrift at LACMA is an examination of the question: How now? What radical shift in the cultural ground made the word-image conundrum come into focus in the early decades of this century? As Freeman makes plain in the show's catalog, artists had paired picture and text for centuries, albeit not at all in this manner. What happened?

Picabia's eroticized pictures of machines and Schwitters's collages made from bits of printed papers are but two bodies of work that would not have been possible without the pervasiveness of mechanical reproduction. Joan Miró gets more specific, writing "Photo" in elegant script across a painting, and captioning a puddle of blue paint below with the words, "*Ceci est le couleur de mes reves*"—this is the color of my dreams. Mechanical reproduction, in general, and photography, in particular, provide the hardly surprising explanation. All but two of these artists were born between 1880 and 1900, which means they came of age at a moment when the previously convulsive revolution of photography was busily being usurped by the closely related, but still even newer, medium of the movies. The moment was decisive. For not until photography had become normative or conventional—which is another way of saying that once the movies had become the new world of artifice, and photographs had finally become a substitute for natural forms—could the Dada and Surrealist word-image come under careful scrutiny. My complaint, I should emphasize, is itself one of emphasis rather than omission. "The Dada and Surrealist Word-Image" is simply a marvelously enlightening show.

The Minneapolis Sculpture Garden

July 16, 1989 The seven-acre sculpture garden jointly produced here by the Walker Art Center and the city's park and recreation board has been rousingly embraced by the local public. Statistics aren't necessary to confirm it. The proof is visible. The public has voted with its feet. Last week, in the large open field around the garden's fountain, city workers labored in stiflingly muggy heat to unroll new strips of sod upon the trampled grounds. Elsewhere, in numerous areas that have been roped off from swarming pedestrians, tiny seedlings are trying desperately to take root. Paths have been worn into the soil.

No surprise attends the news that the Minneapolis Sculpture Garden, as the park is formally called, has turned out to be so wildly popular in just the few short months since its September debut. Art museums have become fabulously successful entertainment centers during the past two decades, and unusual or atypical formats only enhance the siren call. And make no mistake: Despite its name, the Minneapolis Sculpture Garden is barely a garden at all, and almost entirely a museum. It is indeed constructed of grass, trees, shrubs, flowers, sunlight, and breeze. Yet, in conception, execution, and program, it is as much a museum as the bricks-and-mortar Walker Art Center that stands across the street.

The Minneapolis Sculpture Garden was conceived by Martin Friedman, director of the Walker, and designed by Edward Larrabee Barnes, architect of the museum's 1971 building and its more recent expansion. Internationally, the Walker Art Center is very highly regarded among museums of contemporary art, and its building is widely acclaimed as housing some of the finest and most congenial galleries for the display of modern painting and sculpture. What works well indoors, however, does not necessarily fly outside. Working with David Fisher, superintendent of the city park and recreation department, Friedman and Barnes came up with a distinctly architectural plan. On a north-south axis perfectly aligned with the museum, and linked to it across Vineland Place by a rectilinear stone crosswalk designed by artist Sol Lewitt, the Sculpture Garden is a Modernist grid overlaid on the barren landscape. The horticultural elements include Kentucky bluegrass, linden trees, and Black Hills spruce, but they have been used to imitate carpets, corridors, and walls, all under a ceiling of blue Minnesota sky. The symmetrical "garden" has five galleries. Four 100-foot-square rooms are separated by north-south and east-west corridors. These hallways are lined with linden trees and punctuated by sculpture from the Walker's collection, including bronzes by Henry Moore, Marino Marini, Giacomo Manzu, and Deborah Butterfield.

Two of the grassy, spruce-lined rooms hold large works from the collection—in one, a huge, welded-steel swing by Mark di

Suvero towers overhead, while smaller, nonfigurative sculptures by Tony Smith, Ellsworth Kelly, and Richard Serra comfortably occupy the other. The remaining pair of galleries house temporary exhibitions of commissioned sculpture. The eastern edge of this cluster of outdoor rooms is bounded by a conservatory built of glass. The transparent walls thus architecturally echo the scheme of outdoor galleries. A square, two-story room, which houses a glass sculpture of a leaping fish by the architect Frank O. Gehry, is flanked by two greenhouselike corridors that hold horticultural displays designed by landscape architects Barbara Stauffacher Solomon and Michael van Valkenburgh. The conservatory's function recalls the old Armory building, which occupied the site earlier in the century and was used for many years as a display area for home gardening shows. The long, narrow, heated hallway also provides a warm pedestrian corridor between the Walker's parking lot and the museum—useful during the city's famously brutal winters, if not entirely congenial during the hot and humid summers.

The fifth and largest gallery in the garden is a huge, rectangular room, 200 by 350 feet, which is dominated by a fountain designed by Pop artist Claes Oldenburg and his wife, art historian Coosje van Bruggen. A painted aluminum spoon, 29 feet high and 52 feet long, reaches across a seed-shaped pond to rest on a tiny island. High in the bowl of the spoon is a bright-red maraschino cherry, 9 feet in diameter. The fountain wasn't working on the day I visited; when it is, apparently, the precariously poised fruit is glazed with sheets of water and emits a mild spray from its upturned stem. The *Spoonbridge and Cherry*, in many respects the focal point of the Minneapolis Sculpture Garden, exemplifies the most serious problem with the larger enterprise. The sculpture is disappointingly weak. Oldenburg's most convincing public monuments, such as his flashlight in Las Vegas and clothespin in Philadelphia, maintain a strong formal presence in which the figurative reading of the sculpture is matched by an emphatic abstraction. The result is a pliable, open-ended image that ricochets off the specific context. Such sculptures seem available to the elastic possibilities that characterize a site as distinctly public. By contrast, the abstract swoop of the spoon, which could suggest both high-tech bridge and ancient ship, gets tied down by the big red cherry. Merely figurative, the Swiftian sculpture becomes Brobdingnagian froth.

The principal defect of the Walker's outdoor museum is that woefully few of its forty or so sculptures are distinguished. Well over half were commissioned as temporary displays for the opening or were acquired outright in the past two years. Ruinously, almost none of those is exceptional. As for works that have been in the Walker's collection for many years—well, Marini and Manzu may be historical curiosities, but important artists they are not. Indeed, too much of the collection is composed of work by lesser figures of the twentieth cen-

tury, or of lesser work by only a few major artists. The "gallery" hous-
ing the sculptures by Kelly, Smith, and Serra (this last being the finest
in the collection) is the one happy refuge in the "museum."

The big exception to this discouraging scene is the
grandly named Irene Hixson Whitney Bridge, which crosses a stag-
gering sixteen lanes of freeway to the west and reconnects the isolated
sculpture garden to the luxuriantly urbane Loring Park beyond.
Commissioned from Minneapolis-based sculptor Siah Armajani, whose
work has long examined the poetics of vernacular architecture as con-
crete expression of American myth, this pedestrian thoroughfare grace-
fully weaves together evocations of a railroad trestle and a suspension
bridge. Richly allusive in form, image, and function, his masterful poem-
in-steel about the activity of transition is as fine a public sculpture as I
have seen.

Armajani's mythically resonant bridge also shows why
the Minneapolis Sculpture Garden seems so flat and unimaginative.
No garden in Western culture can ignore the one great source of Eden,
the mythic paradise before the fall. By constructing on its seven acres an
old-fashioned museum without walls, which freezes in place a period
idea, the Walker Art Center has haplessly idealized a conventional in-
stitution. What's wrong with the Minneapolis Sculpture Garden is that
it's short on sculpture, and it's short on garden, too.

case study houses

October 22, 1989 "Blueprints for Modern Living: History
and Legacy of the Case Study Houses" is a terrific exhibition to visit—
but I wouldn't want to live there. As a tourist in the land called
Architecture, I readily concede that I possess neither the technical lan-
guage nor the professional skill to chat confidently and in depth on
domestic buildings, nor on the nuances of their history and demeanor.
And the show, which opened Tuesday at the Museum of Contemporary
Art's warehouse space in Little Tokyo, is nothing if not a gold mine of
historical information. The exhibition represents a monumental research
effort. It's stuffed with details about the postwar housing project it has
carefully exhumed, and filled with insight about the context within
which that extraordinary experiment in social engineering issued forth
and bore fruit.

MoCA associate curator Elizabeth A. T. Smith, who be-
gan work on the show nearly five years ago, was faced with a daunt-
ing task. The influential routes taken by postwar art and architecture
in Southern California are, in scholarly and critical terms, largely un-
traveled paths. Certain individuals have been much studied and discussed,
but the shelf of impressive studies of larger issues is shockingly brief.

As decades pass by, even basic research material gets more and more difficult to assemble. In this regard, "Blueprints for Modern Living" has clearly benefited from its unusual point of origin. The idea of commissioning gifted architects to design prototypes of affordable houses for the projected postwar boom in middle-class families came from John Entenza, publisher of *Arts & Architecture* magazine. With a generous and evolving vision of what he wanted to do—and, notably, with a journal in which to proselytize and document its progress—Entenza launched his series of Case Study Houses.

Beginning in 1944, when the government predicted some fifty million American families soon would be in need of shelter, and continuing until 1966, Entenza commissioned both established and younger architects to design houses. He also tracked down clients willing to build them. The show at MoCA documents the thirty-six plans in the Case Study project, especially the two dozen that actually got built. In an entertainingly theatrical gesture, two houses have actually been constructed inside the museum: Ralph Rapson's eccentric Case Study House #4, designed in 1945 but never built; and perhaps the most famous of them, Pierre Koenig's 1959–60 Case Study House #22, a steel-and-glass pavilion constructed on a cliff in the Hollywood Hills. (A schematic, rather perfunctory third structure also evokes the most widely praised of the houses: the modular 1949 residence by Charles and Ray Eames.) Rapson's nutty "greenbelt house"—so named because it is bisected by an indoor garden, which separates the living areas from the bedrooms—encapsulates in spirited style the visionary simplicity of the program. It features post-and-beam construction, industrial materials, an open floor plan, indoor-outdoor penetration, and a health-conscious regard for the benefits of sunshine and air.

These same elements, highly refined and frankly elegant, describe Koenig's dramatically cantilevered house of steel and glass. A solid plane defines the roof, which floats serenely above the solid plane of the floor. Walls of sliding glass make the house, as a container, nearly transparent. The cantilever allows the living room to hang in space above the city. (At MoCA, the twinkling lights of the city below are ingeniously evoked by two dozen television monitors suspended before a black backdrop.) Even the interior design follows suit: a free-floating fireplace, beds that are suspended planes, kitchen cabinets that levitate.

Despite notable experimentation with materials and techniques, the basic structural and conceptual elements of these houses were not new. Most are identified with International Style architecture of the prewar decades. What was new was their translation and modification to accommodate an unprecedented ideal. If the International Style owed principal allegiance to the European idea of the urban worker, the Case Study program idealized the American concept of the suburban family. Chiefly white and middle class, with Dad at the office and

Mom at home with the kids, the modern family would live in whole-some, ideal harmony in the perfect space. MoCA's inspired decision to construct both Rapson's early house and Koenig's later one suggests the steady, almost excruciating refinement of this ideal as the 1950s progressed. Rapson's funky cheerfulness becomes Koenig's pure abstraction. In a way, the mineral soil of the greenbelt metamorphoses into the crystalline transparency of a new standard of living.

Pierre Koenig
Case Study House #21
published in
The Los Angeles Examiner, 1959

Transformed into an actual environment, the visual utopia of modern abstract art finds limpid apotheosis in the Case Study Houses. This is one reason you find almost no convincing abstract art in Southern California during the period. A gallery filled with contemporaneous painting and sculpture gives ample demonstration. On canvas, visual paradise is merely pictorial; in sculpture, it's a designer bauble. Nor is it any wonder the project came to a halt in the mid-1960s. Whatever pragmatic considerations Entenza might have had, it was finally no longer possible to keep faith with the Case Study dream. The hidden network of social conventions, which formed the firm foundation on which this absolutist reverie had been constructed, was split wide open. The reality no longer fit the model.

In the exhibition, it's important to remember that you're looking at models, not at actual architecture. You may be able to traverse Rapson's greenbelt and poke around in Koenig's kitchen; still, these walk-in models are theatrical sets. They're very well done. (Architects Craig Hodgetts and Ming Fung inventively designed the exhibition.) But they're fake just the same. If, as Mies van der Rohe reputedly said, "God is in the details," you can only get the Son of God in a museum model. Sharp eyes will find minor alterations. For example, a light well in the overhang of Koenig's actual house is inexplicably omitted from the walk-in model at MoCA. More important is the subtle shift in materials and techniques—painted wood for steel beams, a false cantilever, and so forth—as well as the stark change in environmental context.

Nonetheless, there are several impressive aspects to "Blueprints for Modern Living." Among them is its catalog. From the especially informative introductory essay by Esther McCoy, doyenne of American architecture critics, to the chronology of related events at the back, its contents immediately form the subject's standard reference. Ironically, the book's principal drawback is its design. Handsome and clearly laid out, it is physically impossible to hold (when open, the narrow book is more than two feet long). If you can, spring for the sturdier hardcover edition and avoid the floppy paperback.

Also decidedly impressive is the position this endeavor holds: The Case Study House exhibition is a full-scale examination of a major period in the cultural history of Los Angeles—the first that MoCA has undertaken since its founding. That it happened with architecture, rather than art, is worth considering. No doubt it bespeaks a specific commitment on the part of MoCA's director. Richard Koshalek came into the museum profession by way of work in an architectural office, and his deep interest in the subject is well known. Equally noteworthy is that architecture, and especially domestic architecture, is a subject open to broad popular appeal. With *House & Garden* sets as the principal attraction, the visitor becomes an actor on a stage. In a deft marriage of the two archetypal public spaces of the 1980s, the theatrical arena of the museum merges seamlessly with that of the shopping mall. In this way, the exhibition offers a golden opportunity to partake of a trade-off increasingly necessary to the operation of American museums: old-fashioned scholarship meets consumer populism. "Blueprints for Modern Living" is doubly tantalizing because it's a case study all its own.

Thrift store Paintings

March 28, 1990 *Pink Poodle and Hydrant with Text* is among my favorite paintings in the current exhibition at the gallery of Glendale's Brand Art Library. *The Man with No Crotch Sits Down with Girl* is certainly an unforgettable image, too. As paintings go, they're—well, frankly I'm not quite sure what they are. Therein lies the surprising appeal of this large exhibition, which consists of paintings gathered not from galleries or museums but purchased for a few dollars apiece from an untold number of thrift stores. The assembly effortlessly jams the circuits of common expectation, creating a cognitive dissonance that turns out to be refreshingly insightful. This decidedly outlandish show is among the best of the season to date.

"Thrift Store Paintings" includes 104 works, compiled for the occasion by the artist Jim Shaw. Its initial odd appeal comes from the frequently wild humor in the paintings. ("Wee Wee Monsieur," reads the text gaily written across the cartoonish picture of a jaunty pink poo-

dle, who brightly eyes a fire hydrant in an otherwise barren landscape; the infantile cornballism leaves you momentarily blinking in stupefied disbelief.) But the show is not a joke. There is nothing condescending in its tenor. It's played perfectly straight. Save for the fact that these are paintings made by unknown hobbyists and amateurs, rather than by aspirants in the world of art, this could be any exhibition in any reasonably ordinary gallery. Shaw has collected thrift-store paintings for a number of years—he owns nearly half the works on view—and the rest have been borrowed from twenty fellow collectors. (Among them are a number of other artists, including Mike Kelley, Ann Magnuson, and Brad Dunning.) There are paintings in most of the expected categories—still life, portrait, landscape—and there are plain debts to various kinds of art that flourish within the popular mainstream: Surrealism, Norman Rockwell-style magazine illustration, psychedelic posters, religious icons, cover illustrations on science fiction and detective novels, Grandma Moses-style folk art, and more. There is also a clear curatorial hand at work in the selection and arrangement. You'll suddenly find yourself cross-referencing paintings grouped by nominal subject—dogs, nudes, elephants, fantastic landscapes, portraits of shoes—or else juxtaposed according to the aforementioned styles.

The paintings have no known titles, although each is accompanied by a purely descriptive wall label. The descriptions, taken from an inventory list made up for the purely administrative purpose of being able to distinguish one from the other, can be blunt or loopy, depending on the items to be enumerated. The somber *Black Mourner in Tones of Gray* hangs near the flashy *Cosmic Blonde Girl with Liquid Universe and Ballpoint Defacing*, while the dull *Old Man with Zoroaster Book* stares across the room at the provocative *Woman Made of Pillow, Wax Lips and Green Thing*.

The paintings are also anonymous. Some have indeed been signed and dated—the dates range from the 1940s on—but who these painters are, or were, is anybody's guess. The absence of a larger context for the paintings serves to make each one even odder. Occasionally, the astute eye will discover more than one picture by the same hand. In the obvious case of a suite of ten heraldic, vaguely medieval portraits of wives of former Presidents (Grace Coolidge is present, but not Jackie Kennedy), we clearly have an unidentified talent who shall henceforth be known as the Master (Mistress?) of the First Ladies.

Like an anthropologist at a dig—or, depending on your aesthetic tastes, a detective at the scene of a crime—you scan the rooms for evidence in an attempt to make sense of what is going on. But there is no lexicon of useful terms, save those that can be pillaged from the standard repertoire of art history and criticism, by which to chronicle the disparate clues. It seems absurd to invent, as a medievalist would, a "Master of the First Ladies" for a lumpish painting of Lady Bird as a

Texas cowgirl, which is plainly by the same hand as the grim portrait of Pat Nixon. And however correct the attribution, recognizing precedents in Rembrandt or Magritte for paintings of a pipe smoker and a pair of footlike shoes becomes an exercise in utter madness. After all, these paintings fail miserably by every known aesthetic standard. Half the fun is collapsing into hysteria at the very idea of having chosen to paint a picture of an elephant-shaped lamp—a portrait of a lamp!—or going gaga over the sight of a leering, pneumatic bimbo sprawled out in full recline like some raucous, *Playboy*-magazine version of Manet's piercing modern masterpiece, *Olympia*.

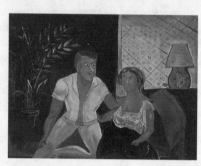

"Miller"
The Man with No Crotch Sits Down with Girl
n.d.

Of course, the crowds in 1863 likewise laughed uproariously at Manet's art—a small realization that quietly kicks this most remarkable show into place. "Thrift Store Paintings" is a literal Salon des Refusés, an anthology for our time of all that is rejected and cast off from the "academy" of conventional, acceptable ideas about art. Napoleon III had established his Salon des Refusés as a means by which to mollify the large number of angry artists eliminated from the officially sanctioned salon, through which an artist's livelihood and reputation could be secured. Inadvertently, he brought to the foreground art's new embeddedness in social conflict. Manet, who wanted nothing more than to be embraced by the very academy that modern history soon would relegate to the ash heap, seized the day: In *Luncheon on the Grass*, his low-down image of a self-assured prostitute stared imperiously in the face of the raucous, bourgeois crowds who thronged to see it.

It would be silly to think that the Brand Library show means to argue for the unsung aesthetic genius lurking inside the bins at your nearby Salvation Army. (Its bargain-basement Olympia is plainly no Manet.) Rather, as an installation of found objects, created by a very gifted artist, "Thrift Store Paintings" turns the tables. As much as the anonymous artists whose work is on view, it is the audience—its tastes, values, and points of identification or contention—that Shaw has deftly made the resonant subject of this show. That he chose to install it in a suburban, community-run gallery is telling, as is his pointed

omission from the assembly of but a single artistic style: Abstract painting, vaunted pinnacle of modern high culture, has been curatorially refused. Despite all the usual platitudes that claim the contrary, the exhibition adroitly manages to suggest the ways in which our modern conceptions of art function to divide us into warring camps. The beauty of this presentation is that, in fact, there is something here to appeal, in one peculiar way or another, to virtually everyone who sees it.

IS L.A. a world-class Art city?

April 8, 1990 The claim gets made with almost metronomic regularity, but is it true? Is Los Angeles really "a world-class city" for art?

Let's put the short answer this way: As long as there's an irresistible need to assert that it is, it probably isn't. Naked boosterism is fine for the Chamber of Commerce and elected officials, whose honest duty it is to enthusiastically champion the people who keep them in business. But it's deadly for culture, which gets inadvertently trampled under the cheerleaders' stomping feet. The long answer is—well, longer, more complex. Art of a caliber equal to that produced anywhere is certainly made here and has been at least since 1911, the year Edward Weston set up his photography studio in Glendale. But that doesn't mean the cultural life of the city has long been distinguished.

The phrase "world-class city," which came into vogue in the push toward the 1984 Olympic Games, is sound-bite shorthand for cosmopolitanism—a rather more intimidating term. And cosmopolitan is indeed what Los Angeles is in the feverish throes of becoming. Today, the city is straddled between worldliness and its numbing inverse, the deep-seated provincialism that long ago made it the Official National Joke in matters cultural. For art, the dilemma couldn't be more important.

Cosmopolitanism, or worldliness, is an elusive subject. Because it's essentially an inclination or a mental attitude, a way of thinking and behaving, it resists by-the-numbers calculation. That's why the people who incessantly tabulate and tout square footage—the endlessly subdividing County Museum of Art, the two-venue Museum of Contemporary Art, the overstuffed Norton Simon Museum, the gigantic (and unbuilt) J. Paul Getty Center, assorted private foundations—as the surest sign of world-class stature are hopeless. Pridefully pointing fingers at the burgeoning number of museums is, in fact, a sign of lingering provincial insecurity.

Museums are certainly consequential. As social spaces in which the prospect of sensual gratification is condensed, they're great places in which to have private epiphanies in public. (Museums gained a reputation for being great pick-up spots because they reek of this intoxicating atmosphere.) Art's identities are always changing, and those

331

identities don't take shape in isolation. Museums, as culture's clubhouses, can bring a variety of social and artistic forces together as a focal point.

When regarded chiefly as emblems of civic accomplishment and distinction, however, this socially interactive, clubhouse function gets narcissistically transformed: The museum becomes a private looking glass in which we unsociably admire our own beneficent reflection. To identify with your city by identifying with its real estate is a common, even wildly popular, pastime. The national paradigm is currently Donald Trump, whose galloping career has been built by shamelessly exploiting the vulgar power of precisely this antisocial juvenility. He wants you to be seduced, out there along Wilshire Boulevard, by the prospect of seeing your ego reflected in the world's tallest building. Vanity is not the problem. (Who isn't, in some small way, vain?) The source of the pride is.

In a cosmopolitan milieu, acutely observed points of comparison get made more vigorously about works of art than about the relative grandeur of the civic emblems that house them. At the 1984 opening of the much-beloved Temporary Contemporary, the Museum of Contemporary Art's satellite in Little Tokyo, grandiosity was in short supply. The unvarnished simplicity of the place was of the utmost significance. Anonymously built as a hardware company's warehouse a half-century ago and left nominally raw as square footage when refurbished for museum use, this modest building suddenly set the skewed relationship between art and clubhouse into proper perspective. That's why the place is beloved. In an era of furious, high-profile clubhouse building both here and abroad, the museum quietly went against the grain. Radiating a startlingly cosmopolitan aura, the achievement made MoCA an international sensation virtually overnight.

After decades of repeated design debacles at the building of new culture clubs elsewhere in town, the Temporary Contemporary also had gone against the grain of local history. Tradition was eloquently upended, setting into motion a thoroughly galvanic cycle of provincial-into-cosmopolitan awareness. The earlier hiring of Arata Isozaki as architect for MoCA's principal home, then being constructed from scratch on a vacant lot on Grand Avenue, could finally be cast as a decision of great significance. New architecture is routinely claimed as a building art, and in the making of art the quality of the artist is always central. But those pious clichés, suddenly injected with life, could now be taken seriously. The emergent cycle was capped with the joyful hiring last year of Frank O. Gehry as architect for the new Disney Concert Hall, the fourth theater for the Los Angeles Music Center, just up the block from MoCA's home. The old provincial debate for such glamour projects had been: Which *local* or *nonlocal* architect is right for the job? In successive stages, it had been replaced by: Which *architect* is right for the job, including those whose practice is based in Los Angeles?

The distinction between the old debate and the new one seems small, but such meticulous refinements are in fact decisive. (God is in the details, as Mies van der Rohe taught us.) Incautiously used, adjectival terms like *local* art, or even *Los Angeles* and *California* art, can be ruinous. The reason is plain: Great art is placeless. I don't mean art isn't deeply rooted in the locality in which it gets made or that its contours aren't profoundly shaped by a thousand critical nuances of context. Neither do I mean that art is universal, as if the very idea of art as a kind of visual Esperanto wasn't itself the product of a highly specific moment in the modern industrialized West. What I mean is that art opens up experience, and it's onerous to try to put art or experience in its place.

Gehry intuitively understands this cosmopolitan sense of placelessness. Gehry, whose own work is especially indebted to cues taken from works of art, had overseen the refurbishing of the Temporary Contemporary. His canny decision to pretty much leave the warehouse alone, architecturally, created a dazzling kind of "negative space"— an architectural no-place, in which the roaming pleasures of aesthetic experience were vivified. In the process, Gehry did manage to put dramatically in its place the former status of the culture club. Hardly a peremptory civic emblem, his nuts-and-bolts building declared itself not to be the end of the laborious effort called a museum. The building was just the beginning.

One way to measure the condition of the art scene in Los Angeles is to see whether or not it's an active participant in art's currently vigorous, newly international conversations. That means identifying whether or not artists who choose to live and work here can develop important reputations beyond the outskirts of town. Now there's evidence that some artists can. John Baldessari, Bruce Nauman, and Edward Ruscha all were making first-rate art in the robust 1980s, a fact that has not gone unnoticed internationally. But all three had initially stirred interest during the first rush of L.A.'s prominence as an art scene twenty years ago—and none was able to secure that initial reputation for at least a decade or more. Likewise the sculptor Chris Burden, whose subsequent emergence as a performance artist in the 1970s was as spectacular as it was short-lived. Only now is Burden receiving the kind of high-profile attention commensurate to the importance of his work.

The "arrival," internationally, of all four by the late 1980s is today being followed closely by that of artist Mike Kelley. But the path of Kelley's emergent career in the last ten years has been starkly different from his predecessors': Almost immediate admiration in Los Angeles has led steadily to enthusiastic interest in both New York and Europe. Kelley is thirty-six. Baldessari, Ruscha, Nauman, and Burden range in age from forty-three to fifty-eight. The generational difference is notable. Kelley is the first artist working in Los Angeles whose developing reputation—locally, nationally, internationally—is fully coincident

with the developing maturity and resonance of his extraordinary art.

At the risk of getting buried beneath a pile of demo-graphic flow charts that would devolve into comic monologue, this is a clear sign of a newly cosmopolitan character at work in this city. It is not, however, the signal for a testimonial dinner with self-congratulations offered all around. After all, we are talking about the reputation of a single artist, and of an only slightly larger number of artists who are linked by a single gender and ethnicity. Opportunities have opened for a variety of artists in a variety of places, because the internationalism that characterized the art scene of the 1980s has wrecked the possibility of total dominion being held by a powerfully monolithic center. Today, an artist doesn't get to be an active player in the international discourse without participation in the art scenes of New York and Europe, whose pull is strong. An artist does, however, get to be an active player without Los Angeles, whose influence remains weak.

In this youthfully cosmopolitan city, too few individuals are seizing the day. And I don't mean the artists. Major collectors of contemporary art—major being a distinction I make according to volume of passionately informed activity in the international art scene, not according to volume of dumb money spent—play a number of important cultural roles. One serious one is noticeably lacking here. Major collectors don't yet seem to know the clout they wield, or perhaps how to wield it, in helping to establish important new artists. *Not a single one played a significant part in the wider appreciation of Mike Kelley's art.* Critical and institutional champions of Kelley's work steadily presented themselves throughout the 1980s, as did a few collectors who were influential locally. In general, though, and except for isolated works by the artist, major collectors in Los Angeles have felt more secure consuming art by established names—which is to say, names being established elsewhere.

For collectors, establishing new artists translates into the commitment of aggressively informed acquisition—a decidedly nerve-wracking thing to do. After all, when you're out there in a relatively unpopulated field, dense with thorny underbrush, and are relying on your eyes, your ears, your charms, and your wits to get by, the prospect for doom is immense. And given the newly international stakes, you'll be called on to vigorously defend your unheard-of position. Vigorously arguing unheard-of positions is the national sport in cosmopolitan culture. I'm a wee bit biased in this regard, because I'm speaking of an area dear to my heart. But art criticism takes a variety of forms, and assembling a collection can be among the most persuasive.

So, of course, can writing. But writing plainly suffers as an avenue for informed, contentious argument when there's virtually no place to publish. This absence, widely noted, is commonly followed by claims of the dearth of critics locally, as if criticism could become a venerable, far-flung practice when there is no place in which to pub-

lish—no place, that is, except venues whose editors reside on the other side of the country and whose agendas are their own. The actual problem lies elsewhere: Pathetically few art dealers in Los Angeles pay the matter the slightest attention. Major dealers of contemporary art—major being a distinction I make according to volume of passionately informed activity in the international art scene, not according to volume of dumb money made—play a number of important roles in a cosmopolitan milieu, including as supporters of critical debate. That's done principally through indirect channels, by way of the advertising that gets art magazines published. Therein lies a tale.

Last year, a disaster waiting to happen called *Artcoast* magazine blew into town, trailing lots of razzle-dazzle. But the screamingly awful name—I imagined a phalanx of blissed-out subscribers drooling, "Let's go *Artcoast*ing," as they set out on skateboards for the Santa Monica gallery crawl—was a dead giveaway of gruesome things to come. (The moniker had been chosen by the magazine's publisher, a lapsed Madison Avenue marketing whiz.) The publication proudly positioned itself as a journal of, by, and for the culture of the Pacific Rim—which is to say, a navel-gazing promotional journal of, by, and for provincial culture. It sank like a stone, disappearing into the abyss after issue No. 2.

Also last year, a small journal financed on a shoestring and called *Art issues.* began publishing literate, sometimes quirky, frequently insightful criticism. The punctuation in the magazine's title slyly transforms it into a declarative, two-word sentence—"Art issues *period*." This knowing gesture is miles apart from the blithering nothingness of *Artcoast*, with its local pitch. All 10 issues have been worth reading. Still, woefully few galleries regularly advertise.

Gallery ads aren't in magazines to bring customers in the door or to "buy" reviews. Their function is to assist in creating a dense atmosphere of importance around the discussion of art, and then to place the gallery and its artists in proximity to that momentous debate. Symbiosis between commercial galleries and disinterested criticism is crucial, but prospects for worldly engagement are dimmed when a big chunk of the equation is missing. *Artcoast* was emphatically promotional in style and substance. *Art issues.* emphatically isn't. That the former folded fast while the latter struggles on is at least encouraging. For art, it might signal a crack in the boosterish, public relations mentality endemic to Los Angeles.

Demolishing that mentality is essential because boosterism is provincial. Boosterism is about justifying the value of a place—*your* place—by encouraging identification with your city, your state, your country. Being "true to your school" means reciting a pledge of cultural allegiance, the taking of a loyalty oath with which to justify your worthiness to belong. Adolescent in temperament, the association gets made in order to hold at bay an inchoate horror at the dawning prospect

of finding yourself out there, all alone, in a grown-up world utterly indifferent to your existence. Dysfunction is inevitable in a climate tyrannized by effusive self-promotion and mawkish public relations because adolescence is prolonged. Los Angeles, the glistening oasis that public relations built from little more than semiarid desert scrub, suffers special burdens in this regard. Relentless promotion is a way of life, as habitual as breathing, and bolstered by historic tradition.

By contrast, the intricate pleasures of cosmopolitan culture are calibrated by the sharp resonances of aesthetic experience, which is always anarchistic and destabilizing. (That's why conservatives hate art so, and why the art world's typically ascribed profile is liberal.) The great and wondrous paradox of cosmopolitan culture is that civilization gets generated by the willingness, even eagerness, to engage the stresses and strains of aesthetic anarchy—of art that goes against the grain. As surely as in politically repressive regimes, refinements of aesthetic experience get dulled in an atmosphere dense with cultural boosterism, where blunt enforcement of the law of the land is paramount. Gleeful aesthetic anarchy isn't wildly compatible with thickly bureaucratic demands.

In our era of woozy national drift, the problem is compounded. America's favorite pastime (after baseball) is to periodically flirt with the strangling embrace of the loyalty oath. If you doubt it, think of assorted instrumental issues preoccupying the strained energies of the day, from gross claims that the Pledge of Allegiance and flag-burning are topics pivotal to our pressing national debate, to shameful campaigns against free speech in programs supported by the National Endowment for the Arts. Sentimental illusions and the fears they conceal repeatedly divert us. Finally, art needs no justification, no defense, no supervision *in loco parentis*. What art needs is sly challenge, discerning argument, delirious intercourse. It needs a light touch, too. When we talk of art, we are not talking of healing the sick, feeding the hungry, clothing the naked. We are not talking of moral obligations, but of gratuitous activity. Americans, thanks to the storied tenacity of their Puritan heritage, have always had trouble with art because it doesn't come to them "the old-fashioned way." You don't earn the right to receive the gifts that art is prepared to give. You accept the offer or you don't. Either way is fine. But if you choose to engage art's ongoing conversations, you certainly have to pay close attention amid the deafening racket of competing voices. Cosmopolitanism is characterized by a constant refusal to be bound by established habits or ingrained prejudices, old or new. By definition, it's open to perpetual flux.

Today, *multicultural* is the new buzzword being most vigorously pushed to replace *world-class* as boosterish civic emblem. As an adjective for art it doesn't really mean much. As an adjective for Los Angeles, though, it speaks volumes. *Multicultural* speaks of a dawning consciousness of the untapped power available in a culture whose ori-

Last Chance for Eden

gins and offshoots both are international. It speaks of the urge toward cosmopolitanism. As a term, *multicultural art* is as windy and supererogatory as *cosmopolitan art*. That it's a new coinage likely has to do with subconscious recognition of old failures in old cosmopolitan centers and with an up-front desire to acknowledge today's abundance of new constituencies—principally Asian and Central and South American—that often were remote from European linkages of the past.

As Americans, we have from the very start defined ourselves not simply according to who we are (or think we are), but according to who we are *not*. This is probably to be expected of a nation of immigrants. No matter how much fealty to assorted heritages we truly feel, immigrants (and especially their grown children) are people who are not about to undergo the unnerving traumas of relocation to an alien land simply to let themselves be identified as exactly who had been left behind. The specific identity of "who we are *not*" has typically been multiple and fluid, with different bogeymen assuming the spotlight at different moments in history. America's postwar engines have been driven by the incantatory declaration: We are *not* Communists. Today, as an end to the Cold War is declared, winding down the protracted postwar era, the "who" that we have for so long *not* been has evaporated like a mirage. Anchorless, America's negative identity flails in wild and woolly flux. Who are we *not* going to be now? Externally, the Japanese are, for all the obvious reasons, the leading candidates for jingoist denial. At home, the candidacy is held by a familiar litany of beleaguered, second-class citizens—blacks, Latinos, women, gay people, Jews—as the steadily rising tide of hate crimes eloquently attests.

In its artistic life, Los Angeles has long vigorously identified itself according to who it is not: L.A. is not New York. (Drat! I swore I'd get through this without ever mentioning Them.) Lots of things distinguish the two places. None is more important than this: Unlike urban New York, which took a nineteenth-century European and industrial model to unprecedented heights, Los Angeles is a powerful suburban metropolis constructed as twentieth-century America's mass-culture model. As such, it is the central symbol for a paradox unique to our time.

The city of colossal dreams and endless promises that's always in the ascendant, Los Angeles is also notorious for never quite being able to make it over the top, for repeatedly failing to make the grade. The Sisyphean paradox is this: Wretched failure is perversely essential to mass culture's whopping triumphs. Desire is the fuel that turns the engines of consumption, and relentless disappointment is what generates perpetual desire. (The tensions inherent in this contradictory phenomenon, and the spiritual, moral, emotional toll it takes, have been the great subject of Mike Kelley's disturbing and deeply moving art.) Mass culture demands its quota of degradation in order to flourish and prosper. To degrade is to de-differentiate, to generalize, to break down and

make less specific. Degradation is the antithesis of refinement, and re-
finements of experience are the province and the pleasure of art.

The claim "L.A. is not New York" is true—but, whether
said with pride or derision, repeatedly declaring the obvious certainly
makes for dull conversation. More important, the fact that it's said at
all seems darkly masochistic. For whatever else it is, New York is a promi-
nent aberration in American culture at large: Its artistic life has un-
remittingly courted the difficult pleasures of aesthetic anarchy. If Los
Angeles is not yet New York in the eagerness with which it courts this
cosmopolitan attitude, those worldly stresses and strains are nonethe-
less all around. They're just waiting to be engaged.

The Criticism of Robert Hughes

November 18, 1990 No art critic has ever had a larger au-
dience in his own day than Robert Hughes has in ours. And not since
the late Lord Kenneth Clark, whose television series *Civilization* became
a national obsession in the early 1970s, has a writer on art claimed a more
substantial place in the public eye.

For twenty years, Hughes has occupied the critic's chair
at *Time* magazine. In 1980, the already vast public visibility inherent in
that post expanded exponentially as the Australian-born critic hosted
a widely followed BBC television series, broadcast the following year
on PBS, called *The Shock of the New*. The eight-part sequel to Clark's
"Civilization" chronicled the modern era and was accompanied by a
book of the same name that many schools now use as an introductory
text (a revised and updated edition has recently been issued). Three years
ago, Hughes's elaborate history of the colonial settlement of Australia,
The Fatal Shore, became a surprise bestseller. While not an art book, its
success nonetheless added significantly to the critic's renown, which will
likely aid in drawing considerable attention to a new anthology of his
criticism, *Nothing If Not Critical: Selected Essays on Art and Artists*, being
published this month by Alfred A. Knopf.

Long before the celebrity profile that graces this month's
Vanity Fair, a reliable barometer of Hughes's unprecedented public pop-
ularity made itself known. The occasion was a May 1987 lecture he
delivered at UCLA. Because tickets sold out almost immediately, the venue
had been switched from the comfortable Dickson Auditorium—seating
capacity 411—to the lavish, multitiered Royce Hall. A good crowd for
a lecture by an art critic is more commonly one-tenth the astounding
1,400 people who showed up that night.

Television, of course, is the reason they came. Art and
broadcasting have rarely been congenial bedfellows. That Hughes was
able to use the medium well in *The Shock of the New* is one measure

Last Chance for Eden

of his skill. Another is the writer's oft-remarked felicity as a pungent phrasemaker, a skill honed on tight space and fairly strenuous deadlines at *Time*, and more than appropriate to the sound-bite brevity of TV. Timing was important too. *The Shock of the New* had aired just as the updraft of the 1980s art scene was gathering into what would become gale force. Hughes emerged a familiar and articulate spokesman on a topic in which few Americans receive any serious education; thereafter, he was regularly on hand in the pages of *Time* to guide them through the coming storms.

Hughes's remarkable popularity of course begs the question of just how good his critical insights are. He's clearly among the shrewdest and most entertaining writers around, but is his sharp prose a sustaining diet or a fix of tasty junk food?

Evidence of the answer to this question was also offered that night at Royce Hall. The passage of time has not diminished the memorable impact of the event. Hughes's performance—and it was a performance, complete with theatrical ruffles and flourishes, as any satisfying lecture must necessarily be—was greeted with audience hoots and hollers and stompings of the feet, all of which grew in fervor and intensity as the preachment pressed on. To anyone who had read him with any regularity, there was nothing new in what the critic had to say. He railed against ham-fisted Neoexpressionist painters and the know-nothing collectors whose sizable bank accounts transformed them from fry cooks into household names. He lampooned the egregious "Boonies"—artists represented by quintessential 1980s SoHo dealer Mary Boone, she of the 200 pairs of shoes and countless magazine profiles. He excoriated the art schools of America, where high value is placed on the bleats of self-expression emanating from ill-read twenty-year-olds, but none at all is placed on teaching students how to draw. He flayed the show-biz mentality of museums and the crushing dominance of the marketplace.

Hughes had written all these things many times before—and still does, as the newly penned introduction to *Nothing If Not Critical* attests once again. (It carries the Brechtian title "The Decline of the City of Mahagonny.") But coupled with a stylish delivery in his rumbling Aussie voice—sort of dockyard Shakespeare—it was the very familiarity of what he had to say that contributed to the near-Pavlovian responses of the crowd. At times, the raucous howling that greeted Hughes's searing verbal taunts approached the rhythmic pace of call-and-response, with the speaker giving witness and the audience roaring, "A-men!" Had Mary Boone, through some cruel twist of cosmic fate, wandered into the auditorium that evening, the crowd would likely have turned in unison and torn her limb from limb.

Meanwhile, few seemed to notice the implications of what Hughes had to say. His lecture, like most all his criticism, turned

on a belief in a precipitous decline in Western art since the 1960s. Three densely interrelated topics were diagnosed as causes of the culture's illness. The first was the unprecedented arrival of a mass audience for art, which arose from a complex of factors that came together in postwar American social life. In this vastly expanded marketplace, all manner of worthless art could now find at least some acceptance, thus dragging down the general level of cultural taste. Second, the visual world itself had been irreversibly polluted, thanks to the all-pervasive and consumption-oriented drivel spewed out by the ubiquitous television set. The tube made perceptual idiots of the new audiences for art and, worse, of the new artists themselves. And third, the simultaneously diminished expectations of both the new mass audience and the mass of new artists meant that, in our time, art had degenerated into nothing but a vainglorious species of mass theater. Unlike any previous epoch in history, the primary purpose of art had now become merely the seamless delivery of entertainment.

Something of grave importance was indeed to be learned from what Hughes was saying, but you had to listen between the lines to find it. For here was a stunning damnation of the debilitating effects of mass culture being delivered by a critic who, for nearly two decades, had plied his trade in the mass-est of mass culture publications (Henry Luce, the founder of *Time*, practically invented mass media). Here was a vitriolic assault on television being spoken by the only art critic in history who had ever been a television star, and who owed his audience that night to the fact. And here was a critical lament for the decline of cultural discourse into a species of raucous entertainment being offered by a masterful stand-up comic, who held his boisterous audience in theatrical thrall.

Disingenuous? Or undiscerning?

Maybe a bit of both. As a critic, Hughes frequently assumes the role of gadfly, attempting to rouse his readers from a perceived complacency that allows the art world follies to thrive and even escalate. Ironically, this is his greatest failing. It leads him to write as if he's standing on a golden perch somewhere outside the tawdry culture he is criticizing—when, like everyone else, he is deeply entangled in its murky web, both contributor to and beneficiary of its glories and its sins, its foibles and its charms. The failure speaks of a certain blindness, and blindness is something of a liability for a critic of the visual arts.

Perhaps this blind spot is an accident of birth. Born in Australia in 1938, Hughes was literally an outsider to the European and American culture that sequentially colonized his native land, and about which he was subsequently to commentate after extended sojourns in France, Italy, and England. (The critic was initially trained as a painter, too, but once insisted to an interviewer that his failure in the discipline did not color his critical demeanor.) Whatever the cause

or explanation, the newly published anthology makes one thing clear: Without the ugly national mood of cynicism that came to dominate the 1980s, Hughes would have been bereft of a large and receptive audience for his liveliest topic. (Although he has written about art since 1966, all but eight of the ninety-four essays chosen for reprint in the anthology date from the 1980s.)

His criticism can be roughly split into two big chunks—views on art before 1960 and art after—and the principal difference between them is that art before 1960 is treated with deferential seriousness, even when the ultimate judgment is negative, while art after 1960 is regarded with glum suspicion, thus infecting any positive judgment with an Old Testament glow of moral triumph over worldly degradation. This trajectory was first laid out in *The Shock of the New*, which weekly chronicled the downhill slide of modern life. Rather than the standard chronological survey from 1880 to 1980, Hughes had devised an illuminating structure for his history of modern art. He traced several tenacious artistic themes—the unconscious, the utopian future, earthly paradise, etc.—as they metamorphosed through the century. And in each chapter, art seemed to get worse as our own time approached.

Yet, Hughes principally consulted acclaimed art and artists for his view of history, while art since the 1960s was shown as a full array of the good, the bad, and the ugly. History thus seemed populated by giants—some larger than others, it's true, but all grandly mythologized—while the present had to suffer fools. The hoariest populist-canard of Modernism—namely, that modern art is a hoax, with artists out to fool a gullible public—was selectively updated to fit our own time. Offering the inside skinny, only the critic could be trusted as faithful guide through the underbrush. The unfortunate result, repeated in almost every essay addressing recent art that Hughes chooses to write, is an exaggerated self-importance. The 1980s represent the climactic descent, the big drop at the end of a roller coaster's teaser-dips—"Decline in the City of Mahagonny"—and Hughes is its bard. Our problems are "big" now, because so much more is at stake than ever before. As the analyst and judge of those "bigger" problems, Hughes's stature is commensurately aggrandized.

Save for some notable exceptions—which include, inexplicably, such flimsy talents as the decorative salon artists Jennifer Bartlett and Donald Sultan, the pale Realist painters Antonio López Garcia and Avigdor Arikha, and the society Expressionist John Alexander—art, for Hughes, has today largely gone to seed. This discomfort with the present is matched by great reassurance in thinking about the past. Hughes's true strength as a critic is paradoxically to be found in his writing about artists long dead and buried—or, interestingly enough, living in Britain. (He's a great fan of Francis Bacon, Lucien Freud, Frank Auerbach, and Leon Kossoff, and for some his enthusiasm came in the

Robert Hughes

face of general critical silence in the United States.) Perhaps the pantheon (and Britain) appeals to his sense of hierarchy.

Whatever, he writes with admirable clarity and wit. His range is exceptional, and he's enormously well-read. In the anthology, his take on Holbein's drawings goes to the core of their compelling mystery, while the essay on Nicholas Poussin is a model of the short review. And he regularly invokes history as a contemporary guide, as in an insightful commentary on the sudden collapse of the reputation of the early seventeenth century's Guido Reni at the hands of nineteenth-century critic John Ruskin, designed to make the overnight art-stars of the 1980s feel a chill. Hughes would love nothing more than to play Ruskin to Julian Schnabel or David Salle today. But the critic's glib dismissals of so much contemporary culture tend toward the feeble—*ad hominem* insults, amusing if typically unargued (the curse of the facile stand-up comic). The classic example is his recurrent plaint that our artists simply cannot measure up, because rare is the painter today who knows how to draw. (Hughes is, incidentally, partial to painters, whose work accounts for seventy-five of the ninety-four essays in the anthology. As a result, he's pleased to go on for endless fulminating pages about how decrepit a painter is Schnabel, while he can barely scrape together a paragraph in passing on Germany's Joseph Beuys and has nothing at all to say about other crucial artists of the period, such as Bruce Nauman.) Drawing is Hughes's litmus test.

And an oddly immutable test it is, as if a timeless appeal to masterful draftsmanship could keep any culture, at any time and place, afloat on the seas of artistic glory. Hughes can grossly overpraise a less than minor painter such as Sultan simply because he finds his drawings "unequivocally successful." He can reserve the highest accolades from a major painter such as Eric Fischl because of the artist's wobbly draftsmanship. Yet he can be unreserved in extolling the grandeur of a dead artist like Jackson Pollock, while remaining silent about his notorious inability, in the classical sense meant by Hughes, to draw.

The Fischl case is revealing. Hughes remains lukewarm because Fischl has, in effect, been learning to draw even as his figurative paintings have been receiving broad acclaim. (A student at CalArts in the 1970s, when graphite had been traded in for video cameras, Fischl was never trained in the manual skill.) The critic is right when he observes that Fischl's handling of paint "will slide from a passage of assured colloquialism to one of smearing and prodding." But then he'll bizarrely separate out this pressing visual fact to conclude that "whatever awkwardness his work harbors, he is up to something worthwhile—at least on the plane of psychic narrative." It never occurs to Hughes that Fischl's telling psychic narrative—a story of monstrousness and innocence in modern suburbia—is in part carried by the wrenching mix of determined sincerity, smooth facility, and embarrassed awkwardness

342 *Last Chance for Eden*

in his painting style, rather than in spite of it.

Because the modern invention of the camera and of mechanical and electronic reproduction have obviously played a role in altering the traditional relationship between drawing and art, it is odd that neither photography nor a single photographer is addressed in the anthology. (The closest Hughes comes is a mixed review of a retrospective of video artist Nam June Paik.) He may have a highly developed working knowledge of the mass mediums of television and magazines, but Hughes's understanding of the modern "image haze" is surprisingly thin. A 1987 ode to Degas' friend, the British painter Walter Sickert, is telling in this regard. Hughes attempts to undercut the post-Warhol school of artists who "appropriate" from mass-media sources by claiming Sickert did it first, and long ago: "Sickert's huge but obviously unofficial 1936 portrait of Edward VIII stepping from a car and about to don his busby was based, like Warhol's Jackie 30 years later, on a news photograph." Close, but not quite. For Warhol's Jackie wasn't based on a news photograph at all; it *was* a news photograph, mechanically reproduced on canvas in a sly masquerade of painting.

The distinction is narrow, but it harbors a wide gulf in which contemporary life is actually lived. That Hughes cannot perceive the difference explains why the critic is repeatedly at a loss, whenever he leaves the more settled precincts of the history of art.

Hate Mail

December 1990　Maybe you got the letter in the mail. Computer-driven epistles soliciting money for all manner of efforts, from political campaigns to magazine subscriptions, now comprise a prominent segment of postal activity in the United States. This recent missive, signed by critic Hilton Kramer, is one of those:

Dear Reader:

Do you have the feeling nowadays that something has gone terribly wrong with the arts? Do you sometimes have the impression that our culture has fallen into the hands of the barbarians?

Does it make you angry when you see museums putting on shows that are trivial, vulgar, and politically repulsive? Are you appalled when leading universities abandon the classics of Western thought for the compulsory study of "third world" propaganda?

Are you offended by the claim—recently supported by the Rockefeller Foundation and the National Endowment for the Arts—that the Western tradition of classical music (Bach, Mozart, Beethoven, et al.) is now to be considered nothing more than the narrow "ethnic" interest of a remnant of European immigrants?

Are you apprehensive about what the politics of "multicultural-

ism" is going to mean to the future of our civilization?

Well, there is a lot happening in our culture today that inspires such feelings of apprehension and dismay, and there is only one magazine devoted to the arts and the current cultural scene—The New Criterion: A Monthly Review—*that addresses these issues with the criticism and the candor this grave situation calls for.*

I write today to ask you to join us as a subscriber in this critical effort to combat the mounting pressures that we all face from forces now determined to deconstruct our culture and dismantle the values that once made our civilization the envy of the world. [etc., etc., etc.]

The interlocutor's style adopted in this plea for subscriptions—Do you have the feeling? Does it make you angry? Are you offended? Are you appalled? Are you apprehensive?—might best be described as the Late Mannerist phase of a classic gambit. Hilton Kramer has been a vaudevillian of the imminent apocalypse, rolling his banjo eyes in print and yelping, "Katie! Bar the door!" ever since his days as chief art critic of *The New York Times*. Now, apparently, the "barbarian" hordes of "third world" "ethnic" "multiculturalism" have finally reached the threshold.

Its language may be a tad more mandarin, but the technique applied in Kramer's direct-mail solicitation is no more subtle than the one employed by Jerry Falwell, Donald Wildmon, Robert Dornan, Pat Robertson, Jesse Helms, William Dannemayer, or any of the rest of the New Right disciples who learned their cash-cow lessons at the knee of Richard Viguerie, master of the mailing list. Any effective, direct-mail money-raiser must accomplish a thrust-and-parry: first, play on real and pressing fears the way a virtuoso plays on the fiddle; then, offer yourself as a benighted St. George, ready to slay the dragon—if only you could get the funds to buy a new lance.

My favorite example of this proven tactic, even after having read *The New Criterion's* challenging screed, remains a desperate plea once issued on behalf of the National Conservative Political Action Committee, and reportedly penned by Helms himself, which warned: "Your tax dollars are being used to pay for grade school classes that teach our children that CANNIBALISM, WIFE-SWAPPING and the MURDER of infants and the elderly are acceptable behavior." The NCPAC letter simply shows a lot more literary imagination than one that goes on to elliptically warn that your tax dollars are being used to pay for obscene art.

Eight years ago, Kramer launched his neoconservative journal with the aid of a $100,000 grant from the very rich, and very conservative, John M. Olin Foundation (president: William Simon, a business tycoon; former Secretary of the Treasury; board member of the Nicaraguan Freedom Fund, which channeled money to the Contras; past president of the U.S. Olympic Committee; director of a Saudi holding company;

and board member of such right-wing think tanks as the Heritage Foundation, the Hoover Institution, and the Manhattan Institute—this last established by William Casey, late chief of the CIA). In his inaugural issue, Kramer pledged that the Olin-sponsored project would somehow offer a critical perspective that would be utterly "disinterested— capable of producing criticism of such integrity that it stands apart from the blizzards of publicity and the unacknowledged social scenarios that today dominate the arts and traduce their objectives."

That initial claim has been quoted in the new direct-mail plea. Just how one hand of *The New Criterion* accomplishes said act of purity and grace, while the other grubby paw fishes around inside the Olin cookie jar, has never been exactly clear. Yet, the direct-mail solicitation itself stands in sharpest opposition to the claims of disinterestedness and integrity that Kramer makes within its paragraphs. For, typically, disinterestedness and integrity aren't words associated with race-baiting epithets hurled for the singular purpose of selling magazines.

Within the last year, however, the direct-mail machine that has driven conservative politics for more than a decade has suddenly faced an acute shortage of fuel. With the swift collapse of communism in Eastern Europe, the New Right has been stripped of its most venerable fund-raising dragon. As a fiscal stopgap Helms, Wildmon, Robertson, and others who were facing expensive reelection campaigns or faltering empires seized upon a Spenglerian "decline of civilized culture." Throughout the antidemocratic saga of their assault on the National Endowment for the Arts—anti-democratic because it is based on majoritarian and exclusionary principles—you could hear the direct-mail machines humming. From the very beginning, the editor of *The New Criterion* has been, through his writing, a principal actor in the saga. Now, with this charming piece of hate mail, where no barrier separates the phony claim of disinterested evaluation from outright sales talk, Hilton Kramer has joined the masters of the money-machine.

Degenerate Art

When I hear the word "culture," I release the safety catch of my Browning revolver.

NAZI WRITER HANNS JOHST, IN HIS 1934 PLAY *SCHLAGETER*

March 10, 1991 In 1934, Gustav Hartlaub became the first museum director in Germany to be fired by the National Socialist government. He had been director of the Kunsthalle Mannheim since 1923, and he had made the museum an important center for the new art of the day. During his tenure, exhibitions of Edvard Munch, James Ensor, Max Beckmann, Oskar Kokoschka, and the Bauhaus school were or-

ganized and shown, while purchases were made of modern paintings by Ensor, Beckmann, Marc Chagall, George Grosz, E. L. Kirchner, Robert Delaunay, and many others. Shortly before Hartlaub's ousting by the Nazis, Chagall's stark and commanding 1912 portrait of a Jewish rabbi, who has pinched a bit of snuff from a little jar by his open book, was removed from the museum by authorities and put in a window display on a public street. Beside the picture was placed a dramatic sign: "Taxpayer, you should know how your money was spent!"

If the invocation sounds familiar, that's because a claim of taxpayer money supposedly wasted on vulgar art has been revived of late in the United States. A few politicos have repeated it like a mantra in relentless assaults on the National Endowment for the Arts:

> "No artist has a preemptive claim on the tax dollars of the American people to put forward such trash," declared Jesse Helms on the Senate floor, referring to federally funded exhibitions of photographs by Andres Serrano and Robert Mapplethorpe.

> "As Congressman Dana Rohrabacher [R.-Long Beach] so aptly explained," wrote Los Angeles County Supervisor Michael D. Antonovich in a letter to the *Times*, "public financing of the above is inappropriate use of taxpayer funds."

> "The National Endowment for the Arts: Misusing Taxpayers' Money," exclaims the title of a recently published broadside from the Heritage Foundation, a prominent right-wing think tank with ties to the White House.

Comparing today's troublesome efforts at government censorship of the arts with the brutal repressions of the Nazi regime of the 1930s is, of course, risky business. The United States in the 1990s is hardly the Germany of a half-century ago. And, regardless of how frankly evil certain politicians in our midst seem to be, Adolf Hitler they are not. Still, it would be equally foolhardy to ignore undeniable parallels between the Nazi purge of modern art between 1934 and 1937 and the politically motivated attempts at artistic censorship that have grabbed headlines during the past two years. For this reason, it's worth paying special attention to the benchmark exhibition called "Degenerate Art: The Fate of the Avant-Garde in Nazi Germany," now at the Los Angeles County Museum of Art.

This exhaustive and expansive show, skillfully organized by LACMA curator Stephanie Barron, examines a worst-case scenario of daunting proportions. The silencing of the avant-garde in Germany was critical to establishing the totalitarian terror of the era. The LACMA show chronicles the tightening of the noose. Literally thousands of mod-

ern paintings, graphics, and sculptures were rounded up from state-funded German museums. That they were state-funded is crucial to know. Like today's attack on the NEA, which is a federal agency, and on such publicly supported museums as Philadelphia's Institute of Contemporary Art and Cincinnati's Contemporary Arts Center, the National Socialist assault on modern art was first launched through entities affiliated with government and thus endowed with an imprimatur of officialdom.

Chagall's *Rabbi* was among the paintings denounced as offensive to populist officialdom and among the hundreds that the Führer personally approved for inclusion in "Entartete Kunst," the 1937 display in Munich of so-called "Degenerate Art." (Unfortunately, the Chagall could not be borrowed for LACMA's presentation.) The Munich show meant to ridicule modern art and thus inflame the German public. A special point was made of labeling each work by artist's name, title, and date—and of listing the price paid by taxpayer money for its public acquisition. The show was a huge popular hit. Its seven rooms were loosely divided into a variety of rather vague themes, but two recurrent ones stand out: religion and sex. Like taxpayer appeals, these are highly personal and highly emotional topics. We saw their usefulness again in the initial blitz on the NEA, as Mapplethorpe's sexually explicit pictures and Serrano's photograph of a cheap plastic crucifix submerged in urine made for a one-two punch of supposed obscenity and blasphemy.

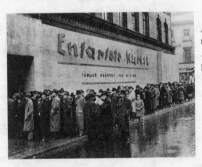

Anonymous German from the *Hamburger Fremdenblatt* published 1938

"Insolent mockery of the Divine," began the Nazi slogan written on the wall next to Emil Nolde's monumental 1911 painting *Life of Christ*, in the first room of "Entartete Kunst." The gallery contained only religious paintings, most of them vividly Expressionist, while the second room was devoted solely to paintings made by Jews. (Six of the 122 "degenerate" artists were Jewish.) The third room featured nudes. "An insult to German womanhood," raved the heading on one group of bold, Primitivist paintings and carvings. A self-consciously male society, National Socialism made sharp distinctions between depictions of women meant for private use and those appropriate for public—and therefore political—display. The often wild sensuality

Degenerate Art

of Expressionist art violated those public prohibitions.

In the admirable catalog accompanying the LACMA show, historian George L. Mosse demonstrates how any threat to the Nazi version of manliness was held to be a public threat to moral respectability. "Entartete Kunst" was organized explicitly to demonstrate the consequences of any rejection of social and sexual norms. The German word *Entartete* was actually a biological term, which described a plant or animal that had changed to such an extraordinary degree that it no longer belonged to its species. When applied to *Kunst*, or art, it meant painting and sculpture that was so "inherently deformed" as to no longer constitute art at all. The eradication of modern painting and sculpture did not constitute an aesthetic assault, for the work of Chagall and the rest simply wasn't considered art by National Socialists. LACMA's Barron points out another essential fact: The eventual extermination of millions of Jews, homosexuals, and the mentally disturbed did not, in the Nazi mind, constitute genocidal murder, because they weren't considered human beings at all. "Entartete Kunst" was an early warning of that ideology's grotesqueness.

"I don't even acknowledge the fellow who did it was an artist," said Jesse Helms to his Senate colleagues in his 1989 rebuke of the photograph by Andres Serrano. Denying artistic status, and thus legitimizing the political repression of a point of view, is a venerable tactic. So is the more elaborate route taken by neoconservative critic Samuel Lipman in his NEA assault. He adopted the aforementioned distinction between public—and therefore politically sanctioned—display and private use in his condemnation of federal funding for art that rejects social and sexual norms. "People have always had their private pleasures," he wrote, "and as long as these pleasures remain private, confined to consenting adults, and not immediately injurious, the public weal remains undisturbed. But, now we are told that what has been private must be made public.... But we can say no, and not only to our own participation as individuals in this trash."

Conservatism's version of manliness is violated by public affirmation of homosexuality. NEA sanction of Mapplethorpe's art—and that of Tim Miller, Holly Hughes, and John Fleck—is thus intolerable. Their threat to a reigning social and sexual norm of manliness is held to be a public threat to moral respectability. Similarly, the recent Heritage Foundation report condemns the federal agency for a supposed "bias against traditional forms of art and traditional values in general"—which is to say, condemns it for funding any art that veers from social norms in the United States today. For these observers, as for many others, a purge of the NEA would demonstrate the consequences of that rejection. With this political objective in mind, the average citizen's distrust of modern art can be leveraged to formidable effect, simply through the vigorous use of populist rhetoric.

Last Chance for Eden

Significantly, the National Socialists advanced their cause through a thundering, carefully orchestrated clash between modern art and populist sentiment. The golden glow of populism resonated with the beleaguered German people of the depression era. In a slumping United States, it has been the order of the day for quite some time as well. During the 1988 presidential campaign, to cite an obvious example, George Bush's image-savvy advisers made an explicit point of having the candidate regularly seen and photographed extolling the virtues of pork rinds and beef jerky, with country singing stars Loretta Lynn and Crystal Gayle beaming at his side. Their aim was simple. At a time of rising economic uncertainty, growing skepticism over seemingly insurmountable domestic social problems, and edgy discomfort with the nation's decline in global stature, relative to other ascendant powers, this was no time to be extolling as the people's choice a wealthy, Yale-educated, Connecticut blueblood. The Bush portrait needed to be redrawn. Better the picture of a go-it-alone Texas wildcatter at the helm than one of an effete Eastern snob. And so, the picture was artfully changed. Bush's handlers deftly relegated an elitist portrait of their candidate to history's musty attic, where all tattered or out-of-date items go. In its place, facing the national living-room sofa on TV, they boldly hung a populist version of their man. The Uptown Wimp was transformed into an All-American Guy. Voters smiled.

Politics has, and always has had, an aesthetic dimension. This image-crafting game has been played ever since there have been politicians to play it, but the nature of the game has been dramatically changed by television and electronic technology. In our media-driven era of overnight ratings and instant polls, where popular opinion is immediately gauged and then sold back to itself, a fervently populist style is appropriate.

There is a price. Rote repetition of majoritarian slogans, which populism requires, squashes citizenship's argumentative public spirit, flattening it into narcissistic self-congratulation. An idealized profile gets held up in a mirror, and we are vainly asked for our approval. Actual independence and individuality—the sense of being an American citizen—is denied. Populist eras tend to be very bad times for art. Majoritarian slogans just don't fit well with a discipline whose very basis is the vigorous diversity of free expression. In our own populist moment, art has been taking a serious buffeting. It could be worse—and it might well get to be.

During difficult times, any art's rejection of social norms is easily exploitable by clever politicians waving populist banners. The Führer suppressed the avant-garde in similar ways and for similar reasons, but he also actively championed conventional, academic art. Across the way from "Entartete Kunst," he mounted "Grosse Deutsche Kunstausstellung"—the Great German Art Exhibition—the first of eight

Degenerate Art

annual shows. Hitler had been a failed painter in his Austrian youth, but the dictator's staunch support for charming landscapes of the Fatherland, exalted military subjects, stoical portraits, and chaste nudes was far more than simple dilettantish enthusiasm. Politically, Hitler knew how useful the arts could be: By promoting only art the masses enjoyed and understood, his own authority and power could be enhanced. The aesthetic dimension of the Nazi program lay in its deft creation of a basic populist illusion that the people actually rule. Coercive contempt for the individualism and integrity of the rank and file was easily concealed. That is why, when the Heritage Foundation condemns the National Endowment for the Arts for "spending millions on art that the vast majority of Americans find neither uplifting, ennobling, beautiful, nor meaningful"; or when Dolo Brooking, director of the arts administration program at Cal State Dominguez Hills, complains that the NEA erred in giving grants to difficult projects because "the people were entitled to understand the arts they were supporting"; or, when Sen. Helms scoffs, "I like beautiful things, not modern art," it is worth pausing for a long and reflective moment. For whose real benefit are they trying to silence art?

On Drawing

March 31, 1991 Some insist that most of the principal achievements of art since the 1960s add up less to a sign of the richness of contemporary culture than to an indictment of its utter bankruptcy. Various culprits are claimed responsible. One primary offense, the grumble goes, is that too few artists today know how to draw. Generally, what is meant by the complaint is that few of today's younger, widely acclaimed artists have learned how to draw in the traditional, academic manner. Rigorous, extended technical training in the manual skills of draftsmanship has largely disappeared from the curricula of leading art schools. Art, the thinking goes, is the worse for it.

A rising chorus of complaints about a perceived atrophy of contemporary drawing skills emerged in the past decade. It rode the wave of renewed interest in figurative painting that was a hallmark of the 1980s. Traditionally, drawings were most often meant to be steps in an extended process whose grand finale was a painting. So the Neoexpressionist crudeness of much 1980s figurative painting has been explained—by naysayers—as the result of a woeful "failure" in underlying drawing skills.

The appropriate response to this cavalier charge is, simply, "Bunk." Within the life of art today, the "fallen" place of traditional concepts of drawing is a false issue. Perfection in academic drawing skills is no more a guarantor of great paintings than failure in those skills

promises bad ones. At the Los Angeles County Museum of Art, the delightful exhibition called "Why Artists Draw: Six Centuries of Master Drawings from the Collection" contains many renderings in graphite, chalk, and pastel that are, in an academic sense, exceptional, by painters of decidedly less than stellar reputation or achievement.

An adept, red-chalk study for an allegorical figure of Africa, meant to become a spandrel decoration, is a lively and cleverly composed invention by Carlo Maratta; yet the artist, who had been the most fashionable Roman painter of the late seventeenth century, ranks today as merely a pleasant Baroque artist whose star faded fast. Because no ideal and everlasting model exists against which all paintings may be judged, the appeal to drawing as a painter's timeless anchor is bogus. Aesthetic standards, which are multiple and sometimes even contradictory, are also temporal. It's no accident that "Why Artists Draw" spans precisely six centuries, rather than four or ten or some other number. For traditional drawing is a value that was forged in the crucible of the Renaissance.

Michelangelo is among the greatest draftsmen of all time. In 1563, the year before his death, he also took on a novel job. With Duke Cosimo I de' Medici, Michelangelo served as codirector of the new Accademia del Disegno—the first official art academy anywhere, founded that year in Florence by the painter and historian Giorgio Vasari. The Academy of Design had a specific aim, which went on to shape the future programs of state, royal, and even private academies that would spring up in Rome, London, Paris, and elsewhere in subsequent generations. Simply, the academy meant to elevate the hitherto rather lowly status of the artist, lifting him above the ranks of mere craftsman. The legendary, titanic struggles between Michelangelo and his papal patron in Rome, Julius 11, are the most extreme demonstration of why the need was felt. Michelangelo—and Cosimo and Vasari—conceived of the artist as something different from what he had been throughout the Middle Ages: a hired worker, as would be found in any guild, whose job was the faithful execution of someone else's artistic ideas.

How this transformation was to be achieved can be seen, in part, in the kinds of drawings that began to proliferate. As the separate categories devised for the show at the County Museum attest, drawings since the Renaissance have been of different kinds and have had several uses. A compositional sketch was a preliminary step in an artist's realization of a finished work in another medium, such as a painting or a sculpture. A figure study was meant to elaborate the precise details of figures that would appear in a final composition. Sometimes a figure study was just done as an exercise, as hand-eye gymnastics meant to hone an artist's manual skills. Then there was the *bozzetto*, a final, highly finished composition, frequently used as a virtual transfer pattern for a fresco or tapestry.

Certainly the variety of drawing types reflects the aca-

demic emphasis on practical study—on the traditionally demanding craft involved in making a work of art. But this new, loosely ordered variety reflects something else as well, something that was crucial to the aspirations of the emerging academy. The status of the artist could not be raised merely by requiring practical study and expertise in craftsmanship. If artists were to do more than passively execute artistic programs laid out by others, it would henceforth be necessary to require a depth of theoretical and intellectual inquiry from painters and sculptors, too. That could be accomplished through the study of history, myth, church doctrine, nature, mathematics, and many other subjects, all of which would conspire to deepen and enrich the language of art. But it could also be represented in another way.

More than any other medium in the repertoire, drawing is the one in which the activity of the artist's mind can register itself most directly, without intervention, in visual form. Points of view are worked out, possibilities tested, visual speculation made, decisions set down. Drawings are a kind of "aesthetic electroencephalogram." They possess a liveliness unlike any other medium because, typically, they can be described as a direct transcription of artistic thought. Compositional sketches, figure studies, and the like record the processes by which that thought blossoms, develops, and is refined. A new emphasis on drawing was one of several ways theoretical inquiry could be made demonstrably integral to art-making.

Without explanation, the six centuries surveyed in "Why Artists Draw" peter out after World War II, coming to a screeching halt by 1960. The most recent works are small abstractions from that year by the sculptors David Smith and Eva Hesse. Because artists didn't just suddenly stop making compositional sketches or figure studies, the date of the survey's end would seem to be more than mere coincidence. In part, the reasons artists draw have changed dramatically in postwar generations. Another category of drawings identified by the show includes those that are not made as a prelude to some other end but that are executed as an end in themselves. This is not a new idea, as sheets by Tiepolo, Ingres, Braque, and others in the exhibition make plain. But, undeniably, the genre is prominent in the twentieth century and proliferates in contemporary art to a degree it never has before. Why? The 1960s witnessed a profound shake-up in the hierarchy of artistic mediums. As it did, there was no reason a drawing had to be conventionally regarded as a first, second, or third step on the road to something else—including the maker's road to legitimacy as a bona-fide artist. A number of useful explanations for this shake-up can be offered, but one in particular has to do with drawing itself.

The basis for realignment had been indeliberately prepared in the previous decade by the celebrated success of Jackson Pollock's drip-paintings. The artist had made them, of course, by dripping paint

in linear streams from the end of a brush or, more commonly, a stick onto unstretched canvas laid out on the floor. By the late 1950s, these shimmering skeins of paint had been acclaimed internationally as a monumental achievement. Pollock's drip method has been described in many ways, but none has been so astute as that emphasized last year by Steven Naifeh and Gregory White Smith, the artist's biographers. Hovering above the plane of the canvas, moving his body, his arm and his wrist in a continuous and improvisational choreography literally suspended in air, Pollock, they said, was drawing in space. Where that drawing fell to earth became a painting. In these stunningly beautiful works, no hierarchy of drawing and painting can be identified. Drawing and painting are instead inseparable, one irrevocably fused within the other. No "before" or "after" can be sorted out. And perhaps most important, drawing's lively quality as the direct transcription of artistic thought now coursed through painting, too, generating an ineluctable electricity.

The proliferation, since the 1960s, of drawing as an end in itself therefore shouldn't be surprising. Nor should the irrelevance of traditional forms of drawing to whole segments of artistic practice, including many varieties of painting. In a fundamental way, Jackson Pollock brought to a close the European tradition of drawing. Today, the significance of manual skill or craft in drawing is wholly dependent on the individual artist's aim. Some need it, some don't. After all, Pollock's epochal triumph was arrived at despite a notorious "failure" on his part: In the academic sense, the artist couldn't draw a lick.

MOMA in L.A.

August 11, 1991 Remarkable as it might seem, there are signs that the Museum of Modern Art might join the late twentieth century before the late twentieth century comes to an end.

Typically, and with good reason, the venerated New York institution is thought of as the most important and distinguished museum of its kind. From its unrivaled collection, filled with more pivotal works of twentieth-century Western art than any other, to its historic role as a successful proselytizer for modern art through groundbreaking exhibitions and acclaimed publications, MoMA holds a special place in the pantheon of art museums. With equally good reason, however, the Museum of Modern Art also occupies a rather less exalted—some might even say negligible—position in matters of the art of its own time. Tension between the museum's accepted role as codifier of the achievements of the past and its thornier position as arbiter of the unsettled artistic issues of the present day is a dilemma of long standing. Generally, it has been resolved on the side of history.

When MoMA opened its doors in 1929—a new and pro-

gressive institution dedicated to all that was bafflingly modern in the tumultuous world of art—the exhibition program was inaugurated not with a show of the new Parisian Surrealism, nor of the interdisciplinary inventions of the German Bauhaus, nor of the radical abstraction of Mondrian and Dutch De Stijl, all of which had been boiling over in the fecund European art centers of the previous decade. Instead, the Modern opened with a rich display of paintings by Cézanne, Van Gogh, Gauguin, and Seurat—the historic "founding fathers" of twentieth-century art, all of whom had been dead for a generation or more.

MoMA's conflicted relationship to contemporary art has been especially evident since the 1960s. A formerly daring and lonely outpost of twentieth-century art was by then an established, mainstream fixture in the newly anointed capital of international culture—which meant that hitherto unknown demands were being pressed at every turn, while its established reputation was now at stake. In a way, the Modern had become something of a victim of its own success.

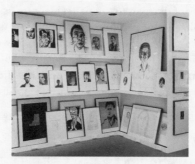

"Head-On/
The Modern Portrait"
1991

Now might be an appropriate moment to examine the museum's conflicted relationship to recent art, and for two particular reasons. One is a simple matter of convenience. For the summer months, the Museum of Modern Art has virtually colonized Los Angeles. The three most prominent local venues for the display of twentieth-century art are presently host to high-profile exhibitions that originated on Manhattan's West 53rd Street. Together, they made up a large—and revealing—chunk of MoMA's exhibition schedule for the last season. At the Museum of Contemporary Art, "High & Low: Modern Art and Popular Culture" has filled the galleries with undisputed masterworks, together with some of the pop-culture source material, such as comic books and advertisements, upon which that art depended. The Los Angeles County Museum of Art is the site of "Liubov Popova," a retrospective survey of paintings, drawings, and designs for textiles, theater sets, and costumes by the great Russian avant-gardist, which continues through Sunday. And "Head-On/The Modern Portrait," a display of more than 140 paintings, prints, drawings, photographs, and sculptures selected from

Last Chance for Eden

MoMA's permanent collection by the American portrait artist Chuck Close, occupies the galleries of the Lannan Foundation.

Second, a variety of developments during the 1980s do bear witness to the Modern's stepped-up efforts to come to terms with its historically troublesome relationship to contemporary art, but none has been more dramatic and hopeful than last fall's appointment of a curator charged specifically with the art of the present day. There had been such an appointment several years before, but this time, adding substance to the symbolism, the announcement was followed by an immediate clearing of the decks to accommodate for this autumn a substantive exhibition of recent art. Robert Storr, a highly respected, New York-based critic, painter, and freelance curator, was named to the post. October is the designated month for his debut exhibition of site-specific installations, titled "*Dis*locations," which will feature work commissioned for the occasion from Louise Bourgeois, Chris Burden, Sophie Calle, David Hammons, Ilya Kabakov, Bruce Nauman, and Adrian Piper.

To get an idea just why this news was dramatic and hopeful, here's a little test. MoMA describes "*Dis*locations" as an effort to examine the return of installation art to international prominence after a decade in which painting and sculpture as self-contained mediums had been the focus of consideration. Now, name the last substantive show the museum organized that tried to get a handle on a recent, specific, yet broadly influential development in contemporary art. Time's up. By my recollection, it would have to be the big survey of Conceptually oriented art titled "Information"—a show that was mounted exactly twenty-one years ago. Your kid could have been born, raised, and graduated from college since then. When our flagship museum of twentieth-century art goes that long between such shows, you get an inkling that contemporary culture is barely a consideration, never mind a priority.

"*Dis*locations" signals that something notable is afoot, but the Modern's evident desire to regain a prominent role of leadership in the international dialogues of contemporary culture is not brand new. Signals have been building. Some were as blunt, if finally unfortunate, as the renovation and expansion program at its much beloved midtown building, a program that, among other banalities, unveiled to the world in May 1984 a perfectly awful array of subterranean galleries for temporary exhibitions. Other signs were more optimistic, perhaps none more than the well-received 1989 retrospective of Andy Warhol's art. MoMA had made a colossal blunder in the 1960s, hitching its wagon more tightly to the wan airiness of Color-field painting than to the far more trenchant developments of Pop, Minimalism, and Conceptual art. Warhol's belated anointment spoke a quiet mea culpa. Among artists who had emerged since the dawn of the 1960s, only one had hitherto seemed to be regarded by MoMA as crucial—the abstract painter Frank Stella, remarkably the subject of not one but two career surveys at the museum. The Warhol

show was a signal event, for it was his brand of Pop that had emerged as a touchstone for its generation, as well as for a whole generation of younger artists who, to their astonishment and delight, were suddenly welcomed into MoMA's aesthetic orbit.

At least, they thought they had been welcomed in. Almost immediately there was reason for doubt. The virtual hail of critical condemnation that crashed down on that other, more recent colossal blunder—the exhibition "High & Low: Modern Art and Popular Culture"—suggested they now felt otherwise. "High & Low" is a traditional, even academic accounting of specific sources in popular culture that have turned up in the work of twentieth-century artists from Pablo Picasso to Jeff Koons. In great and gruesome detail, it chronicles its subject in ways that could only be supported by those who fervently wish that great events in the last twenty-five years of art and critical thought had never happened—including the art of Warhol. A museum simply couldn't claim to understand the significance of Warhol and mount a show like this.

"High & Low" was the much-anticipated debut presentation by Kirk Varnedoe, MoMA's newest director of its department of painting and sculpture, and thus holder of perhaps the most powerful curatorial position of its kind in the world. Smart, charming, ambitious, and by all accounts dedicated to reinvigorating MoMA, Varnedoe is also an academic who came to his museum post from the faculty of New York's prestigious Institute of Fine Arts. (His former student, *New Yorker* art critic Adam Gopnik, collaborated on the MoMA show with him.) Before "High & Low," he had virtually no track record in the difficult curatorial task of organizing persuasive exhibitions of postwar art. In 1984, Varnedoe had participated in the contemporary section of another highly problematic MoMA show, "'Primitivism' in 20th-Century Art: Affinity of the Tribal and the Modern," spearheaded by his mentor and predecessor in the department directorship, the formidable William Rubin. Like "High & Low," "Primitivism" paired modern masterworks with sources outside traditional Western art, in this case from tribal cultures. Significant scholarly detective work was accomplished, but a storm of dissent arose over the show's implied endorsement of what many felt to be the artistic equivalent of ethnographic colonialism. Similarly, "High & Low" took heat for tacitly implying that, whenever so-called high culture needed a boost of adrenaline, it went slumming among the low pleasures of the working class.

Notably, neither "Primitivism" nor "High & Low" was as much a museum exhibition as it was a kind of three-dimensional lecture—a display that lined up modern masterpieces and their sources side by side, rather like a slide presentation in a university class. Pedagogy may work fine in the professorially ruled classroom, but few in the functioning art world took kindly to being treated like unknowing stu-

dents of so central a feature of recent art. They yelped, rightly, at the quietly condescending pretention.

Both shows marshaled facts with considerable erudition. Yet, perhaps most important, both also viewed the work of Western artists principally through a lens of formal analysis. Formal analysis of the history of modern art has always been MoMA's forte. For one obvious example, see the installation of its extraordinary collection of painting and sculpture, which is guided by stylistic taxonomies. For another, see its aforementioned commitment to Color-field painting, a genre practically invented by formalist critics. You could plow through the often remarkable two-volume catalog to "Primitivism" and come out the other end thinking modern artists were mainly attracted to tribal art by its powerful formal qualities. Likewise, you could get through "High & Low" without ever finding out why Warhol chose specifically to paint cans of soup, from among the endless list of supermarket possibilities. Although undeniably useful, art-historical formalism has long since been toppled as the central doctrine of contemporary artistic discourse. Dissonance between MoMA and a significant segment of its most attentive audience therefore seems inevitable.

The museum's historical retrospective of Liubov Popova (1889-1924) is symptomatic of this formalist problem. Popova was an artist who absorbed with astonishing rapidity and skill the most advanced aesthetic ideas of her day, ideas that were principally worked out in the paintings and sculptures of other innovators, which she incorporated into her own ambitious work. Many of her canvases are beautiful and provocative. However, her true brilliance came later, after she stopped painting, when she transformed those ideas in astonishing designs for textiles, costumes, and theatrical sets. In the MoMA show those extraordinary final works get short shrift because of an apparent, hidebound faith in a formalist hierarchy that puts painting and sculpture at the apex of art. The exhibition is exciting because a crucial artist, hitherto obscured, is brought into the spotlight. Nonetheless, it feels forced and flat. It's a "classic MoMA" show: Popova's reputation is resuscitated, but to accomplish the task her actual achievement has been distorted.

Ironically, the Modern is probably the museum least likely to be able to deal conceptually with an artist such as Popova, who moved among different artistic disciplines and brilliantly wove several together. Established on a corporate model, MoMA is notoriously Balkanized into six separate curatorial departments—painting and sculpture; drawings; prints and illustrated books; architecture and design; photography; and film—each with its own director. Sometimes, they seem to operate as walled fiefdoms beleaguered by internecine warfare. Originally, the creation of these individual departments spoke of a commitment to inclusiveness in considering the breadth of modern artistic creativity. MoMA made news by taking such once-radical steps as mounting shows

of industrially designed objects and accepting movies into its purview. Contemporary art, however, has become increasingly hybridized, with clear distinctions among disciplines vigorously challenged in the work of many crucial artists. Now that disciplinary distinctions are often impossible to make, the departmental structure can be a serious impediment. "High & Low," for example, suffers as an exhibition exclusively of painting and sculpture—it contains not a single work made with a camera—because the subject of popular culture is unthinkable without the modern arrival of mechanical reproduction.

Overcoming that departmentalized impediment was one of many motives apparent in "Head-On / The Modern Portrait" at the Lannan Foundation. Chuck Close chose portraits from most every department of the museum and jumbled them together in an installation design that recalls a storeroom—the messily vital place where work in MoMA's collection languishes when not publicly sorted out for display in discrete departmental galleries. Close's show was third in a new series called "Artist's Choice," inaugurated by Varnedoe. (The late sculptor Scott Burton and painter Ellsworth Kelly had previously been invited to organize shows from MoMA's great collection.) Varnedoe also hired Robert Storr and paved the way for his "*Dis*locations" show. All these decisions speak of a welcome and insightful effort to open up the museum to diverse voices. They are Varnedoe's most important actions to date.

Close's curatorial decision to mix up mediums stood in stark contrast to typical MoMA shows. Coincidentally, however, when shown in New York last winter, "Head-On" overlapped on the schedule a sprawling, in-house exhibition called "The Art of the Forties," also drawn from every nook and cranny of the museum's collection. Its first gallery alone included a Jackson Pollock screenprint, a photographic portrait of Winston Churchill by Yousuf Karsh, a U.S. Air Force poster by Leo Lionni, Picasso's grisaille painting *The Charnel House*, and Charles Eames's molded plywood study for the nose cone of a glider. "The Art of the Forties" surveyed an especially volatile decade. Significantly, that period was the crucible for radical shifts in Western culture—shifts that would give rise to the very conception of a new identity for art, one that didn't seem to be strictly "modern" and so came to be called "contemporary." The show was seriously flawed, but its surprising multidisciplinary thrust was widely—and gratefully—noted.

MoMA's general ambivalence about contemporary art has always been acutely felt within the display of its permanent collection. The final room in the chronologically ordered galleries of painting and sculpture is devoted principally to the 1970s and 1980s, but the selection has never seemed more than haphazard and arbitrary. Never, that is, until the last several months. A visit last spring showed how Robert Storr had reinstalled the gallery to make a number of points. The dis-

play speaks volumes about MoMA's current aspirations and their sharp divergence from orthodoxy. In addition to often sensitive juxtapositions, Storr scored a polemical bull's-eye.

The room contains a dozen works. The earliest is a 1963–64 torso sculpture by Louise Bourgeois, a major artist of the New York School. The most recent are a 1990 sculpture made from afghans and stuffed animals by Mike Kelley, and a 1990 painting by the expatriate Abstract Expressionist Joan Mitchell. In between are works by Alice Aycock, Eva Hesse, Ralph Humphrey, Lois Lane, Elizabeth Murray, Dorothea Rockburne, Susan Rothenberg, Richard Serra, and Jackie Winsor. The proportion of artists who are women (nine) to those who are men (three) is just about the exact opposite of what one usually finds in shows of recent art, despite the profound influence of feminism in contemporary culture. In fact, this single room holds more than twice the number of works made by women than will be found in all the prior galleries of twentieth-century painting and sculpture combined. The recentness of the work is also given depth and resonance by having been bracketed by artists of an older generation—Bourgeois is seventy-nine; Mitchell, sixty-five—whose sensibilities were shaped by the postwar efflorescence of art in New York. Storr's selection of "new" art doesn't just chronicle the young and the restless. And Kelley, who is the youngest of the group and thus an avatar of the most recent developments in art, is significantly not based in New York. His floor piece makes obliquely critical reference to the drip-paintings of Jackson Pollock, which were executed on the floor, and thus to the origins of the schism that opened between "the modern" and "the contemporary." But his sensibility is inseparable from a mass-culture milieu, which makes Kelley's residence in Los Angeles telling.

Right next to the door, Kelley's is the final work in the Museum of Modern Art's sweeping chronology of twentieth-century painting and sculpture. When you leave the hallowed halls, you can't help but be convinced that something momentous might well be under way.

African-American Quiltmaking

August 14, 1991 "Who'd a Thought It: Improvisation in African-American Quiltmaking" is an exhibition with a demonstrative title and a point to make. Not all approaches to the familiar folk art of quiltmaking are the same, the show insists; hitherto obscured is a venerable tradition particular to American descendants of the African diaspora. Who, indeed, would have thought it?

The exhibition's slangy title was taken from the impromptu name given to one quilt in the show, which was organized by the San Francisco Craft and Folk Art Museum and is now con-

cluding a 3½-year tour at the Long Beach Museum of Art. Pieced by Francis Sheppard in 1986 and quilted by Irene Bankhead the following year, the aforementioned bedcover is in the shape of an irregular square (its four sides are slightly curved) whose concentric pattern of strips of black cloth alternating with patched, multicolored zigzags is crisscrossed by a big X. Here's the hitch: Only three of the four arms of the X are anchored to the corners of the square, where you might expect them all to be. The fourth veers off by at least a foot, giving the otherwise regular pattern a visual kick that sends it spinning like a pinwheel. The outward spin is enhanced by the slight curves in the sides of the square, which make the concentric bars resemble ripples from a stone dropped into a pond. The name of this unusual quilt wittily zeroes in on the larger tradition the show means to identify. A pattern that would have been stable, uniform, and static has been transformed into an exuberant, mobile, improvisatory surprise. Who'd a thought it?

This improvisational style isn't the same as that of so-called crazy quilts, in which fabric remnants are sewn together helter-skelter without regard to pattern, form, rhythm, or composition. Instead, improvisations are light on their feet, adapting to the specific, ever-changing context as the making of the quilt goes along, rather like a storyteller making up a tale from scratch. A definite rhyme and reason mark the scheme, even if their source can't immediately be detected. To borrow the terminology of jazz, the concentric squares of the "Who'd a Thought It" quilt's background form a riff, or a basic theme composed from a constantly repeated phrase, while the free-wheeling X is like a solo improvisation that plays across the riff and sets the whole thing soaring. Jazz and blues and scat and gospel and other musical forms common to black culture are, in many respects, the aural equivalent to the visual style of improvisation that the exhibition demonstrates.

That demonstration is concise. The show features just twenty-eight quilts, most dating from the past fifty years, and all are from the Oakland collection of Eli Leon. (Several of the more than 300 quilts in Leon's collection were seen at the California Afro-American Museum in 1986.) But the selections do their job well, offering a good introduction to the subject while articulating a number of salient points.

One is that using the most familiar traditions of European-American quiltmaking as the standard by which to judge the African-American quilts in the show inevitably means the latter will come up short. Erroneously, they'll seem filled with mistakes, disabilities, errors in form, judgment, and compositional skill. Emma Hall's 1940 design for a "Double Wedding Ring" quilt, and Mattie Pickett's for a 1986 "Texas Star" show why. Each takes considerable license with a famous traditional quilt pattern. The poised, geometric regularity of delicately linked, often flowery circles in a standard Double Wedding Ring is pretty much maintained by Hall. Visually, however, the staid delicacy has been trans-

formed into boisterous revelry by her eccentric colors and percussive, internal patterns. The quilt evokes a festive wedding reception more than a genteel wedding service. Pickett's revolves around a rich but highly ordered central starburst, in typical fashion, but there all similarities with a common Texas Star cease. Beyond the central pattern, out at the margins, a wild galaxy of tumbling stars explodes the symmetrical regularity common to its counterpart among white quilters. Pickett's Texas Star is ecstatic, not stately.

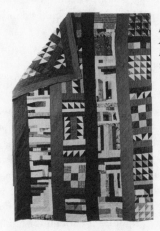

Anonymous American
Afro-Traditional Quilt,
Improvisational Strip
19th century

That these improvisations on standard designs are anything but errors in composition or failures of technical skill is made plain in a rare, double-sided "strip" quilt, anonymously made in the nineteenth century. One side is perfectly regular and symmetrical, exquisitely sewn with every stitch in place, but the other is a fanciful, equally deft improvisation on the strip motif. Both are remarkable. This nineteenth-century example—the only one in the show—also means to suggest a direct link across time and continents to African traditions that were forcibly carried across the Atlantic by the slave trade. Rosie Lee Tomkins's dazzling 1985 concatenation of pieced velvets is convincingly related to the so-called flexible patterning of African raffia embroideries. In the exhibition, a small selection of cloths from Ghana, Nigeria, and Zaire—modern states that correspond to the Central African regions from which most slaves were taken—show patterns that echo formal and conceptual structures, if not outright styles, of those pieced by modern African-American quiltmakers.

Drawing links between the African-American piecing of velvet scraps and the patterning of bark cloth painted by Pygmy women in Haut Zaire is a complex business. (If you want to try it yourself, follow a trip to the Long Beach Museum with a visit to the Margo Leavin Gallery in West Hollywood, where, coincidentally, an exhibition of dec-

orated Pygmy bark cloth has lately gone on view.) As "Who'd a Thought It" makes plain, the cataloging of motifs and the reconstruction of the paths taken in the evolution of the tradition are projects only just begun. The African side of the equation needs to be fleshed out. The American side, by contrast, is fully in evidence. Music critic Gene Santoro has said that the broad collection of musical idioms we call jazz, which are united by their common embrace of improvisation, are avatars of the quintessentially American practice of self-invention. So are these often amazing quilts. They celebrate established tradition while simultaneously using it as a backdrop against which their own hitherto unheard-of songs are visually sung.

worker photography between the wars

August 31, 1991 Photojournalism isn't what it used to be. What it used to be, long before the ascendancy of television as the principal conduit for newsworthy images, was the only game in town.

As the only game in town, photojournalism was a device that could easily be used to represent to the public only a narrow range of interest, which appealed to those who controlled the press. Because images distributed as news always carry with them the invisible ghosts of those pictures deemed not significant enough for public display, the line between "objective" photojournalism and "subjective" propaganda can never be sharp and defined.

Hans Schiff
Police Van (Köln)
1931

"Camera as Weapon: Worker Photography Between the Wars," which opened this week at San Diego's Museum of Photographic Arts, examines an early facet of European photojournalism that was born of a desperate frustration with the narrowness of the mainstream press, and of a committed desire to show what was not being shown in the dark and difficult days of Germany's Weimar Republic. Perhaps for the first time in the United States, this concise gem of an exhibition lays out the story of the so-called worker photography movement of the

1920s and 1930s, including its impact beyond German borders. If the worker photography movement doesn't immediately register, that's because it has long since been overshadowed by two competing developments from the period. One was the extraordinary avant-garde work being generated in exciting profusion, including but not exclusively from the Bauhaus, by such artists as Laszlo Moholy-Nagy and Albert Renger-Patzsch. The other was the photojournalism disseminated through middle-class publications like BIZ, the *Berliner Illustrierte Zeitung* (Berlin Illustrated Newspaper); and MIP, the *Münchner Illustrierte Presse* (Munich Illustrated Press).

Photojournalism had been transformed by a new, "you are there" intimacy, which was made possible by newly miniaturized cameras, high-speed lenses, and fast film. The picture press flourished. BIZ and MIP told exciting photographic stories of powerful politicians and influential businessmen and of big events like the war in Ethiopia in compelling pictures and photo essays commissioned from the gifted likes of Albert Eisenstaedt, Felix H. Man, and André Kertész. What BIZ and MIP did not tell was candid stories of exploited child labor and the unemployed, and of little events like the populist idealism of the poor and disenfranchised—of whom there were many in the devastated wake of World War I. Instead, BIZ and MIP published the very pictures worker photography was designed to combat, in new and aggressive publications that meant to undermine established power through the simple display of what the mainstream habitually repressed.

And combat it was. The warlike inference of the show's title, "Camera as Weapon," is taken from the words of German artists, which are excerpted on the galleries' walls. Eugen Heilig, whose photographs range from images of the demeaning conditions in sweatshop factories to one of a sign forbidding Jews to enter a public park near Berlin, explained of the worker movement: "We learned to use the camera as a weapon in the class struggle." And the powerful graphic artist George Grosz, many of whose prints and drawings were published alongside worker photographs (two are included in the show), with which he sympathized, declared: "I considered all art senseless unless it served as a weapon in the political arena."

Why this artistic rattling of sabers? In the convincing view of the show's guest curator, Leah Ollman, the two decades between the first and second world wars in Germany did not really represent a period of peace, merely a change in the way certain battles were being fought, and why. The guns and gas of World War I gave way, in the tenuous coalitions of the Weimar Republic and the rise of National Socialism, to the social and cultural fights of the 1920s and 1930s, before sinking back into the guns and missiles of World War II. Worker photography represented one important weapon, wielded in a kind of civil war that raged in the period between the two militaristically expan-

sionist wars. It's important to emphasize that photography was, for most workers, not a tool for making art, but a means by which a self-identified class of people gave themselves a voice. (In spirit, these pictures might best be likened to those that would be produced in the late 1930s by such American artists as Dorothea Lange and Gordon Parks for the Farm Security Administration.) One clear indication of the resonant power of that hitherto unheard voice is the rapidity with which it spread beyond Germany: The exhibition includes a substantial section of related work produced in Switzerland, Holland, and Czechoslovakia.

To have an idea what that kind of empowerment could mean, today's equivalent might be the spread of video cameras—thanks once again to miniaturization and portability—from corporate television networks to the hands of artists and, finally, to ordinary citizens. The 1991 videotape showing the unspeakable beating of Rodney King finds its photographic ancestors in Hans Schiff's remarkable 1931 pictures of police surveillance of citizens on the streets of Cologne, taken from a high vantage point that makes their own surreptitiousness remarkably chilling.

Few of the photographers encountered in the show are familiar. The reason may be that their work was rarely credited in the worker publications of the day—a concession to group solidarity appropriate to the communist ideology many embraced—and because vintage prints of their photographs did not, in many cases, survive the Nazi era. The 122 pictures in the show include many that were recently printed (some expressly for this exhibition, which will travel to three venues nationally) from original negatives that had been stashed away and hidden for years. Whatever the case, these pictures of persecuted minorities, of blind and war-crippled beggars, of great masses of the unemployed, and of "honest labor" sanctified through allusions to Greek ideals of the human form, are not always above appeals to the sentimental and melodramatic. Kurt Beck's *Give Us This Day Our Daily Bread*, to cite one egregious example, is a ring of outstretched hands surrounding, like a care-worn crown of thorns, an empty bread tin.

At the other end of the spectrum are nineteen extraordinary photomontages by the great John Heartfield. The Berlin artist, who anglicized his name as a protest against German nationalism, is represented by pages published in issues of the *Arbeiter Illustrierte Zeitung* (Workers Illustrated News), or *AIZ*, for which he produced more than 200 works. His brilliantly inventive assaults against the darkening shadow of fascism brought together the social commitment of worker-photographers and the aesthetic experiments of the Modernist avant-garde. Indeed, the show's illumination of the long-obscured significance of worker photography to Heartfield's distinguished practice is the fundamental achievement of "Camera as Weapon." The curator's excellent essay in the catalog accompanying the show touches every necessary

Last Chance for Eden

artistic base and gives a good accounting of events. While the small, pamphletlike book is certainly appropriate to its subject, a full, copiously illustrated study is plainly warranted, now that worker photography is back from obscurity.

mexico: splendors of thirty centuries

october 4, 1991 "Mexico: Splendors of Thirty Centuries" is not the same exhibition that had its debut a year ago at New York's Metropolitan Museum of Art. It's both more and less than that. In its inexorable march across the continent, which included an interim visit to San Antonio, this staggering assembly of some 400 carvings, paintings, and examples of the decorative arts created outsize anticipation for its glories and wariness about its politics. The show lives up to its publicity, but in unexpected ways.

Anonymous
*Sor Ana María de San
Francisco y Neve*
ca. 1750

Artistically, its pre-Columbian material is predictably marvelous, its modern work generally dismal. Perhaps the greatest achievement of the show, opening Sunday at the Los Angeles County Museum of Art, has been the new prominence afforded to the art produced in the interim. A bright light has been shined into a hitherto dark hole. Reference to Mexican art typically conjures images either pre-Columbian or Modern, from powerfully blunt ritual carvings at ancient Olmec temples to the panoramic Modern murals by *los tres grandes*—José Clemente Orozco, Diego Rivera, and David Alfaro Siqueiros. Now, these are likely to be joined by Colonial images—art executed during the 300 years after Cortés' brutal destruction of the great Mexica (or Aztec) civilization and before the upheavals of the nineteenth century that led to

the modern revolution.

At one end of this new spectrum stands a spectral, shockingly Minimalist full-length portrait of a young novitiate (circa 1750), which seems conjured from 100 subtly different shades of white. An unidentified artist miraculously conveys the Catholic mystery of devotional marriage to Christ, as well as the nerve-wracking human capacity for such heady renunciation of the flesh. He deftly places the girl's finger into the closed pages of a prayer book, which she holds at her bosom as if in effigy of the stigmata.

At the other end is the lush and aggressive Baroque spectacle of a late-seventeenth-century altarpiece. Its heavy encrustation of gold-leaf carving frames melodramatic paintings of the Seven Sorrows of the Virgin. The ensemble, here flanked by polychromed carvings of archangels from another cathedral, at least begins to suggest the near-hallucinatory heights religious artifacts could reach in such (immovable) spectacles as the Jesuit seminary at Tepotzotlán, just outside Mexico City.

In between these extremes of modesty and lavishness, the intricate threads of foreign influence on indigenous style are demonstrated by a display of decorative and secular arts. Thanks to the robust trade lines of the Manila Galleon, which linked Spain's colony in the Philippines with its colony in the Americas, those styles trace roots to Asia as well as Europe. Most exquisitely in pottery, but in needlework as well, Chinese motifs are everywhere apparent.

The greatest loss in the exhibition comes at what should be—and was, in the New York debut—a tour de force. The moment of transition between the pre-Columbian grandeur of various Indian civilizations and the vicious colonization launched by an entrepreneur from Spain is appropriately blunt, even startling. Step across the threshold from a gallery devoted to exquisite artifacts from Tenochtitlán, imperial capital of the Mexicas, into one that heralds the arrival of Catholicism and the conquest, and the swift eradication of an entire civilization by a tiny band of Spaniards is viscerally felt. What is not clearly seen, however, is the remarkable absorption of great Indian traditions into Spanish ones. Some pivotal works have been deleted from the tour. Absent is a small and extraordinary mosaic of feathers fashioned as *The Mass of St. Gregory* (1539), thus exploiting an Indian technique to render a Catholic miracle. A monumental stone cross, carved in an echo of pre-Columbian style to evoke the crucifixion, is present but apparently couldn't fit through museum doors; it stands outside in the courtyard. Some objects do survive in the gallery to tell the tale, including a great silver-gilt chalice with feather-mosaic insets (it's from LACMA's own collection). But gone are two large, rare, sixteenth-century manuscripts and a life-size image of the Virgin of Guadalupe, made from inlaid mother-of-pearl in the late 1600s.

The absences dull this critical episode. Colonialism's

power is simply more intelligible when one confronts a cult image of the Virgin of Guadalupe knowing the cult was born in 1531 of a vision on the hill of Tepeyac, a pre-Hispanic shrine sacred to a mother-goddess (Tonantzin). The absorption of Indian faith into Spanish myth is crucial to understanding the nature—and the power—of the Colonial aesthetic. The exhibition names the three centuries following the conquest the "Viceregal period," after the ruling viceroys appointed by Spain. Usefully, the term identifies the courtly nature of the art, but it also betrays a certain nervousness. It replaces what everyone else calls "Colonial"—and colonialism is a highly charged subject today.

Nowhere is the triumph of colonialism clearer than in a darkly sumptuous, ten-panel folding screen attributed to Juan Correa (circa 1645–1716). One side depicts the first meeting of Cortés and Moctezuma, the other shows personifications of the four continents into which Spain had expanded its authority. Correa has dressed the Aztec ruler as a Roman emperor. The implication of Spanish conquest as heir to the ancient Roman empire makes Moctezuma's imminent fall sweepingly "heroic." Meanwhile, on the reverse, the sumptuous lords and ladies of America, Asia, and Africa are all given the physical features of Europeans, the benchmark being portraits of Spain's King Charles II and his French wife Marie-Louise d'Orléans. You won't find analysis of these unmistakable evocations of colonial power in the entries of the show's otherwise useful catalog. (The book, like the show, is immense, its 712 pages weighing in at 7½ pounds.) They're less likely to interpret meaning than to airily extol "the splendor of the Baroque." This reticence has fueled the noisy charges of political manipulation that have followed "Mexico: Splendors of Thirty Centuries" on its tour. And, in fact, not since the legendary "Treasures of Tutankhamun" traveled the nation in the 1970s, in order to prepare the citizenry for a fundamental shift in hitherto strained U.S. relations with Egypt, has an art exhibition had so deep and far-reaching a political ramification as this one. It's too much to claim that "Splendors" has a hard agenda that can be tied to a particular government administration, past or present, in Mexico or the United States. But, as surely as art of the "Viceregal" period represents prevailing political sentiments of its time, so complex currents in our own are inevitably embodied in this officially sanctioned show.

The significance afforded to a public and environmentally scaled art—from pre-Columbian temple sites to Baroque extravaganzas to the Modern mural movement—is one central thread of 3,000 years of Mexican culture. Indeed, the artistic lowpoint of the show occurs in the tumultuous nineteenth century with the arrival of autonomous easel painting. Any exhibition of singular objects—paintings, sculptures, artifacts—is thus unavoidably fragmentary and false. You can't send a pyramid or cathedral on the road. But "Splendors" makes every effort to remind the viewer of the art's public context through gallery

photomurals and catalog illustrations—every effort, that is, except in the case of the twentieth-century muralists. Necessarily represented in the show by easel paintings, which are rarely their great works, *los tres grandes* are afforded neither photomurals nor significant catalog illustrations to illuminate the public commitments upon which their principal importance rests. So, the blockbuster ends with a whimper. Represented by easel painting, individualism and private action are held aloft on a grand foundation, built by the collective achievements of pre-Columbian and "Viceregal" forebears. This wishful thinking sharply recasts Mexico's artistic history.

In fact, truly modern individualism is embodied in Mexican folk customs of the nineteenth and twentieth centuries. But *arte popular* is here downplayed. Rooms full of minor canvases by hack academics and pale regionalists threaten to swamp the small pictures by Hermenegildo Bustos—notably, a self-taught amateur clearly under the spell of the newly invented camera, and the one great painter of Mexico's nineteenth century. And the perfunctory inclusion of just four small ex votos—public offerings painted on tin, in heartfelt gratitude for divine intervention in temporal suffering—obscures a fundamental source of Frida Kahlo's important Modern images. It's doubtful that organizers would have filled the pre-Columbian galleries with second- and third-rate work, the way they have the nineteenth- and twentieth-century rooms, if greater art was available. But if you're looking only for art supported by an aristocracy, and the aristocracy largely adored mediocrity, that is what you get.

"Mexico: Splendors of Thirty Centuries" is an amazing, abundant array, which will not likely come our way again anytime soon. For that reason it should be seen by anyone who cares about art and about Mexican culture. For that same reason, it should also be seen with a careful eye.

101 Years of California Photography

March 3, 1992 Among accidents of history, the relatively proximate births of photography (1839) and of the state of California (1850) may not be cataclysmic, but it is curious. It means you could probably tell a major chunk of the story of photography simply by drawing on the pictures made by photographers who lived or did considerable work in the state.

In essence, that is precisely what has been done in the engaging show and catalog called "Watkins to Weston: 101 Years of California Photography, 1849–1950." On view at the Santa Barbara Museum of Art, where it opened Saturday, "Watkins to Weston" brings together the work of sixty-five photographers in three distinct, if not

entirely separate, eras that will be familiar to anyone who has followed the general history of black-and-white camera work. First are the "pioneers," who explored the new medium while they simultaneously explored the new California territory in the wake of the nineteenth-century gold rush. Next came the Pictorialists, intent on endowing mechanically made images with the status of art. Last came the Modernists, who simply accepted the camera as an artistic tool and sought to exploit its unique properties as a mode of purely modern vision.

Carleton E. Watkins
*Dam and Lake, Nevada
County, Near View*
ca. 1871

Each of the show's three sections has been organized by a different guest curator—Thomas Weston Fels, Therese Heyman, and David Travis, respectively—while the whole was overseen by Santa Barbara Museum curator Karen Sinsheimer. The drawback to this procedure is a somewhat disjointed presentation, and a show and catalog that have perhaps too many disparate things on their collective mind. Its virtue is the decided expertise brought to bear in each area. The show is characterized by a host of superlative images—some familiar, some not—and the catalog offers numerous insights.

One of the chief early pleasures of the show is a remarkable thirteen-panel panorama of San Francisco, made in 1877 by Eadweard Muybridge and bound into a large book. Famous for his multiple photographic studies of figures in motion, examples of which are also on view, Muybridge here turned his camera to the task of making a sequential vista of the booming city. Pencil notations on the panorama, which is inscribed by the artist to Mrs. Leland Stanford, indicate that it was taken from the top of Mark Hopkins's nearby home. A sense of power and authority is conveyed by the dramatic sweep of the long, horizontal image, which encompasses all that the eye can see: mansions, row houses, excavation pits, churches, construction sites, shops, schooners in the bay, the far-off hills, the canopy of sky. (There is, of course, no Golden Gate Bridge.) Like a Chinese scroll that records an imperial voyage, this panorama marks a kind of royal voyage of the eye, which sees from a privileged vantage point.

Common among the early landscape pictures is the rep-

resentation of nature as a grandly idealized world of order and harmony. In Muybridge's picture of the Yosemite Valley, a lone pine in the distance functions as a kind of visual spindle, around which a perfect cylinder of space has been carefully orchestrated from trees, cliffs, and stream. Muybridge has a certain prominence in this early section, but nowhere is the classical construction of landscape imagery more brilliantly executed than in Carleton E. Watkins's photograph of a log dam built to create a shimmering lake in the wilderness. The power of nature and the authority of culture balance on point in this extraordinary image, which manages to make a monumental incursion into the raw frontier feel like the construction of the Parthenon. Surely it ranks among the greatest pictures made in the nineteenth century.

The Pictorialist section of the exhibition is diverse, as befits its representation of a growing emphasis on individualization of expression. For many of these artists, including Edward Sherriff Curtis, Anne W. Brigman, and the young Edward Weston, the use in their pictures of emphatic artifice or elements of abstract design was meant to counter dismissive claims that photography was merely a mechanical transcription of the world. Pictorialism often made conscious appeals to visual traditions familiar from the history of painting and the graphic arts—a kind of "guilt by association" approach to confirming the medium's artistic status. Among them, perhaps none is more disconcerting than that exploited by members of Southern California's numerous Japanese-American camera clubs. In pictures from the mid-1920s, Shigemi Uyeda's flat, decoratively patterned puddles of water floating on an oil ditch and Kentaro Nakamura's diagonally curling wave seem remarkably abstract and crisply modern, especially when compared to the fuzzy, softly focused pictures of so many of their contemporaries. That Uyeda and Nakamura were drawing on traditions of Japanese painting, rather than of Western art, explains the odd and singular appeal of their exquisite work.

The show's Modernist section contains many images that have come to be regarded as classics of California photography—pictures by Ansel Adams, Willard Van Dyke, John Guttman, Dorothea Lange, Man Ray, Margrethe Mather, Edmund Teske, Minor White, Max Yavno, Imogen Cunningham, and more. While their pictures were made for a variety of purposes, ranging from the personal to the commercial, the show only makes a casual nod to the new advertising work that, in a different way, was so important to the period. The inclusion of three Hollywood glamour photographs—Greta Garbo by Clarence Bull, Ann Southern by George Hurrell, and Orson Welles and Rita Hayworth by Robert Coburn—is certainly appropriate. Yet, it makes me wonder about other absences. Why no examples of the voluminous, Chamber of Commerce-style photographs designed to sell an image of Los Angeles to the rest of America, much the way Hollywood glamour photographs sold movie stars?

Perhaps that's too Postmodern a view for a show that stops in 1950. The first section (1849–90) assembles photographs that see nature as raw material to be shaped and molded into an ideal vista. The second section (1890–1925) recognizes the process of idealization as art and seeks to mimic with the tools of photography the techniques of painting—to recall its look, themes, and subjects, and to probe psychological spaces. And the third section (1925–50) finally turns away from painting to idealize the camera itself as a purely modern maker of dreams, aspirations, and images.

The show's organizers don't say why they chose to stop in 1950, although historical excursions do typically tend to get muddier the closer they get to the present day. Still, a coda that took a skeptical look at camera images from a contemporary vantage point might have been a nice ending for the show (which is admirable regardless). Imagine, for example, Muybridge's remarkable panorama of San Francisco paired with Edward Ruscha's great *Every Building on the Sunset Strip*, a foldout panorama of Los Angeles made almost exactly a century later. It's unlikely Ruscha knew of Muybridge's precedent. But the thread of idealization that marks the first century of California camera work would have been definitively shown to have snapped. That's another chunk of the story of photography that can be told through images made in California.

The Brave New NEA

May 31, 1992 The National Endowment for the Arts is teetering at the brink of the abyss, thanks to the recent decision of its new acting chairman to overturn grants for two mainstream exhibitions duly recommended by a selection panel of professional peers and by the advisory National Council on the Arts. In unprecedented protest, two sitting panels walked out, and other grant recipients returned money. Citing the climate of repression, composer Stephen Sondheim and novelist Wallace Stegner refused the National Medal of Arts.

Few were surprised by the acting chairman's unilateral action. Angry, yes; surprised, no. For that is why the White House had maneuvered Anne-Imelda Radice into the agency's top spot. In fact, more such reversals can be expected. In the Bush administration, Radice is the NEA's Clarence Thomas. The analogy is not frivolous. One goal of the Reagan Administration had been to weaken job discrimination protections. In 1982, the President plucked Thomas from the vast Washington bureaucracy to head the pivotal Equal Employment Opportunity Commission. Thomas, then a thirty-three-year-old assistant secretary of education, could claim no stellar qualifications for so important a civil rights post. Instead, three significant attributes stood

out: First, he was a conservative Republican. Second, he was an insider in the Washington maze. And finally, he was an African-American.

Ronald Reagan had just been battered by a failed confirmation process for Detroit businessman William Bell, his first nominee to head EEOC. With no documented record of civil rights activity and scant administrative experience, the choice was lambasted as an "embarrassment" by civil rights groups. Bell was dropped, and Reagan tried again. Thomas prevailed. Despite sharp criticism from the civil rights establishment over his views on affirmative action, charges of gross inexperience, which had toppled Bell, did not apply. What did apply was the same largely unspoken qualification he shared with Bell. As a conservative Republican who was black, Thomas would provide a degree of invulnerability to any charge of racism that might attend the Administration agenda he would be asked to fulfill. His own "equal employment opportunity" would stand as a symbolic shield for the President. A decade later, with affirmative action in disarray and Thomas installed on the Supreme Court, the romping success of the strategy is plain. So, here it comes again at the beleaguered NEA.

John E. Frohnmayer, President Bush's first appointment to the agency's chair, was forced out in February after NEA policies for unfettered support of the arts emerged as a presidential election issue. The White House had nudged Frohnmayer toward resigning last fall. Push came to shove with the strong showing in the New Hampshire primary of far-right challenger—and rabid NEA foe—Patrick J. Buchanan.

Insuring the line of NEA succession, the White House last year installed Radice at the agency. Campaign politics accelerated her advancement. On March 1, she was promoted to senior deputy; on May 1, to acting chairman. A former functionary in the office of the architect of the U.S. Capitol and founding director of the National Museum of Women in the Arts, which opened to critical catcalls in 1987, Radice is not qualified for what amounts to the most important arts post in the federal government. Instead, three significant attributes stand out: First, she is a conservative Republican. Second, she is an insider in the Washington maze. And, finally, she is an open lesbian. As with Thomas at the EEOC, these "qualifications" explain a lot about the goings-on at the embattled agency.

The far-right attack on the NEA has targeted art that addresses feminist and gay subject matter: Robert Mapplethorpe's posthumous retrospective "The Perfect Moment"; the so-called NEA 4 (performance artists Karen Finley, John Fleck, Holly Hughes, and Tim Miller); a show about AIDS at New York's Artists Space; *Tongues Untied*, a film about black gays; a display of the AIDS Quilt; the literary anthology *Queer City*; and more. The focus of the purge is plain.

Bush's dilemma in the NEA crisis has been how to accommodate the far right, whose ballots he will need next fall, without

totally alienating the large, often influential arts constituency, who recognize the NEA's fundamental importance. Like Solomon with the disputed infant, one answer now shaping up is to cut the arts in two: Save NEA support for big arts institutions—major museums, symphonies, and theaters that inevitably tend toward cautious programming—and sever NEA support in the more unpredictable areas of independent artists, university programs, and artist-run spaces, where most of the alleged "trouble" has been.

Bush, however, also needs to establish a "kinder, gentler" distance from extremists, whose malicious attacks derive from an antipathy toward homosexuals and women who challenge traditional roles. That's where Radice comes in. As a conservative Republican who is also a lesbian, she provides a degree of invulnerability to charges of homophobia and sexism during the NEA purge. Like Thomas before her, she stands as a symbolic shield for the President.

One glaring distinction does separate Reagan's appointment of Thomas from Bush's advancement of Radice. For good or ill, Reagan believed in the necessity of turning back the clock on job discrimination. There was never any doubt that Thomas was serving the President's conservative principles. By contrast, Bush has never shown even nominal interest in domestic arts policy. Radice may be unqualified, but as a willing White House hit man she is cynically destroying the NEA's exemplary record of democratic decision-making, all for the benefit of the President's reelection campaign. Except for Washington's Golden Rule of self-preservation, principle has nothing to do with it.

The NAMES Project AIDS Memorial Quilt

October 4, 1992 They're bringing the Quilt back to Washington. Again. When the NAMES Project AIDS Memorial Quilt was first laid out on the Capitol Mall in October 1987 during the mammoth National March for Lesbian and Gay Rights, its 1,920 panels covered a space larger than two football fields. Conceived two years before in San Francisco by activist Cleve Jones, who wanted a way to publicly eulogize a friend, the quilt had grown with dizzying speed. Friends, relatives, loved ones, spouses, and the euphemistic "longtime companions" of men and women who had succumbed to AIDS rallied around the idea. Because in the United States gay men had been hardest hit by the epidemic, the project offered a means for replacing with love the cruel stigma that surrounded the disease. In each hand-stitched panel the wicked image of a demon had been wiped away by the singular face of a human being. Out there on the Capitol Mall, the quilt bore silent, shocking witness to the thousands of lives lost and to the exponentially greater number of lives touched by the epidemic.

One year later, the quilt returned to Washington. This time 8,288 panels filled the Ellipse across the street from the White House. The symbolism of its placement was inescapable. Barely one month before the presidential election, its tragic, dignified presence quietly but firmly asked an awful question, 8,288 times over: Why, in all the years of the Reagan–Bush Administration, had the nation's two highest elected officials not only failed to take the lead in combating a national health emergency, but actually participated in erecting roadblocks to the fight?

The following October, the quilt was spread out on the Ellipse yet again. Now, it had grown to more than 10,000 panels, filling the lawn with mourners. Early in his term, President Bush had done something his predecessor never had during all eight years of his, by delivering a speech that addressed the subject of AIDS. But those fulsome words hung stale and brittle in the autumn air just beyond the President's backyard, because determined White House action had not followed the oratory. The quilt, covering the ground like a funeral shroud, said: We are growing in number, and we will not go away.

NAMES Project AIDS Memorial Quilt Washington, D.C. 1988

And now the quilt is back. At ten o'clock Friday morning, the unfolding ceremony will begin. While the names of dead men, women, and children are read aloud from a podium, the quilt's individually sewn, 6-by-3-foot panels will be joined edge-to-edge on the grass. This time they won't be laid out on the Ellipse, because that sizable plot of sod has become far too small to contain it. With more than 21,000 handmade panels, the quilt today is more than ten times the size it was during its first display in Washington five years ago. (Even at that, it represents fewer than one in every seven AIDS deaths in the United States.) So at the start of the Columbus Day weekend, and continuing through Sunday afternoon, it will spread out from the base of the soaring Washington Monument, filling the gently rolling lawn of Presidents Park all the way down to the stately Lincoln Memorial.

The symbolism of this year's display is as sharp as ever—even sharper, given current circumstance. This weekend marks the Columbus quincentenary. Another presidential election looms. The cur-

rent occupant of the White House is fresh from a Republican convention at which hate was a rallying cry, cultural civil war an organizing theme, and bigotry a platform plank. What more dramatic contrast to those malicious ideals could possibly be imagined than a monumental work of art, conceived in love, created with inclusive generosity, and offered up in dignity? In this political season of mean-spirited rhetoric and hollow posturing, the quilt stands as a model of American citizens' resilience and of their refusal to be silent and docile in the face of government inadequacy. Spontaneously generated, this simple yet simply grand expanse of decorated cloth is an extraordinary work of American folk art—certainly the greatest of our century, and perhaps of all our national patrimony. The quilt has called upon a deeply revered, nearly vanished tradition and stunningly revived it for modern life.

Births, marriages, harvests, anniversaries—in American quilts of the preindustrial era, milestones of a hard and difficult existence were stitched into the daily fabric of a family's life. Quilts assumed the status of tangible memory when passed down between generations, recording family history. And when the situation demanded, they wrapped the corpses of the dead, blankets for a final resting place. A quilt was sometimes made communally and sometimes in solitude. Cleve Jones made the first of the NAMES quilts by himself, but in an inspired gesture he soon turned the project into a national quilting bee. (Jones, appropriately enough, was raised a Quaker.) Either way, for eighteenth- and nineteenth-century Americans, a quilt was a priceless gift when given by one person to another. Now, for twentieth-century Americans, the NAMES quilt is among the most precious gifts we have given to ourselves in our often callous and brutal postindustrial world.

There are lots of famous names registered in its threads: entertainers Peter Allen and Liberace; director-choreographer Michael Bennett; attorney Roy Cohn; fashion designers Perry Ellis, Halston, and Willi Smith; comedian Wayland Flowers; philosopher Michel Foucault; artists Keith Haring and Robert Mapplethorpe; actors Rock Hudson and Charles Ludlum; U.S. Rep. Stewart B. McKinney; ABC News anchor Max Robinson; writer Vito Russo; Washington Redskin Jerry Smith; Olympic athlete Dr. Tom Waddell; AIDS activist Ryan White; B-52's guitarist Ricky Wilson; and more.

Still, one source of the quilt's artistic power is its overwhelming anonymity. When you walk the paths between the rows of panels, there is certainly an inevitable shock of recognition when you come upon the name of someone you know, either personally or from the public realm. But who are the tens of thousands of faceless people who made this astonishing, ever-growing tribute? Who are all the utterly unknowable strangers so lovingly commemorated before you? The NAMES Project Foundation in San Francisco has produced an affecting book titled *The Quilt: Stories From the NAMES Project*, which answers some

of those questions, as does the eloquent documentary movie *Common Threads: Stories from the Quilt*, which won an Academy Award in 1990. It's the nature of popular art to want to portray the private person behind the public face, and both the documentary book and film are moving in that way. But the quilt itself is different. In the very tension between the anonymity of its subject matter and its intensely personalized form, the achingly mysterious beauty of mortal flesh is vivified.

Operating on the powerful plane of symbol, this masterpiece of American folk art has entered the public consciousness in a way few more formal works of public art ever do. Monuments are vessels created to hold individual memory, while public monuments are meant to hold communal ones. The NAMES quilt has erected a graceful bridge between the two, linking private grief with public mourning. This is of special significance, given the nature of the disease that claimed the lives it means to commemorate. From the start AIDS was hidden away in the shadows because of legitimate fear of ignorant reprisals from the hysterical or the hateful. But the quilt is a memorial, and in a manner quite unlike any other it has nudged to the foreground one crucial if often disregarded function of any monument: It is meant to be experienced socially, in the communal presence of others, so that it might articulate and make visible the human ties that bind us. It's remarkable to be in the presence of the quilt, and to be in the presence of innumerable others who have come to see it. For one brief, incandescent moment, we are released from the terrible prison of our modern privacy.

This week, in the grassy field of Presidents Park, the quilt will take its proper place among the venerable "official" monuments of Washington. As thousands of volunteers and hundreds of thousands of expected visitors gather to partake of the awful rite once more, one thing is clearer than ever: The NAMES Project AIDS Memorial Quilt is moving and authentic evidence of the enduring power of traditional, American, family values. For if it isn't, those incantatory words have no meaning—except to belie the ugly emptiness of our national soul.

Inventing Still Life

November 25, 1992 Where did still-life painting come from? As an independent genre, the depiction of fruits and flowers, tableware, books, and musical instruments was a relatively late arrival to the family of subjects in Western painting. The odd example can be cited as far back as classical antiquity, but not until the seventeenth century (and then principally in Holland) did still life move from the modest role of supporting player into the dramatic foreground. A remarkable new show at the J. Paul Getty Museum in Malibu goes a very long way toward answering that vexing puzzlement. And it does so in ways that

are keenly insightful, frequently beautiful in their examples, and not a little astounding in their guiding premise.

Symbolic depictions of still-life objects—a white lily in a transparent glass vase, for example, discretely placed at the feet of the Virgin Mary—have been around for centuries. They occupied important if peripheral positions in countless works of medieval and early Renaissance art. Yet, paintings that focus all visual care and central attention on a tomato or a floral bouquet menaced by a caterpillar or an unusually prickly gourd were a very long time in coming. When they came, however, they came with a vengeance. As no doubt befitted the booming mercantile culture of seventeenth-century Holland, a kind of "bureaucratization" of still-life painting rapidly evolved. Painters soon specialized in certain motifs, highly refining their techniques, the better to capture fiercely competitive market share: Pieter Claesz and Willem Heda rendered radiant breakfast pieces; painters in Leyden (a university town) specialized in displays of books and manuscripts; Abraham van Beyeren regularly laid out lavish banquet tables; Willem Kalf went after wealthy (rather than bourgeois) clientele with sumptuous images incorporating exotic utensils in gold, silver, and porcelain. And perhaps most popular of all, flower pieces—from Ambrosius Bosschaert the Elder's abundant vases early on, to countless examples in the next century—were the *sine qua non* of the still-life genre. A visit to the L.A. County Museum of Art's current exhibition "A Mirror of Nature: Dutch Paintings From the Collection of Mr. and Mrs. Edward William Carter" gives magnificent evidence of the range and technical bravura that soon marked the new genre.

The sheer quantity and broad public popularity of seventeenth-century still-life painting—and of its plentiful offspring in the several centuries since—has always made the question of its origins an interesting one. Typically, explanations of its emergence have zeroed in on the dramatic reorganizations of social life that accompanied the new genre's arrival. The answers have been varied and apt: the rise of Protestantism, with the attendant decline of religious subject matter; the emergence of a merchant class, which sought to see its own pursuits of pleasure reflected in art; a new scientific interest in precise classification of nature, which challenged artists to refine their visual skills; and more.

Yet, something always seemed to be missing from the tale. The leap of still life from obscurity into prominence was rather sudden, almost as if it had been born, like Athena, full-grown from the head of Zeus. An intermediary step (or steps) appeared to have vanished. Amid the plethora of social explanations, where was the visual evidence of the process of movement away from the periphery into the center of the artistic field?

The Getty show reveals one major but previously missing stride, and it does so by shining a bright light into a surprising and hitherto dark corner: manuscript illumination. When you think

Inventing Still Life

of this genre you immediately think of the Middle Ages, not the Renaissance and beyond, when handwritten, hand-painted decoration of liturgical books was finally usurped by the revolution of the printing press. In post-Gutenberg Europe, illuminated manuscripts were rather like an appendix in the body of art: identifiable, yes, but with no apparently pressing function. Or, so it seemed. The Getty exhibition proposes otherwise in a small but utterly absorbing presentation that gathers together a variety of objects from the fifteenth, sixteenth, and seventeenth centuries. There are seven illuminated manuscripts, five drawings, thirteen printed books, and two paintings.

The centerpiece is a showy, astonishingly beautiful, and, as it turns out, critically important manuscript—the *Mira calligraphiae monumenta*, or *Model Book of Calligraphy*—whose sumptuously written text was penned by the extraordinary calligrapher Georg Bocskay in 1561–62, and whose exquisite and often clever illuminations were painted thirty years later by the last great Flemish manuscript painter, Joris Hoefnagel. This is Hoefnagel's show. "Art and Science: Joris Hoefnagel and the Representation of Nature in the Renaissance" is the first exhibition anywhere devoted to his art, and it coincides with the Getty's recent issuance of a lovely facsimile edition of the manuscript. Featuring perceptive and clearly written texts by Hoefnagel scholars Lee Hendrix and Thea Vignau-Wilberg, and an introduction by Getty curator of manuscripts Thomas Kren, it is an auspicious debut for the museum's facsimile program. With 170 excellent color plates reproducing every page at actual scale, it's also a bargain—in spite of a seemingly hefty price of $125.

This late sixteenth-century model book is a kind of electrified battleground, a highly charged site for a heady display of aesthetic one-upsmanship. Bocskay had been invited to write the calligraphy by Holy Roman Emperor Ferdinand 1, and he used the occasion to pull out all the stops. Meant to be looked at rather than actually read, the text is written in a wide variety of elaborate styles, frequently enlivened by mind-boggling interlaces, elegant flourishes, and embellishments of gold and silver. Sometime he wrote his text in mirror-writing or in microscopic size, which couldn't be read at all, except with lenses and at great effort.

As a model book, the extravagantly handwritten manuscript was meant to be an authoritative source. Hovering in the background of Bocskay's extraordinary achievement was the threat—and the liberation—presented by the mechanical printing press. As Hendrix's essay declares, before the advent of the printing press handwritten books were concerned with the preservation of texts; after, printed books were about a text's dissemination. An obvious tension vibrates between these different forms with differing purposes.

Bocskay's sovereign exercise, created for the pleasure of the emperor in a world being newly engulfed by the force of the printed word, insisted Ferdinand 1 was keeper of the dazzling "model," from

which all textual authority would flow. Thirty years later, long after Bocskay's death, Ferdinand's grandson Emperor Rudolf 11 gave the manuscript to Hoefnagel to decorate. Why Bocskay had left ample blank spaces on many of the written pages nobody knows for sure (he may have intended the text to be illuminated in some way), but Hoefnagel plainly saw an opening—and he ran with it. Entrusted with these astonishing folios, Hoefnagel set about painting exquisitely detailed pictures of fruits, flowers, vegetables, insects, and, once in a while, a small animal, all in a manner that would draw the eye and mind away from the grandeur of the calligraphy, subverting its authority. Hoefnagel wanted to assert the primacy of the purely visual, and he chose natural elements as the vehicle.

Illuminated by Joris Hoefnagel; scribe Georg Bocskay
Mira calligraphiae monumenta (Model Book of Calligraphy)
completed in 1596

In the exhibition, six illuminations from fifteenth- and early sixteenth-century handmade books show how plants and insects were commonly used as border decorations. At the same time, artists were beginning to isolate these very elements for scrutiny in their paintings. Albrecht Dürer's astonishing watercolor of a seemingly sentient *Stag Beetle* (1505) represents the apogee of this development: Probably drawn from a dead specimen, the brilliance of its illusionism is such that it looks as if the bug could leap off the page. Another watercolor—and an unanticipated bonus in the show—is German painter Martin Schongauer's luscious rendering of crimson peonies in assorted poses and states of blossom, which was executed around 1473 as a study for *Madonna of the Rose Garden*, his celebrated altarpiece in Colmar. This drawing is the earliest known life study in all of Northern European art and was acquired quietly, without fanfare, by the Getty a few months ago.

What Hoefnagel did in his elaborate illuminations for the model book was to move such marginal renderings of plants and insects out from the backgrounds of paintings and away from the sup-

porting borders of traditional manuscripts and onto pictorial center stage. There, through scale, color, precision, and even witty composition, they dominate the page.

When you look at Hoefnagel's daring illuminations of Bocskay's extraordinary book of calligraphy—paintings made on an existing work of art and which, page after page, never make a misstep— you begin to understand the immensity of the artist's conviction and achievement. He lavished them with the same focused scrutiny that characterized the watercolor studies made earlier by Schongauer and Dürer. And not long after this extraordinary conceptual shift was completed, still-life painting began to come into its own as an independent entity. It would be too much to draw a straight line from, say, Schongauer and Dürer through the decorative borders of manuscripts to Hoefnagel, and then on to still-life painters like Ambrosius Bosschaert and to the printed scientific manuals that began to proliferate. History doesn't work in neat, linear ways, and the Getty show does not imply as much. Instead, it has gathered together a kind of ambient cloud of cultural and artistic forces, in which Hoefnagel's manuscript illuminations, made for perhaps the most important patron of the day, act like a lightning bolt announcing a thunderclap, which is followed by an abundant shower.

The vietnam women's memorial

October 17, 1993 Located on a gently rolling stretch of the National Mall in Washington, D.C., an imperial city filled with extraordinary sights, the Vietnam Veterans Memorial is as essential a place to visit as the Washington Monument or the Lincoln Memorial, between which it gracefully unfolds. Few Americans would dispute that today, eleven years after it was erected, this gravely beautiful work of art ranks as the single greatest monument to have been designed in our time. Its two walls of black, highly polished granite reach out into the earth in a wide V-shape, some 450 feet long, creating a sense of gentle enclosure for private contemplation within a communal public space. A deeply personal sense of connectedness is evidenced by the common sight of a note folded and tucked into its crevices, flowers laid at its base, a photograph propped against its granite face. With its chiseled list of the names of American servicemen and servicewomen who died in Vietnam, the walls are intimately known to countless people.

Sadly, however, this exalted monument is undergoing significant erosion. Despite the special place the Vietnam Memorial occupies in the hearts of almost all who have visited the site, and despite its grand significance in the annals of modern design, the meaning of the memorial is quietly being altered. Originally, the monument's design respectfully directed your thoughts to the complex nature of mil-

itary sacrifice, marked by the awesome mix of excruciating pain and humble pride. It took no position on the appropriateness of the war, because Vietnam endures as the most divisive international conflict in the nation's history. Some vigorous supporters of the war, however, have never been satisfied with such a monument. They've always believed it should send a specific message. Specifically, they want the memorial to declare from the heart of official Washington that the Vietnam war was a good and noble cause.

Efforts to accomplish this goal began even before the wall was built—before the moving power of its deceptively simple design had been experienced, before it was embraced by the American people as a place like no other. Certain small "additions" were proposed almost from the moment the design was unveiled in 1981, additions that eventually came to be incorporated into the plan. On November 11—Veterans Day—another, even newer modification of the great design will be dedicated. This one elaborates on the central feature of the earlier alteration.

Like the first big change, the second calls for the addition of a bronze statue to the site. Joining a 1984 sculpture of three battle-weary soldiers dressed in fatigues, which was fashioned by Washington-based sculptor Frederick Hart, a bronze depiction commemorating American servicewomen will soon be erected nearby, down a leafy path about 150 feet from the wall. This figural grouping, sculpted by Santa Fe-based artist Glenna Goodacre, has as its centerpiece a female nurse caring for a wounded male soldier; behind them, a second woman anxiously searches the sky, perhaps for a medical evacuation helicopter, while a third woman pensively kneels at the back. This monument to women's heroism was conceived in direct response to the addition of Hart's earlier statue. Some 11,000 American women served in Vietnam, yet Hart's heroic image depicted only men. Women's numbers were small compared to male combatants, but they nonetheless served selflessly (none were drafted) and often with valor, mostly in the health professions. Many female veterans were rightly angered by their exclusion and invisibility. Thus was born the privately funded Vietnam Women's Memorial Project, which commissioned its own statue to remedy the perceived mistake. Years were spent navigating the course of congressional approval. So was $4 million.

Ironically, Goodacre's design, commissioned to right a wrong, turned out to share something fundamental with Hart's. Both are works of monumental kitsch, fashioned by artists of meager talents. And both do damage to the great memorial. His figures amount to big toy soldiers, effectively reducing the National Mall to a backyard playground where war games imagined by little boys are acted out on the grass. Three slightly larger-than-life bronze soldiers stand in a mildly aggressive wedge formation, proud, cautious, ever at the ready. The alert figures seem on guard for sudden shelling or sniper fire—

which, apparently, might erupt at any moment from behind the Lincoln Memorial. Hers will be equally absurd, based on a review of photographs of the sculpture, for it offers as moving insight a cornball recitation of a wheezy artistic cliché. The pretentious central figure of a nurse seated on a pile of sandbags, cradling in her arms a wounded male soldier lying horizontally across her lap, is very familiar in the annals of Western art. The composition is plainly meant to recall Renaissance depictions of the lamentation of the Virgin Mary over the dead body of Christ. Formally, Goodacre is no Michelangelo. But self-indulgent fantasies of artistic ego are only a minor problem here. The major worry is the saintly, even godlike ethos of the sculptural ensemble. With its transcendent iconography of human mortality and spiritual salvation, the statue casts a false light of sanctity over an inescapably conflicted event. The presumptuous image of a Vietnam Pietà is hardly representative of so discordant an episode in America's history. Doubts about the war are erased by its coarsely inappropriate visual overture, which conjures sentiments of "Onward, Christian Soldier."

Together with the earlier bronze, the statue subtly ascribes a new and official meaning to the war being commemorated—and it's a bleak and troubling change. The Vietnam Memorial is being framed by a distinct political posture of moral goodness, which was blessedly absent from the original design. Indeed, the absence of any posturing—pro or con—is a pivotal reason for the brilliant success of the existing memorial.

The extreme polarization of opinion over Vietnam pitted American against American. Everyone chose sides—to a recalcitrant degree unheard of in the United States since the Civil War. Just about the last thing a truly commemorative monument could endure was a political point of view that indulged one side over the other, either opposed to or in favor of American military involvement in Southeast Asia. The genius of the original monument was that it simply refused the divisive choice. Architect and sculptor Maya Lin was a student at Yale when her design was selected by an eight-member jury from among 1,420 submissions to an open competition. Her contemplative plan was simple, almost stark, focusing on a chronological listing, etched into the granite walls, of the names of 57,692 Americans (8 of them women) then thought to have died in Vietnam between July 1959 and May 1975. Regardless of one's political position on the war, the reality of the body-bag was the inescapable center of Vietnam. With graceful compassion, Lin's abstract design looked that reality in the eye. She carved out a secular but spiritual space for sober and loving reflection.

It wasn't that her proposal was apolitical. No work of art, least of all one commissioned for the state as an official commemoration in the nation's capital, can escape politics. But the peaceful, gently sheltering space she envisioned was a firmly voiced declaration

that an authentic memorial is sacred soil—which is to say, no place for grandstanding of any kind, whether heroic or recriminatory, extolling patriotic fervor or principled dissent. People might argue endlessly and passionately whether those who served in Vietnam were heroes or victims. But not here, not in this place, not before a list of names consecrated with human blood. This was a public place for private thoughts and individual reconciliation, regardless of one's political position for or against the war. The abstractness of the monument's design, and its mirrorlike surface which reflected your face in the rows of names, allowed every visitor to bring whatever political viewpoint they wished to their remembrance of the dead.

When Lin's design was chosen in May 1981, the war had been over for nearly six years. Deep wounds in the nation's psyche, as profound as any physically engendered by the conflict, remained painfully raw and exposed. A small but vocal chorus of detractors from her plan began to emerge. Within six months, their complaints had risen to a noisy din. For some fervent supporters of American military involvement in Vietnam, the simple absence from the monument of an assertive endorsement of the war's moral rightness was considered an affront. Perhaps conditioned by the habitually polarized sentiments that marked the war years, they could only perceive the absence as an antiwar statement. The absence was in fact no such thing, as even conservative columnist— and enthusiastic supporter of the war—James J. Kilpatrick understood and duly noted. He wrote several perceptive columns lavishing praise on Maya Lin's design.

Still, it was 1981. "Morning in America." Buoyed by the suddenly rising tide of the Reagan Revolution, some saw a chance to claim the memory of Vietnam in the name of a particular politics. An onrush of bizarre interpretations and ludicrous charges about the proposed memorial issued forth, all calculated to sink the plan. The V-shape of the granite wall was earnestly claimed to be a covert allusion to the splayed fingers flashed as a peace sign by antiwar protesters. Its black color, simply necessary to create a mirrorlike surface, was declared a symbol of shame. Cold Warriors rattled the usual sabers. Columnist Patrick J. Buchanan penned a zealous denunciation, in which he ominously charged that a member of the selection jury had long-standing ties to the American Communist Party. Tom Wolfe, the novelist and well-known hater of Modern art and design, wrote a lengthy rant in which he condemned the choice of a monument that was abstract, rather than figurative. Going abstract, Wolfe elaborately fumed, was "symbolic of a Red Guard-style cultural revolution." William F. Buckley's conservative journal, the *National Review*, vigorously objected to the plan. So did conservative Congressman Henry J. Hyde (R.-Ill.), who tried to abort the entire project. He described the design as "a political statement of shame and dishonor" in a letter circulated to Congress

and sent to President Reagan.

And then there was Ross Perot. The Dallas business-man, who had supported the war, had also been an early backer of a memorial to Vietnam veterans. He had given $160,000 to underwrite the competition to choose a design. But when Lin's winning plan was duly announced, he derisively described the granite wall as "a tomb-stone" and "an apology, not a memorial." Perot, an avid collector of sun-shiny, anecdotal paintings by the American illustrator Norman Rockwell, tried to get her project stopped. It has been alleged—and the *Washington Post* has reported considerable evidence—that he was behind the hiring of Roy Cohn, the infamous lawyer and former Red-baiting aide to the late Sen. Joseph McCarthy, who inexplicably began to harass the memorial committee. Fiscal irregularities were charged and an audit de-manded of the privately funded project. Perot has denied involvement in Cohn's activity. (In any case, a 1984 report by the General Accounting Office gave the Vietnam Veterans Memorial Fund a clean bill of health.) But this self-styled tribune of the people also commissioned one of his famous public opinion polls, in hopes of tapping populist ire. Of the 587 returned POWs who were asked, however, more than half did not respond; only one third replied that they didn't like Lin's design.

Unrecorded is whether any of those 178 dissenters sub-sequently changed their minds when the finished monument was un-veiled to broad acclaim—or, for that matter, whether Buchanan, Wolfe, Buckley, Hyde, or Perot did, either. By 1982, however, when it became clear to Perot and his allies that the plan would not be scrapped, dra-matic changes in Lin's design were sought. With the help of James Watt, Ronald Reagan's Secretary of the Interior, and Republican Senator John Warner of Virginia, Frederick Hart's bronze sculpture of alert soldiers was commissioned and added to the plan. So was a huge flag-pole, proposed for the vertex of the V, which would effectively transform the granite walls below into a pedestal for Old Glory. Billed as a heal-ing compromise, the scheme in fact completely trashed the original design. At the insistence of Washington's Fine Arts Commission, the flag-pole scheme was eventually altered. With the Hart sculpture, it was moved to an entry area half a football field away from the monument proper, where they stand today. There they retain an awkward, ancillary feel-ing. Who even remembers the lumpen sculpture with any emotional specificity, after encountering the gut-wrenching wall?

Still, the effect of the statue's presence within the memo-rial site should not be minimized—especially because it will soon be joined by Heroizing Statue No. 2. The way in which the "women's bronze" was meant to correct the error of the "men's bronze" shows how polit-ical posturing merely keeps the wound of Vietnam an open sore. Festering resentments might now erupt in the face of other perceived inequities. For example: Like Hart's hopelessly vulgar statue, Goodacre's casts its one

Last Chance for Eden

black soldier in the role of the faithful sidekick—a Tonto to the white Lone Ranger, who is the centerpiece of the heroic action. Given the disproportionate number of African-Americans who served in Vietnam— a war fought principally by soldiers drawn from among the poor and lower-middle classes—the stereotypical casting is repugnant.

Politically motivated works of art always invite arguments, and when arguments get stirred up in the vicinity of Vietnam, the lives of dead Americans become mere fodder to be fed to the cannons of your political viewpoint. Lin's design was remarkable because it actually set aside divisive quarrels over the nobility of the cause. The accumulating alterations in bronze, however, demand taking sides. In the process they are sealing an awful fate, which makes a mockery of the truth of Vietnam. For it doesn't matter on which side of the argument you stood—or stand. Slowly, ineluctably, the site is being transformed into a memorial to just another splendid war.

can L.A. Help Heal the Arts?

January 27, 1994 Today at noon, Club 100 of the Music Center and the Town Hall of Los Angeles will jointly host a distinguished panel of local politicians and arts administrators to discuss an oft-heard subject: Can the arts help to heal L.A.?

The panel was put together long before last week's earthquake. It's safe to say the immediate wound in need of healing is riot-related, while other urban ills, such as homelessness or gang violence, could easily be included. And, as is so often the case with such issue-oriented presentations, the question is actually rhetorical. Its answer has been decided well in advance, and the answer is "Yes." Club 100 president Genevieve McSweeney observes in the press release announcing today's event: "The Music Center, along with the other arts organizations in the city, is examining how the arts can be utilized to help solve some of the many problems facing our community." So today's panel of experts will be expected to tell us how, not whether, the arts can help to heal riot- and recession-torn L.A. That's too bad. Far more consequential would be a prominent public forum in which to vigorously dispute such entrenched claims, which conceive of art as a species of social therapy.

Our therapeutic culture, which has made an industry of ravenously diagnosing endless social illnesses and recommending innumerable cures, is now swallowing the arts whole. It's time to reconsider, not to reconfirm, because the notion of art healing civic sicknesses is finally rather like the idea of Miss America bringing world peace. It's a nice sentiment, and we've learned to expect to hear it touted. But, in the end, who can really believe it? I'm not talking here about the economic im-

pact the arts can have on a community, which is huge. I am talking about the impact art itself has on a community. Back-handedly, the distasteful imposition of a therapeutic ideal implies that art is not of much significance unless it can be put to demonstrable economic or social use.

Is the Sistine Chapel ceiling really most important because it's a boon to Italian tourism? Or because its presence in the Vatican brings diverse audiences together in one place? Is that what Michelangelo had in mind when he began to paint? From the therapeutic angle, the persuasive excitement of the Sistine Ceiling's beauty, which is the source of its artistic significance, doesn't count for much. Beauty and significance are qualities more subtly demanding and harder to codify than tourist receipts or the interaction of crowds. In fact, gnawing discomfort with the way that truly powerful art makes urgent demands on its audience might be exactly what causes some people to want to transform it into therapy. One hallmark of therapeutic culture is that it turns the tables: Rather than art making demands on an audience, now the audience gets to make demands on art. No wonder the art that results typically seems powerless and wan.

The therapeutic ideal for art is not new. Its local application to pressing civic problems updates an old riff: Remember all the grand claims once made for art as international diplomacy, claims born of the Cold War era? Then, the perceived crisis was a threat of nuclear war. Under cover of diplomacy, government agencies such as the U.S. Information Agency and entrepreneurial businessmen such as Armand Hammer put art at the service of their political and business aims.

Not much has changed. Art still rides in the back of the bus: Note that no member of today's distinguished panel at the Music Center is an artist. There will be two politicians (County Supervisor Yvonne Brathwaite Burke and City Councilman Joel Wachs), two civic bureaucrats (County Arts Commission president Eunice David and Cultural Affairs Department grants director Roelle Hsieh Louie), and three institutional administrators (CalArts president Steven D. Lavine, County Museum of Art curator Stephanie Barron, and Music Center president Shelton g. Stanfill). Among them are gifted, insightful, and articulate individuals. But, they are not artists.

The question "How can the arts help to heal Los Angeles?" is heard most often from institutional representatives because, when a city is in crisis, bureaucracies always hunker down for self-preservation. Surrounded by daunting social and economic problems, they funnel arts resources toward proposed social and economic solutions. Public and private programs get designed to urge artists to follow the institutional initiative. Alas, trying to get artists to follow institutional directives is precisely backward. Some artists do it—eagerly—knowing that's where the always scarce funding lies. But it's backward nonetheless.

Neither is its influence benign. A primary public focus

on managing art's impact just contributes to an erroneous perception that art, in its own right, is worthless. In fact, in this critical time it's the arts institutions that should be actively getting behind artists and what they do, not the other way around. Art's authentic power comes from the pleasure and excitement created in the beholder. Institutions can't cause that, only talented artists can. Yet therapeutic culture usurps the role of assigning art's power by claiming it for institutions. So rather than inquiring if the arts can help heal Los Angeles, today's panel might be better equipped to reverse the issue: Can Los Angeles, including its civic and private institutions, help to heal the arts? For the arts are suffering as they generally do in American life, from trivialization and neglect.

Getting an affirmative answer to that more apposite question would require clear-eyed conviction, because there's only one way our institutions can accomplish the task. It's not so mysterious: If arts agencies in L.A. would compose their programs in rigorous support of the diverse range of great art that first-rate artists already make, the troubled and fractured cultural life of Los Angeles would be on its way to healing quite nicely.

Two Murals, Two Histories

February 20, 1994 This is a story of two murals. Although it unfolds in Los Angeles, self-styled capital of modern mural painting in the United States, it is a pivotal story that has remained mostly hidden for more than half a century. One part of the tale was dramatically revealed last October, when the newly refurbished Central Library opened its doors to the public after more than six years of renovation and expansion, including the cleaning of a major mural cycle in the main rotunda. The second, even more important chapter should be unveiled within the next year or so, when art conservators for the Getty Conservation Institute complete some demanding labors on Olvera Street. The two murals couldn't be more different from one another, even though they date from the same moment and were painted a scant ten blocks apart. Indeed, one could be described as the artful declaration of an official fantasy, the second as the dramatic assertion of an unofficial reality. Together, they speak to one another across space and time, giving shape and depth to history in a way that only art can.

Near the plaza of El Pueblo, where the village of Los Angeles had been established late in the eighteenth century, a painter was hard at work in the late summer and early fall of 1932. On a south-facing exterior wall on the second floor of Italian Hall, once a thriving community benevolent association, the great Mexican muralist David Alfaro Siqueiros (1898–1974) had been commissioned by F. K. Ferencz,

director of the Plaza Art Gallery, to paint a mural that would be called *America Tropical*. Siqueiros's vision of tropical America was painted in segments across an 18-by-80-foot brick wall facing a rooftop beer garden that overlooked Olvera Street. Working with a changing team of assistants for forty-seven days between August and October, he sketched out a luxurious jungle scene filled with huge, tangled vegetation, both vaguely erotic and threatening. In the center of the shallow, flattened space loomed a richly decorated pyramid, its twin entrances cleverly merged with a pair of actual shuttered windows in the building's brick wall. Totemic sculptures flanked the temple, while a tall, carved stone arose in the jungle at the left. Compositionally balancing the monolith, a small building was painted around a door at the right end of the wall. Again the mural's illusion merged with the building's physical design.

Neither the decorated pyramid nor any of the carved sculptures can be stylistically pinpointed to one ancient civilization or another. A sculpture by the temple's base, for example, loosely recalls an 800-year-old Chacmool figure from the Yucatan, but not with specificity. Siqueiros's designs aren't Mayan, Toltec, Aztec, or Olmec. Or perhaps it would be more accurate to say his style is all of those and more, as his fresco fuses a variety of pre-Columbian styles.

Still, Siqueiros's aesthetic is even more complex. The artist had worked with Diego Rivera and José Clemente Orozco in the government-sponsored mural campaign in Mexico City between 1922 and 1924. A veteran of his country's civil wars, he had also traveled to study art in France, Italy and Spain. In Barcelona in 1921, he had issued a formal manifesto to the Artists of America. With youthful exuberance, Siqueiros had exclaimed, "Let us live our marvelous, dynamic age!" Recalling the fiery rhetoric of the Italian Futurist painters, he sought to inject his art with a vigor commensurate to the technological and political upheavals that marked the tumultuous new century. While painting in Mexico City, Siqueiros was also drawn into trade-union organizing. First he joined the Union of Technical Workers, Painters, and Sculptors. Later, in Jalisco, he became president of the National Federation of Mineworkers. Finally he served as secretary of Mexico's Communist Party. He came to Los Angeles in 1932, to teach at the old Chouinard School of Art, after a year spent in prison for participating in a banned May Day celebration in Mexico City.

In addition to its sources in ancient Mexico, *America Tropical* was inflected with the grave simplicity and muted color of the early Renaissance murals of Masaccio, which Siqueiros had so greatly admired in Italy, as well as with a flattened, distilled form and space that is thoroughly modern. Overall, this complicated merger complied with the pointed directive Siqueiros had set out a decade before, in his flamboyant manifesto. By turning to ancient sources for his hybrid style, and by experimenting with such untried modern techniques as the

use of an airbrush, he sought a "synthetic energy" that would manage to avoid "those lamentable archeological reconstructions (Indianism, Primitivism, Americanism) which are so in vogue here today but which are only short-lived fashions." It's as if the Olvera Street mural declared that Siqueiros's artistic identity must be taken as the sum of his own social, cultural, and personal histories.

When the mural was nearly complete, Siqueiros dismissed his assistants and set to work on a final, dramatic flourish. Directly in front of the ancient temple, smack in the visual center of the mural, he painted an Indian lashed with ropes to a wooden cross. Above the crucified figure an eagle spreads its wings, its razor-sharp talons clutching the cross. Over at the right, he added two figures crouching atop the building he had painted around the door in the wall. A peasant revolutionary clutches a rifle across his chest, while a second figure garbed in generic Indian dress points his rifle directly at the eagle. Not surprisingly, when Siqueiros's mural was finished and publicly unveiled, pandemonium ensued. A crucified Indian peon and revolutionary soldiers attacking a symbol for the United States were not seen by the city's political leadership as flattering images. Nearly a third of the mural, the portion visible from Olvera Street below, was quickly covered over with white paint. A few months later, Siqueiros was deported.

Despite the feverish outcry, however, it's clear that Siqueiros's *America Tropical* is not anti-American. It's anti-authoritarian. Ornithologically speaking, his painted eagle is no more specifically American than his temple and sculptures are specifically Mayan or Aztec in style. Like them, the eagle is generic, as much a symbol of Mexico or the Hapsburg Empire as of the United States. The depiction of its assault by rifle-toting representatives of "the people" speaks of the artist's revolutionary distrust of governmental authority of any kind.

Meanwhile, several blocks south, at the corner of Fifth and Grand, another painter was putting the finishing touches on an expansive mural cycle. Painted between 1927 and 1932 in the magnificent rotunda of the city's new Central Library by the highly regarded American illustrator Dean Cornwell (1892–1960), the panels depict the colonization of California by Spanish conquistadors, missionaries, and their descendants. Employing a pastel palette of pinks, yellows, greens, and blues fashionably reminiscent of those used by the celebrated Philadelphia illustrator Maxfield Parrish, Cornwell told a peaceful fairy tale of California's founding by Christian Spanish settlers.

Through sweetly crystalline forms, the paintings in the rotunda's four monumental lunettes create a luxurious pageant. Powerful and beneficent representatives of the King of Spain and the Catholic Church bring the gifts of civilization, order, and progress to a primitive, subservient, yet noble population of indigenous people. One lunette shows the arrival of Spanish conquistadors in great ships. Another de-

picts the Catholic Church's investiture in the New World; a third portrays its construction of the California missions. The last shows the coming of the railroad and the arrival of transcontinental commerce, spanning the United States "from sea to shining sea." Eight smaller panels flank the four lunettes, portraying a variety of other episodes in California history, large and small, including depictions of weaving and pottery making, of the gold rush, and of harnessing and harvesting the bounty of the fields. Throughout Cornwell's murals, peace and prosperity flourish under the guiding authority of church, state, and commerce. Everywhere, the Europeans and their descendants are portrayed as stoical leaders, while the "noble savages" work.

David Siqueiros
America Tropical
(detail)
1932

Needless to say, Cornwell's vision was warmly embraced by the civic Establishment, which had commissioned it. In fact, its very spirit was inescapably linked to the milieu in which Siqueiros's combative mural had taken shape. The Mexican painter's ode to the seductive pleasures of tropical America had been expected to complement a newly revitalized area. El Pueblo, which had long since fallen into decay and disarray, had been the focus of a vigorous municipal campaign to transform the city's historic but neglected birthplace into a charming tourist attraction. Christine Sterling, a civic leader who led the effort along Olvera Street, envisioned the short, narrow avenue as a colorful Mexican marketplace filled with artisans' shops, strolling mariachis, and eateries. "Olvera Street holds for me all the charm and beauty which I dreamed for it," she had happily declared when the marketplace opened to the public in 1930, "because out of the hearts of the Mexican people is spun the gold of romance and contentment. No sweeter, finer people live on this Earth than the men and women of Mexico." As a tourist venue imagined by an Anglo member of the local oligarchy, the lighthearted fantasy on newly refurbished Olvera Street bore about as much likeness to the actual historic pueblo or to an authentic Mexican marketplace as Cornwell's murals did to the brutal facts of California's conquest and settlement. Olvera Street was, in its ersatz way, a sort of 1930s prelude to today's eclectic Universal Studios CityWalk, with its glittery imitation of an actual urban street.

As L.A. sagged under the darkening cloud of the Great

Depression in the early 1930s, both the library murals and the touristy marketplace were suffused with Southern California optimism. They told official histories, one in paint and one in real estate, spruced up and prettified for ease of civic consumption. Siqueiros, however, wasn't swallowing any of it. Conflicts over immigration were raging then as they are today, likewise exacerbated by pitiless economic stresses of the period. That the painter might hold a rather different view of the region and its history was certainly to be expected. It probably goes without saying that, offered a wall to paint above the quaintly idealized marketplace on Olvera Street, he might vigorously embrace the chance to make a corrective work of art declaring an independent vision. Siqueiros unveiled his mural in October, Cornwell finished his five-year project in November. (The signature panel on Cornwell's mural is accompanied by the date 1933, which might refer to its dedication.) Given the timing, did Siqueiros mean *America Tropical* to be a direct reply to Cornwell's "official history" of Southern California? There is no record as to whether the Mexican artist had seen the nearby library murals, with their gauzy motifs of sunshiny bliss, but it wouldn't be surprising if Siqueiros had. After all, a prominent visiting muralist might be expected to stop in to see a colleague's nearly finished work-in-progress in a public building a few blocks away, especially as the library murals were surely the most important civic commission of the day.

The differences between Siqueiros's dramatic mural and Cornwell's elaborate painted pageant are pretty blunt. However, among the more subtly revealing points of comparison is the prominent religious imagery both employ. Cornwell repeatedly evokes the Christian symbol of the Madonna and Child, which underscores an identification between the golden land of California and an untrammeled New Eden. At the Central Library, the lunette describing the investiture of the Catholic Church shows, just to the left of center, a radiant young Indian woman holding her baby at her side. These sweetly painted surrogates for the Virgin and Child are surrounded by what appears to be a heavenly aureole. (In fact, the halo is a large pottery vase standing behind them.) This secular allusion to the Mother of God is placed at the feet of a lavishly robed Catholic bishop. On the cleric's richly decorated garment, directly in line with the woman's head, is an embroidered image of an enthroned Madonna and Child: California is subtly identified with miraculous birth. Echoes of this "New World Madonna" appear elsewhere in Cornwell's mural cycle, but nowhere is the image more telling than in the climactic railroad lunette. There, in the center of the picture atop a crowded pyramid of people, another woman holds her baby at her side; this time, the encompassing halo is the arching white cover to a Conestoga wagon in which they ride. The culmination of this ceremonial California narrative thus represents a notable transformation. For its personification of sacred birth has quietly shifted, from an indigenous

woman and her child to American pioneers arriving from the East.

By contrast, Siqueiros's bold crucifixion is of a wholly different order. Over at Olvera Street, Siqueiros's crucified peasant is a Christian symbol that does not tell of miraculous birth. Instead, rebirth is on Siqueiros's mind. A crucifixion is a tragic icon whose substance is mortal suffering and death. Here, an exemplar of the indigenous population has been lashed to the conqueror's Christian cross, erected before a sacred ancient temple. The European conquest is likened to Christ's crucifixion, as the brutal death of one civilization makes way for the new life of another. Siqueiros's crucifixion, however, is also aligned with two revolutionary figures—one modern, one ancestral—who take aim at the victor's modern symbol. *America Tropical* is a poetic evocation of a continuing struggle for social transformation, and for the promise of resurrection of the Americas.

In her comprehensive 1993 survey book *Street Gallery: A Guide to 1,000 Los Angeles Murals*, Robin J. Dunitz chronicles almost twenty extant murals that predate Siqueiros's, which is the only surviving public mural by the artist in the United States. Yet, the L.A. tradition of artists speaking with an independent voice through paintings on neighborhood walls begins with *America Tropical*. The painting ranks as the fountainhead for the modern mural movement in the city. Not surprisingly, since the late 1960s its aggressive street poetry has been of special interest to the Chicano movement and its artists. What's remarkable about its influence is that, for decades, the mural has been as much legend as fact, for although it was known through photographs, its deterioration has been severe. Efforts to restore it to its rightful place of prominence began in earnest almost a quarter-century ago. The road back has been long and difficult, and countless individuals—artists, historians, civic activists—have contributed to the endeavor.

The significance of the mural places the current conservation effort among the most important the Getty has yet undertaken. Since 1988, the conservation institute has worked with the Friends of the Arts of Mexico Foundation, El Pueblo de Los Angeles State Historic Monument, and project consultant Luis C. Garza to rescue the mural. Portions of the plaster had been loosened by years of rain and earthquakes. Paint eroded. Siqueiros had used an unstable binding medium called nitro cellulose for his pigments, which has hastened the disappearance of his colors in direct sunlight.

The portion of the mural censored with white paint by outraged civic leaders in 1932 ironically gained an added measure of security. The Getty's conservation team, headed by Augustin and Cecelia Espinoza, have removed the remaining white paint, cleaned and consolidated the surface, and reattached loose plaster to the wall. A new temporary shelter was built to protect the mural from the elements. Seismic stabilization and structural reinforcement of Italian Hall is slated

to begin soon. (The Northridge temblor seems not to have damaged the building or the mural.) Architectural plans are under way for a permanent shelter to be built, along with a shaded, public-viewing platform and a contextual display of related historical information, both on the adjacent rooftop. If all goes as planned, the site could at last be opened to the public as early as next year. More than 1.5 million people annually visit El Pueblo, and the Siqueiros mural will surely rank among its most important attractions.

Of course, the painting is only a shadow of its original self. Conservators can work wonders, but they cannot magically restore what has been so tragically lost. The library murals, preserved indoors and narrowly escaping total destruction in the 1986 arson fire, retain almost all their original pageantry; the worn and faded Siqueiros mural is a ghostly shade. Still, like all ghosts of time past, *America Tropical* exerts its own haunting spell. Project consultant Luis Garza is surely correct when he speculates that, once open, the mural will become a shrinelike site for Latinos in Los Angeles. For the tale of these two murals is indeed a tale of two cities, and one whose resonant dynamic is still being felt.

Illustrations

p 6: Peter Alexander, *Sunset*, 1975. Mixed media on velvet, 28 x 40". Private collection. Courtesy James Corcoran Gallery, Venice, California.

p 13: John Baldessari, *Two Dwarfs*, 1990. Gelatin silver prints, 82 x 89½". Collection Alan Hergott and Curt Shepard. Courtesy Margo Leavin Gallery, Los Angeles. Photography: Douglas M. Parker Studio, Los Angeles.

p 16: Hannelore Baron, *Untitled*, 1982–83. Mixed media assemblage, 8½ x 5 x 3⅛". Courtesy Jack Rutberg Fine Arts, Los Angeles.

p 19: Billy Al Bengston, *Buster*, 1962. Oil and sprayed lacquer on masonite, 60 x 60". Museum of Contemporary Art, San Diego.

p 21: Wallace Berman, *Homage to Artie*, 1965. Verifax collage and paint on paper, 18 x 20". Collection Lannan Foundation, Los Angeles. Photography: Susan Einstein.

p 24: Elmer Bischoff, *Girl Wading*, 1959. Oil on canvas, 82⅝ x 67¾". The Museum of Modern Art, New York, Blanchette Rockefeller Fund.

p 29: Jonathan Borofsky, *Ballerina Clown*, 1989. Aluminum, steel gear motor, aluminum mesh, urethane, and fiberglass, 30' x 17'6" x 5'. Collection Renaissance Homeowners Association.

p 32: Chris Burden, *The Other Vietnam Memorial*, 1991. Copper, aluminum, Cor-ten steel, 13'8" x 9'11" diameter. Collection Lannan Foundation, Los Angeles. Photography: Susan Einstein.

p 37: Hermenegildo Bustos, *Self-Portrait*, 1891. Oil on metal, 13⅛ x 9½". Museo de la Alhóndiga, Guanajuato, Mexico.

p 40: Vija Celmins, *German Plane*, 1966. Oil on canvas, 16 x 26". Collection Chermayeff & Geismar Associates. Courtesy Chermayeff & Geismar, Inc. Photography: Schenk & Schenk.

p 43: Larry Clark, from *Teenage Lust*, published 1983. Courtesy of Larry Clark and Luhring Augustine Gallery, New York.

p 46: Ron Davis, *Roto*, 1968. Oil on canvas, acrylic resin, and fiberglass, 62 x 136". Los Angeles County Museum of Art, M.69.8, museum purchase, Contemporary Art Council Funds.

p 49: Roy Dowell, *Untitled #405*, 1988. Acrylic and sand on panel, 24 x 20". Collection Judy and Jeff Gold. Photography: Douglas M. Parker Studio.

p 50: Lorser Feitelson, *Hardedge Line Painting*, 1963. Enamel on canvas, 72 x 60". Los Angeles County Museum of Art, M.64.7, anonymous gift through the Contemporary Art Council.

p 51: Helen Lundeberg, *Double Portrait of the Artist in Time*, 1935. Oil on fiberboard, 47¾ x 40". National Museum of American Art, Smithsonian Institution, 1978.51.

p 57: Judy Fiskin, *Untitled Geometric Façades*, from "Dingbats," 1982. Gelatin silver print, 2¾ x 2¾". Collection Eileen and Peter Norton. Courtesy Patricia Faure Gallery, Santa Monica. Photography: James Franklin.

p 64: Hendrik Goltzius, *Jupiter and Danäe*, 1603. Oil on canvas, 68¼ x 78¾". Los Angeles County Museum of Art, M.84.191, gift of the Ahmanson Foundation.

p 71: David Hammons, *Bag Lady in Flight*, 1982 (recreated 1990). Shopping bags, grease, and hair, 48 x 113 x 5". Collection Eileen and Peter Norton. Courtesy Jack Tilton Gallery. Photography: Ellen Page Wilson.

p 74: Palmer C. Hayden, *Died wid His Hammer in His Hand*, 1944–47. Oil on canvas, 29 x 28". The Museum of African American Art, Los Angeles, gift of Miriam Hayden. Photography: Armando Solis.

p 77: Roger Herman, *Father/Mother*, 1982. Oil on canvas, 83 x 56". Collection Douglas Kennedy. Courtesy Roger Herman.

p 89: Jim Isermann, "Flowers," 1986. Installation at Kuhlenschmidt/Simon Gallery, Los Angeles. Courtesy Feature, New York. Photography: Tony Cuñha.

p 92: Alexej Jawlensky, *Elongated Head A*, 1920. Oil on canvas, 13⅜ x 9⁷⁄₁₆". Long Beach Museum of Art, the Milton Wichner Collection.

p 95: Larry Johnson, *Untitled (Jesus + I)*, 1990. Ektacolor print, 61 x 84½". Collection Stuart and Judy Spence. Courtesy Margo Leavin Gallery, Los Angeles. Photography: Susan Einstein.

p 100: Mike Kelley, *Disembodied Militarism* (detail), 1988. Acrylic on paper, 54 x 35¾". Collection Lannan Foundation, Los Angeles.

p 108: Vitaly Komar and Alexander Melamid, *Unity*, 1993. Mixed media, 30 x 90'. Lobby installation, First Interstate World Center, Los Angeles. Courtesy Maguire Thomas Partners. Photography: Jay Venezia.

p 114: Leon Kossoff, *Booking Hall, Kilburn Station No. 2*, 1977. Oil on board, 42½ x 48". Courtesy L.A. Louver, Venice, California. Photography: Thomas P. Vinetz.

p 116: Barbara Kruger, *Untitled (Questions)*, 1989–90 (destroyed). Painted mural, 29 x 218'. Mural on Temporary Contemporary South Wall, the Museum of Contemporary Art, Los Angeles. Courtesy Barbara Kruger and the Museum of Contemporary Art, Los Angeles. Photography: Gene Ogami.

p 119: Jacob Lawrence, *Harriet Tubman Series No. 7*, 1939–40. Casein tempera on board, 17⅞ x 12". Collection Hampton University, Hampton, Virginia. Photography: Reuben V. Burrell.

p 123: Sherrie Levine, *After Edward Weston: 1*, 1980. Gelatin silver print, 10 x 8". Courtesy the artist and Marian Goodman Gallery, New York.

p 127: Helen Levitt, *Children*, 1940. Gelatin silver print, 6⁹⁄₁₆ x 8⅞". The Museum of Modern Art, New York, anonymous gift. Courtesy Fraenkel Gallery, San Francisco, and Laurence Miller Gallery, New York.

p 130: Roy Lichtenstein, *Look Mickey*, 1961. Oil on canvas, 48 x 69". Partial and promised gift to the National Gallery of Art, Washington, D.C. Courtesy Leo Castelli Gallery, New York.

p 133: Andrew Lord, *31 Black pieces.*, 1985. Painted and fired clay, variable dimensions. Installation at Margo Leavin Gallery, Los Angeles. Collection Andrew Lord. Courtesy Gagosian Gallery, New York.

p 138: Sylvia Plimack Mangold, *Study for Ruler Reflection*, 1976. Acrylic, ink, and pencil on paper, 39¾ x 29¾". Private collection. Courtesy Brooke Alexander. Photography: Ivan Dalla Tana.

p 144: John M. Miller, *Untitled #41*, 1986. Magna on raw canvas, 73 x 65¾". Collection of the artist.

p 147: Elizabeth Murray, *Sail Baby*, 1983. Oil on canvas, 126 x 135". Walker Art Center, Minneapolis, Walker Special Purchase Fund, 1984.

p 149: Alice Neel, *Nancy*, 1981. Oil on canvas, 60 x 40". The Estate of Alice Neel. Courtesy Robert Miller Gallery, New York. Photography: Eric Pollitzer.

p 152: David Park, *Rowboat*, 1958. Oil on canvas, 56¾ x 61". Museum of Fine Arts, Boston, anonymous gift.

p 155: Ellen Phelan, *Meadow Hampshire—Storm: Dark, Low Clouds*, 1989. Oil on linen, 70⅜ x 103¾". Private collection. Courtesy Patricia Faure Gallery, Santa Monica. Photography: James Franklin.

p 160: Pontormo (Jacopo Carucci), *Portrait of Cosimo I de' Medici*, ca. 1537. Oil on panel, 36¼ x 28⅜ ". J. Paul Getty Museum, Malibu, California.

p 164: Liubov Sergeievna Popova, *Objects from the Dyer's Shop (Early Morning)*, 1914. Oil on canvas, 27¾ x 35". The Museum of Modern Art, New York. The Riklis Collection of McCory Corporation (fractional gift).

p 169: Charles Ray, *Self-Portrait*, 1990. Mixed media, 75 x 26 x 20". Newport Harbor Art Museum, Newport Beach, California. Courtesy Feature, New York.

p 172: Rembrandt van Rijn, *The Raising of Lazarus*, ca. 1630. Oil on panel, 37¹⁵⁄₁₆ x 32". Los Angeles County Museum of Art, gift of H. R. Ahmanson & Co., in memory of Howard F. Ahmanson, M.72.67.2.

p 174: Gerhard Richter, *18. Oktober 1977 (Plattenspieler)*, 1988. Oil on canvas, 24¼ x 32⅜". Museum für Moderne Kunst, Frankfurt am Main. Photography: Rudolph Nagel.

p 193: August Sander, *Zwerge (Dwarfs)*, ca. 1910. Gelatin silver print, 6⁹⁄₁₆ x 7". J. Paul Getty Museum, Malibu, California.

p 198: Adrian Saxe, *Shirley's Friend*, 1989. Porcelain and cubic zirconium, 21 x 13 x 9¾". Private collection. Courtesy Garth Clark Gallery, Los Angeles/New York. Photography: Tony Cuñha.

p 201: Jim Shaw, *Anima Figure #2, Water*, 1988. Oil on canvas, 17 x 14". Courtesy Rosamund Felsen Gallery, Santa Monica. Photography: James Franklin.

p 203: Henrietta Shore, *Gloxinia by the Sea*, n.d. Oil on canvas, 26 x 26". Collection James and Linda Ries.

p 206: Alexis Smith, *Same Old Paradise*, 1987. Mixed-media collage on painted canvas backdrop, 20 x 60'. Courtesy Margo Leavin Gallery, Los Angeles. Photography: Peter Muscato.

p 209: Kiki Smith, *Untitled (Sperm)*, 1990. Lead glass crystal, 6 to 8" each. Collection Lannan Foundation, Los Angeles. Photography: Susan Einstein.

p 212: Gary Stephan, *1 2 5 4 5 8*, 1985. Acrylic on canvas, 34 x 38". Private collection. Courtesy Mary Boone Gallery, New York. Photography: Zindman/Fremont.

p 219: Tung Ch'i-ch'ang, *The Ch'ing-Pien Mountain in the Manner of Tung Yuan*, 1617. Ink on paper, 88⅜ x 26½". The Cleveland Museum of Art, Leonard C. Hanna, Jr. Fund, 80.10.

p 222: Richard Tuttle, *Four*, 1988. Wood, book-binding fabric, Magic Marker, florist's wire, nails, and linen thread, 42⅜ x 62¾ x 81¼". Private collection. Courtesy Richard Tuttle. Photography: Yves Paternoster.

p 225: Bill Viola, *The Theater of Memory*, 1985. Video/sound installation. Newport Harbor Art Museum, Newport Beach, California. Photography: Kira Perov.

p 226: Andy Warhol with Otto Fenn, *Nose Job*, 1952. Gelatin silver print and ink, 9¹⁵⁄₁₆ x 8¹⁄₁₆". The Andy Warhol Foundation for the Visual Arts. Photography: Otto Fenn.

p 236: John Singleton Copley, *Sir William Pepperrell and His Family*, 1778. Oil on canvas, 90 x 108". North Carolina Museum of Art, Raleigh, purchased with funds from the state of North Carolina.

p 244: Ken Price, *Wart Cup*, 1967. Ceramic, 3½" high. Collection Donna O'Neill.

p 249: Albrecht Dürer, *Knight, Death, and the Devil*, 1513. Engraving, 9¾ x 7⅜". Los Angeles County Museum of Art, Los Angeles County Funds.

p 274: Silvestro Lega, *Il Pergolato (The Trellis)*, 1868. Oil on canvas,

29¼ x 36½". Pinacoteca di Brera, Milan. Courtesy Scala/Art Resource, New York.

p 277: Kentaro Nakamura, *Evening Wave*, ca. 1927. Bromide photograph, 13 %₆ x 10⅝₆". Collection Dennis and Amy Reed.

p 284: Mark Rothko, *Tentacles of Memory*, ca. 1945–46. Watercolor and ink on paper, 21¾ x 30". San Francisco Museum of Modern Art, Albert M. Bender Collection, Albert M. Bender Bequest Fund Purchase.

p 287: Cindy Sherman, *Untitled*, 1981. Color photograph, 24 x 48". Courtesy the artist and Metro Pictures, New York.

p 300: Gustave Moreau, *Salome Dancing Before Herod*, n.d. Oil on canvas, 56½ x 41 ⅟₆". The Armand Hammer Collection, the Armand Hammer Museum of Art and Cultural Center, Los Angeles.

p 307: Anonymous Attic, *Marble Relief of a Victorious Boy Athlete*, ca. 470–460 B.C. Marble, 18⅞ x 1½". National Archaeological Museum, Athens, Greece.

p 310: Bruno Cuomo (Doug Hammett), *Sleeping Beauty (Paper Weight and Bolo Tie Sets)*, 1989. HIV-positive blood and semen, resin, wood, sand, and Plexiglas, 10 x 11 x 11". Private collection. Photography: Art Works.

p 315: Neroccio de' Landi, *Madonna and Child with Saints John the Baptist and Catherine of Alexandria*, ca. 1480. Tempera and gold leaf on panel, 22½ x 22⅞". The Norton Simon Foundation, F.65.1.44.P.

p 320: Joan Miró, *Le Renversement*, 1924. Oil, pencil, charcoal, and tempera on canvas board, 36⅜ x 28⅟₆". Yale University Art Gallery. Gift of Collection Société Anonyme.

p 327: Pierre Koenig, *Case Study House #21*, 1959-60. Photograph published in *The Los Angeles Examiner*, April 19, 1959.

p 330: "Miller," *The Man with No Crotch Sits Down with Girl*, n.d. Oil on canvas, 22 x 29¾". Courtesy Jim Shaw.

p 347: Anonymous German, from the *Hamburger Fremdenblatt*, published 1938.

p 354: "Head-On/The Modern Portrait." Installation at Lannan Foundation, Los Angeles, June 25–September 7, 1991. Photography: Susan Einsten.

p 361: Anonymous American, *Afro-Traditional Quilt, Improvisational Strip*, 19th century. San Francisco Craft and Folk Art Museum. Photography: Geoffrey Johnson.

p 362: Hans Schiff, *Police Van (Köln)*, 1931. Gelatin silver print, 5 x 7". Special Collections, Farleigh Dickinson University Library, Florham-Madison Campus, Madison, New Jersey.

p 365: Anonymous, *Sor Ana María de San Francisco y Neve*, ca. 1750. Oil on canvas, 70⅞ x 47¼". Church of Santa Rosa de Viterbo, Querétaro, Mexico.

p 369: Carleton E. Watkins, *Dam and Lake, Nevada County, Near View*, ca. 1871. Albumen photograph, 16¼ x 21⅜". J. Paul Getty Museum, Malibu, California.

p 374: *AIDS Memorial Quilt*, on display in Washington, D.C., 1988. Courtesy NAMES Project, San Francisco. Photography: Marcel Miranda 111.

p 379: Illuminated by Joris Hoefnagel; scribe Georg Bocskay, *Mira calligraphiae monumenta (Model Book of Calligraphy)*, folios 1–129 written in 1561–62, illuminations added after 1591; folios 130–51 completed in 1596. Pen and ink, watercolor, gold and silver paint on vellum and paper, 6⅟₆ x 4⅞ " (leaf size). J. Paul Getty Museum, Malibu, California.

p 390: David Alfaro Siqueiros, *America Tropical* (detail), 1932. Painted mural, 18 x 80'. Olvera Street, Los Angeles. Courtesy El Pueblo de Los Angeles National Monument.

Acknowledgements

In most cases the titles of the articles in this book have been simplified. In the order of their appearance here we gratefully acknowledge the original publications and the present copyright holders of the selected material.

Artists

"Peter Alexander" from *Peter Alexander: A Decade of Sunsets* (Los Angeles Municipal Art Gallery, 1983): 11−17.

"Charles Arnoldi and Laddie John Dill" first published as "The Mystery of the Missing Art," *Los Angeles Herald Examiner* (Sept. 18, 1983). ©Hearst Publications.

"John Baldessari 1" first published as "Sharp Pencils." *Elle* 12 (Mar. 1990): 208, 210.

"John Baldessari 11" first published as "An Affirmative Answer from John Baldessari," *Los Angeles Times* (Apr. 27, 1990). ©1990, *Los Angeles Times*, reprinted with permission.

"Hannelore Baron" first published as "Assemblages Out of Turmoil," *Los Angeles Herald Examiner* (Dec. 4, 1987). ©Hearst Publications.

"Billy Al Bengston" first published as "More Macho Dandyism," *Los Angeles Herald Examiner* (Dec. 11, 1988). ©Hearst Publications.

"Wallace Berman" first published as "Clearer Picture of Artist Emerges in His Facsimiles," *Los Angeles Herald Examiner* (Jan. 24, 1988). ©Hearst Publications.

"Elmer Bischoff" first published as "Elmer Bischoff Deserves Better than the Laguna Retrospective," *Los Angeles Herald Examiner* (Jan. 11, 1987). ©Hearst Publications.

"Lee Bontecou" first published as "Bontecou 'Sculpture': Hybrid Eruptions," *Los Angeles Times* (Apr. 5, 1993). ©1993, *Los Angeles Times*, reprinted with permission.

"Jonathan Borofsky" first published as " 'Ballerina Clown'—The Court Jester of Venice," *Los Angeles Times* (Dec. 22, 1989). ©1989, *Los Angeles Times*, reprinted with permission.

"Chris Burden" first published as "A Monumental Burden," *Los Angeles Times* (June 28, 1992). ©1992, *Los Angeles Times*, reprinted with permission.

"Hermenegildo Bustos" first published as "Mexico's Unsung Master," *Los Angeles Times* (Dec. 15, 1991). ©1991, *Los Angeles Times*, reprinted with permission.

"Vija Celmins" first published as "Vija Celmins' Picture Planes," *Art issues.* 21 (Jan.-Feb. 1992): 15 - 17. Reprinted courtesy of The Foundation for Advanced Critical Studies.

"Larry Clark" first published as " 'Teenage Lust' for Ordinary Life," *Los Angeles Herald Examiner* (Feb. 22, 1984). ©Hearst Publications.

"Ron Davis" first published as "Davis' Daring Dodecagons," *Los Angeles Herald Examiner* (Sept. 24, 1989). ©Hearst Publications.

"Roy Dowell" first published as "Concrete Aims for Abstract Art," *Los Angeles Herald Examiner* (Feb. 3, 1989). ©Hearst Publications.

"Lorser Feitelson and Helen Lundeberg" first published as "Recognizing the Overlooked Masters," *Los Angeles Herald Examiner* (Apr. 12, 1981). ©Hearst Publications.

"Eric Fischl" first published as "Born-Again Painting" in *Eric Fischl*, exhibition catalog (New York: Mary Boone/Michael Werner, 1984).

"Judy Fiskin" first published as "Taxonomic Dingbats" in *Judy Fiskin* (Beverly Hills: Art Press, 1988): 36–38.

"Helen Frankenthaler" first published as "Frankenthaler Retrospective Raises Questions," *Los Angeles Times* (Feb. 9, 1990). ©1990, *Los Angeles Times*, reprinted with permission.

"Frank O. Gehry" first published as "Frank Gehry Wins 1989 Pritzker Prize," *Los Angeles Herald Examiner* (May 1, 1989). ©Hearst Publications.

"Hendrik Goltzius" first published as "Making the Gods Mind Their Manners," *Los Angeles Times* (Apr. 5, 1992). ©1992, *Los Angeles Times*, reprinted with permission.

"Leon Golub" first published as "The Brutal Camera Eye of Leon Golub," *Los Angeles Herald Examiner* (Dec. 23, 1984). ©Hearst Publications.

"David Hammons" first published as "Beauty in Discards and Discord," *Los Angeles Times* (Aug. 21, 1991). ©1991, *Los Angeles Times*, reprinted with permission.

"Palmer C. Hayden" first published as "Echoes of the Harlem Renaissance," *Los Angeles Herald Examiner* (May 22, 1988). ©Hearst Publications.

"Roger Herman" first published as "Label His Paintings 'Exceptional,' " *Los Angeles Herald Examiner* (Sept. 26, 1982). ©Hearst Publications.

"Eva Hesse" first published as "Yale Stages Eva Hesse Retrospective," *Los Angeles Times* (July 15, 1992). ©1992, *Los Angeles Times*, reprinted with permission.

"David Hockney" first published as "David Hockney's Photographs," *Aperture* 89 (Feb. 1982): 32–34. ©Aperture, New York, 1982.

"George Inness" first published as "Inness as the First Modernist? The Evidence Doesn't Stand Up," *Los Angeles Herald Examiner* (Feb. 23, 1986). ©Hearst Publications.

"Jim Isermann" first published as "The Return of Flower Power," *Los Angeles Herald Examiner* (Jan. 26, 1986). ©Hearst Publications.

"Alexej Jawlensky" first published as "Eye-Opening Portraits by Jawlensky," *Los Angeles Times* (Jan. 25, 1991). ©1991, *Los Angeles Times*, reprinted with permission.

"Larry Johnson" first published as "The Rime and Reason of Stories Coldly Told," *Los Angeles Times* (Dec. 20, 1990). ©1990, *Los Angeles Times*, reprinted with permission.

"Mike Kelley I" first published as "Artist Mike Kelley Redefines 'Sublime,' " *Los Angeles Herald Examiner* (Apr. 8, 1984). ©Hearst Publications.

"Mike Kelley II" first published as "Mike Kelley, at Large in Europe," *Los Angeles Times* (July 5, 1992). ©1992, *Los Angeles Times*, reprinted with permission.

"Mike Kelley III" first published as "Nothing Like a Little Enlightened Impurity," *Los Angeles Times* (July 1, 1994). ©1994, *Los Angeles Times*, reprinted with permission.

"Ellsworth Kelly" first published as an untitled essay in *Ellsworth Kelly at Gemini, 1983–1985* (Los Angeles: Gemini G.E.L., 1985).

"John Frederick Kensett" first published as "Nature Is Artist's Central Character,"

Los Angeles Herald Examiner (July 28, 1985). ©Hearst Publications.

"Vitaly Komar and Alexander Melamid" first published as "Leave Them to Heaven," *Los Angeles Times* (Mar. 7, 1993). ©1993, *Los Angeles Times*, reprinted with permission.

"Jeff Koons" first published as "Jeff Koons: A Scrubbed New Life," *Los Angeles Times* (Dec. 14, 1992). ©1992, *Los Angeles Times*, reprinted with permission.

"Leon Kossoff" first published as "Artist with a Sense of Urgency," *Los Angeles Herald Examiner* (May 16, 1982). ©Hearst Publications.

"Barbara Kruger" first published as "MoCA's Flag Mural: It's a Wrap," *Los Angeles Times* (July 4, 1990). ©1990, *Los Angeles Times*, reprinted with permission.

"Jacob Lawrence" first published as "Panels Take a Small Look at Large Lives," *Los Angeles Times* (June 14, 1993). ©1993, *Los Angeles Times*, reprinted with permission.

"Annie Leibovitz" first published as "Phoenix Fax: Annie Leibovitz," *Art issues.* 23 (May-June 1992): 28–29. Reprinted courtesy of The Foundation for Advanced Critical Studies.

"Sherrie Levine" first published as "Painting in the Corners of a Man's Art World," *Los Angeles Herald Examiner* (Oct. 26, 1986). ©Hearst Publications.

"Helen Levitt" first published as "Epiphanies Out of the Corner of Helen Levitt's Eye," *Los Angeles Times* (January 12, 1994). ©1994, *Los Angeles Times*, reprinted with permission.

"Roy Lichtenstein" first published as "The '60s Were Only the Beginning of Roy Lichtenstein's Sober Career," *Los Angeles Times* (February 1, 1994). ©1994, *Los Angeles Times*, reprinted with permission.

"Andrew Lord" first published as "Lord of the Latter-Day Impressionists," *Los Angeles Herald Examiner* (June 9, 1985). ©Hearst Publications.

"Édouard Manet" first published as "Edward Manet Still Leaves You Breathless," *Los Angeles Herald Examiner* (Oct. 2, 1983). ©Hearst Publications.

"Sylvia Plimack Mangold" first published as "Mangold: Probing the Nature of Perception," *Los Angeles Times* (Oct. 13, 1992). ©1992, *Los Angeles Times*, reprinted with permission.

"Robert Mapplethorpe" first published as "Sacred/Profane," *Los Angeles Herald Examiner* (July 2, 1989). ©Hearst Publications.

"Allan McCollum" first published as "McCollum's 'Perfect Vehicle' Shifts to High Gear," *Los Angeles Herald Examiner* (May 26, 1989). ©Hearst Publications.

"John M. Miller" first published as "John M. Miller Moves Aboveground," *Los Angeles Herald Examiner* (Dec. 14, 1986). ©Hearst Publications.

"Elizabeth Murray" first published as "Popeye Meets Picasso in MoCA Survey," *Los Angeles Herald Examiner* (Aug. 16, 1987). ©Hearst Publications.

"Alice Neel" first published as "Triumphant Images Highlight Exhibit," *Los Angeles Herald Examiner* (Apr. 5, 1983). ©Hearst Publications.

"David Park" first published as "The 'Golden Age' of Park," *Los Angeles Herald Examiner* (Mar. 19, 1989). ©Hearst Publications.

"Ellen Phelan" first published as an untitled segment in *Los Angeles Herald Examiner* (Oct. 20, 1989). ©Hearst Publications.

"Lari Pittman I" first published as "Pittman's Newest Work—Radical," *Los Angeles Herald Examiner* (Dec. 8, 1985). ©Hearst Publications.

"Lari Pittman II" first published as *Lari Pittman Paintings, 1992*, exhibition catalog (Vienna: Galerie Krinzinger, 1992).

"Jacopo Pontormo" first published as "Mannerist Master a Must for Museum," *Los Angeles Herald Examiner* (May 28, 1989). ©Hearst Publications.

"Liubov Popova" first published as "Popova Exhibition Confirms Russian's Avant-Garde Stature," *Los Angeles Times* (June 21, 1991). ©1991, *Los Angeles Times*, reprinted with permission.

"Stephen Prina" first published as "Prina Paints the Color of Money," *Los Angeles Herald Examiner* (July 28, 1989). ©Hearst Publications.

"Charles Ray" first published as "Sculptor Takes Himself out of Picture," *Los Angeles Times* (Aug. 5, 1990). ©1990, *Los Angeles Times*, reprinted with permission.

"Rembrandt van Rijn" first published as "The Raising of LACMA," *Los Angeles Times* (Mar. 8, 1992). ©1992, *Los Angeles Times*, reprinted with permission.

"Gerhard Richter" first published as "Powerful Works on the Richter Scale," *Los Angeles Times* (Jan. 14, 1990). ©1990, *Los Angeles Times*, reprinted with permission.

"Mark Rothko" first published as "Mark Rothko Exhibition Engages in Worthwhile Myth-bashing," *Los Angeles Herald Examiner* (June 8, 1986). ©Hearst Publications.

"Henri Rousseau" first published as "MoMA Exhibit Tackles the Myth and Legend of Henri Rousseau," *Los Angeles Herald Examiner* (Mar. 17, 1985). ©Hearst Publications.

"Edward Ruscha I" first published as "Against Type: The Silhouette Paintings of Edward Ruscha," *Parkett* 18 (1988): 80–84. ©Parkett Press Ltd.

"Edward Ruscha II" first published as "Proto Pop: Ed Ruscha: Word Plus Image Equals Art," *Elle* (Dec. 1990): 152, 154.

"August Sander" first published as "Different Worlds: Traumatic Visions," *Los Angeles Times* (May 23, 1991). ©1991, *Los Angeles Times*, reprinted with permission.

"Adrian Saxe I" first published as "Artist's Vessels Sail on a Revolutionary Sea," *Los Angeles Herald Examiner* (Nov. 10, 1985). ©Hearst Publications.

"Adrian Saxe II" first published as "The Human Value of California Clay," *Los Angeles Times* (November 13, 1993). ©1993, *Los Angeles Times*, reprinted with permission.

"Jim Shaw" first published as "Shaw's Wildly Funny Narrative Saga," *Los Angeles Times* (Dec. 7, 1990). ©1990, *Los Angeles Times*, reprinted with permission.

"Henrietta Shore" first published as "A Return from Obscurity," *Los Angeles Times* (May 20, 1990). ©1990, *Los Angeles Times*, reprinted with permission.

"Alexis Smith" first published as "A Collage Education," *Los Angeles Times* (Apr. 1, 1992). ©1992, *Los Angeles Times*, reprinted with permission.

"Kiki Smith" first published as "Body Language," *Los Angeles Times* (July 7, 1991). ©1991, *Los Angeles Times*, reprinted with permission.

"Gary Stephan" from *Gary Stephan*, exhibition catalog (New York: Mary Boone/Michael Werner, 1986).

"Wayne Thiebaud" first published as "Thiebaud Delivers Masterful Strokes with a Loaded Brush," *Los Angeles Herald Examiner* (Jan. 19, 1986). ©Hearst Publications.

"Tung Ch'i-ch'ang" first published as "China's Artist of the Ages," *Los Angeles Times* (July 18, 1992). ©1992, *Los Angeles Times*, reprinted with permission.

"Richard Tuttle" first published as "Witty Work Jumps Right Off the Wall," *Los Angeles Herald Examiner* (Dec. 25, 1987). ©Hearst Publications.

"Bill Viola" first published as " 'Theater of Memory,' Like a Palpable Dream," *Los Angeles Herald Examiner* (Aug. 4, 1985). ©Hearst Publications.

"Andy Warhol" first published as "Andy Warhol & Company—Rethinking the Art of the Sell," *Los Angeles Times* (Jan. 19, 1990). ©1990, *Los Angeles Times*, reprinted with permission.

EXHIBITIONS, EVENTS, ETC.

"Miss Piggy and the *Pietà*" first published as "Is This Pig Really a Piece of Fine Art?" *San Diego Reader* (Dec. 13, 1979).

"American Portraiture in the Grand Manner" first published as "Illusions of Grandeur," *Los Angeles Herald Examiner* (Nov. 29, 1981). ©Hearst Publications.

"Exile" first published as "*This* Building Houses an Art Gallery?" *Los Angeles Herald Examiner* (June 2, 1982). ©Hearst Publications.

"Authentic Reproductions" first published as "Are 'Authentic Reproductions' the Next Best Thing to Being There?" *Los Angeles Herald Examiner* (June 20, 1982). ©Hearst Publications.

"Otis Clay" first published as " 'Otis Clay': A Revolution in the Tradition of Pottery," *Los Angeles Herald Examiner* (Sept. 29, 1982). ©Hearst Publications.

"The Vatican Collections" first published as " 'The Vatican Collections' Is Junk Food for the Eye and Soul," *Los Angeles Herald Examiner* (Nov. 27, 1983). ©Hearst Publications.

"Nuremberg: A Renaissance City" first published as "City of Nuremberg Finally Gets Some Artistic Respect," *Los Angeles Herald Examiner* (Feb. 26, 1984). ©Hearst Publications.

"MoCA: A New Museum for Los Angeles" first published as "The Emergence of MoCA: A New Museum for Los Angeles," *The New Criterion* (Apr. 1984): 6–10.

"The Olympic Art Fiasco" first published as "Report from Los Angeles: The Olympic Art Fiasco," *Art in America* 9 (Oct., 1984): 17–21.

"L.A. Freeway: The Automotive Basilica," *Public Interest* 74 (Winter 1984): 152–57.

"The Place for Art in America's Schools" first published as "Two Major Flaws Dilute Getty Art Report," *Los Angeles Herald Examiner* (Apr. 3, 1985). ©Hearst Publications.

"Art in the San Francisco Bay Area" first published as "Decline, Fall. How the San Francisco Art Scene Slid into the Bay," *California* (July 1985): 40, 42.

"The Macchiaioli" first published as "Strange but True: A Valuable Historical Exhibition," *Los Angeles Herald Examiner* (Mar. 9, 1986). ©Hearst Publications.

Acknowledgements

"Japanese Photography in America" first published as "Japanese Picture Paintings: Old-fashioned or Pioneering Art?" *Los Angeles Herald Examiner* (May 18, 1986). ©Hearst Publications.

"An Open Letter to Attorney General Edwin Meese" first published as "Get Hip, Ed: Every One of Those Nudie Paintings Is Dangerous," *Los Angeles Herald Examiner* (June 1, 1986). ©Hearst Publications.

"Abstract Surrealism into Abstract Expressionism" first published as "Art Wrought on Paper Receives Its Proper Due," *Los Angeles Herald Examiner* (July 27, 1986). ©Hearst Publications.

"Photography and Art: Interactions Since 1946" first published as "Putting 'Photography and Art' in Sharp Focus," *Los Angeles Herald Examiner* (June 14, 1987). ©Hearst Publications.

"American Craft Today" first published as " 'American Craft': Poetry of the Superficial," *Los Angeles Herald Examiner* (Sept. 13, 1987). ©Hearst Publications.

"Musée d'Orsay" first published as "Art's Finest Home," *Los Angeles Herald Examiner* (Oct. 18, 1987). ©Hearst Publications.

"Wallraf-Richartz Museum/Museum Ludwig" first published as "A Whiff of Cologne," *Los Angeles Herald Examiner* (Nov. 1, 1987). ©Hearst Publications.

"Van Gogh's Market" first published as "A Crazy Price for a Dirtied Piece of Cloth," *Los Angeles Herald Examiner* (Nov. 12, 1987). ©Hearst Publications.

"The Armand Hammer Collection" first published as "Is This Art Worth Its Own Museum?" *Los Angeles Herald Examiner* (Jan. 31, 1988). ©Hearst Publications.

"Mira! The Canadian Club Hispanic Art Tour" first published as "Crocked Concept," *Los Angeles Herald Examiner* (Apr. 8, 1988). ©Hearst Publications.

"Picasso: Creator and Destroyer" first published as "A Cross-Eyed Portrait of Picasso," *Los Angeles Herald Examiner* (June 10, 1988). ©Hearst Publications.

"The Human Figure in Early Greek Art" first published as "A Different Perspective on Exhibit," *Los Angeles Herald Examiner* (Nov. 20, 1988). ©Hearst Publications.

"Against Nature: A Show by Homosexual Men" first published as "Transforming Our View of the AIDS Experience," *Los Angeles Herald Examiner* (Jan. 15, 1989). ©Hearst Publications.

"Painting in Renaissance Siena" first published as "Sienese Painting Gets Framed at Metropolitan," *Los Angeles Herald Examiner* (Feb. 26, 1989). ©Hearst Publications.

"Richard Neutra at UCLA" first published as "Bidding Adieu to Yet Another L.A. Edifice," *Los Angeles Herald Examiner* (June 11, 1989). ©Hearst Publications.

"The Dada and Surrealist Word-Image" first published as "I Remember Dada . . ." *Los Angeles Herald Examiner* (June 18, 1989). ©Hearst Publications.

"The Minneapolis Sculpture Garden" first published as "Midwest Museum without Walls," *Los Angeles Herald Examiner* (July 16, 1989). ©Hearst Publications.

"Case Study Houses" first published as "Exploring Domiciles in 'Blueprints,' " *Los Angeles Herald Examiner* (Oct. 22, 1989). ©Hearst Publications.

"Thrift Store Paintings" first published as " 'Thrift Store' Show: It's Priceless," *Los Angeles*

Times (Mar. 28, 1990). ©1990, *Los Angeles Times*, reprinted with permission.

"Is L.A. a World-Class Art City?" *Los Angeles Times* (Apr. 8, 1990). ©1990, *Los Angeles Times*, reprinted with permission.

"The Criticism of Robert Hughes" first published as "The Bard of Art's Decline," *Los Angeles Times* (Nov. 18, 1990). ©1990, *Los Angeles Times*, reprinted with permission.

"Hate Mail." *Art issues.* 15 (Dec. 1990-Jan. 1991): 28–29. Reprinted courtesy of The Foundation for Advanced Critical Studies.

"Degenerate Art" first published as "The Ties That Bind," *Los Angeles Times* (Mar. 10, 1991). ©1991, *Los Angeles Times*, reprinted with permission.

"On Drawing" first published as "Why the Artist Can't Draw—and Why We Shouldn't Care," *Los Angeles Times* (Mar. 31, 1991). ©1991, *Los Angeles Times*, reprinted with permission.

"MoMA in L.A." first published as "Slouching Toward the Present," *Los Angeles Times* (Aug. 11, 1991). ©1991, *Los Angeles Times*, reprinted with permission.

"African-American Quiltmaking" first published as "Quiltmaking Show with the Feel of Jazz," *Los Angeles Times* (Aug. 14, 1991). ©1991, *Los Angeles Times*, reprinted with permission.

"Worker Photography Between the Wars" first published as "Photos as Weapons of the People," *Los Angeles Times* (Aug. 31, 1991). ©1991, *Los Angeles Times*, reprinted with permission.

"Mexico: Splendors of Thirty Centuries" first published as "Illuminating History's Dark Corners," *Los Angeles Times* (Oct. 4, 1991). ©1991, *Los Angeles Times*, reprinted with permission.

"101 Years of California Photography" first published as "Shooting California," *Los Angeles Times* (Mar. 3, 1992). ©1992, *Los Angeles Times*, reprinted with permission.

"The Brave New NEA" first published as "The Brave New NEA: Now It Does Whatever the White House Wants," *Los Angeles Times* (May 31, 1992). ©1992, *Los Angeles Times*, reprinted with permission.

"The NAMES Project AIDS Memorial Quilt" first published as "A Stitch in Time," *Los Angeles Times* (Oct. 4, 1992). ©1992, *Los Angeles Times*, reprinted with permission.

"Inventing Still Life" first published as "The Still Life's Great Leap Forward," *Los Angeles Times* (Nov. 25, 1992). ©1992, *Los Angeles Times*, reprinted with permission.

"The Vietnam Women's Memorial" first published as "More Is *Not* Better," *Los Angeles Times* (Oct. 17, 1993). ©1993, *Los Angeles Times*, reprinted with permission.

"Can L.A. Help Heal the Arts?" first published as "The Question Should Be: Can L.A. Help Heal the Arts?" *Los Angeles Times* (Jan. 27, 1994). ©1994, *Los Angeles Times*, reprinted with permission.

"Two Murals, Two Histories." *Los Angeles Times* (Feb. 20, 1994). ©1994, *Los Angeles Times*, reprinted with permission.

selected bibliography

A complete bibliography of Christopher Knight's writings from 1979 through 1994 has been compiled and deposited with the Archives of American Art, Huntington Library, San Marino, California.

Los Angeles Herald Examiner

Christopher Knight published his first article with the *Herald Examiner* on May 25, 1980. By the middle of August 1980 he was contributing two articles per week, eventually writing 859 columns before the newspaper folded on November 2, 1989. All of the Hearst newspapers are on microfilm at the following repositories: Library of Congress, Washington, D.C.; California State Library, Sacramento; University of California Library, Los Angeles.

Los Angeles Times

Christopher Knight published his first article in the *Times* on December 15, 1989. Since that date he has contributed regularly to both the daily and Sunday newspapers. The *Los Angeles Times* is available from 1985 to the present through the following on-line electronic service providers: Dialog® Information Services, Mead Data Central (Nexis®), Dow Jones News/Retrieval®, DataTimes®, and the CompuServe Knowledge Index File; in addition, on-line interactive news, advertising, and information services are available through TimesLink®. The *Times* is available on CD-ROM from Dialog and on microfilm from University Microfilm International (UMI).

Other writings by Christopher Knight

"Michael C. McMillen." In *Eight Artists: The Elusive Image*, pp. 41–42, 45. Exhibition catalog. Minneapolis: Walker Art Center, 1979.

"Michael C. McMillen." *Arts + Architecture* 1 (Fall 1981): 22–23.

"Scanga's Object-Ciphers." *Art Xpress* (Jan.-Feb. 1982): 29–33. Re: Italo Scanga.

"Peter Shelton." In *trunknuts, WHITEHEAD, floater*, pp. 2–7. Exhibition catalog. Victoria, British Columbia: Open Space Gallery, 1982.

"Against Sculpture." In *100 Years of California Sculpture*, pp. 16–19. Exhibition catalog. Oakland: Oakland Museum, 1982.

Untitled. In *"The Grand": A Mixed Media Art Installation*. Program notes for the dedication of Alexis Smith's Keeler Grand Foyer installation, DeVos Performing Arts Hall, Grand Rapids, Michigan, Sept. 19, 1983.

"A Taste for the Figurative." In *Changing Trends*, pp. 24–27. Exhibition catalog. Laguna Beach: Laguna Beach Museum of Art, 1983.

"On Native Ground: U.S. Modern." *Art in America* 9 (Oct. 1983): 166–74. Re: The 1916 "Forum Exhibition of Modern American Painters."

"Anguished Artist of the Interior." *The New York Times Book Review* (Jan. 1, 1984): 8. Review of *About Rothko*, by Dore Ashton (Oxford University Press).

"Brainstorming with Borofsky." *Vanity Fair* 47 (Sept. 1984): 96–98. Re: Jonathan Borofsky.

"Borofsky: The Visible Man." *Flash Art* 121 (Mar. 1985): 20–22. Re: Jonathan Borofsky.

"A Return to Eden." *Harper's Bazaar* 3280 (Apr. 1985): 214, 254. Re: "John Frederick Kensett: An American Master" exhibition, Worcester Art Museum, and "George Inness" exhibition, Metropolitan Museum of Art.

"The Persistent Observer." In *25 Years of Space Photography*, pp. 8–19. Exhibition catalog. Pasadena: Baxter Art Gallery, California Institute of Technology, 1985.

Art of the Sixties and Seventies: The Panza Collection. New York: Rizzoli International Publications, 1986. Oral history with collector Giuseppe Panza di Biumo, Milan.

"Panofsky's Hat." In *The Barry Lowen Collection.* Exhibition catalog. Los Angeles: Museum of Contemporary Art, 1986.

"Kim MacConnel." In *Kim MacConnel*, pp. 5–17. Exhibition catalog. New York: Holly Solomon Gallery, 1986.

"The Perceptual Dramas of James Turrell." *Artspace* 10 (Spring 1986): 9–10.

"Roger Herman." In *Roger Herman.* Exhibition catalog. Medellín, Mexico: Galería Arte Contemporaneo, 1986.

"Terry Winters." In *Terry Winters*, pp. 21–30. Exhibition catalog. Santa Barbara: University Art Museum, 1987.

"Ruscha in Context: In the Beginning Was the Word." In *Edward Ruscha*, pp. 43–59. Exhibition catalog. Lake Worth, Florida: Lannan Museum, 1988.

"Composite Views: Themes and Motifs in Hockney's Art." In *David Hockney: A Retrospective*, pp. 23–38. Exhibition catalog. Los Angeles: County Museum of Art, 1988.

"The Towers as Art: Christopher Knight, Art Critic." In *The Watts Towers*, pp. 55–57. Oakville, Ontario: Mosaic Press, 1988.

"John Baldessari." Program notes for the Skowhegan School of Painting and Sculpture Anniversary Awards Dinner, Apr. 19, 1988, p. 7.

"Mike Kelley's Sad Sacks." In *Mike Kelley.* Cologne, Germany: Jablonka Galerie, 1989.

"A Stitch in Time." *Art issues.* 2 (Feb. 1989): 16–18. Re: The NAMES Project AIDS Memorial Quilt.

"An American Sampler." *Hartford Monthly* (Feb. 1989): 43–47. Adapted from a review of "An American Sampler: Folk Art from the Shelburne Museum" exhibition, originally published in the *Los Angeles Herald Examiner*, Feb. 24, 1988.

"Obscurs objets du désir: une fôret de signes." *Art Press* 138 (July-Aug. 1989): 21–25.

"Ascetics vs. Aesthetics." *Advocate* 556 (July 31, 1990): 38–40. Re: Homophobia and the conservative Christian agenda.

Chris Burden. Exhibition catalog. Vienna, Austria: Galerie Krinzinger, 1992.

"Instant Artifacts" and "Bohemia and Counterculture." In *Wallace Berman: Support the Revolution*, pp. 33–53. Exhibition catalog. Amsterdam: Institute of Contemporary Art, 1992.

"Charles Ray's Still Lifes." *Parkett* 37 (Sept. 1993): 46–51.

"Jim Isermann's Suburban Bauhaus." *Art issues.* 33 (May/June 1994): 29–31.

index

a

Abstract Expressionism, 23, 217, 254, 359; re Elmer Bischoff, 25-26; re Lee Bontecou, 27-28; decline of, 18, 40-41; in the mid-1960s, 79; introduction of figure into, 270; "The Irascibles," 130; re Mike Kelley, 102; re Roy Lichtenstein, 131; masculinity and, 205; re David Park, 151-154, 272; pastiches of, 18, 40-41; re Jackson Pollock and Mike Kelley, 100; re Robert Rauschenberg, 76; recapitulations and rhetoric of, 129; relation to Otis Clay, 244-245; relation to Pop art, 226-228; re Gerhard Richter, 176; ritual in, 91; re Edward Ruscha, 186, 191; the sublime in, 97

Abstract Surrealism, 283-286

academic art, 38-39, 108, 183, 251, 274, 294, 349-353, 368

Adams, Ansel, 286-287, 370

Adams, John, 251

aesthetics, 12, 103, 174, 266-267, 293

African-Americans, 70-76, 118-120, 141-142, 309, 337, 359-362, 372, 385

The Agony and the Ecstasy, 78

Ahmanson, Howard F., 172

AIDS, 159, 209, 309-312, 372-376

Ailes, Roger, 321

Albers, Josef, 18, 254

Albright, Thomas, 90, 269-273

Alexander, John, 341

Alexander, Peter, 5-8

Alexander, Robert, 317-318

Alhóndiga de Granaditas Museum, 35, 37

Allen, Peter, 375

Almaraz, Carlos, 259

Altdorfer, Albrecht, 248

Altoon, John, 80

America. *See* United States

American Craft Museum, 290-291

Americanism, 118, 389

American scene painting, 74, 154

Amico, David, 254

Anderson, Jeremy, 271

Apollinaire, Guillaume, 181, 321

Apollo Belvedere, 65, 247-248

Arcadia. *See* Eden

Archer M. Huntington Art Gallery, University of Texas, Austin, 248-249

Arco Center for the Visual Arts: "Los Angeles and the Palm Tree: Image of a City," 257

Arikha, Avigdor, 341

Armajani, Siah, 325

Armitage, Merle, 203

Armory Show, 202

Armstrong, Richard, 152, 206

Arneson, Robert, 271

Arnold, Matthew, 56

Arnoldi, Charles, 8-10

Arp, Jean, 89, 104, 156, 267

Artaud, Antonin, 77

Artcoast magazine, 335

art collectors, 46, 162, 259, 295; in Los Angeles, 251, 254-256, 299-303, 334

art criticism, 47, 329, 356, 372; re Chris Burden, 33-34; craft's lack of, 290; forms of, 334; re Robert Hughes, 338-343; re Mike Kelley, 334; magazines in Los Angeles, 335; reassessing Modernism, 142; reassessing nineteenth century, 106; teaching of, 266-267

art critics, 34, 46-47, 62, 190-191, 290, 328, 338-343, 348, 355

art dealers, 335, 339

Art Deco, 130, 199

art education, 13, 96, 266-269

arte popular. See folk art

Artforum magazine, 46, 121-122, 190

Art in America magazine, 34, 36

Art Institute of Chicago, 257

Art issues. magazine, 335

Artists Space, New York, 372

ARTnewsletter, 297

ARTnews magazine, 150, 270

Art Nouveau, 90

arts-and-crafts movement, 291

Arts & Architecture magazine, 326

Ash Can School, 203

AsherFaure Gallery, 155

Ashton, Dore, 178

Askevold, David, 99

assemblage, 44, 62, 71, 156, 217

Auerbach, Frank, 113, 341

Aulenti, Gae, 294

Avery, Milton, 149, 244

Aycock, Alice, 359

b

Baader, Andreas, 175-177

Bachardy, Don, 82

Bacon, Francis, 341

Baldessari, John, 10-15, 41, 286-288, 333

Bambi, 111

Banham, Reyner, 261

Bankhead, Irene, 360

Bannard, Walter Darby, 46

Barbizon School, 86-87

Barnes, Edward Larrabee, 300-301, 323

Baron, Hannelore, 16-17

Baroque, 14, 127, 211, 247, 295, 351, 366-367

Barr, Alfred, 252

Barragan, Luis, 63

Barron, Stephanie, 346, 348, 386

Bartlett, Jennifer, 341

Batoni, Pompeo, 247

Baudelaire, Charles, 100, 132-133, 161

Bauhaus, 287, 308, 345, 354, 363

Bausch, Pina, 257
Baziotes, William, 244
beach. See surf
Beaux, Cecilia, 236
Becher, Bernd and Hilla, 193, 287
Beck, Kurt, 364
Beckett, Samuel, 228, 273
Beckmann, Max, 175, 182, 345-346
Beijing Palace Museum, 220
Bell, Larry, 145
Bell, William, 372
Bellini, Giovanni, 301
Bengston, Billy Al, 17-20, 243-244
Benjamin, Walter, 242
Bennett, Michael, 375
Bergson, Henri, 134
Berman, Wallace, 20-23, 288
Bernini, Giovanni, 247
Beuys, Joseph, 298, 342
Beyeren, Abraham van, 377
Bischoff, Elmer, 23-26, 152, 270
Blackburn, Joseph, 236
Black Death, 314-315
Blake, Nayland, 311
Blake, William, 201, 224
Bliss, Lizzie P., 252
BlumHelman Gallery, Santa Monica, 45-46,
 222-223
Boccioni, Umberto, 164
Bocskay, Georg, 378-380
Boime, Albert, 273, 275
Bomberg, David, 113
Bontecou, Lee, 26-28
Boone, Mary, 339
boosterism, 107, 257, 336
Borghese, Pauline, 183
Borofsky, Jonathan, 28-31, 108
Bosch, Heironymous, 260
Bosman, Richard, 303
Bouguereau, Adolphe-William, 182
Bourgeois, Louise, 355, 359
bourgeoisie, 38, 112, 193, 274-275, 295, 326,
 330, 377, 385
Bousschaert, Ambrosius (the elder), 377, 380
Brancusi, Constantin, 112
Brand Library art gallery: "Thrift Store
 Paintings," 328-331
Brandt, Bill, 287
Braque, Georges, 83, 164, 190, 286, 304, 352
Breton, André, 286
Brezzo, Steve, 231-235
Brigman, Anne W., 370
Brodsly, David, 260-265
Broodthaers, Marcel, 287
Brooking, Dolo, 350
Brown, Julia, 255
Brueghel, Pieter, 219
Buchanan, Patrick J., 372, 383-384
Buchloh, Benjamin, 177

Buckley, William F., 383-384
Buddhism. See Zen
Bull, Clarence, 370
Bullock, Wynn, 287
Burden, Chris, 31-34, 333, 355
bureaucracy, 33, 56, 117, 260, 336, 377, 386
Buren, Daniel, 13
Burgin, Victor, 287
Burnett Miller Gallery, 169-171
Burton, Scott, 358
Bush, George, 349, 371-375
Bustos, Hermenegildo, 34-39, 368
Butterfield, Deborah, 323
Butterfield, Jan, 10, 26

C

CalArts. See California Institute of the Arts
Caldwell, John, 110
Calendar magazine, 234
California, 63, 151-152, 167, 259, 368, 389-391
California Afro-American Museum, 360;
 "Hidden Heritage: Afro-American Art,
 1800-1950," 73
California Assemblage movement, 22
California clay, 198
California Institute of the Arts, 13, 95, 99, 186,
 195, 258, 342, 386
California School of Fine Arts. See San
 Francisco Art Institute
California State University, Dominguez Hills,
 350
California State University, Fullerton art
 gallery, 8
Calle, Sophie, 355
camp, 95, 311
Canova, Antonio, 183
capitalism, 91, 267
Capitalist Realism, 41
Caponigro, Paul, 286
Capponi Chapel, 160
Caravaggio, Michelangelo Merisi da, 247
Carlson, Cynthia, 108
Carmean, E.A., Jr., 59-60
Carnegie International Exhibition, 99
Carpaccio, Vittore, 212-213, 215
Cartier-Bresson, Henri, 128
Casey, William, 345
Catholicism, 36, 98, 102, 246-248, 297, 366,
 389-391
Cellini, Benvenuto, 281
Celmins, Vija, 39-42
Central Library, Los Angeles, 316, 387, 389, 391
Centre Georges Pompidou, 190, 292
Cézanne, Paul, 76, 132-134, 147, 154, 213, 221,
 252, 286, 354
Chagall, Marc, 346-348
Chase, William Merritt, 202
Chernobyl, 280
Chicano movement, 392

Childs, Lucinda, 251

Chippendale, 241

Chirico, Giorgio de, 181

Chouinard Art Institute, 186, 190-191, 195, 198, 388

Chouinard School of Art. *See* Chouinard Art Institute

Christianity, 66, 72-75, 93, 119, 158, 166-167, 172-173, 176, 200-201, 211, 235-238, 247, 263, 281, 314, 347, 366, 382, 389, 391-392

Christiansen, Keith, 313

Christie's, 160-163

Church, Frederick Edwin, 5, 96-97

Cikovsky, Nicolai, Jr., 85-87

Cinderella, 111

civil rights, 188, 372

Civil War, United States, 33, 87, 106, 119, 382

Claesz, Pieter, 377

Clark, Lord Kenneth, 338

Clark, Larry, 42-44

classicism, 65-66, 74, 86, 306-309

Clay, Henry, 119, 236

Clearwater, Bonnie, 178-179

Clement, Felix-Auguste, 182

Cleveland Museum of Art, 221

clichés, 156-157; Abstract Expressionist, 129, 228; architecture as art, 332; of automobile culture, 261, 265; California car culture, 167; decoration as effeminate, 159; fashion consciousness, 89; as formal structure, 6; historical ideas, 96; L.A.'s identification with Light and Space, 5; Modernist idealism, 112; movie-star, 121; painting as a field of language, 184; Pop, 108; re Edward Ruscha, 185; sunsets, 5, 7; three about Los Angeles, 260; universality of art, 267; re Vietnam Women's Memorial, 382; visual and verbal, 108; youth as purity, 101

Close, Chuck, 138, 354-355, 358

Cobb, Henry, 318-319

Coburn, Robert, 370

Cohn, Roy, 375, 384

Cold War, 27, 337, 383, 386

Cole, Thomas, 5, 224

colonialism, 356, 365-368

Color-field painting, 12, 46, 59, 355, 357

Communism, 50, 68, 252, 337, 383-384, 388

Comstock, Anthony, 280

Conceptualism, 10, 12, 18, 31, 40, 57, 95, 159, 201, 208, 254, 288, 355

conservatism, 343-350, 372-373

Constable, John, 224

Constructivism. *See* Russian Constructivism

Contemporary Arts Center, Cincinnati, 347

Contemporary Arts Museum, Houston, 17

Cooper, Dennis, 309, 312

Cooper, Helen A., 79

Copley, John Singleton, 236-238

Corcoran Gallery of Art, Washington, D.C.:

"Robert Mapplethorpe: The Perfect Moment," 139-142

Corey, Irwin, 273

Corinne A. Seeds University Elementary School, 316-319

Cornell, Joseph, 16

Cornwell, Dean, 389-393

Correggio, Antonio Alegri da, 281

Cortés, Hernando, 365, 367

Cotan, Juan de Sánchez, 233

Cotter, Holland, 34

counterculture, 23, 90

Courbet, Gustave, 38, 293, 308

Couture, Thomas, 135

Cox-Rearick, Janet, 161

craft, 47, 198, 289-292, 352, 359-362

Crawford, Ralston, 265

Crisis magazine, 74

critical thinking, 255, 267, 270, 290, 292, 294

Crocker Art Museum, 64

Cubism, 71, 83, 131, 132-133, 147, 153, 164, 178, 304-305

Cubo-Futurism, 51, 165

culture, mass, 14, 79, 102, 142, 186, 188-192, 226, 267, 359

Cunningham, Imogen, 141-142, 370

Cuomo, Bruno. *See* Doug Hammett

Curtis, Edward Sherriff, 370

d

Dabrowski, Magdalena, 163, 165

Dada, 71, 319-322

Dali, Salvador, 285

Dallas Museum of Art, 146

Daniel Weinberg Gallery, 123-124

Dannemayer, William, 344

Danto, Arthur, 34

Dark Ages, 308

Darwin, Charles, 106

Daumier, Honoré, 302

David, Jacques Louis, 76-77

Davis, Ron, 44-48

Davison Art Center, Wesleyan University, 137

DeCamp, Joseph, 238

decoration, 7, 17, 19, 29, 49, 88, 90, 107, 143, 156-159, 199, 208, 341

decorative arts, 199, 242-243, 300, 365

Degas, Edgar, 29, 182, 293, 302, 343

Degasis Moran, Diane, 52

De Kooning, Willem, 24, 130, 186, 227-228, 254-255, 321

Delacroix, Eugène, 293

Delaunay, Robert, 182, 346

De Menil, Dominique, 254

democracy, 84, 95, 116, 157, 194, 261, 345, 373

Deng Xiaoping, 321

Denis, Maurice, 135

Derain, André, 182

De Stijl, 354

Dibbets, Jan, 287
Didion, Joan, 261, 263
Diebenkorn, Richard, 23, 151-152, 270
Dill, Guy, 30
Dill, Laddie John, 8-10
Disney, 13, 63, 94, 112, 129-130, 332
Di Suvero, Mark, 323-324
Döblin, Alfred, 194
Documenta, 258
Dornan, Robert, 344
Douglas, Aaron, 118
Douglass, Frederick, 118-120
Dove, Arthur, 120, 149
Dowell, Roy, 48-49
Downes, Rackstraw, 138
Dracula, 131, 139
Drexler Lynn, Martha, 199
DuBois, W.E.B., 73-74
Duccio di Buoninsegna, 301, 314
Duchamp, Marcel, 71, 186, 198, 271, 280, 321-322
Dunitz, Robin J., 392
Dunning, Brad, 329
Du Pont, 240
Durand, Asher B., 5
Durbe, Dario, 273
Dürer, Albrecht, 66, 247-251, 283, 379-380
Duyckinck, Gerardus, 236

e

Eakins, Thomas, 237-238
Eames, Charles, 326, 358
Eames, Ray, 326
École des Beaux Arts, 135
Eden, 26, 59, 111, 119, 204-205, 263-265, 302,
 341, 391
Edwards, Mel, 71
Eisenhower, Dwight D., 23
Eisenstaedt, Albert, 363
Elderfield, John, 60
elitism, 232-233, 349
Ellis, Perry, 375
Emerson, Ralph Waldo, 5
Ensor, James, 163, 345-346
Ensslin, Gudrun, 175
"Entartete Kunst", 347-350
Entenza, John, 326-327
Equal Employment Opportunity Commission
 (EEOC), 371-372
Ernst, Max, 182
Espinoza, Augustin and Cecelia, 392
ethnicity. See multiculturalism
Evans, Walker, 123, 128, 193
Exile gallery, 239-240
existentialism, 23, 94, 102, 227-228
Expressionism, 10, 76-78, 129, 217, 259, 303,
 341, 348
"exquisite corpse," 157
Eyck, Jan van, 112

f

Fairbrother, Trevor, 228
Falwell, Jerry, 344
family values, 376
Fantin-Latour, Henri, 302
Farm Security Administration (FSA), 364
Farnese Hercules, 65
fascism, 174, 193, 276, 364
Fattori, Giovanni, 275
les fauves, 182
Federal Art Project. See Works Progress
 Administration
Federal style, 241
Feitelson, Lorser, 49-52
Fels, Thomas Weston, 369
feminism, 27, 126, 205, 274, 305, 359
Ferber, Herbert, 28
Ferencz, F.K., 387-388
Fern, Arnold, 311
Ferus Gallery, 20, 22
film. See movies
Finkelpearl, Tom, 71
Finley, Karen, 372
First Amendment, The, 140
First Interstate World Center, 107-110
Fischbach Gallery, 81
Fischl, Eric, 13, 53-56, 282, 342
Fisher, David, 323
Fisher Gallery, USC: "The California Sculpture
 Show," 257; "Hendrick Goltzius and the
 Classical Tradition," 65-67
Fiskin, Judy, 56-58, 193
Fitzpatrick, Robert J., 258
flag-burning, 336
Fleck, John, 348, 372
Flower Power, 88-89, 91, 200
Flowers, Wayland, 375
FMR journal, 36
folk art, 36, 329, 368, 376
Ford, Gordon Onslow, 284-285
formalism, 11, 15, 26, 86, 88, 103, 124-126,
 216, 257
Fort Lauderdale Museum of Art, 286
Fort, Ilene, 202
Foucault, Michel, 375
Fra Angelico, 247, 313
Fragonard, Jean Honoré, 280-282
Francesca, Piero della, 301
Frankenstein, Alfred, 270
Frankenthaler, Helen, 41, 58-61, 139, 228
Frash, Robert, 26
Frederick S. Wight Art Gallery, UCLA, 318;
 "Lorser Feitelson and Helen Lundeberg: A
 Retrospective Exhibition," 50-52; "The
 Macchiaioli: Painters of Italian Life, 1850-
 1900," 273-276
Freeman, Judi, 321-322
French Academy, 182

Freud, Lucien, 341
Freud, Sigmund, 90, 201
Frick, Henry Clay, 300
Frick Museum, 162, 299-303
Fried, Michael, 46-48, 124
Friedman, Martin, 323
Friedrich, Caspar David, 223
Frimkess, Michael, 244-245
Frohnmayer, John E., 372
Funk art, 198, 270-271
Futurism. *See* Italian Futurism

g

Gale, Dorothy, 183
Gance, Abel, 77
Gare d'Orsay, 294
Garth Clark Gallery, 195, 243-245
Garza, Luis C., 392-393
Gaugin, Paul, 87, 252, 295, 354
Gehry, Frank O., 17, 20, 61-63, 251, 255, 324, 332-333
Gemini G.E.L., 103
gender, 19, 205, 334
George Doizaki Gallery, 259, 277
German Expressionism, 77, 175
German Gothic, 295
Gérôme, Jean-Léon, 182
Gershwin, George, 206
Gerstler, Amy, 206
Getty. *See* J. Paul Getty
Giacometti, Alberto, 209-211
Gignoux, Régis François, 86
Gilbert and George, 289
Giorgione, 136, 233
Giotto, 119
glamour, 6, 18-19, 31, 146, 226, 370
God, 8, 10, 15, 22, 52, 187, 204, 314, 327, 333, 391
Goethe, Johann Wolfgang von, 248
Gogh, Vincent van, 78, 87, 92, 180, 224, 252, 293, 298-299, 302, 354
Golden Age, 26, 49, 154
Goldin, Amy, 238, 263
Goltzius, Hendrick, 63-67
Golub, Leon, 67-70
González, Julio, 132
Goodacre, Glenna, 381, 384-385
Goodyear, A. Conger, 252
Gopnik, Adam, 356
Gordon, Allan M., 73
Gorky, Arshile, 40, 59, 286
Gottlieb, Adolph, 284
Goya, Francisco José de, 135, 176, 183, 282
graffiti, 115, 260
Graham, John, 284
Graham, Robert, 112, 259-260
Grand Palais, 181
Grandma Moses, 329
Graves, David, 83-84
Great Altar of Zeus, 68

Great Depression, 118-120, 188, 205, 390-391
Greco, El, 213
Greek Ministry of Culture, 306, 308
Greenberg, Clement, 11, 15, 41, 124, 130, 190
Grey Art Gallery, New York University, 17, 226-228
Grien, Hans Baldung, 248
"Grosse Deutsche Kunstausstellung", 349-350
Grosz, George, 346, 363
Grundberg, Andy, 286
Grunwald Center for the Graphic Arts, UCLA: "Sylvia Plimack Mangold: Works on Paper, 1968-1991," 137-139
Guston, Philip, 223
Gutenberg, Johann, 250, 378
Guttman, John, 370

h

Haacke, Hans, 13, 31-32
Hall, Emma, 360-361
Hallward, Basil, 45
Halston, 375
Hamilton, Ann, 168
Hammer, Armand, 280, 299-303, 386
Hammett, Doug, 311-312
Hammons, David, 70-72, 355
Hampton, Virginia, University Museum, 118
Happenings, 217
Harcourt, Glenn, 65
Haring, Keith, 121, 375
Harlem Renaissance, 73-75, 118
Harmon Foundation, 118
Hart, Frederick, 381, 384
Hartlaub, Gustav, 345-346
Hartmann, Sadakichi, 140
Haussmann, Baron Georges-Eugène, 294
Hawkins, Richard, 309
Hayden, Palmer C., 73-76
Heade, Martin Johnson, 5
Heartfield, John, 364
Heda, Willem, 377
Heilig, Eugen, 363
Helms, Jesse, 344-345, 346, 348, 350
Hendrix, Lee, 378
Henri, Robert, 202
Henry, John, 75-76
Henry Francis du Pont Winterthur Museum. *See* Winterthur Museum
Henson, Jim, 231
Heritage Foundation, 345, 346, 348, 350
Herman, Roger, 76-78
Hesse, Eva, 79-81, 138, 352, 359
Heyman, Therese, 369
Hickey, Dave, 186, 227-228
"high art," 89, 201, 228
high culture, 232, 331, 356
Hines, Thomas S., 318
Hiromu Kira, 277
Hispanic art, 259, 303-304

history painting, 54
Hitler, Adolph, 32, 79, 346, 349-350
Hockney, David, 81-84
Hodgetts, Craig, 327
Hoefnagel, Joris, 378-380
Hofer, Candida, 193
Hoffman, Hans, 13, 49
Holbein, Hans, 342
Hollein, Hans, 295
Hollywood, 50, 61, 185, 188, 189, 207, 226, 370
Holo, Selma, 65
Holocaust, The, 16, 68
Home Federal Savings and Loan, 233
Homer, Winslow, 190
homosexuality, 141-142, 159, 207, 228, 281,
 309-312, 337, 348, 372-376
Hopkins, Henry, 50, 185
Hopper, Edward, 49
Howard, Robert, 271
Hudson, Rock, 375
Hudson River School, 5, 7, 86, 97, 105, 265
Huebler, Douglas, 13
Hughes, Holly, 348, 372
Hughes, Langston, 73
Hughes, Robert, 338-343
Hulten, Pontus, 253, 255
humanism, 104, 249, 308
Humphrey, Ralph, 359
Huntington Library and Art Gallery, 199
Hurrell, George, 370
Hussein, Saddam, 32
Hyatt Foundation, 61
Hyde, Henry J., 383-384

i

identity politics, 113
Impressionism, 91, 131, 257, 292-293, 308;
 California, 204; French, 87, 275; Italian, 275
Indianism, 389
Indochina. See Vietnam
industrial revolution, 295
Ingres, Jean Auguste Dominique, 352
Inness, George, 85-88
Institute of Artistic Culture, Moscow, 163
Institute of Contemporary Art, New York, 71
Institute of Contemporary Art, Philadelphia, 347
Institute of Contemporary Arts, London:
 "Mike Kelley: Works 1979-1991," 98-101
Institute of Fine Arts, New York, 356
Institutions, 30, 72, 96, 110, 163, 234, 251-256, 259,
 269, 289, 315-316, 318, 325, 334, 373, 386-387
International Center of Photography, New York,
 121
International Style, 144, 252, 326
Interview magazine, 122
Irwin, Robert, 145, 198
Ischar, Doug, 311
Isermann, Jim, 88-91
Isherwood, Christopher, 82

Isozaki, Arata, 239, 332
Italian Futurism, 113, 131, 164, 388

j

J. Paul Getty: Center for Education in the Arts,
 266-269; Center for the History of Art and
 Humanities, 331; Conservation Institute,
 387, 392; Trust, 162, 266-269
J. Paul Getty Museum, 160-163, 213, 289, 295;
 "Art and Science: Joris Hoefnagel and the
 Representation of Nature in the Renais-
 sance," 376-380; "August Sander: Faces of
 the German People," 192-194; "Sixteenth-
 Century Northern European Drawings," 65-67
Jack Rutberg Fine Arts, 16
Jackson, Jesse, 70
Jackson, Michael, 266
James, Henry, 97
Japanese-Americans, 276-279
Jaramillo, Virginia, 303
Jawlensky, Alexej, 91-94
jazz, 74, 90, 154, 360, 362
Jeu de Paume, 292
Jewish Museum, New York, 59
John E. Anderson Graduate School of Manage-
 ment, UCLA, 316-319
John Herron School of Art, 40
John M. Olin Foundation, 344
Johns, Jasper, 24, 184-186, 191, 272
Johnson, Larry, 94-95
Johnson, Phillip, 63, 108
Johst, Hanns, 345
Jones, Cleve, 373, 375
journalism, 43, 270, 305
Judaism, 79, 337, 347-348, 363
Judd, Donald, 61, 63
Judeo-Christian, 78

k

Kabakov, Ilya, 355
Kabuki, 257
Kahlo, Frida, 368
Kalf, Willem, 377
Kandinsky, Vasily, 59, 93, 182, 286
Karsh, Yousuf, 358
Kauffman, Craig, 198
Kaye Shimojima, 278
Kellein, Thomas, 99
Kelley, Mike, 13, 95-103, 209, 254, 329, 333,
 337, 359
Kelly, Ellsworth, 103-104, 144, 167, 324-325, 358
Kennedy, Jackie, 228, 329
Kensett, John Frederick, 5, 105-107
Kent, Adaline, 271
Kentaro Nakamura, 277, 370
Kerouac, Jack, 188
Kertész, André, 363
Kiefer, Anselm, 286

Kilpatrick, James J., 383
King Tut, 231, 233, 241
King, Rodney, 364
Kirchner, E.L., 346
Klee, Paul, 123
Klein, Yves, 167
Kline, Franz, 121, 186, 227
Koenig, Pierre, 326-327
Kokoschka, Oskar, 345
Komar, Vitaly, 107-110
Koons, Jeff, 110-113, 356
Koshalek, Richard, 328
Kossoff, Leon, 113-115, 341
Kramer, Hilton, 343-345
Kren, Thomas, 378
Kruger, Barbara, 115-118, 286-287
Kuhlenschmidt/Simon Gallery, 88
Kunstakademie, Düsseldorf, 193
Kunsthalle, Basel, 99
Kunsthalle Mannheim, 345

l

Lacy, Bill N., 61
Laguna Art Museum, 202; "American Craft Today," 289-292; "Elmer Bischoff," 23-26; "David Park," 151-154
La Jolla Museum of Contemporary Art. *See* Museum of Contemporary Art, San Diego
Lakich, Lili, 108
L.A. Louver gallery, 21, 113
Laloux, Victor, 294
Lancher, Carolyn, 182
Landi, Neroccio de', 313
Lane, Lois, 359
Lange, Dorothea, 364, 370
Lannan Foundation, 31, 175; "Body/Language," 209-212; "Head-On/The Modern Portrait," 354-355, 358
Laocoön, 131
Larsen, Susan C., 255
Lassaw, Ibram, 28
Lattin Duke, Lani, 266
Laurencin, Marie, 302
Lawrence, Jacob, 118-120
Lega, Silvestro, 274-275
Leger, Fernand, 123, 182
Leibovitz, Annie, 120-122
Leo Castelli Gallery, 89
Leonardo da Vinci, 160, 258, 281, 302
Levine, Sherrie, 122-126, 286-287
Levitt, Helen, 126-128
Lewitt, Sol, 81, 208, 323
Leyden, Lucas van, 66
Liberace, 375
Lichtenstein, Roy, 41, 129-131, 138, 217-218, 227, 272
Life magazine, 311
Light and Space, 5, 145, 254

Lin, Maya, 32-34, 382-385
Linda Cathcart Gallery, 200
Lionni, Leo, 358
Lipman, Howard, 254-255
Lipman, Jean, 254
Lipman, Samuel, 348
Lipton, Seymour, 28
List Visual Arts Center, Massachusetts Institute of Technology, 146
Little Orphan Annie, 188
Locke, Alain L., 73
Lone Ranger, The, 385
Long Beach Museum of Art, 92, 360-361; "Alexej Jawlensky: From Appearance to Essence," 91-94
López Garcia, Antonio, 341
Lord, Andrew, 131-134
Lorenzetti, Pietro and Ambrogio, 314-316
Lorrain, Claude, 86
Los Angeles, 10, 12, 18, 22, 32, 39, 47, 61, 63, 64, 71, 76, 81, 143, 153, 166, 169, 184, 202, 217, 243, 254, 256-260, 260-265, 277, 286, 301, 328, 354, 359, 370-371; *Artforum* published in, 46, 190; as artistic center, 20; artists in, 190; commercial galleries in, 239; contribution to contemporary art, 5; diversity/ multiculturalism in, 110; downtown, 252; founding ethos of art in, 101; L.A. Pop, 198; Los Angeles Basin, 264; as modern-day Siena, 316; murals in, 387-393; New York art establishment's indifference to, 151; as outside high-culture mainstream, 207-208; El Pueblo de la Reina de los Angeles, 109, 263, 387, 390, 393; public artworks in, 108; real-estate gentrification in, 29-30; as "Second City" of American art, 49-50; state of art and artists in, 385-387; as world-class art city, 331-338
Los Angeles Conservancy, 319
Los Angeles Contemporary Exhibitions (LACE): "Against Nature: A Show by Homosexual Men," 309-312
Los Angeles County Arts Commission, 386
Los Angeles County Museum of Art (LACMA), 45, 172, 197, 202-205, 296, 300-303, 331, 386; "American Portraiture in the Grand Manner: 1720-1920," 235-238; "The Avant-Garde in Russia: 1910-1930," 163; "Billy Al Bengston: Paintings of Three Decades," 17-20; "The Century of Tung Ch'i-ch'ang: 1555-1636," 219-221; "The Clay Art of Adrian Saxe," 197-200; "The Dada and Surrealist Word-Image," 319-322; "A Day in the Country: Impressionism and the French Landscape," 257, 259, 298; "Degenerate Art: The Fate of the Avant-Garde in Nazi Germany," 192, 345-350; "Helen Frankenthaler: A Paintings Retrospective," 58-61; "The Human Figure in Early Greek Art," 306-309; "George Inness," 85-88; "Mike Kelley," 101-103; "John Frederick

Kensett: An American Master," 105-107;
"Jacob Lawrence: The Frederick Douglass and
Harriet Tubman Series of Narrative
Paintings," 118-120; "Helen Levitt," 126-128;
"Masterpiece in Focus" (Goltzius), 64-67;
"Mexico: Splendors of Thirty Centuries," 35-
39, 365-368; "A Mirror of Nature: Dutch
Paintings From the Collection of Mr. and
Mrs. Edward William Carter," 377; "Photo-
graphy and Art: Interactions since 1945," 20,
286-289; "Liubov Popova," 163-166, 354, 357;
"Why Artists Draw: Six Centuries of Master
Drawings from the Collection," 350-353;
"Women Artists, 1550-1950," 149
Los Angeles Institute of Contemporary Art
(LAICA), 195-196, 259
Los Angeles Modern Art Society, 202
Los Angeles Music Center, 332, 385-386
Los Angeles Times, 280, 346
Los Angeles Valley College art gallery;
"Japanese American Photography in Los
Angeles, 1920-1945," 276
Louis, Morris, 15, 41, 46, 59, 130
Louvre Museum, 134-135, 257, 292
love, 66, 112, 373, 375
Loyola Marymount University art gallery:
"Alice Neel: Paintings, 1933-1982," 148-151
Luce, Henry, 340
Lucie-Smith, Edward, 289, 291
Ludlum, Charles, 375
Ludwig, Peter and Irene, 254, 295, 297
Luminism, 265
Lundeberg, Helen, 49-52
Lust for Life, 78
Luther, Martin, 250
Lutheran Reformation, The, 249, 269, 280
Lyon, Lisa, 141-142
Lyrical Abstraction, 59

m

Macchiaioli, 273-276
Maenz, Paul, 297
Magnuson, Ann, 329
Magritte, Rene, 122, 285, 320-321, 330
Maholy-Nagy, Laszlo, 277, 287, 363
mainstream culture. *See* culture, mass
Malevich, Kazimir, 15, 163-165, 167
Malraux, André, 182
Man, Felix H., 363
Man Ray, 370
Manet, Édouard, 134-137, 176, 182-183, 280,
282, 293, 330
Mangold, Robert, 138
Manhattan. *See* New York, NY
Mannerism, 52, 63, 65-66, 148, 160, 344
Manzanar, 117
Manzu, Giacomo, 323-324
Mapplethorpe, Robert, 139-142, 346-348, 372,

375
Maratta, Carlo, 351
Marden, Brice, 138, 144
Margo Leavin Gallery, 14, 132, 361-362
Marin, John, 59, 178
Marini, Marino, 323-324
Martin, Agnes, 126, 144
Martini, Simone, 314
Marx, Leo, 263
Masaccio, 313, 388
Mason, John, 196, 243, 245
Mather, Margrethe, 370
Matisse, Henri, 13, 74, 99, 120, 123, 131-132,
154, 182, 247
Matta Echuarren, Roberto, 284, 286
Maxwell, Hamish, 289
McBride, Henry, 252
McCarthy, Joseph, 68, 384
McCarthy Gauss, Kathleen, 286
McCollum, Allan, 142-143
McCoy, Esther, 328
McKinney, Stewart, 375
McLuhan, Marshall, 90
media, mass, 13-14, 18, 53, 68-69, 122, 234,
238, 272, 288, 340, 343
Medici, Duke Cosimo I de', 161, 351
medieval art, 377
Meese, Edwin, 279-283
Meier, Richard, 63, 295
Meinhof, Ulrike, 175-177
Melamid, Alexander, 107-110
Mendoza, Tony, 303
Mengele, Joseph, 100
"Metropolis" (exhibition), 99
Metropolitan Museum of Art, New York, 105,
246, 301, 365; "Édouard Manet," 134-137;
"Painting in Renaissance Siena, 1420-1500,"
313-316; "Treasures of Tutankhamun," 231,
233, 241, 367
Metzinger, Jean, 164
Meurent, Victorine, 134, 280
M.H. de Young Memorial Museum: "The Vatican
Collections: The Papacy and Art," 246-248
Michelangelo, 65, 52, 78, 119, 161, 219, 231-235,
281, 351, 382, 386
middle class. *See* bourgeoisie
Midler, Bette, 121-122
Miller, John M., 143-145
Miller, Tim, 372
Ming Fung, 327
Minimalism, 18, 27, 54, 59, 62-63, 79, 81, 102,
132, 143-146, 148, 168, 201, 207, 214, 223,
355, 366
Minneapolis Sculpture Garden, 323-325
Miró, Joan, 59, 104, 123, 156-157, 182, 215,
244, 271, 284, 286, 320-322
Mitchell, Joan, 359
Mnouchkine, Ariane, 257
Modern Art Museum of Fort Worth, 59

Modernism, 51, 120, 151, 234, 383; American, 58, 278; re John Baldessari, 12, 15; re Hermenegildo Bustos, 36; a canard of, 341; collapse of, 194-195, 253; European, 59, 85-86, 285; its faith, 45, 50; re Florence and Siena, 314-315; re Robert Graham and Jeff Koons, 112; and the grid, 294, 323; re John Heartfield, 364; High, 171; as ideal domain of freedom, 26; re George Inness, 85-88; re Roy Lichtenstein, 130-131; re Sylvia Plimack Mangold, 138-139; Mexican, 365, 367-368; re Alice Neel, 149; nineteenth-century, 308; photographic, 369-370; reassessing, 142, 309; re Henri Rousseau, 183; its self-consciousness, 74-75; re Jim Shaw, 201; re Henrietta Shore, 203-205; re Alexis Smith, 207-208; re Gary Stephan, 215; re Alfred Stieglitz, 287; tenets of, 96; re Wayne Thiebaud, 216, 218

Mondrian, Piet, 89, 98, 138, 224, 254, 354

Monet, Claude, 293

Monroe, Marilyn, 180, 228

Monterey Peninsula Museum of Art, 202

Montreal Museum of Fine Arts, 174

Moore, Henry, 323

morality, 14, 33, 44, 48-49, 97-98, 103, 105, 112, 150, 152, 157, 159, 171, 177, 199, 201, 211, 265, 280, 311-312, 319, 336-337, 348, 382

Moreau, Gustave, 280, 302

Morisot, Berthe, 136

Morris, Robert, 81

Morris, William, 291

Morris Hambourg, Maria, 128

Mosse, George L., 348

Motherwell, Robert, 228

movies, 11, 13, 65, 77-78, 96, 185-188, 206, 233, 308, 322, 372, 376

Mullican, Matt, 13

multiculturalism, 19, 110, 336-337, 343-345

Munch, Edvard, 345

Municipal Art Gallery, Los Angeles, 259; "Art in Clay," 257; "Mira! The Canadian Club Hispanic Art Tour," 303-304; "Monochrome Painting," 166-168

Münter, Gabriele, 93

Muppets, The, 231-235

murals, 68, 107, 115-118, 153, 260, 387-393

Murphy, Brian, 17

Murray, Elizabeth, 146-148, 359

Musée d'Orsay, 292-295

Musée Picasso, 292

Museo del Pueblo, Mexico City, 35

Museo Pio-Clementino, 247

Museum Boymans van Beuningen, 190

Museum of African American Art, Los Angeles: "Echoes of Our Past: The Narrative Art of Palmer C. Hayden," 73-76

Museum of Contemporary Art, Bordeaux, 99

Museum of Contemporary Art, Los Angeles (MoCA), 95, 98, 116, 227, 239-240, 331-333; "The Automobile and Culture," 257-259; "John Baldessari," 11, 14-15; "Blueprints for Modern Living: History and Legacy of the Case Study Houses," 325-328; "Lee Bontecou: Sculpture and Drawings of the 1960s," 26-28; "The First Show: Painting and Sculpture from Eight Collections, 1940-1980," 251-256, 295; "A Forest of Signs: Art in the Crisis of Representation," 117-118, 142-143, 166, 322; "High & Low: Modern Art and Popular Culture," 354, 356-358; "Roy Lichtenstein," 129-131; "Elizabeth Murray: Paintings and Drawings, 1976-1980," 146-148; "Edward Ruscha," 189-192; "Alexis Smith," 205-208; "Summer 1985: Nine Artists," 223

Museum of Contemporary Art, San Diego: "Golub," 67-70; "David Hammons," 70-72

Museum of Modern Art, Frankfurt, 174, 298

Museum of Modern Art, New York (MoMA), 32, 46, 59, 163, 167, 209, 226, 251-256, 284, 289, 318, 353-359; "The Art of the Forties," 358; "Artist's Choice" series, 358; "Dislocations," 31, 33, 355, 358; "Information," 31, 355; "Modern Architecture: International Exhibition," 252; "'Primitivism' in 20th-Century Art: Affinity of the Tribal and the Modern," 356-357; "Henri Rousseau," 180-184

Museum of Photographic Arts, San Diego: "Camera as Weapon: Worker Photography Between the Wars," 362-365

museums, 34, 270, 331-332

Muybridge, Edweard, 369-371

Muzak, 111

Myers, John Bernard, 228

Myron, 121

mysticism, 92, 107, 161

mythology, 68, 95, 120

myths, 26, 37, 243, 325, 352; of Modernism, 12, 139, 201, 341; of "neutral" space for display of art, 295; Roman, 66; of self-expression, 78, 291

n

Nabis, 295

Naef, Weston, 192-193

Naifeh, Steven, 353

Naismith, James, 71

NAMES Project AIDS Memorial Quilt, 372, 373-376

Nam June Paik, 343

Napoleon III, 330

The Nation, 34

National Council on the Arts, 371

National Endowment for the Arts (NEA), 117-118, 281, 336, 343, 345-350, 371-373

National Endowment for the Humanities (NEH), 241

National Gallery, Prague, 181

National Gallery of Art, Washington, D.C., 62, 85, 88, 279, 293, 301-302, 306
National Institute of Fine Arts, Mexico, 35
National Museum of Women in the Arts, 372
National Portrait Gallery, 121
National Review, 383
National Socialism. *See* Naziism
Native Americans, 76, 109, 248, 263, 389; Aztec, 109, 388-389; Maya, 22, 388-389; Mexica, 365-366; Olmec, 365, 388; Pre-Columbian, 365-368, 388; Pre-Hispanic, 367; Toltec, 388
Nauman, Bruce, 81, 333, 342, 355
Naziism, 16, 79, 100, 173, 192, 276, 345-350, 363-364
NEA 4, 372
Neagle, John, 236
Neel, Alice, 148-151
Nelson-Atkins Museum of Art, 219
neoconservatism. *See* conservatism
Neoclassicism, 74, 308
Neo-Dada, 271
Neoexpressionism, 10, 24, 67, 76, 78, 95, 144, 254, 259, 272, 276, 339, 350
Neoplasticism, 254
Neo-Platonism, 55, 231
Neoprimitivism, 74
Nepomuceno Herrera, Juan, 36
Neutra, Richard, 63, 316-319
New City Gallery, 143
The New Criterion, A Monthly Review, 343-345
Newhall, Beaumont, 192
New Image painting, 214
Newman, Barnett, 15, 102, 256, 284
New Negro Movement, 73-75, 118
Newport Harbor Art Museum, 259, 283; "Inside Out: Self Beyond Likeness," 149; "The Interpretive Link: Abstract Surrealism into Abstract Expressionism; Works on Paper, 1938-1948," 283-286; "David Park: Unyielding Humanist," 152; "Charles Ray," 168-171; "Success is a job in New York...: The Early Art and Business of Andy Warhol," 225-228; "Wayne Thiebaud," 216-218; "Typologies," 193
New York, NY, 10-11, 16, 20, 26, 31, 44, 59, 73, 79, 106-108, 117-118, 132, 146, 149, 202, 209, 217, 246, 284, 299-303, 333, 339, 353-359, 366; Abstract Expressionism leaves, 272; art establishment in, 49, 151; *Artforum* moves to, 190; artists in, 334; art world's exclusionary focus on, 39, 47, 49, 151, 153; critics in, 34, 46-47; re Hans Hoffman, 13; L.A. is not, 337-338; re Helen Levitt, 127-128; as modern-day Florence, 316; re David Park, 153; postwar art world in, 137, 152, 359
New Yorker magazine, 356
New York Review of Books, 98
New York School, 13, 18, 27, 47, 58-59, 203, 228, 359

New York Society of Women Artists, 202
New York Sun, 252
New York Times, The, 33, 62, 286, 344
Noland, Kenneth, 59
Nolde, Emil, 93, 347
Northridge earthquake, 393
Norton Simon Museum, 313, 331
Novak, Barbara, 7

O

Oakland Museum, 153
ocean. *See* surf
October journal, 282
O'Keeffe, Georgia, 59, 125, 202, 233, 283
Old Masters, 86, 136, 144, 160, 254, 300, 302
Oldenburg, Claes, 61, 63, 132, 147, 324
Ollman, Leah, 363-365
Olympic Arts Festival, 256-260
Olympic Games, 331, 375
Op art, 124, 126, 145
Operation Desert Storm. *See* Persian Gulf War
Orozco, José Clemente, 365, 388
Orozco Muñoz, Francisco, 35, 68
Orpheus movement, 269
Otis Art Institute. *See* Otis College of Art & Design
Otis Clay, 196, 198, 243-245
Otis College of Art & Design, 20, 48, 195, 196, 243-245
Otis/Parsons. *See* Otis College of Art & Design

P

Paalen, Wolfgang, 284
Pach, Walter, 35
Pacific-Asia Museum, 259
Pacific Rim, 259
Palazzo Pùbblico, 315
Palevsky, Max, 239-240
Pan Pacific Auditorium, 316
Panza di Biumo, Giuseppe and Giovanna, 254
Paolo, Giovanni di, 313
Park, David, 23, 76-77, 151-154, 270-272
Parkett magazine, 227
Parks, Gordon, 364
Parrish, Maxfield, 389
Pattern and Decoration art, 157
Paz, Octavio, 36
Peale, Charles Willson, 236
Peale, Rembrandt, 236
Pei, I.M., 63, 292, 318
Peloponnesian War, 33
People magazine, 235
Performance Art, 18, 168
Perot, Ross, 384
Persian Gulf War, 32, 34
Petersen, Martin, 234
Phelan, Ellen, 155
Philadelphia Museum of Art, 64

Philip Morris Cos., Inc., 289, 291
Phillips, Sandra S., 128
Phoenix Art Museum: "Annie Liebovitz: Photographs, 1970-1990," 120-122
photojournalism, 43-44, 68, 362-365
Photo-Realism, 41, 82, 176
Picabia, Francis, 98, 321-322
Picasso, Pablo, 29, 62, 68, 83, 132, 147, 164, 182, 190, 206, 219, 231, 244, 255, 280, 286, 304-305, 356, 358
Pickett, Mattie, 360-361
Pictorialism, 277-278, 369-370
Piero di Cosimo, 160
Pietà, 119, 382
Pinocchio, 159
Piper, Adrian, 355
Pissarro, Camille, 302
Pittman, Lari, 156-159
Pixchure, Johnny, 311
Playboy magazine, 112, 280-281, 330
Pledge of Allegiance, 117, 336
plein air, 67, 204
Plimack Mangold, Sylvia, 137-139
Plotinus, 55, 225
Poland, Reginald, 203
politics, 18, 23, 33, 68, 70-71, 76, 115, 157, 174, 194, 199, 209, 231, 250, 295, 303, 311, 343-345, 348-349, 383-385
Polke, Sigmar, 41
Pollock, Jackson, 46, 59-60, 80, 100-101, 130, 217, 227-228, 254-255, 284, 342, 352-353, 358-359
Pomona College, 68
Pontormo, Jacopo, 160-163
Pop Art, 42, 67, 102, 146, 201, 218, 254, 271, 295; emergent, 40, 79, 190, 253, 356; re Frank Gehry, 63; re Roy Lichtenstein, 129-131; in Los Angeles, 198; re Elizabeth Murray, 147; re Edward Ruscha, 188; as seachange, 18, 27; as subversive, 91, 108; re Andy Warhol, 225-228, 355-356
Pope Gregory XV, 251
Pope John Paul II, 246
Pope Paul III, 98
Popeye, 147
Popova, Liubov, 163-166, 354, 357
popular art, 49, 89, 105, 183, 234
popular culture, 5, 6, 57, 78, 122, 129-130, 180, 207, 226, 232, 234, 242, 257, 354, 358
populism, 232-233, 328, 348-349
pornography, 44, 279-283
Postimpressionism, 87, 93, 257, 292-293
Postmodernism, 15, 24, 108, 144, 159, 184, 253, 294, 371
Post-Painterly Abstraction, 59
Potter, Carter, 311
Pousette-Dart, Richard, 284
Poussin, Nicholas, 219, 342
power, 10, 13, 66-67, 69-70, 76, 161, 332, 386-387

Precisionism, 265
Price, Ken, 196, 243-245
Primitivism, 47, 347, 389
Prina, Stephen, 166-168
Prince, Richard, 286
Print magazine, 191
Pritzker Architecture Prize, 61-63, 295
propaganda, 251, 290, 362
Protestantism, 377
Proust, Antonin, 134
provincialism, 146, 203, 205, 259, 269, 271, 331, 335
P.S. I Museum. See Institute of Contemporary Art, New York
psychedelia, 88, 90, 97, 122, 200, 273, 329
Public Broadcasting System (PBS), 178, 338
public art, 29-30, 31, 33, 107, 110, 237-238, 262
El Pueblo de Los Angeles State Historic Monument, 387, 390, 392-393
Puritanism, 112, 336

q

Queen Anne style, 241-242
Queens Museum, NY, 289
Quick, Michael, 85, 88, 202, 235
Quinn Sullivan, Mary, 252

r

racism, 174, 177, 279, 309, 372
Radice, Anne-Imelda, 371-373
Rand Corporation, 267
Raphael, 65, 136, 247
Rapson, Ralph, 326-327
Raspe, Jan Carl, 175
Rauschenberg, Robert, 76, 186, 272, 288, 321
Ray, Charles, 168-171
Read, Sir Herbert, 305
Reagan, Ronald, 13, 167, 293, 371-374, 383-384
Realism, 36, 39, 63, 74, 118, 137, 218, 293, 303, 341
Redon, Odilon, 182
Reed, Dennis, 277
Regency, 14
religion, 99, 274, 329, 347, 352, 391
Rembrandt van Rijn, 63, 172-173, 219, 302
Renaissance, 14, 47, 65-66, 161, 74, 114, 131, 161, 183, 232, 234, 248-251, 295, 301, 308, 313-316, 351, 377-378, 382, 388
Renaissance Society, Chicago, 166
Renger-Patzsch, Albert, 363
Reni, Guido, 342
Renoir, Auguste, 163, 302
Réunion des Musées Nationaux de France, 181
Revere, Paul, 110, 241-242
Richard Kuhlenschmidt Gallery, 143
Richter, Gerhard, 39-41, 173-177
Riley, Bridget, 124, 126
Risorgimento, 273-274

Rivera, Diego, 153, 365, 388
Robertson, Pat, 344-345
Robinson, Max, 375
Rockburne, Dorothea, 359
Rockefeller, Abby Aldrich, 252
Rockefeller, David, 31
Rockefeller, Nelson, 31, 241
Rockefeller Foundation, 343
rock 'n' roll, 102, 200
Rockwell, Norman, 329, 384
Rococo, 14, 211
Rodchenko, Alexander, 123, 163
Romano, Marc, 311
Romanticism, 90, 97, 223-225, 267, 270-271, 293, 303
Rosamund Felsen Gallery, 95, 156
Rose, Barbara, 46-48, 60
Rosenberg, David, 150
Rosenberg, Harold, 55, 150
Rosenberg, Julius & Ethel, 68
Roszak, Theodore, 28
Rothenberg, Susan, 359
Rothko, Mark, 22, 86, 88, 177-180, 255, 284
Rouault, Georges, 182
Rousseau, Henri, 180-184
Route 66, 185
Rowan, Robert, 254
Rubens, Peter Paul, 247-248
Rubin, William, 182, 356
Ruff, Thomas, 193
Ruscha, Edward, 11, 13, 41, 57, 184-192, 227, 255, 288, 333, 371
Ruskin, John, 24, 242, 342
Russian Constructivism, 63, 104, 131, 164
Russo, Vito, 375
Ryman, Robert, 144

S

Saatchi, Charles and Doris, 254
Salle, David, 13, 342
Salon d'Automne, 182
Salon des Indépendants, 181
Salon of 1865, 134
Samaras, Lucas, 54
Samples, Candi, 282
Sander, August, 192-194
San Diego Fine Arts Gallery, 203
San Diego Magazine, 234
San Diego Museum of Art: "The Art of the Muppets," 231-235
San Diego Union, 231, 233
San Francisco Art Institute, 213, 270
San Francisco Bay Area Beat movement, 22, 270, 273
San Francisco Bay Area Figurative Painting, 23, 152, 217, 270-271
San Francisco Craft and Folk Art Museum: "Who'd a Thought It: Improvisation in African-American Quiltmaking," 359-362

San Francisco Museum of Modern Art, 50, 216, 270; "Jeff Koons," 110-113; "Mark Rothko: Works on Paper," 177-180
Sano di Pietro, 313
Santa Barbara Museum of Art: "Art of the States," 259; "Eight Figurative Painters," 113; "Watkins to Weston: 101 Years of California Photography," 1849-1950," 368-371
Santayana, George, 6
Santoro, Gene, 362
Sargent, John Singer, 237
Sarto, Andrea del, 160
Saslow, James, 281
Sassetta, Stefano di Giovanni, 313
Saxe, Adrian, 194-200
Scheyer, Emmy, 93
Schiele, Egon, 123
Schiff, Hans, 362, 364
Schindler, Rudolph, 63
Schlesinger, Peter, 82
Schmalenbach, Hugo, 296
Schnabel, Julian, 254, 342
Schongauer, Martin, 379-380
Schoonhoven, Terry, 260
Schreiber, Taft and Rita, 254
Schwartz, Sanford, 54
Schwitters, Kurt, 16, 321-322
Scripps College, 243
sea. See surf
Segal, George, 132
Semina journal, 22
Serra, Richard, 138, 255, 324-325, 359
Serrano, Andres, 346-348
Seurat, Jacques, 29, 252, 354
Sèvres porcelain, 197
sex, 19, 22, 51-52, 54, 64-67, 69, 76, 78, 81, 100, 102, 111, 132, 140-142, 159, 161, 196, 197-198, 210-211, 215, 279-283, 311-312, 347
Shakespeare, William, 236, 257, 339
Shanghai Museum, 220
Shapiro, Michael, 174
Shattuck, Roger, 181
Shaw, Jim, 200-201, 328-331
Sheeler, Charles, 265
Sheppard, Francis, 360
Sherman, Cindy, 286-287
Shigemi Uyeda, 277, 370
Shore, Henrietta, 202-205
Shoshana Wayne Gallery, 210-211
Sickert, Walter, 343
Siebenbuerger, Valentin, 248
Sierra, Paul, 303
Simon, William, 344
Simpson, Glen, 292
Singerman, Howard, 179
Singing Nun, The, 99
Sinsheimer, Karen, 369
Siqueiros, David Alfaro, 365, 387-393
Sischy, Ingrid, 122

Siskind, Aaron, 287
Sister Corita, 99, 102
Sistine Chapel, 52, 161, 386
skateboards, 335
Smibert, John, 236
Smith, Alexis, 205-208
Smith, David, 28, 352
Smith, Elizabeth A.T., 26, 325
Smith, Gregory White, 353
Smith, Jeffrey Chipps, 248
Smith, Jerry, 375
Smith, Kiki, 209-212
Smith, Paul J., 291
Smith, Roberta, 33
Smith, Tony, 324-325
Smith, Willi, 375
Smithson, Robert, 13, 138
Soby, James Thrall, 251
social documentarians, 127
Socialist Realism, 76, 108
Social Realism, 74, 153, 285
Soldner, Paul, 243
Solomon R. Guggenheim Museum, 60, 129,
 178
Sondheim, Stephen, 371
Song of Bernadette, 15
Sontag, Susan, 140
Southern California, 9, 45, 47, 113, 153, 185,
 195, 257, 259, 262-263, 325, 370, 391
Spencer, Lady Diana, 235
Spengler, Oswald, 269, 345
Spohn, Clay, 271
Springinklee, Hans, 248
Stackpole, Peter, 265
Stackpole, Ralph, 153
Stalin, Joseph, 68
Staller, Ilona, 112
Star Wars, 308
Stassinopoulos Huffington, Arianna, 304-305
Stauffacher Solomon, Barbara, 324
Stegner, Wallace, 371
Stella, Frank, 9, 46, 321, 355
Stephan, Gary, 212-216
Sterling, Christine, 390
Stern, J.P., 218
Stieglitz, Alfred, 15, 278, 287
Still, Clyfford, 47, 49, 96-97, 255, 269-271
Stillman, Chauncey Devereaux, 162
Stirling, James, 63, 295
St. Louis Art Museum: Gerhard Richter, "18
 Oktober 1977," 173-177
Storr, Robert, 355, 358-359
Strand, Paul, 141-142
Stroganov Institute of Art and Design, 108
Struth, Thomas, 193
Stuart, Gilbert, 236
Stuart Regen Gallery, 94
sublime, the, 96-97, 228
suburbia, 12, 55, 56, 58, 63, 88, 191, 201, 262,

326, 330. 337. 342
Sully, Thomas, 236
Sultan, Donald, 341-342
Suprematism, 164-165
Supreme Court, 279-280, 372
surf, 6, 7, 19, 29-30, 101, 167, 213
Surrealism, 27, 51, 80, 89, 131, 147, 156, 178,
 181, 271, 283-286, 303, 319-322, 329, 354
Sutherland Harris, Ann, 150-151
Swedenborg, Emanuel, 86-87
Symbolism, 93
Syrop, Mitchell, 209

t

Takemoto, Henry, 196, 244
Tanager Gallery, 228
Tanguy, Yves, 284
Tarbell, Edmund, 237
Tatlin, Vladimir, 163-164
Taylor, Elizabeth, 228
television, 22, 49, 68, 96, 188, 201, 224-225,
 232, 243, 281, 304, 338-340, 343, 349, 364
Temple, Shirley, 188
Temporary Contemporary. See Museum of
 Contemporary Art, Los Angeles
Teske, Edmund, 370
Théâtre du Soleil, Le, 257
therapeutic culture, 385-386
Thiebaud, Wayne, 216-218
Thomas, Clarence, 371-373
Tibol, Raquel, 36
Tibor de Nagy Gallery, 46
Tidmus, Michael, 311
Tiepolo, Giovanni Battista, 352
Tilburg, Johannes van, 29
Time magazine, 339-340
Times Mirror Corporation, 258
Tintoretto, Il, 213, 219
Titian, 66, 136, 139, 219, 280
Tobey, Mark, 22, 284
Tomkins, Rosie Lee, 361
Tonelli, Edith, 273, 275
Tonto, 385
Tortue Gallery, 42
Toulouse-Lautrec, Henri de, 233
Toyo Miyatake, 277
Traut, Wolf, 248
Travis, David, 369
"triumph of American painting", 24, 88
Trumbull, John, 241-242
Trump, Donald, 332
Tsujimoto, Karen, 216-217
Tubman, Harriet, 118-120
Tung Ch'i-ch'ang, 219-221
Turner Dailey Gallery, 202-205
Turrell, James, 145
Tuttle, Richard, 222-223
291 gallery, 278

U

Uccello, Paolo, 313
Uffizi Museum, 160
Ulrike Kantor Gallery, 76
Unger, Oswald Matthias, 295
United States, 70, 72, 95, 98, 120, 185-186, 190, 209, 259, 263, 382-383, 389, 392
Universal Studios CityWalk, 390
University Art Museum, University of California, Santa Barbara: "Nuremberg: A Renaissance City," 248-251; "Rowing: Integrity and Tradition," 259
University of California, Irvine, 46
University of California, Los Angeles (UCLA), 39-40, 50, 58, 273, 316-319, 338-339; School of Architecture and Urban Planning, 318. *See also* Frederick S. Wight Art Gallery
University of California, Santa Cruz, 261
University of Michigan Museum of Art, 137
University of Southern California (USC), 61. *See also* Fisher Gallery
U.S. Information Agency, 386
Utopia, 136, 148

V

Van Bruggen, Coosje, 324
Van der Rohe, Mies, 144, 327, 333
Van Dyke, Willard, 265, 370
Vanity Fair magazine, 121, 338
Vantongerloo, Georges, 104
VanValkenburgh, Michael, 324
Varnedoe, Kirk, 356, 358
Vasari, Giorgio, 160, 351
Vatican, The, 231, 246-248, 386
Vauxcelles, Louis, 181
Velasco, José María, 39
Velázquez, Diego, 15, 135, 138, 219
Venus de Milo, 234
Venus of Willendorf, 279
Victorians, 88, 280
Vietnam Veterans Memorial, 32-34, 380-385
Vietnam War, 31-34, 67-68, 133, 173-174, 380-385
Vignau-Wilberg, Thea, 378
Viguerie, Richard, 344
Viola, Bill, 223-225
Virgin of Guadalupe, 366-367
Vlaminck, Maurice de, 302
Von Werefkin, Marianne, 93
Vorticist school, 113
Voulkos, Peter, 195-196, 243-245

W

Waddell, Tom, 375
Walker, John, 302
Walker Art Center, 143, 301, 323-325
Wallraf-Richartz Museum/Museum Ludwig, 295-298
Walsh, John, 163

Warhol, Andy, 12, 41, 88, 91, 130, 190, 218, 225-228, 235, 272, 288, 343, 355-356
Warner, John, 384
Washington Post, 384
Washington Project for the Arts, 140
Watkins, Carleton E., 368-370
Watt, James, 384
Watteau, Jean Antoine, 29
Watts Towers, 260
Weegee, 128
Weiner, Lawrence, 13
Weisman family, 254
Welling, James, 286
West, Benjamin, 236, 248
Weston, Edward, 123, 141-142, 203-204, 265, 277, 331, 368, 370
Whistler, James, 237
White, Minor, 287, 370
White, Ryan, 375
Whitney Museum of American Art, 72, 99, 101, 152, 169, 206, 209-212
Wildmon, Donald, 344-345
Wilson, Ricky, 375
Wilson, Robert, 256-257
Winkelmann, J.J., 248
Winsor, Jackie, 359
Winterthur Museum, 240-243
Wolfe, Tom, 383-384
Wolff, Kevin, 311
Wols (Alfred Otto Wolfgang Schulze), 254
Wood, Wallace, 10, 14
Worcester Art Museum, 105
Works Progress Administration (WPA), 119
World's Fair, 231, 235
World War I, 93, 113, 165, 192, 269, 276, 363
World War II, 28, 39-40, 117, 202, 272, 276, 283, 286, 293, 296, 352, 363
Wright, Elizabeth, 174
Wuppertaler Tanztheater, 257

Y

Yale University, New Haven, CT, 281, 349, 382; School of Art and Architecture, 79, 138
Yale University Art Gallery, 113: "Eva Hesse," 79-81
Yavno, Max, 370

Z

Zen, 19, 31, 109, 167
Zola, Émile, 135